ART OF WAR

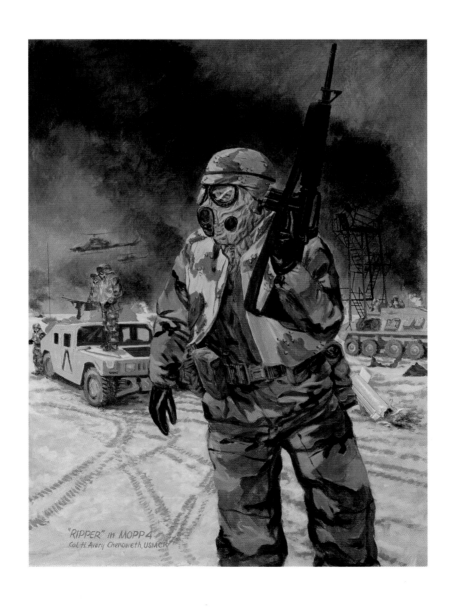

"RIPPER" in MOPP 4
Col. H. Avery Chenoweth, USMCR

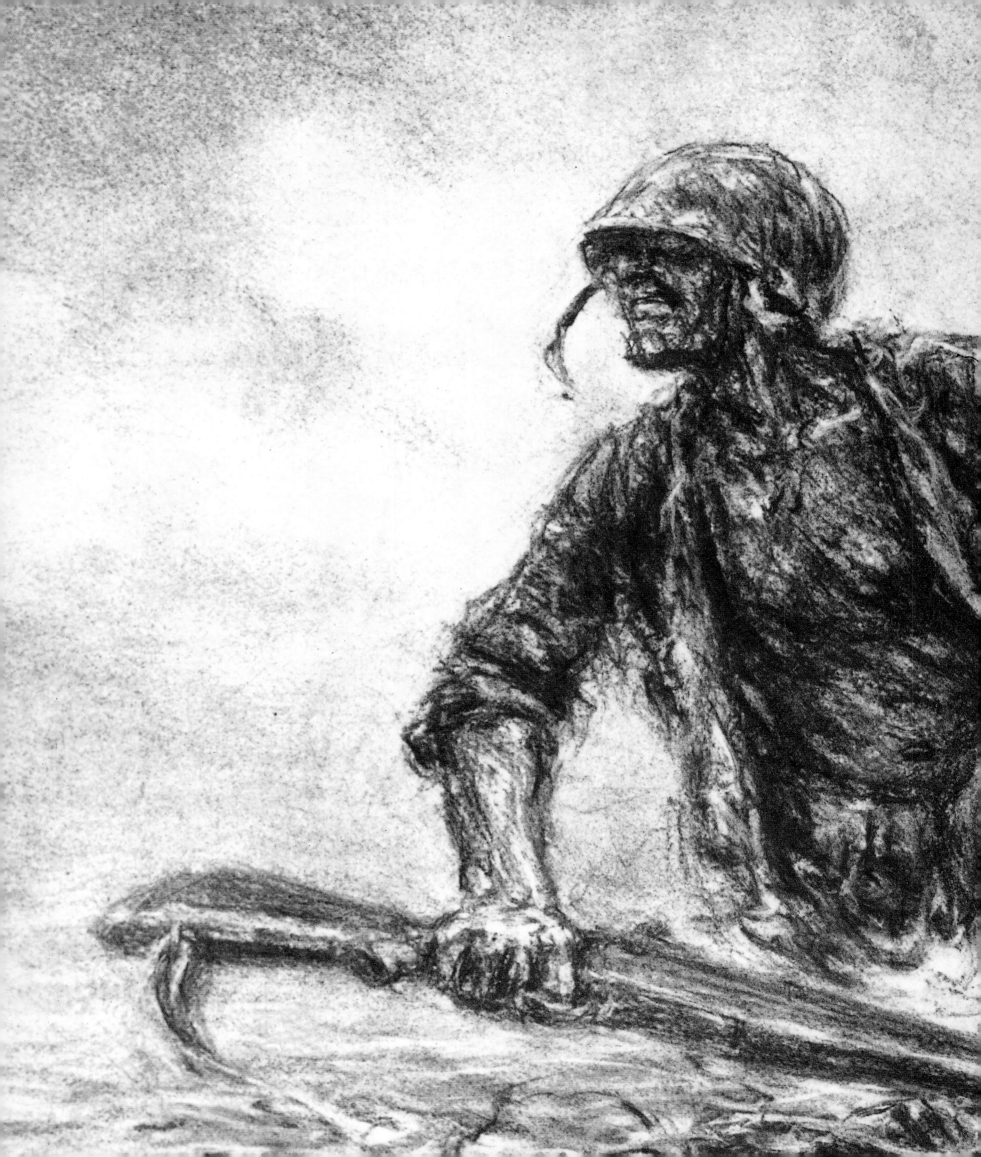

ART OF WAR

Eyewitness U.S. Combat Art
from the Revolution
Through the Twentieth Century

Col. H. Avery Chenoweth, USMCR (Ret.)

FRIEDMAN/FAIRFAX

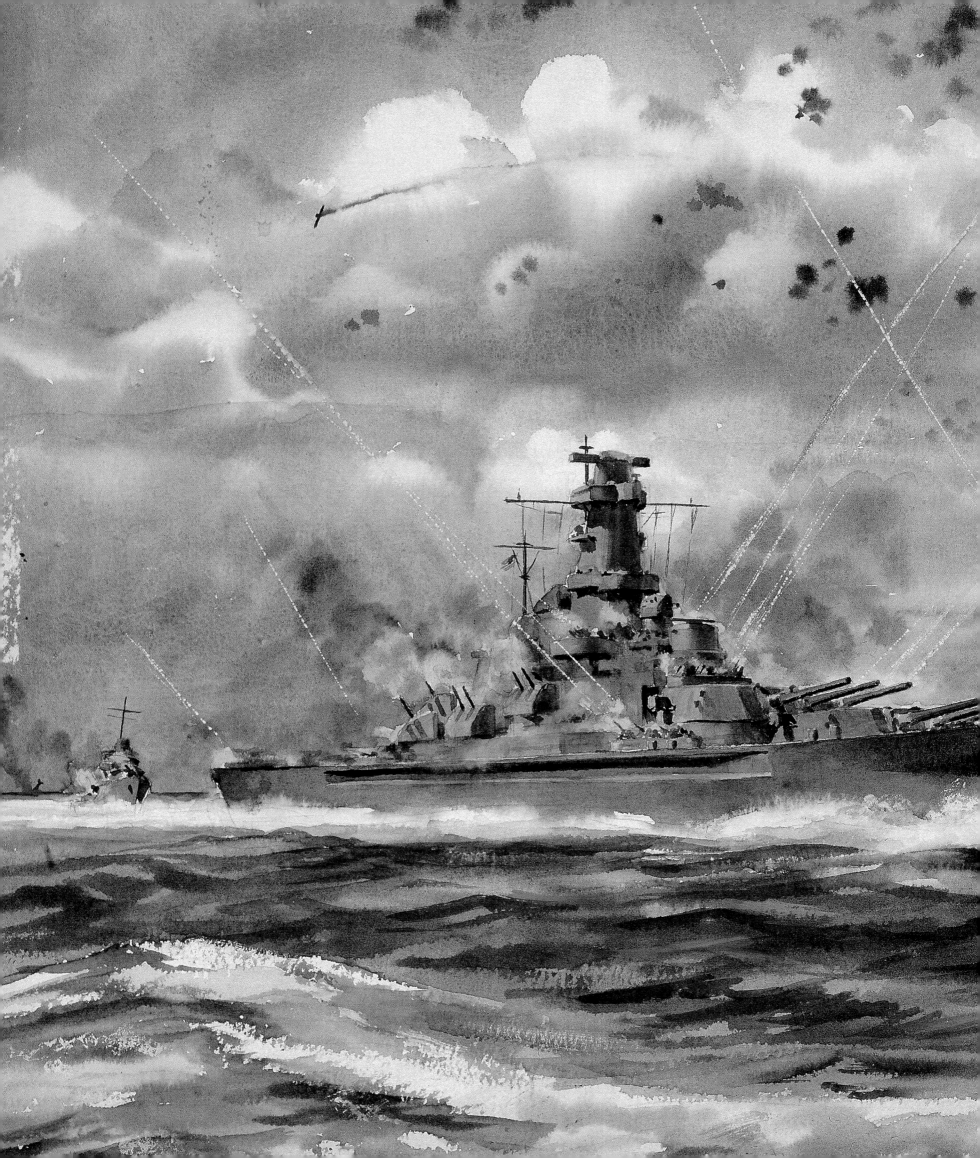

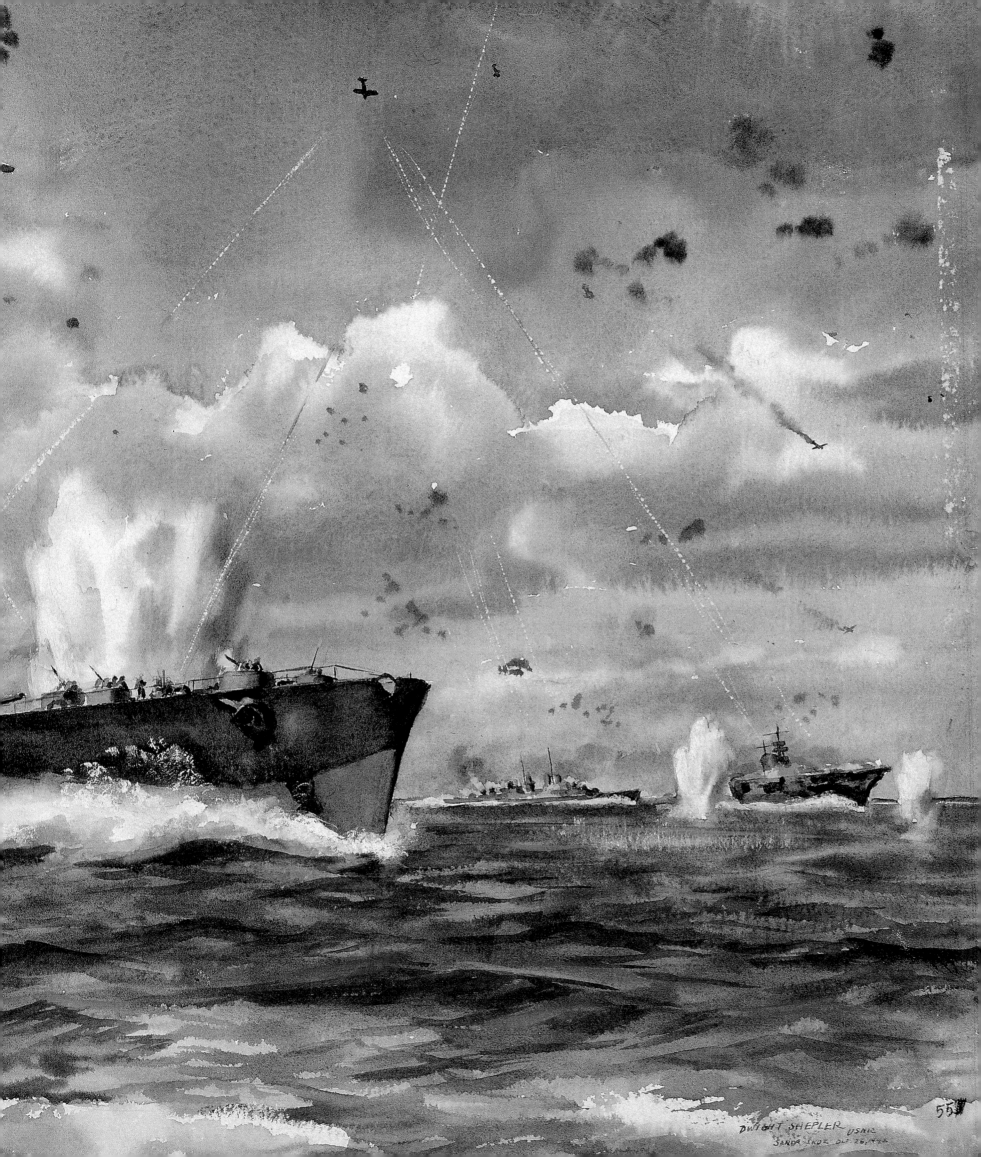

DWIGHT SHEPLER USNR
SANTA CRUZ OCT 26, 1942

55

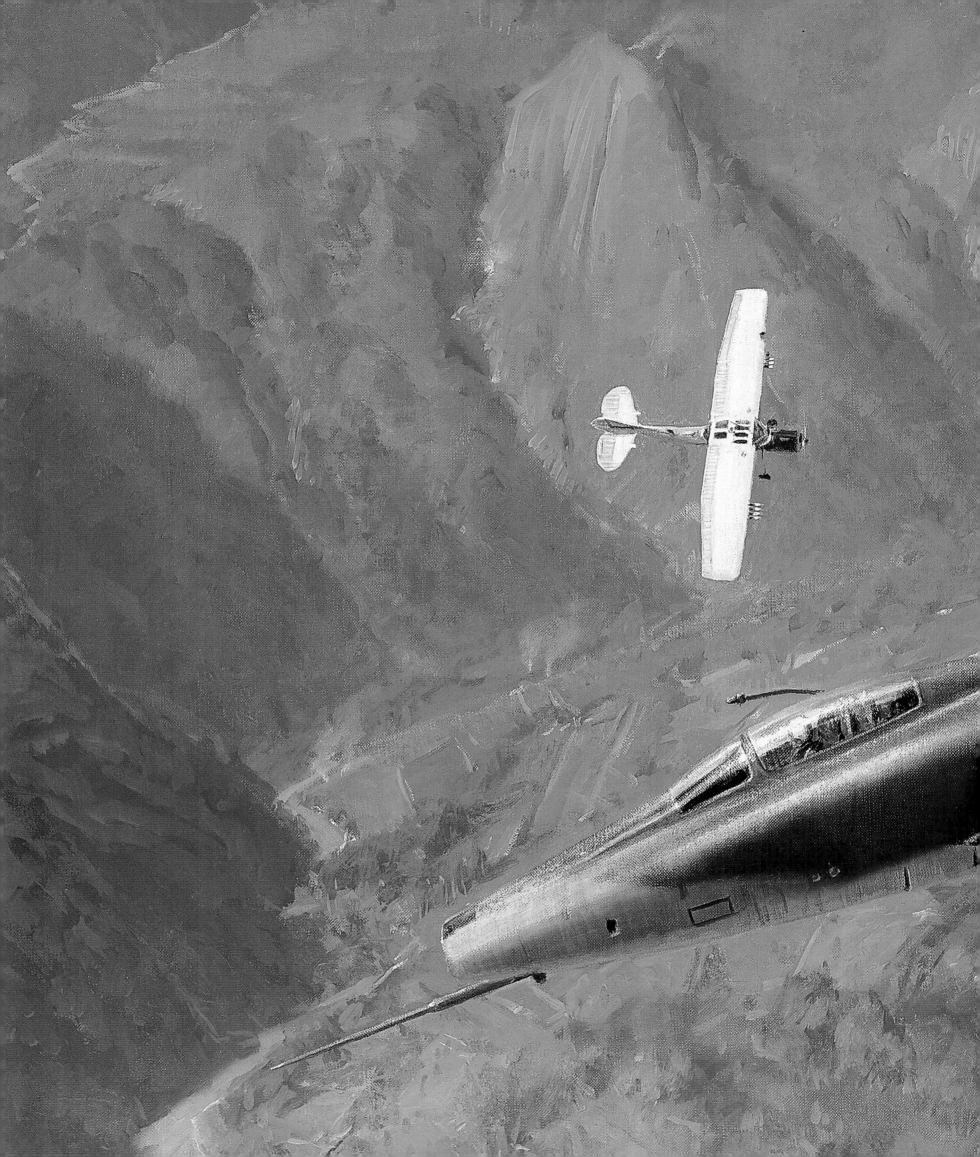

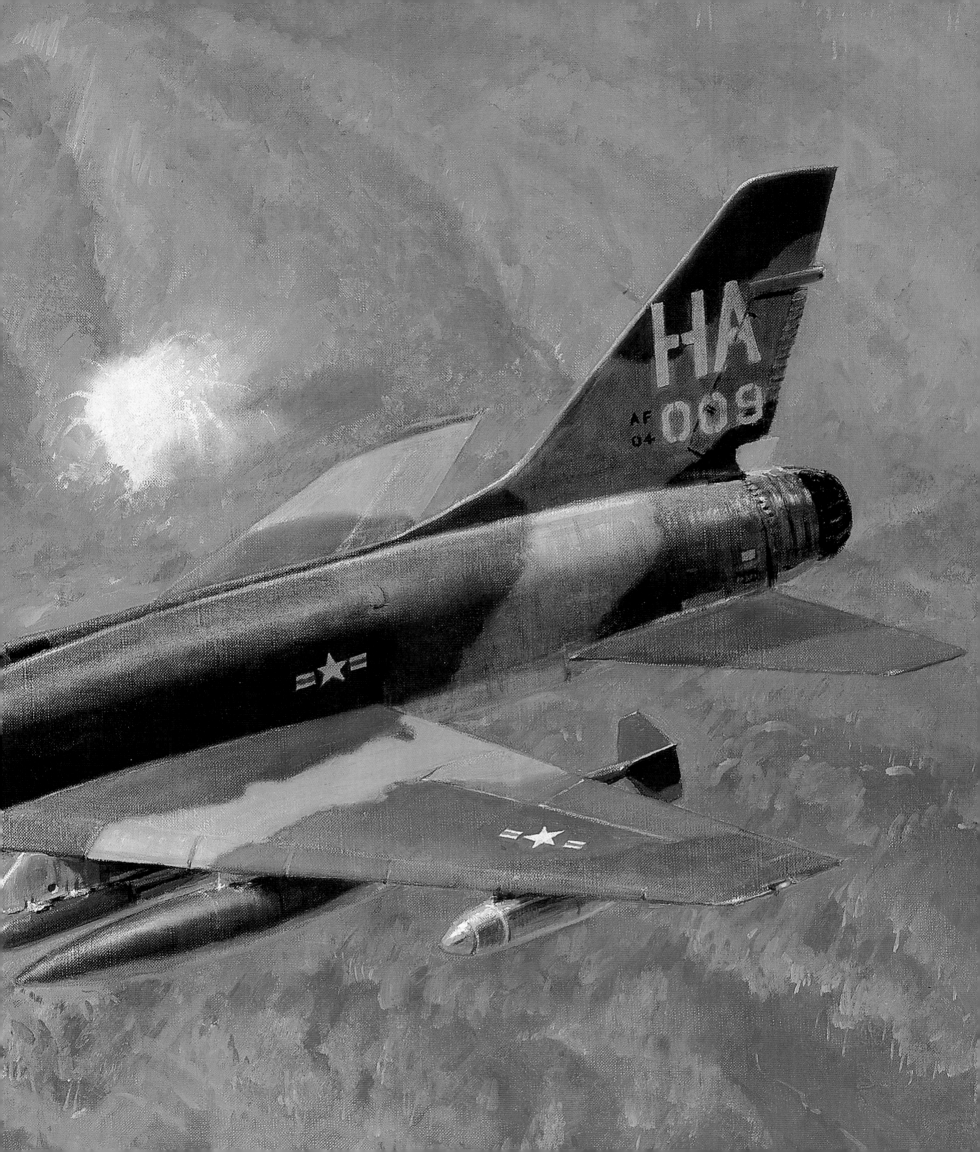

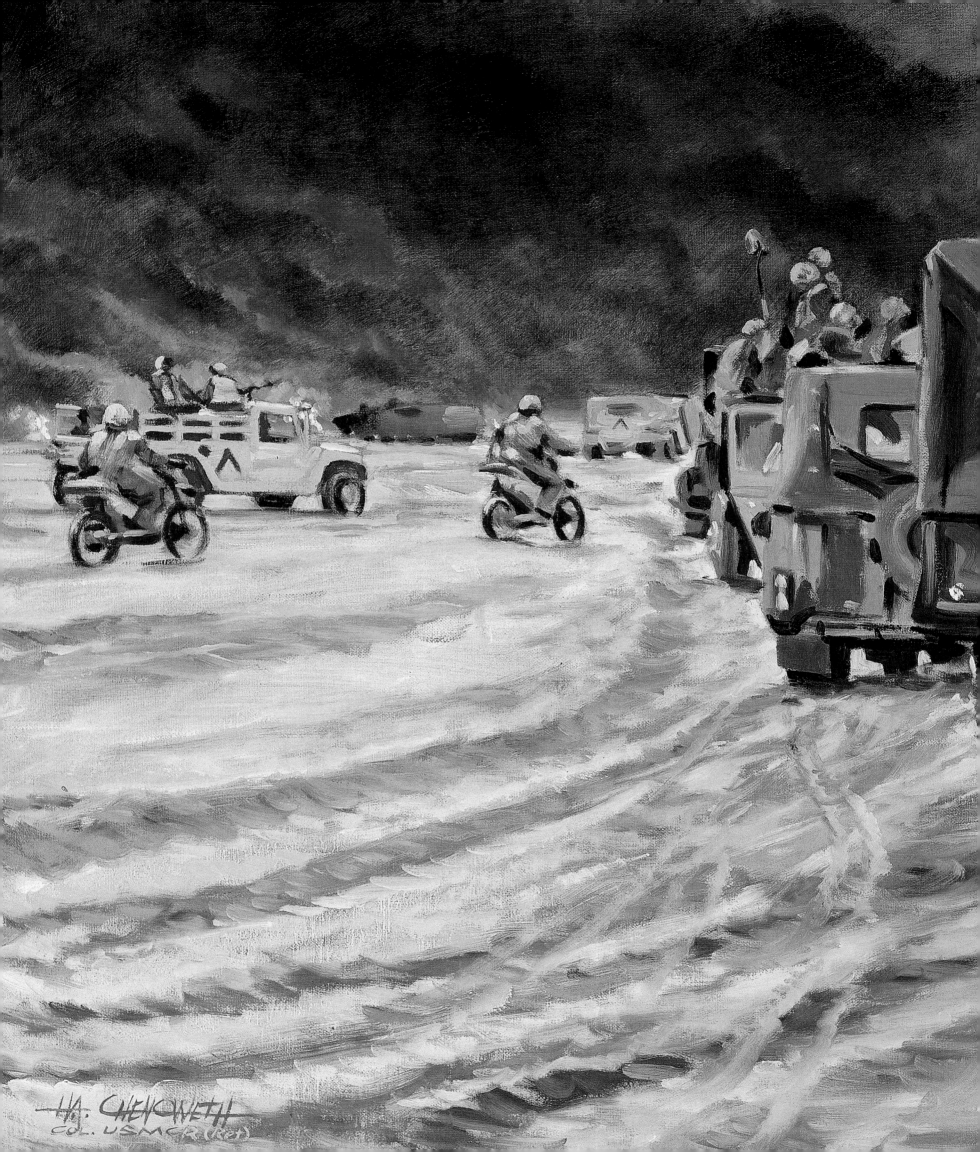

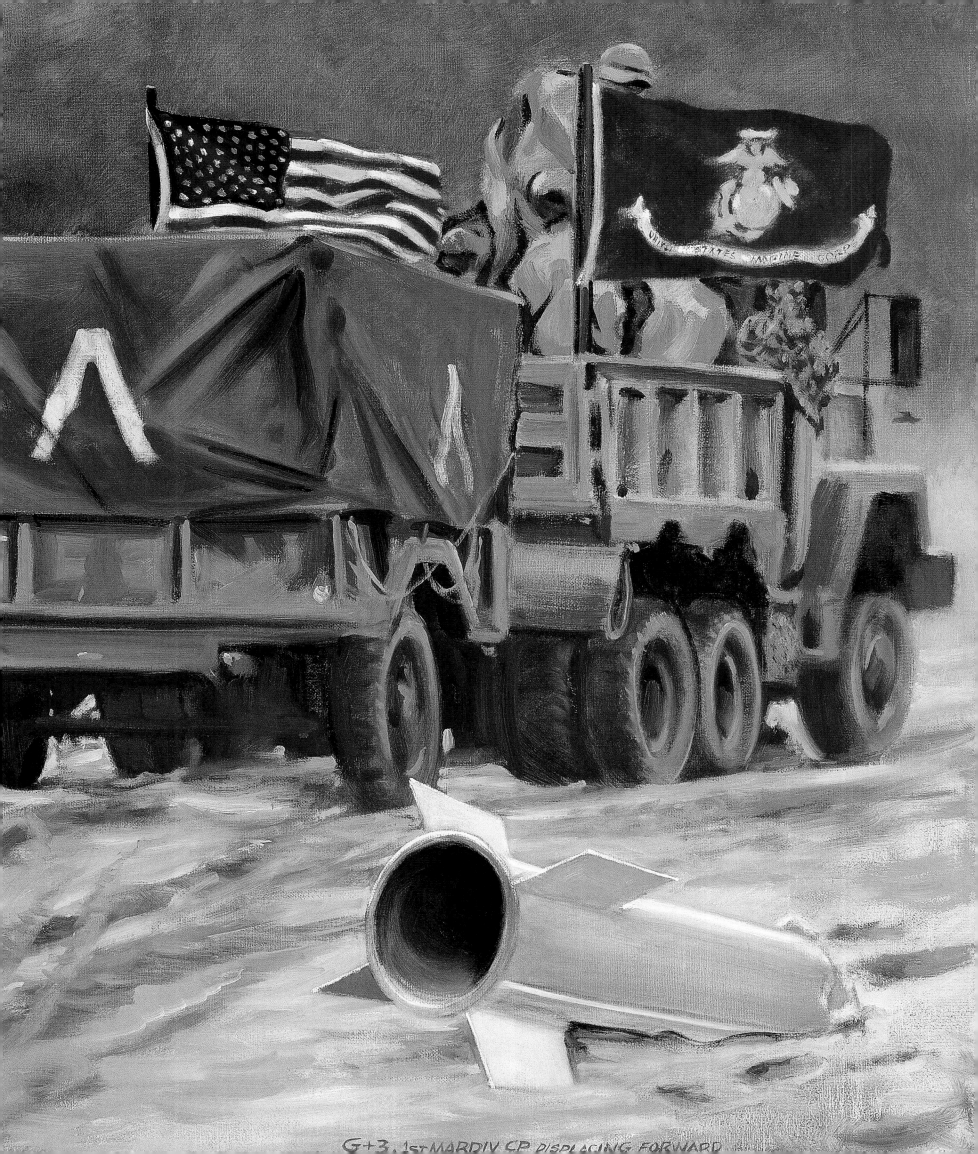

G+3, 1st MARDIV CP DISPLACING FORWARD

A FRIEDMAN/FAIRFAX BOOK

© 2002 by Michael Friedman Publishing Group, Inc.

Please visit our website: www.metrobooks.com

Chenoweth, H. Avery.
 Art of war : eyewitness U.S. combat art from the revolution through the twentieth century / H. Avery Chenoweth
 p.cm.
 Includes index.
 ISBN 1-58663-311-2 (alk. paper)
 1. War in art. 2. Art, American. 3. Soldiers as artists. I. Title.

N8260 .C48 2002
751'.9355'0973--dc21

2002072574

Project Editor: Nathaniel Marunas
Editors: Betsy Beier, Chris Kincade
Art Director: Kevin Ullrich
Designers: Daniel Lish, Wendy Ralphs
Photography Editor: Lori Epstein
Production Manager: Michael Vagnetti

Color separations by Bright Arts Graphics (Singapore) Pte Ltd.
Printed in China by Leefung-Asco Printers Ltd.

1 3 5 7 9 10 8 6 4 2

Distributed by Sterling Publishing Company, Inc.
387 Park Avenue South
New York, NY 10016
Distributed in Canada by Sterling Publishing
Canadian Manda Group
One Atlantic Avenue, Suite 105
Toronto, Ontario, Canada M6K 3E7
Distributed in Australia by
Capricorn Link (Australia) Pty, Ltd.
P.O. Box 704, Windsor, NSW 2756 Australia

Page 1: *MOPP 4*, by Col. H. Avery Chenoweth. MOPP 4 stands for "Mission Oriented Protective Posture at maximum '4'"—the top priority for a poison gas alert. It indicates that the complete gas protective suit—boot wraps, trousers, coat, gloves, and gas mask—had to be worn. U.S. troops attacked in the Persian Gulf War in either MOPP 2 or 3, only reverting to condition 4 a few times when mobile detectors sounded an alert.
USMC Art Collection

Pages 2–3: Civilian artist Kerr Eby went in with the Marines in their deadly assault at Tarawa and made this sketch of the action.
USN Art Collection

Pages 4–5: In Lt. Dwight Shepler's *Air Defense*, the USS *South Dakota* is seen in action during the Battle of Santa Cruz in the October 1942 Solomon-Guadalcanal campaign.
U.S. Navy Art Collection

Pages 6–7: In Maj. Wilson Hurley's *Happy Valley* an F-100 Super Sabre comes in for a bombing and strafing run in Vietnam.
Wright-Patterson AFB Museum

Pages 8–9: Chenoweth depicts the action on the last day on the four day war in Kuwait, when the 1st Marine Division encountered heavy smoke, sporadic rain, cool temperatures, and mud.

Opposite: Civilian artist Kerr Eby shows an impromptu graveside religious service, in this case held by a combatant, perhaps a buddy of the victim.
U.S. Navy Art Collection

Dedication

I proudly dedicate this book to three outstanding Marine officers, gentlemen, and friends, who each in turn became my mentor and greatly influenced the course of my "sideline" career as combat artist/illustrator during my forty-five-year association with the United States Marine Corps.

Gen. Samuel Jaskilka, USMC (Ret.), former Assistant Commandant of the Marine Corps and highly decorated veteran of three wars, was a captain in 1952 when he saw my combat sketches from Korea and steered me to the Division of Information and assignment as head of the First Marine Corps Combat Art Team.

Col. Raymond Henri, USMCR (Ret.) was head of the Marine Corps combat art program in World War II and a veteran of Iwo Jima. A founder and commanding officer of Public Affairs Unit 1-1, New York City, of which I also was a member, he was called back from retirement to active duty during Vietnam to again head the Marine Corps combat art program and to organize its art collection. I served under his direction as a combat artist in Vietnam in 1967 and 1969. Henri, a recognized author and poet, died in 1986.

Brig. Gen. Edwin H. Simmons, USMC (Ret.) is a highly decorated veteran of three wars. Simmons created and headed the Marine Corps Division of History and Museums in the magnificently renovated old barracks building at the U.S. Navy Yard in Washington. His efforts have been of inestimable value in the preservation of Marine Corps history—written, oral, and pictorial. It has been my privilege to have contributed to those efforts, which included my last combat art tour, covering operations *Desert Shield* and *Desert Storm* in the Persian Gulf War.

Simmons is a rare breed of military officer: an inspiring combat infantry leader as well as a writer and intellectual whose erudition is unequalled in military circles. He was decorated for bravery and is the author of major works about Marine Corps history. I consider myself fortunate to have witnessed his ongoing tenure as director of Marine Corps History and Museums for more than a quarter century. His perspicacity, vision, professionalism, broad knowledge, and foresight have served him well during this period in the creation of a lasting monument to the history of the Marine Corps.

These three U.S. Marine Corps officers exemplify the model naval officer as succinctly (if quaintly) described by Capt. John Paul Jones:

Besides being a capable mariner [professional], he should be as well a gentleman of liberal education, refined manners, punctilious courtesy, and the nicest sense of personal honor. When a commander has by tact, patience, justice, and firmness, each exercised in its proper turn, produced such an impression upon those under his orders, he has only to await the appearance of his enemy's topsails upon the Horizon.

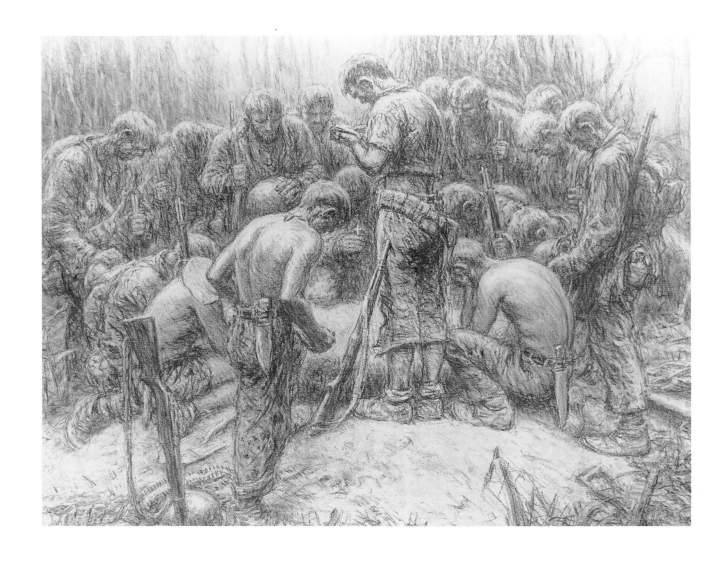

Acknowledgments

It is with deep gratitude and appreciation that I acknowledge the contributions, suggestions, assistance, and forbearance of the following people who helped with the writing of this book:

First, the Navy, Marine Corps, and civilian combat artists with whom I liaised and who assisted and offered suggestions; the dean of the World War II group, Tom Lea, who afforded me insights never before published, and the pleasure of his conversation at Quantico when he was awarded the Distinguished Service Award by the Marine Corps Historical Foundation; Albert K. Murray and John Groth, both of whom I met briefly years ago; former Marine combat artist and noted American Western artist, Harry Jackson; another noted Western and Air Force combat artist, Wilson Hurley; the godfather of all combat artists, Howard Brodie, who graciously provided some valuable material for use in the book.

On the Marine Corps side of the house, the late M.Sgt. John DeGrasse, USMC, my combat art teammate back in the Korean War; S.Sgt. Jim Fairfax, USMC (Ret.); colonels Charles Waterhouse, USMCR (Ret.), Ed Condra, USMC (Ret.), Mike Gish, USMCR (Ret.); Lt. Col. Donna Neary, USMCR; Maj. Burton E. Moore, USMCR; CWO Charles Grow, USMC; and retired Marine colonel and historical writer Joseph H. Alexander. On the Navy side, Capt. John Charles Roach, USNR, and former prisoner of war Capt. John Mike McGrath, USN (Ret.). Also, noted aviation artist Keith Ferris, who directed the Society of Illustrators' efforts in assigning civilian artists to the Air Force program during the Vietnam War.

At the Marine Corps Historical Center and Museum: former Deputy Director Brig. Gen. Edwin H. Simmons, USMC (Ret.), and former Deputy Director of Museums Col. Brooke Nihart, USMC (Ret.), both of whom proofed and critiqued this manuscript; Art Curator Maj. John "Jack" T. Dyer, USMCR (Ret.); former Chief Historian Benis Frank; Curator of Special Projects Richard A. Long; Exhibits Chief James Fairfax; Librarians Pat Morgan and Evelyn Englander; writers Anne A. Ferrante and Charles R. Smith; and Head Archivist Nancy Miller.

At the Naval Historical Center: former Director Dean C. Allard, Ph.D.; Combat Art Historian Henry Vadnais; Director, U.S. Navy Museum, Oscar Fitzgerald, Ph.D.; Senior Historian William S. Dudley, Ph.D.; Chief, Early History, Mike Crawford, Ph.D.; the late Curator of the Navy Art Collection, John Barnett, and the present curator, Gale Munro; Photo Chief Charles Haberline; and Glenn E. Helm, Library Reference Section.

At the Marine Corps Historical (now Heritage) Foundation: Brig. Gen. Simmons and Col. John Miller.

At the Navy Historical Foundation: Adm. James L. Holloway III, USN (Ret.) and Captain Ken Coskey, USN (Ret.).

Marine Corps Gazette Senior Managing Editor Col. John E. Greenwood, USMC (Ret.), for permission to use Sgt. Packwood's cartoons of Korea.

At the U.S. Naval Institute: Senior Editor, Naval Institute Proceedings, Col. John Miller.

At the U.S. Naval Academy Museum: Kenneth J. Hagan, Ph.D., Museum Director and Archivist, Professor of History, and Captain, USNR (Ret.); Curator James N. Cheevers; Mrs. Maureen Ward, Administrative Assistant.

Mr. Geoffrey C. Beaumont, who provided valuable insights into the work of his father, Navy artist Arthur Beaumont.

At the U.S. Coast Guard: Historian Robert L. Scheina, Ph.D.; Bob Browning, Ph.D.; Jim Ward, Department Chief; John Thorne, Historian; Kevin Foster, Art Archivist; Public Affairs Chief Frank Dunn, USCG; and Gail Fuller, USCG Curator.

At the U.S. Coast Guard Academy: Curator Valerie Kinkaid.

At the Center for Military History (Army): Head, Museums Division, Mr. Judson E. Bennett; former Curator Marylou Gjernes; Renée Klish, Curator; and Kevin Cruise, Assistant.

Head of the Air Force Art Program at the Pentagon: former Senior M.Sgt. Robert J. Arnold, USAF (Ret.).

At the Wright-Patterson Air Force Base museum: Maj. Gen. Charles Metcalf, USAF (Ret.); Jeffery Underwood, Ph.D., acting Curator; and Wesley B. Henry, Chief, Research Division.

At the Museum of American Art: Chief Curator, Smithsonian Institution, Virginia Macklenberg, Ph.D.; Curator of Naval History, Smithsonian Institution, Harold D. Langley, Ph.D.; Director, Parris Island Museum, Stephen Wise, Ph.D.; Military Specialist, Reference Section, Library of Congress, George S. Hobart; and reference specialists Maja Keech and Virginia Wood.

At the Prints and Photographic Division, National Archives, Still Picture Branch, Special Archives Division: Jonathan Heller.

At the Museum of the Confederacy: Registrar Malinda W. Collier and Manager of Photographic Services Corrine P. Hudgins.

Walters Art Gallery: Director Roy Corbett and Associate Director/Curator, William R. Johnston.

At the Virginia Historical Society in Richmond: Nelson Lankford, also Editor of *The Virginia Magazine of History and Biography*.

At the National Vietnam Veterans Museum: President and former combat Marine, Ned Broderick.

Thanks to cartoonist Bill Mauldin and his publisher, W.W. Norton & Co., for permission to reproduce his cartoons.

And a great measure of thanks to all those at Barnes & Noble's subsidiary Michael Friedman Publishing Group: former Editorial Director Sharyn Rosart, current Editorial Director Nathaniel Marunas, Editor Betsy Beier, Art Director Kevin Ullrich, Designer Dan Lish, Photo Editor Lori Epstein, Digital Imaging Specialist Daniel Rutkowski, and all the others who helped bring this book to life.

A special thanks to editor Chris Kincade. It was a distinct pleasure to work on the manuscript with him via the Internet. His talent and professionalism added much to the quality of this book.

And deep appreciation to Hugh Lauter Levin for forwarding this manuscript to the Michael Friedman Publishing Group, and to Jim Muschette on the Levin staff for providing valuable visual materials.

And, finally, thanks to my wife, Lise, whose inspiration kept me going.

Military Title Abbreviations

Adm., Admiral

Amn., Airman

Brig. Gen., Brigadier General

Capt., Captain

CBM, Chief Boatswain's Mate

Col., Colonel

Comdr., Commander

Cpl., Corporal

CPO, Chief Petty Officer

CWO, Chief Warrant Officer

Ens. Ensign

1st Lt., First Lieutenant

1st Sgt., First Sergeant

Gen., General

G.Sgt., Gunnery Sergeant

L.Cpl., Lance Corporal

Lt., Lieutenant

Lt. Col., Lieutenant Colonel

Lt. Comdr., Lieutenant Commander

Lt. (jg), Lieutenant, Junior Grade

Maj., Major

Maj. Gen., Major General

M.Sgt., Master Sergeant

Pfc., Private First Class

PO, Petty Officer

Pvt., Private

Rear Adm., Rear Admiral

Smn., Seaman

S1c., Seaman, First Class

2nd Lt., Second Lieutenant

Sfc., Sergeant, First Class

Sgt., Sergeant

Sp4c., Specialist, Fourth Class

S. Sgt., Staff Sergeant

Supt., Superintendent

T2g., Technician, Second Grade

T.Sgt., Technical Sergeant

Vice Adm., Vice Admiral

WO, Warrant Officer

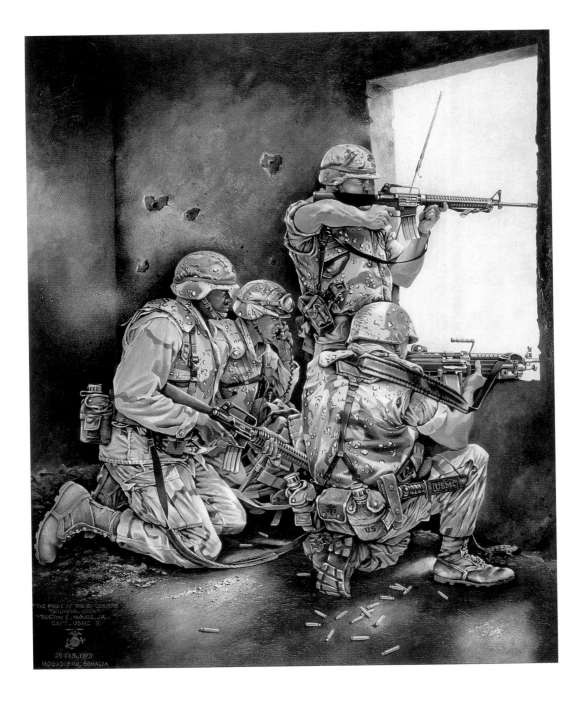

Left: Noted wildlife artist Burton Moore's painting of Marines of the 3rd Battalion, 11th Marines, in a fire fight at the American Embassy in Mogadishu, Somalia.
USMC Art Collection

Page 14: Civilian artist Tom Lea's haunting *Down from Bloody Nose–Too Late.*
U.S. Army Art Collection

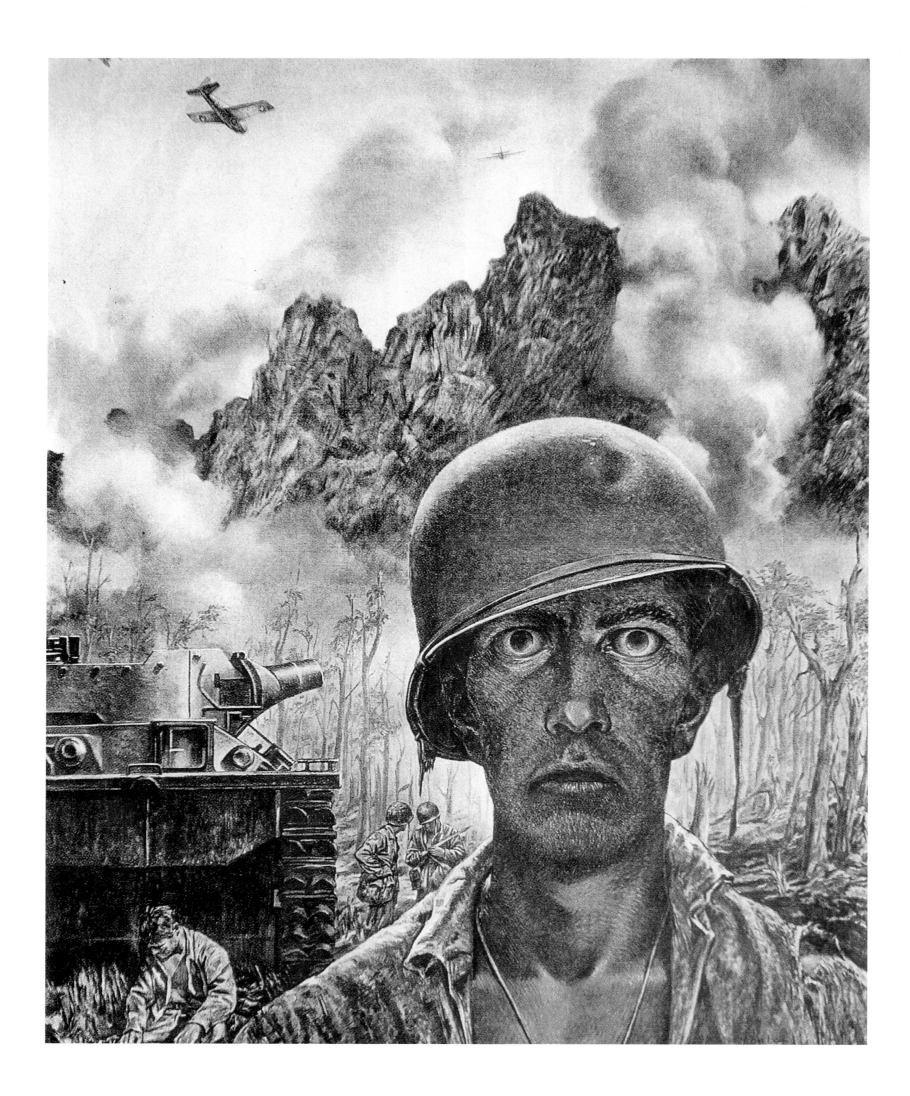

"He who has never felt a wound can hardly paint a scar."
ANONYMOUS

CONTENTS

Foreword

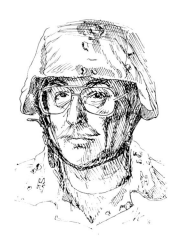

Retired Marine Corps Reserve Col. Horace Avery Chenoweth, Sr., multitalented, ever enthusiastic, ever energetic, and with proper artistic credentials, undertakes in *Art of War* a daunting task: the first-ever rationalization for and the organization of the combat art of the entire United States armed services—Army, Navy, Marine Corps, Coast Guard, and Air Force.

Col. Chenoweth pursues several theses, which need to be understood because they shape the book and because they are based on almost a half century of his own experiences.

Chenoweth argues that "battle art" has been a form of documentation throughout history and even prehistory, whether we are speaking of Stone Age scratchings on a cave wall or of the grand paintings of the nineteenth century. But he insists upon a number of distinctions and clearly defines a term used heretofore somewhat loosely. "Combat art," by his definition, is the most authentic form of battle art because the artist does it from his own observations or experiences in battle. If the battle art does not come from the experience of the artist himself, then it is something other than combat art.

This is a tough criterion. It puts outside the ken of this book some famous historical battle paintings by prestigious artists, because those artists did not experience the subject firsthand, but worked from imagination or at best from research or reconstruction based on the experience of others. "The spark of authenticity of the actual observer is absent," says Chenoweth.

In the same vein, he distinguishes between illustration and fine art. The distinction has little or nothing to do with the talent or technical skill of the artist. Illustration has a specific, usually fairly narrow, purpose. Fine art captures a universal quality. The same artist can cross the line, back and forth, according to Chenoweth, between art and illustration. Many fine artists and fine illustrators did combat art, as did many amateurs and even prisoners of war. The distinction is that they were all there, on the spot, in the heat of things.

Military types are for the most part a pragmatic lot, and they like their art to be realistic. They tend to prefer the photorealistic results more easily achieved in an oil or acrylic painting to the more impressionistic representations typical of pastels or watercolors. Moreover, they like art that they can easily recognize and understand rather than abstract expressions. But Chenoweth would argue that realism stems more from the artist's interpretation of reality rather than from the technique or medium. All the same, most of the artwork in the canon and in this book are in the realistic tradition.

Born in 1928 in Jacksonville, Florida, Col. Chenoweth attended the University of the South at Sewanee, Tennessee, the Yale School of Painting, and graduated from Princeton University with an A.B. in Art History in 1950. During his undergraduate days he spent two summers at Quantico, Virginia, in the Platoon Leader's Course, which led, upon graduation, to a commission as a second lieutenant in the Marine Corps Reserve. The Korean War began, and in short order he was called to active duty and sent to Korea in January 1951, where he was a rifle platoon leader in the 5th Marines, 1st Marine Division. Later, showing the sketches he had done in brief moments during combat, he was assigned as officer-in-charge of the Marine Corps First Combat Art Team for the Division of Information at Headquarters Marine Corps. As such, he re-created paintings of his experiences in Korea and the Marine Corps' atomic warfare exercises at Yucca Flat, Nevada, in 1952. He studied painting at the Corcoran Art School while stationed in Washington, DC, and later earned an MFA in painting at the University of Florida, the thesis for which became the basis for this book.

For forty-five years thereafter, he pursued a career in the visual arts, mostly in television and advertising in New York City, alternating with periods of active duty as a military artist. In organized reserve units, he trained in amphibious warfare, attended command and staff schools, and completed the Reserve Naval War College course.

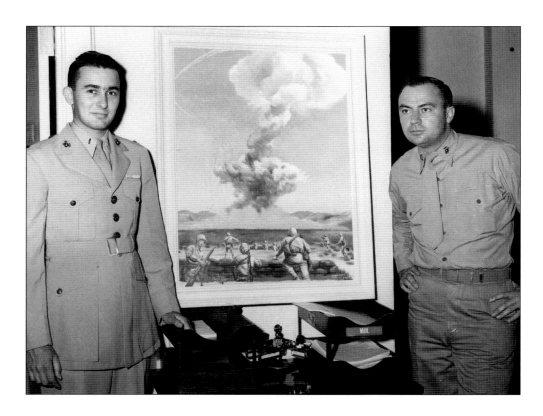

My own experiences over a quarter century heading the historical and museums efforts of the Marine Corps bear out Col. Chenoweth's theses. Combat art certainly adds a unique and invaluable dimension to military history, as Chenoweth points out, complementing the more familiar written and photographic perspectives.

In this book, Chenoweth has done an invaluable service to the overall historical effort in researching and documenting most of the combat artists of the U.S. military services since the American Revolution, and in choosing the representative works here from the rare and scattered collections that still exist. Many of these artists would otherwise have been forgotten, and as such, *Art of War* promises to become a major resource for military and art historians alike.

For the Persian Gulf War, although already on the retired list, Col. Chenoweth voluntarily came back on active duty for fifteen months beginning in the winter of 1990. In Saudi Arabia, he served as the Marine Corps' field coordinator for combat art. His charge to artists working in the program was: "It is imperative that your work be firsthand and original. The distinctive way that you as an artist see the activity and record it is what makes combat art valid."

Chenoweth went through the ground war with the 1st Marine Division and produced some fifty paintings and dozens of drawings and sketches. For his work, he was honored by the Marine Corps with the Legion of Merit.

The Marine Corps Historical Foundation also gave Chenoweth its prestigious Col. John W. Thomason Award for Artistic Achievement in 1991 for his body of work on the Persian Gulf War. He had previously won the award in 1988 for a series of "portraits" of Marine aircraft, making him the award's only two-time recipient. (Thomason was a highly respected Marine artist and writer, whose pen-ank-ink work in France during WWI marked the beginnings of Marine Corps art.)

Four of Chenoweth's portraits of early Marine Corps Commandants were hung in the Pentagon. In addition to the innumerable pieces from the three wars he served in that he had donated to the Marine Corps Combat Art Collection, his work is to be found in the Princeton Art Museum collection, the British Royal Marines Museum, and numerous corporate and private collections in the United States and abroad. A compulsive—and experienced—teacher, he has also taught art at all levels and given lectures on combat art at the Smithsonian Institution, various military branches, and civic clubs.

Col. Chenoweth's overall contribution to the U.S. Marine Corps has been exemplary; this book on combat art is a seminal work and a valuable effort of even wider importance to the field of military history.

—Edwin H. Simmons,
Brigadier General, United States Marine Corps, Retired
Director Emeritus, Marine Corps History and Museums

Below: In Kuwait, Col. H. Avery Chenoweth painted Navy chaplains Lt. Steve Dugaitas and Capt. Stanley Scott as they prepared for the next day's engagement by reviewing the ninety-first psalm in the Old Testament, which calls for God's protection in battle. Few slept soundly that night. **USMC Art Collection**

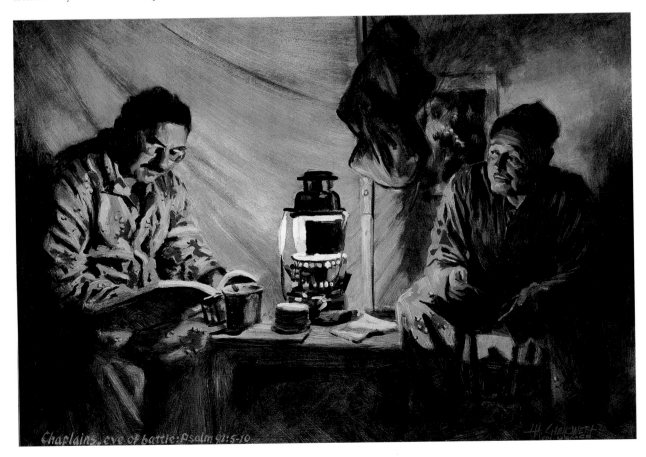

Chaplains, eve of battle: Psalm 91:5-10

Preface

In "Experience by Battle," a 1943 article for *Life* magazine, author John Hersey, no stranger to war, described the combat artists he had come to know in World War II: "These men were warriors who carried strange weapons—rolls of canvas, tubes of precious turpentine paints, brushes, pencils, and notebooks. A further strength of these paintings lies in the fact that the artists are in no important way different from our fighting men. These artists are not long-haired, loud-talking aesthetes. They are normal, healthy, peace-loving men…most of them have been through rough times. One of them worked as a field hand, road worker, fruit picker, lumberman. Another once sold score cards in a ball park. Two have held boxing titles. Two of them are in the Navy in this war, and two others were in the last war. Our fighting forces are made up of men like these."

Although the artists in the following book are brave men and women who faced deadly peril like any combatant, the combat artist is something of a contradiction: in a dangerous combat situation, they are the ones reacting with a concern for aesthetics. Certainly, Marine Capt. John Thomason, who wrote and illustrated one of the most popular books to come out of World War I, *Fix Bayonets!*, must have appeared out of place as he lead his men during the Battle of Belleau Wood, stopping momentarily to sketch on the back of a paper wrapper. Often, though, it is just such a situation of stark terror that triggers the universal insights and unexpected moments of paradoxical beauty that the artist is moved to capture. The sensations of battle are like no other; one cannot help but react deeply, and artists are able to express in visual terms the essence of what others see and feel as well.

Still, the "art" of war is generally overlooked or dismissed by the art critic and historian, perhaps because it is seen as illustration or, in some cases, propaganda. The best of it, though, should be recognized for adhering to a set of values that major, contrived war pieces by historically recognized fine artists do not. In fact, though they have never received the artistic accolades given to the war scenes of Rubens, Velázquez, West, and Goya, artworks such as Conrad Chapman's series on Confederate forts, Frederic Remington's artistic coverage of the Spanish-American War, and Kerr Eby's sketches of the Battle of Tarawa are every bit as substantive. These artists were actually there, in combat, and portrayed what they personally saw and felt, not what they learned later. (With the possible exception of Francisco Goya, none of the earlier artists mentioned created their battle scenes from firsthand experience.)

At the very least, combat artists understand the true nature of battle in a way nonparticipants cannot. For instance, combat is sporadic and hardly ever sustained at a prolonged high pitch. In fact, most combatants and combat artists fight boredom during the interim between battles. Preparation, training, and the mundane routine of camp life fill the void.

In World War II in the Pacific, months upon months of preparation would precede one Marine unit's short, horrendous clash on a Japanese-defended beachhead atop a tiny, obscure volcanic atoll. Or months and possibly years at sea on escort, patrol, surveillance, and transport duty would lead up to a ship's unfortunate rendezvous with a Japanese Kamikaze plane, scant weeks before the end of the war. Even large-scale land campaigns are rarely continuous, interlocked affairs. They are usually sporadic engagements, with pockets, lines, and areas of resistance constantly in flux. And, more often than not, combat artists find themselves in dull periods. Yet these moments are as valid a part of the combat whole as the actual fighting, and their pictorial record of such lulls equally as important. Often, the top brass in Washington, far from the fighting zone, would criticize the output of combat artists for portraying this "inactive" side of combat activity. In the case of World War I's Army "Eight" (see Chapter 5), the high command expected melodramatic illustrations for propaganda purposes and were disappointed in the depiction of so much rear echelon nonfighting.

When critics complained that World War I Army artist J. André Smith's portrayals were too peaceful and calm (for instance, depicting quiet nights in a dugout), he retorted that "artists were endeavoring to portray military life as truthfully and honestly as possible without resorting to sensational tricks and fakes." Consequently, combat art is not all blood and guts. Rather, the combat artist portrays everything and anything that interests him and that contributes to the telling of the story pictorially.

Unless he is observing from the air, any combatant has a perspective of war that is small, personal, and rather limited. It is the same for the combat artist, whether he is focusing on the broadest panorama or the smallest detail. The challenge is simply capturing what is there and what takes place. Often the combat artist compacts time frames, overlaps events, and synthesizes actions into a universal essence. Visually, these composites can sometimes better explain what happened than a series of isolated minor events or details would. Some artists stress the human factor (faces, figures, and body action); others, the machinery and tools of war. Taken together, all these perspectives tell the complete story.

As a theme for literature or art, war, which is both fascinating and repellant, has always been compelling. For people who have never tasted combat, it might seem romantic, some sort of glorious adventure. For people

who are thrust into combat, though, it is more often a brutal reality that they would just as soon not repeat, however well they might have survived or proven their mettle. When looked at overall, combat art tends less to portray gore and death than it does the in-between moments—the serendipitous periods of beauty between ghastly events, the sudden revelation of some universal truth—that offer us insight into the great yet fragile forces of life and death.

Furthermore, eyewitness combat art should be viewed as a legitimate form of historical reportage. The world is familiar with eloquent written descriptions of historic engagements and with the photographs of engagements since the mid-nineteenth century. Eyewitness combat art, especially since the Civil War, is the vital third element that can help us expand and amplify the historical record.

The unusual qualities of the combatant-artist are perhaps best exemplified by the early American artist Charles Willson Peale. As his biographer, Charles Coleman Sellers, describes it, when the Philadelphia Militia was called up in 1776, Peale "donned his brown uniform [which he designed for himself as a lieutenant], his black tri-cornered hat, sword, musket [with telescopic sights of his own invention], a quarter cask of rum, tucked his painting kit under his arm and led off his company of eighteen men." A veteran of many battles, including the Battle of Princeton, the future Col. Peale laid aside his powder horn for his paint box whenever he had the opportunity, and, using bed ticking for canvas, painted magnificent portraits of Generals George Washington, the Marquis de Lafayette, Nathanael Greene, and others. Although battle was not Peale's primary artistic inspiration, one old Continental said of him when he died, "He fit and painted, painted and fit."

In the final analysis, the work these combat artists produced has earned its rightful place in the annals of U.S. history. The recognition they have received since the Civil War is, perhaps, testimony to the fact that war must be witnessed and experienced to be honestly portrayed. As someone, taking liberty with Shakespeare's words, once said, "He who has never felt a wound can hardly paint a scar." Though few combat artists were actually wounded in battle, these words remain a fitting tribute to the long line of patriot-artists who have experienced combat, from the Revolution to today. To honor them, *Art of War* features combat artists of all the military service branches (the U.S. Army, Navy, Marine Corps, Coast Guard, and Air Force), as well as the civilian artists who found themselves eyewitnesses to battle.

It should also be noted that every effort has been made to evaluate and fairly balance the combat art portraying the engagements of all the military services. However, in some cases, records, recollections, information, and actual artwork were not fully available. This is a shame, especially in light of combat art's success in World War II. Since then, the service branches have had ample opportunity to collect biographical materials, oral histories, and the artists' comments on their works of art (i.e., where the action was, how the piece was executed, what conditions were like, and so on). As of this writing, however, no service has a concise history of its combat art program, and some can provide no more than the names of their artists—often without the rank of the individual. Nor have the Society of Illustrators, the Navy Art Cooperation and Liaison Committee (NACAL) groups, or the Salmagundi Club compiled any records. Only the Marine Corps took photographs of its combat artists in Vietnam, although it, too, failed to chronicle their activities historically.

The caliber of artistic talent that was available or emerged in each war varied as well. In Vietnam, for instance, the efforts of the NACAL civilian artists greatly assisted the Navy and Marines' combat art efforts, as the Society of Illustrators did the Air Force's. But while the Army did have its own uniformed artists, and some civilians did contribute, their collective output did not match the quality of work from the *Life* magazine and Abbott Laboratories artists who had covered the Army in World War II. Therefore, if a particular service's combat art in certain wars appears sparse, it is because that material was not available or because it was not of the same caliber as others.

For the historical record, every available name of the artists who served in combat in or with the armed services since the Revolution, and who left a visual eyewitness account of it, is included in this book. I was able to find the names of more than 650 artists who served in combat and have listed them in the appendix, by service branch/engagement. Also, historical background material has been provided to help the reader better understand the artists' achievement and how those achievements fit within the overall picture of events.

—H. Avery Chenoweth, Sr.
Colonel, U.S. Marine Corps Reserve, Retired
Ashburn, VA
March 30, 2001

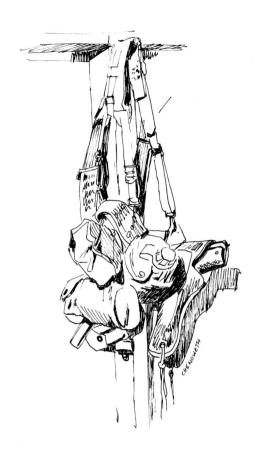

Above: 782 Gear, by Chenoweth.
USMC Art Collection

Introduction

The names of most of the artists in this book will not be found in today's art histories, but these military artists are unsung heroes of an under-recognized but valid branch of art history. In fact, the combat art reproduced here, a cross section of the best American work done from the Revolution to today, should be viewed as fine art in the best sense. Although illustrative—that is, descriptive of observed events—combat art is not illustration, as that term is normally understood (i.e., as an imaginative, after-the-fact visual reconstruction, usually for commercial purposes).

While combat art falls into the broad realm of historical painting, the distinguishing characteristic that separates combat artists from fine artists and illustrators—and their work from war art, battle art, battle pieces, and war illustration—is that they actually participated in or observed the military actions depicted in their art. They were there on the spot, either performing military duties in the heat of battle or as witnesses.

A few of these artists died on assignment. Artist-correspondent James O'Neal was killed in a Civil War battle, and two others lost their lives in World War II: Lt. Comdr. McClelland Barclay, USNR, aboard a missing LST in the Pacific, and sixty-three-year-old *Life* artist-correspondent Lucien Labaudt, in a 1943 air crash on his way to China. Some, too, received awards for heroism (Bronze Stars to Lt. Comdr. Dwight Shepler, USNR, in World War II, and Marine Reserve Maj. Mike Leahy in Vietnam). Whatever their individual stories, their work is of inestimable value to the historical account. Before the perfection of military photography early in the twentieth century (Mathew Brady's Civil War work notwithstanding), in fact, the artwork of artists in the field was the only extant visual evidence of battle. Even as recently as World War II, depictions of the night actions of several South Pacific engagements by Navy artists Lt. Comdr. Edward Grigware and (then) Lt. Dwight Shepler remain the sole visual records. Artists who have seen a battle can remember it and compact, encapsulate, and "panoramitize" it, where photographers cannot.

Above and beyond its rightful place in the historical archives, the best work of these combat artists should be recognized for its own merit, not simply as the self-promotion of the various branches of the military or the routine documentation of war. These artists managed to capture other times, other worlds, and some of the essential truths thereof. Beyond surface style or fashion, every period of our past has its essence, a unique collection of qualities that is so often the fodder for nostalgia. Readers who have lived through some of the events depicted in these pages will savor this quality; perhaps others will look upon the events with new insight.

The Ingredients of Combat Art
Tactical Military Art

From time immemorial, the most basic application of military art has been practical, tactical: topographical sketches, military battle aids, maps, strategic reconnaissance sketching, and, as of World War I, camouflage. Before the camera's perfection, as one can imagine, a sketch of enemy fortifications and maps showing potential battle areas and key terrain features were essential elements of information necessary for the conduct of war. Particularly prevalent was the panoramic bird's-eye view, either actually observed from an elevated position or constructed from an imagined aerial perspective.

These bird's-eye views were always of value to the commander in making the best use of topography—so much so, in fact, that when the U.S. Military Academy was created at West Point in 1802, Military Graphics (or Drawing) was a mandatory course in its curriculum. Noted artist Col. Robert Weir instituted the program and taught it for a number of years. Almost every officer who graduated was a competent and accurate sketcher, and many produced rather commendable student work, including Robert E. Lee, Thomas "Stonewall" Jackson, Ulysses S. Grant, William T. Sherman, Jefferson Davis, James McNeill Whistler, and Edgar Allan Poe. (The latter two did not graduate, though they went on to full artistic and literary careers.) By the Civil War, West Point's focus on sketching fundamentals turned out to be quite valuable for both sides. In *Eye of the Storm*, a book of recently discovered Civil War sketches, maps, and diary entries by Union mapmaker-artist Pvt. Robert Knox Sneden, editors Charles F. Bryan, Jr. and Nelson D. Lankford point out that most available maps at the time were obsolete and worthless for military use. According to the editors, one officer complained that they "knew no more about the topography of the country than they did about Central Africa"; consequently, both North and South devoted considerable time to the production of accurate maps. Topographers were given special treatment and allowed to move about freely.

At sea, too, there was a long tradition of ship's officers sketching important engagements for the historical record, including shoreline profiles as adjuncts to charts. Although sketching was not a part of the early curriculum when the U.S. Naval Academy was founded in 1845—the Academy concentrated instead on engineering and English—the superintendent, Capt. Franklin Buchanan, USN, may have been the same Lt. Buchanan whose

sketches of the War of 1812 were used as models for Nicholas Pocock's paintings. If these are in fact by the same Buchanan, it's odd that the superintendent did not feel the necessity to put such a drawing course in the Annapolis curriculum. Regardless, he must have recognized the value of a naval officer's being able to sketch what he saw. A modern example of the long-standing naval tradition of combat sketching occurred in the recent Gulf War. When, in one instance, cameras could not do the job, Sgt. Charles G. Grow, a Marine combat artist looking through binoculars, did a quick, accurate sketch for an artillery fire mission called in to destroy an enemy target.

As for the tactical value of camouflage, early in World War I, the French and British sensed the value of using trompe l'oeil effects and employed artists to come up with designs, colors, and variations in values of black and white to fool non-color photography. Since shipping was vital to the British, they hacked up the silhouettes of their vessels with dizzying, jagged lines and colors meant to confuse enemy submarines. U.S. Army artist Ernest Peixotto observed ships "brilliantly camouflaged like wasps, queerly striped with black and white, with spots between of yellow, grey-blue, and water-green." Sometimes painted in low visibility colors and "toned like Monet's pictures with spots of pink and green," they never failed to fascinate Peixotto. Even today, modern hi-tech aircraft are painted radar-blind gray, and aviation artist Keith Ferris has even designed a false canopy that is painted on a plane's underside to confuse opposing pilots in their high-speed, split-second visual identification encounters.

A story goes that Spanish cubist artist Pablo Picasso, who was living in Paris as a neutral during World War I, was strolling Boulevard Raspail in 1916 when he was startled to spot a convoy of military trucks painted "cubistically," in his style of jagged prisms, broken shapes and edges, and zigzagging lines. A year later, a young artist and U.S. Navy seaman, Norman Rockwell, was initially assigned to paint camouflage on airplanes. (When his extraordinary talent was discovered, Rockwell was instead sent stateside to paint portraits of admirals and other officers, apparently a higher priority for such talent during World War I.)

Combat Art versus Illustration

For our purposes, combat art is defined as art done only *in* or *from* actually observed or experienced battle, as opposed to historical battle art or illustration created from the imagination. The latter two are valid in their own right and the result of after-the-fact research and reconstruction, quite often from eyewitness accounts. Illustration, though, is always imaginary, often fanciful, and the spark of

authenticity of the actual observer is absent. The give-away is usually the point of view the illustrator has taken, often one from which it would have been impossible to have viewed the scene. Notable examples include the perspective from the enemy's side as our troops attack, as Frank Schoonover portrayed in some World War I works, or the noted Navy artist Griffith Baily Coale's panoramic, almost fisheye view of the Japanese navy under attack during the Battle of Midway—a vantage point that would have been available only to the sole surviving pilot from two attacking torpedo squadrons, Ens. George Gay. Floating in the water after his and all the other aircraft had been shot down, Gay alone would have had the perspective from which Comdr. Coale paints. Perhaps he questioned Ens. Gay for accuracy; at any rate, his excellent mural (now at the Naval Academy) is ultimately a reconstruction—he compacted the action and added artistic overtones based on after-the-fact research.

Ironically, it is Thomas Hart Benton, not known for combat art in the same way Coale is, who comes closer to defining combat art with his portrayal of the submarine *Dorado*. Although Coale's work is a closer depiction of reality, Benton's is based on firsthand experience. Still, Benton has taken the experience witnessing the *Dorado*'s target practice and turned it into a contrived scene of the *Dorado* shelling an enemy ship. His fanciful

Below: A magnificent example of high quality illustration is R.G. Smith's depiction of Comdr. Denny Wisely in his F-4 Phantom shooting down a North Vietnamese, Russian-made MiG fighter over North Vietnam. The work falls into the category of illustration for the simple reason that it is imagined, a reconstruction, since Smith could not have been there to witness the event; he would not have been allowed to go into a combat situation, even in an accompanying aircraft. The risk would have been too high, both for him and for the Navy aircraft and crew.
Courtesy of the Artist

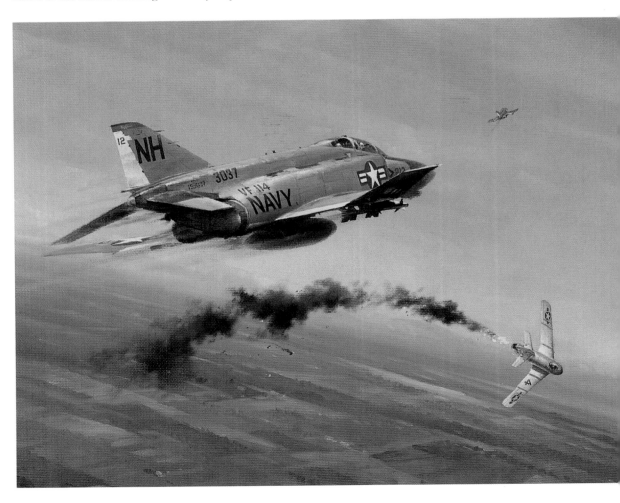

work, then, is not true combat art, but instead an eyewitness illustration.

Some discussion of illustration is necessary. While in art any subject matter, as well as its artistic treatment, might be termed "illustrative," that is portraying an incident or event, the term "illustration" when applied to art of the nineteenth and twentieth centuries usually refers to commercial or advertising art. And, while some illustration is meant to stand alone, like Currier & Ives' prints in the nineteenth century, or Civil War illustrations and aviation art created today, the term "illustration" mainly refers to artwork created for a specific purpose to convey a commercial message, usually accompanying advertising. Both fine art and illustration employ the same standards (as expressed in Simon Jennings' *Complete Guide to Advanced Illustration and Design*) of recognized aesthetic properties (sensory, formal, technical, and expressive), the same elements (line, shape, form, texture, space/perspective, color, value), and the same principles of design (balance, unity, emphasis, contrast, pattern/repetition, movement, and rhythm).

Illustration, in particular advertising art, is often a group effort, originally conceived by a creative team. The project is then turned over for basic layout to an art director, who in turn hires an illustrator to finish the work, often projecting and tracing images from various sources. The composition of the design, as laid out by the art director, usually calls for specific blank areas to be incorporated into the picture for the later overlay of headline and text copy. The end result will appear in the advertisement, cover, or article. And, because of the specific use of the illustration, it will tend usually to be arresting in design and anecdotal in subject—in short, it is often theatrical, if not melodramatic.

The fine artist (including the combat artist) goes in another direction, focusing instead on the essence of a scene or situation in order to capture its universal quality or meaning. Such works of art, as opposed to illustrations, are meant to stand on their own to make their particular visual statements and ultimately to be exhibited independently as so-called salon works. Commendably, none of the combat artists in this study seem to have had artistic restrictions or directions imposed upon them.

The dean of American illustrators, Norman Rockwell, may have put it best. Maintaining that illustration was more demanding than fine art, he pointed out that "a fine arts painter has to satisfy only himself. No outside restrictions are imposed upon his work. The situation is very different in commercial art. The illustrator must satisfy his client as well as himself. He must express a specific idea so that a large number of people will understand it; and there must be no mistake as to what he is trying to convey. Then there are deadlines, taboos as to subject matter…the proportions of the picture must conform to the proportion of the magazine…. Fine arts painters, working entirely out of their own instincts and feelings, refuse to allow any restrictions to be superimposed on their paintings by others." As James Montgomery Flagg, an earlier illustrator and one opposed to false sets of pictorial values, expressed it, "The only difference between a fine artist and an illustrator is that the latter can draw, eats three square meals a day, and can afford to pay for them." Quite often an artist will take the more practical route and earn a livelihood as a commercial artist or illustrator in order to sustain his fine art work; both avenues, of course, take a high degree of artistic talent, training, and natural proclivity.

Many combat artists have crossed back and forth between art and illustration, most notably Winslow Homer (Civil War), William Glackens (Spanish-American War), Kerr Eby (World War I), Dwight Shepler (World War II), and Charles Waterhouse (Vietnam War), all of whom began their art careers either as illustrators or art directors. Obviously, an illustration background hardly prohibits an artist from transcending illustration. In World War II, for example, Jon Whitcomb came to the Navy with a reputation for sleek, sophisticated illustrations of fashionable women for magazine ads and articles, yet, as a Navy combat artist during Pacific battles, Lt. Whitcomb turned out excellent artistic works.

Not all illustrators were able to do so. During the Vietnam period, the Navy Art Cooperation and Liaison Committee (NACAL) program was organized by commercial illustrators to offer their services to cover the war. For the most part, however, they failed to make the transition from their distinctive, marketable, advertising/commercial styles, consequently producing work that, with only few exceptions, is not generally on a par with the best combat art of World War II. Still, most artists who saw battle portrayed it without illustrative overtones, simply, straightforwardly, and in the fine art tradition.

Reality and Artistic Realism

The art historian and critic have already investigated and assimilated satisfactorily the terms "reality" and "realism" as they apply to art. But since the two terms also affect combat art, they bear touching upon here. Only at the end of the nineteenth century, when art began to break its traditional bonds and unleash newfound potential, was the art world then able to define what art had actually

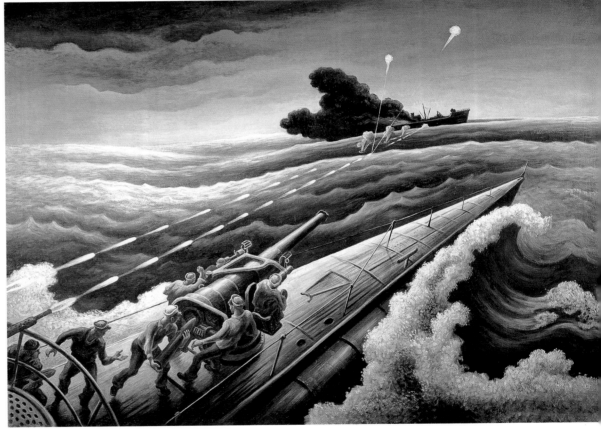

been up to that point. According to historian-critic Sir Herbert Read, art had reflected the world, but only through interpretation and imagination, with the artist's intellect creating a perspective and exact situation in which to place subject matter. Earlier, critic Conrad Fiedler had likewise pointed out that art ultimately stemmed from the artist's desire and ability to transform his visual perception into a material form. In other words, as Read says, "the artist expresses what he perceives, and perceives what he expresses." Reality was early thought

Above: Noted regional artist Thomas Hart Benton went on a shakedown cruise aboard the sub *Dorado* early in World War II and illustrated this target practice in his unique style. Perhaps for artistic reasons, the artist depicted two side-by-side streams of tracer shells; in reality, however, the shells from alternating twin 40mm automatic cannon would be spaced several dozen yards apart.
U.S. Navy Art Collection

to be an actuality that could be glimpsed, if never fully grasped. It was recognized that nature was one thing, art, another. So, in attempting to reflect reality, artistic interpretation through the style of realism was acceptable.

For countless generations, most artists working within the western tradition had attempted to faithfully reproduce their impressions of the world as they saw it, resisting to a greater or lesser degree (and with varying degrees of success) the desire to interpose their conscious feelings and their intellects between their subjects and the representations thereof. In the nineteenth century, French artist Paul Cézanne, considered by many the father of modern art, sought an even greater objective reality in his paintings, eliminating the intervention of either the artist's mind or emotions by stripping nature down to its essential forms of cylinder, sphere, and cone. Cézanne even went as far as declaring that light does not exist for a painter. Thus, his contribution to the art world was significant, albeit restrictive; of course, artists went on to portray the marvel of light and its effects in nature in countless traditional and nontraditional manners.

Shortly after the turn of the twentieth century, the new antitraditional modern concept was perhaps expressed best by Henri Matisse, who said, "Exactitude is not truth." Simply put, the universal, not surface detail or accidental light, is the essence. This became the thesis for the whole modern period in art of that century. One of its greatest artists and eloquent proponents, Paul Klee, pointed out that the intention of the artist should "not be to reflect the visible, but to make visible." In other words, art on a canvas, which once reflected an interpreted reality, could now become a reality in itself: unique, with a life of its own, something that should be judged independently as an expression in and of itself.

Here is where modern art and traditional art parted company, the latter retaining recognizable subject matter and reflecting reality. And that is where the schism still stands today: the vanguard explores uncharted paths of creativity, rejecting the mere reflection of the visible world. Traditional realism, meanwhile, sails familiar waters. Both may some day come to the realization that neither branch need be exclusive, that both continue to be valid courses. Of course, while traditional realism holds its steady course, the avant-garde "schools" are ever-changing, and often dissipate after an initial burst of energy, making it difficult at any given moment to know where the cutting edge lies. It is quite natural, therefore, that combat art should have held to the traditional path of realism, reflecting and expressing what the artist witnessed. In only a few instances during all U.S. wars have combat artists created artworks in other

Opposite Top: Early Italian Renaissance
artist Paolo Uccello's fanciful tableau of 1445
depicts the Battle of San Romano.
National Gallery, London

Opposite Center: Michelangelo's study
for the *Battle of Cascina*, ca. 1504, an intended
companion to a fresco by Leonardo. Neither
work was completed.
Albertino, Vienna

Opposite Bottom: A later interpretation
by Peter Paul Rubens of a study by Leonardo
for the *Battle of Anghiari*.
The Louvre, Paris

than a realistic style, the best, perhaps, being Marine Maj.
George Harding and civilian Millard Sheets in World War
II, whose semiabstract styles were quite vivid and unique
in the annals of combat art.

Art and Photography

A final artistic element germane to a discussion of reality
in art is the use of photography by artists, particularly
combat artists, in two important respects: perspective
and the copying of photographs. Perspective involves the
optical phenomenon (or mechanics) of binocular versus
monocular vision. The human eyes, of course, afford two
viewpoints spaced a few inches apart, by which human
vision is given the extra dimension of depth perception.
Monocular, or single-lens, vision, such as that of an ordi-
nary camera, does not capture the perception of depth;
in fact, it often distorts it. Consequently, the perspective
recorded on film may be far from the "objective truth" it
purportedly depicts. The degree of distortion depends on
how much shorter or longer the focal length of the camera
lens (i.e. a wide-angle or telephoto) might be from the
normal focal length.

The artist, with his binocular vision, is able to
instantly register depth and to focus on whatever he is
analyzing, while his mind interprets, selects, rejects, or
enhances either the details or the overall picture. Mostly
because we become enamored of and ultimately trust all
things mechanical, we tend to forget that the human eye
and the human mind are the superior instruments.

While an illustrator must oftentimes use or copy
photographs, the slavish copying of a photograph by
an artist is hardly valid artistically. It is one thing for
publishing house illustrators to copy Mathew Brady's
photographs in order for them to be reproduced in a line-
cut form. It is quite another for an artist to copy someone
else's photograph and pass the representation off as his
own work. In the realm of art, this is simply appropriating
another's visual work, "re-seeing" what someone else saw.
(In many cases, it's also a copyright violation.)

By the same token, it is acceptable for the artist to
re-create from his own photographs; he is using, in effect,
the same eyes that saw the scene and took the photo-
graph. Thus, the camera becomes another tool at his dis-
posal. Especially in battle, a quick action or fleeting
moment that cannot be sketched can be captured for
future reference by the artist with his camera. It goes
without saying that contemporary combat artists find the
camera indispensable. When the artist collects the details
that have interested him or have had an impact on him,
the bits and pieces can culminate later into an idea that
will ultimately become a painting. But all the references,

the bits and pieces, whether recorded by quick sketch or
camera, all belong to this same artist and therefore are
a valid part of his own experience. So, if looked at as a
tool rather than an end in itself, photography can be
used legitimately by an artist.

Viewed from this perspective, it is all the more
remarkable that early combat artists, especially the
great Navy, Marine, Coast Guard, *Life* magazine, and
Abbott Laboratories artists of World War II, did not
rely on the camera (except for *Life*'s Franklin Boggs).
The great works of Shepler, Lea, Eby, Fischer, Reep,
and Dickson were done on the spot—or at least fresh
from memory.

Likewise, the motion picture camera has not yet
had much effect on combat artists, other than perhaps
replaying a series of events to refresh memory. Now that
modern technology has made available small, compact
videotape and digital cameras, perhaps combat artists
of the future will make use of such devices. Still, in this
author's experience, no video cameras were used in the
Gulf War by combat artists. They were used profusely,
of course, by combat photographers, now called video-
graphers. New digital technology, used with laptop
computers, may be the wave of the future, both for
combat photographers and combat artists.

Prologue: An Overview
Battle Art Throughout History

Art depicting combat, that is, fighting between opposing
persons, groups, forces, armies, or navies, is as old as
the most ancient of civilizations, that of Sumer in
Mesopotamia. Sumerian tablets, circa 3000 B.C., have
been unearthed by archaeologists. The tablets, with
ornate carving and precious stones and gold inlay, com-
memorate war and peace in an artistic style distinctive
to that civilization. Human figures are depicted with
small rotund bodies and large profiled heads with eyes
looking forward, straight at the viewer. The subject mat-
ter deals with the ruler, the king, glorifying his deeds
and achievements, which involved a great deal of warring
with neighboring tribes. Looking back five millennia,
the tablets allow us to appreciate a unique artistic style
and decipher the history of an ancient civilization. Such
works of art tell us much about the people who created
them, providing a window into the past that adds immea-
surably to the book of human knowledge.

In the ruins of an ancient Egyptian temple at
Mednet Habu, there is a bas-relief fresco of the first
known saltwater sea battle ever depicted, circa 1190 B.C.,
between the Egyptian forces of Rameses III and the

"sea peoples," possibly the Philistines and their allies, the Mycenean Greeks, who were roving about after the breakup of their civilization. In this ancient pictorial recording, four Egyptian ships, supported by archers on shore, contend with five invading ships off the Nile Delta. From this fresco, done by a group of nameless artisans, we can discern details about the armament, weaponry, and tactics in use at the time (e.g., the invaders utilized only sails, the defenders, oars as well as sails, and had supporting infantry ashore).

Compulsory glorification of a powerful ruler no doubt tended to taint the facts. Nevertheless, archaeological relics offer a glimpse into the life, styles, and weapons of ancient times. They can also reveal which events were considered important enough to record. With early military art, we have the opportunity to view history—at least the contemporary interpretation or summation of it—through the eyes of human beings alive at the time. These artists, however, created their works within a highly formalized style distinct to their culture: Assyrian, Egyptian, Minoan, and Attic civilizations in the Near East; Indian and Chinese in the Far East; and Aztec, Mayan, and Incan in the Western Hemisphere. Only in the fifth century B.C., in the emerging Greek culture, did any semblance of individual style appear and artists' identities become known. Incredibly, the golden age of Greece burst into full bloom within a few years after their victorious naval battle in 480 B.C. at Salamis, which stopped the Persian advance into the West. This afforded a respite from protracted war, and the result was the flowering of classical Greek art, which still awes mankind. Yet little of the art depicted realistic battle; instead it was mostly mythologized, imaginary contests.

By the time of Christ, the Romans had become world conquerors and learned the value of depicting the heroic deeds of emperors and glorifying their reigns. Bas-relief carvings on the Emperor Titus' triumphal arch at the entrance to the Roman forum depict his triumphant return after sacking Herod's temple and razing Jerusalem in A.D. 70. A half century later, Emperor Trajan erected in Rome a monumental column with a continuous spiraling frieze commemorating his glorious exploits against the Dacians (in the area of modern Romania) in A.D. 113. The frieze depicts specific events from the military campaign, including detailed depictions of the Roman troops collecting food, building, and marching, as well as engaging in actual combat.

The Bayeux Tapestry is a rare example of secular art from the Middle Ages. It is also one of the few surviving depictions of combat from that turbulent epoch.

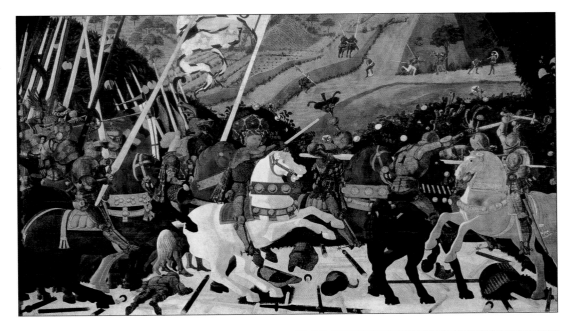

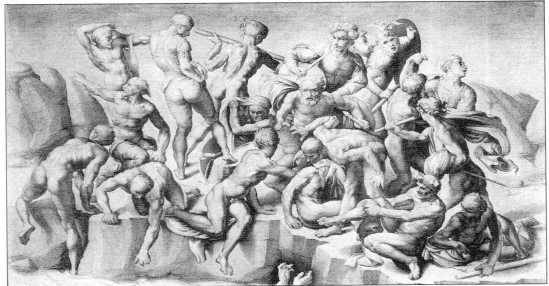

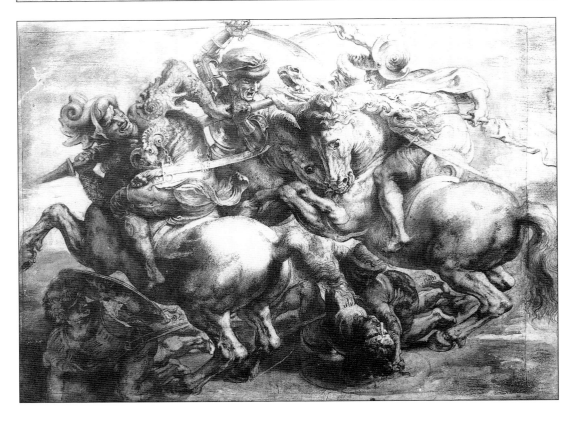

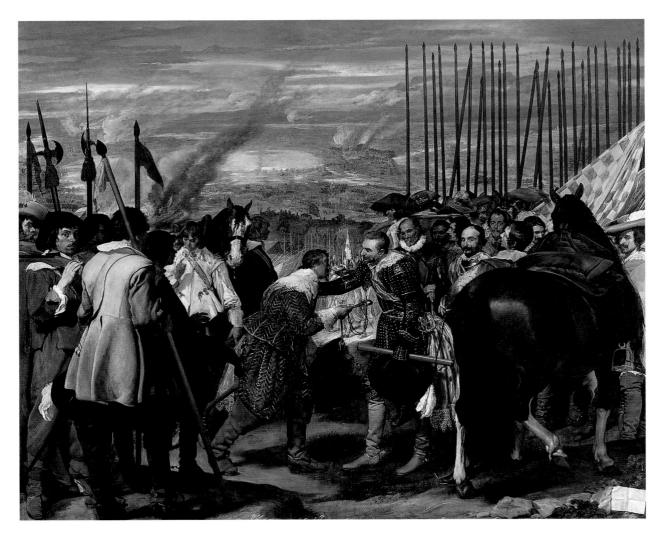

The tapestry commemorates William the Conqueror's decisive victory at Hastings in A.D. 1066, which sealed the Norman conquest of England. Measuring 231 feet (70m) long and eighteen inches (46cm) high, the Bayeux Tapestry is a work of embroidery on an unbleached linen background. More than seventy scenes unfold in a continuous scroll fashion, including notable events from the Battle of Hastings and the retreat of the defeated English.

Four hundred years later, Italian artist Paolo Uccello painted his *Battle of San Romano*, although he had not been an eyewitness to the event. He depicts not so much a battle but a staged pageant, with colorful but lifeless cutout figures of men and toy-like horses. More an exercise in scientific perspective than an attempt at realism, Uccello's intricately composed painting has a charm and excitement that mirrors the age in which it was created (but not the grim reality of battle).

In the early 1500s, Leonardo da Vinci and Michelangelo were commissioned to create companion frescoes for the Palazzo Vecchio in Florence that would depict, respectively, the battles of Anghiari and Cascina. Neither artist was able to finish his work—only fragments of sketches remain. Nor can one assume that either great artist ever witnessed a major military engagement. Each envisioned and re-created his battle subject using grandiose compositions of entwining, twisting, contorting (and in Michelangelo's case, nude) bodies, which evidenced an obsession with the then-recently rediscovered classical antiquities of the Greeks and Romans. Historical accuracy was not a major consideration for Michelangelo, who instead focused on a composition of sculptural figures. As we can ascertain from his writings, though, Leonardo at least attempted to paint convincingly the details of the action—the dust and the litter logically associated with battle.

During the initial age of exploration of the New World, the French Huguenot Jacques Le Moyne de Morgues managed to escape a massacre by Spanish explorers while accompanying the second French expedition to Florida in 1564 as a mapmaker and visual recorder. He later re-created his impressions in historically valuable, if somewhat fanciful and stylized, watercolor renderings of the New World. Théodore De Bry's engravings of Le Moyne's drawings and those of the English artist and explorer John White, who worked slightly later (in 1591), helped stir the imaginations of subsequent explorers and colonizers.

Depictions also exist of the 1571 Battle of Lepanto, the largest sea battle prior to World War II, when the European Holy League summarily defeated the Ottoman Empire in the Mediterranean Sea, stopping once and for all the Muslim expansion westward. The scenes are a melee of boats, oars, spikes, bows and

arrows, cannonades, pennants, and bodies engaged in close-in fighting. Whether from eyewitnesses or from after-the-fact descriptions, the paintings no doubt capture the essence of that pivotal naval battle in the last days of galley vessels.

War themes were used by many artists (Titian, Rubens, Velázquez, and David, for example) from the Renaissance through the Baroque, and Rococo to the Neoclassical period in the first part of the nineteenth century. Most presented war in a grandiose, idealized manner, often with the victor accompanied by swirling cherubs and other allegorical devices. More successfully, Spanish artist Diego Velázquez's *Surrender of Breda* is a decidedly partisan portrayal of a chivalrous acceptance of surrender by a less-than-welcome invader-conqueror. Although a majestic work of art, Velázquez's scene was artistically contrived in 1640, fifteen years after the event, for propagandistic purposes.

It is likely mid–seventeenth century French painter Nicolas Poussin's concept of battle (not the actual battle itself) that is conveyed in his allegorical *Rape of the Sabine Women*, in which the composition is an impossibly ordered chaos of classical human forms. Not so for one Samuel Blodget, who was on the other side of the Atlantic during the new continent's French and Indian War. Blodget, as well as military officers of the English, Continental, and French armies, did on-the-spot sketches of phases of that skirmish. Blodget actually observed and sketched from a hilltop the *View of the 8 September 1755 Battle at Lake George*, which was engraved and published shortly afterward.

Edging closer to "reality" was the expatriate colonial painter Benjamin West, who weathered the Revolution safely in England. His 1770 French and Indian War battlepiece, *Death of General Wolfe at Québec*, helped to change the course of art at the time, moving it away from the neoclassicism of Poussin and others. West's astonishingly "realistic" treatment of this battle scene, which, of course, he had not witnessed, eliminated the usual classical toga-clad figures and attempted faithfully to portray the dying Wolfe, with his uniformed staff officers around him and a Mohawk Indian warrior prominently in the foreground to identify the locale as the New World. Historically, neither the Indian nor the officers were at the scene, making West's unorthodox painting a fine example of after-the-fact interpretation and studio recreation. Although the painting was severely criticized by the art cognoscenti of the time, West was commissioned by King George III to produce several duplicates of it. The painting helped set a realistic trend for subsequent art. West maintained that art's purpose

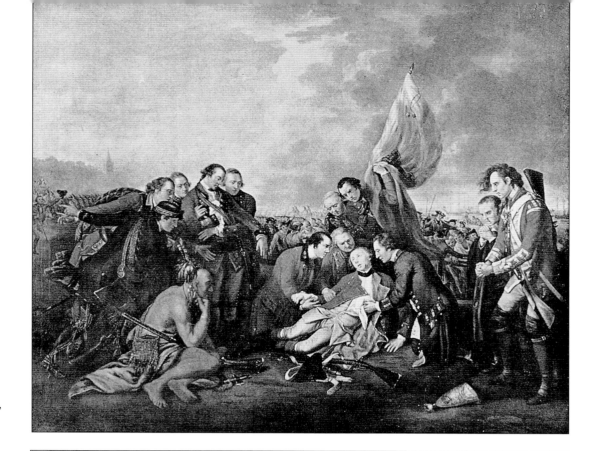

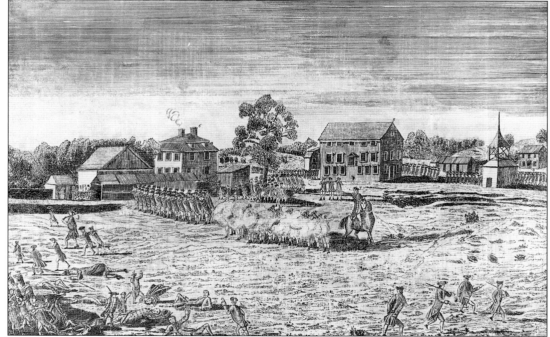

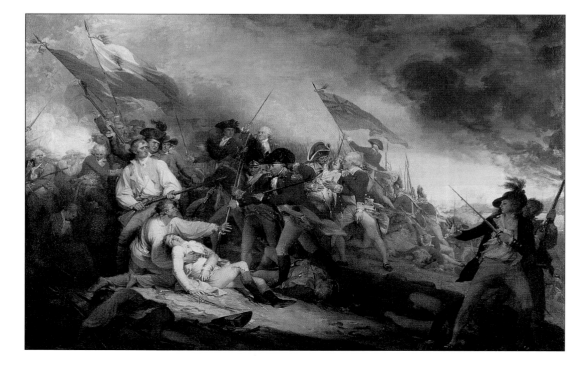

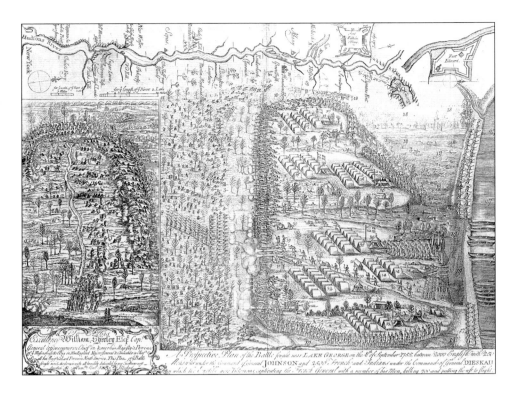

was not to please the eye but to elevate the mind. Following the latter course, he explained that "the same truth that guides the pen of the historian should govern the pencil of the artist." He also believed that the art of painting had powers to dignify man by transmitting to posterity his noble actions. Hence, in his own mind there was no need for him to have been an eyewitness.

At about the same time that West was challenging classical artistic conventions, in the colonies, John Trumbull, a one-eyed, twenty-eight-year-old, Harvard-educated artist, colonel, and aide-de-camp to Gen. George Washington, observed the British onslaught up Breed's Hill (mistakenly identified as Bunker's Hill) outside of Boston. From his experiences and sketches, he later painted the dramatic *Death of General Warren at Bunker's Hill*, as well as other American Revolution battle scenes. Congress later commissioned him to enlarge four of them for the new Capitol rotunda, where they can

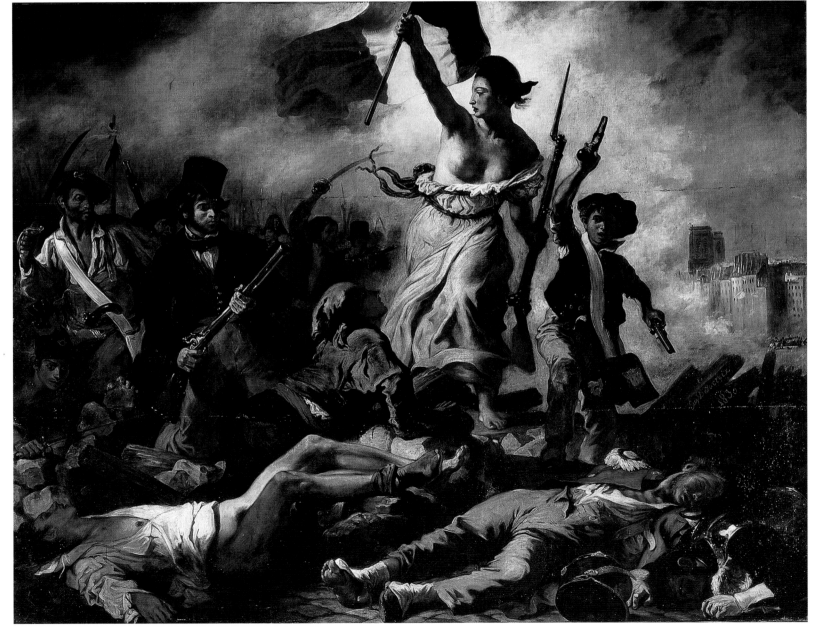

be seen to this day. Shortly after Breed's Hill, though, Trumbull, miffed at receiving fewer perquisites than he had expected, resigned his commission and went to England to study with West. He was in good company. Artists John Singleton Copley and Gilbert Stuart had decided to sit out the Revolution safely in the mother country, too, only returning afterward—quite unlike combatant-artist-colonel, Charles Willson Peale, who had stayed and "fit and painted."

At the beginning of the nineteenth century, the Spanish painter Francisco de Goya shocked the world by graphically depicting the brutality, horror, and revulsion surrounding the massacre of innocent Spanish civilians by the troops of Emperor Napoleon I, scenes Goya might well have witnessed himself. In a series of paintings and engravings entitled *Disasters of War*, Goya created a powerful and clear message in his art that could not be ignored—despite the Catholic church's criticism.

Going a step farther, the French romantic artist Eugène Delacroix exploited battle art as propaganda— that is, art meant to influence or to create an intense reaction to stimulate intended action—in his monumental *Liberty Leading the People*. The painting became a rallying device for revolutionaries in the 1830s and beyond. Romantic and realistic in style and allegorical in nature, the painting had a tremendous impact on the public and was eventually purchased by the French government. Although it was based on Delacroix's observation of the storming of the barricades (a scene into which the artist probably painted himself, carrying a musket), *Liberty Leading the People* represented an idea, not an incident— a universal concept, not a moment in time.

While the eighteenth century had been one of great political upheavals, the nineteenth was to become one of vast and world-shaking technological advances that had consequent effects upon art. Up to the latter quarter of the nineteenth century, realism, or naturalism—making objects recognizable and visually comprehensible—was the primary criterion of art. An artist's ability to make a subject look right or natural was taken to be the mark of true talent.

The camera would change everything. Earlier inventions, such as the camera obscura, the camera lucida, and perspective devices, afforded artists some degree of accuracy beyond their own observations. Still, it was not until the middle of the nineteenth century that the newly invented medium of photography enabled them—or anyone—to capture reality, albeit without color. Joseph Nicéphore Niépce's invention in the 1830s immediately affected art. Some, like French artists Gustave Courbet and Edgar Degas and the American Thomas Eakins,

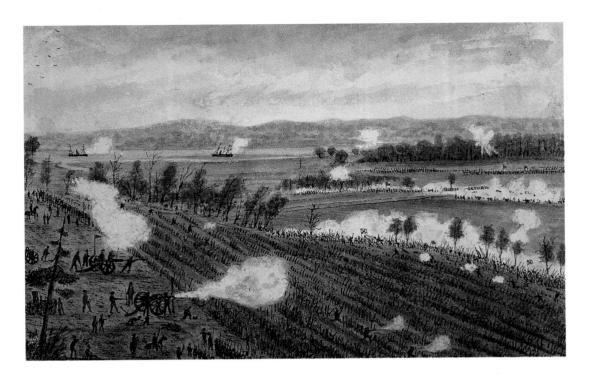

used the camera as a tool, an aid to drawing and painting; others began to realize that photography could free them from slavish adherence to realistic detail since a mere machine could now accomplish this. Art soon broke from its traditional bonds, giving vent to impressionism, expressionism, abstraction, cubism, and a never-ending host of other variations and spin-offs.

Although the new device was fascinating in that a bit of the real world could be captured forever, it took almost another century before photography was able to capture everything in nature: motion, color, high speed, atmosphere, mood, and micro detail. Around the turn of the twentieth century, Eadweard Muybridge's stop-motion photographs of a galloping horse forever changed equine art when the true movement of the legs was seen, for the first time, progressively in animation. It was also a seminal moment in the development of photography, helping to build a medium that could now capture action.

Reportorial Illustration

During the latter half of the nineteenth century, one avenue of art remained virtually untouched by the stylistic revolutions taking place: reportorial illustration, the precursor of true combat art.

An early invention of the nineteenth century, lithography affected both art and communications, helping the illustration field flourish. Lithography was the reproduction of grease pencil drawings off of a smooth stone surface that had been covered with water and rolled with ink. The surface of the stone held the water, which repelled the ink; the grease lines, in turn, repelled the water and held the ink. Thus, paper applied with

Opposite Top: Samuel Blodget's *Perspective Plan of the Battle Near Lake George* was based on events he witnessed in 1755.
New York Public Library

Opposite Bottom: Eugène Delacroix's *Liberty Leading the People* was an overt propaganda piece in 1830. The man in the stovepipe hat carrying the musket is probably a portrait of the artist himself. The bare-breasted "Liberty" is, of course, allegorical.
The Louvre, Paris

Above: Mapmaker and diarist Pvt. Robert Knox Sneden made hundreds of sketches during his service with the Union army, including this one of the Battle of Malvern Hill. Here, he gives us a bird's-eye view of the action on 1 July 1862, when rebels attacked Weeden's Battery and the 14th Brooklyn Regiment on the west side of Crew's Hill.
Virginia Historical Society

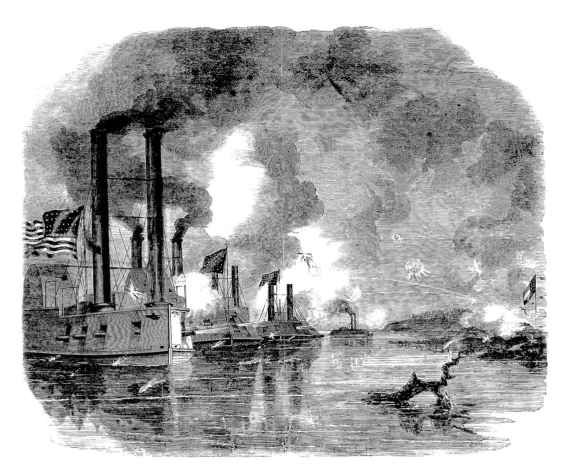

Above: Based on a combat sketch from an artist in the field, this wood engraving is typical of the kind that were published in the numerous weekly journals during the Civil War. The small wood engravings could be "put to bed" in the flatbed presses alongside the set type, allowing a wide variety of illustrative matter to appear in printed materials.

pressure and pulled off would retain a reverse image of the drawing. Within a short time, great lithographic publishing houses sprang up, turning out quantities of artistic prints, music, and printed matter—some in color—for a voracious public. American litho publishers such as Currier & Ives and Sarony & Major soon employed scores of artists to create or copy artwork. The level of quality and degree of sophistication was understandably low in many cases, but the pictures are an important part of nineteenth century Americana and offer a glimpse into those times.

Advances in mechanical reproduction would also have a profound impact on combat art. When England fought the Russians in the Crimea in the 1850s, the *Illustrated London News* sent artist-correspondents to the scene to depict events. The sketches were dispatched back to London, where they were re-created as engravings onto wood blocks for the newer printing presses, which churned out a huge volume of printed materials to feed an insatiable public's appetite for news and illustrations of current events.

The American Civil War

When its Civil War erupted, the United States was not far behind England in the proliferation of printed illustrations. Journals such as *Frank Leslie's Illustrated Newspaper*, which was founded in 1855 by a former *Illustrated London News* wood engraver, and *Harper's Weekly* employed dozens of artists. Studio artisans would engrave on wood the sketches from the artists that the publications sent to

cover the war fronts, both North and South. These artist-journalists in the field were true combat artists, living with the armies and sketching the battles. The trick was to get the sketches back quickly to the publishers for engraving and a timely publication run. Winslow Homer and scores of lesser-known but highly competent artists—including Edwin Forbes, Henry Lovie, the brothers William and A.W. Waud, Thomas Nast, and Theodore Davis—complemented the work of historians and the few photographers in the field (Mathew Brady, James and Alexander Gardner, and Timothy O'Sullivan) covering the war. Unfortunately, the printed versions of the Civil War artist-journalists were consistently inferior to the originals. Photography had an immediate effect, presenting unflinching portraits of war's grim toll to the public for the first time, but the technology was still very young. The collodion wet plate negative at that time was so slow to retain an image that no action shots could be taken, only static poses and still scenes. Likewise, printing presses could not handle the halftones of photography; that would only come with photo-engraving three decades later. As an historical tool for later writers and artists of every kind, of course, Civil War photography has proven invaluable.

The Spanish-American War

War artist-journalists covered the Spanish-American war rather thoroughly, possibly because of the journalistic pressure that to a great extent both brought the war about and led to its speedy conclusion. Artist Rufus Zogbaum was with Adm. Dewey at the battle of Manila Bay and later depicted the victorious naval officer on the bridge of the battleship *Olympic* directing the engagement. Other noted illustrators like Howard Chandler Christy, William Glackens, and Frederic Remington covered the landing of troops in Cuba and the subsequent fighting, as did a combatant, Army Pvt. Charles Johnson Post.

World War I

The tradition of the artist-correspondent was well established by the beginning of the twentieth century. Minor conflicts in remote parts of the world were being covered by the journals, especially in Britain. Consequently, when World War I began, British artists were organized and sent to the war front by their government. The United States, following the British example, commissioned eight prominent artists into the U.S. Army Engineers and sent them with the American Expeditionary Force to the French battlefront in 1918. Talented young Marine officer John W. Thomason was serving with the Marine Fifth Regiment, and, always a combatant, he also managed to sketch his impressions during battle.

War art, of course, was done on both sides of the conflict. A German veteran of World War I trench warfare, Otto Dix was so affected by his experiences that he abandoned his avant-garde style and adopted war as subject matter—to such an extent that it became a debilitating obsession, as he continued to suffer from anxiety attacks, nightmares, and the constant dread of death. For the remainder of his life, he turned out highly controversial paintings that, to him, exemplified war's evil nature, atrocity, and stupidity. Even as the fledgling Nazi party stalked the streets of Germany in 1932, Dix defiantly turned out a large altarlike triptych, at which one was presumably meant to "worship" war. The panels depict soldiers in the misty dawn, and the centerpiece is a repulsive slaughter in the trenches. Dix represents himself on the right as a soldier aiding a wounded comrade, while a subpanel shows soldiers sleeping in a tomblike space, as if in the sleep of death. At the time, Dix's work was described as having "a unique, harsh, dispassionate quality." His paintings are certainly disturbing, showing nothing but the abject horror of war that he experienced, and continue to speak universally against war.

Modern artist Pablo Picasso's painting *Guernica* was named in honor of the little Basque village that was bombed mercilessly by the Germans in 1937, an incident that took the lives of uncounted innocent noncombatant men, women, and children. Taking place during the Spanish Civil War, it was a dress rehearsal by the Nazis and Fascists for the onslaught that started World War II, and Picasso used the incident to create a visual outcry against such atrocity. The Spanish artist utilized his inimitable abstract style, with contorted, agonized bits and

Above: German soldier and artist Otto Dix was so disturbed by his experiences in World War I that it greatly influenced his later work. His *War Triptych* is a denunciation of war for which he was chastised by the Nazi party.
Neue Meister, Dresden

Opposite Bottom: Prior to the Vietnam War, personally interpretive art was perhaps best exemplified by the works of German World War I veterans Otto Dix and George Grosz, who produced visual damnations of war emanating from their own personal experiences. At the outset of World War II, Spanish painter Pablo Picasso also expressed his outrage over the fascist-Nazi bombing of a small Basque village in his monumental *Guernica.* Although he was neither an eyewitness nor a combatant, his personal interpretation is every bit as powerful as the works of Dix and Gross.
Museo del Prado, Madrid

pieces of figures and animals in an expressive, cerebral work of ghastly fantasy. Since Picasso had only heard reports of the bombing, his rendition was imagined. Still, the massive twelve foot (3.7m) by twenty foot (6.1m) mural painting, in mostly grays and blacks, is without doubt a condemnation and thereby as important a piece of antiwar propaganda as the works of his forerunner, Goya. *Guernica* remains a powerful visual comment on indiscriminate brutality in the twentieth century.

World War II

By the time World War II started, more and more attention was being given to war art coverage. Again, following the lead of the British already in the war (and based on its own experiments with government-sponsored art projects during the Depression), the U.S. government contracted with a number of artists and sent them off to war. Inexplicably, however, support was withdrawn by Congress, and the effort was short-lived, stranding the

artists around the globe. Fortunately for them and for the country, more farsighted, though profit-minded, publications immediately hired the artists and had them continue their assignments. Thus, *Life*, *Collier's*, and *Fortune* magazines, as well as Abbott Laboratories, amassed superb collections of authentic combat art. The individual armed services, too, had the foresight to seek out their own artists already in uniform and assign them to combat art duties.

Wars of the Second Half of the Twentieth Century

The monumental war art of World War II set the stage for subsequent efforts by artists in Korea, Vietnam, the Persian Gulf, and in many other far-flung regions of the world. The legacy of all of these artists is a visual treasure unlike any other in the nation's civilian or military archives. Perhaps one day their works will be properly appreciated for their artistic, as well as for their journalistic merits. Fortunately, many of these artists were excellent writers and have thereby afforded unusual insights into their feelings, their modi operandi, and the effects of their war experiences.

Above: Marine Capt. Don Dickson's wartime sketches on Guadalcanal depicted the GI of World War II as a gritty rifleman down in the foxholes, stoically facing the enemy.
USMC Art Collection

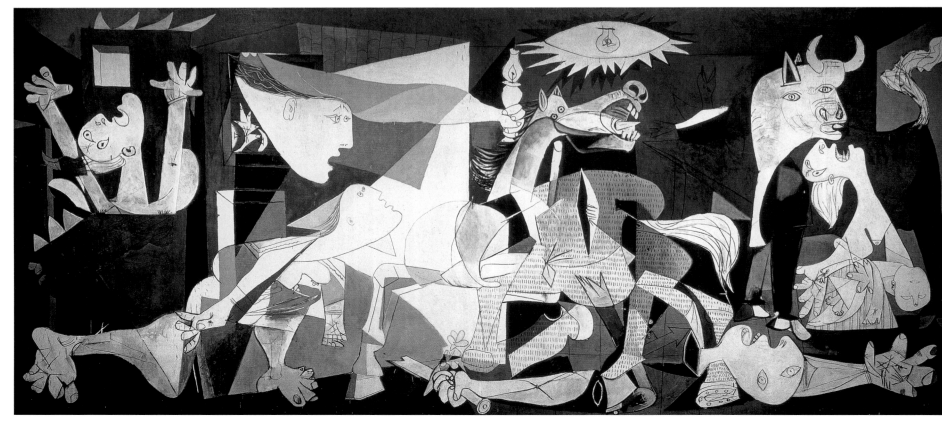

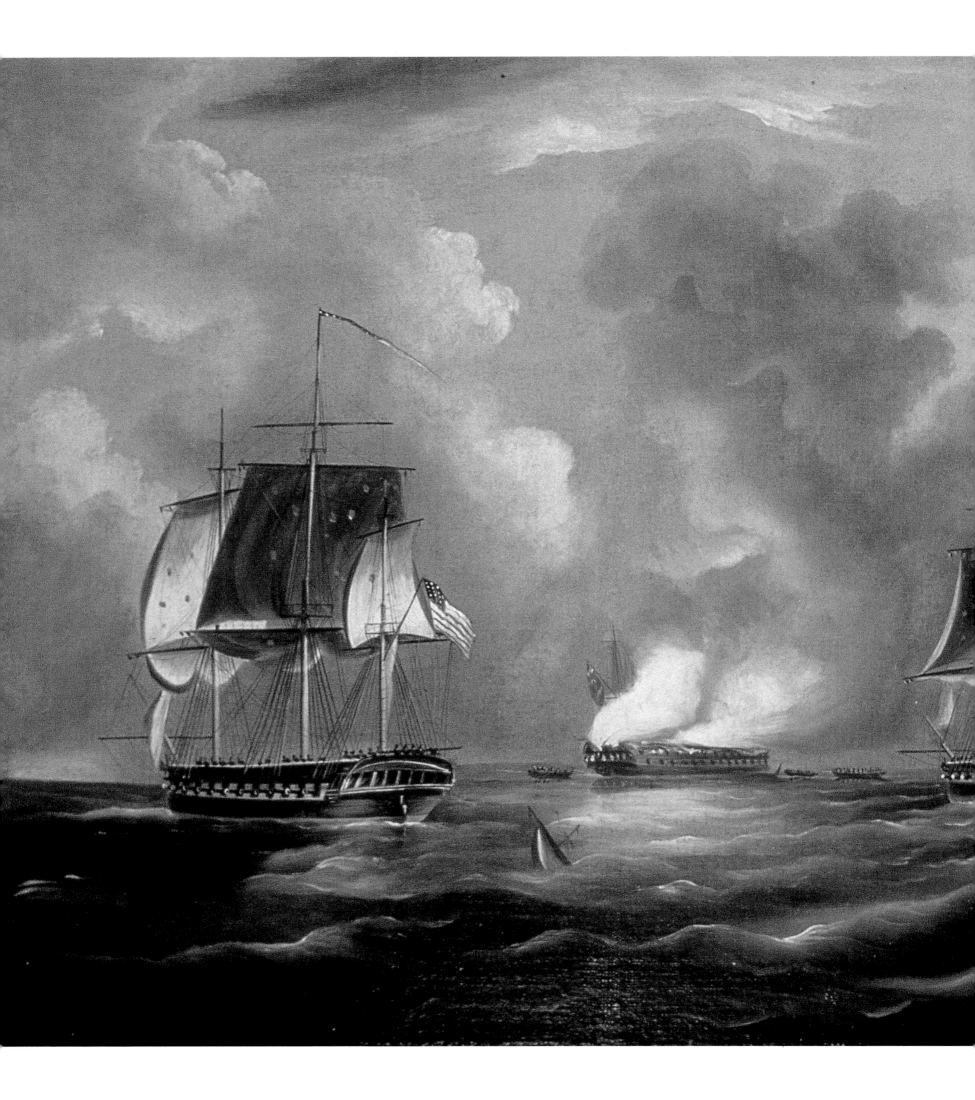

CHAPTER *One*

Auspicious Beginnings

I f the thirteen original American colonies are envisioned as a beachhead in a new world, it is easy to understand the early colonists' reliance on the sea at their backs. It offered not only a vital lifeline, but a reassuring connection to the civilized world they had left behind. The coastline, with its bustling ports, was the geographic limit and the backbone of the slowly westward-encroaching strip of colonization. This tenuous ribbon of coastline was America's real frontier until the nineteenth century. Therefore, it is not surprising that, aside from popular portraiture, early colonial art tended to depict ships and harbors and the activities that surrounded them.

Since life was harsh, requiring useful skills and a great deal of cooperation among struggling settlers, those with artistic talent gravitated toward more practical activities, such as sign and coach painting. In some cases, artists did undertake itinerant portraiture, for which there was a small but constant demand in the days before the camera. What may be the earliest example of true combat art by an inhabitant of the New World is a rare self-portrait by Capt. Thomas Smith, painted circa 1675–90. Somewhat naive in style and obviously based on Italian portraiture the self-taught captain must have seen in his travels, the self-portrait includes the scene of a naval battle, visible through a window behind the sitter's right shoulder. It may be one Captain Smith witnessed himself or participated in, since it was important enough for him to include in his own portrait.

During the French and Indian War, in the mid-eighteenth century, some of the main events of that struggle were captured by artists. English, Colonial, and French officers did on-the-spot combat sketches, and colonial Samuel Blodget actually viewed the 1755 battle at Lake George, observing and sketching it from a hilltop. Twenty years later, colonial artists were ready to cover an engagement with more far-reaching consequences.

The Yankee Rebellion

Printing presses were active in colonial times, and important news of the day was often illustrated by artists and published soon after an event in the form of broadsheets, pictorial matter with textual commentary. Paul Revere was quick to engrave and distribute a scene of the Boston Massacre, an obvious propaganda piece that helped fan the flames of the rebellion. Amos Doolittle, who viewed the 1775 battle sites of Lexington and Concord after the fact, did four engravings of how he imagined the late spring battles to have looked, preparing the prints for sale by December of that year. Ralph Earl, enjoying a well-earned reputation as a limner of portraits (a term derived from the flat, linear style of manuscript illumination and miniatures), also painted reconstructed versions of the same battles. Another noted limner, Christian Remick, painted a watercolor of the British forces landing in Boston Harbor and encamping on the Common in 1775, a scene he might well have witnessed, as perhaps did Thomas Davies, who the following year executed a watercolor

This portrayal of the battle between the USS *Constitution*, known as "Old Ironsides," and the HMS *Guerrière* in the War of 1812 is attributed to noted maritime painter Thomas Birch.
U.S. Naval Academy Museum

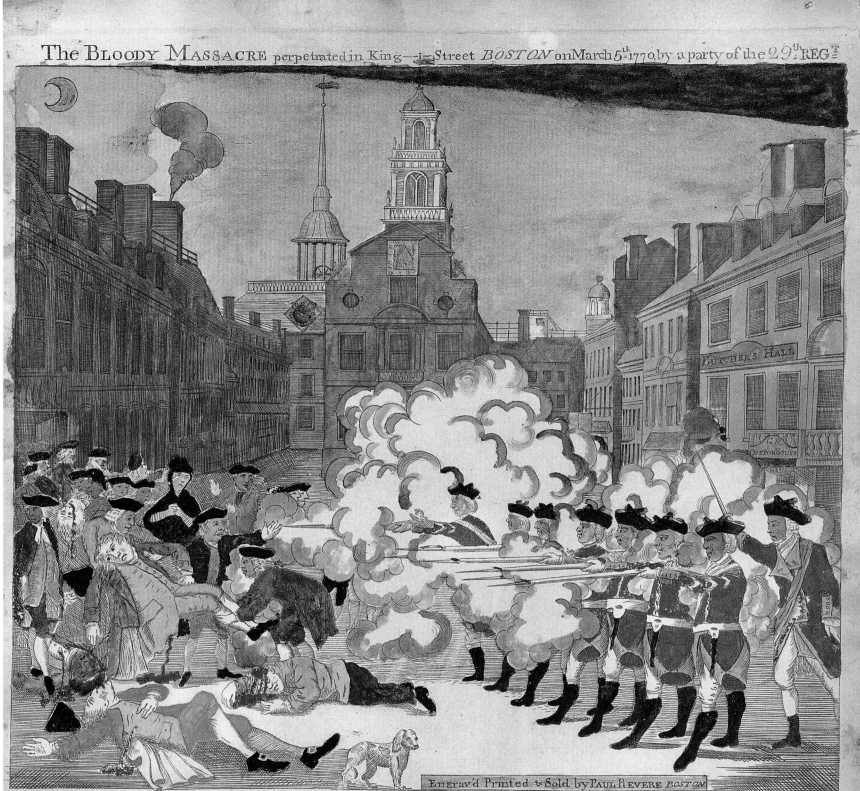

The BLOODY MASSACRE perpetrated in King—l—Street BOSTON on March 5th 1770 by a party of the 29th REGt

BUTCHER'S HALL

CUSTOMHOUSE

Engrav'd Printed & Sold by PAUL REVERE BOSTON

Unhappy BOSTON! see thy Sons deplore,
Thy hallow'd Walks besmear'd with guiltless Gore:
While faithless P—n and his savage Bands,
With murd'rous Rancour stretch their bloody Hands;
Like fierce Barbarians grinning o'er their Prey,
Approve the Carnage, and enjoy the Day.

If scalding drops from Rage from Anguish Wrung
If speechless Sorrows lab'ring for a Tongue,
Or if a weeping World can ought appease
The plaintive Ghosts of Victims such as these;
The Patriot's copious Tears for each are shed,
A glorious Tribute which embalms the Dead.

But know, FATE summons to that awful Goal,
Where JUSTICE strips the Murd'rer of his Soul:
Should venal C—ts the scandal of the Land,
Snatch the relentless Villain from her Hand,
Keen Execrations on this Plate inscrib'd,
Shall reach a JUDGE who never can be brib'd.

The unhappy Sufferers were Messrs SAML GRAY, SAML MAVERICK, JAMS CALDWELL, CRISPUS ATTUCKS & PATK CARR
Killed. Six wounded; two of them (CHRISTR MONK & JOHN CLARK) Mortally

depicting the landing of the British Forces on 20 November 1776. In June of that year, Lt. Henry Gray of the 2nd Regiment under Col. William Moultrie, participated in and sketched on the spot the Battle of Fort Moultrie, which involved action with the ships guarding the harbor at Charleston, South Carolina. A French artist, Dominic Serres, the Elder, either from sketches done by officers aboard the ships or from his own observation, portrayed the rout of the British flotilla sent to thwart the retreat of Gen. George Washington's army up the Hudson River in August 1776. It was met with withering fire from rebel shore batteries.

The Continental Army was born at Lexington, Massachusetts, in April of 1775, and the Continental Navy and Marines were created the following October and November, respectively. Continental Marine Capt. Matthew Parke, in charge of the detachment of Marines aboard the light frigate *Alliance* from January 1779 to May 1782, was an artist, as were many ship's officers of that and later periods. Earlier, in the March 1776 raid on New Providence in the Bahamas, Parke had served as one of senior Marine Capt. Samuel Nicholas' two lieutenants aboard the *Alfred*, the flagship of the inept Commodore

Esek Hopkins, Commander-in-Chief of the Navy of the United Colonies. Following his duty on the *Alfred*, Parke served in 1779 aboard the *Alliance* when her French captain Pierre Landais' erratic and cowardly action almost gave back the decisive and heralded victory of Capt. John Paul Jones' *Bonhomme Richard* over HMS *Serapis*. On the voyage home, after a mutiny and Landais' usurpation of Jones' command, Parke was placed under arrest for eleven days aboard ship for refusing to pledge allegiance to the unbalanced Landais. (After the voyage, Landais was summarily stripped of both his command and commission, thus vindicating Parke.) The Marine officer later painted on canvas the *Frigate Alliance Passing through Boston Lights in 1781 Returning from France*, which was his recollection of the voyage. The tranquility of the scene belies the frigate's tumultuous history.

Seminal Combat Art

The distinction between after-the-fact illustration and eyewitness combat art, as that term is now defined, was not as clear two hundred years ago. The value of such pictorial records must not have been generally comprehended either, and the lack of speedy transportation

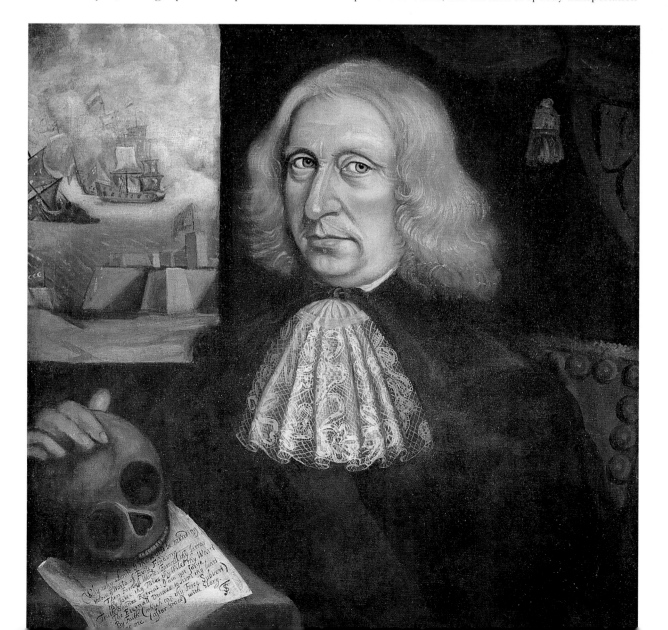

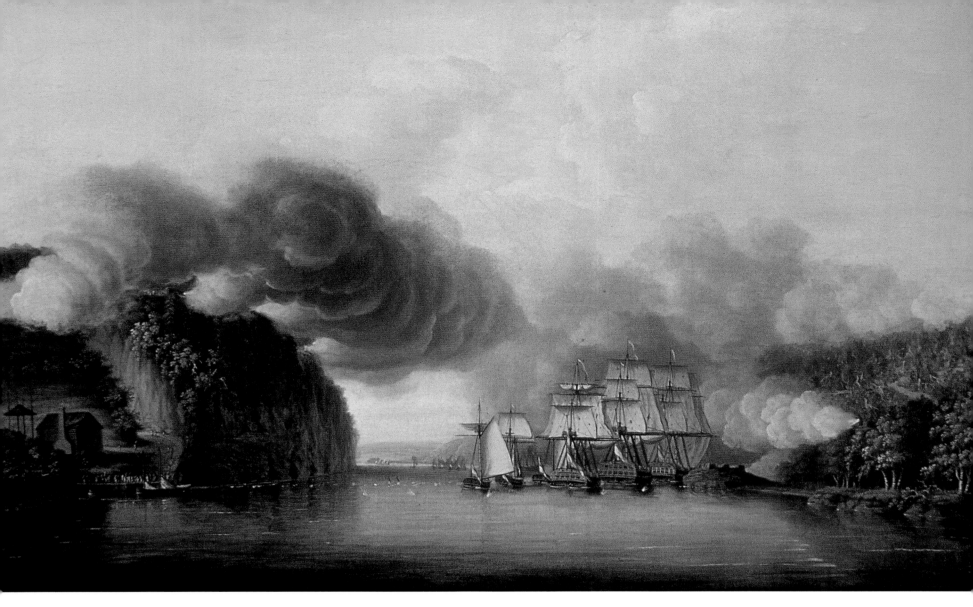

and communications certainly made the art less than timely. The closing years of the eighteenth century saw a sustained period of marine painting, a genre brought to fruition by Dutch marine artists of the sixteenth and seventeenth centuries and picked up in the eighteenth by the English marine painters Peter Monamy, Robert Dodd, Sir Richard Paton, Thomas Mitchell, and Nicholas Pocock.

The English and French seafaring traditions had fostered the sketching talents of ship's officers, if only for military purposes. Often, however, their sketches became the bases for after-the-fact engraved depictions, from which larger compositions and reconstructions were then done by the aforementioned handful of noted, and mostly English, marine painters of the times. Therefore, it is virtually impossible to pinpoint with any degree of accuracy whether any finished battle art of this period, either American or British, was ever done by an eyewitness. However, a two-panel scene of the 1776 Battle for Lake Champlain, sketched by an unnamed British ship's officer, is historically accurate and probably the work of an actual observer. Likewise, Royal Navy Lt. William Elliott is known to have been quite active artistically, and among a sizable collection of his signed works

are two that may have been eyewitness accounts: *Battle in the Delaware River* and *The End of the Richard-Serapis Battle*.

French naval officers also portrayed the sea battles from their vantage points. Jones' victory over the *Serapis* off England's Flamborough Head was quickly printed in Paris by one M. Guérin, possibly from the sketch of a French naval officer who had witnessed the battle during the afternoon and moonlit night of 3 September 1779. The *Bonhomme Richard*'s triumph was followed by other battle scenes by Pierre Ozanne, who was naval construction officer in the fleet of Comte D'Estaing and who depicted the French fleet's assistance to Washington off Delaware, Staten Island, and Newport in 1778, actions in which he had participated. Artists such as Toulénard, Claude Jacques Notté, and Louis Phillipe Crépin also painted battle scenes of note, although it is not certain if these latter artists were eyewitnesses. Jones' victory, aboard a refurbished French vessel, was almost as popular in France as it was in the colonies; even noted British artist Sir Richard Paton illustrated it, despite derision of the battle in England.

The majority of naval actions were undertaken by colonial privateers. These privately owned or state-supported commercial vessels were outfitted with cannon

and given letters of marque granting official permission to operate as commerce raiders—with the freedom to seize and auction off "prizes." Their actions were depicted after the fact by George Ropes, L. Robelle, and John Benson Willobank (possibly all engravers), in such works as, respectively, *Logistics Life-Line from France to St. Eustatius in the Leeward Islands, Conyngham Captures English Mail Boat,* and *Revenge in Action.* (Conyngham's privateering adventures, it should be noted, would lead to a commission as a captain in the Continental Navy, an indication of how institutionalized the raiders were.) There is also a depiction of the evacuation of Charlestown, Massachusetts, in 1782 signed "Pyle." Although not true combat art, these are minor but important pieces of the historic and artistic record.

Ultimately, battles at sea proved more decisive in the American Revolution than land engagements. For proof, look no further than Lord Cornwallis' surrender to Washington, which came after Adm. de Grasse's French fleet had stood off the British fleet, bottling up the British army on the Yorktown peninsula. Even though, throughout the period, the British had their hands full fighting elsewhere, their naval blunders in the New World allowed a small—and for the most part unprofessional—bunch of seafarers to defeat His Majesty George III's supposedly superior navy. George Washington's earlier prophetic words had been fulfilled: "In any operation and under all circumstances, a decisive naval superiority is to be considered the basis upon which every hope of success must ultimately depend." (The British would learn their lesson from this, however, and defeat the combined fleets of the Spanish and French at Trafalgar in 1805.) Fortunately, artists recorded much of the naval action for posterity though none of the extant artistic works of this period can be verified as eyewitness combat art.

Continuing Early Naval Actions

With a strong seafaring tradition, the new nation was compelled in its infancy to rely on naval action numerous times for its very survival. Armed with new men-of-war, the young American navy displayed remarkable prowess, winning a string of unlikely victories and giving birth to a number of legends.

The most significant of the sprinkling of sea battles was one involving one of the six original men-of-war, the USS *Constellation.* On 9 February 1799, it captured the

Below: Capt. John Paul Jones' decisive victory against a supposedly superior British navy became a popular theme for artists of the time. Here, English artist Thomas Mitchell has rendered his imagined version, no doubt aided by participants' descriptions. This depicts the moment in the Jones victory when, with his *Bonhomme Richard* dismasted and sinking, the American skipper is reported to have been hailed in French by his British opponent, "Avez-vous amener votre pavillons?" ["Have you struck your colors?"] Jones famously replied, "Non! Je n'ai pas à l'instant commencer la bataille!" ["No, I have not yet begun to fight!"]
U.S. Naval Academy Museum

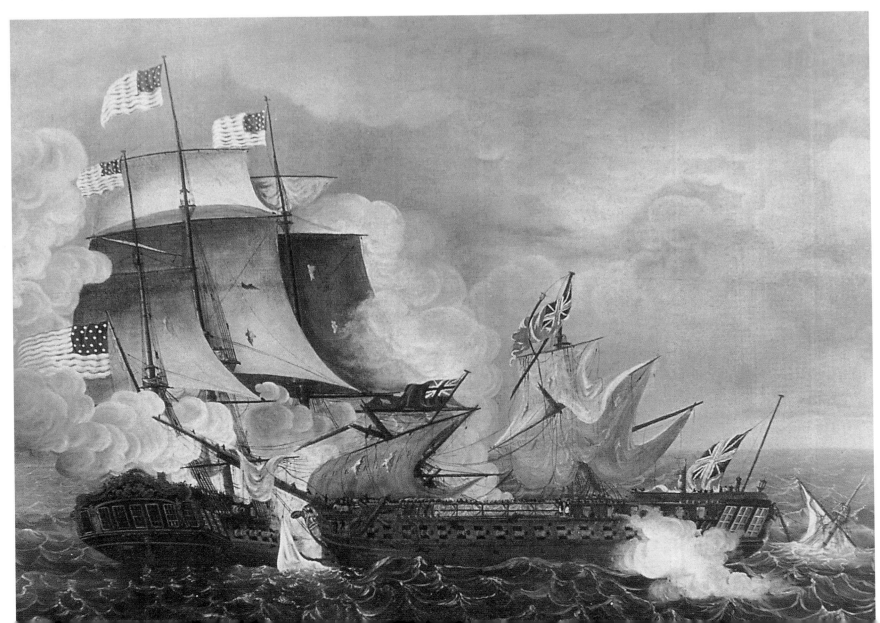

French frigate *l'Insurgente* in the West Indies, a scene later portrayed by artist Edward Savage, who was not, of course, an eyewitness. However, he has the distinction of being the first native-born American to turn out a print of a naval battle. Savage painted two scenes of the encounter and published them in May of 1799. Artistically, they are a bit stylized but possess a unique, if not wholly authentic, perspective. Seascape artist Robert Salmon also painted young Capt. Isaac Hull's successful raid in 1800 at Puerto Plata, Santo Domingo, where the sloop-of-war *Sally* overtook the French corvette *Sandwich* and launched Marines ashore to capture the shore batteries. The depiction was most likely reconstructed from eyewitness accounts.

Earlier, on 4 August 1790, Congress had authorized the construction of ten vessels and inaugurated the Revenue Cutter Service, the forerunner of the present-day U.S. Coast Guard. Not always well-received by privateers and other local merchantmen (due, no doubt, to bitter memories of British revenue harassment), the Revenue Cutter Service nonetheless did enforce customs and tariffs on maritime commerce. Throughout the nineteenth century, the service also participated in coastal patrol activities in conjunction with the U.S. Navy, engaging as well in every major war up to the present day.

The Barbary Pirates: "To the Shores of Tripoli"

On the heels of the American-French *affaire de guerre*, the pirates of North Africa's Barbary coast began to harass American merchant shipping before boldly declaring war on the United States. Prevented by the new Constitution from declaring war or even retaliating under such circumstances, President Thomas Jefferson nevertheless ordered a naval blockade of the Tripolitan coast in 1801 to bring the renegade pasha and his corsairs to terms; it was, in effect, the first instance of gunboat diplomacy.

The American squadron, consisting of the *President*, the light frigates *Philadelphia* and *Essex*, and the schooner *Enterprise*, sailed past Gibraltar in July of 1801. After two indecisive years of maneuvering, bluffing, and shuffling of squadrons—with not even the guns of the *Constitution* strong enough to silence the Tripolitan shore batteries—the new commodore, Edward Preble, lost the *Philadelphia*, its captain, William Bainbridge, and the entire crew to the Tripolitans during an attempt to secure a peace treaty with the neighboring Moroccans. Under cover of darkness, however, Lt. Stephen Decatur, commanding the schooner *Intrepid*, led a now legendary raid to reclaim and burn the *Philadelphia* at anchor. Meanwhile, Marine Lt. Presley O'Bannon was leading a relief column, with a small band of Arabs and Marines, 400 miles (644km) across the desert in a flanking movement on neighboring Derna. Helped to a great extent by Decatur and O'Bannon's efforts, the Americans ultimately defeated the Barbary pirates, thereby putting an end to a fascinating footnote in American naval history and adding the line "to the shores of Tripoli" to the *Marine Hymn*.

Fortuitously, one of the crew of the *Philadelphia*, Smn. Charles DeNoon, watching the *Intrepid's* nighttime raid from his prison cell overlooking the harbor, drew a crude sketch of the burning of his ship on the night of 16 February 1804. It is the only known eyewitness account of this event in existence.

Another of the captured *Philadelphia's* crew, Lt. David Porter, was to play an important, though tangential role in the coming War of 1812 with the British. Participating in some of the many victorious naval battles against the imposing British Navy, which had only recently defeated the French-Spanish fleets at Trafalgar, Porter had taken

Armed Forces of a New Nation

As the end of the eighteenth century approached with the United States a fledgling but independent nation, danger still lurked, especially on the high seas. Piracy, seizure of ships and cargo, and the impressment of seamen to serve in the British navy were not uncommon. The French Revolution notwithstanding, the major European powers were constantly warring, with foreign military engagements bound to impact the new nation. Consequently, the new U.S. Congress, in a special act of 27 March 1794, not only provided for the establishment of a professional navy, but also voted appropriations for the building of four men-of-war naval vessels of sufficient tonnage—and gun power—to protect American shipping. Not quite a match for British ships-of-the-line, with their three decks of sixty-four to a hundred guns, these two-deck, forty-four- to fifty-gun large frigates were, however, superior to all existing frigates. The Constellation, Constitution, Congress, *and* Chesapeake *(the* United States *and* President *were added later) were the U.S. "pocket battleships" in the age of sail and a far cry from the "used merchandise" John Paul Jones had had to sail almost twenty years earlier.*

Congress also created both the Department of the Navy and the United States Marine Corps on 30 April 1798 (although the Marine Corps celebrates its birth date as 10 November 1775, when the Continental Congress authorized the raising of two battalions of Marines). Not long after, the United States became involved with France in a quasi-war that took place mostly at sea.

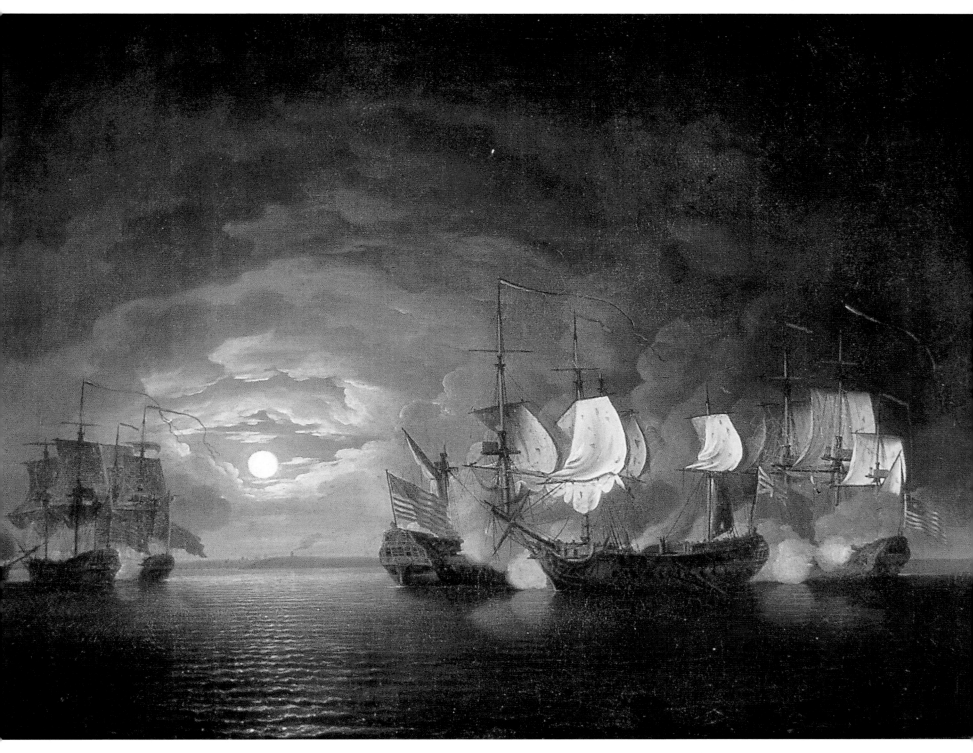

command of the light frigate *Essex* by 1812. After missing a rendezvous with other U.S. naval vessels, Capt. Porter embarked on a seventeen-month cruise that took him around the southern tip of South America, through treacherous waters around Cape Horn, and deep into the Southern Pacific on a series of victorious raiding parties. He ultimately journeyed all the way past the Galápagos Islands to the Marquesas. On her return, unfortunately, the *Essex* encountered HMS *Phoebe* and *Cherub* at Valparaiso, Chile, on 28 March 1814. It turned out to be the bloodiest single-ship action of the war. Porter lost more than half his crew of almost 300, with eighty-nine killed; the British lost five killed. Among the survivors was a thirteen-year-old midshipman, David G. Farragut, destined for fame fifty years later.

Capt. Porter, to history's good fortune, was an accomplished artist and kept an illustrated diary throughout his voyage, which he published in Philadelphia in 1815. From his sketches he later made finished watercolors, some of which were copied and published later in the century by Capt. William B. Hoff, USN. In 1834, (then) Commodore Porter published his complete, detailed written account as *The Cruise of the Essex*, and illustrated it with his eyewitness sketches.

The "Marine School" of Painting and the War of 1812

The English "marine school" tradition spanned both the American Revolution and the War of 1812 and continued well into the nineteenth century. Nicholas Pocock was

Above: The end of the engagement between HMS *Serapis* and *Bonhomme Richard* is portrayed here by Thomas Buttersworth, a noted British marine painter of the late eighteenth and early nineteenth centuries.
U.S. Naval Academy Museum

joined by a younger generation of artists, whose work came to be labeled American since they ultimately settled in the United States. They included Thomas Birch, who emigrated at age twenty-one in 1800, and Robert Salmon, as well as brothers Thomas and James C. Buttersworth. (The Buttersworth brothers retained their English connections. James actually served for a time as an official artist and draftsman on the staff of British Adm. Horatio Lord Nelson, though whether he or his brother ever witnessed battle action is only conjectural.) The pictorial re-creations of the Buttersworths, Pocock, and Birch were, nevertheless, historically accurate and of high artistic quality. Their work was complemented by improved engraving techniques such as stippling and mezzotint, which softened the etched-line work, and by the addition of color in what are known as aquatints.

James Buttersworth's son, James E., dropped the "s" in his last name and went on to gain fame in the middle of the century as an American marine painter, notably for his *Yankee Clipper Ship* series, which was reproduced by the lithograph house of Currier & Ives after the Civil War. Birch, a landscape painter as well as a marine artist, was subsequently elected to the Pennsylvania Academy of Fine Arts. While presumably never an eyewitness, Birch was nonetheless especially inspired by the War of 1812, and up to the 1820s he painted numerous works illustrating it, such as *Wasp and Frolic*, *Hornet and the Peacock*, *Battle of Lake Champlain*, and *Battle of Lake Erie*, to cite only a few. As present-day art historian John Wilmerding notes, Birch was unsurpassed at rendering the movement of water and the quality of light and air.

Although not of the so-called English school, Neapolitan painter Michele Felice Cornè was an outstand-

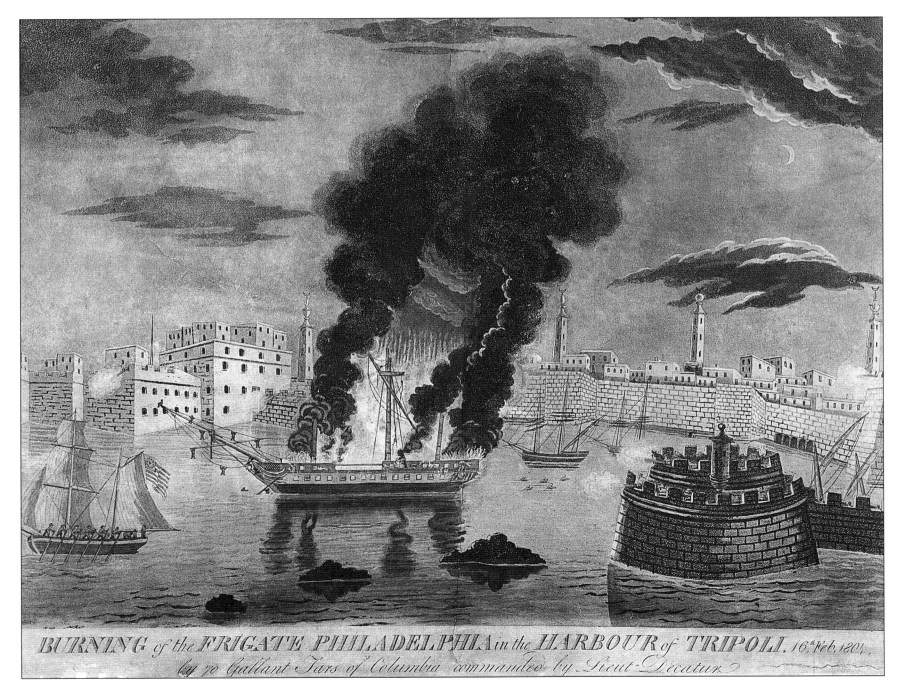

BURNING of the FRIGATE PHILADELPHIA in the HARBOUR of TRIPOLI, 16th Feb 1804, by 70 Gallant Tars of Columbia commanded by Lieut Decatur

ing marine artist who depicted some of the American squadrons' naval engagements in the Mediterranean. Later befriending Capt. Preble, former commander of the squadron that had blockaded Tripoli, Cornè based his painting of the 3 August 1804 events, *Preble's Squadron Attacking the Tripolitan Fleet*, on detailed explanations of the ships' positions by Preble himself. (A letter titled "To Secretary of the Navy from Captain Edward Preble, U.S. Navy" confirms the origin of the painting: "Sir When last at Boston I delivered the Navy agent a painting of the first Attack on the Tripolitan shipping & Batteries by the Squadron which I had the honor to Command— The view of the Town & situation of the squadron & enemies naval force is tolerably correct. I hope it may meet your approbation…")

Cornè spent considerable time in the United States, permanently settling in Salem, near Boston, in 1779. Twenty-four of Cornè's sea battle paintings of the War of 1812 were engraved and published in *The Naval Monument* by Abel Brown in Boston in 1816. One of Cornè's large paintings, *Close Engagement 1812*, was "painted and executed under Directions from Commodore Hull [the captain of the *Constitution*, who also described to him in great detail the battle against HMS *Guerrière*] & Captain Morris." It was engraved by J.R. Smith for public consumption. Other works of Cornè's were engraved by William Hoogland, such as the *Capture of American Flotilla, New Orleans, 1814*, and *Constitution's Escape from the British Squadron after a Chase of Sixty Hours*. His accurate renditions of the USS *Constitution* were invaluable in the 1850s, when the old vessel was reconstructed and refurbished from stem to stern.

Of particular note also were the engravers Benjamin Tanner and Cornelius Tiebout of Philadelphia, who in the first quarter of the nineteenth century made excellent steel plate engravings of the works of many marine artists, especially Birch. The engravings include Birch's four-panel series in oil of the 19 August 1812 engagement of the *Constitution* and the *Guerrière*. Birch's painting entitled *United States and Macedonian* was engraved with color by Tanner and published in 1814.

The Great Lakes battles later in 1813 were depicted in numerous works, such as Birch's *Perry Changing Ships on Lake Erie*, John James Barralet's *Perry's Victory on Lake Erie*, and Hugh Reinagle's *MacDonough's Victory on Lake Champlain*. A Navy lieutenant recorded only as Buchanan (later Supt. Buchanan?) did sketches of some of these actions; several were also engraved by Nicholas Pocock.

Untoward events and reversals, such as the burning of Washington by the British on 24 August 1814 and the bombardment of Fort McHenry in Baltimore Harbor on 13 and 14 September 1814, were also depicted and printed. A contemporary, unattributed watercolor rendering of the Fort McHenry action (where Francis Scott Key jotted down his immortal *Star Spangled Banner* lyrics to a bawdy English tavern tune) appears quite authentic, as does a creditable aquatint by John Bowers. All the artists conceivably could have watched the bombardment from shore.

During the war, there were only three major land engagements: a successful American operation in the Great Lakes and into Canada; a large-scale offensive into the U.S. Capital in which the British burned the White House, shelled Baltimore, and then withdrew; and lastly—and unbeknownst to both sides, two weeks after a peace treaty had been signed—the famous Battle of New Orleans. There, on 8 January 1815, Gen. Andrew Jackson's army slew 2000 British, losing only seventy of their own. Several depictions of this battle exist, but they cannot be confirmed as the work of eyewitnesses.

Since the youthful nation had unexpectedly defeated a superior and more experienced British Navy—and with few land victories to speak of—the subsequent popularity of the war's U.S. naval victories brought forth a flurry of marine pictures. In more than 200 previous engagements, the British navy had suffered only five defeats; in the War of 1812, it suffered fourteen in eighteen, mostly single engagements against the Americans. The U.S. Navy's victories were aided in no small measure by the perfection of elevating fixed gunsights that enabled all guns to fire at the same angle, with devastating effect; the British broadsides, by comparison, often missed entirely.

Almost every naval battle had been accurately recorded in some talented ship's officer's sketch, which was later painted by an artist or engraved and printed, then sold to the public. Thus, the stage was set for the flourishing of the popular lithographic prints that would supplant engravings and mezzotints and virtually mold the taste of the century to come.

Above: Capt. David Porter is portrayed by an unidentified artist of the early nineteenth century. His son, Adm. David Dixon Porter, also became a distinguished officer, serving in the Civil War. Both were skilled artists themselves and kept illustrated diaries of their wartime adventures. **U.S. Naval Academy Museum**

Below: During the extended voyage of the *Essex* around the southern tip of South America and on to the Marquesas in the southwestern Pacific, artist-captain David Porter filled his journal with sketches of several engagements with British vessels. The journal includes this rendering of his own ship's demise in a confrontation with the *Phoebe* and *Cherub* in the harbor of Valparaiso, Chile, 28 March 1814. **U.S. Navy Historical Collection**

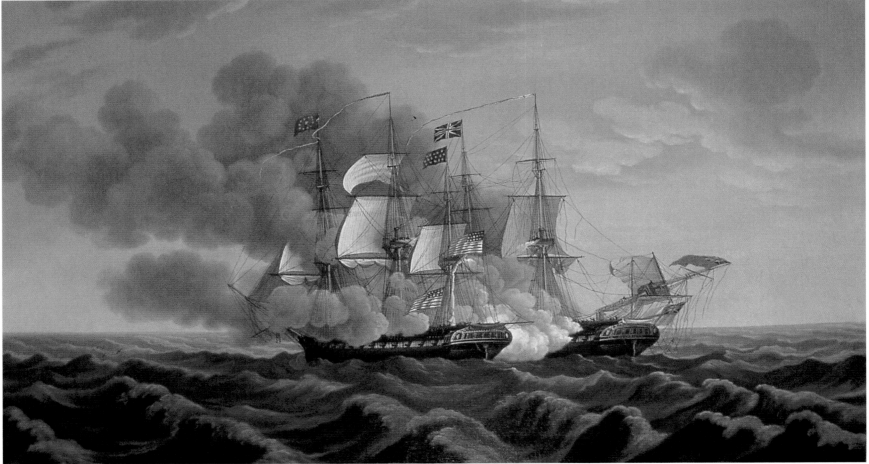

Pages 46–47: No doubt drawing upon Capt. Isaac Hull's detailed description, Neapolitan artist Michele Felice Cornè painted a four-panel series of the decisive encounter between the USS *Constitution* and HMS *Guerrière*, which took place 750 miles (1,207km) off Boston on 16 August 1812. With the wind from the northwest, Hull maneuvered "Old Ironsides" to the windward side of his English opponent, Capt. James Dacres. Anticipating that the *Guerrière* would open fire at long range, Hull sailed the *Constitution* with the wind, heading straight for the British ship while presenting a smaller target. The *Guerrière* turned hard to port

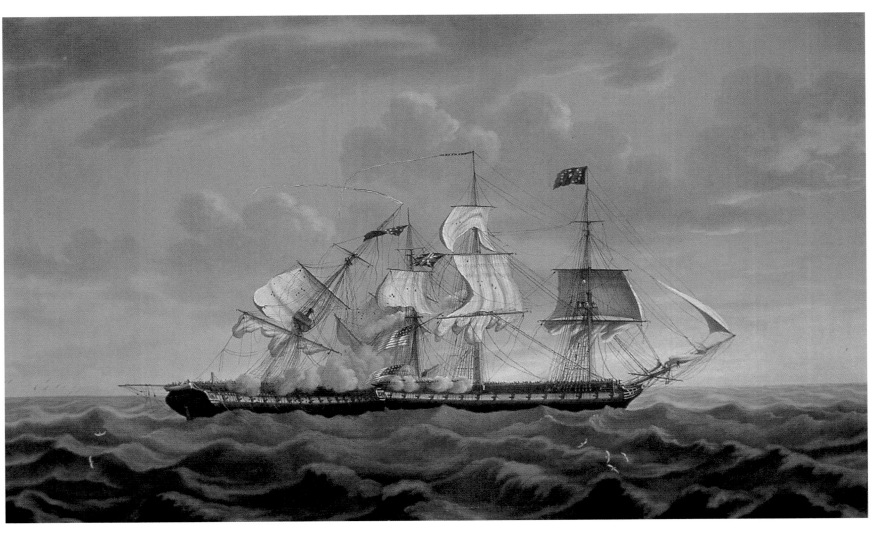

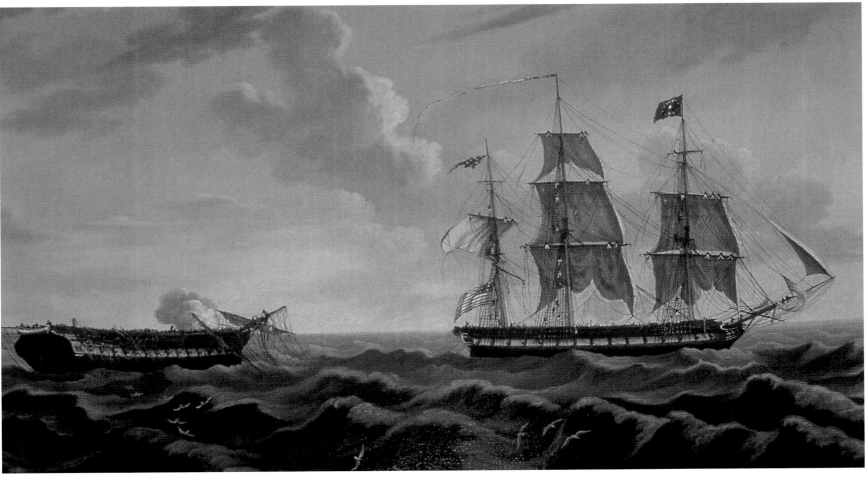

when the American vessel neared and suffered a crushing broadside from its guns. The *Constitution* then turned and raked the damaged *Guerrière* with an opposite broadside. The dismasted British ship, having entangled its bowsprit in its opponent's mizzenmast, fired a gun to leeward to signal surrender. Instead of following the seafaring tradition of accepting the vanquished's sword, Capt. Hull flipped a coin for Dacres' hat.

U.S. Naval Academy Museum

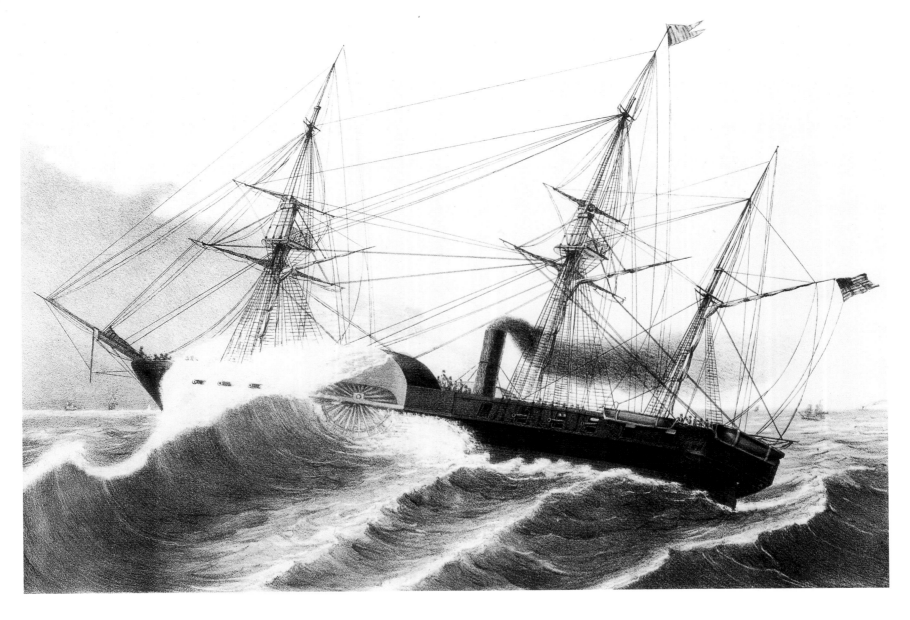

American settlers' rights. An army lieutenant by the name of Ulysses S. Grant wrote that the U.S. Army presence was nothing more than a deliberate provocation to force the Mexicans to declare war. (He might have added, "…thus fulfilling the slogan Manifest Destiny," a term coined to justify westward expansion.) Before full-fledged war broke out, the commander of the U.S. Pacific naval squadron, overstepping his authority and "jumping the gun" in late 1842, actually captured Yerba Buena, the present site of San Francisco, from the Mexicans. (He was later forced to relinquish it lest the action precipitate hostilities.)

The War with Mexico: 1846–1848

Mexico did indeed declare war, on 24 April 1846, whereupon Gen. Zachary Taylor's U.S. Army in Texas crossed the Rio Grande and fought its way through the battles of Palo Alto, Matamoros, and Monterey. At Buena Vista, they joined another U.S. Army column that had fought its way farther north from El Paso and through Chihuahua.

Meanwhile, Gen. Winfield Scott's expeditionary forces invaded Vera Cruz on the southeastern coast of the Gulf of Mexico. This assault employed a naval amphibious force under the command of Commodore Matthew C. Perry. The naval expedition cruised with its steam-powered paddle wheels, tall sail ships, and attendant barges and landing boats into the Tabasco River in order to secure a foothold with the Marines. After a two-week siege and bombardment, Vera Cruz fell, and Scott's troops pressed on to Mexico City, fighting numerous engagements along the way at Cerro Gordo, El Pedregal, Contreras, Churubusco, and El Molino de Rey. They finally stormed the fortified bastion of Chapultepec, forcing the Mexicans to surrender. (It was at the last battle that the legendary "Halls of Montezuma" became a part of the *Marine Hymn*, in tribute to the fierce fighting of the Marine contingent that seized the National Palace of Montezuma in the heart of the city.) The subsequent Treaty of Guadalupe Hidalgo in 1847 fixed the present U.S. southern boundary and gave the United States the territories of New Mexico and California—just before gold was discovered in California.

Artists of the War

Several artists participated in the Mexican War, and the events of that conflict have stirred the imaginations of

Above: A stormy area capable of sudden tempests, the southwest Gulf of Mexico was the site of numerous shipwrecks during the Army's amphibious operations at Vera Cruz. Here, Lt. Henry N. Walke portrays the U.S. steam frigate *Mississippi*, commanded by Commodore Perry, plowing through high seas on its way to assist the stricken steamer *Hunter*. More than twenty-three ships were wrecked in similar storms during the operation.
U.S. Naval Academy Museum

Above: English artist James Walker accompanied the American Army during actions in the Mexican war. His *Storming of Chapultepec* (Sept 13, 1847) was commissioned to hang in the U.S. Capitol.
USMC Historical Center

Opposite: Samuel Chamberlain documented scenes from the Mexican War, including "Harney's Dragoons Swimming the Rio Grande," which shows American troops on their way to Mexican territory to attack California from the east.
U.S. Military Academy Museum

illustrators ever since. James Walker, an English artist living in Mexico City, was expelled from the city at the outbreak of hostilities and immediately offered his services to the U.S. Army as an interpreter. He accompanied the American army, observing and sketching the momentous events. After the war, Congress commissioned Walker for a number of large mural paintings to adorn the Capitol and to memorialize the war and American westward expansion. His style is recognizable by a certain inflated quality to his figures. In 1857, he painted his monumental, nine-and-a-half-foot (3m) high by twenty-foot (6m) wide *Storming of Chapultepec*, for which he was paid $6000. (Removed from the Capitol a hundred years later at the request of a Mexican ambassador, it now hangs in the U.S. Marine Corps Museum at the Washington Navy Yard.)

Also on hand at the battle for Mexico City was German architect and dilettante Carl Nebel, who later produced a number of undistinguished works, which he lithographed and published in 1848 as *The War Between the United States and Mexico Illustrated*. Although an eyewitness to the events he depicted, such as Gen. Winfield Scott's entrance into Mexico City, for some reason, Nebel saw fit to clean up the uniforms. Perhaps he did so to appeal to the popular, fastidious tastes of the times and eschew the ugliness of war, but he robbed his scenes of both realism and believability. Of more historical and artistic value was the work of a U.S. Navy lieutenant, Henry N. Walke. As the commander of the bomb-brig *Vesuvius*, he participated in the Tabasco River operation and helped land a Marine contingent prior to the Battle of Vera Cruz. Walke, an accomplished artist, did sketches and watercolor paintings on the spot. Not much is known about him except that he was a career naval officer who, during the Civil War, also engaged in river operations and, again, sketched his observations. Following both wars, he had his sketches and watercolors published in lithographic plate form, which offer remarkable records of both periods and are notable artistic achievements as well.

Comanchas on the War Path.

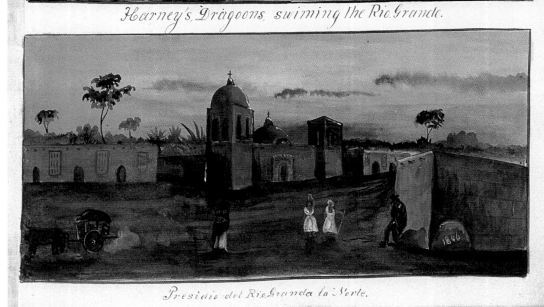

Harney's Dragoons, swiming the Rio Grande.

Presidio del Rio Grande la Norte.

Henry N. Walke was truly a combatant-artist. Distinguishing himself militarily during the Tabasco River operation, he was promoted to captain. Later, in 1861, he received a wartime commission as rear admiral and was given command of the ironclad *Carondelet* on the Mississippi, where he figured prominently in the battle for Island No. 10 and at Shiloh, Memphis, and Vicksburg.

Another naval officer, Lt. Charles C. Barton, served aboard one of the ships in the Tabasco River flotilla, consisting of seven gunboats and sixty-five surf boats. Unopposed, the fleet landed a U.S. Army brigade (with 300 Marines) in full view of the Vera Cruz harbor, the gateway to the interior and the capital. Barton sketched the 9 March 1847 landing, as well as others during the operation, thus perpetuating, along with Walke, the time-honored tradition of line-officer artists. His scene of the landing at Vera Cruz and another of a rendezvous of forces prior to the landing were redrawn on stone by

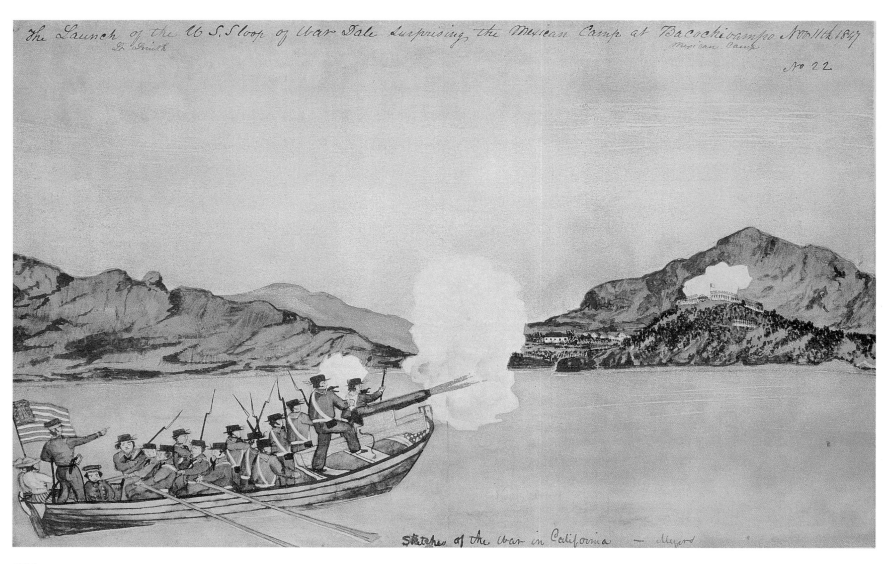

The Launch of the U.S.S. loop of War Dale Surprising the Mexican Camp at Bacochivampo Nov 11th 1847

Sketches of the War in California — Meyers

Above: William H. Meyers used watercolors to depict the USS *Dale*'s armed launch that surprised a Mexican camp on 11 November 1847.
Franklin D. Roosevelt Library, Hyde Park, New York

Opposite Top: Meyers annotated this watercolor sketch, *The Mexican Troops Are Driven from Guaymas 17 November 1847*, with the following summation: "Seamen of U.S. Sloop Dale in possession of the fort—dislodging the enemy from the surrounding houses—Guaymas. Gen Smith commanding, Midshipman Houston, Boatswain Potley." It is extraordinary that Meyers' watercolor paintings have survived. After finishing and drying them, he folded each four times into packable, flat squares.
Franklin D. Roosevelt Library, Hyde Park, New York

Opposite Bottom: Meyers' *The Battle of San Pasqual* was annotated with the following: "General Kearny, reinforced by sailors and California Volunteers, fighting his way to San Diego. 6 December 1846."
Franklin D. Roosevelt Library, Hyde Park, New York

H. Dacre and published as lithographs by P. S. Duval in Philadelphia in the same year.

The Unsung War on the Pacific Coast
Naval Sketches of the War in California by Gunner William H. Meyers, USN

Artistic coverage of the war along the western coastline of the California Territory was undertaken by a navy gunner and warrant officer, William H. Meyers, aboard the U.S. sloop-of-war *Dale*. A Philadelphian, Meyers joined the Navy in 1841 and resigned because of poor health in 1848. In the interim, he managed to amass a quantity of valuable watercolors depicting a little-known aspect of the war with Mexico.

In 1842, Meyers had been aboard the sloop-of-war *Cyane*, accompanying Commodore Thomas Jones on the *United States*, when American naval forces preempted hostilities and captured Monterey. (Later ordered to restore it to Mexican authority, Jones was relieved of his command as a consequence.) When war was finally confirmed, Yerba Buena (now San Francisco), Los Angeles, and San Diego were readily seized.

Army Col. Stephen Kearny's column, which had marched across the desert all the way from Kansas via the Santa Fe Trail, met trouble on the outskirts of San Diego,

clashing with the Mexicans at San Pasqual. A task force of some thirty sailors and Marines was quickly dispatched from the naval squadron and sent to the Army's aid, arriving just in time to help turn the tide and save the surrounded Army troops.

Fortunately, Meyers, who took part in the action, also sketched it, either from memory or on the spot. An untrained artist of limited talent, his ingenuous portrayals nevertheless possess an artistic charm, as well as obvious historical accuracy. Cruising up and down the coast in Commodore Stockton's Pacific Squadron, the *Dale* participated in mostly seaborne landings and on-shore engagements against the Mexicans. Among the highlights Meyers depicted was the decisive defeat of the foe on the plains of La Mesa near Los Angeles. Landed ashore once more to augment Kearny's forces, Meyers' detachment endured a series of hard-fought skirmishes at Santa Clara in the north and San Gabriel in the south on their way to Los Angeles. Later, at Guaymas, on the eastern coast of the Gulf of California, the *Dale*'s valiant landing force endured a surprise attack, which Meyers dutifully portrayed in great detail—and possibly with great relish, since he had participated in the heat of the battle, an extraordinary experience for a sailor—and for an artist.

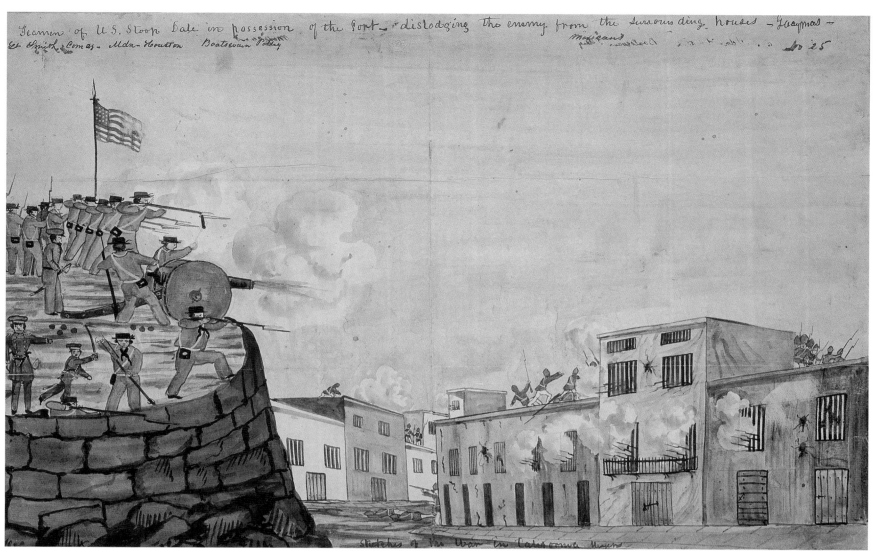

Seamen of U.S. Sloop Dale in possession of the Port—distodging the enemy from the surrounding houses—Guaymas—Mexico

Lt Smith Comdg—Mdn Houston Boatswain Tilley

Nov 25

Sketches of the War in California Myers

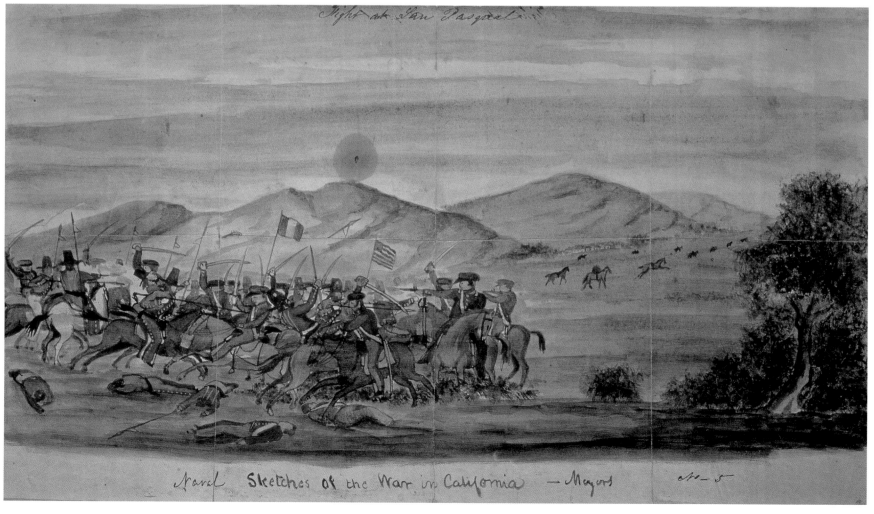

Fight at San Pasqual

Naval Sketches of the War in California—Myers No 5

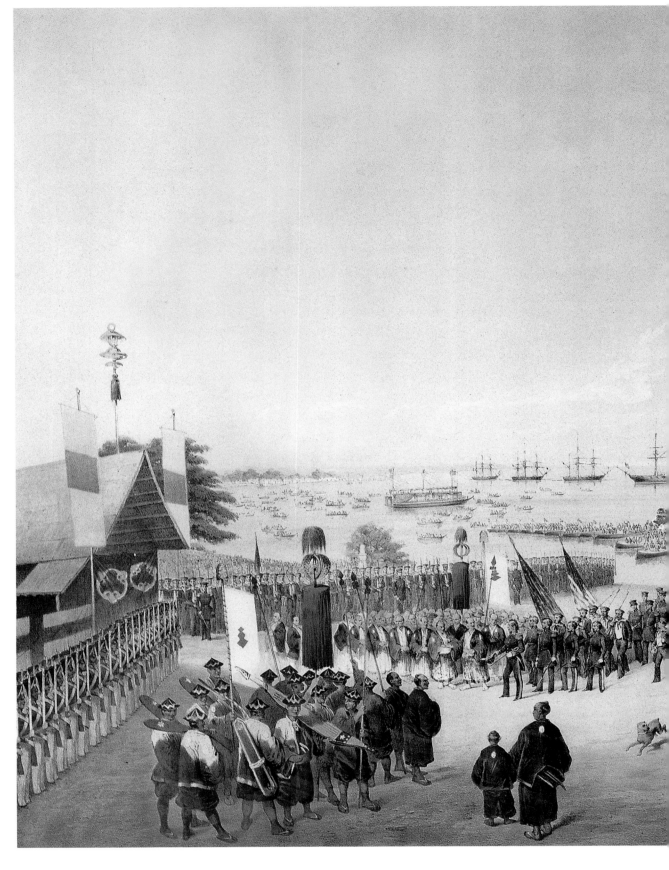

Other U.S. Navy Expeditions

Since the first half of the nineteenth century was still an age of exploration, as well as expansion, it is worth mentioning that the U.S. Navy—while called upon to physically protect American interests in such remote places as Qualah Battoo, Sumatra (1832), and Canton, China (1856)—also sent out eleven scientific expeditions. Several of these missions, which were not of a combat nature, were faithfully recorded by ship's artists. The 1838–42 voyage to the Antarctic and the South Pacific headed by Lt. Charles Wilkes, a skilled artist himself, was depicted by civilian artist-scientist Alfred T. Agate, who created the visual record as Capt. Porter had done during the odyssey of the *Essex.* Commodore Matthew C. Perry's famous expedition to isolationist Japan in 1853–54 was chronicled by an official Navy artist named Wilhelm Heine. Most plausibly from his own on-the-spot sketches, Heine later executed a number of large,

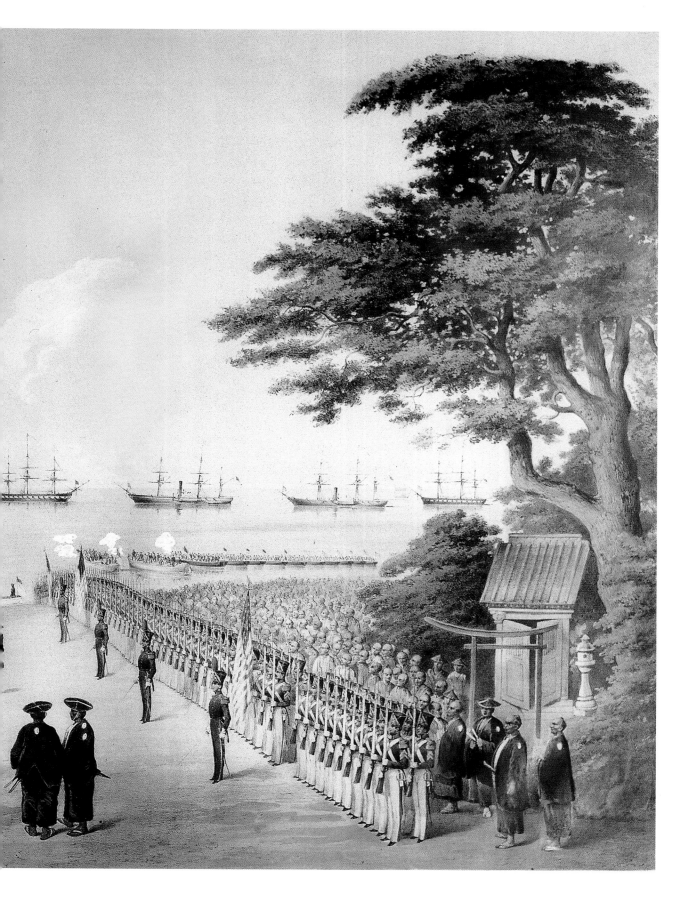

panoramic paintings of the impressive ceremonies staged by both sides. It is interesting to note that the Japanese, no doubt equally intrigued by these "barbarians" from over the horizon, depicted the ships and men of the U.S. Navy in their own decorative and distinctive style.

CHAPTER *Three*

A Nation Divided

On 4 March 1861, Abraham Lincoln was sworn in as the sixteenth president, immediately inheriting a secession crisis that threatened to unravel the Union. The previous month, following South Carolina's lead, seven Southern states that depended on slave labor for their agrarian economies had formally broken away from the Union, creating the Confederate States of America and electing former Secretary of War Jefferson Davis as president. In April and May, after fighting erupted in Charleston harbor, four more states seceded and joined the Confederacy.

In what would become the deadliest war the nation was ever to face (of three and a half million men under arms, 650,000 died in battle), Americans were quickly forced to choose sides. With rail transportation still fairly primitive and the telegraph just beginning to connect major population centers, loyalty, more often than not, began at home. Hence, when the rift occurred, many people were torn between duty to country and duty to their homes and way of life.

Nowhere was this felt more painfully than at West Point and Annapolis. The band of brothers trained there broke along state lines: Robert E. Lee, Thomas J. (later "Stonewall") Jackson, Jefferson Davis, and Franklin Buchanan would opt to serve their native states, which were a part of the Confederacy, while Ulysses S. Grant, George G. Meade, George McClellan, and others would lead major armies for the North. Veterans who had fought side-by-side in the Mexican-American War found themselves squaring off against each other in a conflict that pitted neighbor against neighbor—and, in the case of Thomas F. and Percival Drayton, brother against brother.

After graduating from West Point and serving as a South Carolina state senator, Thomas F. Drayton had become a prosperous planter on Hilton Head Island—and thus a proponent of the Southern cause. When war broke out, he was commissioned a brigadier general in the Confederate States Army. His brother, Percival, meanwhile, had become a career Navy officer and would remain loyal to the Union as commander of the gunboat *Pocahontas*. Their paths crossed on 7 November 1861 in the Battle of Port Royal Sound. After a storm had forced Percival to miss Union Adm. Samuel F. DuPont's initial attack, as well as the subsequent circling bombardment of Rebel forts protecting the harbor and town of Beaufort, Comdr. Drayton arrived at the Atlantic coast just off Hilton Head. Gen. Drayton was defending Fort Walker on the island, with all his guns pointed towards the sound, not the ocean. In a position to deliver withering enfilade (flanking fire) from the *Pocahontas*, Percival ultimately forced his brother to abandon the fort, and the Union occupied it. The brothers never spoke again.

Evening Gun, Fort Sumter, 1863 is Conrad Wise Chapman's romantic rendering of the destroyed fort guarding the harbor at Charleston. After driving the Union forces out (and thus precipitating the Civil War), Confederate forces occupied the fortress, which was then subjected to constant bombardment by Federal ships standing offshore. The gunships succeeded in reducing the fort practically to rubble, although they recaptured it only after it was abandoned at the close of the war. Chapman visited Sumter under fire many times. His primary duties were to sketch Rebel fortifications in the area for Gen. Beauregard.

The Museum of the Confederacy, Richmond, Virginia

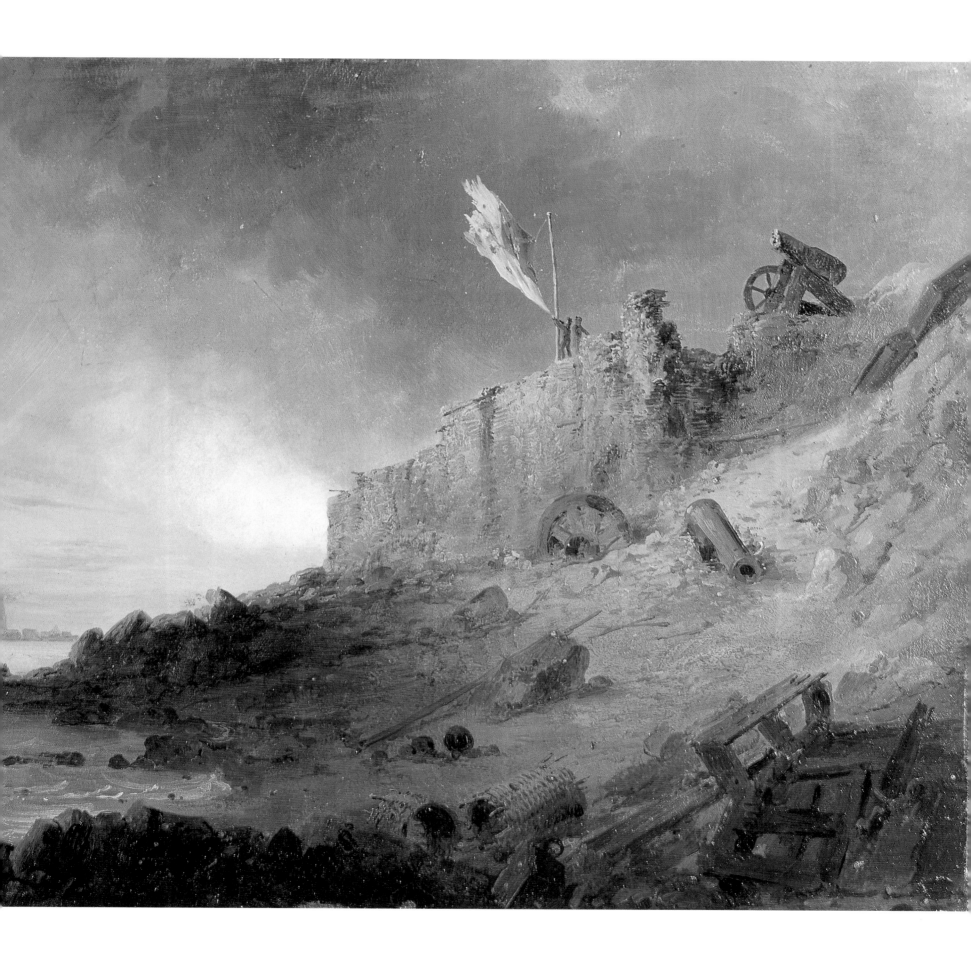

While the South's military skill outshone the Union's for the first three years, it was the North's strategy—and beginning in 1864, its feisty, combat-hardened general, U.S. Grant—that ultimately prevailed, reuniting the nation. Union strategy had called for clearing Northern Virginia to protect Washington, isolating the nonindustrialized South through beachheads and naval blockades along the Atlantic, controlling the Mississippi River, and finally, cutting the South in half. The last component led to some of the fiercest fighting in the war, from Vicksburg and Jackson in Mississippi to Chattanooga, Tennessee, and ultimately to Atlanta, culminating with Gen. William Techumseh Sherman's destructive "March to the Sea."

In the East, Lee's Army of Northern Virginia managed to continually outfox the Army of the Potomac, delivering a string of defeats to a succession of commanders. In July 1863, however, the stand-off in Gettysburg, Pennsylvania, would put an end to his offensive capabilities. Once Grant took command of the Eastern troops, he relentlessly hounded Lee through the wilderness northwest of Richmond, through Spotsylvania, and finally to the gates of the Confederate capital itself. On 2 April 1865, after a nine-month siege of Petersburg and Richmond, Gen. Lee telegraphed President Davis in Richmond with the succinct words: "My lines are broken in three places. Richmond must be evacuated this evening." For another week, Grant doggedly pursued Lee's exhausted army westward through Virginia, before finally corralling it by a small town called Appomattox Court House. There, the esteemed icon of the Confederacy surrendered on 9 April.

Art of the Civil War
The Artist-Correspondents of the Weeklies and Soldier-Artists in Combat

All told, a wealth of artists emerged during the war, some independents like David Blythe in the South and James Walker in the North, and some uniformed soldiers like George Caleb Bingham and sailors like Xanthus Russell Smith. Most, however, were in one way or another associated with the illustrated weekly journals: Winslow Homer, Edwin Forbes, Frank Vizetelly, William and Alfred A. Waud, Allen Redwood, Theodore R. Davis, Robert Weir, and Henri Lovie.

By 12 April 1861, when the first Confederate cannonball hit Fort Sumter in the mouth of the Charleston harbor, a sizable newspaper industry was already in full swing. In New York, *Frank Leslie's Illustrated Newspaper* sent artist-correspondent William Waud to the Confederate side to cover the Fort Sumter affair. *Harper's Weekly* commissioned sketches from naval officers inside the fort, while *Southern Illustrated News*, the *Magnolia Weekly*,

DeBow's Review, and *Index*, plus daily newspapers in large and small cities throughout the country, also dispatched reporters. With telegraphic communication, the spread of news was rapid, though the illustration of it less so. (A Currier & Ives chromolith print of the Sumter attack, however, did go on sale to the public within weeks of the event.)

The only means of adding pictorial matter to newspaper printing at the time was, of course, through wood engraving, which was a slow, time-consuming, and tedious process. Nevertheless, the journals were quick to capitalize on pictorial coverage of coming events and hired and dispatched what they termed "artist-correspondents" to the various armies in both the North and South. A successful precedent had been set less than a decade earlier by the *Illustrated London News*, when it had sent special artist-correspondents to cover Britain's 1854 Crimean War with Russia.

A number of fine artists and illustrators were hired by the journals, while others enlisted in the armies or served with the forces as artist-observers. *Leslie's* attracted some eighty artists, among whom were noted painters Forbes and Lovie. Forbes turned out a large body of work from his experiences and even made a living off his war art for years afterward, featuring the work in several published books. At war's end, *Leslie's* boasted that during the four years of fighting it had at least one of its trained artists at every important engagement and had published three thousand pictures of battles, sieges, bombardments, and other scenes incidental to the war. *Leslie's* had also been smart enough to provide each of its artists with a special sketchbook, complete with copyright notice in the bottom left-hand corner. The artists would annotate their quick, on-the-spot drawings with details and further descriptions to the engravers, who would ultimately transform their work into finished, printable pictures. When not in combat action, the artists created detailed sketches of camp life, military hardware and armament, and the like for reference for the finishers back at the home office. Photography played a similar, if less pervasive, role during the Civil War. The few photographer teams were spread out widely, and the photo process was slow and complicated, so no action pictures could be taken. Consequently, the journals only resorted to using photographs on occasion. Their artist-correspondents were doing what photojournalists do today: reportorial illustration.

Harper's Weekly, competing neck-and-neck with *Leslie's*, also had its stable of artist-correspondents. Among their scores of artists were the notable Waud brothers from England; a neophyte cartoonist named Thomas Nast (who never ventured into the field); Homer, at the time a

FRANK LESLIE'S ILLUSTRATED NEWSPAPER

Entered according to the Act of Congress in the year 1862, by FRANK LESLIE, in the Clerk's Office of the District Court for the Southern District of New York.

No. 326—Vol. XIII.]　　　　NEW YORK, FEBRUARY 22, 1862.　　　　[Price 6 Cents.

THE PRESIDENTIAL PARTY.

There has been a social innovation at the White House, and the experiment has been a brilliant success. Hitherto there have been but two variations in the social amenities of that establishment, namely State dinners and "receptions"—the former dedicated to the entertainment principally of Foreign Ministers and heads of Departments, the latter to "the people" in the widest acceptation of the term. In other words, "a reception" consists in throwing open the Presidential mansion to every one high or low, gentle or ungentle, washed or unwashed who chooses to go, and the net result is always a promiscuous, horrible jam, a species of social mass-meeting. They have been made thus indiscriminate from a false deference to the false notion of democratic equality, which certainly is practised by no private family, however humble, and which no one has a right to exact from that of the President.

On ordinary occasions, when comparatively few people are in Washington, the receptions, bad enough at best, are still endurable by people of sharp elbows and destitute of corns, and who don't object to a faint odor of whiskey; but now when the city is filled to overflowing, and military operations have called there thousands where there were formerly only tens, all anxious to visit the White House and catch a glimpse of the President—under these altered conditions, the horrors of a reception have been augmented past endurance, and to a degree repelling the refined and better portion of the residents, temporary or permanent, in the Capitol.

To call these around her, and meet a social exigency which all recognized, and at the same time to pay a graceful tribute to the most distinguished among the men, and the most beautiful and brilliant among the women in Washington, Mrs. Lincoln hit upon the expedient of a Presidential Party, in the same sense, and under such conditions as a party is understood and practised by respectable people in private life. To that end cards of invitation were issued to about 500 persons, or as many as the Presidential mansion could readily accommodate without confusion, for Wednesday evening February 5th, and the result was, as we have said, a complete success. The gathering, whether in respect of the intellect, attainment, position, beauty and elegance of those composing it, was equally remarkable and brilliant. Among the men, it comprised all the heads of Departments, the leading members of both Houses of Congress, the divisional commanders of the army of the Potomac, and the Foreign Ministers, besides a considerable number of men distinguished in art, science and literature, sojourning for the time being in the city. Among the ladies present were the female members of the families of these eminent personages, embracing among them an amount of beauty of face and grace of form, brilliancy of intelligence, tastefulness of dress, and general elegance, probably never before equalled on this Continent. Indeed, no European Court or capital can compare with the Presidential circle and the society of Washington, this winter, in the fresh-

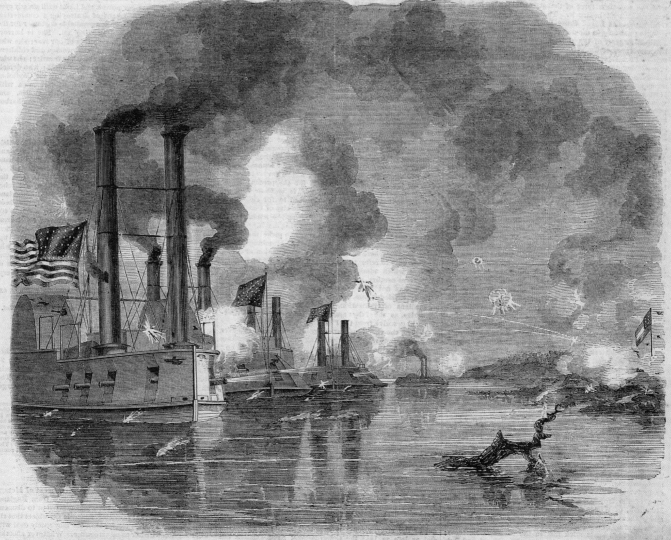

THE WAR IN THE WEST—THE NATIONAL GUNBOATS, COMMANDED BY FLAG OFFICER FOOTE, BOMBARDING FORT HENRY, TENNESSEE RIVER, FEBRUARY 6.—SEE PAGE 212.

penniless but promising illustrator (who surpassed the others and became a well-known fine artist following the war, curiously enough turning to sea and marine subjects, which he shunned during the war); T.R. Davis, who was wounded twice in battle; and James O'Neal, who was killed in battle. In addition to the home-grown artists, foreign journals dispatched many artist-journalists to the U.S. civil conflict as well.

Not everyone was impressed with the war coverage by these so-called war artists. *The Cincinnati Times* accused the illustrated journals of churning out "little better than a sensational farce." In retrospect, their crankiness could indicate that the *Times* just did not have the wherewithal to keep up with the times—or perhaps it was just plain envy at the successes of the picture journals.

Many noted mid–nineteenth century American artists rallied to the flags—either the Stars and Stripes or the Stars and Bars. One of the few Marines to serve in the Civil

War, Lt. Robert L. Meade (reportedly the uncle of Gen. George G. Meade) was captured in one of the skirmishes near Fort Sumter and spent his captivity in Rebel prisons in Charleston and Columbia. An artist, he sketched his experiences (most likely afterward) in a half dozen drawings. He later went on to become a brigadier general and commanded Marines during the Boxer Rebellion in China at the turn of the century.

Albert Bierstadt, the well-known painter of breathtaking, romantic panoramas, covered some important battles. Sandford Gifford joined the Union forces and continued to paint, as did Confederate George Caleb Bingham, who enlisted as a private and subsequently rose to captain—only to be captured with his entire company. Eastman Johnson evidently witnessed the battle of Antietam, which was the basis of his painting entitled *A Ride for Liberty*, showing a slave family fleeing on horseback.

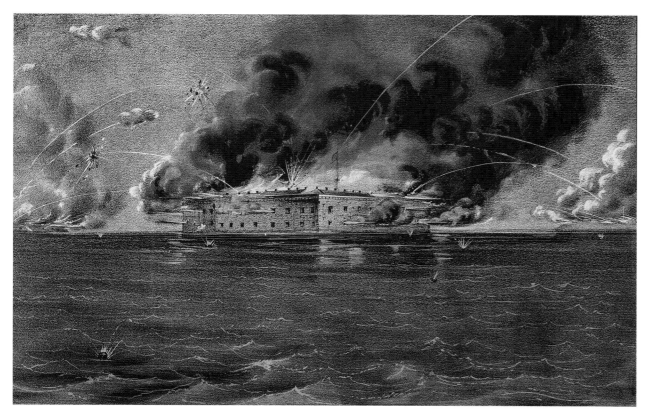

Left: This Currier & Ives chromolith print, depicting the Confederate bombardment of Union-held Fort Sumter, went on sale to the public within three weeks of the event. Possibly using eyewitness accounts telegraphed to New York, the litho artists executed this imaginative and timely illustration.
Museum of the City of New York

Below: John Ross Key painted *The Bombardment of Fort Sumter* in 1865. The Yankees had managed to keep a toehold on a sandy spit at the mouth of the Charles River, with their fleet remaining anchored offshore in preparation for an assault on Charleston. The shelling occurred throughout the war until the Rebels abandoned Charleston in the final months of the conflict to escape Gen. William T. Sherman's destructive march through Georgia and South Carolina.
Greenville County Museum of Art, South Carolina

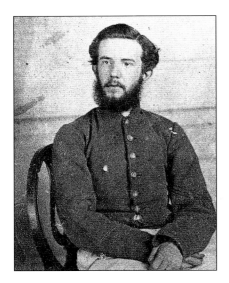

Above Left: Son of noted artist John Gadsby Chapman, Conrad Wise Chapman, then living in Rome, headed straight for his adopted home of Virginia when the Civil War broke out. He saw action, was severely wounded at the Battle of Shiloh, and ultimately turned out a magnificent series of oil paintings depicting the fortifications around Charleston, South Carolina *The Museum of the Confederacy, Richmond, Virginia*

Above Right: In *Battery Rutledge, December 3, 1863,* "Coonie" Chapman depicted himself (in the foreground with musket) on the bulwarks guarding the Charleston harbor. The deeply shadowed foreground—a technique termed *repoussoir*—was characteristic of nineteenth-century academic painting. The scene captures preparations for battle in the bright tranquillity typical of South Carolina's low-country climate. *The Museum of the Confederacy, Richmond, Virginia*

Oppposite Top: A steel engraving from a painting by Conrad Chapman shows the CSS *H.L. Hunley,* a prototype submarine. During the Revolution, a barrel-shaped semisubmersible had been invented by a colonist, though it had proved unseaworthy. A century later, the *Hunley* had far greater potential, though it too had limited success. On the night of 17 February 1864, the nine-man, hand-cranked, cigar-shaped submersible, with an explosive on a long pole at its bow, managed to ram the Federal ship *Housatanic,* which sank in three minutes, taking 150 crewmen with her. The submarine, which may have suffered collateral damage in the explosion or flooded when the hatches were opened for fresh air, sank mysteriously off Charleston Harbor. The craft was named afterwards for its skipper, H.L. Hunley. The hulk was located in 1995 and brought to the surface in 2000; it is being conserved for study and public view. *U.S. Navy Photo Archives*

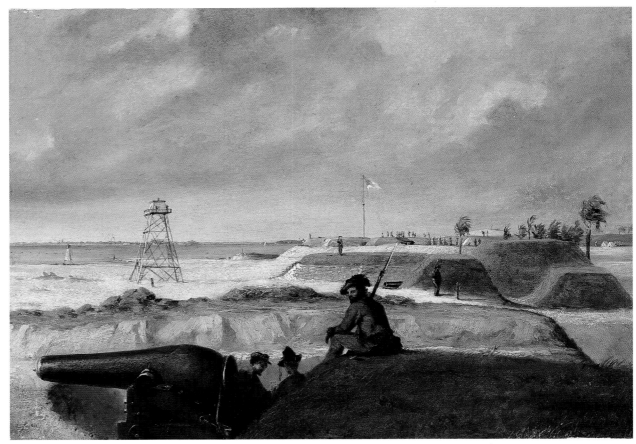

Other minor artists of the period, like Julian Scott, James Hope, David Blythe, and Edward Lamson Henry, also volunteered. Englishman James Walker of Mexican War fame also turned up to cover the conflict. In the South, the German artist Adalbert Johann Volck produced a lot of work in his trademark heavy-lined style. One of the better combat artists, Allen Carter Redwood, served as a courier to Confederate Gen. Lunsford Lomax and rose to major; he was captured briefly before returning to serve in the second Battle of Bull Run. The city of Charleston alone was home to many artists who portrayed the three-year Yankee siege of the city, although the works of William Aiken Walker, A. Grinevald, and Lawrence B. Cohen are the only examples still in existence. On duty for the Confederate Army, John Ross Key was an accomplished artist, and the grandson of Francis Scott Key.

All told, many amateur artists in uniform on both sides sketched whenever they could, and much of their work remains. Remarkably, the majority of combatants could read and write, and their letters home offer invaluable details, as well as innumerable sketches.

Conrad Wise Chapman

A Volunteer Combatant-Artist

In artistic talent, Conrad Wise Chapman probably surpassed his father, historical painter John Gadsby Chapman, becoming one of the finest Southern painters of his time. Chapman the younger also appears to be one of the most unlikely artists to have covered the war. As a teenaged artist with an already budding reputation, Chapman was living with his artistic family in Rome when war broke out. He quickly sold some of his paintings to pay for passage home to his adopted Virginia, where he joined the fray. Although he was born in the District of Columbia, his father had always instilled in him the idea that the Commonwealth of Virginia was the embodiment of everything beautiful and sacred in the world. Consequently, he considered himself a son of the state and felt he owed her his allegiance—as had many West Point- and Annapolis-trained officers, including Gen. Lee.

Landing in "Yankee" New York, Chapman found he had to travel via Kentucky (a border state) to reach the Confederacy. Arriving in Louisville, he joined the 3rd Kentucky Regiment as a private on 30 September 1861. An ingenuous, trusting soul, "Coonie" Chapman quickly endeared himself to all his military companions. His first taste of battle came in early April 1862 at Shiloh, where he suffered a severe head wound that took months of recuperation to heal. Later, when he was transferred to Richmond and taken under the protective wing of his namesake, Brig. Gen. Henry A. Wise (a close friend of Chapman's father), he did many sketches of camp life while attached to perimeter guard duty. His gentle countenance masked an inner recklessness, and he was, by

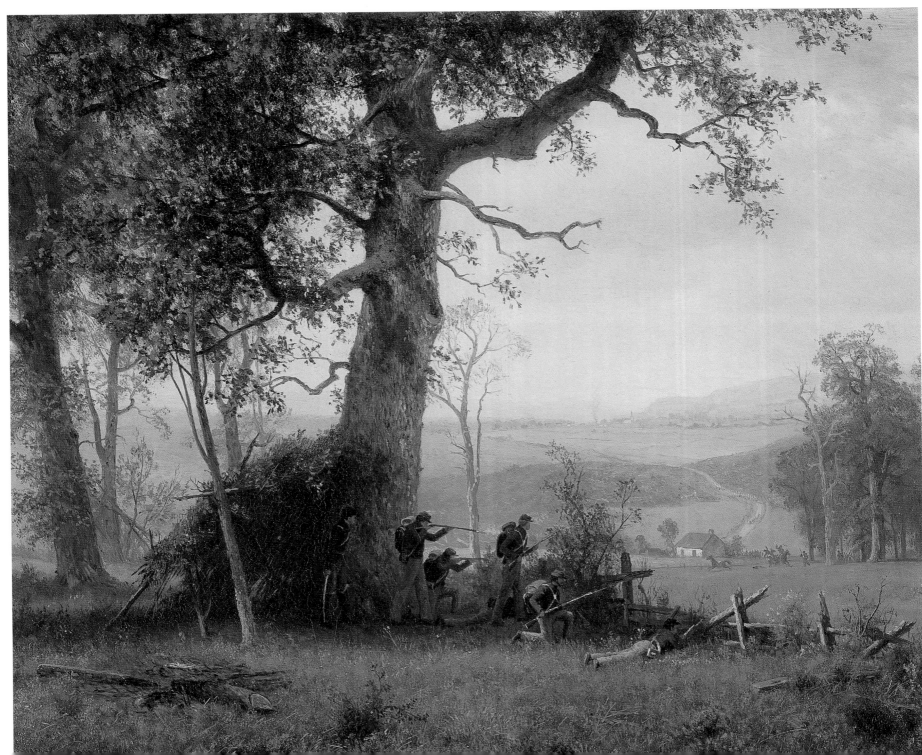

Below: Struggling young illustrator Winslow Homer covered the Union Army in the Peninsula and Northern Virginia for *Harper's Weekly.* When he left the battle areas, he, like numerous other artists, turned his many sketches from the field into finished paintings. Unlike Chapman, Homer eschewed war subject matter after the conflict ended and turned to fine arts, becoming one of America's best-known nineteenth-century painters. In this magnificent painting titled *Prisoners from the Front,* he shows Rebel detainees being interrogated by a Union officer. *Metropolitan Museum of Art*

all accounts, a brave and talented soldier. His regimental colonel, John Snow Wise, son of the general and governor of Virginia from 1856–60, described Coonie's role in the brilliant raid at Diascund Bridge: "[I]…could not restrain the impetuosity of Cooney [sic] Chapman…. [T]he fellow fairly reveled in fighting."

Recovering from a subsequent illness, Chapman made beautiful sketches of Confederate camps and other scenes, despite the scarcity of art materials. In the autumn of 1863, Chapman's brigade, under the command of Gen. Wise, was ordered to the defense of Charleston.

When the overall commander, Gen. P.G.T. Beauregard, requested that complete maps be made of all Charleston's defenses, Gen. Wise suggested that Chapman be detailed to paint pictures of the various forts to accompany the maps. Thus, for some months, he was able to pursue his artistic activities, often under severe bombardment from the Federal forts and constantly marauding Union fleet at the mouth of the harbor. (Union forces had captured and held the spit of sand at Cummings Point on Morris Island; they were also firing from Battery Gregg and Fort Watson, reducing their former stronghold, Sumter, to rubble.)

Col. Wise described Chapman's work on the exemplary series of paintings he would finish later in Rome: "Often he sat on the ramparts of Sumter [and] other forts under heavy cannonade [bombardment] while painting these pictures, and those who saw him said he minded it no more than if he had been listening to the Post band. Chapman held cannon-balls and shells in great contempt. These pictures are simply exquisite, in atmosphere, in detail, in colouring, and in all the military concomitants which the artist knew so well…[and] there is nothing like them in any archives of the Confederacy."

Eventually, Chapman was able to board a Confederate blockade-runner in darkness and make his way back to Rome, where he finished the paintings of his impressions of the great "War Between the States." He tried to return to complete his three-year enlistment, but was detoured via Mexico and Texas, where he learned of the South's surrender. Utterly distraught, he remained in beautiful Monterrey, Mexico, to paint and supplement his meager finances. His earlier head

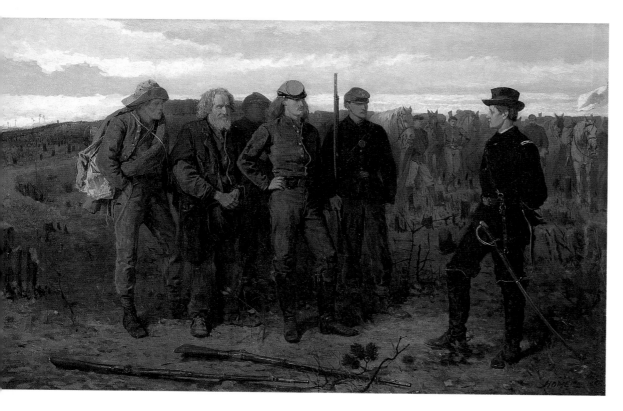

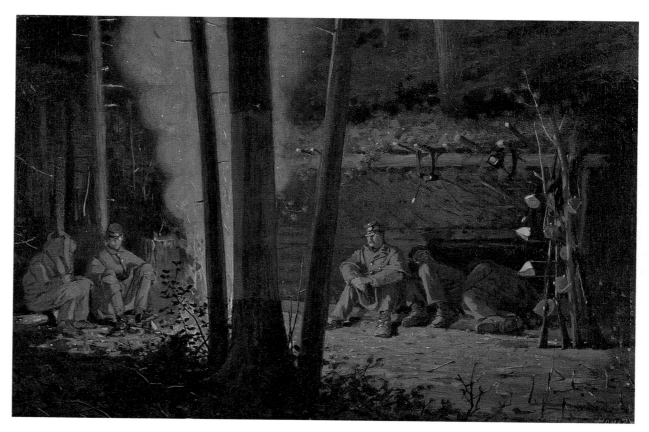

Right: A campfire at a night bivouac is portrayed in Homer's *In Front of Yorktown.* These must be Northern city boys, because any country boy would know that stripping the bark off the trunk of a tree (foreground) for kindling would kill the tree. *Yale University Art Gallery; Gift of Samuel Rossiter Betts, B.A. 1875*

wound quite possibly contributed to the mental instability that plagued him throughout the rest of his life. Following the death of his wife in Rome, he began to wander about Mexico and the United States. Apparently, he went "mad" while painting a mural in England. Committed for a time to an asylum, he again roamed almost penniless, trying to paint and rebuild his reputation; eventually, he remarried. When the Spanish-American hostilities broke out just before the turn of the century, the wizened, white-haired fifty-six-year-old tried vainly to offer his artistic services to the U.S. Army to cover that war. Rejected, he returned to his beloved Virginia, dying there in 1910.

The newsletter of the Museum of the Confederacy in Richmond aptly summarizes him: "If there ever was a man who loved Virginia, it is Chapman. If there ever was a brave, simple, unselfish, devoted Confederate soldier, he is the man. He possesses the elements of a great artist, and, in [the thirty-one Charleston] sketches, has left a series of works which should forever preserve his name and associate it in grateful remembrance with the cause he loved so well, and served so faithfully." Chapman's excellent series of the Sumter bombardment can be seen in the Museum of the Confederacy in Richmond, Virginia.

Robert Knox Sneden
Chronicler of the Union Solider

One of the most remarkable accounts of the war comes from the recently discovered diary and sketches of Union Pvt. Robert Knox Sneden. An untrained artist, budding

architect, and talented writer, Knox wrote 5000 pages on his experiences with the Union Army, accompanying the text with 500 very accurate watercolor paintings.

This extraordinary find is a treasure trove of details on certain aspects of camp life, maneuvers, strategy, and personalities heretofore unknown. Edited and published by the Virginia Historical Society, *Eye of the Storm*, along with Ben Bassham's book on Conrad Wise Chapman, provides marvelous new insights on the art of the Civil War.

Although he remained a private throughout the war, Sneden's talent as a mapmaker quickly made him an indispensable asset on the staff of Gen. Samuel P.

Above: Winslow Homer's charcoal and white chalk sketch on green paper depicts a wounded soldier being given a drink from a canteen.
Cooper-Hewitt Collection, Smithsonian Institution

Below: *The Dead Line, Andersonville Prison, Ga.: Shot by the Guard While Taking a Part of the Dead Line for Firewood* portrays a grim scene during Pvt. Sneden's imprisonment by the Confederates. Despite the conditions of deprivation, filth, and disease, Sneden managed to survive, write about, and illustrate his experiences.
Virginia Historical Society

Right: A special artist for *Frank Leslie's Illustrated Newspaper*, Henri Lovie joined the Federal expeditionary force going up the Mississippi River in June 1861. Lovie witnessed and sketched Brig. Gen. Nathaniel Lyon's death at the Battle of Wilson's Creek, Missouri, on 10 August.

Below: This engraving of Lovie's sketch was no doubt made back in New York and run in the weekly newspaper. Rather than showing Lyon tumbling from his horse after being fatally shot (as Lovie sketched him), the engraver has chosen a less demoralizing portrayal, with Lyon in the saddle, just prior to being hit.
New York Public Library

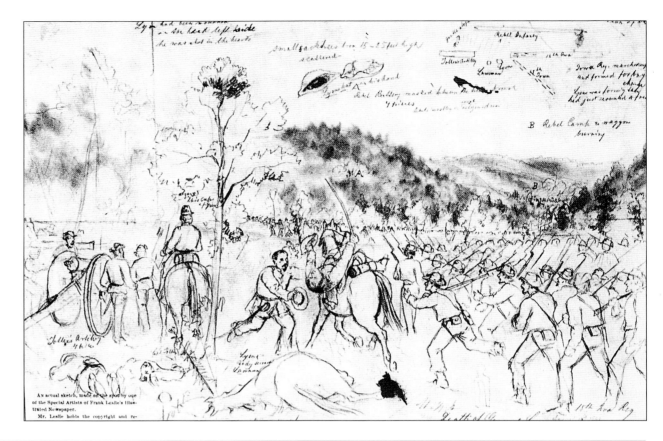

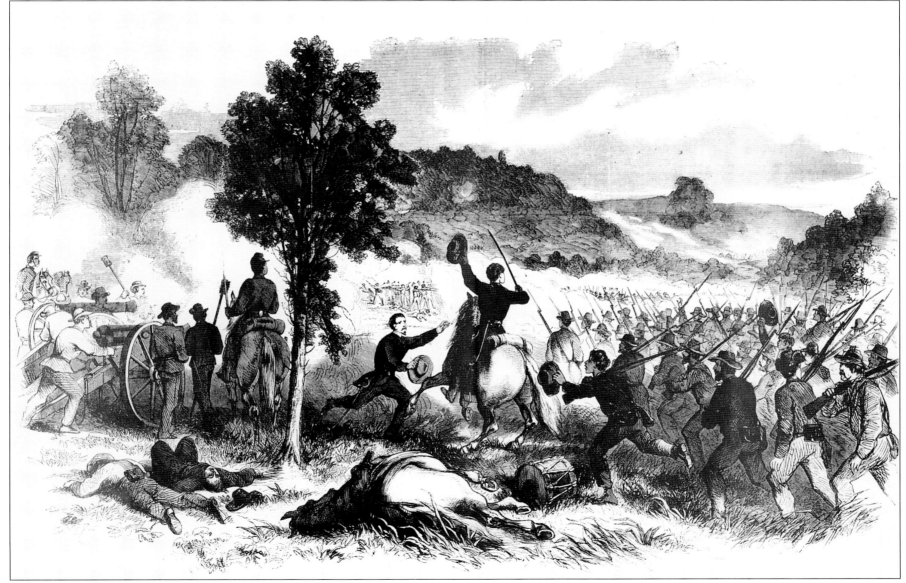

Heintzelman's III Corps, one of McClellan's four corps that collectively made up the Army of the Potomac. As a mapmaker, Sneden not only enjoyed certain comforts, but was also in a unique position to view the war.

Sneden's fascinating narrative and watercolors (some of which he did from his sketches after the war) detail the important contribution of military mapmakers. As Sneden tells it, the defense of Washington relied heavily on maps made from reconnaissance patrols that were then lithographed and "tiled" together for large panoramic views. Using these maps, Union generals were able to set up proper defenses and anticipate strong points and avenues of attack from the Confederates.

Critical, too, was the contribution of balloonist Professor Thaddeus Lowe, whose hot-air balloon Sneden portrays in a number of his paintings. Tethered either to the ground or to ropes winched by ground crews, Lowe or a military observer could go aloft one thousand feet (305m) and observe enemy activity for miles around, often with a telescope. The resulting descriptions and interpretations helped Sneden keep his maps updated and his military commanders informed.

While Sneden's art work is amateurish, his scenic renderings of encampments and battlefields are of tremendous historical value. He sketched a number of battles he observed from the command group on the periphery, accompanying McClellan's army throughout the Peninsula Campaign. In November 1863, he was with a detachment of Gen. Meade's army near the small Brandy Station railroad junction, just east of Culpepper, when his military career was rudely interrupted; a patrol of the notorious Mosby's Raiders captured him and his companions.

Although an unfortunate turn of events for Sneden, his capture was ultimately fortunate for posterity, as the peripatetic artist and writer continued to use his talents during his internment, seemingly without pause. He illustrated his detailed descriptions (much of them done in a secretive shorthand hidden from his captors) of his arduous treks from one prison camp to another. In 1864, he was taken to a new Confederate prison near Macon, Georgia, that would become forever known simply as the reviled Andersonville. In his time there, he managed not only to survive, but to document, by writing and sketching, the ordeal he and his hapless comrades were subjected to.

Sneden never became the architect he'd hoped to be. After the war, he instead expanded his war diaries and finished his watercolors, perhaps with an eye toward publishing them. In the following decades, however, much was published about the war, and Sneden probably gave up on his efforts due to competition and lack of financial backing. When Sneden died in 1918, they were

passed on to his survivors, who were unaware of their importance. Consequently, the diaries and art ended up in separate storage facilities, mostly forgotten. Providentially, the art was discovered in 1994 and reunited in 1997 with the diaries by the Virginia Historical Society in Richmond, where they can now be examined.

Above: Artist-correspondent Henri Lovie, on assignment for *Leslie's*, sketched this map of the Battle of Madison Creek, one of the earliest engagements of the war. It was engraved and printed in the paper shortly thereafter. General Nathaniel Lyon, head of the 1st Iowa Infantry Regiment, led a desperate charge here and was killed. The location of Lyon's death is indicated on the map.

Artists' Portrayals of Naval Battles

By the start of the Civil War, revolutionary changes had begun to take place in the navies of the world, including the technological changeover from sail and wood to steam and iron; other scientific and geographical discoveries enabled precise navigation by chronological means. Primitive steam-powered, side-wheeled vessels had been depicted by Walke, Barton, and Meyers in the Mexican operations in the late 1840s. Much improved ships, playing prominent roles in the Civil War in the early 1860s, would be portrayed by one who knew them well, (then) Rear Adm. Henry N. Walke. As he had in 1847, Walke would again command a warship, this time the USS *Carondelet*. He participated in the vicious but victorious Union naval actions in the western rivers and later published another portfolio of combat scenes as he saw and experienced them.

Although Mexican War veterans and U.S. Navy artists Walke and (then) Capt. Charles C. Barton were busy with their fighting duties, fortunately both managed to record visually their impressions of the battles in which they participated. It is interesting to compare their art with what the weeklies turned out of the same events. Some of Walke's sketches, like the *Battle of Memphis*, were copied by Frank H. Schell and Thomas Hogan and appeared in *Harper's*, but the copies were inferior in quality. Xanthus Smith, a noted artist of the period and later the head of the Pennsylvania Academy of Fine Arts, enlisted in the Union Navy and saw extensive action. He depicted the attack by Adm. David Dixon Porter (son of Commodore David Porter of 1812 fame) on Fort Fisher, North Carolina, in December of 1864. Adm. Porter, commander of the Union "Fresh Water Navy" in

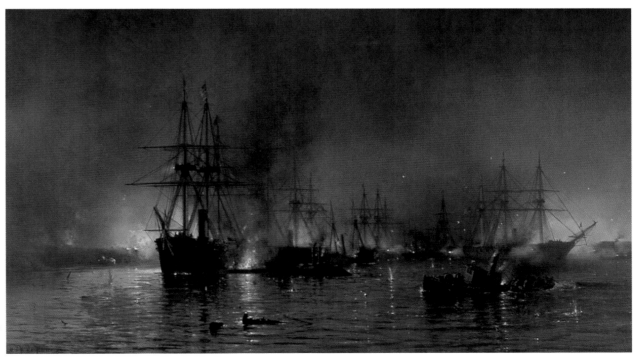

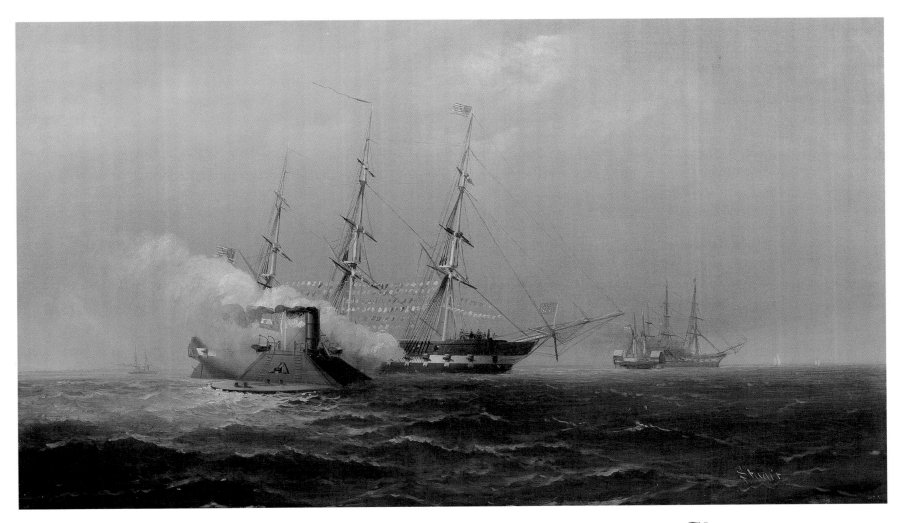

the West, also inherited his famous father's artistic talent and managed to find time to sketch the Confederate destruction of the wooden "dummy" monitor on 28 February 1863, below Vicksburg. He also poked fun at top Navy brass in witty and incisive cartoons. Adm. Porter had his own shipboard artist as well, his aide, Ens. John W. Grattan, who also participated in the fighting. In a series of three sketches, Grattan depicted the joint Army-Navy attack on Fort Fisher, the last major port other than Charleston still in Confederate hands as of 1865.

In Virginia, little-known artist Alexander Charles Stuart did a very fine painting of the famous scene of the *Virginia* (formerly the *Merrimack*) ramming the *Cumberland* off Newport News on 8 March 1862. Stuart may have been working from a sketch of the action by the *Virginia*'s shipboard artist, B.L. Blackford, a lieutenant of engineers, although the point-of-view seems to indicate it is the work of a distant eyewitness, not a close participant. Whether or not Stuart actually saw the engagement is conjectural; however, the painting is of high quality and reminiscent of the work of earlier marine artists Thomas Birch, Robert Salmon, and Michele Felice Cornè. Probable War of 1812 artist and one-time Naval Academy superintendent Franklin Buchanan had commanded the Confederate ironclad *Virginia*, though he did

not skipper her in her historic clash on 9 March 1962 with the Union ironclad *Monitor*, the first confrontation ever between two such metal behemoths. (On 26 April 1864, Buchanan would be promoted to senior admiral of the CSN and given command of the *Tennessee*, which fought valiantly but futilely at Mobile Bay that August.)

The naval engagement between the *Monitor* and the *Virginia* was also painted by noted seascape artist James Hamilton, in a style defined by a contemporary art historian as midcentury romanticism. Three charming, naive paintings by an unknown member of one of the gun crews of the *Virginia* also came out of that famous clash. In a letter dated 2 February 1901, A.H. Fitzgerald, principal of the Manchester, Virginia, Public Schools, described the pictures of this unknown seaman, later acquired by the Confederate Museum in Richmond: "This series of pictures—*Fight of the* Virginia *and the* Monitor—was painted by a member of the gun-crew, taken from the United Artillery of Norfolk, Virginia, to engage in the combat of March 8th and 9th, 1862. After the destruction of the *Virginia*, by the Confederates May 10th, 1862, the men were transferred to Fort Darling, Drewry's Bluff, and it was at this place the pictures were painted, on ticking for want of canvas. The pictures were left with our family in the fall of 1862, and have remained till the present time."

Above: Civilian artist Alexander Charles Stuart may well have witnessed the Confederate ironclad *Virginia* (built over the wooden ship *Merrimack*) ramming the USS *Cumberland* at Hampton Roads, just off Newport News, Virginia, on 8 March 1962. A day later, the *Virginia* squared off against the Union's first ironclad, the *Monitor*. **USMC Art Collection**

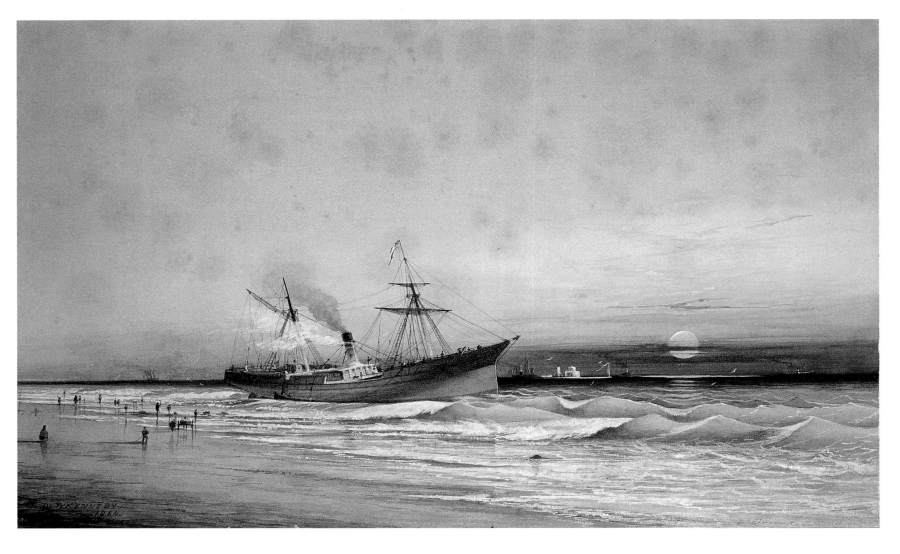

Another seaman, Francis Garland, did an oil painting titled *Bombardment of Forts Hatteras and Clark on August 28–29, 1861* based on his observations. The painting is in the Beverly Robinson Collection at the U.S. Naval Academy. At the same time, the litho houses Currier & Ives, Sarony & Major, and others continued to crank out their hyperbolic versions of the battles—imagined, reconstructed, or copied as individual, stand-alone color pictures, such as *The Splendid Naval Triumph on the Mississippi, Apr. 24th 1862*. These houses, however, did not specifically send artists out into the field to cover the war; in some cases, they embellished sketches from military artists when they were able to get their hands on them—and, in a few instances, probably purloined them.

Even French artist Édouard Manet, later a leading impressionist painter, was intrigued enough to depict the naval battle within view of the beach resort at Cherbourg, France. He and other curious onlookers and vacationers had swarmed there when news of the impending confrontation circulated. It turned out to be an ill-fated clash for the Confederate commerce-raider *Alabama*, which was sunk by the *Kearsarge* on 19 June 1864. Criticized on aesthetic grounds, the obvious eyewitness quality of

the painting went unappreciated at the time. However, American artist Mary Cassatt did perceive its aesthetic quality, rather than its historic value, and persuaded a wealthy Philadelphia collector to buy it.

The art coverage of the Civil War was perhaps best summed up in the 3 June 1865 issue of *Harper's Weekly* following the conflict:

> These artists have not been less busy and scarcely less imperiled than the soldiers. They have made the weary marches and dangerous voyages. They have shared the soldier's fare: they have ridden and waded, and climbed and floundered, always trusting in lead pencils and keeping their paper dry. When the battle began they were there. They drew the enemy's fire as well as our own. The fierce shock, the heaving tumult, the smoky sway of battle from side to side, the line, the assault, the victory—they were a part of it all, and their faithful fingers, depicting the scene, have made us a part also.

The only artist-journalist known to have died in battle was James O'Neal, who represented *Frank Leslie's Illustrated Newspaper*. In 1863, he was killed at Baxter Springs, Kansas, when Confederate guerillas attacked a Federal wagon train he was accompanying.

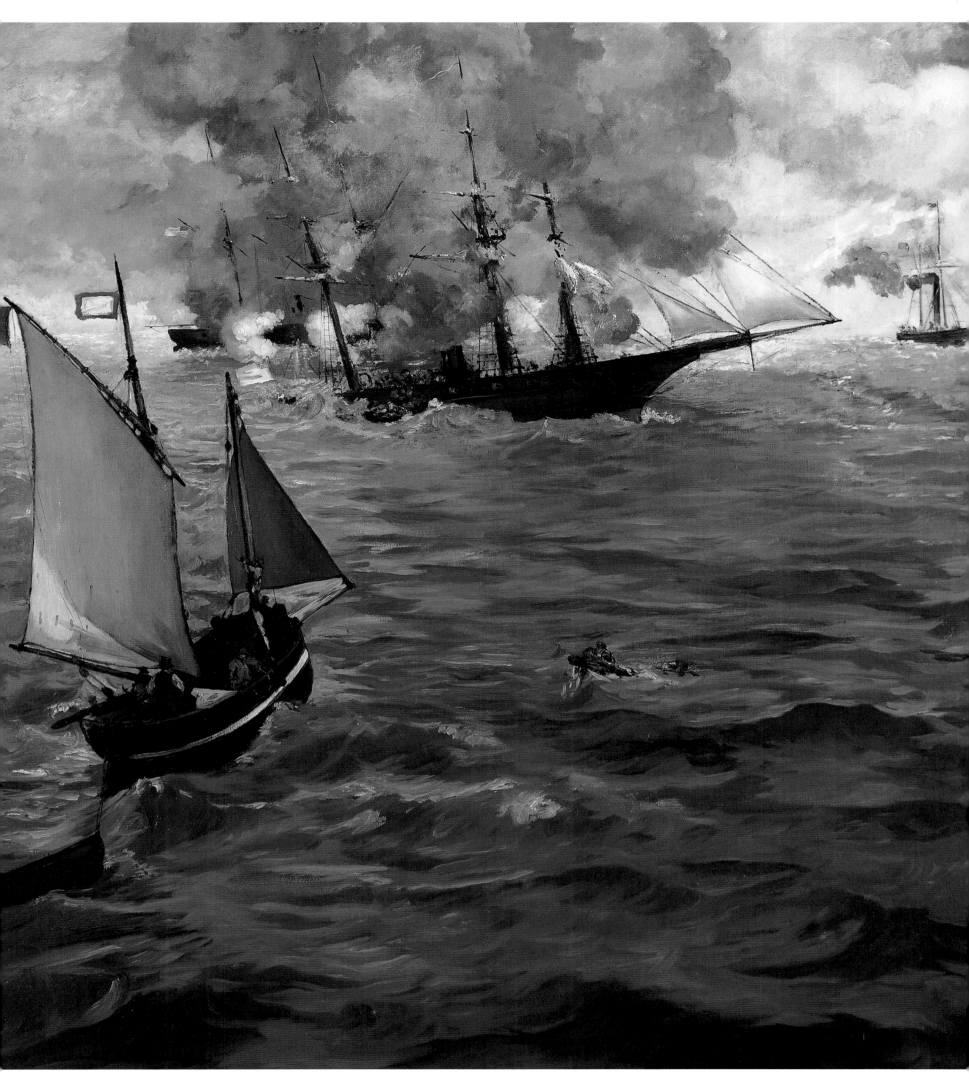

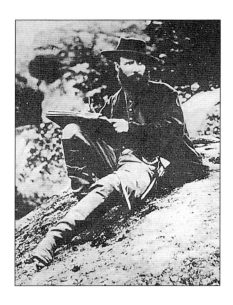

The Culmination of the Nineteenth Century
Technological Challenges to Art

The Civil War journalistic art activity led by the artist-correspondents of *Harper's* and *Leslie's* ushered in the heyday of publishing and the golden age of illustration at the close of the nineteenth century. During the 1850s and 1860s, *Harper's* artwork was particularly strong under its capable art editor, Charles Parsons, who is credited not only with raising the artistic level of publishing to new heights, but also with nurturing a number of promising artists toward subsequent fame and fortune in publication illustration.

The last half of the nineteenth century was also marked not only by spectacular achievement in science and technology—the harnessing of electricity, as well as the inventions of the electric light, the telephone, and other significant items—but by an enormous increase in published material. Publications were, in effect, the major source of entertainment and amusement for the general public. Which was cause and which effect is not clear. However, the number of periodicals at the time of the Civil War was approximately 700; by 1900, there were 5000 more. As wood engraving was replaced toward the end of the century by technologically advanced photo-lithography, photomechanical dry plates, and the rotary press, the expansion of publishing was unprecedented. (A parallel boom time had taken place during the fifty-year period following Gutenberg's invention of the printing press, when some 20,000 volumes, mostly Bibles, were printed.) Expanded markets, expanding production and distribution, not to mention burgeoning employment for artists and artisans, echoed the revitalized spirit of the nation itself, which was growing and spreading, especially westward, with the railroad system that now spanned the continent.

By 1900, with the exponential increase in reading material, more than 4000 libraries were operating nationwide. The public's appetite for literature, aided by liberal illustrations, was insatiable. For a couple of decades after the Civil War, the litho houses continued to flourish, ultimately declining at the end of the century when four-color machine printing supplanted the cumbersome, laborious method of chromolithography. Economically, the call for more illustration meant increased costs for artwork and reproduction, requiring more advertising to offset them. Opportunity exploded as each new opening created another.

Before Currier & Ives vanished from the scene in 1907, it had added its final mark of charming banality to the popular print art form, leaving behind its own version of genre painting in what was known then in Southern painting as the "Fancy" picture. Perhaps derived from "fanciful," the term described a category of paintings where the compositions might tell a story melodramatically, but were not intended to carry a serious message. The chromolithographic pictures depicted—ad nauseam—sweet, sentimental moments such as *The Hero Returns from War*, *Home to Thanksgiving*, etc. Evidently, this had wide appeal for the public. Parallels can be found in subsequent ages with pulp magazines, "B" movies, and soap operas filling similar roles.

Photography

In the Civil War, photography had been unable to capture motion and thus the heat of battle. The long exposures required for the collodion wet plate precluded it. Instead, Mathew Brady, James and Alexander Gardner, and the other photographic teams resorted to static scenes of camp life, posed groups, and the stillness of death after

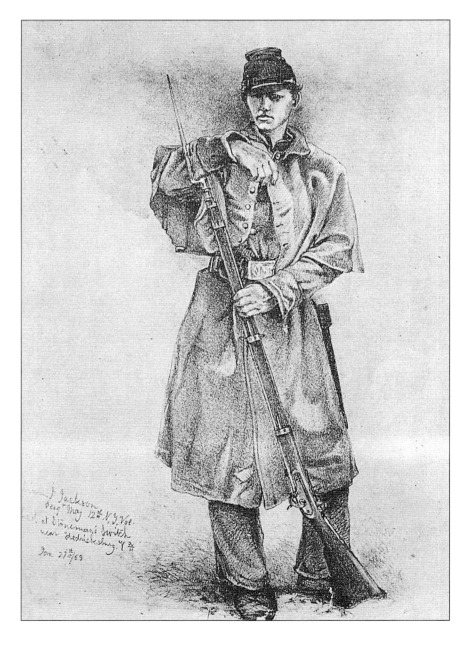

battle. Later, in concert with photomechanical advances, however, photography took a leap forward with the development of the half-tone printing process. This allowed for the reproduction of the continuous tone of photographs, as well as the tonal "wash" of drawings and paintings. Photography was also developing in ways that would set it on its own unique pathway in the arts; faster shutter speeds and faster films allowed for action shots, and ultimately film would be able to capture color. Cameras, such as Charles Eastman's Kodak No. 3 Junior Hand Camera, produced for the amateur, in 1895, and the ubiquitous Brownie of 1905, were becoming increasingly affordable and portable.

Following the Spanish-American war in 1898, photographic journalism gave artist-correspondents a run for their money, especially since the advent of half-tone reproduction of photographs on the new clay-coated papers (slicks). While some artists rejected the use of photography as a corruption of art's purity, others, like illustrators Remington and Glackens, made good use of it, some even tracing from images projected onto their canvases. Even a few artists supposedly above such things

jumped on the photographic bandwagon, including Thomas Eakins, a well-known artist and head of the Pennsylvania Academy of Fine Arts, and many who preferred to paint nature in the comfort of their studios. Projection of photographic images continues to be a primary device used by illustrators today, even more so than at the end of the nineteenth century.

The American Art Scene at the End of the Century

While in the past artists had been supported by church and court, and then in the nineteenth century, by the wealthy and academia, the new patrons for illustrators became the publishers. Drawing on the public's endless appetite for stories with pictures, top illustrators emerged as the elite creators for and governors of the cultural appetites of the day, a role television writers and producers fill now. These illustrators (including Charles R. Parsons, Thomas Nast, Edwin Abbey, Howard Pyle, N.C. Wyeth, Arthur Davies, and Frederic Remington) were known by name and recognized by style. They helped shape American character, embracing and nurturing its aspirations and, in effect,

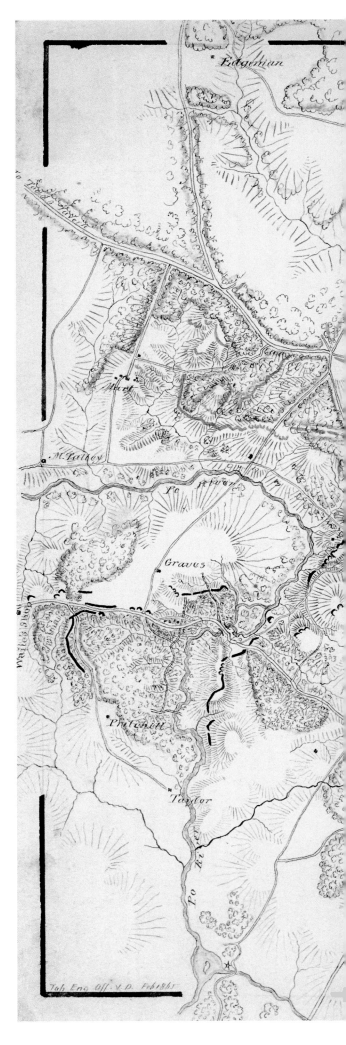

Above: This sketch by Southern combat artist J.E. Taylor depicts an unusual reconnoiter by Confederate mapmaker Jedediah Hotchkiss (pictured on the right), a former school teacher from New York, and General John Gordon, of Gen. Early's staff. They disguised themselves as farmers harvesting corn in order to collect information for the upcoming battle at Cedar Creek on 19 October 1864.

Right: A detail of a map by Hotchkiss showing the area west of New Market and north of Bridgewater in Virginia's Shenandoah Valley, where the battle of Cedar Creek took place. The map is from a pamphlet Hotchkiss called *Report of the Camps, Marches, and Engagements, of the Second Corps, A.N.V.*

creating our conception of the American dream, as the noted modern illustrator Albert Dorne pointed out.

Meanwhile, American fine artists of the period were plodding along in traditional realism, distinguishing themselves here and there in such camps as the Hudson River School, the Western scenic and Indian painters, and certain romantics. Most, interestingly, seemed oblivious to the earth-shaking artistic movements, especially impressionism and post-impressionism, then rocking Europe. As contemporary art historian John Wilmerding notes, the Civil War had a curiously neutral effect on American painting.

Among late–nineteenth century combat artists, Frederic Sackrider Remington stands out. Today considered a fine artist, Remington was then an unabashed illustrator, at the time considered quite an honorable profession. An Easterner and a Yale graduate, he was intrigued by the vanishing frontier in the West and headed straight for it in the 1880s. Living with U.S. Cavalry troops then fighting the tail-end of the Plains Wars, he had a keen eye for the details and incidents that made his subsequent paintings all the more authentic. While he painted stand-alone works, they tended to have an anecdotal slant: *Fight for the Water Hole*, *A Dash for the Timber*, *Through the Smoke Sprang the Daring Soldier*, and so on.

Later, after covering the Spanish-American war in Cuba as an artist-correspondent for William Randolph Hearst's *New York Morning Journal* (see the following chapter), he veered away from his reportorial style and began to paint and sculpt more creatively and expressively about his western subjects.

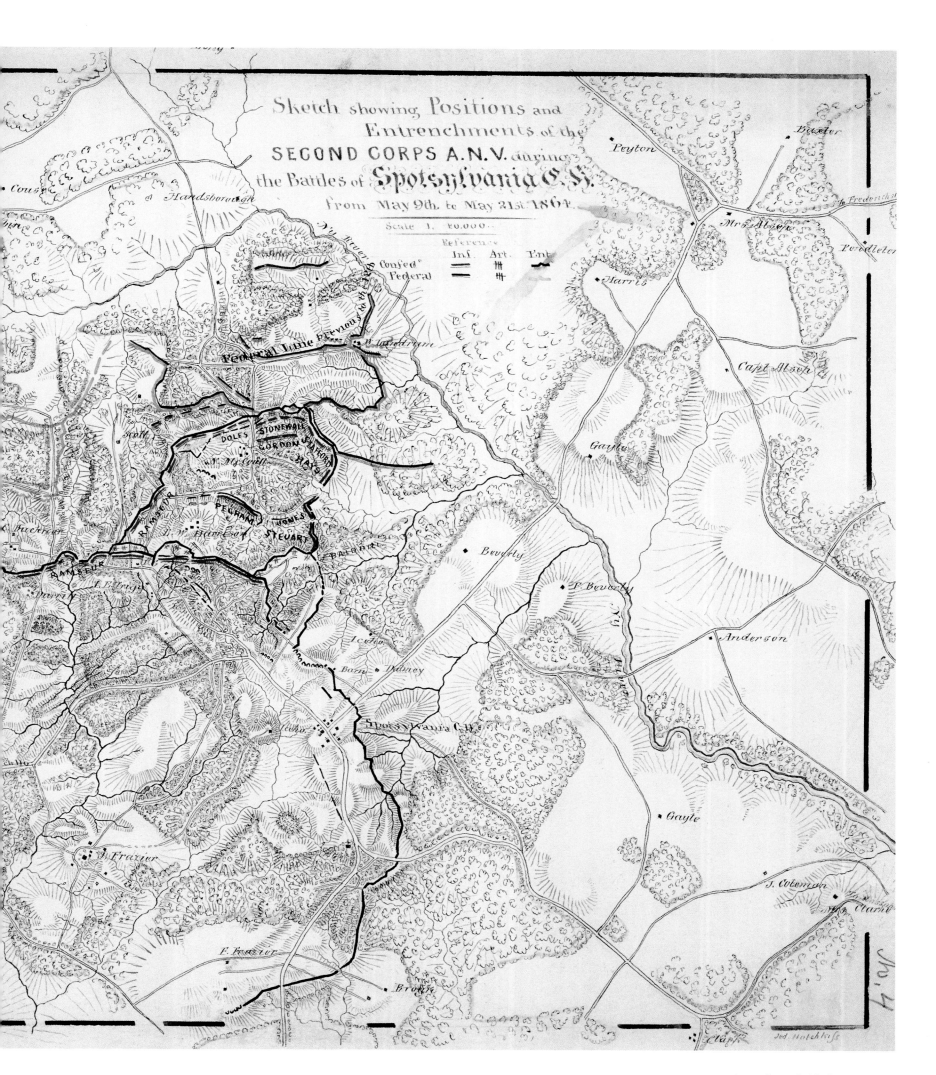

Sketch showing Positions and Entrenchments of the SECOND CORPS A.N.V. during the Battles of Spotsylvania C.H. from May 9th to May 21st 1864.

Right: Frederic Remington was one of America's leading illustrators and fine artists. After studying art at Yale, he headed West and relished the still-wild and untamed lands, even observing some of the final episodes of the Plains Wars with the American Indians. *Battle for War Bonnet Creek* was painted in 1897, most likely from firsthand experience. His stint in the West during the 1880s and 1890s greatly improved his commercial illustrative skills and also paved the way for his combat art during the Spanish-American War. **The Thomas Gilcrease Institute of American History and Art, Tulsa, Oklahoma**

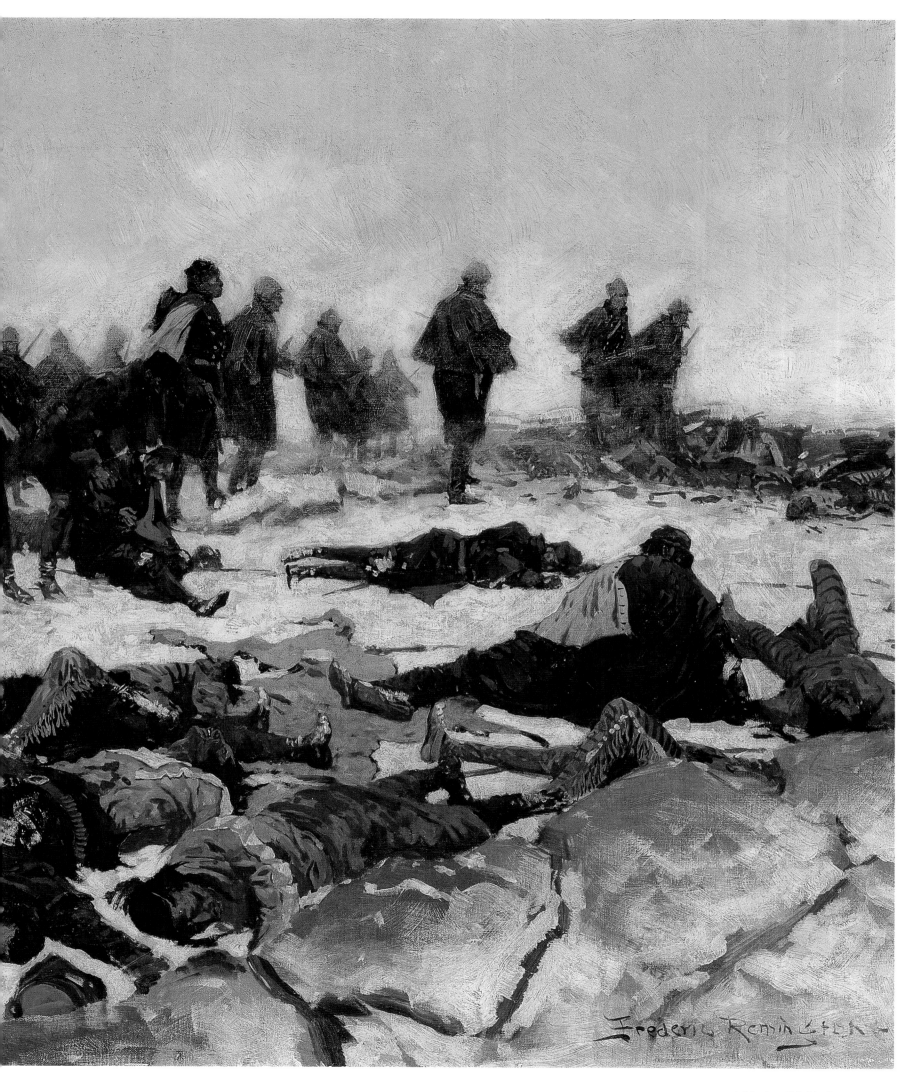

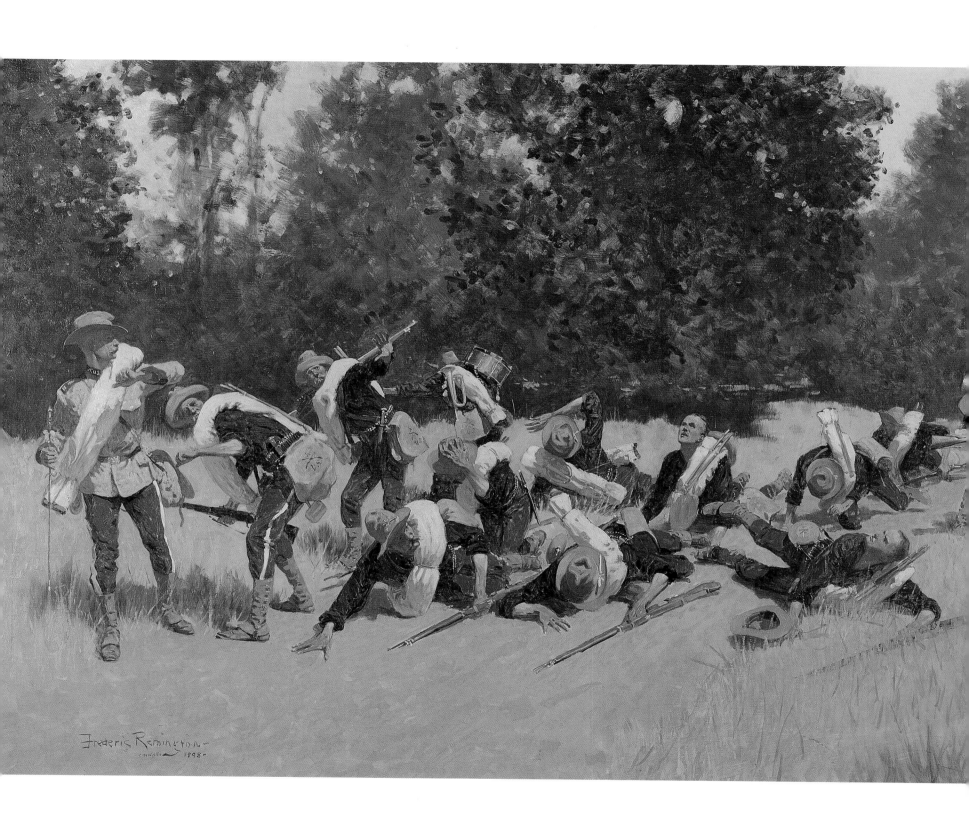

The Spanish-American War

The debate goes on as to whether William Hearst's *New York Morning Journal* and Joseph Pulitzer's *New York Herald* actually brought on the war between the United States and Spain. Still, there is little doubt that the events occurring during the night of 15 February 1898, when a mysterious explosion destroyed the U.S. battleship *Maine* in Havana harbor, elicited a jingoistic response from the American press and even Congress. The fevered cry quickly came for instant retaliation against the Spaniards, who had presumably done the dastardly deed. With yellow journalism at its zenith, the strident cries of the press drowned out the voice of reason, and war was declared. (It was later hypothesized by Adm. Hyman Rickover, father of the Nuclear Navy, that the *Maine* suffered a spontaneous explosion of coal dust adjacent to an ammunition magazine. A survivor also later admitted that it was common practice to sneak a smoke in the powder magazine where the explosives were stored.)

Newspapers and magazines, the predominant communication vehicles of their day, lost no time in sending artist-journalists to cover the pending hostilities. Hearst sent Frederic Remington to Cuba with the instruction, "You provide the pictures; I'll provide the war." Remington, who somehow managed to create artworks of the war for *Harper's* as well, accompanied the U.S. Army 5th Corps and specifically his friend Col. Teddy Roosevelt and his "Rough Rider" troops of the 1st U.S. Volunteer Cavalry. Meanwhile, the *New York Herald* dispatched W.O. Wilson, along with writer Stephen Crane, as a special war correspondent; Wilson's eyewitness sketches were quickly printed to fan the flames of war back home.

Perhaps the most revealing difference between the magazines' studio artists and the true on-the-spot combat artists can be seen in separate depictions of Teddy Roosevelt's famous charge up San Juan Hill by Remington and a lesser illustrator. Working from his studio in New York, illustrator W.G. Read chose an impossible point of view in front of the charge, portraying Roosevelt as a saber-brandishing, swashbuckling cavalry officer, at furious gallop, leading a stampede of ferocious, hard-charging troopers, hats flying, shots firing, bugle blowing, dust billowing, shells exploding—the epitome of "blood and guts" theatricality. No doubt the illustration created quite an impression of the indomitable Teddy Roosevelt for the American public, but Read, plainly, was no eyewitness.

The true charge was more faithfully portrayed by Remington, who depicted the attack from his point of view behind and to the side of Roosevelt. His lesser-known (at the time) painting of Col. Roosevelt leading the attack on Kettle Hill, the first objective on the way to San Juan Hill, accurately shows the cavalrymen dismounted. Since they had not been able to get their horses through a dense thicket, they abandoned them; only Roosevelt is shown on horseback, pistol in hand, urging the troops on. Some of the U.S. troops are falling, apparently shot. (After the first volley of shots was fired, the defenders withdrew, leaving many of their comrades dead; Teddy was credited with one of the kills himself.

Fine artist–illustrator Frederic Remington turned out some of the best work of the war. *The Scream of Shrapnel at San Juan Hill, 1 July, 1898,* captures the psychological terror that comes when unseen death rains from above. Remington convincingly represents the natural response of a column of soldiers.

Yale University Art Gallery; Gift of the artist

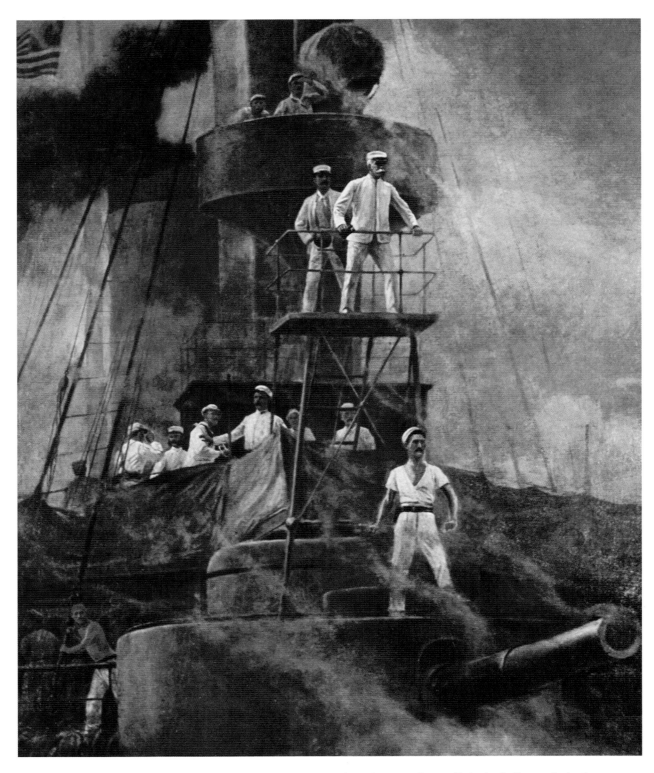

All told, the battles on Kettle and San Juan Hills cost the victorious Americans 102 dead and 335 wounded; the Spaniards, 235 dead and wounded.)

Illustrator William Glackens, later to gain further fame as a member of the Ashcan School in the new century's early decades, was sent by *McClure's* magazine to cover the war. Glackens' use of tonal washes, as opposed to a linear style, was especially adaptable to the new half-tone printing *McClure's* was using. Reproductions of his *Transports Anchored on the Bay, June 10*; *Horses Swimming Ashore*; and *Shelling the Woods Before Landing the Troops* were particularly outstanding and gave a true flavor of

how the operation really looked. George Luks, later active in the Ashcan School, was also dispatched by a publication only to contract yellow fever, a common illness during the war. Unable to complete his assignment, he had to be evacuated. (As a consequence of the war, Army doctor Walter Reed would conquer yellow fever; however, it is tragic to note that of 2700 casualties in the three-and-a-half-month war, only 395 deaths were due to enemy action; the rest resulted from disease and tainted meat in the canned food rations, known as "bully beef.")

Before the conflict began, the U.S. fleet stationed near the Philippines had been alerted to the possibility of war by

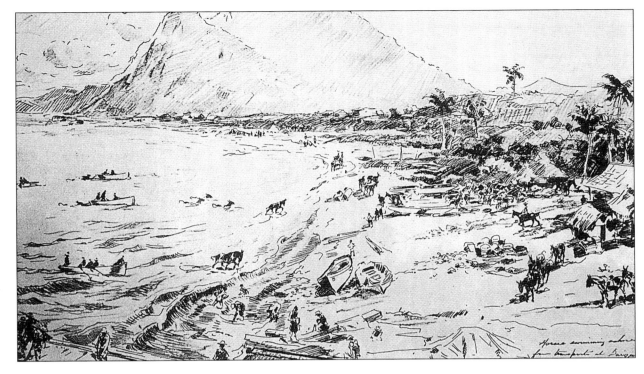

Secretary of the Navy Theodore Roosevelt (a post he resigned to lead the Rough Riders). Illustrator Rufus F. Zogbaum happened to be with Commodore George Dewey aboard the flagship *Olympia* when, following the declarationn of war, Dewey sailed into the line of Spanish warships in Manila Bay, destroying or damaging all eleven of them. Some 300 enemy sailors were killed; Dewey suffered no losses. Mindful of the significance of the action, Zogbaum captured the moment in his dramatic, heat-of-battle depiction of Dewey on the navigating bridge in a determined stance. The artist had, indeed, been present at the scene, but trained as an illustrator, he was not above embellishing a few details for dramatic purposes, especially elevating the commodore to a platform higher than the one he had actually stood on. The result is a less than honest pictorial account and, consequently, the quality of the work is diminished, especially when it is compared to Remington and Glackens' later work on the Cuban front. (Sadly, there was no combat art coverage of the final American naval victory off Santiago de Cuba, only reconstructions published by the litho houses.)

Howard Chandler Christy, who was to make his fame and fortune in the first quarter of the twentieth century as an illustrator and portrait painter, represented *Leslie's Weekly*, *Scribner's*, *Harper's*, and *Century* in Cuba. Along with *New York Herald* correspondent Richard Harding Davis, he found subject matter in the troop landings at Siboney and Daiquiri. Rather than a coordinated amphibious assault as we think of one today, the landing was depicted by Christy as a chaotic event that allowed the troops to doff their soiled uniforms and romp in the

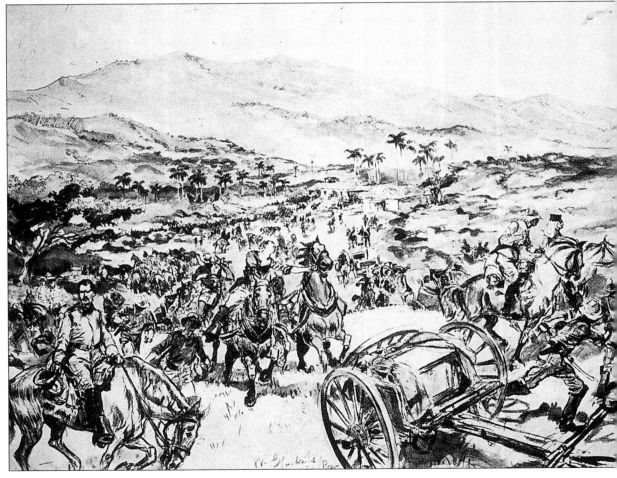

surf, bathing for the first time in a week. In defiance of the critics' belief that he could only paint women, for which he was particularly noted, Christy's war efforts offered naturalistic and compelling depictions of men.

Elsewhere, Christy's neighbor and friend, illustrator Henry Reuterdahl, was working as an artist for the Navy in New York City and would later play a role in military

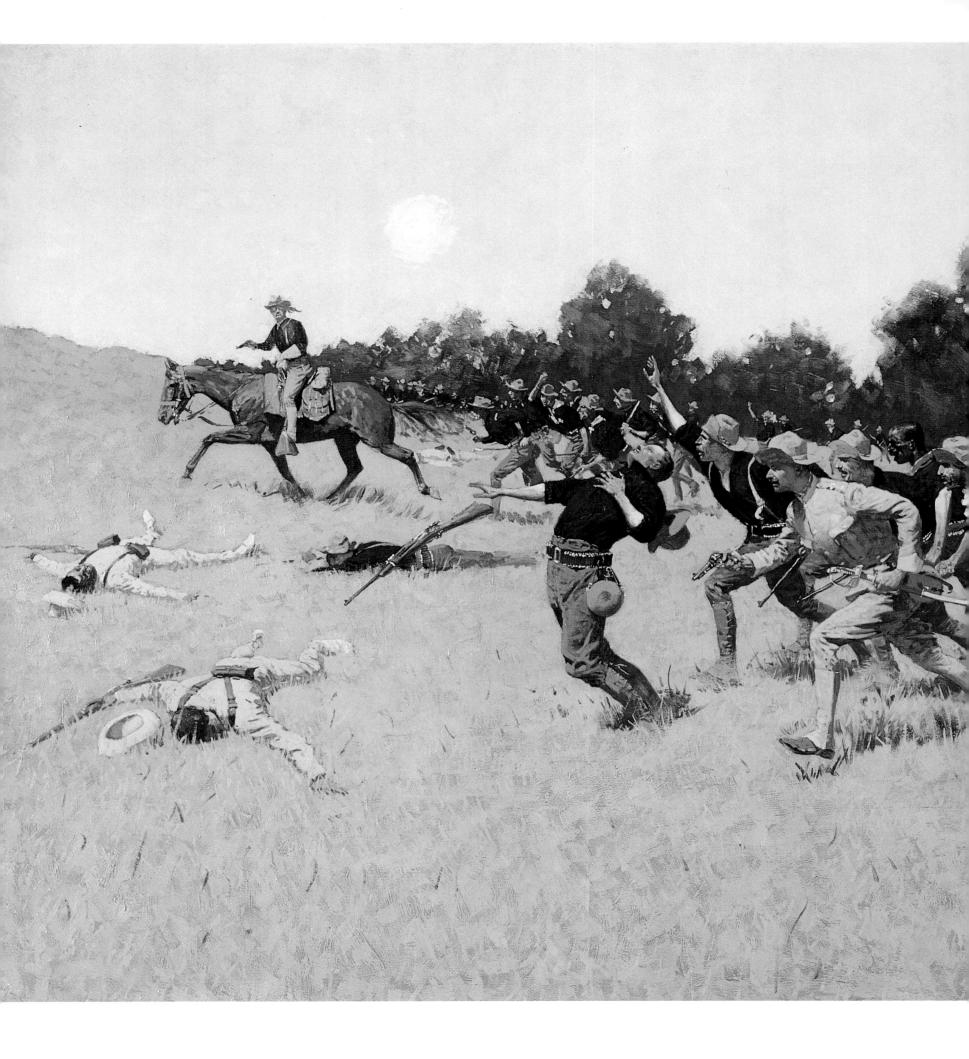

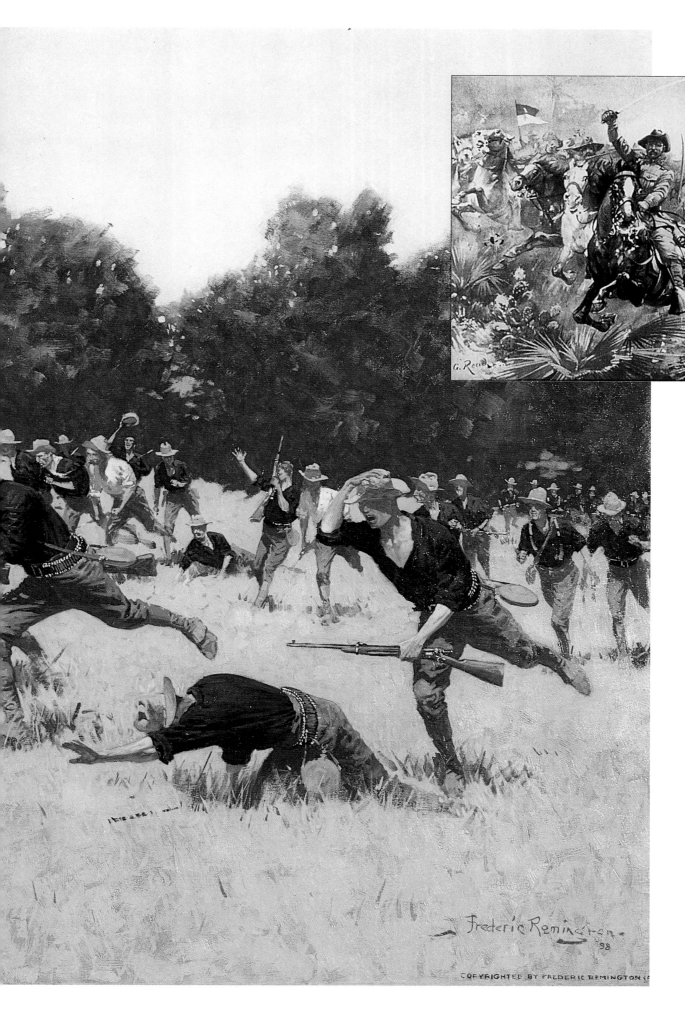

Above: This illustration, with an impossible point of view in front of the charge up San Juan Hill (which did not, for that matter, take place on horseback), was done by W.G. Read in a New York studio. Viewed together, this painting and the Remington to the left show the difference between illustration and combat art.
Library of Congress

Left: Frederic Remington's *Charge of the Rough Riders Up San Juan Hill* is the artist's eyewitness account of the event, in which he participated. Many Spaniards were killed, one by Col. Teddy Roosevelt, who is leading the charge on horseback at the foot soldiers' pace.
Frederic Remington Art Museum

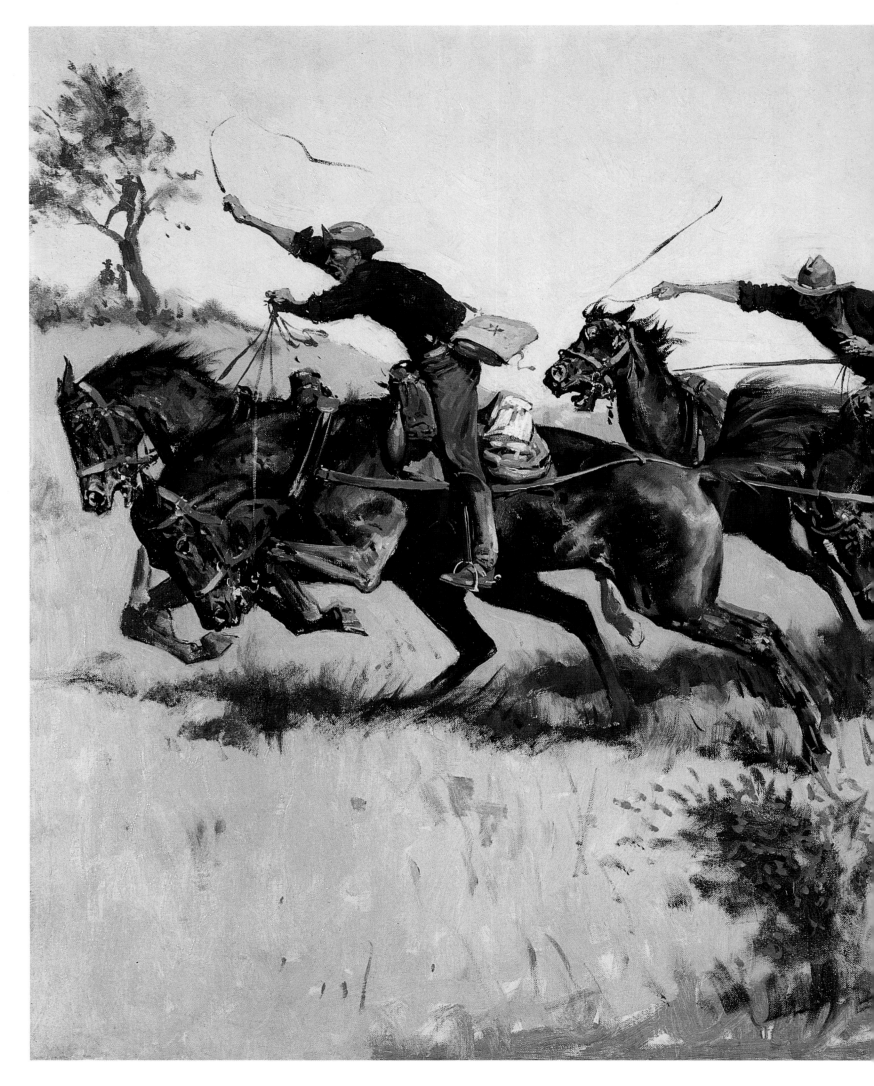

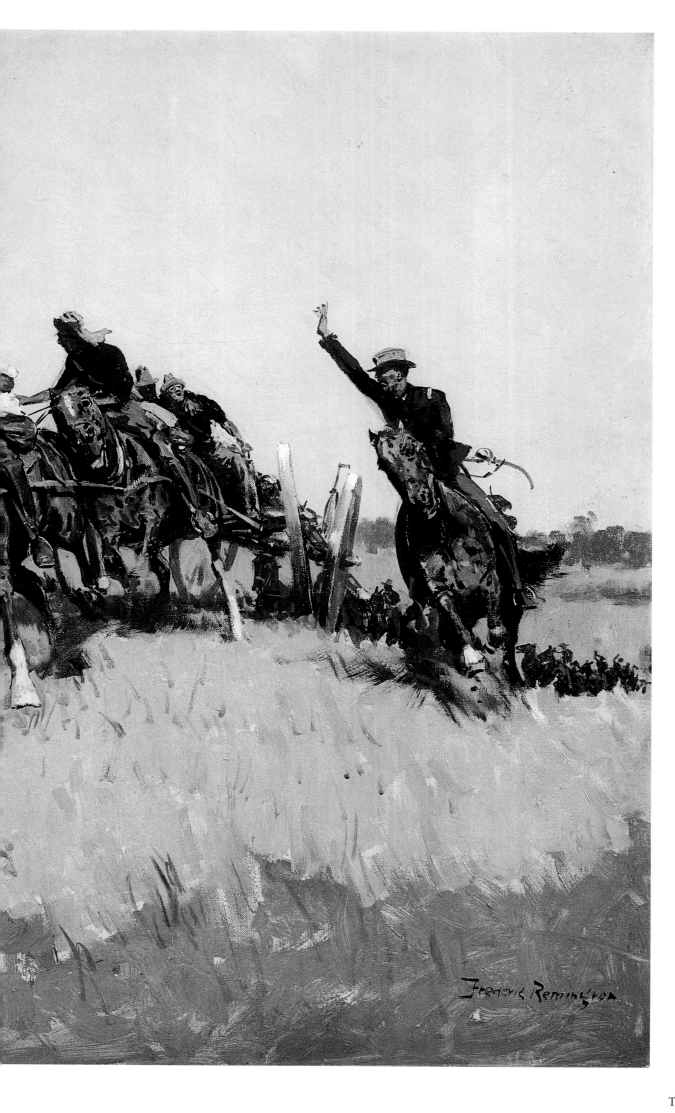

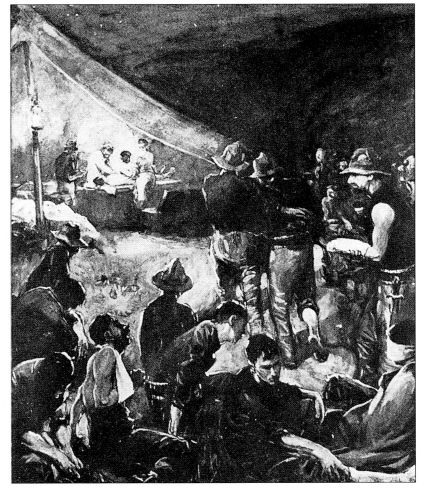

art in World War I. Indiana-born Charles M. Sheldon was a roving war artist–correspondent who covered fighting in the Sudan for British journals in 1896 and the Spanish-American War for *Leslie's Weekly* in 1898, before going to South Africa in 1899 to capture images of the Boer War. (Incidentally, the British military commander of the garrison at Mafeking in South Africa, Maj. Gen. Sir Robert Baden-Powell, also sketched combat, patrol, and camp-life scenes of the long siege. Later, Lord "B-P" went on to found the Boy Scout movement in England. He was joined by two other noted author-artists [although not combat artists], Ernest Thompson Seton and Daniel Beard, in founding the Boy Scout youth movement in the United States.)

A unique talent to come out of the war was Army Pvt. Charles Johnson Post, serving with the 71st Infantry, New York, U.S. Volunteers. Aged twenty-five when the war started, he had studied at the Art Students League in New York under leading artists of the day. His eyewitness renditions complement those of Remington and Christy, who covered the battles as observers, while Post was engaged in actual combat.

Unraveling the thread of true American combat art over the 125 years from the Revolution through the Spanish-American War is a difficult task, though a remarkable patchwork of visual and historic material has emerged. Artists such as Remington, Glackens, Chapman, and Homer created works that, in some cases, transcended their historical value and entered the canon of art history. The pioneering combat artists of the still-growing nation generally avoided grandiosity, theatrics, and embellishment, preferring a simple, straightforward, reportorial style. This style was fostered by the increasingly influential popular press, which began to provide patronage for artist-illustrators.

By the end of the nineteenth century, the new field of reportorial illustration had come into its own, bringing the most talented military artists into well-deserved prominence. Even if not all were seminal artistic achievements, works were produced by military artists that will undoubtedly last as vital historic documents. Indeed, these early trailblazers brought a still-developing style to the doorstep of a century that, in its five major shooting wars, would see the culmination of combat art as a valid and respected historical art form.

C H A P T E R Five

The Dawn of the Twentieth Century

In the period from the American Revolution to the dawn of the twentieth century, the United States saw five major wars and countless minor skirmishes and went through incredible social and technological changes. By the start of the new century, the neophyte world power had established itself as a beacon for those seeking freedom and opportunity.

The European cultural elite remained aloof, however, barely acknowledging their rustic relatives in the New World, and continued to enjoy their position at the apogee of Western civilization. Accustomed as we are to today's instantaneous communications, it can be difficult to fathom the lack of interplay across the Atlantic at the turn of the century. There was some cross-fertilization, of course, with European artists coming to the United States, and American artists going to Rome and Paris (the latter, the acknowledged mecca of the art world in the nineteenth century) to sit at the feet of the masters. Even so, American artists remained relatively oblivious to the European avant-garde in the last quarter of the nineteenth century. European artists such as Monet, Manet, Degas, Renoir, and Seurat were opening the world to impressionism, which stood in direct opposition to the classical tradition of the French Academy. And once those floodgates had opened, the postimpressionist movement, including expressionism and cubism, broke in succession, led by Gauguin, Van Gogh, Toulouse-Lautrec, Matisse, Braque, Picasso, and many others. A few Americans explored these new forms of expression (for instance, Mary Cassatt in Philadelphia and Childe Hassam in New York), but at its start this artistic revolution in France generally remained unknown to the American public. In 1905, photographer Alfred Stieglitz opened the first of his three art galleries in Manhattan to introduce these international modern artists, as well as a sprinkling of home-grown modernists, to America. Still, it was not until the 1913 Armory Show that the door to the modern movement really began to open in the United States.

As modernism swept through Europe, American fine artists for the most part maintained a tradition of landscape, seascape, still life, and figure painting that had been influenced by the romantic and sentimental European sensibilities of the Belle Epoque. The artists of the Ashcan School were an exception to this. Active in New York in the first decade of the twentieth century, these artists rejected the academy tradition in favor of a raw, realistic depiction of the world around them. And that world was changing fast.

The United States emerged from the Gilded Age of the late nineteenth century with a flurry of radical cultural and social transformations. Following the war with Spain, the acquisition of foreign territories had positioned the United States as a world power, and the country entered the twentieth century with boldness and confidence, if not bravado.

In 1903, the Wright brothers' contraption, which gave mankind functioning wings for the first time, captured the world's attention. By the time the United States entered the European war in 1917, the airplane—which had been quickly turned into a weapon of war—the tank, and the submarine would transform warfare.

Two Soldiers at Arras, 1917, a watercolor sketch by John Singer Sargent. Sargent witnessed firsthand the horrific effects of mustard gas while in Northern France.

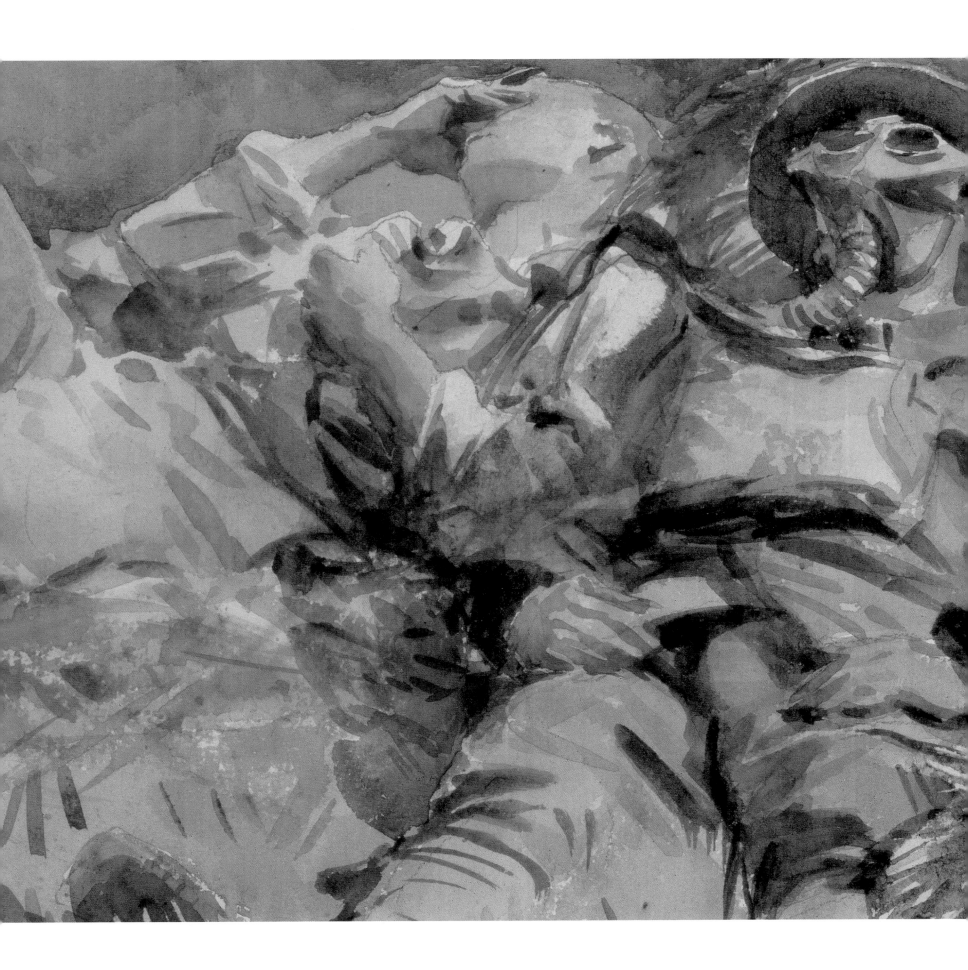

The European Art Scene

In contrast to the dreary, turn-of-the-century fine art scene in the United States, vibrant, expressive art movements were being unleashed in Europe, not only in France, but in Germany, Switzerland, and Italy as well. Prior to the outbreak of hostilities in 1914, there was much interplay among artists in Berlin, Paris, and Zürich —so much so that the loss on the battlefields of several important artists from these places was taken as a blow to the whole borderless European arts community.

Artists on both sides dutifully answered the call to arms, mostly as combatants rather than combat artists. For the French, Georges Braque, Fernand Léger, Raymond Duchamp-Villon, Frantisek Kupka, André Derain, and Roger de La Fresnaye, among others, donned uniforms; in Germany, August Macke, Franz Marc, Max Ernst, and Otto Dix headed for the front lines. (Macke and Marc, both founders of the Blue Rider movement [*Der Blaue Reiter*], lost their lives on the battlefield.) Some artists, however, managed to escape the front: Henri Matisse on account of age; Marcel Duchamp, Amedeo Modigliani, and Chaim Soutine because of health; and Pablo Picasso because he was a citzen of neutral Spain.

When war was declared, Braque, whose paintings had been on exhibit in Berlin and Dresden at the time, was called to serve. The following year, he received a severe head wound from which he eventually recovered. Not so fortunate was French poet Guillaume Apollinaire. Also severely wounded in the head, he was trepanned, with a part of his skull removed. He managed to survive the wound only to contract and succumb to the dreaded Spanish flu that was sweeping Europe and which exacted a greater toll than the millions lost to war.

A World at War: 1914–1918

In 1914, following a crushing German onslaught that was stopped just short of Paris in the Battle of the Marne, the Central Powers of Europe (Germany and the Austro-Hungarian Empire) and the Allies (France, Great Britain, and Italy) began what would become a three-year face-off in trenches along the western front. The war would be a series of monstrous clashes that decimated the young men of a whole generation. In 1917, the United States entered the conflict, ultimately becoming a decisive factor. Though the American Expeditionary Force of two million men in twenty-two combat divisions fought in France for only 200 days, from 28 May to 11 November of 1918, it suffered tremendous casualties (53,000 killed, 250,000 wounded). Like their European counterparts, American troops encountered the heinous new weapons of war: poison gas, tanks, aerial dogfighting and bombardment, and submarine warfare.

Austrian expressionist Oskar Kokoschka was also wounded. While Marc died at Verdun—one of the 60,000 men killed in one day—his compatriot Otto Dix survived and went on to condemn war in his paintings. Also in the trenches was an insignificant German artist named Adolf Schickelgruber (a.k.a. Hitler), from whom the world was to hear not long after.

Contrary to the typical artistic temperament, which abhors war and its destruction of beauty, Italian Futurists such as Filippo Marinetti embraced it, issuing a manifesto in 1909 declaring that war was "the only true hygiene of the world." They sped off to war as soon as Italy joined the Allies. A counter statement was formulated in 1916 in Zürich by a group of noncombatant artists who called themselves dadaists and proclaimed that they were anti-everything, especially the war.

Besides mobilizing artists on the home front to produce patriotic posters, and putting some in uniform to execute camouflage painting, the British Army selected one hundred artists and sent them immediately to the front to sketch and paint the battles. Following the first battle at Ypres, when the British officer corps was virtually wiped out, these artists, being university men, were commissioned on the spot and given battle commands.

After compelling the first hundred artists to fight, the British gave 450 others field training and commissions. On 25 June 1915, an exhibition was mounted to show the work of these war artists. Generally, their efforts were panned by the critics for being journalistic, anecdotal, and overloaded with sentiment; worse, the soldiers depicted looked immaculately clean. As *The Nation* put it, "…as long as the story was told and heroism expressed, the artist forgot about color, design, and pictorial effects." Another critic opined that in only rare cases did an artist surpass the stodgy Royal Academy tradition.

In 1917, the Ministry of Information of the British government took over. The ministry quickly commissioned new artists to go to the front (possibly to compensate for the Army's thus far mediocre efforts), thereby laying the foundation for one of the finest official modern military art collections (now in the Imperial War Museum, London). The program did not proceed without some rancor and dictums from its overseer, Lord Beaverbrook, who eventually distanced himself from it due to internal squabbling.

Still, many leading artists of the Royal Academy served and turned out splendid work: Paul Nash (who painted in a semiabstract style and served as an infantry officer), Muirhead Bone, Sir William Orpen, C.R.W. Nevinson (who served in the Royal Ambulance Medical Corps), and Eric Kennington, to mention only a few.

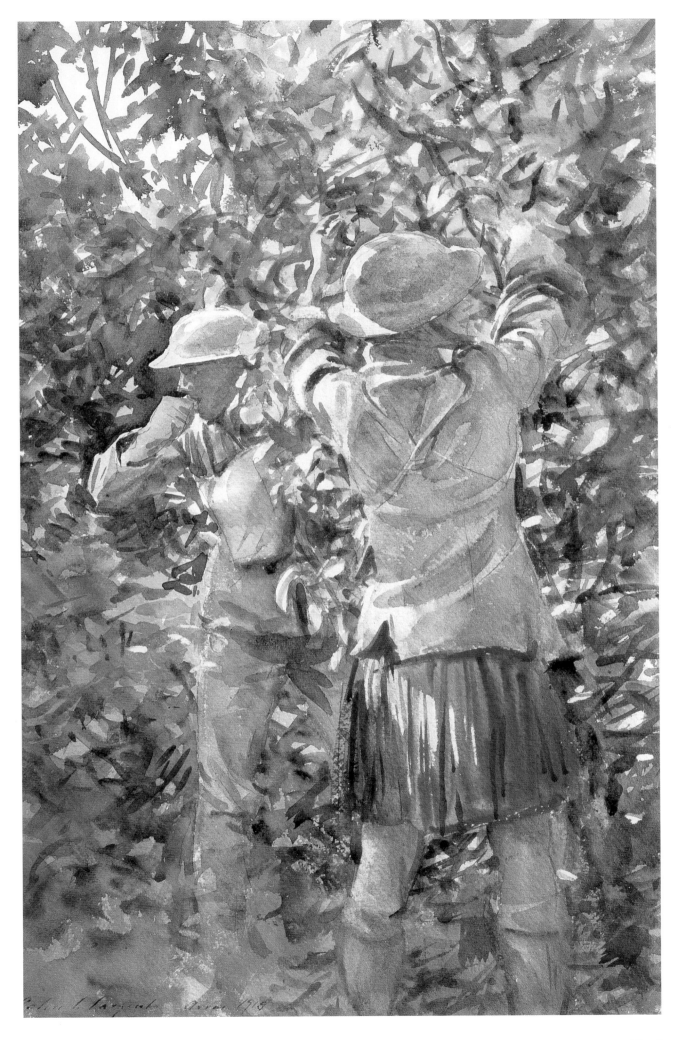

Ultimately, British art coverage of the war, under the Ministry of Information, the British War Memorials Committee, and the Imperial War Museum, was commendable—if frenetic, sporadic, and propagandistic. With photojournalists becoming ubiquitous, of course, combat art also now had to compete with photography, which had advanced considerably since the Civil War.

For the first time, war art had become a topic of serious critical discussion. A timely article entitled "The Future of the War Artist," in the 20 October 1917 issue of *Literary Digest*, pointed out that "the British view was that the war artist filled in where literature failed, as well as disproved the common prejudice that the artist is an unserviceable element in the crisis of war. He was first the recorder, second, the portrait painter of war, taking a fresh standpoint in the history of art."

In 1915, noted British novelist and playwright John Galsworthy wrote that "the things changed least by war will be art." By contrast, critic Armand Dayot wrote in the November 1915 issue of *Century*, "No outburst from official pictures or commissions will raise so vivid an air of truth, so sympathetic an emotion, as that communicated by these artistic jottings, taken from life without any thought of interpretation, with the sole aim of sketching sincerely the impressions received from a genuine vision."

By late spring of 1918, the American Expeditionary Force (AEF) had joined the Allied armies on France's western front, bringing with them some of the United States' leading artists.

John Singer Sargent

Noted American expatriate and fashionable portrait painter John Singer Sargent was inadvertently the first American artist to get caught up in the war. A resident of London since before the turn of the century, Sargent happened to be on one of his frequent sketching-painting trips with friends in the Austrian Tyrol when war broke out in 1914. Briefly detained, with all his artwork and materials confiscated by the Germans, he did manage, with some effort, to get back to London.

Later, perhaps out of mounting boredom with the highly lucrative occupation of painting the portraits of English high society and other notables, he accepted the invitation and challenge personally tendered by Prime Minister Lloyd George. Sargent, who had already seen the works of the British combat artists, was officially charged with gathering material for a large canvas that would memorialize the joint efforts of the British and the Americans, who had recently joined the fray. At age sixty-two, Sargent went off to war in his finery, sporting a white

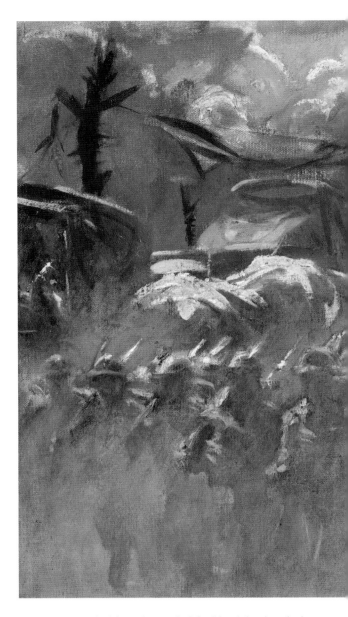

parasol (a practical item he carried for his plein air painting and which American units forced him to camouflage).

Always a delightful and witty dinner companion, Sargent was a raconteur, connoisseur, and bon vivant with an aristocratic flair, though he never quite managed to differentiate between military ranks and seemed totally oblivious to the dreadful danger of incoming artillery shells bursting nearby. Quite naively, he remarked to the British division commander, "I suppose there is no fighting on Sundays." A British Tommy observing him described him as "a sailor gone wrong!"

Nevertheless, Sargent did not flinch from his assignment and was an eyewitness to considerable war action. He worked in charcoal, pencil, watercolor, and oil paints, doing rather polished sketches from which he later executed his finished work. The impact of his war experiences affected him deeply and culminated in the epic battlepiece he was sent to do. He had come across the harrowing sight of a field full of soldiers who had been gassed and were being led, blindfolded, to a dressing station. They could have been British or American— the uniforms and tin-pot helmets were similar. Reflecting upon this choice of subject matter later, Sargent elucidated

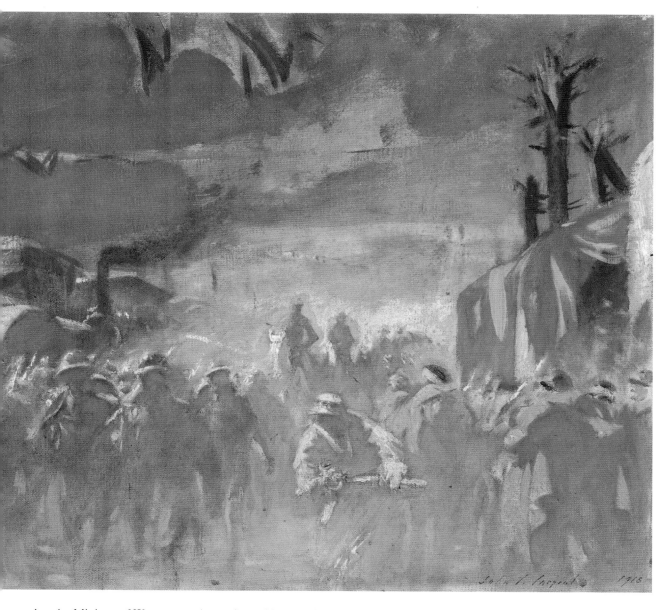

that the Ministry of War expected an epic, and how could he do an epic without masses of men?

The final painting, titled *Gassed*, was seven and a half feet (2.3m) high and twenty feet (6.1m) long, virtually a mural, which he considered his artistic forte. The scene is a shocker. Those who are ambulatory stagger and help each other as best they can in this frightful "blind man's bluff" across an empty, surreal landscape. Huddled in the foreground, like discarded gunny sacks, are the distorted figures of those gassed, wounded, and dying who are unable to stand. The painting is a powerful, unforgettable, and unflinching statement on the horrors of modern warfare.

Sargent was the only American (Europeanized as he was) and the only well-known nonmilitary artist to paint such a protest against war. The so-called Army "Eight" illustrators, who will be discussed later, did not make artistic comments about the war, nor did Marine Corps artist Capt. John W. Thomason, Jr., who fought in the thickest of it. The only one who came close to registering a protest was soldier-artist Kerr Eby, who fought in World War I and was a combat artist in World War II. There was certainly due cause to cry out artistically, for, while

America's casualties were not nearly as great as those of its allies, the country did lose some 50,000 troops, plus a quarter of a million wounded in only six months of fighting—a staggering toll by any standard.

The Europeans may have been more accustomed to the inevitability of war, feeling, perhaps, powerless to stop yet another. However, the most wrenching and bitter visual harangues against such mindless bloodshed came out of defeated Germany by artists Otto Dix and George Grosz, although English artists Paul Nash, C.R.V. Nevinson, and others managed relevant and controversial artistic comments.

John Singer Sargent, as a noncombatant, turned out a quantity of visual impressions of war that were of high artistic quality, as would be expected, yet still reportorial in nature.

U.S. Army Combat Artists

Almost all the American combat art of the Great War was realistic, traditional, and unaffected by European modernist trends. Almost none of it was colored by overtones of propaganda, as British military art was (sometimes openly so). Both fine artists and illustrators did their part. Many were,

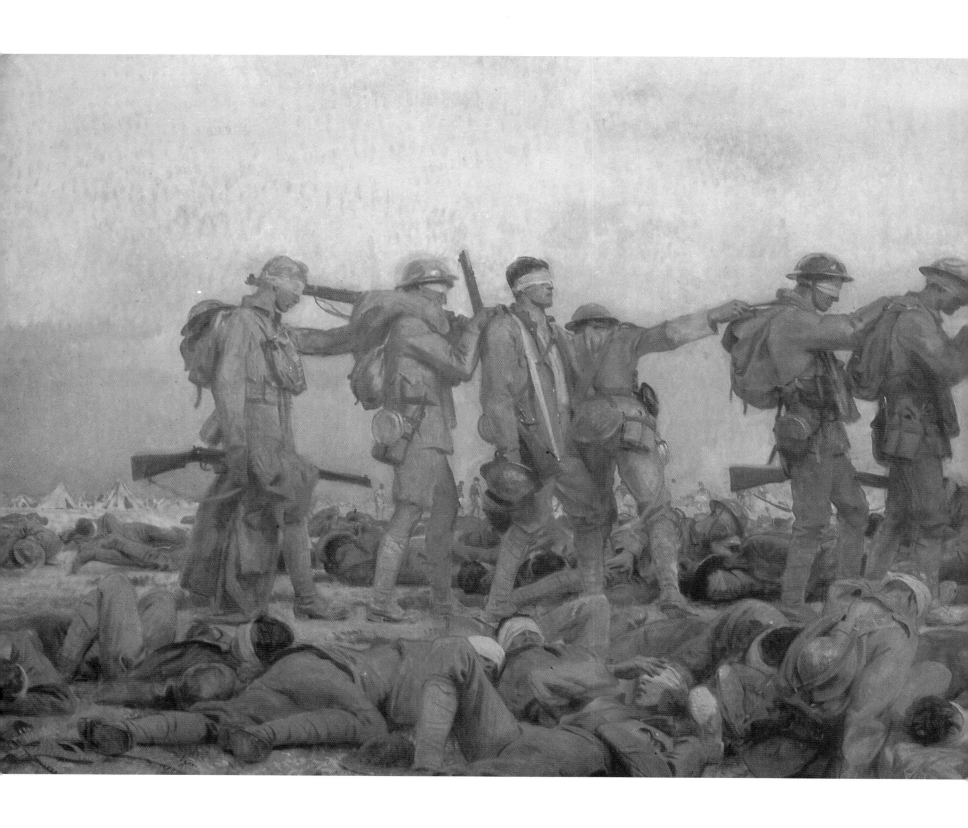

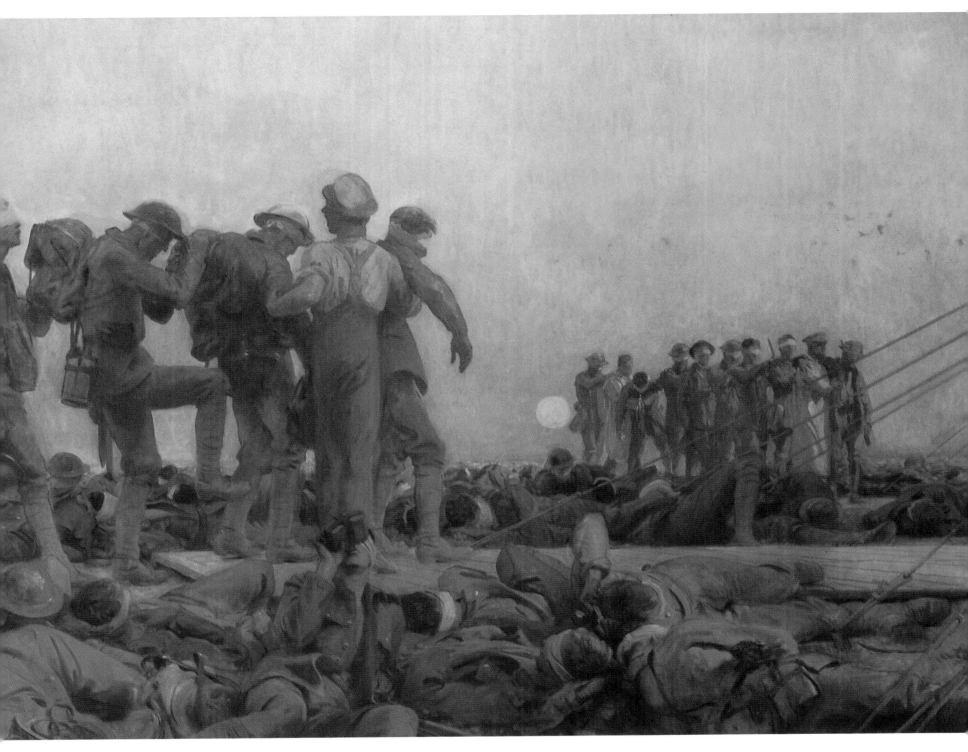

Above: *Gassed*, John Singer Sargent's combat art masterpiece, portrays a stumbling line of wounded soldiers who had been gassed by the Germans. After witnessing the scene, which shocked him tremendously, Sargent used his experience to paint a large work, capturing in universal terms an unfortunately common sight to all Allied soldiers—British, Commonwealth, French, and American. The Allies ultimately retaliated with poison gas themselves in World War I. As American uniforms closely resembled the British, this painting could serve as a tribute to both.

Imperial War Museum, London

Above: In *March to Saint-Mihiel*, Army Sgt. Kerr Eby's portrayal of the ominous cloud that marked the day is so vivid that many soldiers and Marines who had marched in the trudging column recalled the cloud formation years after the war, when this haunting work was published in his book, *War*. A quarter of a century later, as a civilian artist for Abbott Laboratories, Eby accompanied U.S. Marines in World War II into the bloody battles of the Pacific, creating some of the best combat art of that war.
Smithsonian Institution

Right: A touching and all-too-familiar scene following battle is portrayed here by Army Capt. William James Aylward, one of the official eight artists sent to the western front to chronicle World War I. This watercolor, done in July 1918, is entitled *His Bunkie*.
Smithsonian Institution

Opposite: Aylward's *Troops Waiting to Advance at Hattonchâtel, St. Mihiel Drive*, from October 1918. During the final six months of World War I, Aylward accompanied one of the AEF's twenty-two infantry divisions participating in the fierce fighting in France.
Smithsonian Institution

without doubt, deeply and adversely affected by their war experiences, though they stopped short of railing against war in their later work, leaving that to such Europeans artists as the Germans Otto Dix and George Grosz. While a handful of British war artists used modern styles, the Americans were apparently unaware of or not influenced by these modern movements, even though the Armory Show—which had taken place in New York five years earlier—had so boldly introduced modern art to America.

The Army "Eight"

Successful after the fact, the U.S. Army experiment with combat art followed the British example, though with a clearer sense of purpose. Eight prominent magazine illustrators chosen from the Society of Illustrators (William J. Aylwood, Walter Jack Duncan, Harvey Dunn, George Harding, Wallace Morgan, Ernest Peixotto, J. André Smith, and Harry Townsend) were commissioned as captains. With no military training or even basic orientation (except for Smith)—or specific assignments, for that matter—they were sent off immediately to the western front.

As professionals, the "Eight" were familiar with the methods used by contemporary illustrators, who would take extended trips to remote sites in order to research, sketch, and otherwise illustrate location scenes. (Today's more immediate method usually entails working in a studio from resource photographs, CD-ROM libraries, the Internet, etc.) But even if the illustrators instinctively knew what to do and how to fulfill their assignments, some in the higher echelons of the military did not comprehend the importance of their mission, nor did they appreciate the work the "Eight" produced, expecting overt propaganda pieces. Subsequently, none of the artists profited much from their experiences and have never truly been given their due.

Wallace Morgan attached himself to the 5th Marine Regiment and followed it into action at Château-Thierry and Belleau Wood, then into the St. Mihiel salient and on into the Argonne Forest. Capt. Ernest Peixotto also visited the Marines in action in early May of 1918. Army Capt. George Matthew Harding, who twenty years later would be commissioned a Marine captain and cover Pacific battles in World War II, was the only combat artist known to have used a camera for recording his impressions—an ironic distinction since his style tended more toward the abstract than any of the others. (No doubt, Harding used something like the No. 1A Autographic Kodak Jr., with black-and-white No. A-116 Autographic film. How he was able to process and print is a mystery. Certainly, Army and Marine photographic units—if there were any—were not set up to handle such a format. He might well have found a French processor and printer. After all, photography pioneers Joseph Niépce and his countryman Louis Daguerre were French.)

Harding officially reported that "at the front I make as many as sixty sketches or notes during a trip, besides constant observations." He completed his final paintings at his leisure—such as it was—behind the lines. Although he had use of an automobile for transportation, he reported the adverse conditions under which he sometimes had to work: "There still confronts the artist the problems of his craft, to be solved perhaps in a cold drenching rain, with a sketchbook held under one's trench coat, making each pencil mark mean something." Unable to rush to his studio to finish his sketch, the artist could only trudge on, making additional visual notes, sometimes for days and weeks, often able to forage only a meal a day from various

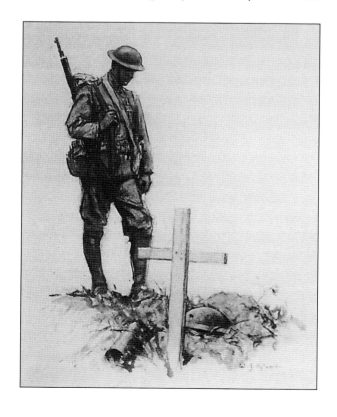

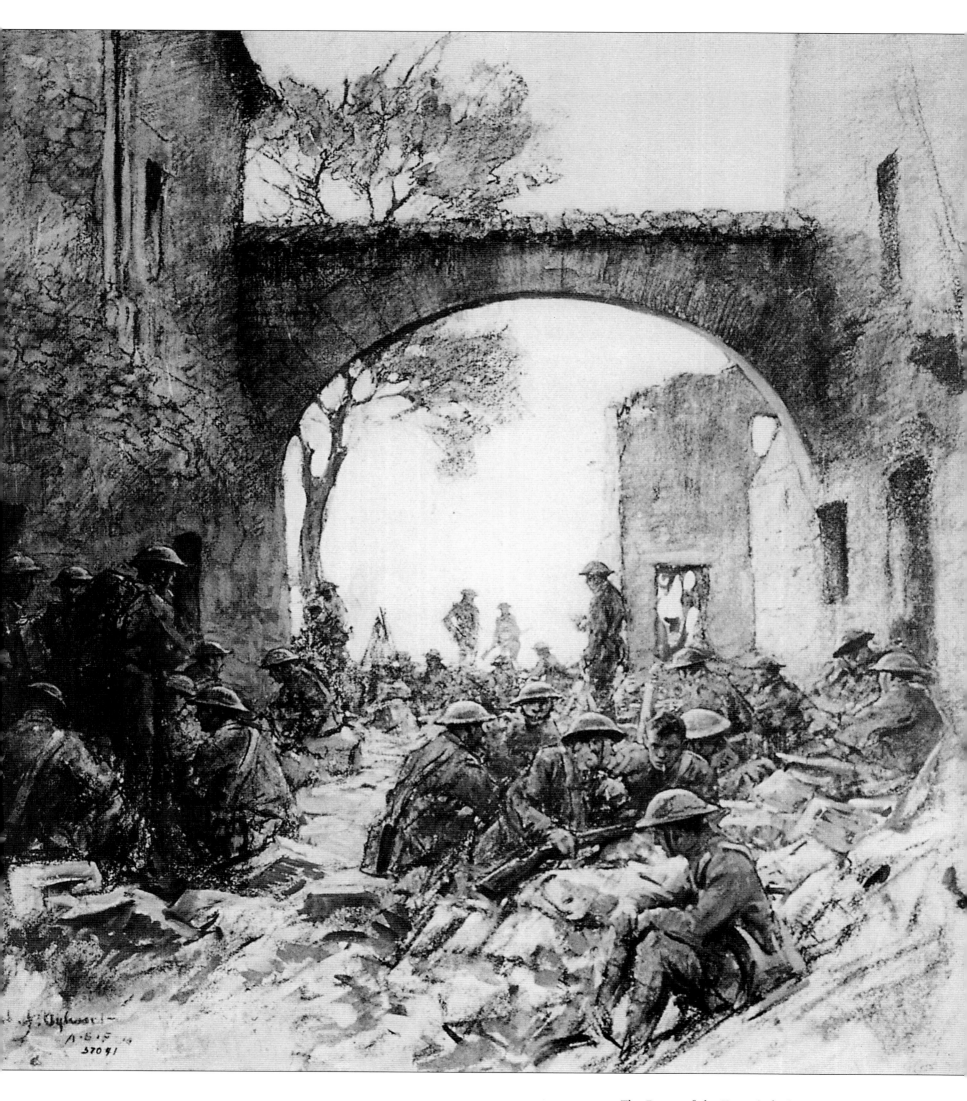

The Reluctant Involvement of the United States in Europe's War

Despite its declared neutrality and the strong isolationist feeling in Congress and the nation, the United States began sliding towards war as early as 1915, when the Germans torpedoed the British ocean liner Lusitania *off the Irish coast, with the resultant loss of 128 American lives. In January of 1917, the United States fully broke off diplomatic relations with Germany and began arming its own merchant ships, at that point already supplying both the French and British.*

By the spring of 1917, the French and British armies had been stalemated for three years, advancing and retreating repeatedly across a narrow strip of no-man's-land separating the fetid, lice-infested trenches of the western front. The Germans had pushed deep into France—almost to Paris. Meanwhile, the British were suffering heavy shipping losses to German U-boats and there was even widespread mutiny among French troops. On the eastern front, Allied Russia had undergone a revolution, and the victorious Bolsheviks ended their war with Germany, thus freeing millions of German troops for the western front. Not only was the German submarine a growing menace, even for neutrals, but there were emerging reports of German atrocities, especially in Belgium, where German troops allegedly bayoneted innocent women and children.

Though totally unprepared for war, the threat to American shipping finally prodded the United States to declare war on Germany on 6 April 1917, and it began rapidly building up its armed forces, almost from scratch. With conscription instituted, the Army and Navy immediately swelled, and training turned frantic. While the buildup continued, the American Expeditionary Force sent liaison elements to France on 13 June 1917. Eventually, twenty-two Army divisions, including two regiments of U.S. Marines, would bring the total sent overseas to two and a half million men. As American troops arrived, sagging Allied morale began to lift—although everyone feared that the green Americans might not fight well. The Germans did not seem to worry about the potential reinforcements, even as the Americans trained intensively until May of the following year, when they got their first taste of combat. The American commanding general, John J. Pershing, refused to let American units be split up and serve under either British or French command. The AEF would remain a unified American force.

The Americans' first test came during the Allied offensive in the late spring of 1918, starting in the Argonne Forest and ultimately advancing to the Meuse River in the southeastern section of the battle line. "Meuse-Argonne" was the largest battle U.S. forces had ever fought up to that time. A quarter of a million American troops were engaged and suffered 125,000 casualties before winning the day. Everywhere, the Americans performed beyond all expectations, fighting fiercely and victoriously for six months and taking heavy casualties (53,400 were killed in battle). Nonbattle deaths totaled 60,000, and during the year following the war, an influenza epidemic swept through Europe and the United States, killing fifteen million Europeans and one million Americans. The fledgling U.S. Army air service lost 289 airplanes and forty-eight observation balloons, but destroyed 781 German airplanes and seventy-three balloons. Capt. Eddie Rickenbacker was the top U.S. ace with twenty-six victories. (He later became president of Eastern Airlines in the thirties.)

The Allies had fought the war to a victorious end, with the Armistice signed on the eleventh hour of the eleventh day of the eleventh month of 1918. Unfortunately, the subsequent Treaty of Versailles exacted severe reparations from the Germans that helped usher in, to a great extent, an even worse worldwide conflagration two decades later. The League of Nations, which was formed to prevent future wars—and which the United States did not join—would sadly flounder and fail.

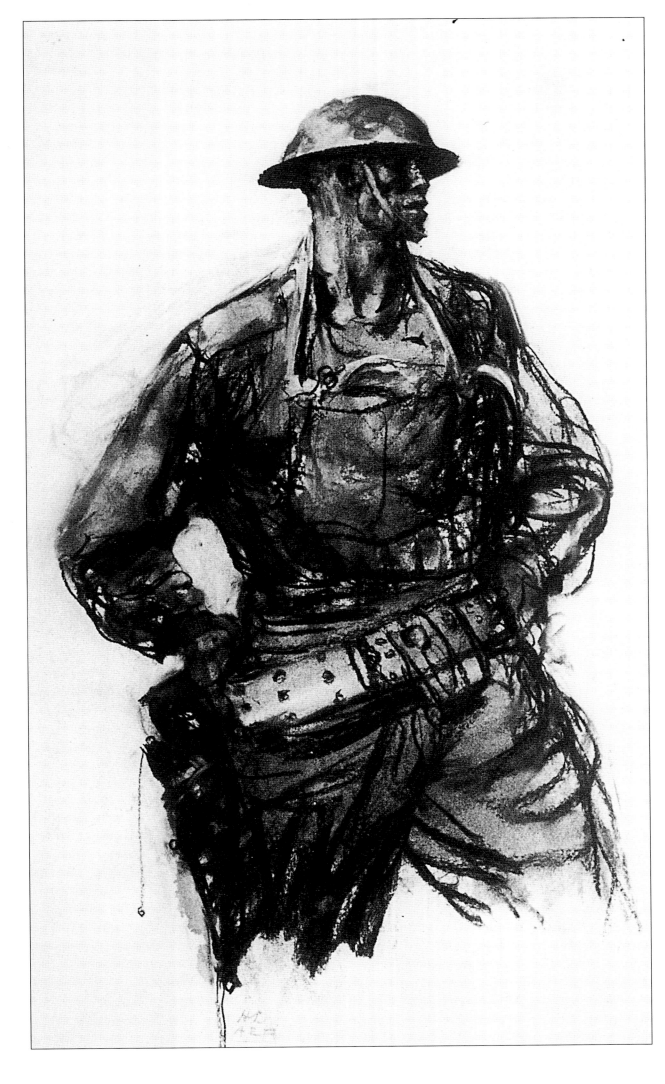

Left: The Machine Gunner, a famous color sketch by Army artist Capt. Harvey T. Dunn, depicts the soldier of the new century. One of the eight illustrators commissioned by the Army to cover the war, Dunn was particularly intrigued by the Marines serving in two regiments of the 2nd Army Division. This sketch epitomizes both the doughboys of the Army and the devil dogs of the Marines. Except for the globe and anchor emblem on Marine helmets, the uniforms were identical.
Smithsonian Institution

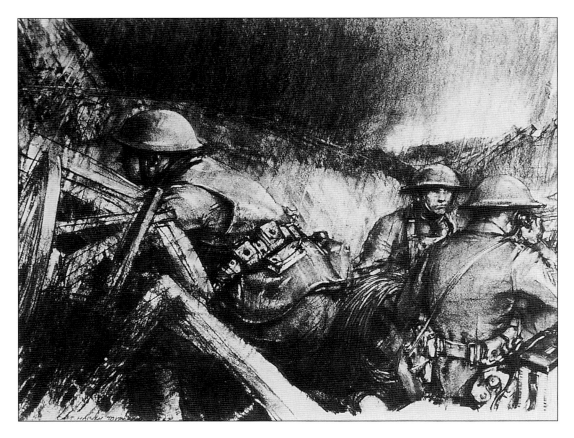

units and grab only a few hours of sleep when the opportunity presented itself.

Capt. Harvey Dunn favored the Marines to an extent, even carrying a Marine Band harmonica, which he played for the troops to put them at ease. (It is often awkward for a senior officer to fraternize with the lower enlisted ranks, as the latter are used to strict discipline, "distance of rank," and showing respect to officers. Forced camaraderie often presented problems, inhibiting troops and compromising the chain of command.) Dunn had gone to Europe "with a fervent desire to picture the war as it really was—the shock and loss and bitterness and blood of it." An imposing figure of above average height, he might well have

been his own model for his most famous drawing, *The Machine Gunner.* Subconsciously, at least, it could have been a self-portrait, as many artists tend to model their figures after themselves, whether they are aware of it or not. *The Machine Gunner*, though the subject is not identified, might well speak for both the Army doughboy and the Marine leatherneck. The stalwart figure seems to epitomize defiant courage, with which any fighting man could identify. Sketching on a special drawing board with continuous paper rollers at the top and bottom, Dunn worked rapidly and constantly. Many of his drawings, however, were done in charcoal, which is a particularly fragile and easily erasable medium, unless it is handled with extreme care. An entire drawing can be smudged or erased even by the slightest swipe of a sleeve cuff or hand heel. Dunn, no doubt, carried some sort of turpentine-thinned shellac fixative, which he would have sprayed on the drawings using a simple mouth-tube atomizer. Of course, his pencil, ink, and ink-wash sketches would not smear, so it is possible that all of his charcoals were done back in rear areas where he could protect them properly with fixative and overlays of tissue, and then pack them with cardboard for shipping. The fact that the artworks must have been passed up the chain of command with unavoidable handling makes it all the more remarkable that they have survived so magnificently.

Certainly, the sketches by Dunn and other combat artists stand up as finished works of art, and it is obvious that they were mostly done while the impressions were fresh in the mind, rather than at a later date. In view of modern-day photocopy and facsimile machines (through which many of author H. Avery Chenoweth's Gulf War sketches were instantly transmitted to Marine Corps Headquarters), it is amazing that so many delicate-media works from almost a century ago—in a war zone, no less—found their eventual resting places at the Smithsonian Institution in such undamaged condition.

Working in various media—oil, watercolor, pastel, crayon, and charcoal—Harvey Dunn created material that is recognized as some of the highest quality artwork produced by the eight army illustrators. It has also been the most popular with the public, possibly because, as an illustrator, he tended at times to slightly exaggerate reality for dramatic impact. His *Machine Gunner* sketch has been used countless times as cover and text illustration.

For the most part, however, the combat art that came from the trenches of World War I qualified as fine art. Though they were illustrators, the "Eight" reverted to their fine art training and, rather than succumb to the temptation to embellish, overdramatize, or propagandize, they portrayed with accuracy and realism the essence of

the subject matter, as well as their own experiences and feelings. Most of these artists had studied at New York City's newly founded Art Students League, which, while offering the necessary illustration courses for commercial artists, concentrated predominantly on the fine arts. Consequently, illustrators of that generation were well-grounded artistically, and most of those who were successful either taught or opened their own schools, as the illustrious "Eight" did after their experiences in the "War to End All Wars."

Gen. John J. Pershing, commander in chief of the AEF in Europe, may have expressed it best when, in countering rear-echelon criticism of the works of the Army artists, he reiterated his substaff's "heartiest approval of these artists' work…that a highly important function of their work is to preserve these scenes in the zone of operations and elsewhere for the historical record of the war, as well as to provide current needs in periodicals." Regarding the action pictures that some in Washington were calling for, Pershing reminded them that, "It is out of the question to have any artist at work in front line trenches or anywhere near them during active engagement."

Fortunately, his word did not filter down to the ranks, and artists did indeed work close to the action, especially Marine Capt. John Thomason, who was a combatant, and the illustrators sent by journals and periodicals like Samuel Johnson Woolf, Will Foster, Lester G. Hornby, Joseph Cummings Chase, and Louis Orr. In light of Pershing's remarks, Army Capt. J. André Smith was assigned to reconstruct the raison d'être for the eight illustrators. He stated, "I am very sure that we all accepted our commissions with the firm belief that we would primarily serve the Government as artists chosen along the line of our particular and individual field of work, and with the idea that the sum total of our drawings, paintings, and etchings would form a separate and distinct pictorial record of the war, valuable not only as historical documents, but also as works of art."

After the war, *Collier's* magazine used many of the illustrations made by these artists in its photographic history of the war. Other publications used their work profusely as well. Of course, photojournalism was having its first real test in war coverage, too, and would soon give combat art a run for its money.

An Army combatant and combat artist on his own, Sgt. Kerr Eby was already serving in the army when the "Eight" were chosen. Eby ended up with the 40th Engineers on the western front and, despite the almost constant activity required of that sort of outfit in combat, managed to do some powerful sketches in charcoal (his preferred medium) and heavy crayon. Witnessing and

participating in much fierce action, he turned many of his sketches into etchings after the war, including a particularly memorable one of Marines entitled *March to Saint-Mihiel*, which depicted an unusual and threatening cloud looming over the column. Many who were in the march that day remembered the cloud vividly when they saw Eby's engraving after the war. In 1936, in a book published by Yale University Press that he titled simply *War*, Eby wrote a commentary to accompany many of the artworks he did "over there." He continued his connection with the Marines in World War II, executing some of that conflict's most dynamic and memorable art.

The U.S. Naval Services

The U.S. Navy, while important in its role as a supporting force, did not see major confrontations with the enemy, as the land forces did. Obviously, sea convoys had to be

Below: At an aerodrome near the front in 1918, Capt. Harry Townsend's charcoal sketch captures the French-made Nieuport fighters flown by American pilots. In their short six months of combat flying, American pilots performed credibly, mostly in one-on-one aerial engagements. Capt. Eddie Rickenbacker, flying a SPAD aircraft, was the top American ace, with twenty-six aerial victories. To attain ace status, pilots had to vanquish five foes.
Smithsonian Institution

escorted by naval ships, and the submarine threat occasioned a number of encounters. The U.S. Marine Corps, always a part of the naval establishment, took a greater combat role, though Marine Corps aviation, still in its infancy and short on airplanes, operated only one squadron in the Azores and four in Flanders supporting the British. Two infantry regiments of the Marine 4th Brigade, the newly created 5th and 6th Marine Regiments, augmented the U.S. Army 2nd Division as land units. The division itself would later be commanded by Marine Maj. Gen. John A. Lejeune and engage in some of the heaviest fighting in the last months of the war: Belleau Wood, Soissons, and Mont Blanc. For the

ferocity of their fighting and accuracy of their shooting, the Marines, who had been called "leathernecks" since the American Revolution, when they wore stiff leather collars designed to deflect saber slashes, earned accolades and a new nickname of respect from their Boche opponents, *Teufelshunde*, or "devil dogs," as well as numerous *croix de guerre* from their French comrades.

Capt. John W. Thomason, Jr., USMC

Marine Capt. John W. Thomason, Jr., a company commander with the 5th Marine Regiment, would eclipse all other combat artists of World War I in fame. He was a professional combatant, as well as, later, a professional artist and writer. Observed briefly during a pause in the fierce Battle of Belleau Wood, he was perched on the edge of a shell hole sketching on a chocolate wrapper with the tip of a burned matchstick. (In tribute to the Marine action, following the battle the French renamed the woods Bois de la Brigade de Marine.) In 1926, Thomason wrote a popular bestseller, *Fix Bayonets!*, in which he told of the experiences of the Marines fighting in France, their occupation of Germany afterwards, and, later, their service in China. This book alone made him stand out among the writers of his day and started him on his road to fame and fortune—even as he remained an active-duty Marine.

In 1909, Thomason had attended Southwestern University at Georgetown, Texas, then Sam Houston Normal Institute, before continuing to study for two years at the Art Students League in New York City. He worked

at the *Houston Chronicle* before joining the U.S. Marine Corps in 1917.

As a first lieutenant and then captain, he led his rifle platoon and company of the 5th Marine regiment in some of the toughest fighting of the war. For heroic acts at Soissons—he took out a German machine-gun nest—Thomason was decorated with the Silver Star and the Navy Cross, second only to the Medal of Honor. The entire 5th Regiment, as well as the 6th, was awarded the French *Croix de guerre* several times for gallantry in action.

In *Fix Bayonets!*, Thomason described the scene in Belleau Wood: "They tried new tactics to get the bayonets into the Bois de Belleau. Platoons—very lean platoons now—formed in small combat groups, deployed in the wheat, and set out toward the gloomy wood. Fifty batteries were working on it, all the field pieces of the 2nd Division, and what the French could lend. The shells ripped overhead, and the wood was full of leaping flame, and the smoke of H. E. [high explosive] and shrapnel. The fire from its edge died down. It was late in the afternoon; the sun was low enough to shine under the edge of your helmet. The men went forward at a walk, their shoulders hunched over, their bodies inclined, their eyes on the edge of the wood, where shrapnel was raising a hell of a dust. Some of them had been this way before; their faces were set bleakly. Others were replacements, a month or so from Quantico; they were terribly anxious to do the right thing, and they watched zealously the sergeants and the corporals and the lieutenants who led the way with canes."

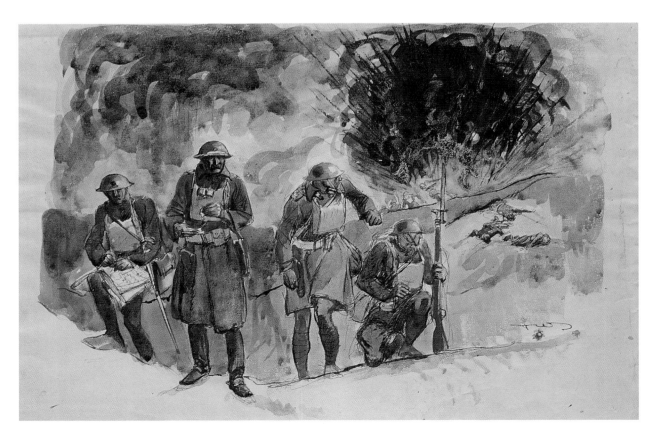

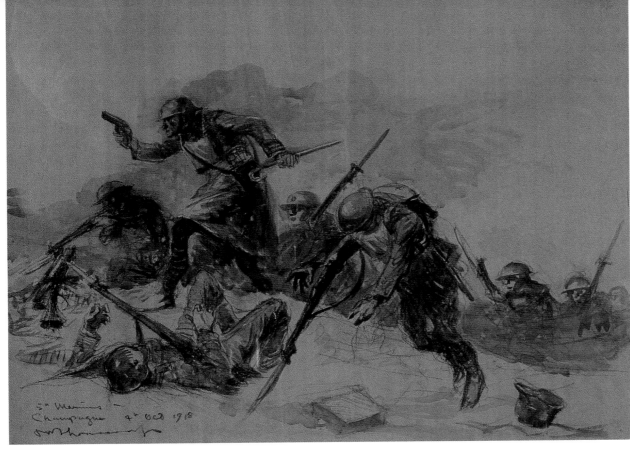

Even before he had tasted combat, Thomason, as was his nature, was sketching Marine activities and French soldiers and civilians, then mailing the sketches home to his wife, Leda. After he had become a veteran, following his first firefight, he wrote to his parents that he hoped some day to write a book about the war—were he fortunate enough to survive it. He openly wondered, though, about his ability to write adequately on "this business of war." Ever true to form, this letter was written on pages torn from a field notebook, and its final sheet contained a full-length pencil sketch of two Marine riflemen cooking their rations in the trenches.

In another letter to his mother, he philosophically reflected, "war is nobody's picnic—but men can endure it and rise superior to it and live through it. So with the most cheerful possible face we can 'carry on' and hope for the best." Lacking art supplies, he lamented, "never in all my life have I so vastly wished for drawing materials…. If I just had a bottle of India Ink—or a few water colors! But I haven't. If I ever get back to a place where they can be procured I can do some things that you will be glad to have." Such artworks were naturally his own personal property (except for those "confiscated" by higher command), not that of the government, like the artwork of the Army "Eight."

Thomason clearly maintained that his first responsibility was the welfare of the men of his unit and that he was personally not interested in earning combat decorations. The souvenir he wanted most was to get himself home. As Thomason later recounted in a letter, "The day after our attack in July [Soissons], I found a Boche note-

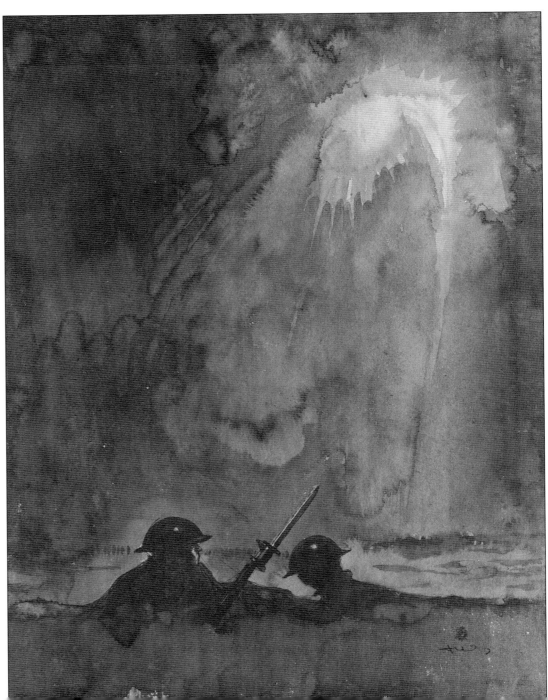

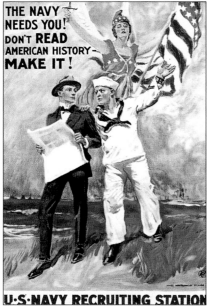

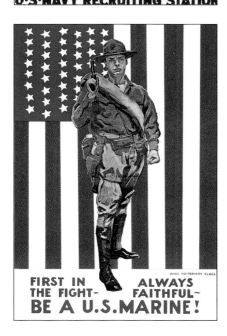

book and some drawing pencils in a Command Post we cleaned out, and got some rather interesting sketches under fire. After we came back, I worked some of them up—all the actual originals I sent home—I think—and the Major, who happened by my shelter when I was working on them, commandeered the best of the finished ones to send to Headquarters, U.S. Marine Corps as a matter of official record. There they will be interred for good. The others—well—there are such difficulties in the way of sending such things home that I have carried them around with me. Anyway, some of them are rather crude and brutal." At the end, he added, "I am well and quite cheerful, considering, and making out fairly well, I think, in the profession of arms."

Many years later, Thomason reflected in a short story, "Salt Winds and Gobi Dust": "We were shot to pieces in the Champagne—I never enjoyed the war afterward."

In *Fix Bayonets!*, he penned a passage describing the Marine occupation duty following the Armistice: "Look at this country [Germany]—winter ploughin' done—everything ship-shape—no shell-holes—no trenches—no barb' wire—who in hell won this war, anyway? You said it. We oughter got in here an' showed the Old Boche what it was like, to have a war in his own yard." Thomason thought President Woodrow Wilson's idealism was out of place in occupied Germany, for the inhabitants retained their hatred of the Allies and were more desirous of revenge than of living in peaceful cooperation. He held no illusions about the world having been "saved for democracy." After his combat experiences, he felt that the soldiers should have made the peace terms, not the politicians.

Before his death late in World War II, Thomason had a unique and illustrious career in the Marine Corps. That he was able to pursue a demanding military career in China, the West Indies, and Nicaragua, and yet still conduct successful and lucrative side careers in literature and art is simply amazing. His biographer, Col. Roger Willock, USMCR (Ret.), who knew him well, points out that Thomason never wasted a moment—he worked early in the morning, before his duty-filled day began, and far into the night. Thomason was another artist who continually crossed the line between fine art and illustration. Perhaps because he used most of his sketches to illustrate his own writings, he tends to be categorized more as an illustrator. However, his World War I and Marine Corps vignette sketches of the twenties and thirties were based on his own eyewitness observations. Many were used as illustrations in *Leatherneck* magazine and scores of civilian publications.

Among the many accolades he received from the literary world, none could surpass the response to *Fix Bayonets!* A review in the *New York World* glowed, "The finest monument of the American Expeditionary Force, and a notable volume of prose with drawings that are of permanent interest to American History." *The New York Evening Post* raved, "Here is a book! Here is war…and here is the soldier as he is, was, and always will be in terms of stress and strain and battle…. It runs as straight as a cleaning-rod. It is keen as a newly-ground sword-bayonet. Splendid as the tale itself is, the illustrations all but tell the story themselves." *Hearst's International* summed it up: "What a Fighter! What a Writer!"

Thomason succumbed to a recurring illness, which he may have contracted in one of the remote outposts where he was assigned duty in mid-World War II, perhaps China, the Caribbean, or the South Pacific. He died peacefully on 12 March 1944 in a naval hospital in San Diego. Following his death, the Navy named a Sumner class destroyer, DD 760, after him. The Marine Corps named a section of the Marine Corps Base at Quantico in his honor, calling it Thomason Park. The state of Texas hung his portrait in the Hall of Heroes at the Austin State Capitol, alongside Sam Houston, Stephen Austin, Davey Crockett, William Travis, and Jim Bowie. In 1987, the Marine Corps Historical Foundation created the Col. John W. Thomason, Jr. Art Award, an engraved plaque and one-thousand-dollar prize that recognizes Marine artists for their achievements and contributions to the Corps. Despite all of Thomason's artistic and literary achievements, he always considered himself, first and foremost, a professional Marine.

Artists, Illustrators, and the War Efforts at Home

Once the United States became engaged in the conflict in Europe, American artists, like the rest of the country, rallied to the flag, offering their services, if not donning the uniform. During the opening decades of the twentieth century, American illustration was still experiencing its golden age, while fine art was belatedly toying with impressionism on the one hand (Childe Hassam) and Ashcan realism (Glackens, Luks) on the other. One of the leading illustrators, Howard Pyle, saw no difference between fine art and illustration. To him, it was "simply a term designating quality and that the best in illustration would certainly qualify as fine art." Yet James Montgomery Flagg flatly admitted that "illustrators work mostly from reference, not out of their heads." Popular illustrators N.C. Wyeth, Frederic Remington, and Howard Chandler Christy had stated that they wanted to be remembered as fine artists. Following his work in the Spanish-American War, Christy had hit his stride, as had Charles Dana

Gibson, whose pen-and-ink sketches of buxom "Gibson girls" were the rage. Flagg jumped right into the war effort in 1917, with a poster of Uncle Sam pointing his finger at the viewer, captioned, "I Want You For U.S. Army." The older crowd of Pyle, Abbey, and Wyeth was giving way to the new breed, which they had influenced and even, in some cases, trained: the Leyendecker brothers, (J.C. and Frank X.), Maxfield Parrish, Walter Biggs, Arthur William Brown, and a young man of promise, Norman Rockwell.

In 1917, Gibson, as president of the recently founded Society of Illustrators, was asked to form and head the Division of Pictorial Publicity of the Federal Committee of Public Information. He proceeded to recruit the top illustrators of the day, who would volunteer their talents to design posters, billboards, and other publicity for the war effort. (When the government wanted to select leading artists to commission and officially send to the front, it called upon Gibson to make the choices.) Henry Reuterdahl, noted illustrator and artist-correspondent during the Spanish-American War, became artistic advisor, as a Navy lieutenant commander, to the U.S. Navy Recruiting Bureau in New York, where he also made posters.

Flagg and Christy created many posters for the Navy Publicity Office. They often featured attractive young ladies dressed in sailor or Marine uniforms, usually giving a recruiting pitch "come-on," such as, "Gee! I Wish I Were a Man. I'd Join the Navy." Another set of posters showed a businessman with a tough look on his face, peeling off his coat as if to fight, captioned "Tell that to the Marines!"; "The Navy needs you!"; or "Want Action? Join U.S. Marine Corps!"

Christy, a veteran artist-correspondent from 1898, wholeheartedly jumped into the war effort early on. With forty posters to his credit by war's end, his name had become synonymous with the Navy. The class of 1921 at the Naval Academy at Annapolis, Maryland, made him an honorary member. Christy endeavored to portray the ideal American beauty, exemplified by his figures of wistful young women looking up to heaven with arms outstretched, diaphanous gowns billowing in the breeze, and an American flag undulating in the background. His other smiling young girls in uniform, an adopted trademark, were supposedly meant to be allegorical images, representing Liberty, Justice, or America. The artist also made numerous public appearances and auctioned off many of his original poster paintings to the highest bidders for Liberty bonds. When the paintings were all sold, he offered to do portraits for $3000 each, donating the proceeds to the bond effort. On one occasion,

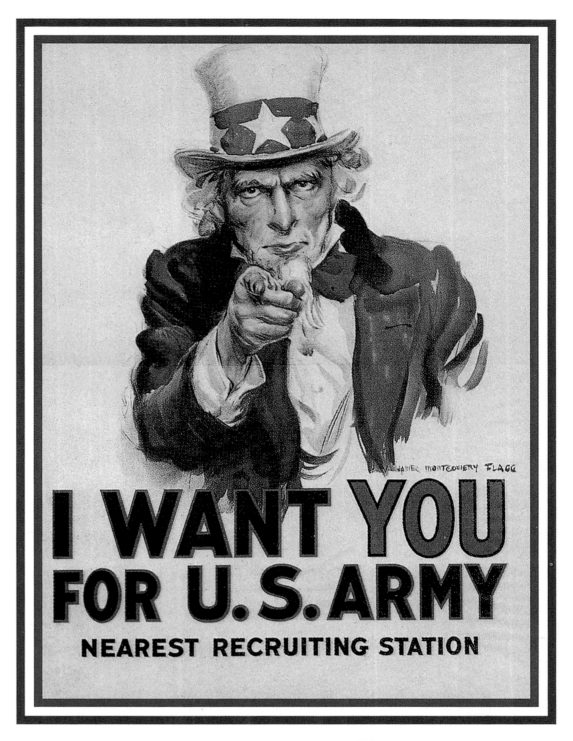

he and celebrity Marie Dressler, staging a "representation" of his poster "Fight or Buy Bonds," allegedly raised $7.4 million in three hours. Shamelessly and gloriously patriotic, the hand-lettered World War I posters were highly effective in their day.

Patriotic Artists Who Did Their Part

In order to mobilize the minds, emotions, and money of the country, President Wilson had originally appointed former editor and columnist George Creel to head the newly created Committee of Publication, which oversaw the Division of Pictorial Publicity that artist Gibson had volunteered to head. The total effort of all the listed artists, who participated without compensation, accounted for 700 posters for fifty separate government departments and private relief organizations. Valued in the millions,

These pages: War posters such as these executed by well-known artists James Montgomery Flagg (above and opposite, middle and bottom), Howard Chandler Christie, and other leading American artists, were posted on fences, windows, and everywhere possible during World War I. The finger pointing at the viewer was a common motif in British recruitment posters of World War I and not surprisingly had a decided influence on similar propagandistic efforts in the United States, which entered the war so much later.

but at a cost of only $13,170.97, the effort was dubbed by Creel as "The Battle of the Fences" (referring to the public locations where most of the posters were placed).

Among those who were either in uniform or donated their services to the national effort were such notable artists and illustrators as George Bellows, Arthur Brown, Kenyon Cox, James Daugherty, Howard Giles, John Held, Jr., the Leyendecker brothers, Harold von Schmidt, and N.C. Wyeth. Oddly, a noted American illustrator, Joseph Pennell, who had been in England during the early part of the war, chose later to cover it from the German side. Meanwhile, well-known illustrator Harry Morse Meyers became an Army pilot, as did Princeton graduate and illustrator Edwin Georgi.

To assist the Marine Corps' recruiting efforts, volunteer artists provided illustrations for posters, articles, and other publicity media; the volunteers included well-known artist-illustrators Howard Chandler Christy, John A. Coughlan, Charles B. Falls, James Montgomery Flagg, Gilbert Gaul, Ole May, Victor Perard, Henry Reuterdahl, Sidney H. Riesenberg, W.A. Rogers, L.A. Shafer, Clarence F. Underwood, Paul Woyshner (who became a Marine master sergeant in the twenties and thirties), and Frederick C. Yohn.

Following his first *Saturday Evening Post* magazine cover in 1916, twenty-four-year-old Norman Rockwell actually enlisted in the Navy in 1917—after stuffing his light, lean frame with bananas, warm water, and doughnuts in order to pass the weight requirement. He was accepted and shipped off to the Navy Yard in Charleston, South Carolina. After discovering a drawing Rockwell had done of a chief petty officer, the base commander sent to New York for the young sailor's brushes and materials and installed the artist in the officers' quarters. Rated a third-class varnisher and painter, he was permitted to do *Saturday Evening Post* covers, boosting his income beyond that of an admiral. Perhaps eager to join the fray, after a year Rockwell wrangled an assignment to Queenstown, Ireland—at least closer to the action—where he was to paint insignia on American naval planes based there. The American transport he was on, however, was ordered to turn back by an American submarine—back, in fact, to Charleston. When the Armistice came on 11 November 1918, Rockwell opted for a quick discharge, and resumed his career. He capped off the war with a 28 November 1918 *Life* cover showing jubilant faces of victorious servicemen.

Also on duty for the Navy was the young Thomas Hart Benton, who had traveled and studied art in Europe and actually experimented with painting in the various avant-garde styles that were bursting forth, especially Stanton MacDonald-Wright's synchromism. In Norfolk, Virginia, when it was discovered that Benton was an artist, he was relieved from the drudgery of hauling coal and ordered to make perspective sketches and drawings of camouflaged ships. Forced to do accurate but mundane drawings, Benton later admitted that this discipline had much to do with bringing his art into focus. As he described it, "My interests became, in a flash, of an objective nature." Shortly after the war, his unique, caricature-like, contorted, three-dimensional style emerged, and he used it to portray the American Midwest in many murals under the government-sponsored Works Progress Administration (WPA) program, thus earning himself a place in the regionalist school of the mid-thirties. Though he missed combat action in this war, twenty-two years later he did portray, as an eyewitness, World War II Navy submarine patrol training activities in the Atlantic.

Louis Bouché was another artist who served in the Navy but did not see combat; like Benton, he participated in the later government art programs of the thirties.

Following the war, in 1919, Navy artist C.E. Ruttan did a series of paintings depicting the first successful crossing of the Atlantic by a flight of Navy Curtiss NC seaplanes. Also, often hailed as the "Navy's Portraitist of Ships," Lt. Arthur Beaumont turned his noted watercolor style to recording naval activities in the decades between the wars.

Unlike their British counterparts, American art critics were inexplicably silent about the art that came out of World War I, perhaps because the public was really not exposed to it until long after the war. The Army's "Eight" never got the wide publicity they deserved. Most likely the public wanted to forget the horror of the war—short though America's participation had been. It was only in the mid-twenties that Thomason's *Fix Bayonets!* brought some attention to the art from the trenches.

It would be a different story during World War II.

"The things changed least by war will be art."
JOHN GALSWORTHY, 1915

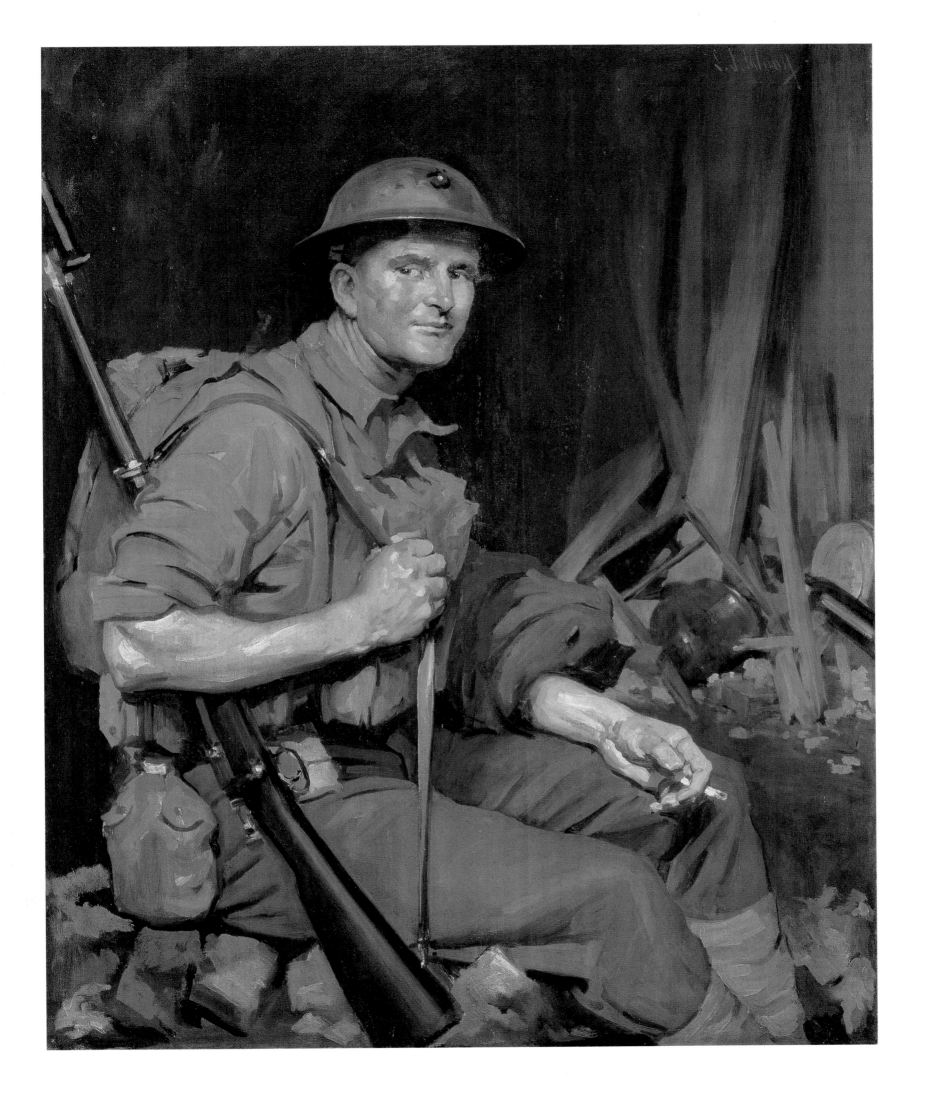

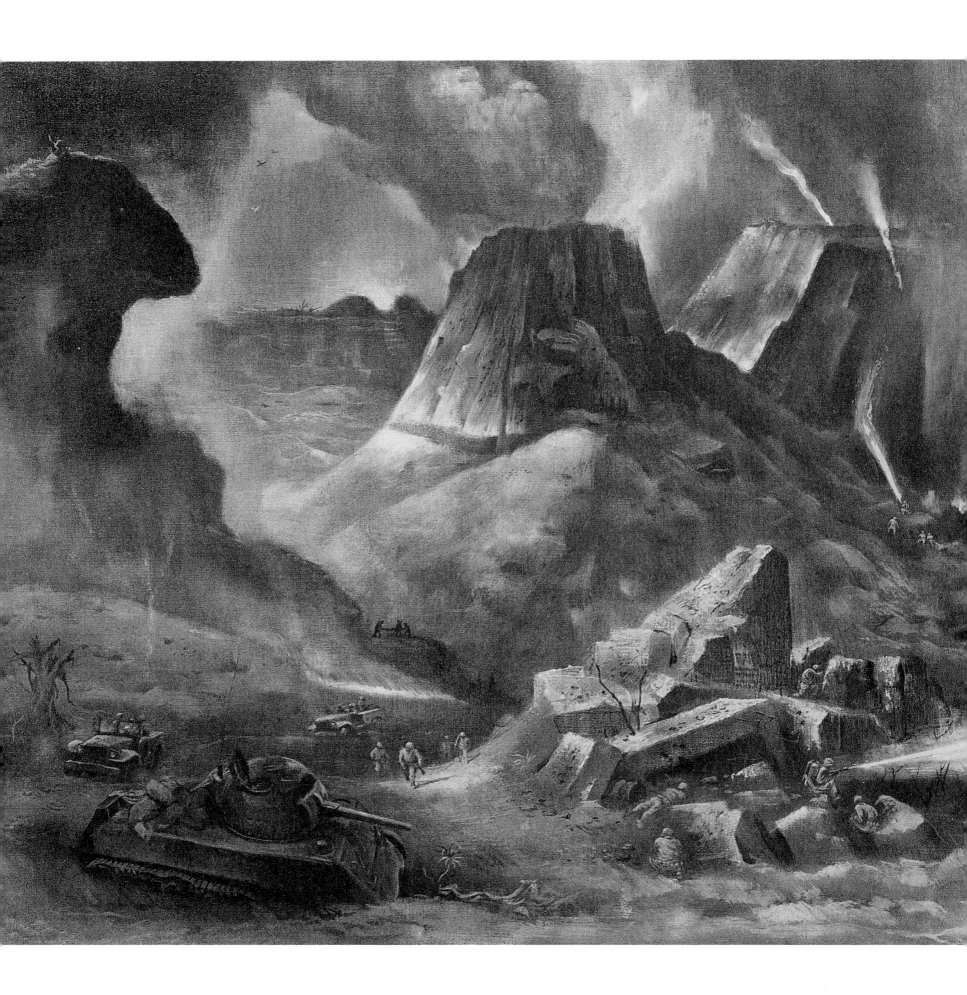

C H A P T E R Six

World War II: 1941–1945

It is interesting to note what transpired in the art world, particularly in the United States, between the world wars, and the effect that this had—or did not have—on artists who were to portray combat in the greatest and most widespread of world conflicts.

Europe had always been the focal point of fine art, as well as the seat of burgeoning movements away from its long-accepted classical-academic traditions. In the last quarter of the nineteenth century, impressionism had emerged in France and changed the course of art forever, opening the eyes of artist and viewer alike to new ways of seeing the world. This was followed by variations: postimpressionism, expressionism, and other artistic and stylistic innovations in the early years of the twentieth century. Despite Alfred Stieglitz's efforts to exhibit their works in his New York Gallery 291, however, none of these European avant-garde artists were yet well known in America. Matisse, Braque, Picasso, and Cézanne are just a few of the now-familiar artists championed in America by Stieglitz. Taking their cue from Stieglitz, twenty-five vanguard American artists staged an exhibition of European modern works (and a sprinkling of traditionalist pieces) at Manhattan's 69th Infantry Regiment Armory in 1913. The Armory Show is now looked back on as one of America's most important art exhibits. The show drew large crowds, though many critics and viewers were shocked and outraged by what they saw.

Nor were subsequent avant-garde art styles immediately welcomed with open arms. Later in the twenties and thirties, though, cubism, abstraction, constructivism, modernism, futurism, synchromism, dadaism, surrealism, Bauhaus, and other new styles would echo in the United States, leaving indelible marks on art, architecture, and even the design of such everyday objects as telephones, utensils, machines, and aircraft. Even Norman Rockwell was touched by the new styles. Persuaded by well-meaning friends that he should spark up his work by getting on the modernist bandwagon, Rockwell dutifully went to Paris, absorbed all he could, bought some Picassos, and returned—only to incorporate the "dynamic symmetry" he had learned with nightmarish results. When wise *Saturday Evening Post* editor George Horace Lorimer gave him some fatherly advice about "being one's self," explaining "that it was conceivably better to have one's work displayed on the *Post*'s covers than to have it embalmed in art museums," Rockwell got back on track.

During the years just prior to World War II, perhaps the greatest influence on art in the United States came from the growing influx of leading European modernists. These artists fled the Nazi and fascist aggression, as well as communist repression, that was spreading throughout Europe and stifling many freedoms, including the free expression of art. Such notables as Hyman Bloom, Fernand Léger, László Moholy-Nagy, Walter Gropius, Josef Albers, Hans Hoffman, Piet Mondrian, Marc Chagall, and George Grosz, to name a few, came to reside in the United States.

Lt. Mitchell Jamieson's mystical rendering depicts the site of fierce fighting on the rugged north end of Iwo Jima. The Japanese had dug a network of interconnected tunnels throughout the island, and the Marines had to ferret them out with hand grenades, rifle fire, and flamethrowers. Some Japanese soldiers chose to die heroically for the emperor in futile and suicidal banzai charges. The few who escaped the Marines headed for the high cliffs and plunged to their deaths. It was preferable to die with honor rather than surrender. More than 22,000 Japanese were killed in the battle.

U.S. Navy Art Collection

Still, aside from the pioneering vanguard, American art generally continued uninfluenced by outside trends through the 1920s and 1930s. On one hand, a style called regionalism prevailed, with both rural and urban artists (Thomas Hart Benton, John Steuart Curry, Grant Wood, Reginald Marsh; Charles Birchfield, Edward Hopper, Peter Hurd, George Bellows, John Sloan, Andrew Wyeth, et al.) dwelling, in everyday terms, on small town and country life—a life that threatened to disappear during the Great Depression. On the other hand, there was social realism, adopted by such artists as Philip Evergood, Ben Shahn, Hyman Bloom, and Bernard Perlin, which visualized the hardships, injustices, and social upheavals brought on by the Depression. It is no surprise, then, that the American artists who served their country in wartime continued to paint in the traditions they had been trained in.

Federal Art Patronage

The U.S. government, coincidentally, played an extraordinary role in the arts during the period between the wars. After commissioning eight leading American artists to visually record World War I, the government, more than a decade later, again fostered art and artists, largely to thwart the devastating effects of unemployment during the Great Depression, brought on by the collapse of the stock market in 1929.

After a short-lived stab at federal art sponsorship—the Public Works of Art Project (PWAP), which specifically gave relief employment to artists from 1933 to 1935— President Franklin Roosevelt's national recovery plan, the "Second New Deal," created the Works Progress Administration (WPA) in 1935. (The first New Deal, the National Recovery Act [NRA] had been ruled unconstitutional.) The Federal Art Project, a subsection of the WPA, contained a Section of Fine Arts under the directorship of one Holger Cahill. In September 1939, the program was changed to the Art Program of the Work Projects Administration of the Federal Works Agency (WPA Art Program), still under Cahill. From March to October of 1942, its title became the Graphic Section of the War Services Division, with Cahill still at the helm, before it changed once more to the Graphic Section of the Division of Program Operations. It was finally disbanded on 1 July 1943.

One of the objectives of the NRA's original art program, the employment of artists to decorate public buildings, spawned the 1934 Treasury Department creation of a Section of Painting and Sculpture under director Edward Bruce. In 1938, it would be renamed the Treasury Section of Fine Arts, changing again in 1939 to the Section of Fine Arts of the Public Buildings Administration of the Federal Works Agency. From 1935 to 1939, a separate program called the Treasury Relief Art Project (TRAP) functioned under WPA as well. Not to be outdone, the Office of Emergency Management created its own similar arts program at the outset of World War II.

Under WPA, many artists were employed in federal art projects under either the "easel" (WPA) or the "mural" (Treasury Department) divisions. Perhaps the more visible were the mural commissions for federal buildings, especially post offices, throughout the country. Artists were paid $23 to $42.50 per week (a decent wage compared to the Army draftee's $21 per month). Those in the easel program worked in their own studios, selecting their own subject matter, and submitted finished works every four to eight weeks. Sadly, in the Depression climate, with political unrest and fears of spreading Bolshevism, there was considerable pressure on Congress to eliminate these programs. Some argued that the government-sponsored artists should not be allowed to pursue their own political agendas through their art. By the beginning of World War II, the dismantling of federal art programs had already begun.

An artist with a particularly satiric bite, Paul Cadmus, took a swipe at the Navy by portraying a shore leave of salacious sailors cavorting with prostitutes, which so shocked Navy brass that they quickly banned the painting from a 1936 exhibit. (It is now exhibited frequently at the Navy Museum in Washington, DC.)

As might be expected, the illustrators were not as hard hit by the Depression as fine artists were; with publishing continuing unabated, so too did the comfortable incomes of these commercial artists.

Wartime Art and Propaganda

Closely tied to England, the United States professed neutrality while prudently preparing itself for the inevitable, invoking conscription in 1940 to build up its own armed forces. The newly reborn and very popular weekly *Life* magazine focused its stable of artists on this military buildup in its "Defense Issue of 1940" and "U.S. Prepares for War" in early 1941. Meanwhile, New York's Museum of Modern Art displayed war art from England in an exhibit entitled "Britain at War," which opened on 22 May 1941 and later traveled on to other American and Canadian cities. The art was high quality, in the tradition of British World War I art, and helped draw more attention to the valiant efforts of the British Isles, at the time considered Western Europe's remaining bastion of the "Free World" amid the Continent's increasingly totalitarian landscape. Some of Britain's finest contemporary artists were represented, including modernists Graham Sutherland and Henry Moore, as well as Muirhead Bone, Eric Kennington, World War I artist Paul Nash, and Lady Laura Knight, a superb realist. Moore and Sutherland were exceptionally original in approach and style. The visualizations turned out were generally rather more

Left: *American Gothic*, by Grant Wood, exemplifies the regionalist style popular in the United States in the thirties and forties. *Art Institute of Chicago*

subdued than the propagandizing theatrics one would have expected. Sir Herbert Read, a leading art critic and historian at the time, wrote in the exhibition catalog that "the quietude and harmony of this British war art was its strength: the mature, emotional truth of an incident registered in the stunned reaction of the observer, apprehension of the total significance without surface detail."

There were 325 official artists in the British War Artists Scheme. Out of the thousands of works produced, slightly more than a hundred were lost, primarily through U-boats sinking the transports that were carrying them to overseas shows.

Despite the American artists flocking to offer their services in the coming war effort, the galvanizing effects of "Britain at War" and other such exhibits, and the burgeoning display of defense art by *Life* magazine and other publications, the value of war art apparently was totally lost on the U.S. government. In mid-1941, when the Federal Arts Projects of New York City came to an end, thousands of paintings were removed from their stretchers and auctioned off by the government to junk dealers as reclaimed canvas—the epitome of mindless bureaucratic insensitivity and an incalculable artistic loss.

The entire WPA fine arts section, which had tried feebly to assist in making defense designs for New York City's Poster Division, petered out and was gone, too, by 1942. In the wake of its final disbanding, 5000 heretofore government-sponsored artists (many, needless to point out, headed for military service) were out of work, and 108,000 paintings, 18,000 pieces of sculpture, 11,200 original prints, and 2500 murals were warehoused— a veritable national treasure.

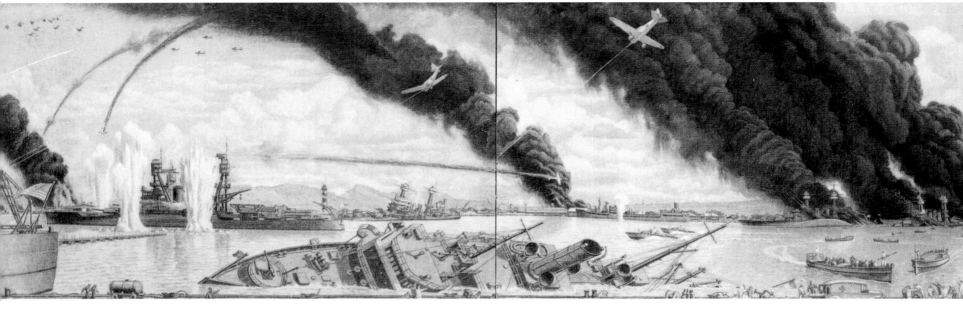

American Artists Gird for War

Above: A panoramic, after-the-fact illustration by Navy combat artist Comdr. Griffith Bailey Coale portrays the surprise attack on the naval base at Pearl Harbor, Hawaii. Taking place on Sunday morning, 7 December 1941, the attack resulted in heavy casualties and the loss of first-line capital ships. ***U.S. Navy Art Collection***

Below: English war artist Norman Wilkinson depicts the British Army evacuating Dunkirk under fire during the 1940 fall of France. After capturing Paris in their blitzkrieg, the German Army then turned its attention toward destroying what was left of the British armed forces. However, with their army less than half a million strong, the feisty Royal Air Force soon turned the tide—in "their finest hour"—against the German Luftwaffe's bombing of London and other English cities. ***National Maritime Museum***

The infamous 7 December 1941 Japanese aerial bombing and submarine attack on U.S. military installations at Pearl Harbor, which finally pushed the United States into World War II, brought on a frenzy of activity that touched the art field as well. By 10 December, more than thirty national artists' organizations, representing some 10,000 practicing artist members, formed "Artists for Victory." The group sponsored the National War Poster Exhibit in April of 1942 to illustrate Roosevelt's "Four Freedoms," and several million man-hours were pledged by American artists to the war effort.

Immediately following Pearl Harbor, the Section of Fine Arts of the U.S. Office of Emergency Management (OEM) also announced a national competition for artists to portray America at war. In response, 1189 eager artists submitted works. There were no prizes, but 109 works were purchased for $30 each and exhibited on 7 February 1942 at the National Gallery of Art in Washington. While none of the artists had actually experienced combat, as the United States was only months into the conflict (Wake Island and Bataan had been major losses, and there were no victories yet), these artists nevertheless attempted to portray order emerging from chaos and stark action instead of melodrama. It was expected that this would be the beginning of a future, permanent collection of war art by the federal government, much along the lines of the successful British effort already under way. In addition, following the precedent set in World War I, OEM's Section of Fine Arts also appointed eight prominent American artists, George Harding (a WWI Army combat artist), Richard Jansen, Ogden Pleissner, Howard Cook, Reginald Marsh, Carlos Lopez, Mitchell Jamieson (who became a Navy artist), and David Fredenthal, to record industrial and military aspects of the war effort.

There were other art exhibitions and stimuli that came forth as well in 1942: a Red Cross Art Competition; poster competitions out of the Graphics Division of the Office of War Information; another out of the Morale Branch of the War Department; and the formation of an Artist's Committee for Civil Defense Council. To more far-reaching effect, the War Department, through its recently formed Art Advisory Committee chaired by the noted American artist George Biddle, commissioned a number of recognized artists to record their impressions of the war for the government. Twenty-three artists already in uniform and nineteen civilian artists were selected to go to the twelve fighting fronts throughout the world. Much as the Army's official eight combat artists had been in World War I, they were organized in "war-artist units" of two to five men each and sent to the

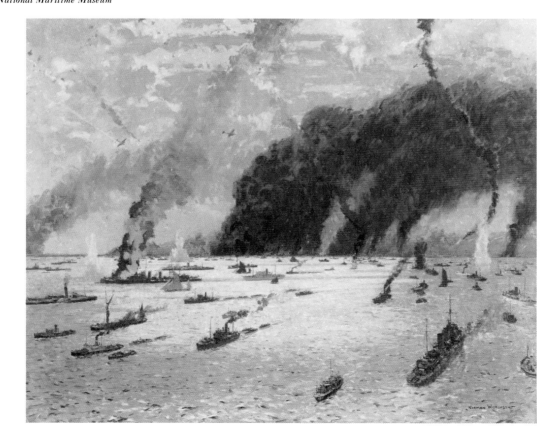

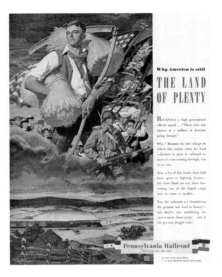

battlefields under the command of the U.S. Army's Chief of Engineers. The first of the units included artists Joe Jones, Henry Varnum Poor, Edward Laning, and Lt. Willard Cumings, who were assigned to Alaska; Aaron Bohrod, Sgt. Charles Shannon, David Fredenthal, and Howard Cook, all sent to the South Pacific; and Biddle and Fletcher Martin, who arrived in Tunisia in May of 1943. The civilian artists were being paid $3800 a year, plus travel, maintenance, and overseas pay, and wore officer's uniforms without insignia, as correspondents did. The danger and risks were their own.

Thus, an excellent program was well under way when a panicky and shortsighted Congress timorously succumbed to fiduciary pressure and dashed all hopes for continued government sponsorship of art. Prior to its adjournment in July 1943, the seventy-seventh Congress failed to be convinced of the importance of such an art project by the War Department and refused to appropriate

Above: A well-known American artist, George Biddle was appointed chairman of the War Department's art committee. He sent nineteen civilian and twenty-three military artists to cover distant battlefronts. Biddle himself spent six weeks sketching at the fronts in Tunisia and Italy with a battalion of the U.S. 3rd Infantry Division.

Opposite Top: Reserve Lt. Comdr. Griffith Baily Coale, the U.S. Navy's first official artist, portrayed the activities of a North Atlantic convoy patrol of supply ships. On their countless voyages back and forth to England and Murmansk, Russia, the ships carried much-needed food and war materiel to the beleaguered Allies facing the onslaught of Nazis on the western and eastern fronts of Europe. The lifeline of supplies and munitions was constantly threatened by the marauding German wolf packs of *Unterseeboote* (U-boats). Observing from an escort destroyer, Coale captured an incredible eyewitness account of the sinking of the destroyer USS *Reuben James* shortly before the United States entered World War II.
U.S. Navy Art Collection

Opposite Bottom: Civilian artist Paul Sample was commissioned by *Life* magazine to portray Navy activities off the East Coast of the United States. Here, sub skipper Comdr. Roy Benson enjoys a brief moment of relaxation while the sub recharges its batteries on the surface and the lookout searches for shipping activity.
U.S. Navy Art Collection

Mission: U.S. War Artist

George Biddle, a noted American artist and the appointed head of the Art Advisory Committee of the War Department, selected and assigned American artists for World War II. In a memo dated 1 March 1942, he explained their mission:

> *In this war, there will be a greater amount than ever before of factual reporting, of photographs and moving pictures. You are not sent out merely as news gatherers. You have been selected as outstanding American artists who will record the war in all its phases and its impact on you as artists and human beings. The War Department Art Advisory Committee is giving you as much latitude as possible in your method of work, whether by sketches done on the spot, sketches made from memory, or from notes taken on the spot, for it is recognized that an artist does his best work when he is not tied down by narrow technical limitations. What we insist on is the best work you are individually capable of and the most integrated picture of war in all its phases that your group is capable of. This will require team play on your part as well as individual effort. It is suggested that you will freely discuss each other's work and assignments, always in the hope of new suggestions and new enthusiasms.*

> *Any subject is in order, if as artists you feel that it is part of war: battle scenes and the front line; battle landscapes; the wounded, the dying and the dead; prisoners of war; field hospitals and base hospitals; wrecked habitations and bombing scenes; character sketches of your own troops, of prisoners, of the natives of the country you visit; never official portraits; the tactical implements of war; embarkation and debarkation scenes; the nobility, courage, cowardice, cruelty, boredom of war; all this should form part of a well-rounded picture. Try to omit nothing; duplicate to your heart's content. Express if you can—realistically or symbolically—the essence and spirit of war. You may be guided by Blake's mysticism, by Goya's cynicism and savagery, by Delacroix's romanticism, by Daumier's humanity and tenderness; or better still follow your own inevitable star. We believe that our Army's Command is giving you an opportunity to bring back a record of great value to our country. Our Committee wants to assist you to that end.*

What more inspiring a mission statement could a civilian artist receive? In September 1942, director of the graphic bureau of the Office of War Information, Francis Brennan, wrote:

> *The issue of art is freedom. Without it, the world of art could not exist. We know that the enemy is trying to destroy freedom—that he has long since chained together his men of talent…we saw it first when he destroyed the works and lives of those whose art was a threat to his evil purposes*

Noted artist Henry Varnum Poor, a member of the Art Advisory Board, wrote to Army artist Pvt. Manuel Bromberg:

> *The U.S. must take the lead and find some way of getting from our finest artists and writers the things they alone can give—a deeply, passionately felt but profoundly reflective interpretation of the spirit and the essence of war.*

a meager $125,000 for it out of the $71.5 billion Army Appropriation Bill for 1943–44. Tangibles (bullets) won out over intangibles (art and human creativity in a still-civilized world). As a consequence, forty-three artists were abandoned, practically in mid-brush stroke, in far corners of the world.

Had it not been for the farsightedness—and commercial-mindedness—of private publications and industry, the work of these artists and an invaluable record of the war would have been forever lost to posterity. *Life*, *Collier's*, *Fortune*, and Abbott Laboratories, among others, quickly snapped up the contracts of many of the artists and retained them on site in their combat art duties. (As an historical footnote, it should be noted that whereas mostly illustrators had responded to the call to portray the previous war, in World War II the fine artists flocking to offer their services outnumbered the illustrators.)

The Big Business Brush with War Art: Life, Fortune, *and* Abbott Laboratories

Early on, *Life* magazine, revitalized and redesigned as a weekly pictorial news vehicle in 1937, had led the way in war art. Its "Defense Issue" of 1940 and the 1942 issue featuring "soldier art" (top prize, $300) had aroused intense public interest in the participation of artists in war. But its real coup had come months before the war actually started, with the hiring of a thirty-five-year-old Texas artist and mural painter, Tom Lea. He was dispatched to a Navy destroyer for North Atlantic convoy escort patrol, and his series of paintings from that extraordinary experience was quickly published. In August 1942, at the height of the great naval battles taking place in the South Pacific, *Life* would send him aboard the U.S. aircraft carrier *Hornet*. In December 1941, *Life* had also dispatched artist Paul Sample to cover naval aviation and patrols in the Atlantic, and later in 1942, asked Coast Guard Reserve Lt. Comdr. Anton Otto Fischer, a noted marine artist, to cruise with the cutter *Campbell* on North Atlantic convoy duty. *Life*, which sent scores of artists to all battlefronts throughout the conflict, ultimately made a superb contribution to the nation's historical archives by giving its collections to the U.S. Army after the war.

Collier's, *Fortune*, and other publications also sent artists to cover combat, and, for the most part, commercial illustrators were eager to do their part as well. *The Chicago Sun Syndicate* and *Parade* magazine sent noted artist John Groth, and illustrator Robert Greenhalgh covered the Navy for *Yank*, the armed services periodical. Norman Rockwell, enjoying a richly deserved and remunerative reputation as a leading illustrator, touched the pulse and heartbeat of the nation at war by depicting the common

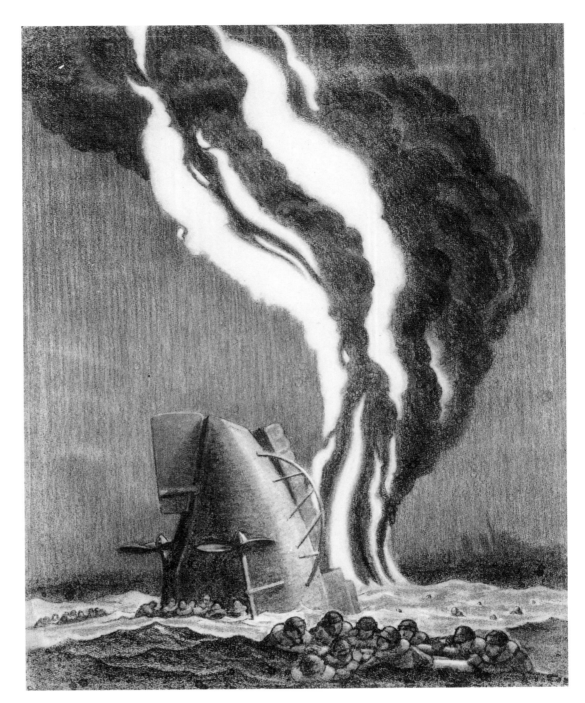

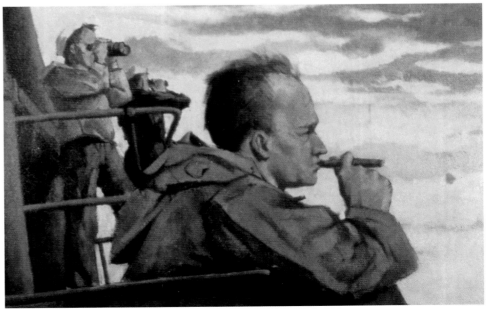

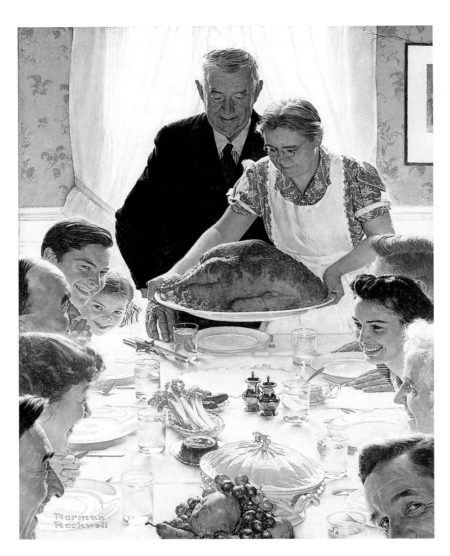

man and woman in his inimitable style, portraying our boys in the services and their moms, dads, and girlfriends at home. Rockwell's "Rosie the Riveter" symbolized the women aiding the war effort by taking over the men's jobs, while his *Saturday Evening Post* covers became the Currier & Ives prints of the middle of the century. The latter was best exemplified in his series of four paintings depicting the "Four Freedoms" President Roosevelt had declared in one of his stirring wartime speeches. As Roosevelt put it, "Freedom of Speech," "Freedom of Worship," "Freedom from Want," and "Freedom from Fear" were the basic goals for which the country was fighting. When Rockwell's renderings were published in the magazine, the response was electrifying, with more than a million requests for reprints. These four posters and Associated Press photographer Joe Rosenthal's famous photo of U.S. Marines raising the American flag atop Iwo Jima's Mount Suribachi were perhaps the most widespread images of World War II.

Too old to go to war this time, Norman Rockwell did more than his part by visually capturing the most precious and universal moments with which so many could relate: the soldier home on leave, cuffs rolled up, helping his Ma peel potatoes for supper; a veteran Marine showing off his Japanese war souvenirs to his little brother and some

neighbors; the homecoming of GI Willie Gillis in his modest tenement backyard; and the unforgettable salty sailor getting another of his girlfriends' names tattooed on his arm crossed off so the latest could be added.

Many other illustrators too old for war duty painted stirring and imaginative war illustrations for corporate advertisements, including Meade Schaeffer, Dean Cornwell, and Douglass Crockwell. Cecil Calvert "C.C." Beall painted portraits of a number of decorated war heroes for the cover of *Collier's* magazine and was privileged to be aboard the USS *Missouri* for the Japanese surrender ceremonies, as were illustrator Clayton Knight and Navy combat artists Griffith Bailey Coale and Standish Backus. (Beall's painting was later designated the official one by President Truman.)

Abbott Laboratories

Notable in the corporate business sector was the extraordinary undertaking by Abbott Laboratories, a Chicago pharmaceutical manufacturer. Abbott sent civilian artists to the battlefronts not only to cover the war artistically, but to concentrate on the medical aspects of combat—lifesaving measures and medical advances and technologies. While not, perhaps, wholly altruistic (Abbott was a primary military medical supplier), the company helped

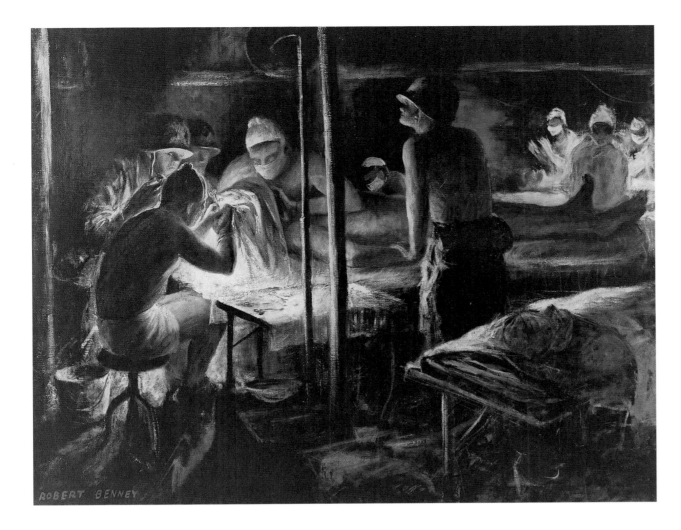

create a valuable record, sponsoring the artistic depiction of many major engagements and the valorous actions of Navy medical doctors and corpsmen and Army medics. The efforts were also a commendable contribution to morale on the home front, assuring those at home that casualties were capably handled and treated.

Guided and advised by Reeves Lewenthal, the director of the Association of American Artists, Abbott Labs President S. DeWitt Clough early in the war began commissioning leading American artists to portray U.S. Armed Forces at war and the role of medicine in war. Already experienced with artistic renderings through its "Great Moments in Medicine" series in the house publication, *What's New*, Abbott mounted an exhibit of war preparation scenes by the now well-known artist Thomas Hart Benton. As part of what turned out to be a memorable show entitled "Year of Peril," Abbott reprinted fifty-five million pamphlet-posters of ten of Benton's works. Later, Benton would take a trial run on the submarine *Dorado* and sketch its activities, this before it was lost on a subsequent combat cruise.

Artists on assignment for Abbott Labs included a mixture of fine artists and illustrators, including Carlos Anderson, Howard Baer, Robert Benney, Thomas Hart Benton, Peter Blume, Franklin Boggs, Chesley Bonestell, Howard Brodie, Francis Criss, John Steuart Curry, Adolph Dehn, Kerr Eby, Ernest Fiene, Don Freeman, Marion Greenwood, Joseph Hirsch, Reginald Marsh, Irwin Hoffman, Julian Levi, Carlos Lopez, David Stone Martin, John McCrady, Georges Schreiber, Henry Varnum Poor, Fred Shane, Lawrence Beall Smith, Manuel Tolegian, and James Turnbull. These participant-observers did not merely produce "studio concoctions," and a number of them (with the exception of Benton and Greenwood) landed at Guadalcanal, Bougainville, and Tarawa, or otherwise placed themselves in harm's way. Their combat art was assembled in six extensive art campaigns devoted to Naval Air, Navy Medicine, Army Medicine, Marines, Amphibious Operations, and Submarine warfare. In May 1945, 250 Army medical paintings went on display at the Corcoran Art Gallery Museum in Washington, DC, while at the same time, one hundred works depicting Navy medicine were shown at the Art Alliance in Philadelphia. Abbott Labs spent more than a million dollars to send artists to the battle fronts, a substantial sum for the war years. After its successful use for publicity, the entire collection of some 1000 oils, watercolors, and drawings was given to the government and ultimately distributed to the various services.

Navy Combat Artists and the War at Sea

The armed services were alert to the value of art as part of the historical record, as well as to its public interest and morale factor. The U.S. Navy was the first to form

The United States at War, 7 December 1941 through 1942

The United States, already reeling from the shock of its abrupt entry into World War II, was subjected to a dismaying six months of one demoralizing defeat after another: the loss of Wake Island and the Marine garrison there; MacArthur's American-Filipino Army's defeats at Manila, the Bataan Peninsula, and Corregidor; and the barbaric sixty-mile (96km) "Bataan Death March" that the conquering Japanese had forced upon American and Filipino survivors. Compounded with the Allies' losses of Singapore and Hong Kong, the defeats indeed heralded dark days, with national morale sinking. To bolster the Allies' confidence and show the enemy he was not invulnerable, President Roosevelt ordered a brilliant strike at the heart of the Japanese Empire. On 18 April 1942, sixteen U.S. Army Air Corps B-25 "Billy Mitchell" twin-engined medium bombers flew off the flight deck of the USS Hornet (CV-8), at sea just 624 miles (1004km) off Japan. Famous 1930s racing flier Jimmy Doolittle, now a lieutenant colonel, led the low-level, wave-skimming flight straight over Tokyo, dropping their bomb loads on military targets, before—incredibly— continuing on to friendly China and crash-landing there. The raid, as expected, lifted Allied morale the world over and stunned the Japanese, who could not believe that their own homeland had been violated. Two of Doolittle's crews were captured by Japanese troops, tortured, and put on trial in Tokyo; two airmen were executed, while four others were sentenced to life imprisonment.

As the Japanese continued their conquering sweeps down the western rim of the Pacific and the island clusters, threatening the U.S. territory of Hawaii, the remnants of the U.S. Navy went into fierce action. Fortunately, the four U.S. aircraft carriers in the Pacific had escaped the devastating blow at Pearl Harbor, and they would more than make up for missing the early battle in the coming year—before they were sunk and replaced.

As the Japanese invading armies approached Australia by sea, the U.S. Navy intercepted them and fought them to a standstill in the Battle of the Coral Sea in May. The Japanese then invaded U.S. territory in the Aleutian Islands. In June, the United States, fearing an invasion of the Hawaiian Islands, positioned the remaining two U.S. carriers (of the other two, one had been sunk, the other heavily damaged in the Coral Sea) and naval task forces north of Midway, the northernmost island in the Hawaiian chain.

Midway would prove a turning point for the Americans, thus far on the defensive. Although two entire U.S. Navy torpedo bomber squadrons were shot out of the sky while attacking four Japanese aircraft carriers, the two armadas, still not in naval gunfire range of each other, clashed fifty nautical miles north of the island on 5 June. Fortuitously, an enormous blunder on the part of a Japanese admiral, who had ordered all his aircraft rearmed on the flight deck of his carrier at one time, gave a sudden advantage to Navy dive bombers who spotted the vulnerable situation and immediately attacked. The result was a devastating blow for the Imperial Japanese Navy. Its four aircraft carriers were totally destroyed and sunk, along with other cruisers and destroyers. What the Japanese had expected to be an easy victory turned into a irreparable defeat from which its navy never fully recovered. Although the U.S. carrier Yorktown was sunk, Midway was the first decisive victory of the war for the United States.

In August, the United States launched a full-scale ground counter-attack, the first in the war and one that would require three more years of tough, island-to-island fighting before inexorably leading to the Japanese home island. The U.S. Navy landed Marines on the enemy-held island of Guadalcanal in the Solomons. That battle would take the rest of 1942 and would require the U.S. Army's participation, while horrendous naval and air battles raged in the waters around it. In November, on the other side of the world, the U.S. Army and its air corps joined the French and British in invading Morocco in North Africa, opening a second front to drive the Germans off that continent—a drive that would eventually lead all the way up the Italian peninsula and merge with the Allied invasion of France in 1944.

The tide was turning, portending ultimate defeat for the Axis aggressors.

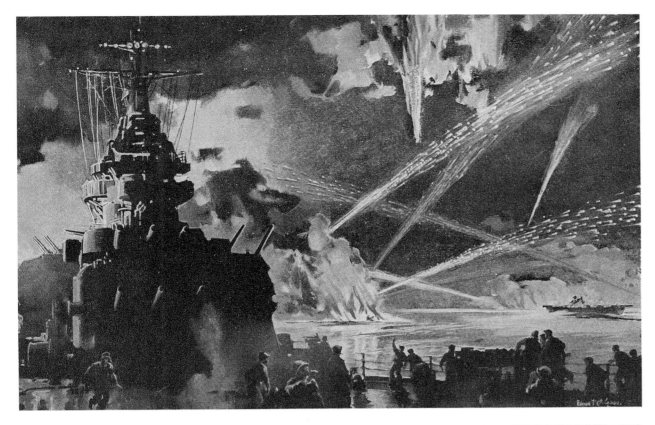

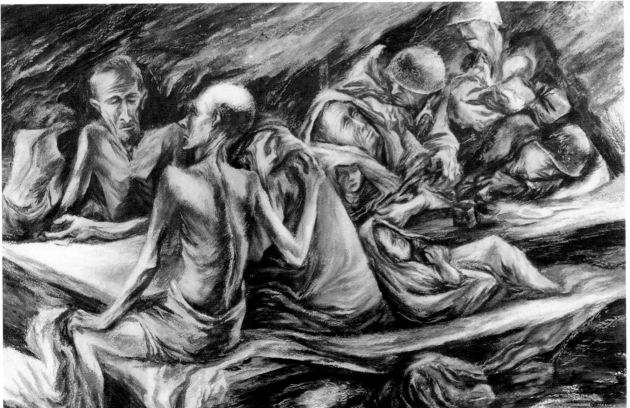

a cohesive program. In September 1941, Chief of Naval Information (CHINFO) Adm. Arthur J. Hepburn foresaw the United State's entrance into the war, and, recognizing that a visual record would be desirable, recalled to active duty a noted mural artist, Navy Reserve Lt. Comdr. Griffith Baily Coale, to cover the "undeclared war" in convoy runs in the North Atlantic. Coale's portrayal of the first overt belligerent action, in which a Nazi U-boat torpedoed and sank the U.S. destroyer *Reuben James*, were used extensively by the Navy and reproduced in *Life* magazine.

Reserve Comdr. E. John Long, an Annapolis graduate and an editor at *National Geographic* magazine, was also recalled to active duty to head all pictorial matter at CHINFO for Adm. Hepburn. Long quickly contacted his friend, Navy Reserve Lt. Comdr. Griffith Coale, now back

Above: Lt. Comdr. Griffith Bailey Coale, USNR, depicted many stirring scenes, as well as recording on-base activities. His work constitutes a valuable historical record.

Top Right: Coale's painting *Convoy Off Iceland: Increasing Gale* portrays destroyers steaming in rough seas on convoy duty.
U.S. Navy Art Collection

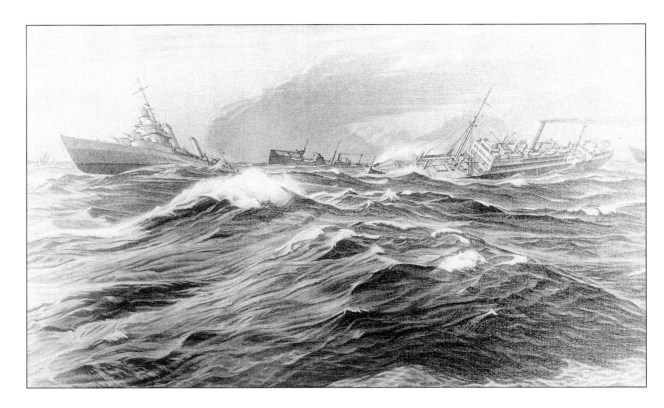

Above: Shortly after graduating from the Pratt Institute in Brooklyn, New York, PO Alexander P. Russo, USNR, joined the Navy. Put to work doing murals, he later joined the art section, and was sent to cover the Sicily operation, and then Normandy, before reassignment to Washington. Following the war, Russo received a Guggenheim Fellowship to complete his education. He taught at the Corcoran School of Art and at Hood College.

from his North Atlantic duty, and put him to work organizing what was to be called the "Combat Art Section." To coordinate the program and run the Art & Poster section, Lt. Comdr. Robert L. Parsons, USNR, then the deputy director of the prestigious Corcoran Gallery of Art, was recalled to duty. Subsequently, Capt. Leland P. Lovette, USN, became the director of the Office of Public Relations, under which the Combat Art Section fell.

A search was begun immediately for professional artists already in the Navy who were also sea-duty qualified deck officers—a basic requirement. Coale knew of a New England artist and sailor, Dwight C. Shepler, through the latter's New York gallery, and discovered he had already secured a commission as a lieutenant (junior grade). Shepler was, in fact, attending an intensive sea-duty course at the Midshipmen's School at Northwestern University in Chicago. Coale wrote and asked the officer-artist if he would like to join the Combat Art Section. Shepler's reply was, of course, "Affirmative!"

Four other fine artists were commissioned or called up from the reserves, giving the section six artists of national reputation, including reserve lieutenants William F. Draper and Albert K. Murray, and Ensign Mitchell Jamieson. The fourth, Lt. Comdr. Standish Backus, Jr., USNR, assigned other duty since March of 1941, was not to become a true combat artist until the end of the war. While the Navy recognized these men as artists, art came second. They were first and foremost line officers with specific combat duties, yet they were to disperse to the various theaters of war and carry out their orders as they saw fit. Lt. Edward Grigware and

Comdr. Edward Millman were dispatched later, as was PO Alexander Russo.

Commercial artists and illustrators responded to the call, too, including reservists Lt. (jg) Jon Whitcomb and Lt. Comdr. McClelland Barclay (who would later lose his life in the line of duty), and chief specialists John Falter (subsequently commissioned a lieutenant on special art projects) and Howard Scott. Their work appeared regularly in the leading popular magazines. Meanwhile, contemporary artist Vernon Howe Baily was given a civilian contract to paint pictures of shipyards from coast to coast, and the talents of World War I veteran-artist John Taylor Arms were also procured. While Thomas Hart Benton continued his series on submarines for Abbott Labs, illustrator Fred Freeman, who after the war specialized in writing and illustrating books on naval lore and subjects, was called to duty as a reserve lieutenant commander and skippered three different ships, including a sub-chaser Atlas 521 and a PCE convoy escort. He participated in the Guadalcanal, Solomon Islands, Saipan, Guam, and Aleutian campaigns, and his firsthand combat-sea duties contributed richly to Navy combat art, as well as to his own later work. CPO Lawrence Urbscheit, while stationed with a PBY patrol squadron at Guantanamo Naval Base, Cuba, also executed a number of fine watercolors and paintings of patrol activities in the Caribbean.

Lt. Dwight C. Shepler, USNR

Born in 1905 in Everett, Massachusetts, Dwight Clark Shepler studied at the Boston School of Fine Arts and at Williams College. Graduating during the Great Depression

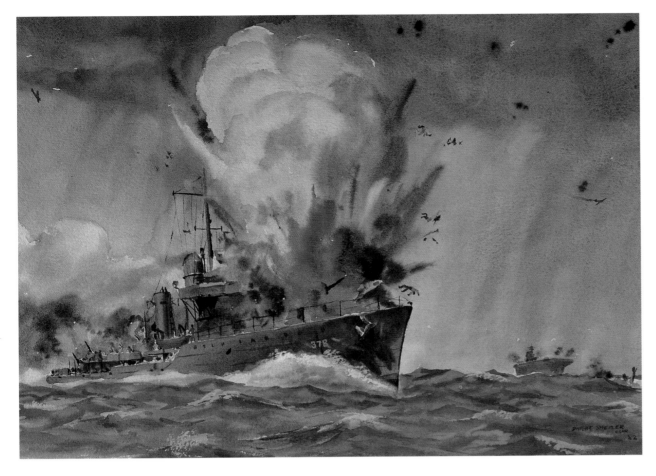

was his first real trial, contributing to his artistic style, which was solidly realistic, almost academic. Even in boyhood, he had been acutely aware of trends in art such as those exposed at the 1913 Armory Show, and, later believing that there was more than one way to paint, he made excursions into various styles. During his more than three-year cruise in the Navy during World War II, though, he admits that he "made tortured and brain-breaking attempts at semi-abstract or allegorical interpretations of what I experienced at sea or on the beach heads; but they largely proved footling in my own estimation."

Until he entered the Navy in early 1942, Shepler had had a weekly feature, written and illustrated with a portrait sketch of some notable, in the *Boston Sunday Herald*. He earned his living as a staff artist on *Sportsman* magazine, thus he was largely a commercial illustrator. As a fine artist, though, he had also exhibited in numerous museums in the United States and abroad, including the National Gallery in London and the Musée de la Marine in Paris. An excellent skier, he also became a pioneer watercolorist of the high ski country, painting the poster for the opening of the Sun Valley, Idaho, resort in 1937. In fact, Shepler's beautiful scenes of skiing helped to popularize the sport. As a sailor, too, he logged 8000 miles (12,872km) around Cape Horn, the Galapagos, and on to California in an ocean-going sloop shortly before the war. The sea and snow-covered slopes were

his favorite subjects, both before and after his extraordinary wartime artistic experiences.

From 1942–45, however, Shepler's subject matter would be war. After completing his midshipmen's schooling and reporting in to the commanders, Coale, Long, and Parsons, in the new Combat Art Section, Lt. (jg) Shepler got his orders to proceed to the Pacific. He wrote, "I was the second tyro artist to be sent out, and Parsons got me a set of orders to Admiral Halsey's South Pacific Force that made Flag Secretaries gape when I handed them over, with the bright light glaring on my stripe and a half. The orders were broad, wide-ranging, and quite autonomous. The implication was that I was supposed to be where the action was, and should be so informed." Lt. Shepler's watches were altered, as well, to allow him more painting time: four hours on and twelve off, instead of the usual four and eight.

Transferring from the USS *Raven*, which had taken him across the Pacific, he went aboard the USS *San Juan*, a colorful antiaircraft cruiser of the fleet's fastest Atlanta Class. He immediately partook in the Battle of the Solomons in October 1942, part of the Guadalcanal offensive and the third great air-sea action of the war in the Pacific. As Shepler watched the battle, the *San Juan* was hit, while the carrier *Hornet* was sunk. *Life* artist Tom Lea had left the carrier only four days previously, shortly after witnessing her sister carrier, *Wasp*, slide to a watery grave.

Right: U.S. Navy combat artist Lt. (jg) Dwight C. Shepler, USNR, was shipped off in early 1942 to the South Pacific. Assigned "line" duties wherever he went, he found himself in the thick of many battles, such as the one shown here between battleships and heavy cruisers off Guadalcanal. The area was later dubbed "Ironbottom Sound" because of the many remains of U.S. and Japanese ships that littered the seabed. Shepler depicts the battleship USS *South Dakota* in an intense surface and air battle.
U.S. Navy Art Collection

Below: *Action on the River* is an eyewitness watercolor by Shepler. In the dense jungle on Guadalcanal, the enemy was often unseen. Protective flankers and bases of fire were constantly necessary; here, three Marines use a fallen tree trunk for cover to protect their buddies as they cross, most likely, the Tenaru River.
U.S. Navy Art Collection

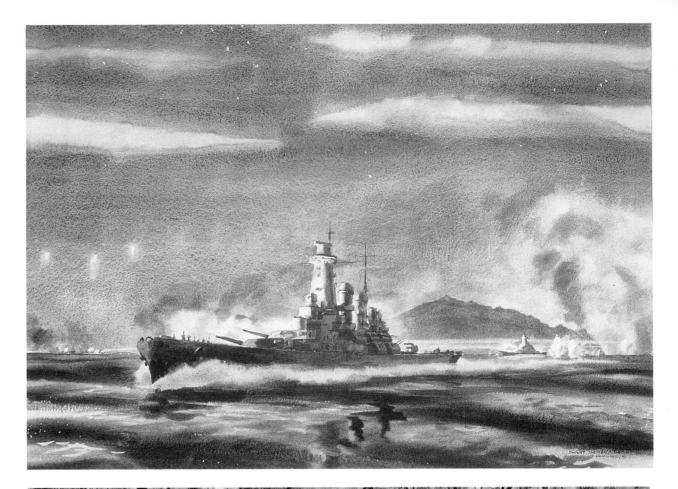

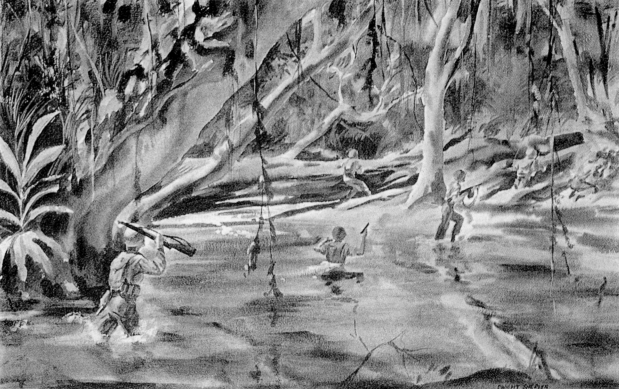

In addition to his depiction of the USS *South Dakota*, Shepler also did an amazing scene of night action off Savo Island that is the only visual record of that particularly crucial nighttime naval action. Later, Shepler went ashore and joined the 1st Marine Division fighting on Guadalcanal, the first counter-offensive of the war and the baptism by fire for the Marines in jungle warfare.

Following the battles in the Solomons, Shepler went to the U.S. Naval Forces in Europe for a year's duty in those dangerous waters prior to the Allies' June 1944 invasion of Europe. Aboard the USS *Champlin* in convoy during an aerial attack, Shepler nevertheless managed to execute a watercolor, about which he later commented, "If you keep your drawing board part of yourself, it's surprising what you can do."

On D-Day, 6 June 1944, Shepler was aboard DD USS *Emmons*, which was assigned to identify targets on Fox Green sector, Omaha Beach, where the U.S.

1st Infantry and 29th Virginia National Guard Divisions landed and engaged in some of the bitterest fighting of the Normandy invasion. His painting of that scene captured what no photograph could.

Back in the Pacific for the final battles of the war, (then) Lt. Comdr. Shepler depicted the Leyte Gulf landing and the PT boat attack and parachute drop on Corregidor. Later, off Okinawa, he depicted a kamikaze just missing the loaded aircraft on the flight deck of the replacement *Hornet* (CV-12). As Shepler described it, "The phenomenon of living under the inhuman threat of Kamikaze attack for months on end is something hard to describe.... In Destroyer Squadron Five operating around Leyte, we lost half the squadron, sunk or badly damaged in a few weeks. As one of the Kamikaze just missed the bridge of the flagship *Flusser*, we could see the expression on the goggled pilot's face as he flashed by to explode in the water in a great flash of bomb and gasoline." Another eyewitness remarked that the pilot "didn't have the nerve," so intentionally missed. Had he not, Shepler's illustrious art career might have been cut short.

In the three and a half years he spent at war in the Navy, Shepler compiled a dramatic history for the nation of more than 300 combat scenes and was awarded the Bronze Star for heroism in combat. After the war, he turned back to a fine art career of marine, skiing, and portrait art, though not before he was commissioned, along with Griffith Bailey Coale and William Draper, to paint murals in the midshipmen's mess at the U.S. Naval Academy's Bancroft Hall.

Lt. Mitchell Jamieson, USNR

Lt. Jamieson, already a promising watercolorist, was a temporary night watchman at the Corcoran Gallery of Art, where he was also studying, when he was commissioned by the Treasury Department's Section of Fine Arts to paint murals for several post offices. Shortly thereafter, the U.S. Navy called upon him to become a combat artist early in World War II.

His first big assignment was to cover the Navy's landing of Army units in the invasion of Sicily in July of 1943. He not only painted a graphic watercolor series depicting the events but also wrote about his experiences; both his watercolors and his account were published in *Life* magazine in its 27 December 1943 issue. His recounting of firsthand experiences under hostile fire, as he sketched and observed, offers keen insight into how a combat artist such as he fared and operated.

Late in 1944, Jamieson was assigned to the Pacific, arriving in February 1945, shortly after the massive and bloody Marine landing on the tiny island of Iwo Jima that brought U.S. forces closer to the Japanese mainland. He went ashore to portray the final stages of the battle. His distinct style and mastery of the watercolor medium made his superb paintings incomparable statements of what that struggle was like. In more than six weeks of constant combat on Iwo Jima, more than 6000 Marines and sailors were killed, with almost 20,000 wounded.

Before Iwo Jima was even secure, aircraft began using it as a base from which to hit the Japanese mainland, and the biggest and last amphibious operation of

Above: Lt. Mitchell Jamieson, USNR, attended the Corcoran School of Art, studied in Mexico and Italy, and executed several federal mural projects. In the Navy art section, he covered the invasions of Sicily, Normandy, Iwo Jima, and Okinawa, with his work appearing in leading magazines. After the war, Jamieson became a professor of art at the University of Maryland.

Below: Radar Plot Room by Jamieson documents a typical scene in the nerve center on a naval warship. Jamieson covered Army and Navy operations in Europe and Navy, Marine, and Army amphibious operations in the Pacific. **U.S. Navy Art Collection**

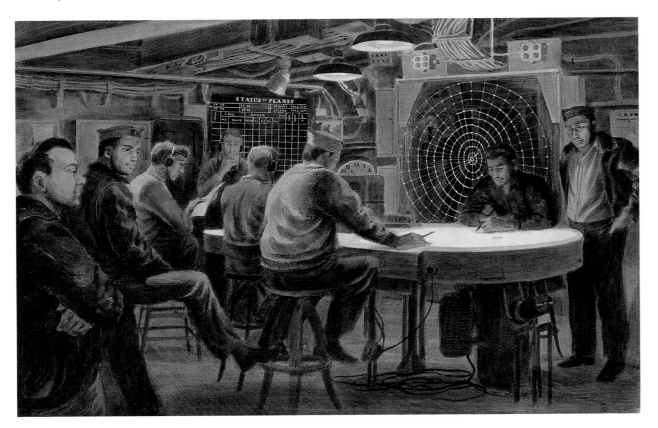

Above: Lt. William F. Draper, USNR

the Pacific war was underway with the combined Navy-Marine-Army invasion of the island of Okinawa, just south of the Japanese main islands. In the northern sector of Okinawa, Lt. Jamieson again accompanied the Marines into battle. His watercolors are done in a style that almost suggests Far Eastern techniques. (Unlike earlier battles, Okinawa saw many Japanese soldiers opting to surrender rather than die. In the air it was not so, as bomb-laden kamikazes flew right into Navy ships just offshore.)

Other Navy Combat Artists

William F. Draper was well known in prewar art circles as a noted portrait painter. After leaving Harvard for the National Academy of Design in New York, he studied in Spain and France. Called to active duty in 1942 and com-

missioned a reserve lieutenant, Draper volunteered for the newly formed Navy Combat Art Section. He covered much of the action in the Pacific theater. As with all the artists and illustrators who came out of the 1930s, he was highly skilled in drawing the human figure.

Albert K. Murray, like Draper, resumed his distinguished portrait career in New York after the war. He was one of the country's leading portrait painters, represented by both Portraits, Inc. and the Grand Central Galleries. He was commissioned by the White House to paint President Kennedy's portrait and by the National Gallery for one of President Nixon. He also was a favorite of the Navy and Marine Corps and painted many of the Navy chiefs of staff and Marine Corps commandants, as well as corporate chief executive officers.

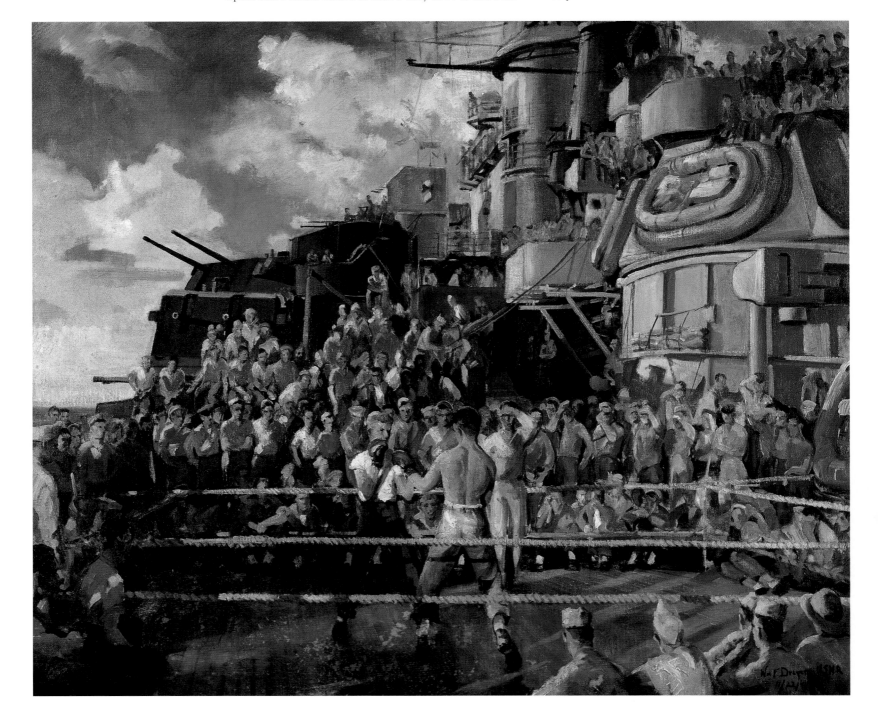

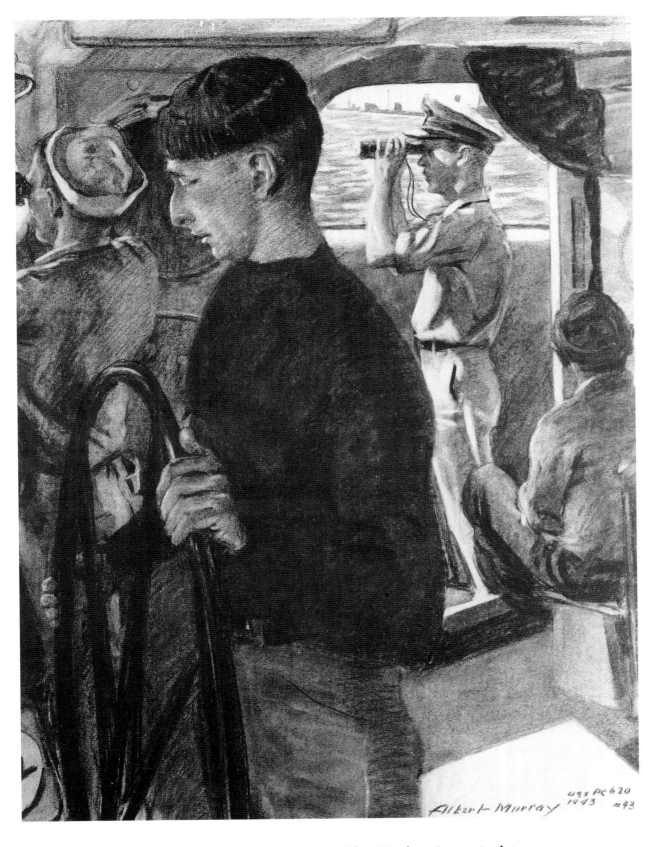

A graduate of Princeton University and already a well-established artist, Comdr. Standish Backus joined the Naval Reserve in 1941. On active duty he served in various posts in the Pacific theater. Backus went ashore in Japan following the surrender ceremonies and executed a number of very sensitive watercolor paintings of the destruction he witnessed, including the devastating damage of the first atomic bomb at Hiroshima.

The Marine Corps Artists

The U.S. Marine Corps, while itself a part of the naval establishment, was caught up in life-or-death rearguard actions against the enemy while also attempting to expand its ranks rapidly. Consequently, it did not have the wherewithal or luxury to appoint a team of artists, and relied heavily on talent already serving to show itself, as Capt. John Thomason had in World War I.

Denig's Demons

Retired Marine Col. ("tombstoned" after retirement to Brig. Gen.) Robert L. Denig, who had served nearly thirty-six years in the Corps, provided an unforeseen talent. On 30 June 1941, the Division of Public Relations was created at Headquarters, Marine Corps, and Marine Commandant Lt. Gen. Thomas Holcomb recalled Denig to active duty to head it. Quick to respond to a new challenge, Denig began collecting experts from the fields of broadcasting, motion pictures, journalism, and commercial art. With great foresight and wisdom, he laid the foundation for a well-oiled recruiting and public relations effort that brought credit to the Marine Corps throughout the war. Luckily, a young reserve officer by the name of Raymond Henri, who was both an accomplished writer and art connoisseur, volunteered to look after the art program.

The first artist to emerge was the well-known Hugh Laidman, who was later commissioned a first lieutenant. He had been recommended by Col. John Thomason, who, although still serving, was in declining health. Former Marine Corps Chief Historian Benis M. Frank described the thinking at the time: "Essentially, the task of the artist was to record with the artist's eye the great and simple doings of men at war, to picture its action, its settings, its tragedy, its humor. Of a more routine nature, but of high practical value, were to be those illustrations made specifically to accompany articles, and some portrait work."

Other Marine artists emerged throughout the war, enabling a large and excellent collection of combat art to be assembled. Several noted illustrators came aboard at the Division of Public Relations and executed work both for the division and for *Leatherneck* magazine. They included Maj. Alex Raymond, USMCR, the comic-strip creator and artist of "Rip Kirby," "Jungle Jim," and "Flash Gordon," and illustrators Dan Content, Tom Lovell, John Clymer, and Tom Dunn, the last eventually going into combat. One of the original "Eight" from World War I, George M. Harding was commissioned a captain in the Marine Corps Reserve and sent to cover action in the South Pacific campaigns; his efforts included accompanying the Para-Marines (although they did not parachute) onto Tulagi, a preliminary attack across from Guadalcanal. All told, the Marine Corps art collection contains the work of sixty World War II artists.

As a former advertising art director and the cocreator of the popular comic strip "[Marine] Sgt. Stoney Craig," a young captain named Donald Lester Dickson was alert to the visual impact and importance of the first U.S. ground counter-offensive against the Japanese: the

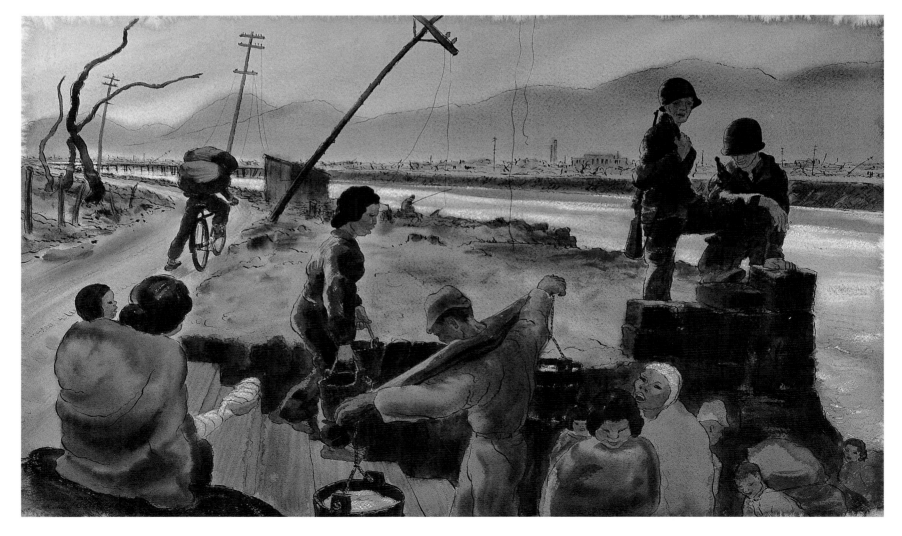

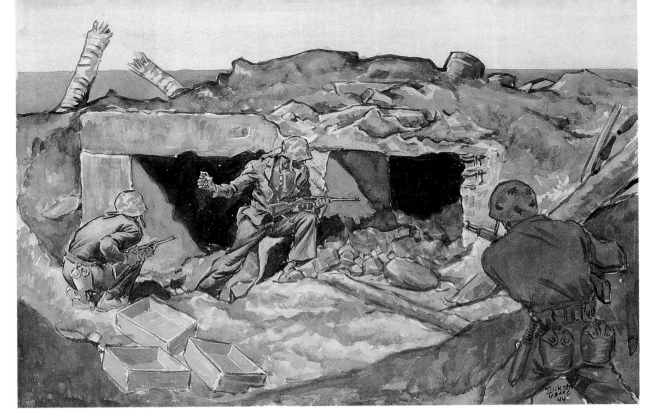

Battle of Guadalcanal. Drawing on his experiences there in the latter part of 1942, Dickson did a masterful series of sketches that epitomize, for all time, the Marines in World War II. Author John Hersey, who used the sketches to illustrate his book of the battle, *Into the Valley*, reflected on Dickson's combat art in a foreword he wrote for Ken McCormick and Hamilton Darby Perry's *Images of War*:

> Dickson's work will not make art history, but it…contributed to the history of the Second World War something that no other form of representation can: a vivid sense of immediacy which gets its power from the individual vision of the artist. His temperament being exactly what it was, Dickson saw the abomination of Guadalcanal, but he also saw, because he had these qualities in himself, the tenacity of those who took part in the fighting, their calm endurance, their deep need to help and support each other, their ability to keep going against what so often seemed hopeless odds—in sum, the simple human urge, felt by so many soldiers all through history, just to survive with a few companions, and go home. Through Dickson's drawings and paintings, we see this one response to warfare, writ large.

Pistol and Palette Marines

Aptly dubbed, somewhere along the line, "Pistol and Palette Marines," the fighting Marine combat artists of World War II produced an inordinate amount of work. Trained first as combat infantrymen (riflemen), as all Marines are, these artists did indeed pack pistols—or whatever other weapons they thought they needed. The list of true combatant-artists includes T.Sgt. Hugh Laidman, T.Sgt. Victor P. Donahue, and Sgt. Elmer Wexler, all of whom, like Donald L. Dickson, sent firsthand combat art back from Guadalcanal. (Later commissioned lieutenant, Laidman would contract malaria but still manage to com-

Above: A cartoonist and advertising executive, Capt. Donald L. Dickson, USMCR, was recalled to active duty as a Marine Reserve captain. He found himself on the staff of an infantry battalion in the first major U.S. offensive against the Japanese at Guadalcanal.

Above Left: Dickson depicts Marines chasing the enemy out of a bunker with hand grenades.
USMC Art Collection

Left: Dickson's impromptu sketches from Guadalcanal not only earned him lasting fame but showed the American public for the first time what the new Marine GI looked like in battle, wearing the newly designed cloche helmet (with a tropical liner) that replaced the British tin pot model from World War I.

Bottom: As sketched by Dickson, a Marine rifleman in the offhand position fires at a sniper. After Guadalcanal, the Marines dumped their beloved, highly accurate Springfield 1903 bolt-action rifle for the Army's new, fast-firing M-I Garand semiautomatic rifle with an eight-round clip.
USMC Art Collection

Above: Pfc. Harry Jackson

Right: Jackson was a radioman when he went in on an early assault wave at Tarawa, receiving three wounds in rapid succession. An artist, he drew and painted his experiences afterward, attracting the attention of Gen. Denig, who gave him other combat art assignments. After the war, he furthered his artistic studies and became one of America's leading painters and sculptors, specializing in Western scenes.
Collection of the Artist

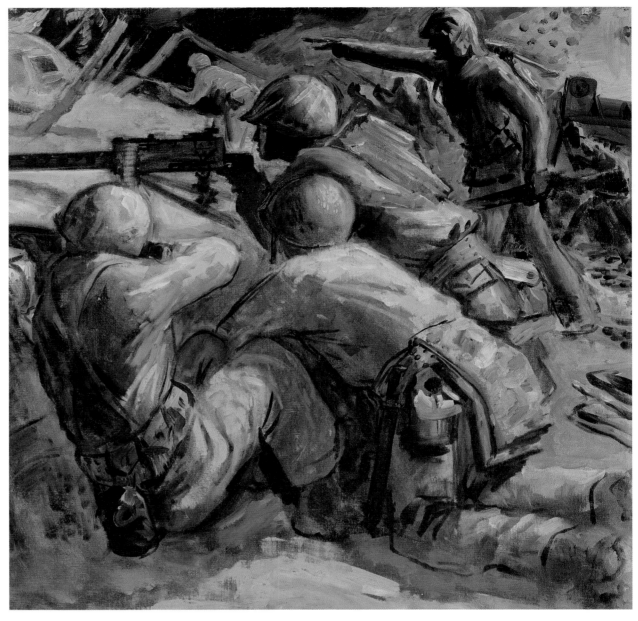

plete sixty watercolors and dozens of pencil and wash sketches.) Later in 1944, on Saipan, combat artist Sgt. John Fabion took a break from his sketching to help capture three enemy soldiers. While on a patrol, he had spotted the Japanese soldiers in a well-dug-in position on the Marines' flank. Instinctively reacting, he overcame them and sent them back to the rear under guard. In another action, Fabion won the Silver Star citation for gallantry. The Vienna-born sculptor, painter, and designer was approaching forty years of age at the time.

These Marine combat artists faithfully portrayed the grim reality they faced. As Maj. Dickson commented regarding his Guadalcanal art, "I'm not interested in drawing Marines who are spick and span and smartly dressed. I don't want to gloss over life out here. It's dirty and hot and 'rugged' and that's the way I want to draw it." First Lt. Herb Merillat described Dickson's work, "He sketched men as they got their orders to go out in the jungle on patrol, tense and alert. He caught their

moods as they came back—grim, worn out, dirty, perhaps with a bandage around a wrist or ankle, dragging on a cigarette. He drew them as they hugged the ground during a bombardment, as they peered across a protecting log trying to spot an enemy sniper, as they struggled across deep muddy streams loaded down with gear, as they charged Japanese emplacements, as they were carried, wounded, from the front."

Combat art of the Marine Corps attracted a lot of national attention Stateside. Stories and reproductions appeared in leading newspapers and magazines and the original works were often placed on exhibit. A full page of Marine combat art was run in one issue of *The Philadelphia Inquirer*, which also put together an exhibit of the originals. Capt. Raymond Henri, given duties as curator, exhibits director, and overall supervisor of all Marine Corps art and artists, was instrumental in getting full-fledged Marine art exhibits at the National Gallery of Art in Washington and the Museum of Modern Art in New

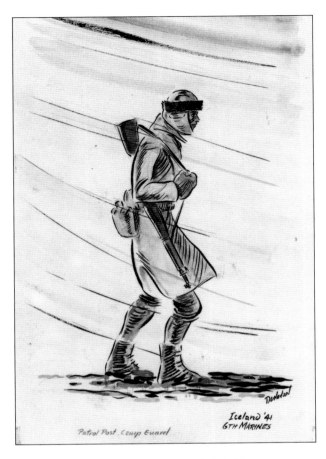

Iceland '41
6TH MARINES

Patrol Post Camp Guard

the Gravure Class, and a special award was given to an unsigned sketch of litter-bearers, found in an ambulance on Guadalcanal. Throughout the war, Marine combat art output was featured in such periodicals as *Architectural Forum*, *Fortune* (which sent its own artists to cover the war), and *The New York Times Sunday Magazine*. The Associated Press offered a feature on Marine Corps artists entitled "Rembrandts with Rifles." Capt. Henri and the entire Division of Public Relations had done an outstanding job in bringing the work of these artists to the attention of the public and the art world.

In 1943, Aimée Crane published a book, *Marines at War*, which further disseminated the efforts of these artists in uniform. Again, Capt. Henri was the guiding hand behind selecting and annotating the works. Those featured were S.Sgt. Francis Loren Boulier, Sgt. John C.

York City. The opening of the show in Washington on 15 November 1943 prompted a request from the British government, with which Capt. Henri complied, for a similar showing at the National Gallery in London.

The 9 November 1943 opening at the Museum of Modern Art in New York occurred in conjunction with the celebration of the 168th anniversary of the Marine Corps, and was attended by government officials and senior officers of the Corps. On the same day, the road show "Pistol and Palette Marine Combat Art" opened at the Taft Museum in Cincinnati, and on 10 November a similar exhibit went up at Marshall Field's giant department store in Chicago. On 15 November, the National Gallery in Washington extended the Marine Corps art show to a full month. From the art critics came highly favorable comments. *Yank*, the weekly newspaper of the armed forces, featured a spread of the works of Donahue, Laidman, Wexler, and Pvt. Paul Ellsworth, describing their pieces as "some of the finest art the war had produced." In the November issue of *The Saturday Review of Literature*, a full-page spread featured the works of Dickson, Donahue, and Pfc. Ralph Tyree.

Marine Corps art also stole the show at Washington's Sixth Annual Outdoor Art Fair in 1943. First prize in the Professional Class went to Marine Reserve Capt. George M. Harding (of World War I fame), while first prize in the Serviceman's Class was awarded to Marine Reserve Maj. Don Dickson. T.Sgt. Elmer Wexler won second in

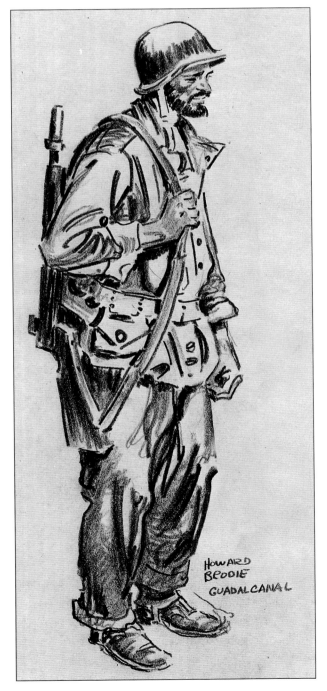

HOWARD
BRODIE
GUADALCANAL

Above Left: Marine detachments were stationed around the globe on guard and garrison duty. Capt. James Donovan, USMCR, caught this lonely sentinel on duty in frigid Iceland.
USMC Art Collection

Above: The rest of the Fleet Marine Forces, consisting of six 25,000-man infantry divisions, saw action in the warmer climate of the Pacific theater in joint Navy-Marine amphibious actions. As (then) Cpl. Jackson shows, Marines in the Pacific dressed in camouflaged helmet cover, herringbone twill utilities, and inside-out "boondocker" ankle boots.
USMC Art Collection

Left: As an Army artist for *Yank* magazine, Sgt. Howard Brodie followed the fighting and in his inimitable quick style portrayed the GI dogface as Dickson did the Marine.
U.S. Army Art Collection

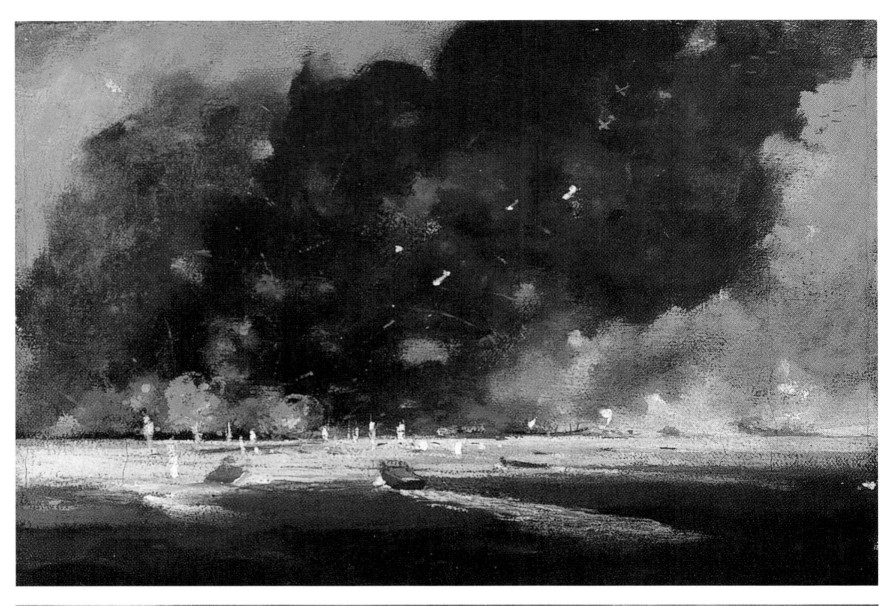

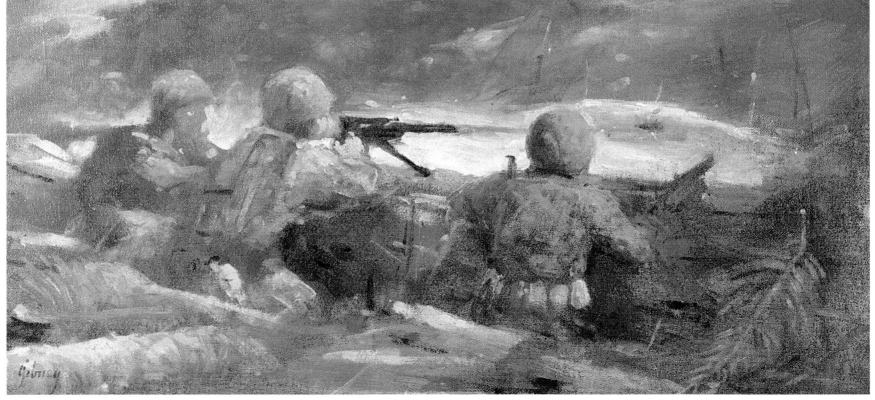

DeGrasse (who went on to become a combat artist in the Korean War), Sgt. James Patrick Denman, Maj. Dickson, T.Sgt. Donahue, Pfc. Edward Francis Dugmore, Pvt. Ellsworth, Sgt. Fabion, Capt. William H. V. Gunnis (an observer and panoramic artist for the Army in World War I who was captured by the Germans in the Argonne, escaped, and was later gassed), Capt. Harding, Sgt. Robert N. Hart, Jr., Pvt. Theodore Hios, Pfc. Harry Andrew Jackson, T.Sgt. Laidman, Cpl. Fred Rhoads, 1st Lt. Carl J. Shreve, Pfc. Ralph Tyree, Cpl. Cynthia Wolfe (who, although she did not get overseas, did a number of drawings of camp life for female Marines), and the unknown artist of *Litter Bearers* from Guadalcanal. Many of these artists saw extensive combat, while some did not leave the States; nevertheless, their visual records were of high quality, as well as being valuable historically. In the humor department, Fred Laswell's Stateside cartoon Marine, Snuffy Smith, would hold his own with his GI compatriots, Army combat cartoonist Bill Mauldin's Willie and Joe.

A July 1945 Marine Headquarters Bulletin listed the "Artists of Action" and reproduced the following: Lt. Kenneth Bald's *Flushing Japs in Swamp*; (then) Lt. Col. Dickson's *Listening Post* and *Too Many, Too Close, Too Long*; (then) M.Sgt. Donahue's *Scrub Team*; Cpl. Tom Dunn's *Sniper and Mortar Fire Kept the Marines Low*; Sgt. Fabion's *Funeral*; Capt. Harding's *The Jump*; (then) Sgt. Hios' *Heading Toward Kwajalein*; Cpl. M.L. Igleburger's *Iwo Jima, Looking like a Huge Mummy Case Partly Submerged*; (then) Sgt. Jackson's *Buccaneer, 1943*; (then) Lt. Laidman's *Stateroom Enroute to Guadalcanal*; Sgt. John R. McDermott's *Outpost Guam*; Pfc. Norman Pate's *Mopping Up*; Pfc. Wayne Seese's *Oozy, Isn't It?*; Pfc. Elmer Smith's *Stretcher Party*; and (then) M.Sgt. Wexler's *Jap and American Dead*.

In addition, other Marines contributed to the program and deserve mention. With ranks noted where available, they were Lt. Malcolm L. Eno, Jr. (with more than 500 sketches and caricatures of Marines in aviation units overseas), T.Sgt. Paul Arlt, Howard A. Terpning, Sgt. Roland P. James (Okinawa), Pfc. Stan Lacy (Tinian), S.Sgt. Lawrence Brinkman, T.Sgt. Sherman Loudermilk (Bougainville, and later Vietnam), Robert Noir (Okinawa), Capt. B. Perin, Cpl. Richard Gibney (Okinawa), Gerard A. Valerio, Sgt. D.N. Roman, M.Sgt. Walter Fritz Gemeinhardt, Capt. James Brown (POW, captured at Wake), E.A. McNerney, Cpl. Donald Moss (Guam), Lt. Houston Stiff (later to come out of retirement to cover Vietnam as a colonel–combat artist), Pfc. Joe Young (Bougainville and Guam), Pfc. J.D. Cochran (Guadalcanal), Sgt. William J. Drout, Cpl. Henry Jaeger, Cpl. Arthur T. McCann, Jr., Pfc. Harry F. Tepker, Pfc. Richard T. Wolff, Sgt. Edward A. Wronski, and Jim

Parmelee. Whether officially recognized or not, whether their work was of professional quality or not, each of these Marine artists captured his own particular sights and experiences during some of the fiercest battles in the history of warfare.

U.S. Army Artists of the War Department

As the War Department (it would not become the Defense Department until after the war) was mounting a program to send artists to the war fronts, the U.S. Army, with its integral Army Air Corps, was also creating a combat art program far broader than what it had put together in World War I. Although business entities would have to pick up the slack when congressional funding was later pulled, art coverage of the coming land battles would be undertaken by civilian and military artists, most selected by New York private art dealer Reeves Lewenthal and signed up by George Biddle. Additionally, the Army would seek talent within its own ranks and form a visual arm to augment its historical sections.

In April 1943, Biddle had dispatched his nineteen civilian and twenty-three military artists to the far corners of the world, mostly to cover Army operations. (While the War Department dragged its heels, Lea, Shepler, Brodie,

The Ground-Air War in Africa and Europe

The draft of 1940 had begun the fast buildup of U.S. armed forces to a wartime peak of more than sixteen million, including women who joined rear guard elements of all the services in order to "free a man for combat." The Army would grow to ninety divisions (18,000 men each) and sixteen separate air forces; the Marine Corps would increase to six divisions (25,000 men each), and the Navy would rebuild its devastating fleet losses at Pearl Harbor, the Coral Sea, Midway, and Santa Cruz to a vast armada of more than 1300 ships, including thirty-three heavy, sixteen light, and fifteen escort aircraft carriers by war's end.

The Allied leaders—Roosevelt, Churchill, and Stalin—had conferred in person early in the war and had decided to open a "second front" in North Africa to relieve both the British, who were being driven to the Nile in Egypt, and the Russians, who were battling the Nazi juggernaut at Stalingrad and the outskirts of Moscow.

On 2 November 1942, Operation Torch, under command of American Lt. Gen. Dwight Eisenhower, landed American, British, and Free French Task Forces at three points in Morocco and along the Algerian coast. From there, they attacked eastward to join in a pincer maneuver, with the British fighting in Tunisia, and eventually forced Nazi Gen. Erwin Rommel's defeated troops to evacuate to Sicily and then up the Italian peninsula.

Below: George Biddle sketched these soldiers of the 3rd Army Division slogging over the plain leading from Monte Caievola, San Angelo, and Madama Maria in their never-ending pursuit of the slowly retreating Germans up the Italian peninsula to Monte Casino. The Germans halted at Monte Casino, which they had transformed into a fortified observation post; when the Allies rolled the Germans up to the monastery, they stopped short of attacking, hoping the enemy would leave the ancient and beautiful monastery without a fight. For weeks, the stalemate dragged on, until finally the Allies were compelled to drive the Germans from their redoubt, sadly reducing the monastery to rubble in the process.
U.S. Army Art Collection

and Dickson had already covered Guadalcanal six months earlier.) Biddle himself, along with noted artist Fletcher Martin, joined the North African campaign and followed on into Italy. Reginald Marsh, noted regionalist painter of the 1930s, was assigned to South America, where critical Allied supply lines and defenses were harassed by German raiders and U-boats.

Many in the military establishment took an enlightened attitude toward combat artists, as is indicated by a letter dated 11 April 1943, from Army Chief of Staff George C. Marshall to Lt. Gen. Dwight Eisenhower, commander of Allied forces in North Africa:

> In our recent exchange of radiograms on the subject, you indicated your approval of a proposed plan to send a group of professionally qualified artists to your theater to obtain an historical record of the war from drawings, paintings and other graphic media.
>
> Such a group for your area is now being selected, and its leader, Mr. George Biddle, will be sent to you by air to arrive in the latter part of the month….
>
> The project as a whole has been placed under the charge of the Chief of Engineers, who requests that, if consistent with your headquarters organization, the unit be attached to the Engineer section of your special staff for administration and supply.
>
> It is requested that Mr. Biddle and his unit be provided with adequate facilities and opportunities and accorded latitude commensurate with the military situation; and that their work be forwarded from time to time, as completed, to the Chief of Engineers.

In July 1943, however, despite the exemplary wisdom of these Army generals, the 77th Congress killed the $125,000 appropriation for war art, reportedly due to an Alabama senator's unenlightened objections to "durn fool things like art!" Fortunately, civilian publications and corporations immediately picked up the contracts of the artists, and they were allowed to continue their assignments. While the war on the ground, at sea, and in the air was being covered by these artists and those of the Navy and Marine Corps, soldier-artists were also afforded opportunities to contribute their unique talents.

The Artists in North Africa

In the spring of 1943, Biddle and Martin arrived in North Africa. There, they would follow what would begin the reversal of fortunes for the thus far victorious Nazi armies.

Above: Redhead Picking Flowers, an incongruous scene stumbled upon in the midst of war, is amusingly depicted by Fletcher Martin.
U.S. Army Art Collection

Above Left: A preliminary sketch by Martin of the scene at Bizerte.
U.S. Army Art Collection

Left: "Bizerte was a shambles, a dead town. Nearly every building was wrecked. A wounded German prisoner said the bombing during those last days was so heavy and constant that no one could eat or sleep. He said all the soldiers had decided it was there they would die," observed Martin when discussing this painting.
U.S. Army Art Collection

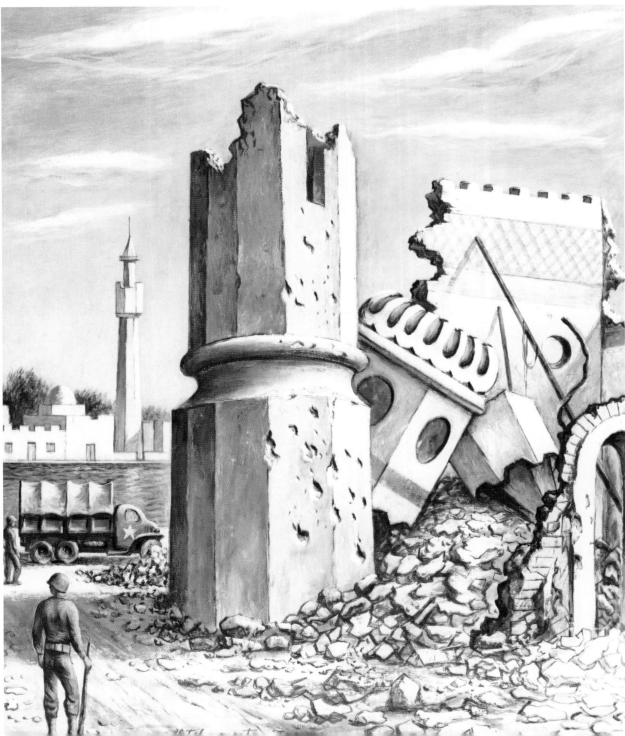

Both artists were products of the 1930s, tending toward a stylized realism, and Biddle, who had earlier published the manifesto for combat artists, was now able to put his precepts into practice. Filling sketchbooks as they went, they covered some of the bitterest fighting of the new American Army's baptism of fire, following the GIs through the deserts and rocky passes, from Algeria to Tunisia, and then on to Sicily and up the Italian peninsula. When the War Department program collapsed, both Biddle and Martin were picked up by *Life* and continued, without interruption, to depict the battles and camp life that would then be dutifully published in the magazine.

Martin, a well-known and admired artist of his time, had left his position as head of the painting department at the Kansas City Art Institute to take the War Department assignment. At the battle front in North Africa, he did several hundred sketches, from which he later painted.

After the war, Martin became the head of the Department of Art at the University of Florida in Gainesville.

Sgt. Bill Mauldin, U.S. Army: Combat Cartoonist

Boyish Army Sgt. Bill Mauldin was the "GI's GI," famous throughout the armed forces for his cartoons in the GI (for "Government Issue") newspaper *Stars & Stripes*. Relentless in his unique pursuit of the humorous twist to the everyday struggles of the frontline dogface, the irrepressible Mauldin stood up to top brass admonitions to go easier with his biting wit.

Mauldin seemed to be everywhere the action was. He was in the thick of the fighting in the Italian campaign and was even wounded and decorated for valor. With ubiquitous sketchbook and impish grin, he hovered over every GI's shoulder—in the dirt and grime with the mud

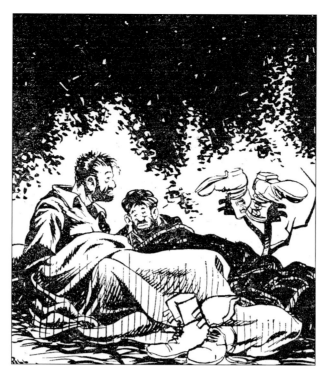

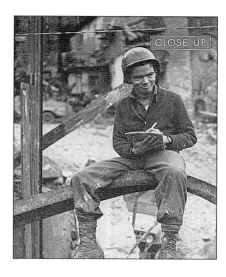

sloggers, in the temporary mess tents, in the foxholes, among the rubble. He reflected everything they were thinking, complaining about, and criticizing—all without cynicism or rancor, but instead with belly-laugh humor. Undoubtedly, his cartoons boosted many a GI's morale.

Bill Mauldin's cartoons are as fresh—and to the point—today as they were when he drew them, almost six decades ago. As one of America's favorite and most famous cartoonists, Mauldin won a Pulitzer Prize for his "Willie and Joe" cartoons.

Capt. Edward Reep, U.S. Army

One of the finest combat artists to come out of the war was Edward Reep, who, fortunately for historians, published a book in 1987 about his three and a half years in the Army. *A Combat Artist in World War II* is not only a well-written and fascinating account of Reep's extraordinary adventures in the Italian campaign, but also features many details regarding the methods of the combat artist. Most combat artists made sketches and completed their finished paintings in their moments away from the fighting. Not Reep. He carried his pen and ink, watercolors, and tempera, brushes, and paper wherever he went, sketching and painting constantly— in rear echelons and right on the front lines, often under intense German artillery and sniper fire. One of his best watercolors was done in the back of a jeep during a heavy downpour. Once, during a snowy winter, a watercolor he was painting in his shelter tent froze—that is, the water of the medium froze—and when he inadvertently placed it near his small fire, the painting melted and flowed off the paper.

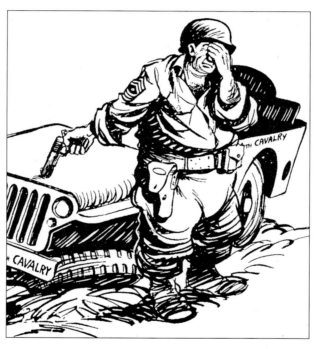

The talented soldier had trained at the Art Center School in Los Angeles, and before going overseas, Reep had done a mural for Gen. "Vinegar Joe" Stilwell at the Presidio in San Francisco. Selected by Biddle's Art Committee to be part of the War Department's original program, Reep had been commissioned a second lieutenant and was subsequently absorbed by the 5th Army Corps' historical unit, whose colonel proved surprisingly receptive to the art program.

When Congress doomed the art program, Gen. Eisenhower personally told the artist, "Lt. Reep, we're establishing the art program with army artists only. The civilians are going home. Now—there are five artists awaiting assignment, and there will be five divisions

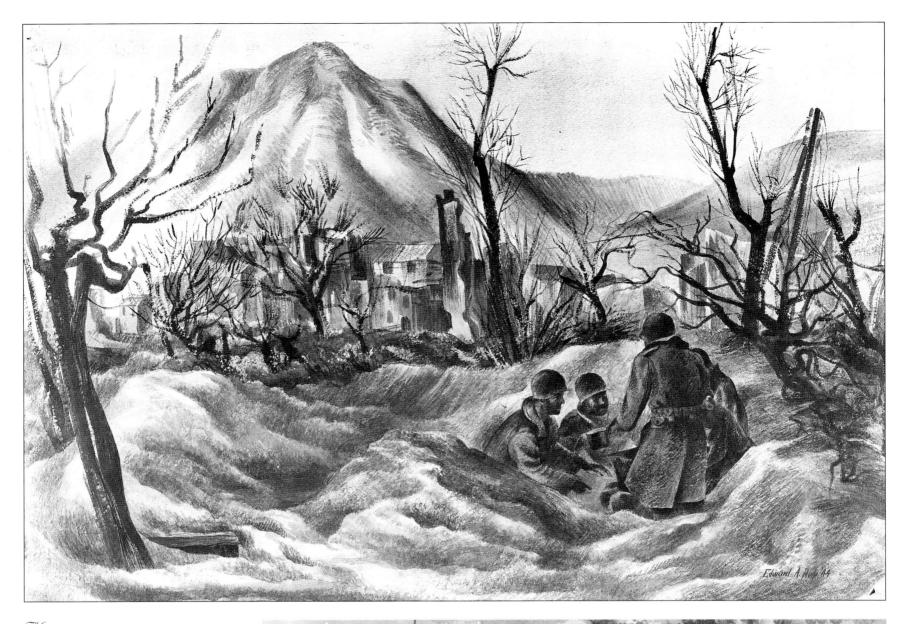

Above: *Coffee Break* is set in a shell crater near Mignano and Monte Rotondo. Capt. Edward Reep executed this watercolor during the campaign.
U.S. Army Art Collection

Right: Reep painted this watercolor of a rare treat enjoyed by a 1st Armored Division soldier. The ingenious GI had rigged a gasoline can with a small trickle leaking under the tub, ignited it, and enjoyed a hot bath—perhaps his first in months.
U.S. Army Art Collection

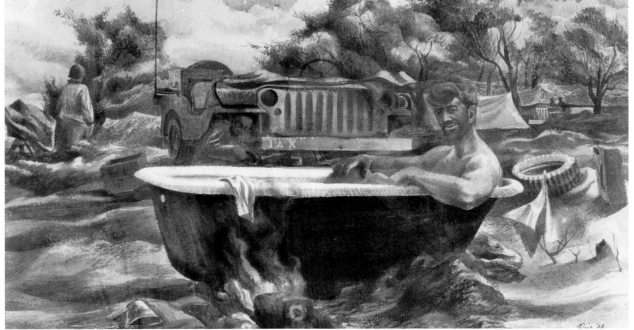

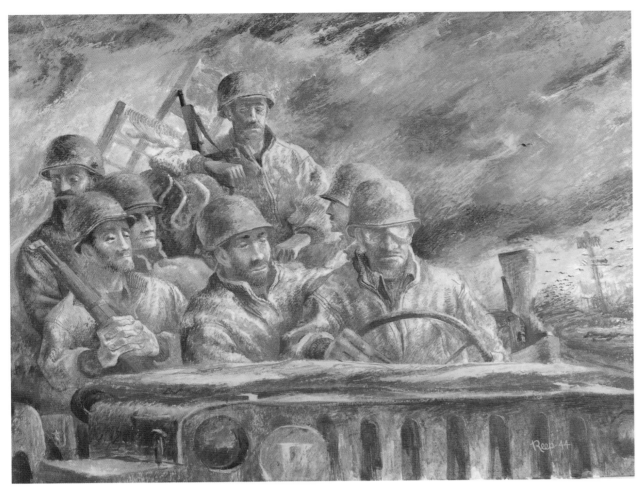

Left: We Move Again, a gouache (opaque water-color) painting done by Capt. Edward Reep in Anzio, typifies the numbness that accompanies continual moving: the men are grubby, tired, unshaven, impassive, and squint their eyes to avoid the dust of the road. As a combat artist, Reep moved, lived, and survived fierce combat with men such as these.
U.S. Army Art Collection

Below: Livergano—"Liver and Onions" takes its name from the GIs' deliberate mispronunciation of a small town in the Northern Apennine mountains. A strategic site, the town was shelled unmercifully day and night. Reep did this pen and ink drawing over a neutral gray-green water-color wash. He often touched up his watercolors with Chinese white, an opaque tempera.
U.S. Army Art Collection

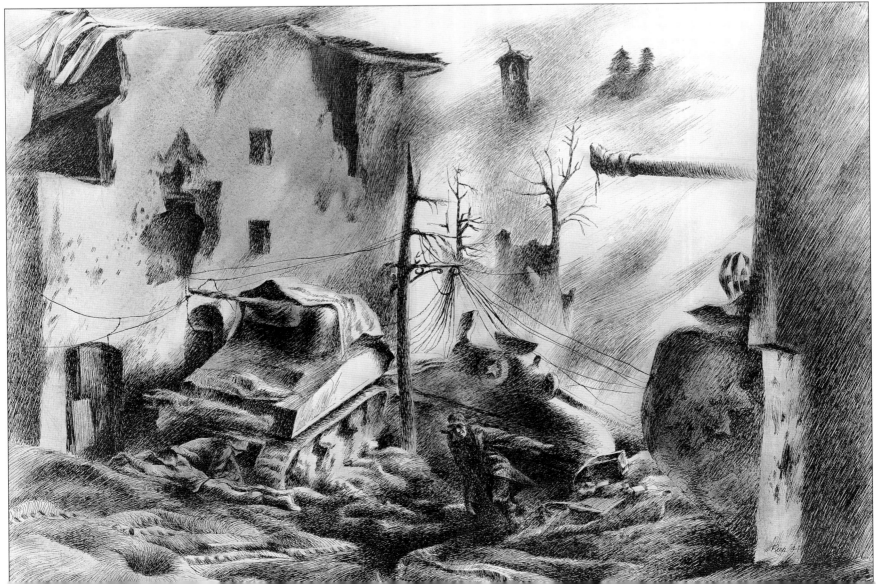

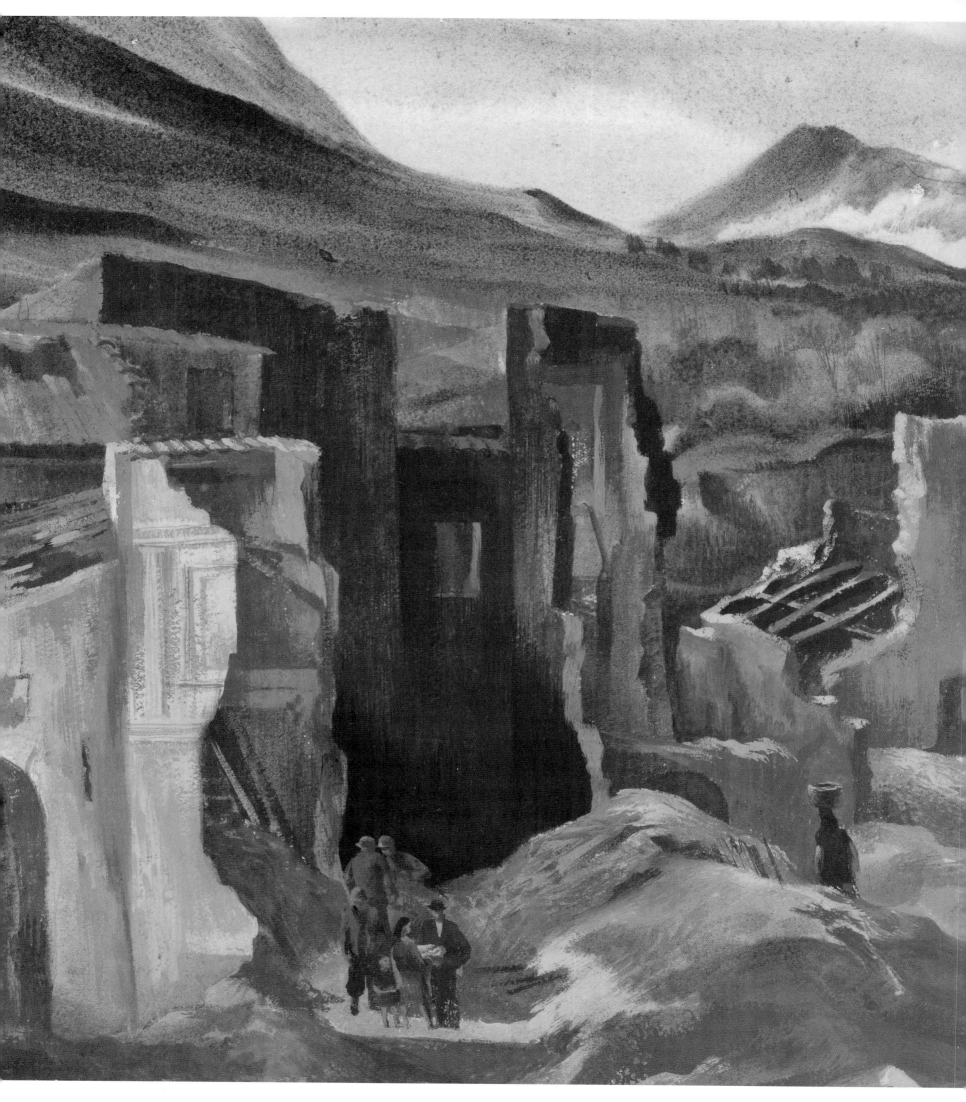

going into Italy. You will head the group, pick a division, and assign each of the others to a division." Reep chose for himself the 1st Armored over the infantry divisions, because, he admitted, he hated to walk. He did, nevertheless, cover many infantry operations.

Other artists joined him in the historical section of 5th Corps: Lt. Rudolph C. Von Ripper, an Austrian-born combat veteran as well as an accomplished artist, and technical sergeants Mitchell Siporin, Savo Radulovic, Frank D. Duncan, Ludwig Mactarian, and Harry Davis. Duncan had attended the Yale School of Fine Art, and Mactarian had studied at the Art Students League in New York and had been an assistant to the noted artist Reginald Marsh, who was on a *Life* assignment during the war. Davis had studied at the John Herron Art School in Indianapolis and had won the Prix de Rome in 1938. After the war, Siporin would head the art department at Brandeis University, while Von Ripper would die a few years later, possibly from the dozens of wounds he had sustained.

Reep, meanwhile, aggressively sought combat situations. He portrayed the battle at Monte Cassino and stayed on the Anzio beachhead for two months, living in a tiny dugout and painting even while taking cover from the constant enemy artillery barrages. He went with the Army to Rome, on to the Arno, and into Milan, where he saw close up the bodies of hanged dictator Mussolini and his mistress. Sketching as he accompanied infantry units in the Italian Campaign, Reep's keen artistic eye and sure pen stroke caught some rare moments in warfare for the Army. He was promoted to captain and personally captured a number of German soldiers.

After the war, Reep rejoined his wife in California and was awarded a Guggenheim Fellowship. He also wrote several books, including *The Content of Watercolor*. In some of his paintings, he portrayed antiwar themes, and he exhibited widely, including a show at the Whitney Museum in New York. Later, he joined the art faculty of East Carolina University and the California Institute of the Arts. Over the years, his style became more abstract, culminating in some memorable interpretations of the Berlin Wall, which had been erected by the Soviets to seal off the Eastern bloc from the West.

The War in the Air

For the first time in the history of warfare, the airplane became a crucial part of operational strategy, with American pilots playing a pivotal role. In the China-Burma-India (CBI) theater, while some supplies were trucked over the torturous Burma Road, Chiang Kai-shek's Chinese forces benefited from timely supply flights over the "hump"

Opposite: Reep saw serendipitous moments of beauty amid the wreckage of war. He depicted one here in the ruins of the Italian town of Mignano, portraying the moment as an abstraction of forms and marching echelons of muted, harmonic colors that dwarf the humans caught in it.
U.S. Army Art Collection

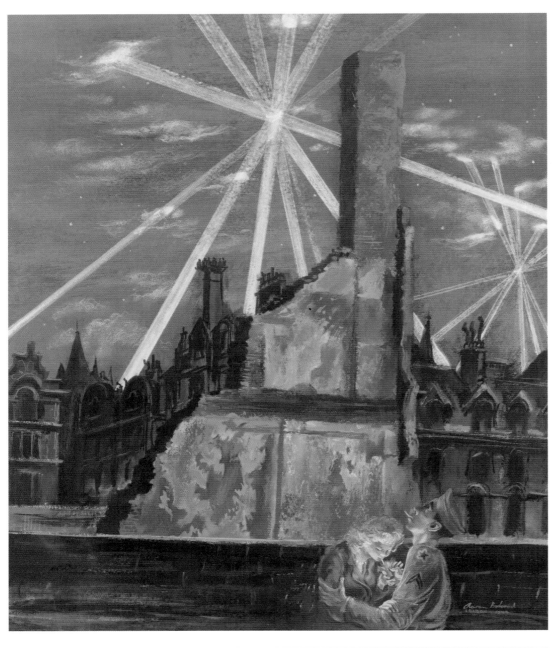

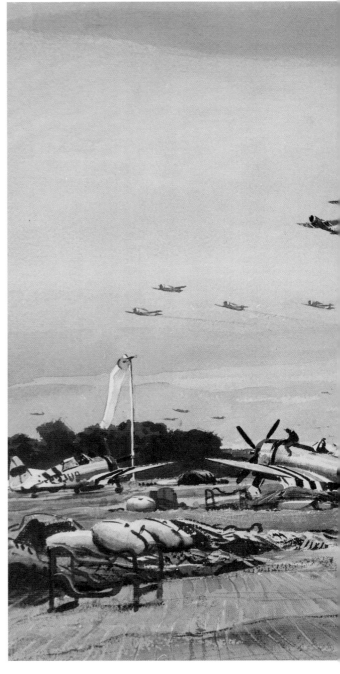

in the southern Himalayas. Even before the U.S. had entered the war, American volunteer pilots had flown for the Chinese in American-made Curtiss P-40 Tomahawk fighter planes, with fierce shark's teeth painted on their noses, as part of the "Flying Tiger" squadrons led by future USAAF general Claire Chennault. During the Battle of Britain, American volunteers had also flown Spitfires in the Royal Air Force's "Eagle Squadron," prior to the United States' entry into the war.

By 1943, as the Mediterranean-Italian Campaign was progressing, American forces had begun building up in England for the long-anticipated invasion across the English Channel to free Nazi-occupied Europe. As the reality of a second front in Europe loomed, the constant aerial bombing of enemy targets, especially those deep in Germany itself, was a critical priority. The United States' entry into the war had helped pull the British back from the jaws of defeat, and both air forces began pummeling

Opposite Top: Aaron Bohrod's *Searchlight Display* catches an intimate moment between a GI and his English girlfriend during an air raid. The searchlight beams that fill the sky are looking, most likely, for German V-1 robot bombs or the more terrifying V-2 rockets that the enemy substituted for their dwindling Luftwaffe aircraft.
U.S. Army Art Collection

Opposite Bottom: *Life* artist Peter Hurd captures the contrast between war and peace in this scene of American B-17 bombers flying off a country airfield near a small village. To better camouflage their whereabouts from enemy aerial observation, both British and American aircraft were dispersed in small groups around the English countryside. The local farmers—and even the horse—depicted here seem quite accustomed to the strange aerial behemoths.
U.S. Army Art Collection

Left: Noted American artist Ogden Pleissner, engaged by *Life* magazine as an artist-correspondent, covered air operations in England and later the Army invasion forces after D-Day in Normandy. The Republic P-47 Thunderbolt fighter-bombers he portrays in this watercolor are the newer, improved models.
U.S. Army Art Collection

Above: *Life* artist–correspondent Aaron Bohrod pictured on the cover of the magazine.

Germany during the invasion buildup—the Brits by night and the Yanks by day.

The daylight bombing campaign of the Army's 8th and 9th Air Forces in England was a distinct war unto itself. Massive air armadas of hundreds of U.S. Boeing B-17 Flying Fortresses and Consolidated B-24 Liberator heavy bombers would saturate enemy targets, flying through intense antiaircraft fire and murderous aerial attacks by Luftwaffe Messerschmitts and Focke Wulf fighters, and the first jets in aerial warfare, the Me 262 twin-engine jet fighter. All too frequently, the Americans would take heavy casualties. Of a flight of one hundred B-17s, sometimes fewer than half would return from a mission.

Depicting the War in the Skies

On his *Life* magazine assignment with the U.S. Army Air Corps' 8th Air Force in England, combat artist–correspondent Peter Hurd accompanied many bombing runs in 1943. He sketched both on the ground with the crews and in the air during combat.

Hurd, who had attended West Point in the 1930s but dropped out to become an artist, is all the more notable artistically because of the medium he preferred: egg tempera. A method predating the Italian Renaissance, egg tempera uses the albumen of eggs, mixed with pigments, as a binding agent. It is a form of watercolor in that it is liquid and fast drying, but it is not as blendable as the water-based medium. Instead, it has to be brushed on in small strokes using small brushes, with darker or lighter, short, cross-hatched strokes overlaid to achieve modeling. At a distance, the human eye blends the strokes optically. It is a tedious, meticulous technique, not one for spontaneity or facile execution under less than perfect studio conditions. It is almost certain that Hurd executed his paintings from sketches, notes, and memory, perhaps after he returned to his New Mexico ranch and studio. Hurd

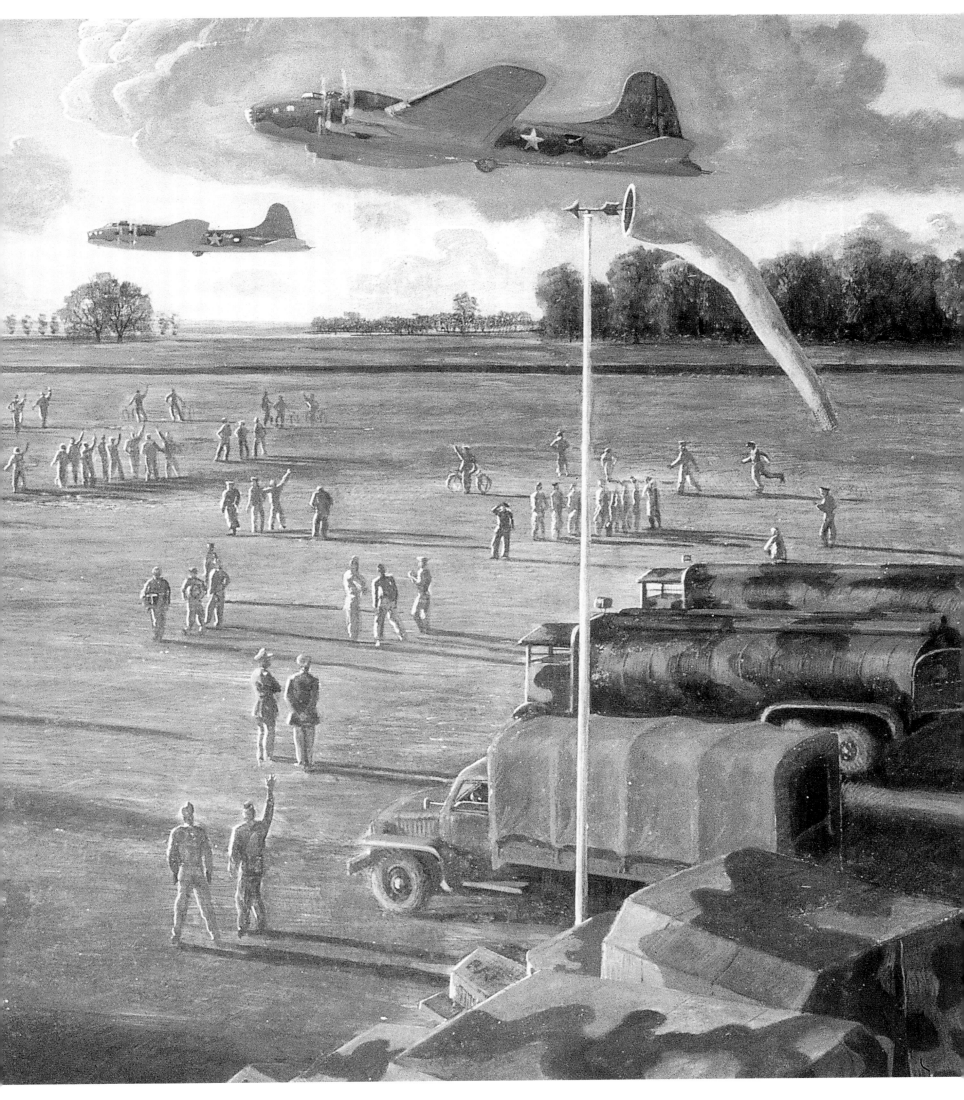

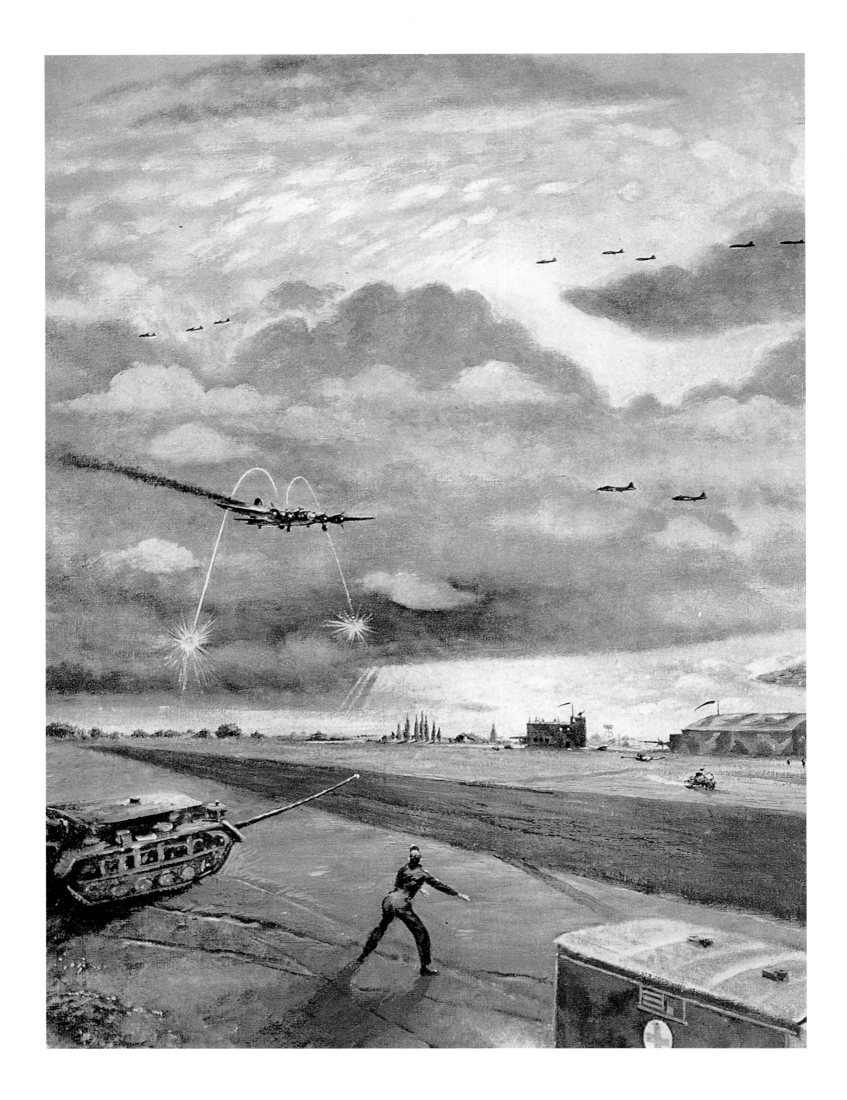

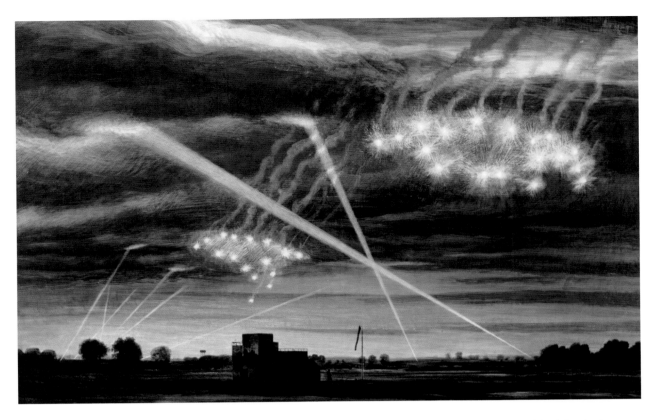

painted his egg temperas on wood panels over which
a shining white undercoat (possibly gesso) had been
carefully painted.

Hurd's paintings, which have a clean freshness and
brilliance of color sometimes not achievable in oil colors,
also display a quality not attributable simply to the
medium he employed. Hurd was used to the clean air,
cool shadows, and blazing sun of his home state of New
Mexico, which he described thusly: "I was born in one
of the earth's most dramatic presentations in enormous
contrasts of color, light, weather, geology, plant and ani-
mal life. It is hard to tell anyone just how painting can
be a religious experience, but it is with me."

Besides Hurd, a number of combat artists accompa-
nied these dangerous bombing missions, most notably
Ogden Pleissner and Floyd Davis. Their work was repro-
duced periodically in *Life* magazine, which was their
sponsor. These artists also covered preparations for the
greatest amphibious operation in the history of the world,
the D-Day invasion of Normandy, forty miles (64km)
across the English Channel. The massive buildup of
American and British forces, with smaller contingents
of Free French and Canadian troops, took until June of
1944. All the while, as the U.S. shipped enormous quan-
tities of supplies, improved equipment, and airplanes,
the air war continued to rage over the skies of Europe.

On many harrowing missions, artists Hurd and Davis
and others observed planes in their formations getting
hit and going down, some with wings shot off, some with
crews bailing out—and still others with no discernable

signs of life from the cockpit as they fell sickeningly
to the ground. Survivors of the downed planes usually
ended up in Nazi prison camps, though a few made it
back across the channel to England, usually after sustain-
ing terrible wounds, many of them burns. There was no
armor plating in the aircraft, and no such thing as body
armor at the time. Nor were the interiors pressurized or
heated; crews wore oxygen masks and fleece-lined leather
flight suits, caps, and gloves to contend with the frigid
temperatures at high altitudes.

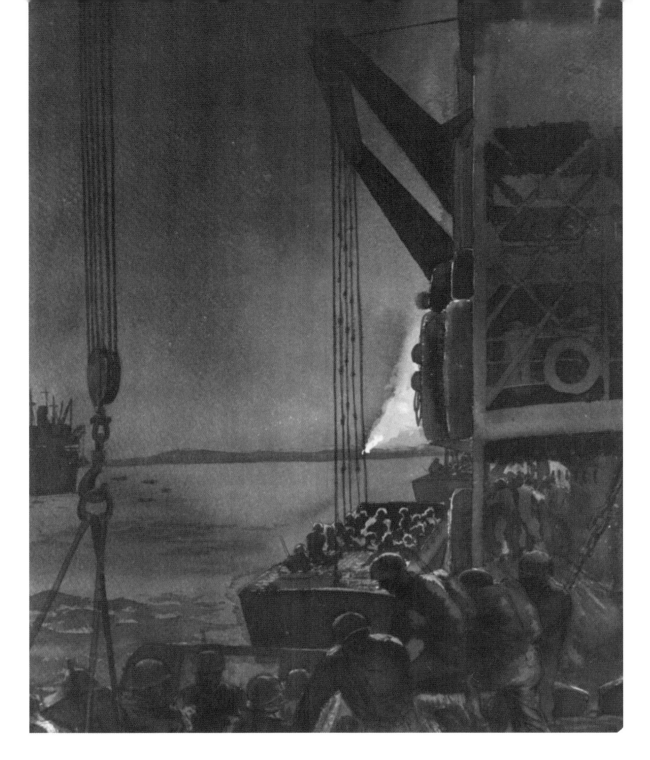

Navy and Coast Guard Artists' Coverage of the Mediterranean Campaign

In 1943, Navy combat artists Mitchell Jamieson, Dwight Shepler, and Albert K. Murray were dispatched to the Mediterranean. Jamieson covered the invasion of Sicily and wrote a compelling story of it to accompany his illustrations of the landings. Both story and paintings were published in *Life*'s 27 December 1943 issue. Murray saw some intense action aboard PT boats guarding the landing ships, often dodging strafing German Me 109 fighter planes.

A chief boatswain's mate in the Coast Guard, Hunter Wood portrayed aerial strafings over the Sicilian landing beaches, while Coast Guardsman Torre Asplund also covered Army landings in Italy and Southern France.

The War in the Pacific

In August 1942, Guadalcanal (one of the Solomon Islands), located 1000 miles (1609km) northeast of Australia, was invaded by U.S. Marines. It was the first ground counter-offensive against any of the Axis powers to date.

Two distinct thrusts in the war in the Pacific would follow over the next three years. Adm. Chester Nimitz commanded the island-hopping campaign in the Central and South Pacific, seizing Japan's forward airfields as U.S. forces edged closer and closer to the Japanese mainland. At the same time to the southwest, Gen. Douglas MacArthur thrust up through the larger land masses of New Guinea, New Britain, Rendova, Bougainville, and the Philippines. MacArthur's and Nimitz's forces would converge in the late spring of 1945 at Okinawa, shortly

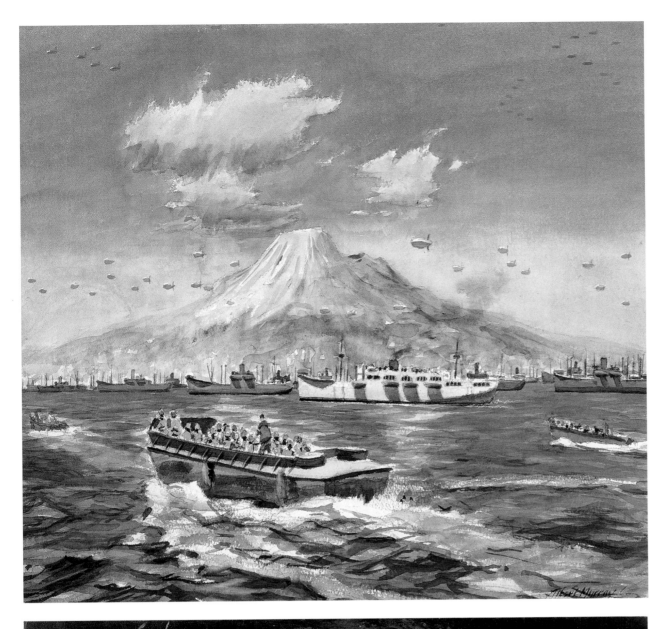

Left: As portrayed by Navy artist Lt. Albert K. Murray, war errupts around dormant Mt. Vesuvius, which silently guards Naples' harbor. U.S. forces invaded both below and above the city of Naples, in a pincer movement that forced the Germans to flee northward.

U.S. Navy Art Collection

Below: The awesome flash of a Navy destroyer's five-inch gun blasting the night is masterfully captured in this watercolor by Jamieson. He served as an official combat artist for the U.S. Navy during operations in the Mediterranean.

U.S. Navy Art Collection

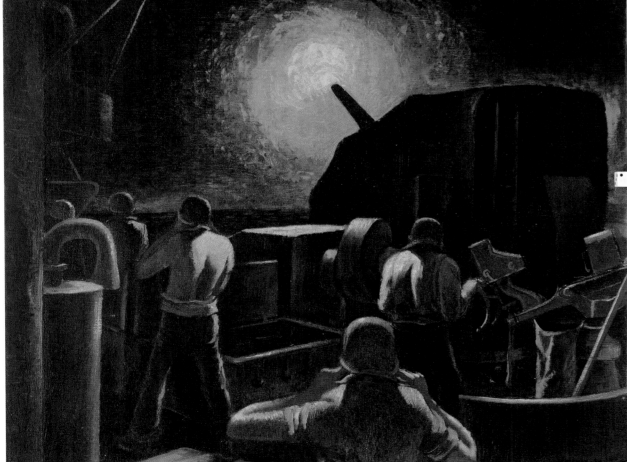

World War II: 1941–1945 149

Right: The muzzle flash of a shipboard gun illuminates the faces of the destroyer's crew for a split second in this watercolor by Lt. Mitchell Jamieson.
U.S. Navy Art Collection

Below: In *Jerry Drops a Glider Bomb*, Lt. Albert K. Murray shows a high-speed PT ("patrol torpedo") boat deftly eluding an aerial strafing. The Nazi swastika on the splashboard indicates the PT boat had previously downed one German aircraft. Murray, serving as a Navy combat artist in the Mediterranean, depicted many of the engagements Navy ships had with attacking German fighter-bombers.
U.S. Navy Art Collection

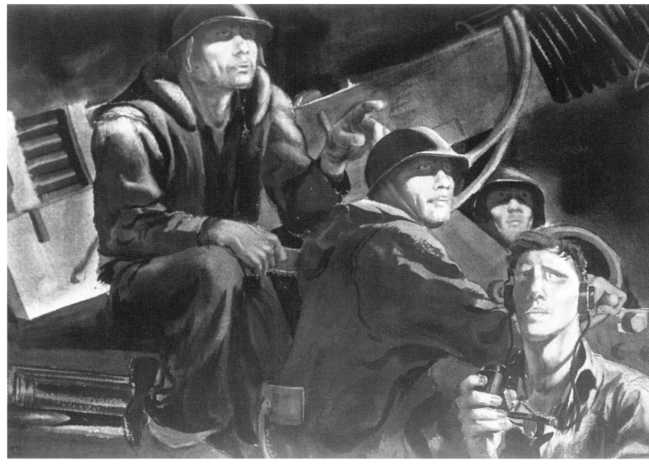

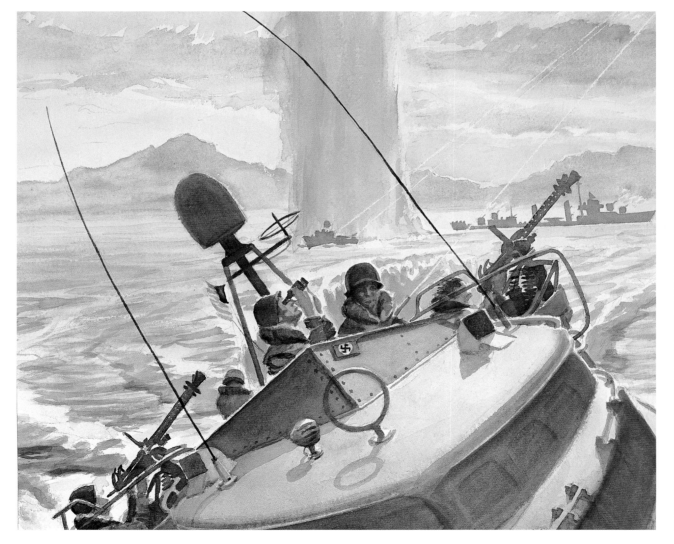

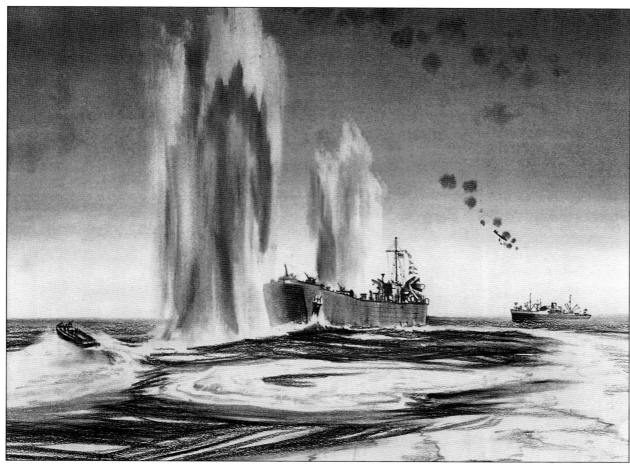

Top Left: Coast Guard artist Hunter Wood was in action in the Mediterranean and later in Normandy on D-Day. In both operations, his landing craft was strafed by low-flying German Messerschmitt fighters, similar to the attack depicted here.

U.S. Coast Guard Collection

Bottom Left: Lt. Dwight Shepler depicts a typical scene aboard a Navy ship during combat. The aid station, especially aboard smaller vessels like destroyers, was often makeshift and the senior medical personnel were likely to be petty officers. More serious cases were transferred as quickly as possible to larger ships with more adequate medical facilities and staffs.

U.S. Navy Art Collection

Below: Hospital Ship USS Solace (AH-5) is portrayed by Abbott Laboratories combat artist Joseph Hirsch. These hospital ships, with their big red crosses identifying them from all sides, carried no weapons as per the Geneva convention. Fully illuminated at night, the ships were welcome havens for the seriously wounded. They could sail to within reasonable distance of the battlefields and had relatively sophisticated medical facilities on board.

U.S. Army Art Collection

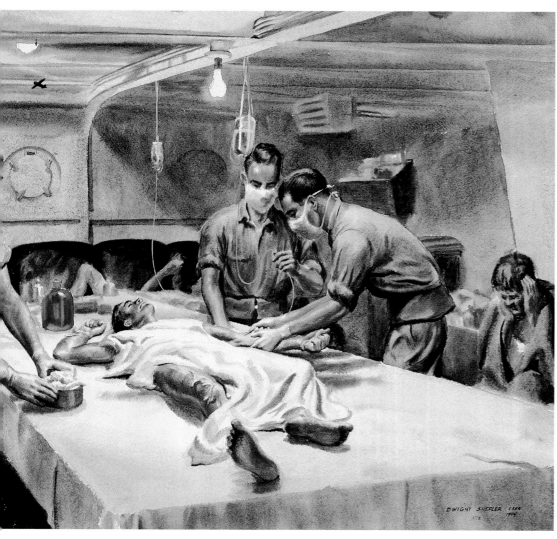

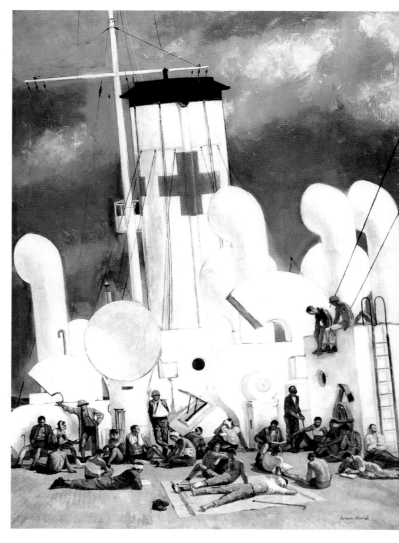

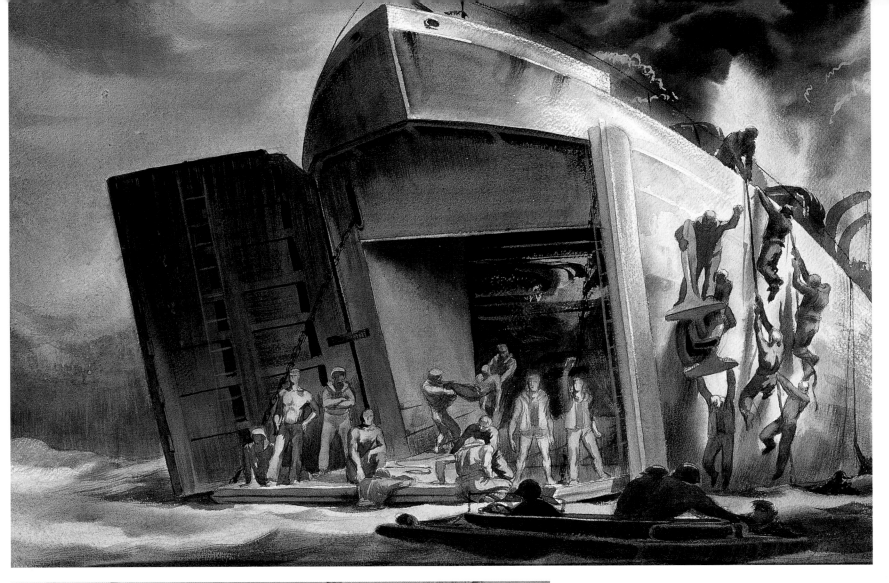

Guadalcanal: August 1942

Both the Japanese Imperial Army and the U.S. Marines fought furiously to maintain beachheads on Guadalcanal. In fierce hand-to-hand fighting, as well as aerial combat, the Marine division and air wing ultimately defeated the Japanese, while the Navy slugged it out with Japanese naval and air units in horrendous clashes that left both sides heavily damaged.

During the early critical phase, when the fighting was nip and tuck, the Army 164th Infantry Regiment reinforced the weary 1st, 2nd, and 5th Marine Regiments. Bringing with them the new Garand M-1 semi-automatic rifle with an eight-shot clip, the Army demonstrated to the Marines that, although their beloved 1903 Springfield bolt-action rifles were good, the Garand was far more effective. Shortly thereafter, the Marine Corps replaced the ".03s" with the M-1s.

After six months, the U.S. Army American Division relieved the Marines, who then rested in Australia before regrouping and training for their next confrontation with the Japanese.

American skill, courage, and (perhaps more important than all the rest) production capabilities would prevail in the end, with Guadalcanal the turning point in the fortunes of the United States and Japan.

Top: Hit fifty yards (46m) offshore, a landing ship tank (LST) burns as troops and crew assist the wounded and abandon ship as best they can. As depicted by Lt. Mitchell Jamieson, patrolling amphibious craft come to their aid.
U.S. Navy Art Collection

after the European war had ended. Okinawa was to be the final jumping-off place for the massive Allied invasion of Japan itself, which portended to be a bloody finale to the Pacific war. Heavy casualties were expected on both sides.

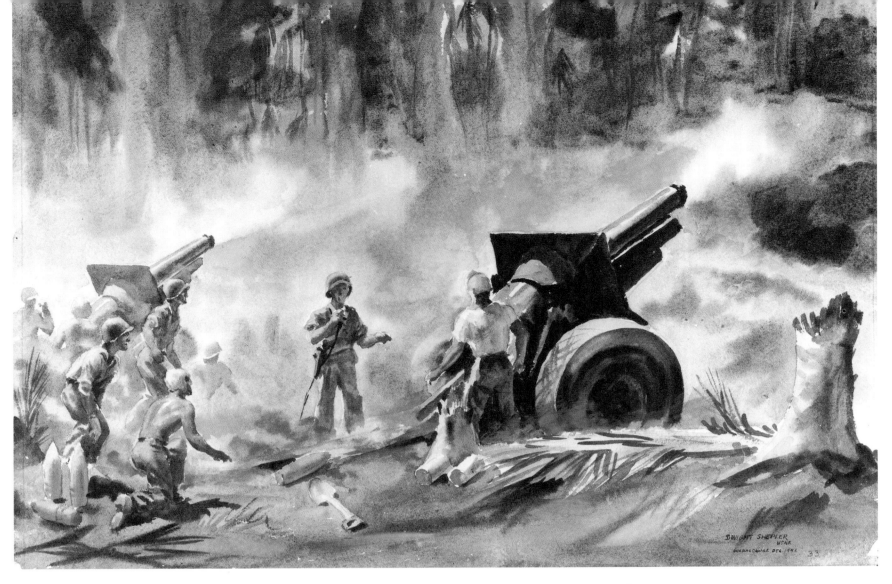

Above: Navy combat artist Lt. Dwight Shepler spent a great deal of time with the 1st Marine Division on Guadalcanal. From patrols in the impenetrable jungle to artillery support teams, Shepler covered the men in action all around him. It was the Marines' first taste of jungle warfare in the tropical, island-hopping Pacific war. Here, Shepler depicts Marines manning 155mm Howitzers.
U.S. Navy Art Collection

Opposite Bottom & Left: In between battles, the essence of the Pacific war was found in the rear echelons and staging areas on many tropical islands. For a time, they became virtual "tropical paradises," especially to the average GI, Marine, and swabbie who had never been away from home before. After chores and duties, there was plenty of time for relaxation—often too much. Boredom frequently prevailed, despite exercise, games, and reruns of the same movie (night after night in many cases). Long after the war, such places tended to take on the glimmer of paradise in fading memories. *Life* combat artist Paul Sample caught the character of a typical South Pacific isle in these watercolor paintings.
U.S. Army Art Collection

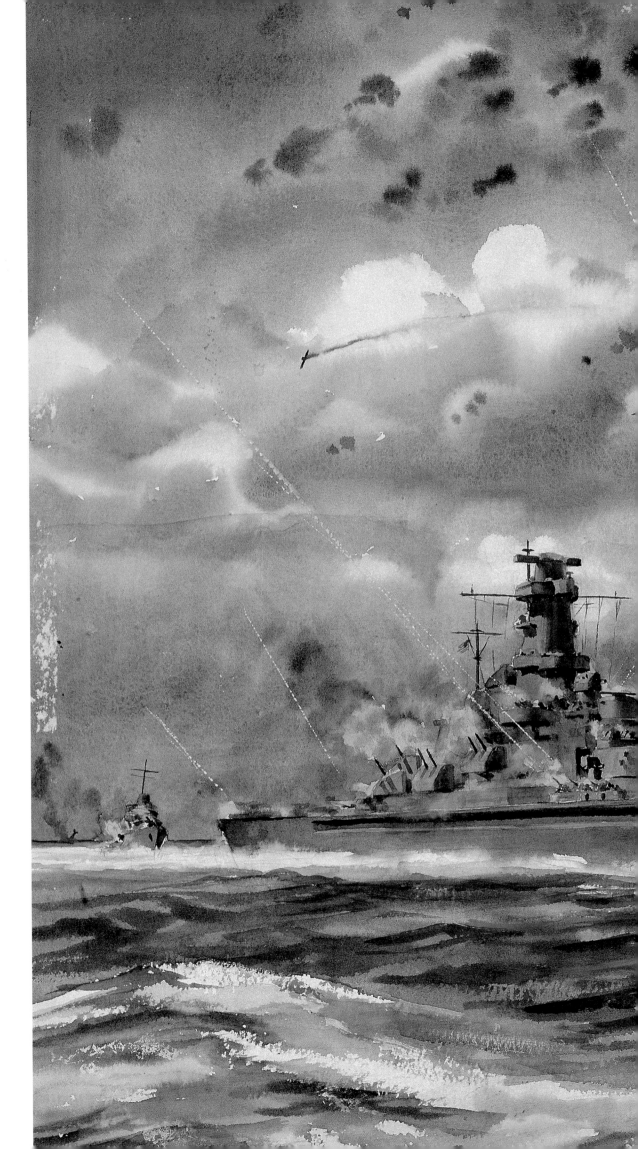

Right: In Lt. Dwight Shepler's *Air Defense*, the USS *South Dakota* is seen in action during the Battle of Santa Cruz in the October 1942 Solomon-Guadalcanal campaign. During the battle, Shepler was serving as a deck officer aboard an antiaircraft cruiser like the one pictured to the right of the battlewagon's bow. This heavily armed battleship fought off dozens of aerial and submarine torpedo attacks during the protracted sea battle. The great naval battles of 1942 (the Coral Sea, Midway, Savo, and Santa Cruz) pitted Allied surface fleets and aerial armadas against those of the Imperial Japanese Navy, based and supplied in Indonesia. For the first time in history, fleets used their fourteen- and sixteen-inch naval guns to fire at targets over the horizon. Japanese fire was directed by aerial observation planes, while the U.S. Navy used newly developed radar in addition to aerial observers. Although some Japanese planes purposely crashed into U.S. warships, kamikazes did not appear until late 1944, in the Battle of Leyte Gulf. By then, the Japanese air force was no longer a match for U.S. flyers, and suicide missions had become a weapon of last resort.

U.S. Navy Art Collection

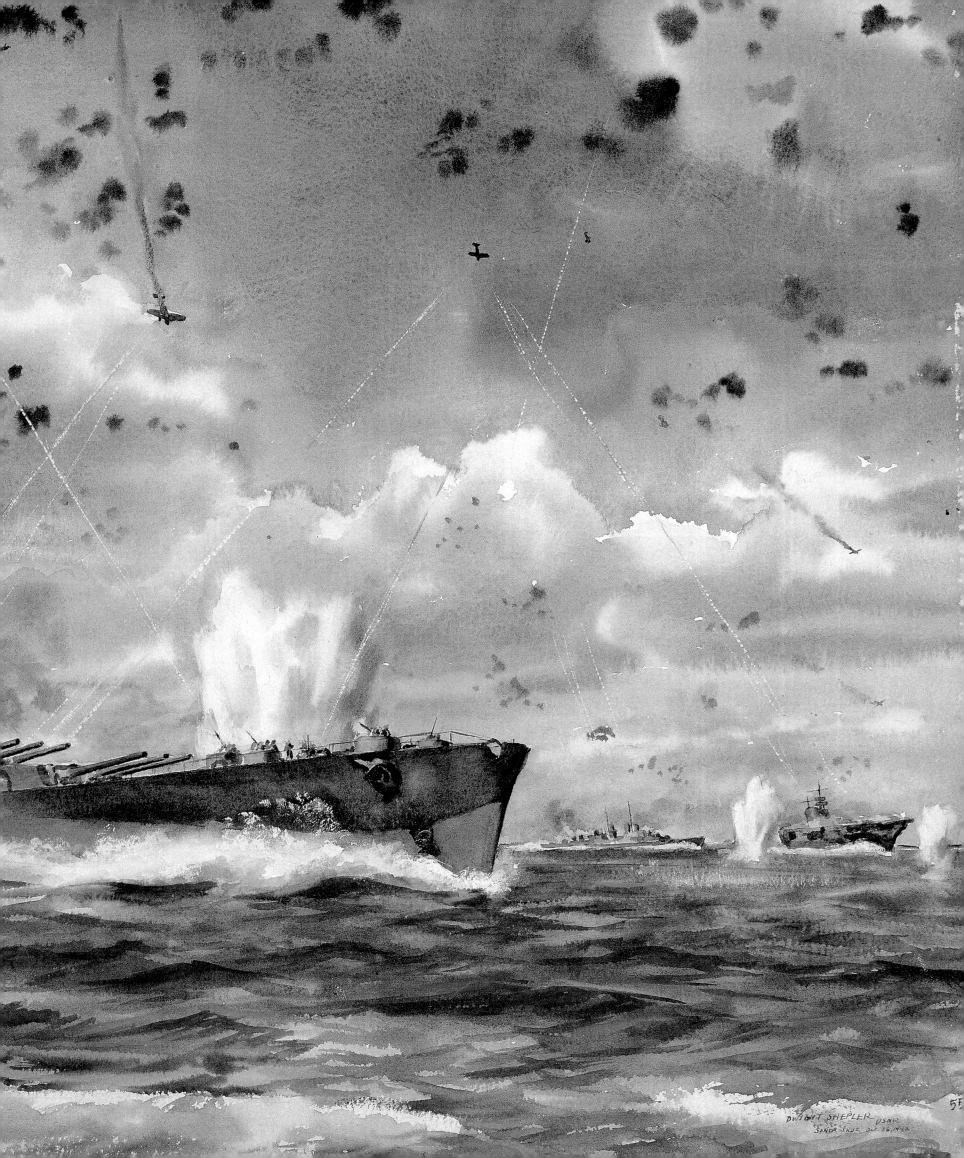

DWIGHT SHEPLER USNR
SANTA CRUZ OCT 26 1942

55

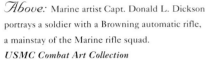 *Above:* Marine artist Capt. Donald L. Dickson portrays a soldier with a Browning automatic rifle, a mainstay of the Marine rifle squad.
USMC Combat Art Collection

Right: Dickson sketched many scenes of Marines in combat.
USMC Combat Art Collection

Far Right: The major objective on Guadalcanal was the airfield, which was captured quickly. Repaired by Navy Seabees and Marine engineers, it was named Henderson Field, after a Marine flier killed at Midway. Though the airfield was under constant Japanese bombardment and naval gunfire, the Marine, Navy, and Army Air Force pilots (code-named the "Cactus Air Force") flew from it constantly. Marine and Navy pilots flew Grumman F4F-3 Wildcats, while the Army Air Corps pilots flew the distinctive Lockheed P-38 Lightnings and the Bell P-39 Airacobras.
U.S. Navy Combat Art Collection

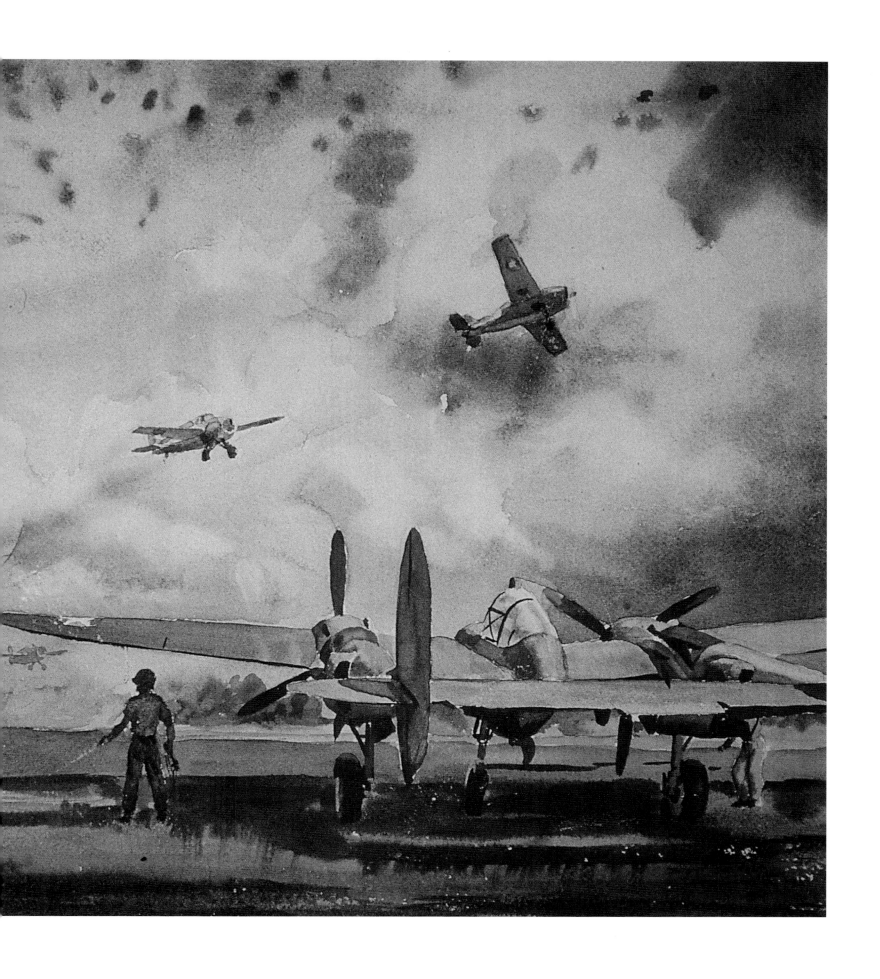

Right: Capt. Donald Dickson's sketch portrays an intelligence-gathering session in the jungle of Guadalcanal.
USMC Combat Art Collection

Bottom: Dickson's completed watercolor of the sketch.
USMC Combat Art Collection

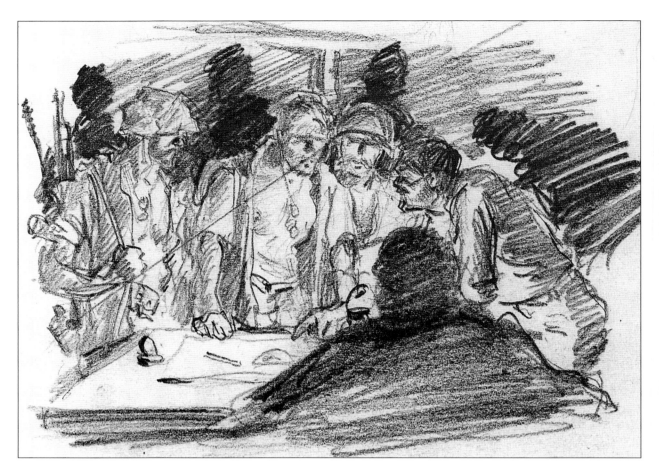

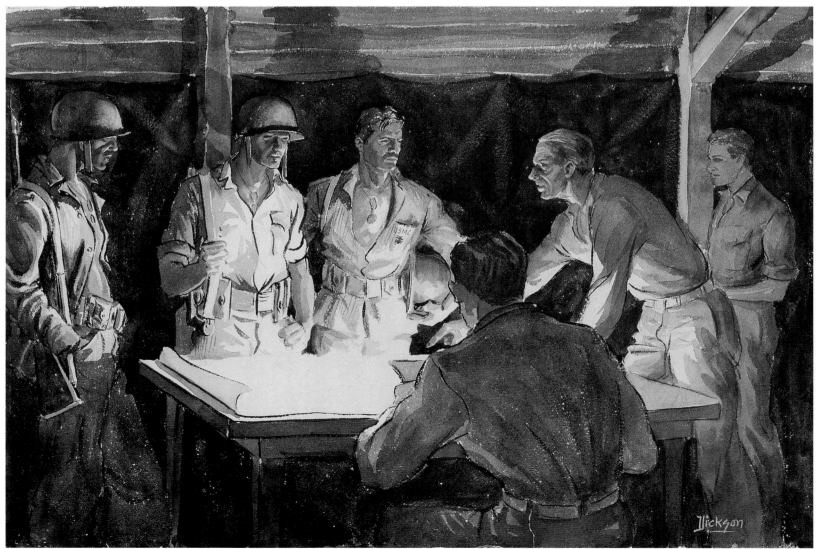

Above: For a Pal, a sketch made by Marine Reserve Capt. Donald Dickson on Guadalcanal. **USMC Art Collection**

Left: After recall to active duty, Dickson found himself in the midst of Guadalcanal, the first great land battle for the Marines. As Marine Capt. John Thomason had in World War I, Dickson sketched when his duties permitted. He filled sketchbooks and executed watercolor paintings of the war. Some of his sketches were used to illustrate author John Hersey's book about the fighting on Guadalcanal entitled, *Into the Valley*. **USMC Art Collection**

Below: Marine Cpl. Walter Anthony Jones was not an official combat artist, though his artistic talent emerged after Guadalcanal. Most likely working from memory or sketches, Jones depicted a quiet moment on the lush island where the tropical tranquility presented a sharp contrast to the harsh realities of war. **USMC Art Collection**

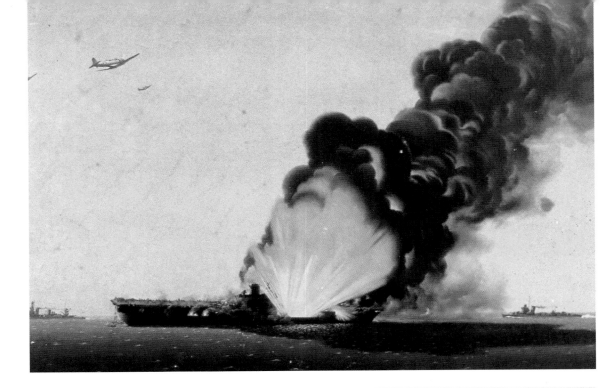

Top: *Life* artist Tom Lea portrayed the sinking of the USS *Wasp*, which occurred during the battle of the Solomons. The artist was watching through field glasses from the stricken carrier's sister ship, the USS *Hornet*.
U.S. Army Art Collection

Middle: Fortunately for Lea, he left the USS *Hornet* just four days before it, too, was sunk, resulting in heavy casualties. Based on his experiences, he chronicled the demise of both ships in this work, including the crew's efforts to stay alive as they abandoned ship and plunged into the burning oil floating on top of the water. Many of the crew were saved by lifeboats or were picked up by escorting destroyers.
U.S. Army Art Collection

Bottom: Lea shows the terrible destructive power of steel on steel, a healthy fear of which is reflected in the eyes of the crewman seen through the observation slit.
U.S. Army Art Collection

Opposite Top: Navy fighter pilot A.C. "Silver" Emerson is immortalized in this painting by Lea, which shows his friend grimly setting his sights on an enemy aircraft. Aerial dogfights between F4F-3 Wildcats and Japanese Zeros were a daily occurrence in the great naval battles of the South Pacific. This battle was in defense of the carrier *Hornet*, where Lea was stationed. The artist has chosen a close-up point of view from an imagined wingman's aircraft flying alongside. Emerson no doubt had posed for Lea earlier. This painting and other Lea originals appeared in the 2 August 1943 issue of *Life* magazine.
U.S. Army Art Collection

Opposite Bottom: In *Direct Hit Below Deck*, Lea portrays the devastating effects of enemy bombs or naval artillery shells exploding within the interior of a ship.
U.S. Army Art Collection

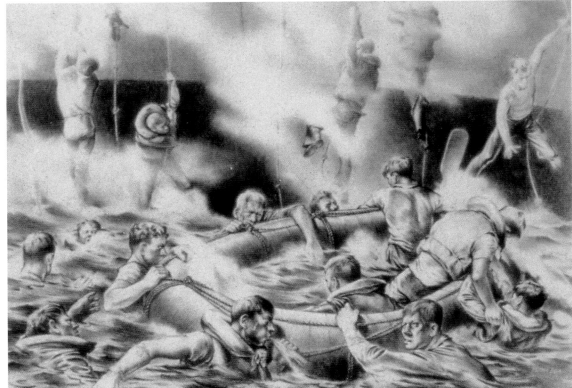

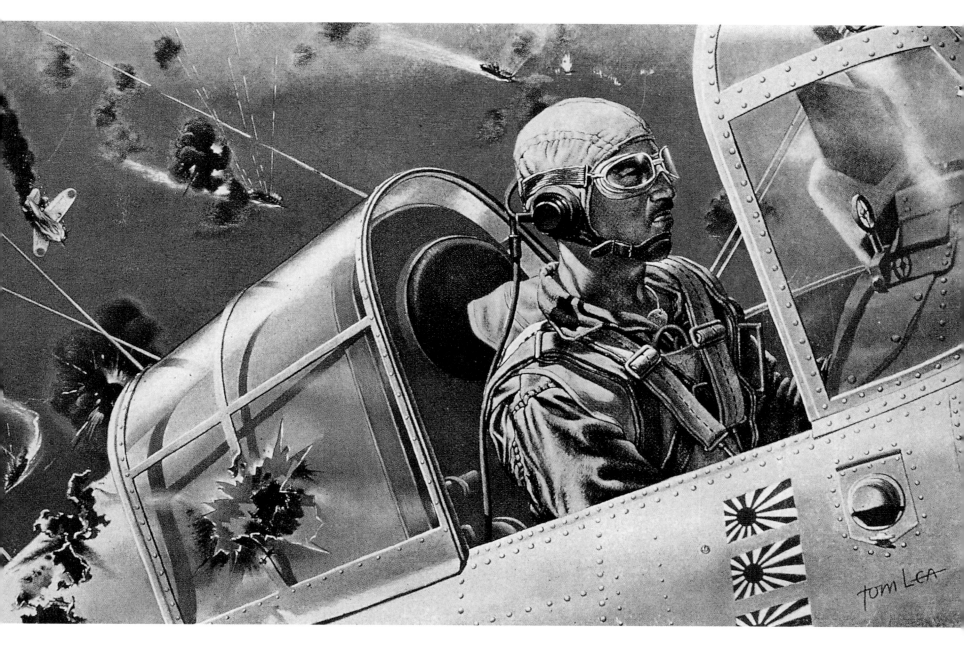

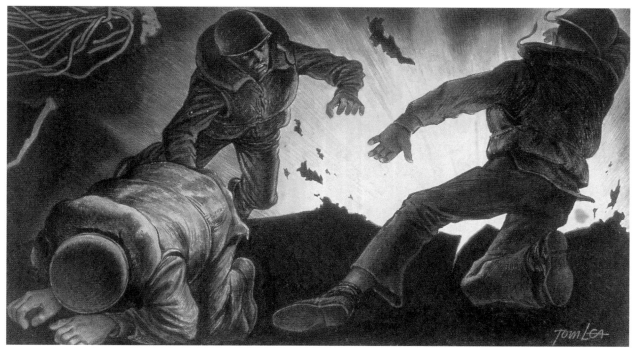

Above: Progressing inland in heavy rain from the beachhead on Rendova, soldiers cautiously advance by leap-frogging: those in the rear cover those darting forward a few yards at a time. In *Taking Cover,* Aaron Bohrod depicts this creeping, deadly advance.

U.S. Army Art Collection

Right: It never fails: just when a can of meat and beans is opened, allowing a soldier to savor a moment to himself, someone has to shout, "Air raid!" What should one do—stifle the fear and go on eating in the filthy jungle foxhole, or dive for safety? Bohrod portrays such a moment in *Air Raid.*

U.S. Army Art Collection

Aaron Bohrod

Of the many fine artists that portrayed World War II, Aaron Bohrod was one of the best. He had studied under John Sloan of the Ashcan School in New York and chose to portray life, especially its seamier side, in Chicago, as Sloan had in New York City. Hired by *Life* magazine, Bohrod covered the Normandy invasion and the South Pacific, particularly the first Army landings in the New Georgia Islands at Rendova, producing a number of memorable paintings, some of which transcend the reportorial and display the more universal qualities found in fine art. His unique style is easily recognizable and has considerable dramatic power.

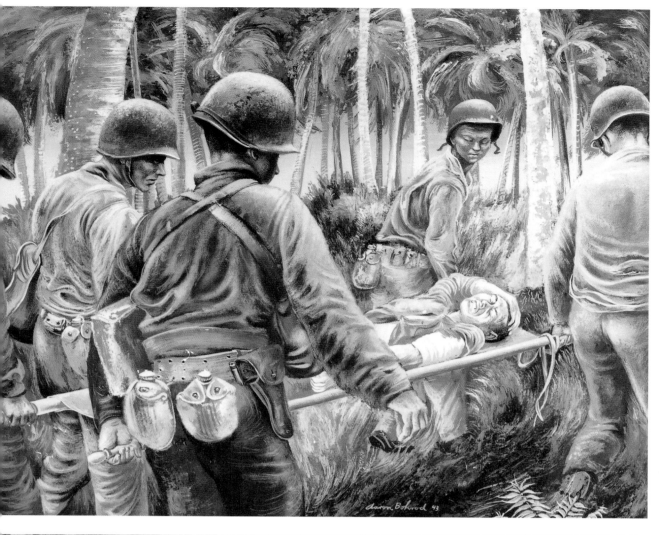

Combat Art of the U.S. Coast Guard
Lt. Comdr. Anton Otto Fischer

Above: No stranger to the sea, noted maritime artist Lt. Comdr. Anton Otto Fischer, USCGR, accepted a wartime commission in the Coast Guard Reserve. His assignment aboard the cutter *Campbell* turned out to be an arduous and icy North Atlantic patrol. *Life* magazine published his paintings from the experience in its 5 July 1943 issue.

Below: Fischer depicts star shells illuminating the night sky over a convoy in which a torpedoed merchant ship burns brightly.
U.S. Coast Guard Collection

Chartered originally in 1776, the Revenue Cutter Service was joined in 1915 by the Life Saving Service and re-designated as the U.S. Coast Guard. The older Lighthouse Service folded in 1939, and the Bureau of Navigation and Steamship Inspection in 1942. The U.S. Coast Guard operated in peacetime under the Department of the Treasury. (It would later be attached to the Department of Transportation.)

In World War II, after reverting to U.S. Navy operational control and expanding its mission to include ocean patrols, the U.S. Coast Guard accumulated its own stable of artists, most notably the widely acclaimed, German-born maritime artist Anton Otto Fischer, who, in 1942 at the age of sixty, was commissioned a lieutenant commander. The seascapes and ship and submarine actions he portrayed are unsurpassed in naval art.

Life magazine secured Fischer's services and, on 10 January 1943, arranged for him to board the 327-foot (100m) Coast Guard Cutter *Campbell*, which had routine submarine patrol for a convoy of merchantmen crossing the North Atlantic via Greenland and Iceland in sub-infested waters. On the icy, storm-tossed Atlantic in the middle of winter, Fischer suffered much discomfort, though his sea legs proved as good as those of men half his age. The crew entertained themselves playing poker, at which Fischer earned almost as much renown as he did from his marine art.

On the eve of his sixty-first birthday, in Capt. Hirshfield's cabin below the bridge, the Filipino mess boy had just brought in a specially baked cake with "Happy Birthday" written across its top. The *Campbell* had been sailing through a pack of enemy submarines all day, making periodic contact and dropping depth charges. Attacks were imminent and tensions high as the cake was about to be cut. What followed is best described in Fischer's own words:

As the Captain and I got up from the table, the general alarm went off in our ears. I ran after him up to the bridge, and there it was on the surface, our sixth submarine in eighteen hours. She was crossing our bow from port to starboard a few hundred yards ahead and couldn't have seen us in the dark. We turned to starboard to ram her, but she turned on a course almost parallel to ours. In a few seconds we were on top of the submarine. It was an eerie sensation to look down from the bridge wing onto her deck and conning tower. A man could have dropped from the cutter's deck to hers. As we passed in that quiet second, the sub's port hydroplane ripped through our hull. Then, as she drifted astern, all hell broke loose. Our after guns opened up, their crews hollering like a bunch of Comanche Indians. Three-inch shells were slamming into the U-boat's hull at pointblank range. You just couldn't miss. And you could see the lines of our 20-mm. tracers sweeping the decks, knocking men off like tenpins. Through the darkness, I could hear men calling in the water, one man shouting, 'Hello, boys,' obviously the only two English words he knew. Then the calls grew fainter and finally died away.

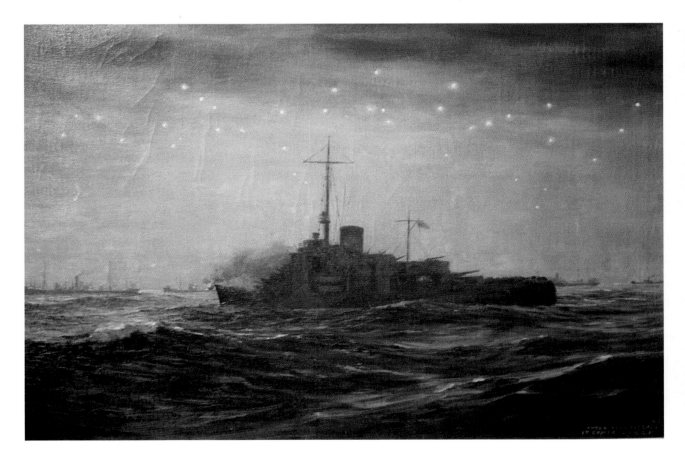

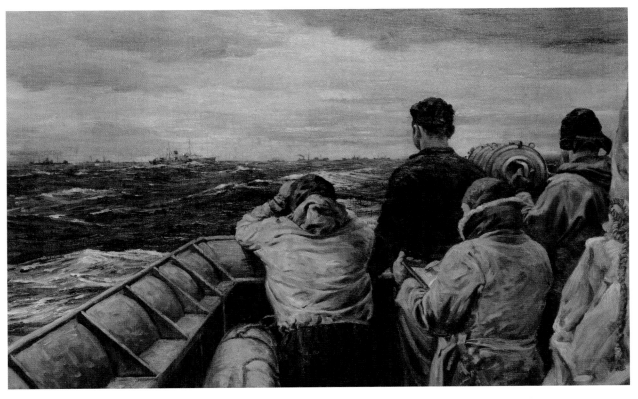

Left: In this magnificent painting, Fischer captures the bleak wind-swept North Atlantic seas through which the vast convoys plowed. *Signaling a Corvette* demonstrates how light signals were used to communicate, since the constant Nazi U-boat menace made radio silence critical. **U.S. Coast Guard Collection**

Below: As depicted by Fischer, the *Campbell* runs in heavy seas on a North Atlantic patrol. Fischer went aboard the cutter *Campbell* for the most interesting—and dangerous—voyage of his life. The cutter sank a marauding German sub it had rammed at sea. As the U-boat and crew sank, the cutter lay damaged while the rest of the convoy lumbered on toward England. The *Campbell* floundered until a sea-going tugboat arrived three days later and towed it to Iceland for repairs. *Life* published the series of scenes from the voyage. **U.S. Coast Guard Collection**

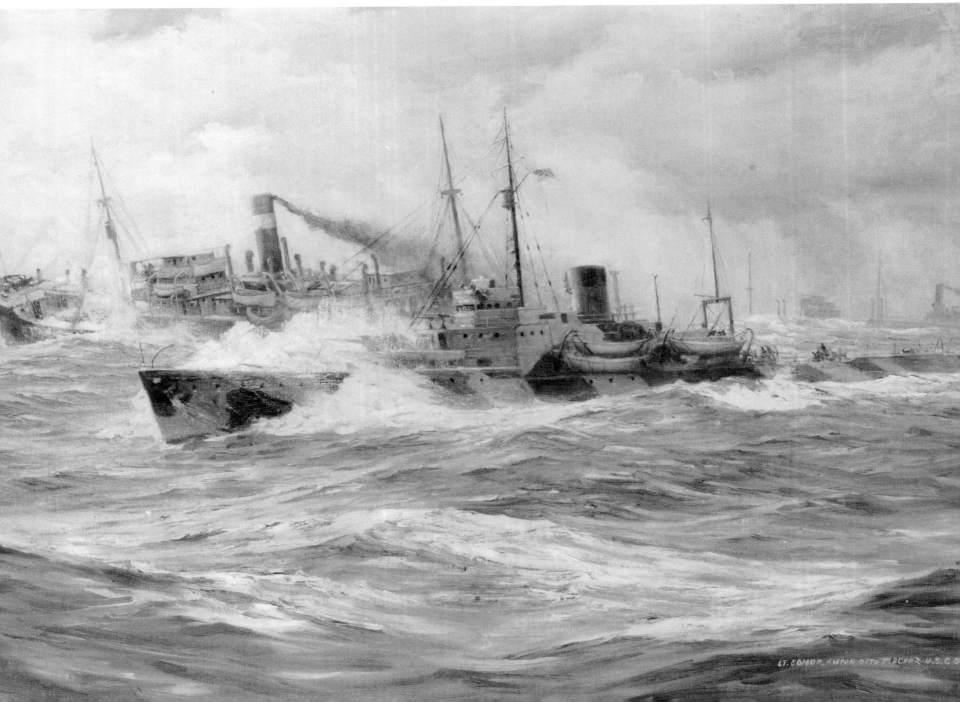

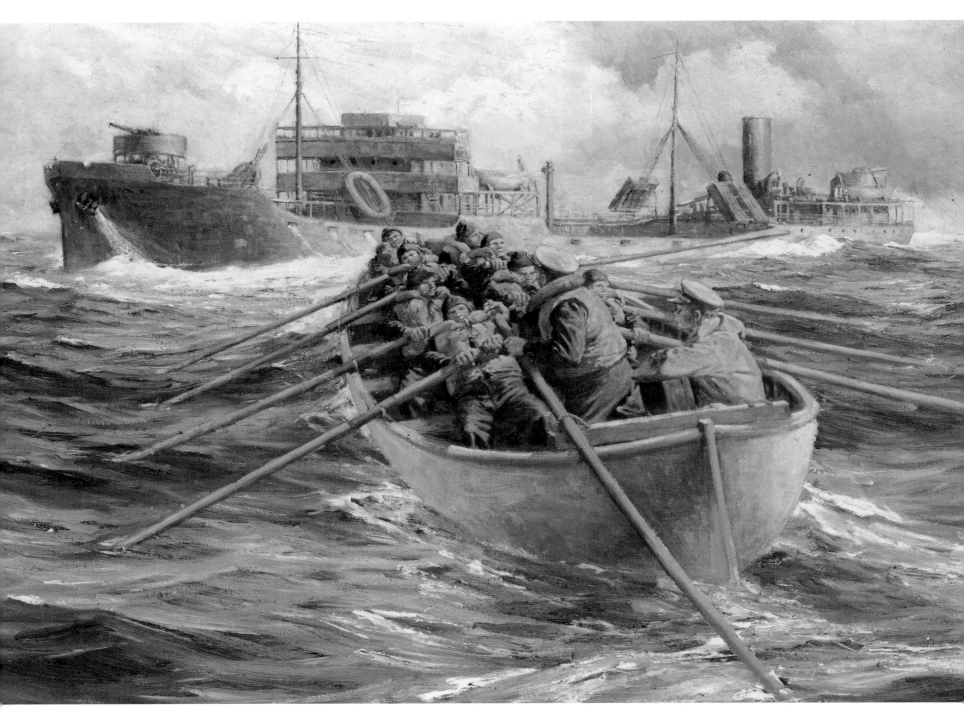

Above: Fischer's *Ship-to-Ship* depicts a difficult maneuver on the high seas. Crews often had to transfer from one ship to another, by rowing a lifeboat in heavy seas and frigid weather. One mishap and they were often "goners."

The *Campbell*'s engine room flooded and all power failed, leaving the wounded ship dead in the water. Hirschfield was bleeding from flying metal that had struck him in the back. The cutter spent a tough night drifting helplessly and expecting at any moment to be stove in by a Nazi torpedo. Finally, a Polish destroyer came alongside to screen them. Three days later, a small tug, which had come unprotected across 800 miles (1287km) of open sea to fetch them, arrived and towed the groaning hulk to safety in the nearest harbor in barren, ice-encrusted Iceland.

Eventually making his way back to his Woodstock, New York, studio with rough sketches and vivid memories, Lt. Comdr. Fischer undertook to add another series of marine paintings to his distinguished repertoire, this time, like none he had ever painted before—firsthand battle depictions of unforgettable experiences. His dramatic paintings were published in the 5 July 1943 issue of *Life* magazine. Many of them now reside permanently at the Coast Guard Academy Museum in New London, Connecticut.

Painted with astonishing accuracy, Fischer's work ranks with the great maritime artists of all time—the Dutch masters, Birch, Cornè, Buttersworth, and others. Equal to these accomplished painters in style, technique, and mastery of the oil medium, Fischer adds an element that many of his predecessors could not—the veracity that comes with eyewitness experience.

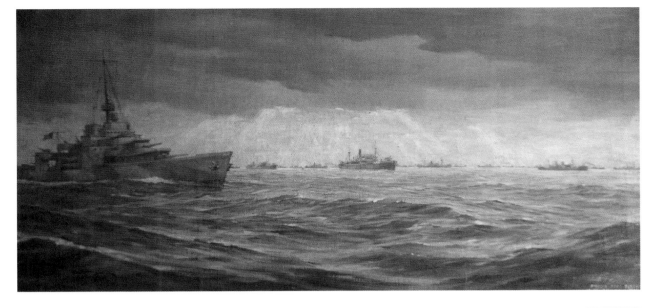

Top: Lt. Comdr. Anton Fischer depicts the scene as, like a brood of giant ducklings herded by protective parents, a massive armada spreads in orderly rows from horizon to horizon, relentlessly advancing at a vulnerable ten knots or so. With constant danger lurking beneath them, the convoys continued, over thousands of miles of hostile ocean, through countless storms and rough seas, to deliver food and war materiel to beleaguered Britain and Russia. These vital convoys were the lifeline that saved the Allies from destruction and the largest assemblages of naval fleets the world has ever seen.
U.S. Coast Guard Collection

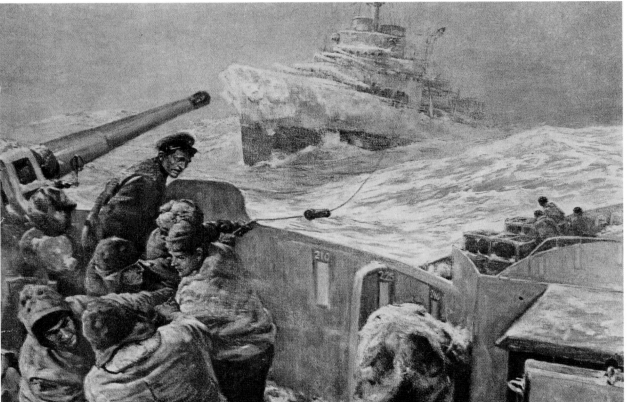

Center: There was no easier way to transfer convoy papers in icy, rough Atlantic waters than by line, often, as Fischer shows here, shot from one ice-encrusted escort cutter to another. With continued radio silence, these watertight containers were the only solution for dispensing information that was too complex to send by Morse code signal lights. The convoy papers carried vital details about ship names, convoy positions, cargoes, and destinations, as well as instructions in case of submarine attack.
U.S. Coast Guard Collection

Bottom: In *Brief Encounter*, Fischer takes an illustrator's point of view for the sake of drama, showing the viewer how the attack on a U-boat would have looked to a detached observer. Fischer faithfully captures the intense and critical moments of victory for the cutter *Campbell*, with the unidentified U-boat about to go under. The entire life-and-death episode transpired in less than five minutes.
U.S. Coast Guard Collection

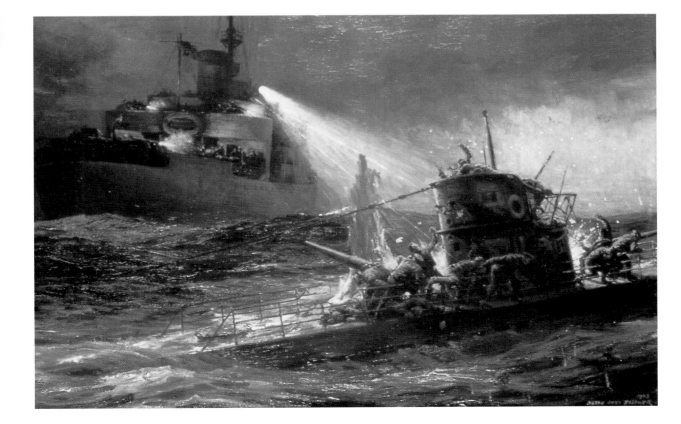

Other Coast Guard Artists

The other active duty Coast Guard artists included a noted muralist from the WPA program of the 1930s, George Gray, who would later head the NACAL program supplying artists for the naval services during the Vietnam War. The mixture of illustrators and fine artists also included such talents as Gary Z. Antreasian, Torre Asplund, Robert Daley, Ralph DeBurgos, R. Dickerson, James Fisher, John J. Floherty, Jr., USCGR, Smn. Gretzer, Sherman Groehnke, Smn. Jensen, Jack Keeler, William Goadby Lawrence, George Payne, Ken Riley, Michael Senich, Norman Thomas, CBM Hunter Wood, H.B. Vestal, and CWO John Wisinski. Most saw action in major engagements in the Pacific and during the Allied amphibious landings in North Africa, Italy, southern France, and Normandy.

The constant menace of a sudden explosion from a U-boat torpedo—which could send an unfortunate freighter, its crew, and cargo to a watery grave—coupled with the frigid temperatures, icy gales, and rough waters of the North Atlantic, made for some of the most arduous duty of the war. Combat in any war zone was usually sporadic and relatively short-lived, with a beginning and an end. Convoy duty was continual, unrelieved, and never-ending. The unsung heroes of this facet of World War II were the civilian crews of the Merchant Marine, who manned the cargo ships and suffered as severely as any combatant. The Merchant Marine was never recognized by Congress as a part of the military, and therefore the crews, despite the dangers and combat they endured, never received the benefits the uniformed military did.

Below: When sonar detected a potential submarine threat, the *Campbell* tossed depth charges into the briny deep as Fischer depicts here. On many occasions, these lethal drums of explosives found their marks, with the tremendous pressure of the underwater explosion crushing the hull of the menacing U-boat.
U.S. Coast Guard Collection

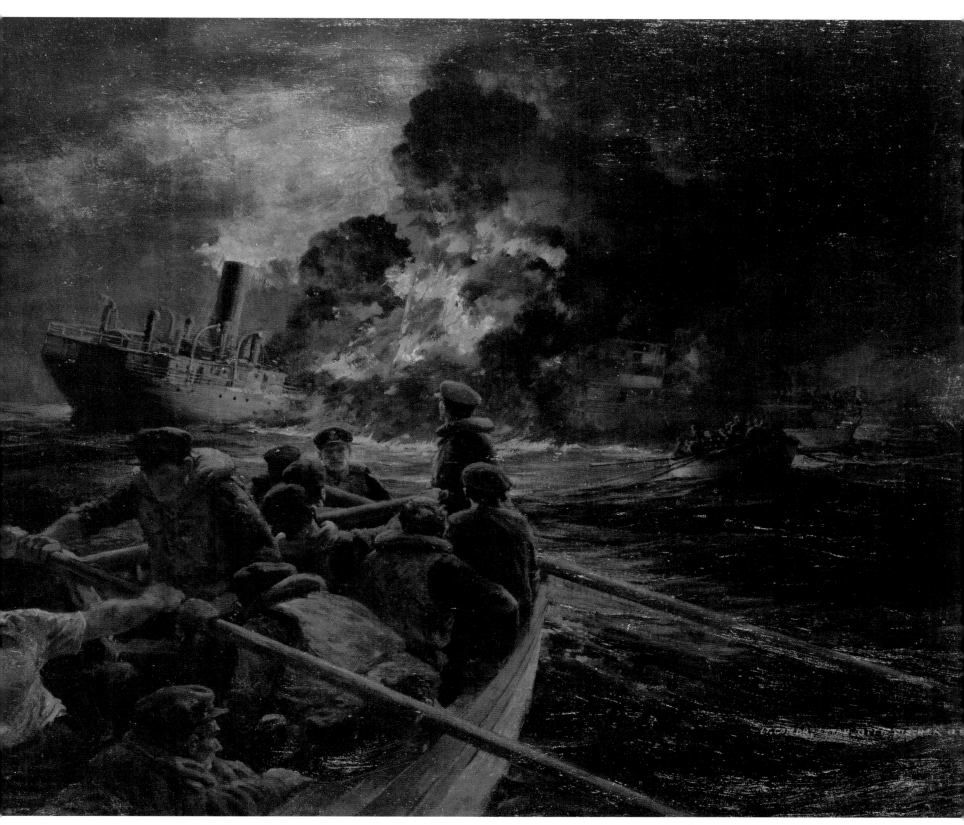

(They did, however, receive union benefits and pay often above that of the military.)

Coast Guard vessels like the *Campbell* and others often had to pick up survivors from torpedoed merchant vessels who had been lucky enough to escape the sinking ships. All too often, though, both crew and cargo went down quickly in the frigid, inky seas. During World War II, incredible scenes, such as those witnessed and pictured by Fischer, were almost commonplace among the Coast Guard,

Navy, and Merchant Marine, which manned most of the cargo ships. Navy gun crews were usually aboard to man the 20mm cannon, 40mm machine guns, and three-inch guns that the cargo ships carried to defend themselves.

Abbott Laboratories' Artist Kerr Eby

Kerr Eby's powerful charcoal-graphite pencil style was already recognizable from his combat art coverage of World War I. In World War II, as a combat artist on

Above: Fischer portrays the lucky survivors of a torpedoed merchant ship being rescued at sea. Those fortunate enough to escape in lifeboats were frequently picked up by patrolling destroyers and Coast Guard cutters like the *Campbell.* As witnessed by Fischer, dramatic scenes such as these gave him subject matter perhaps unequalled in the annals of maritime art.

U.S. Coast Guard Collection

assignment for Abbott Laboratories, he would create some of the most memorable art to come out of the war.

When the Marines landed at Tarawa on 20 November 1943, Eby was there to witness and experience the bloody amphibious assault across a few hundred yards of shallow coral reef surf. Before they could reach the beach, hundreds of valiant Marines were mowed down in a withering hail of enemy bullets. The staggering losses almost spelled disaster for the Americans in their first amphibious landing against a known entrenched force—all concentrated on a small strip of land that was only a mile (1.6km) or so wide. Yet the Marines prevailed, and when the three-day battle ended, more than 4000 Japanese had died while more than 1000 Marines and sailors were killed and another 2500 wounded. (In subsequent amphibious landings, preliminary naval and air bombardments were greatly intensified; even so, many later landings were equally as murderous and bloody, due to the Japanese Army's military code, *Bushido*, which honored valor over life, making surrender out of the question.) Tarawa has since taken its honored place in Marine Corps annals along with Tripoli, Montezuma, and later World War II battles like Saipan, Peleliu, Iwo Jima, and Okinawa.

Kerr Eby was born in Japan to missionary parents in 1889. Moving to the United States in 1907, he studied art and was a printer's "devil" (doing the dirty jobs like

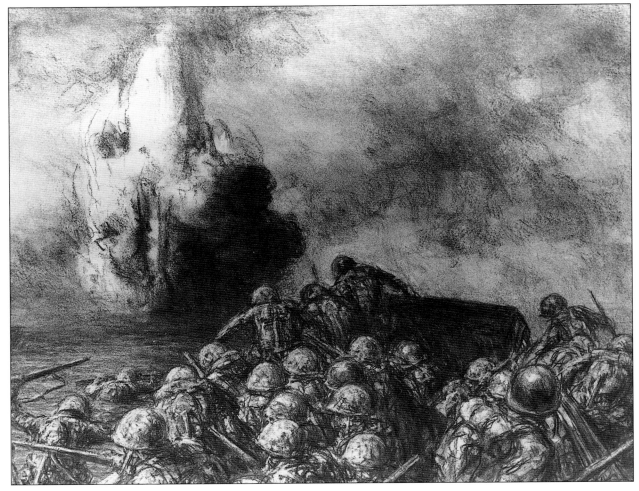

Above: In this February 1944 photo, Eby is shown sketching Marine pilot 1st. Lt. Robert M. Hanson, who was a quintuple ace. (He shot down twenty-five Japanese planes.) Shortly after this sitting, Hanson was reported missing in action over Rabaul. He was awarded the Medal of Honor posthumously.

Left and Opposite: Tarawa was a costly lesson for the Marines. Despite several hours of heavy naval gunfire and aerial bombing pounding the atoll, the force of some 4800 Japanese defenders was hardly affected. Consequently, when a coral reef stopped the Marines' second assault wave one thousand yards (914m) from the beach, forcing the Marines to disembark from their light amphibious vehicles and slog their way through waist-deep surf, the Japanese were able to pummel them with automatic weapon fire. Row upon row of valiant Marines were mowed down in the first hour, with more than 500 dying in the surf without ever reaching the beach. Eby, incredibly, was among those who reached the beach. His intense experience and keen eye culminated in a series of eyewitness sketches of remarkable artistic merit. As portrayals of the horrors of war, Eby's Tarawa sketches stand with the work of artists like Francisco Goya, Otto Dix, and Tom Lea.
U.S. Navy Combat Art Collection

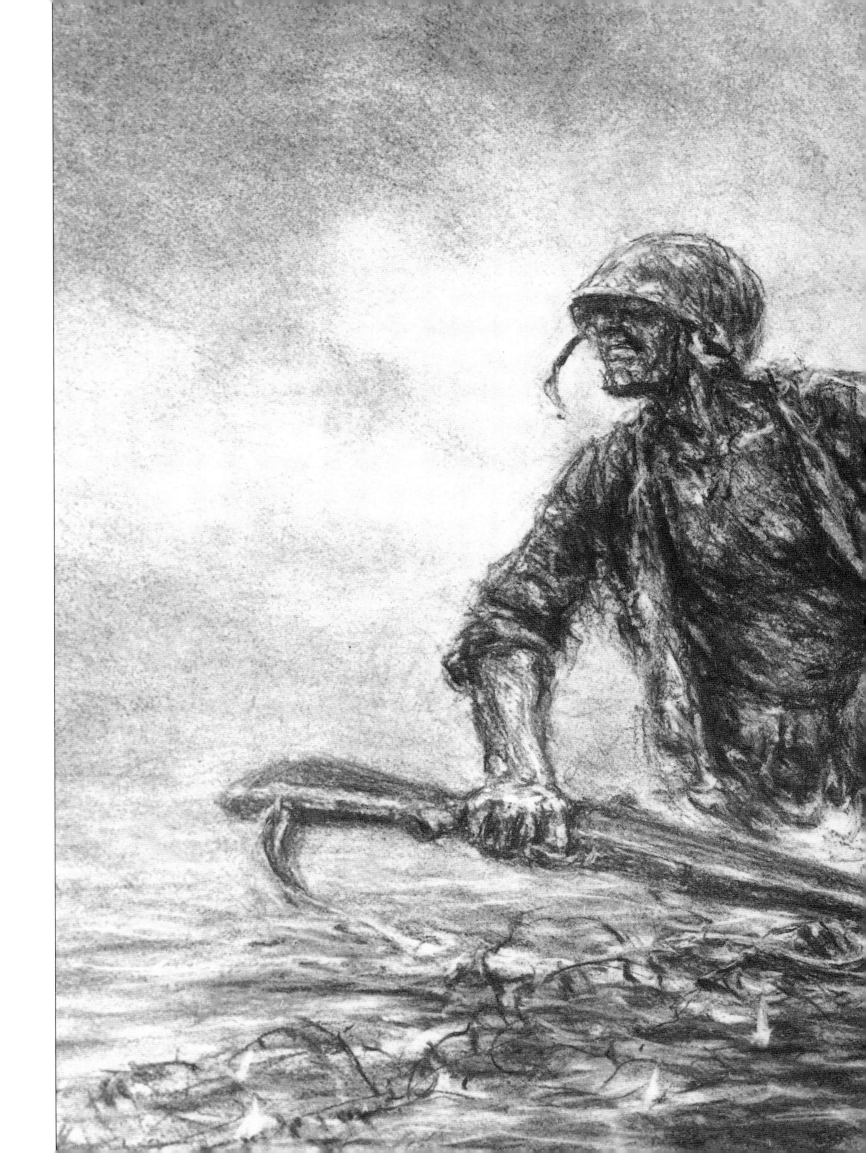

World War II: 1941–1945 173

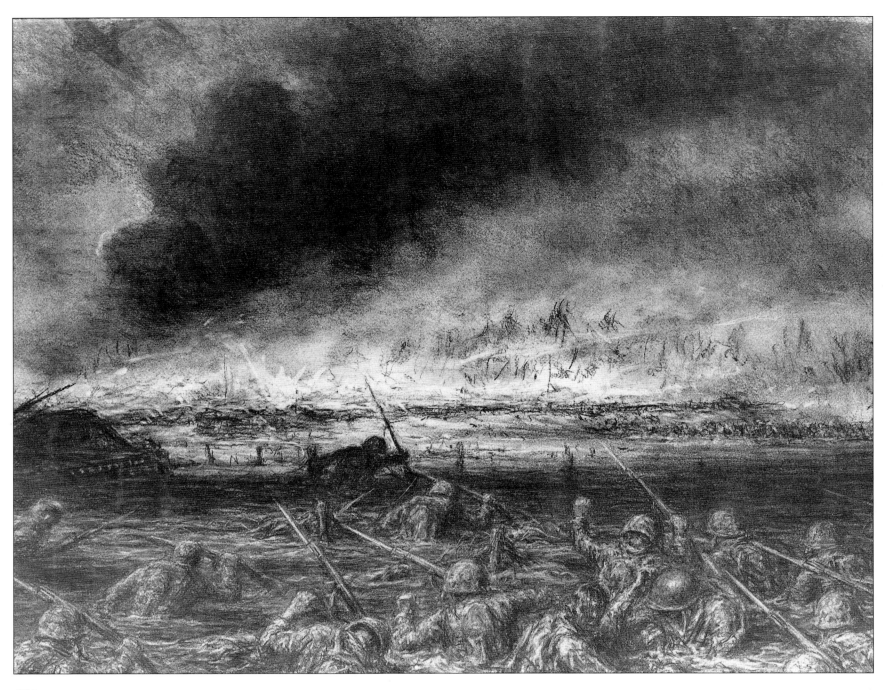

Above: Eby's sketch of Marines struggling through the surf to reach the beachhead at Tarawa.
U.S. Navy Combat Art Collection

inking the plates) for a small country newspaper. Through study at the Pratt Institute and the Art Students League in New York City, he perfected his unique drawing technique. In 1917, he enlisted in the Army, eventually rising to the rank of sergeant in the Army Engineers. On the battlefields of France, including Belleau Wood, Chateau-Thierry, Saint-Mihiel, and Meuse-Argonne, he made a number of drawings and sketches, which he later engraved. Eby's World War I work gained him national recognition.

He continued to refine his art from the Great War and in 1936 published a collection of his World War I work in a volume entitled simply *War*. His war experiences had profoundly affected him, and in the book's introduction, his friend Dorothy Taylor Arms, wife of the noted artist John Taylor Arms, wrote: "Increasingly, he [Eby] rendered the war in two senses: he transmitted the war experience visually, but also he extracted from it, melted it down into human terms, and clarified its meaning."

Eby's own words in his introduction to *War* disclose the effect that war had on him:

> I write with all humility of spirit, in the desperate hope that somehow it may be of use in the forlorn and seemingly hopeless fight against war. About the prints and drawings in this book I make no comment, save that they were made from the indelible impressions of war. They are not imaginary. I saw them.

He further warned against the horrors of war in the book; yet, when World War II came, he dutifully went off at age fifty-two to portray it again—with biting realism.

Certainly, no more profound indictment of war can be found than in his graphite drawings of the nightmarish hell he found himself in at Tarawa. They are timeless and convey the meanness and agony of combat in universal terms.

After Tarawa, Eby said of his art: "What difference does the medium make? It is the truth. I make these for the Marines. To hell with art."

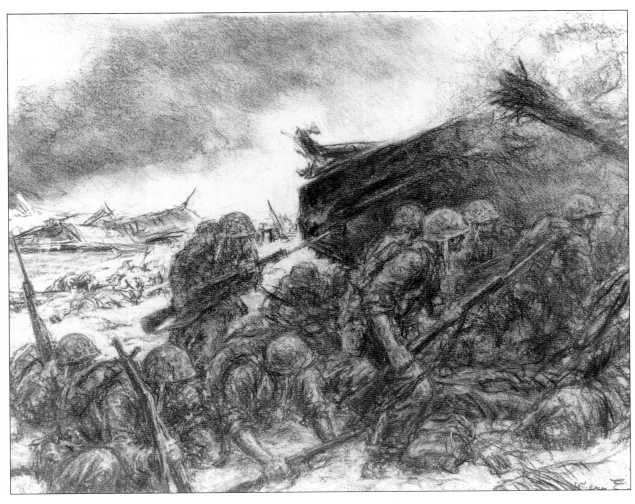

Left and Below: The assault in the Pacific was a new kind of war for Kerr Eby. Although he had fought in the trenches in France in World War I, nothing could have prepared him—or anyone—for the hell that greeted the invading Marines on Tarawa's Betio Island. **U.S. Navy Combat Art Collection**

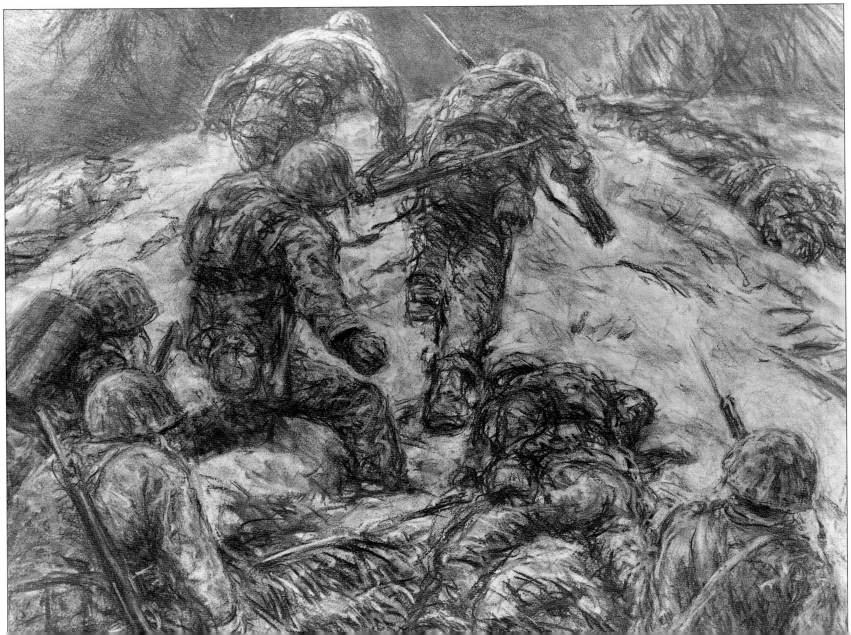

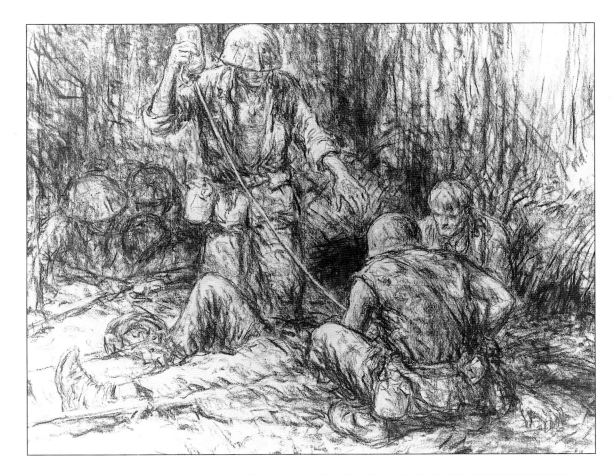

Right: Kerr Eby captures a poignant scene as a wounded Marine is attended to by his buddies. *U.S. Navy Combat Art Collection*

Below: Eby's sketch of the evacuation of wounded Marines in the shifting sands of a bomb crater. *U.S. Navy Combat Art Collection*

Opposite: Eby powerfully depicts the aftermath of the battle on Tarawa's Betio Island. The numerous casualties, debris, and carnage offer mute testimony to the brutality of the battle that took place. It also highlights the futility, in the long run, of such encounters. Shortly, all the carnage will be cleaned up, the wounded evacuated, the dead buried, and the island either abandoned or occupied by a small garrison that will, in turn, be abandoned once its strategic significance ceases to matter. *U.S. Navy Combat Art Collection*

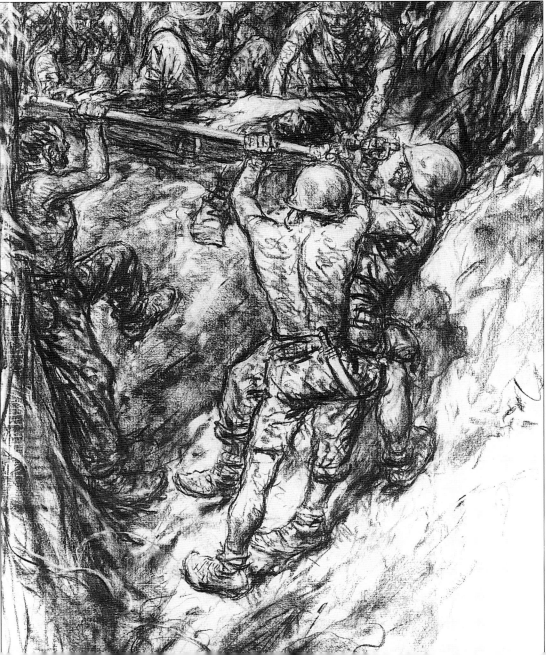

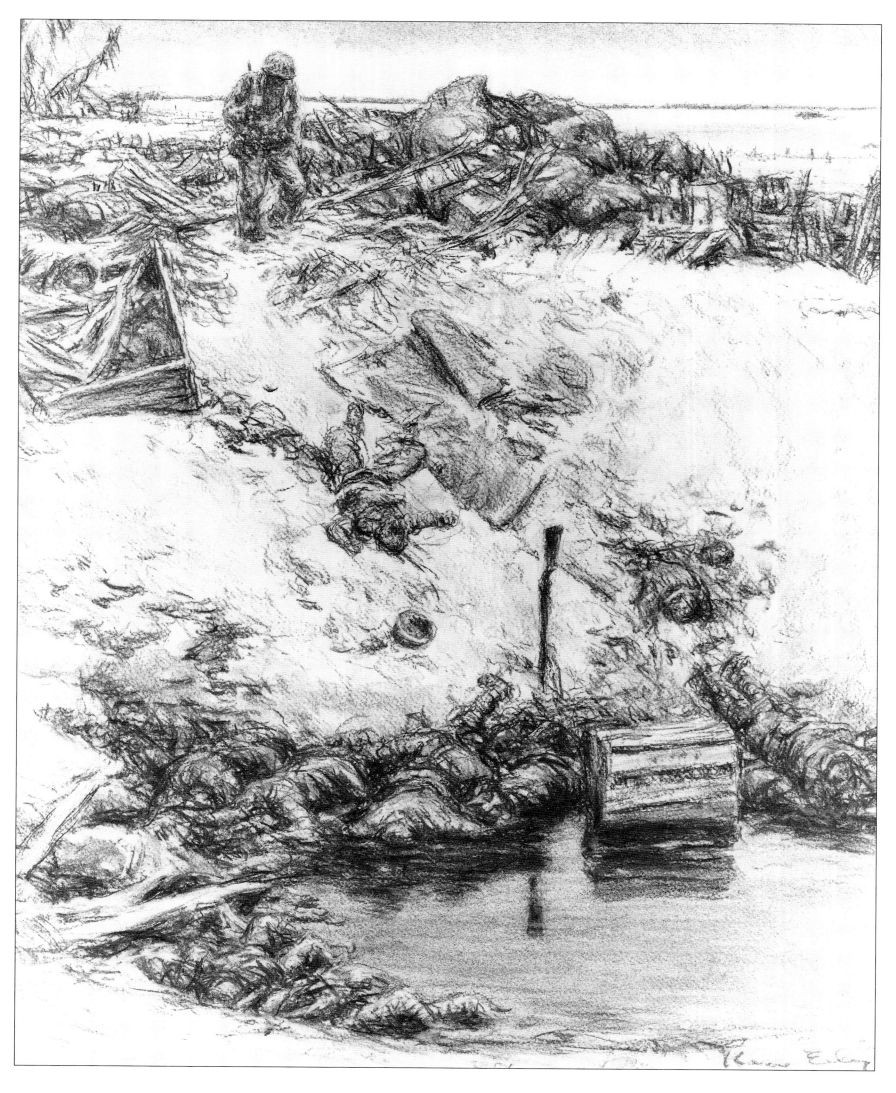

Bougainville: December 1943

During the four months following Tarawa, Kerr Eby was with the Marines in other heavy fighting, including the Battle of Empress Augusta Bay on Bougainville. He lived for three weeks in a foxhole on the front line, rough sketching the jungle fighting and eventually catching malaria, the tropical disease that likely hastened his death two years later. In the foreword to the Abbott Laboratories catalogue published after the war, Marine Maj. Gen. Julian C. Smith, commander of the amphibious assault at Tarawa, wrote of Eby:

> No insight thus afforded can compare with that offered by a perusal of the works of Kerr Eby. For long months, this distinguished artist, no stranger to war, shared the dangerous life of the Marines in the Pacific. He landed with us at Tarawa, and he went on from that terrible battleground to live with Marines fighting in the jungle warfare of Bougainville. He slept on the hard coral, he slogged through the jungle mud, he shared the minor pleasures and the major discomforts of the Marines at war, the good hot cup of coffee at the end of thirty hours, the threat of enemy bombs and shells and bullets near him. Like many a Marine, he fell prey to tropical ills; one of his weeks on Bougainville was spent in a hospital. Kerr Eby was with the Marines long enough to get the feeling of their war, with rapid sketches on the spot, whether in jungle skirmish or at beachhead landing or just living between battles, he used his art to capture that feeling and make it visible to all. It is small wonder, and yet it is the eternal miracle of art, that his finished paintings and drawings are so richly successful. They have caught the dramatic intensity and the spirit of the men at war, the very feeling of the man in battle, the trudging through the jungle and the terrible murky heat, the charge on the pillbox, the savagery, the terror, the exhaustion of battle.

Kerr Eby died in 1946. He was a member of the National Academy of Design and the Institute of Arts & Letters, among other distinctions.

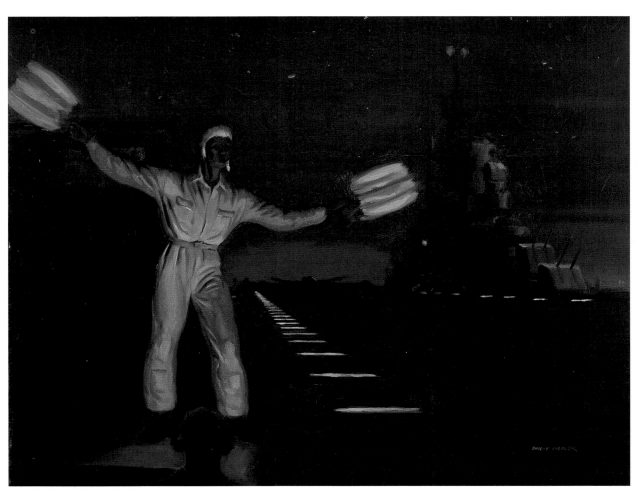

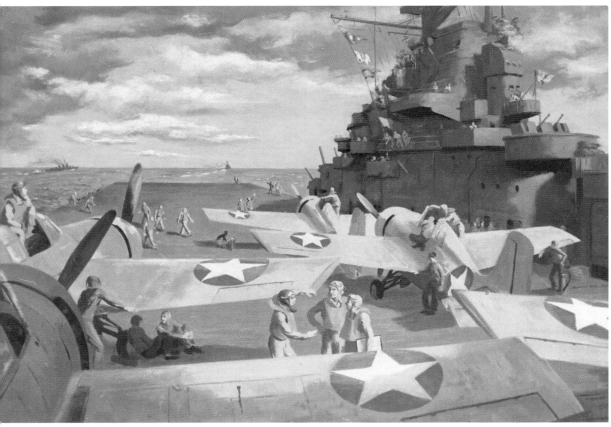

U.S. Carrier and Submarine Operations in the Atlantic and Pacific

After recovering somewhat from the shock of Pearl Harbor and the fleet losses there, the United States was faced with a two-front war on opposite sides of the world separated by two oceans.

Actions in the Atlantic concentrated on protecting merchant convoys from German submarines, since the three capital ships of the German Navy had been sunk by the British. The Coast Guard and small Navy carrier escorts patrolled the Atlantic seaboard to sink any Nazi U-boat brazen enough to surface to shell defenseless "liberty" cargo ships or to land saboteurs on shore. Larger fleet elements were amassed in European waters for the pending invasion of France, although none were aircraft carriers; air cover and interdiction was left to the Army Air Corps.

The war in the Pacific was another matter. Great armadas of ships and planes were needed for the two-pronged attack on the Japanese-held islands. Replacing battleships, aircraft carriers were the new backbone of the fleets. Having lost three of the original four carriers in the early battles of the war, the United States produced almost a hundred new ones by war's end. They formed the core of Navy battle groups and Navy-Marine task forces, which ultimately crushed the Imperial Japanese Navy and its air components.

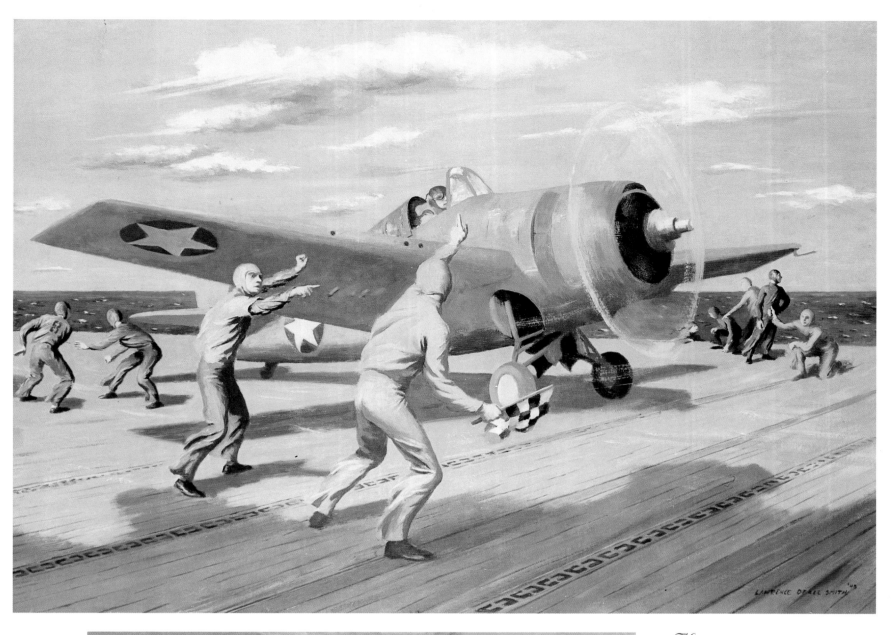

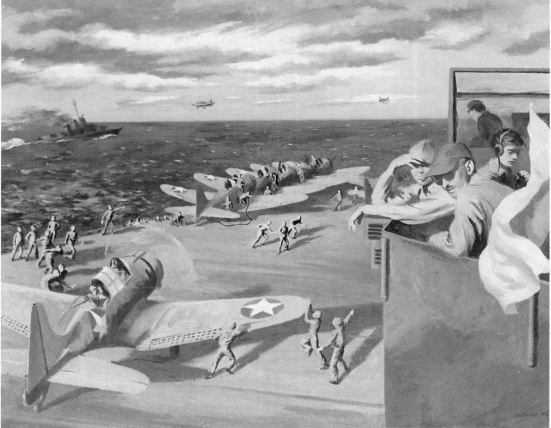

Above: In Lawrence Beal Smith's *To the Attack*, part of the Abbott Laboratories series on naval aviation, a stubby F4F-3 Wildcat is given the takeoff signal by a deck crewman. Early in the war, the United States eliminated the red dot in the middle of the white star insignia because it resembled too closely the large red "rising sun" on Japanese aircraft. Later, a broad white horizontal stripe was added on either side of the circle for easier identification at a distance. Japanese naval aircraft were usually painted white; U.S. Navy planes were blue-gray, while Army Air Corps planes were olive drab.

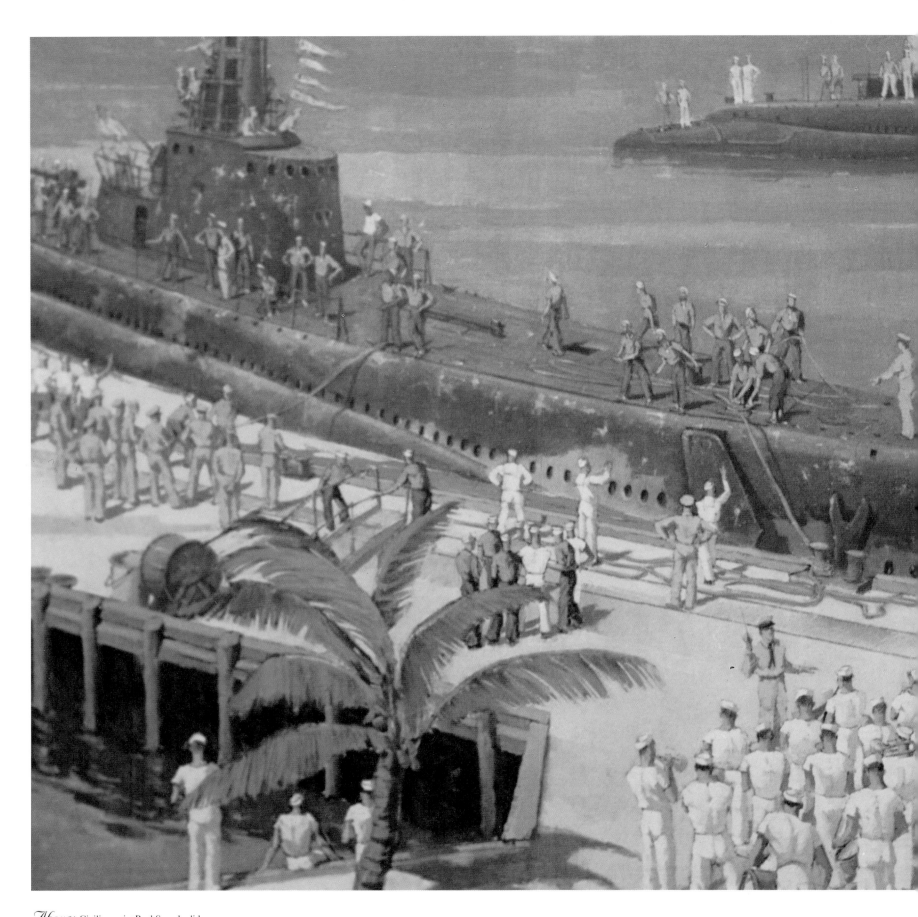

Above: Civilian artist Paul Sample did a number of fine series for *Life* magazine, including one on submarine duty in tropical waters. In *Patrol's End*, the scene at the dock captures the flavor aboard a submarine as it returns from a long patrol. A Navy band welcomes the returning crew with a tune, perhaps the "Beer Barrel Polka," while the excited sailors' thoughts are no doubt fixed on the beer drinking and female companionship they plan to enjoy after months at sea without either.
U.S Navy Art Collection

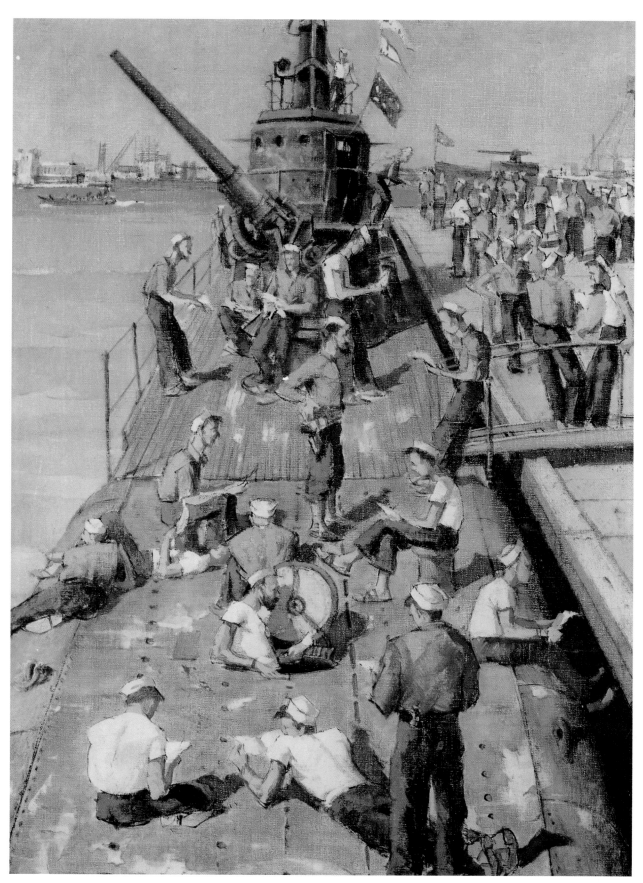

Above: In *Mail Call*, Paul Sample depicts sailors aboard a submarine receiving long-awaited mail from home. Perhaps even more than any of the pleasures afforded by shore leave, mail from home was the most eagerly anticipated event for a sailor. Many of the letters in the sack might be months old, having traveled far and wide to catch up with the sailor's vessel, but every word was read over and over, and every memory cherished, in the semi-privacy of the bunks below decks.
U.S Navy Art Collection

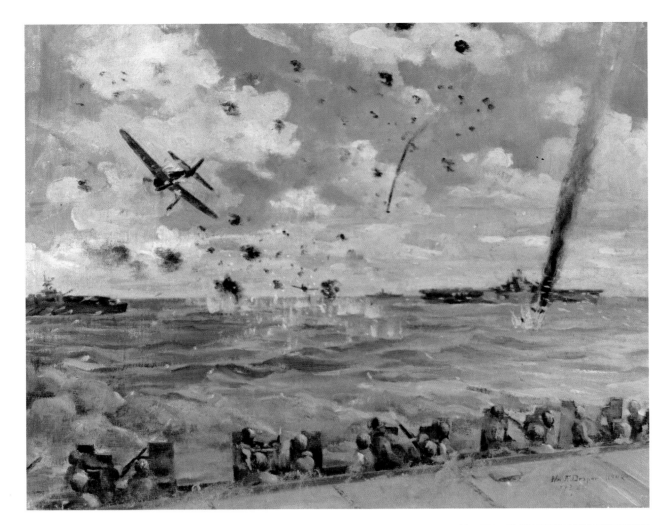

Right: Navy combat artist Lt. William Draper's *Japs Feel the Sting of Our AA* portrays the air and sea battle off Truk that he witnessed from a carrier.
U.S. Navy Art Collection

Below: In *All Hands Below*, artist Georges Schreiber catches a moment of relaxation in the crew's quarters among the live torpedoes. Space was at a premium aboard a submarine; bunks were perched in every nook and cranny, much as hammocks had been in the days of sailing ships.
U.S. Navy Art Collection

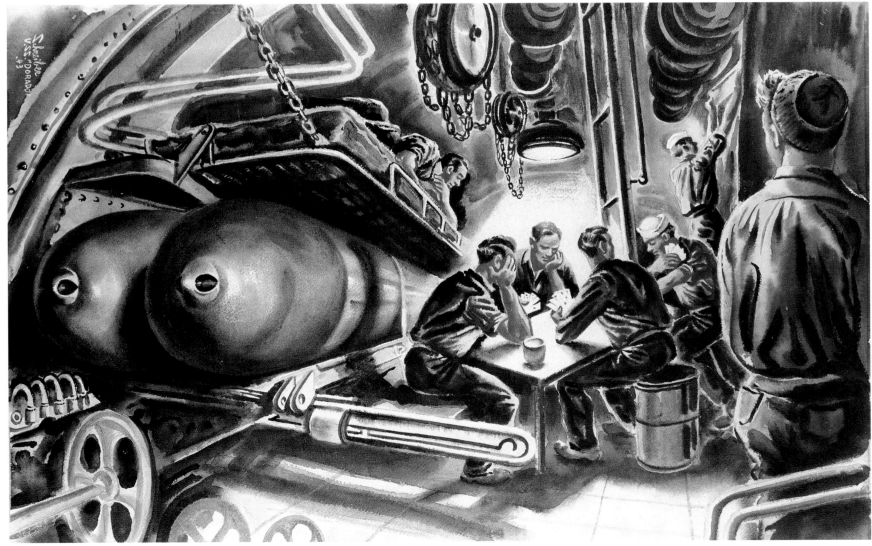

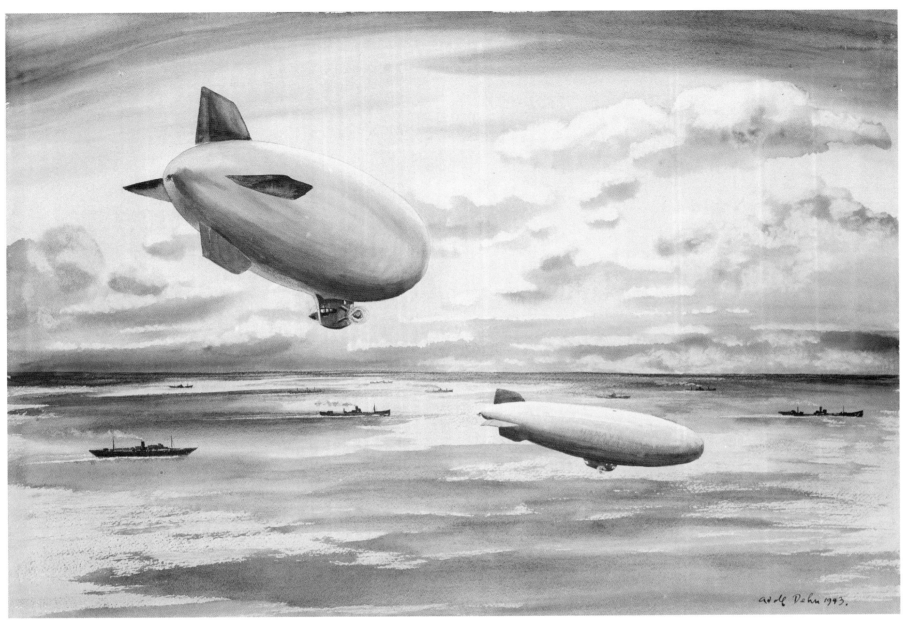

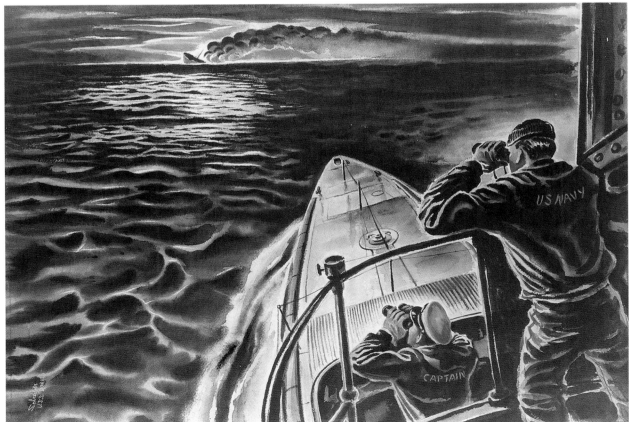

Above: Rigid-frame dirigibles played a minor but important role in World War II. While inflatable barrage balloons were usually tethered aloft on ships to thwart low-flying aircraft, dirigibles had crews who flew them and performed observation duties. These aircraft could drop depth charges in their offshore convoy antisubmarine activities along the Atlantic coast. An Abbott Laboratories artist, civilian Adolph Dehn, captures this activity somewhere off the Atlantic seaboard in *The Convoy Brood.*
U.S. Navy Art Collection

Left: It was quite unusual for a civilian to go on a combat cruise on a submarine; however, in 1943, Abbot Laboratories artists Georges Schreiber and Thomas Hart Benton were able to go aboard the USS *Dorado* on her shake-down cruise. Both artists' paintings of the target practice are similar. Schreiber's, depicted here, was titled simply *The Kill.* The *Dorado* was later lost at sea on a combat mission. Benton's painting is on page 23.
U.S. Navy Art Collection

Right: In his spare time, Navy CPO Lawrence Urbscheit turned out many fine drawings and watercolors depicting the activities of his unit. In this watercolor he portrays the maintenance shop where a PBY Catalina patrol aircraft is being repaired. The beloved PBY competed with the Douglas DC-3 as the best-known airplane of World War II. It was flown in sea regions all over the world, had adequately long range, and was easily maintained. Amphibious, it could land on either land or water.
U.S. Navy Museum

Below: Civilian artist Howard Baer, working for Abbott Laboratories, portrayed some of the many contributions to the war effort by women who, besides office work, did such hands-on jobs as riveting and welding in aircraft maintenance and repair shops. *Patched to Fly Another Day* depicts sailors and WAVs working together.
U.S. Army Art Collection

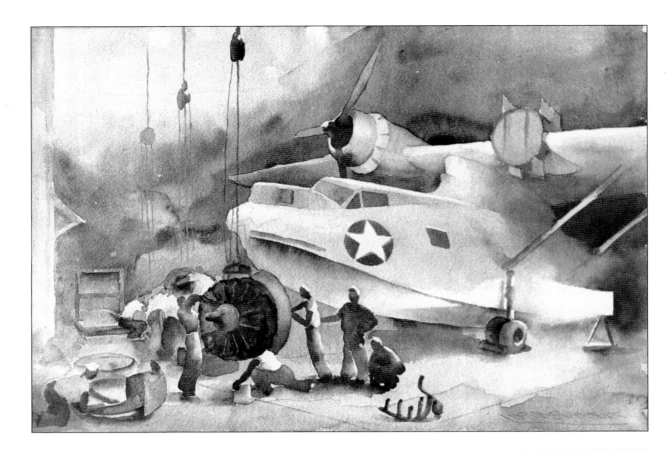

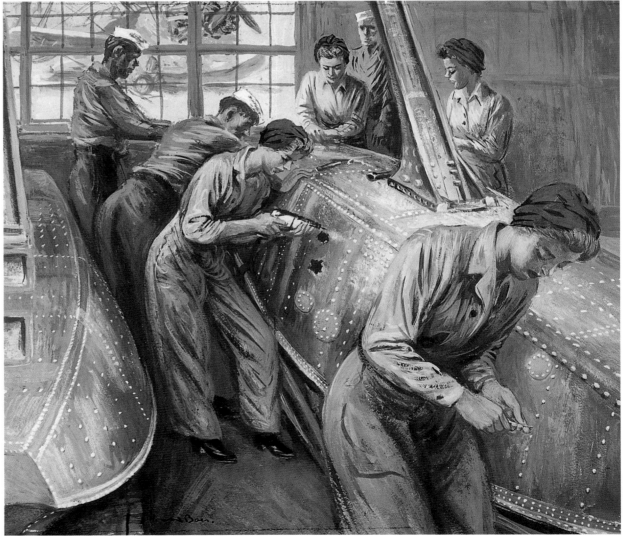

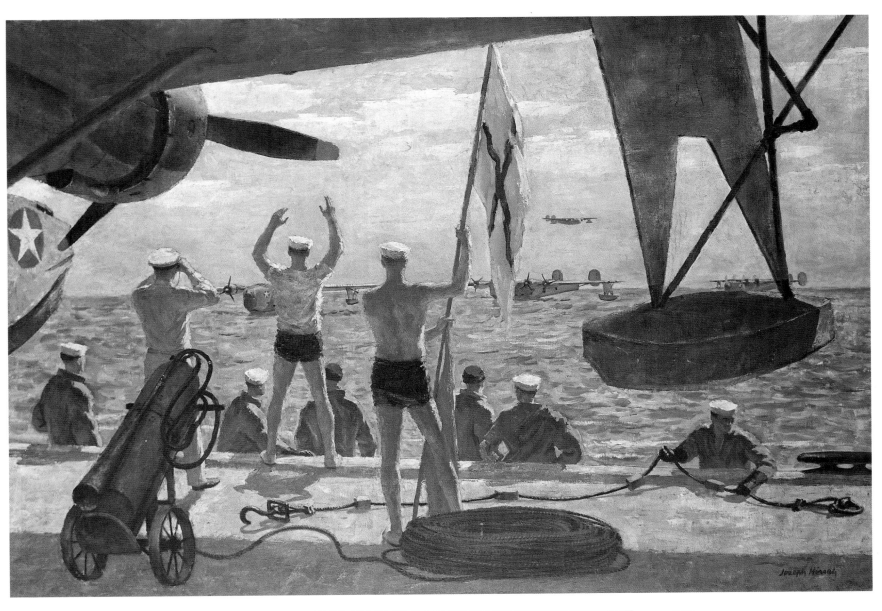

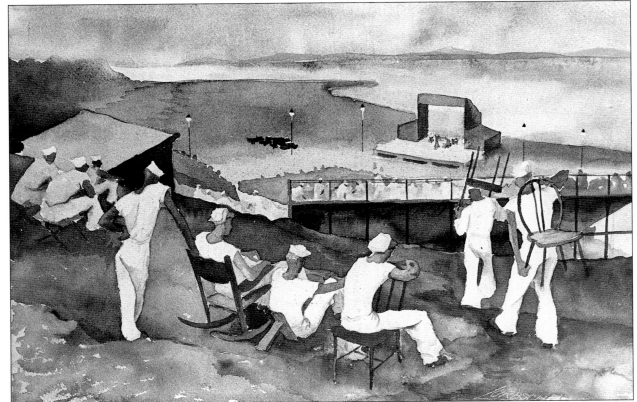

Above: Abbott Labs artist Joseph Hirsch portrays a scene familiar to patrol aircraft crews: the mooring of the Martin four-engine Mars flying boats that are taxiing in the waterway after completing their missions.
U.S. Navy Art Collection

Left: Urbscheit was an undiscovered talent who captured in watercolors his part of the war in the Caribbean. Since it was not an active combat area, there was a great deal of recreational time while surface and aerial patrols were taking place. Throughout all war zones, the evening movies or live USO shows with Hollywood movie stars and entertainers, sometimes performed in outdoor theaters, were eagerly anticipated when enemy air attacks were not imminent.
U.S. Navy Museum

Above: Lt. (jg) Tracy Sugarman poses aboard LST 357.
Collection of the artist

Right: Soldiers off-load an LST in this watercolor sketch by Sugarman. LSTs were used to transport and land troops, vehicles, and supplies on secured beachheads in France.
Collection of the artist

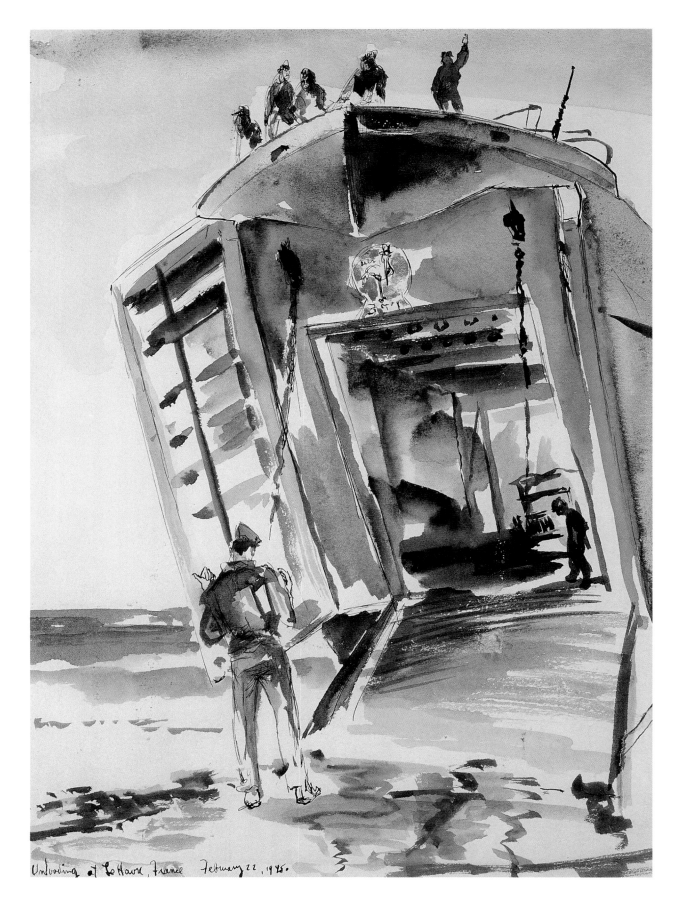

Unloading at Le Havre, France February 22, 1945.

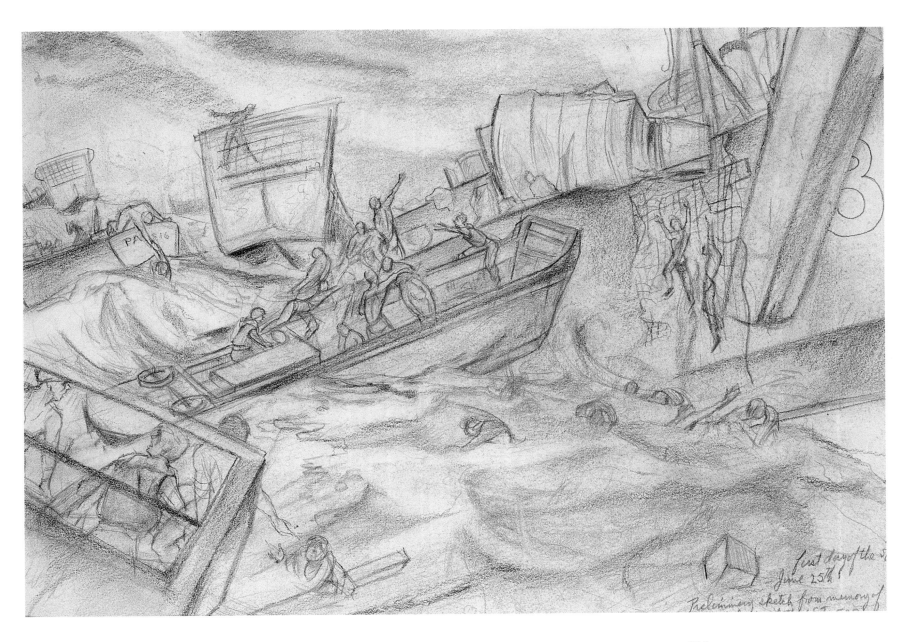

Battlefield Europe

After the victorious Italian Campaign in the Mediterranean, the second step in overturning Nazi domination began on 6 June 1944, when combined Allied forces from England assaulted the beaches of Normandy, France. The retreating and disintegrating Nazi armies would fight American and British forces—as well as the Russians attacking from the east—for another eleven months before the German heartland and the capital of Adolf Hitler's short-lived Third Reich would be crushed.

Tracy Sugarman and the D-Day Invasion at Normandy

Not all artists were discovered and put to work by the military services or the media. There were thousands—perhaps hundreds of thousands—who sketched or painted their experiences for their own amusement and remembrances, or to illustrate the letters they sent home (as Capt. John Thomason had done in World War I). One of

those whose work came to light half a century after the D-Day landing in Normandy was a professional artist named Tracy Sugarman.

In January 1944, Sugarman was commissioned an ensign in the Navy and sent to England to take part in the invasion of France. During his combat tour, he managed to mail some 400 sketches and watercolors, along with love letters, home to his new bride. Fortunately, she saved all of them.

Sugarman's art was brought to the attention of a friend, and on the fiftieth anniversary of D-Day, a selection of his paintings was exhibited at the Navy Memorial in Washington, DC. With the aid of friends, his poignant and moving letters to his wife, June, were edited and, along with a selection of his art, published in a very personal reminiscence entitled *My War: A Love Story in Letters and Drawings*. His letters and artwork offer a unique glimpse of World War II through the eyes of a young, talented naval officer who commanded an LCVP

Above: Chaos reigns as rescue boats attempt to pick up the crewmembers of LST 523, which hit a mine during a storm in the English Channel. Tracy Sugarman, an eyewitness to the event, sketched this tragic and tumultuous scene from memory.
Collection of the artist

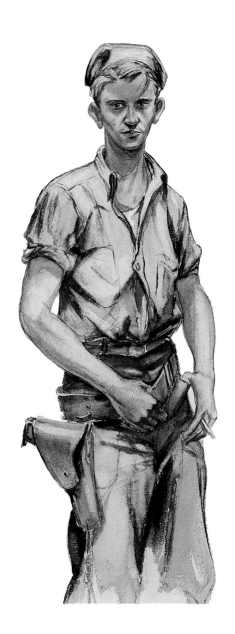

Left: A crowd of onlookers gathers round Sugarman as he sketches at Le Havre, France, in 1944.
Collection of the artist

Below: On the heels of the massive Allied invasion of Normandy the previous June, Lt. Albert K. Murray depicted the virtually unopposed Allied landing on the coast of southern France in mid-August 1944.
U.S. Navy Art Collection

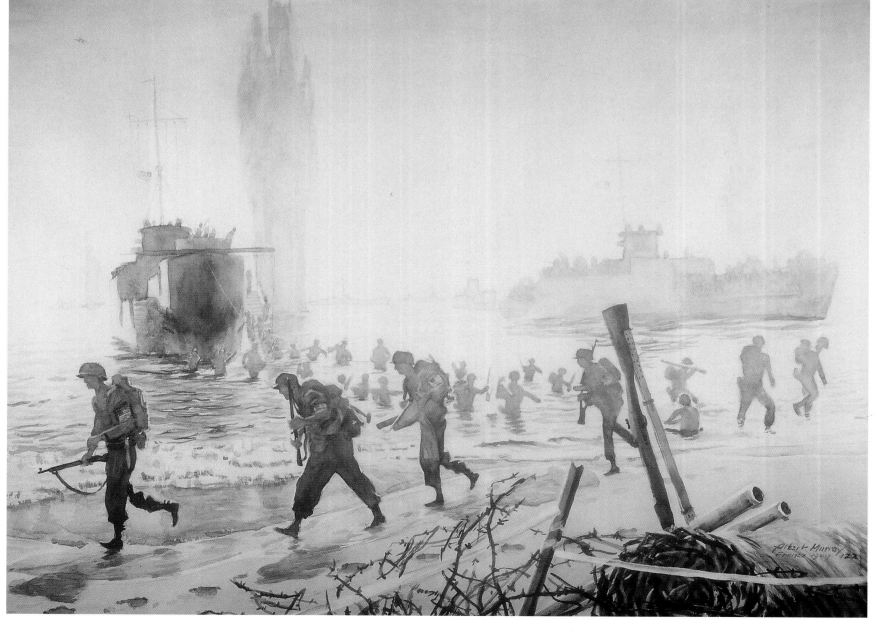

Right: Navy artist Lt. Mitchell Jamieson graphically displays the rough sea at one of the landing beaches on the day of the invasion. Landing craft with both men and supplies were pitched and tossed in the violent surf, throwing them against the underwater barriers that the Germans had strewn along all the beaches on the French coast. Coast Guard crews manned most of the landing craft.
U.S. Navy Art Collection

Below: An LCI (Landing Craft, Infantry) portrayed by Lt. Dwight Shepler as it lay foundering on the beach under hostile fire from Germans defending the heights.
U.S. Navy Art Collection

Opposite Top: Life artist Lawrence Beal Smith shows an ambulance jeep carrying wounded American soldiers back to an aid station. The jeep traverses a dangerous mine field, which has already claimed an innocent bovine victim. A sign with the skull and crossbones and the German word *Minen* warns of land mines.
U.S. Army Art Collection

Opposite Bottom: In the aftermath of a tank battle, *Life* artist Ogden Pleissner conveys the stark destruction in Normandy. The debris of battle, the knocked-out German tanks, the twisted wreckage, the slaughtered animals, as well as the remnants of bodies, weapons, clothing, and personal effects, are all fresh and still smoking.
U.S. Army Art Collection

Pages 194—195: Lt. Dwight Shepler observed the invasion of Normany—code name Operation Overlord—from the DD *Raven* positioned offshore. He later executed this panoramic scene of a sector of the landing.
U.S. Navy Art Collection

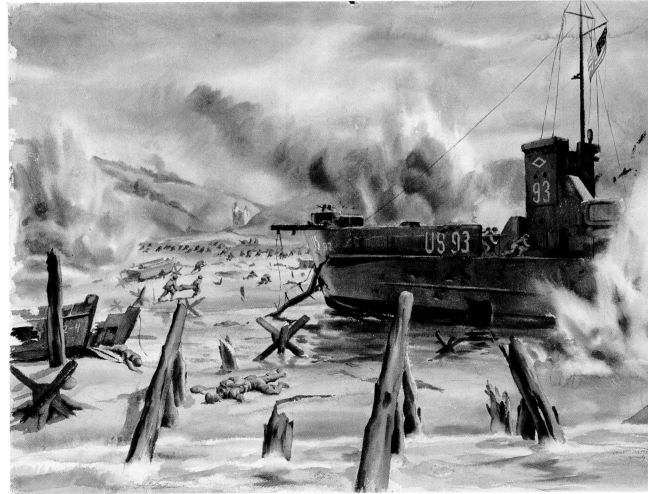

(Landing Craft, Vehicle, Personnel) that brought troops and supplies to Normandy's Utah Beach on 6 June 1944.

Having just graduated from Syracuse University's art studies program, Sugarman was whisked off to war duty in England. The sketches and watercolors he did showed great artistic talent and drawing ability. A certain whimsy in his treatment of figures is reminiscent of Norman Rockwell. Following the war, Sugarman became a nationally known commercial illustrator. Had the Navy discovered his talents (he actually met Dwight Shepler and showed him some sketches), Sugarman might well have joined the distinguished ranks of the official Navy combat artists.

His thoughtful bride no doubt encouraged his art work while overseas. "June's farewell gift of art materials turned out to be a comforting connection to who I was and what I had left behind. Whenever I could steal time on liberties or leave, all that surrounded me, however banal, became grist for my mill. The kids, the villages, the barrage balloons, the pubs, and doughnut wagons, all went into the sketchbooks and got sent home to June," wrote Sugarman.

Reluctant to write June specifics about the invasion, Sugarman described his art instead: "I haven't sketched in a hell of a while, and I think even if I had the materials with me, I would have done very little. D-Day and the days after were not conducive to the old creative instinct. There was a hesitant, negative atmosphere, and too much positive horror and revulsion for a guy to sit and calmly record it. Someday maybe I'll get some of it on paper, but I couldn't then."

Back aboard the liberty ship *T.B. Robertson*, Sugarman wrote in a letter to June, "Invariably when I sketch, a bunch of enlisted men gather around to watch. I've been delighted to find things in some of them I either never knew or had forgotten. Many of them are really and honestly interested and excited by drawing and color. Some of them sit near me and don't say a word—just watch. They're just curious to watch pictures being born, but they're always there. It's funny. The tough language falls away, the laughter's quieter—and they're just kids again."

The Battle of the Bulge

American, British, and Canadian armies—with Free French, Belgian, Dutch, and Polish contingents—blasted their way across Europe, eventually joining up with the Russian armies from the east after almost a year of heavy fighting. The Nazi Wehrmacht—once the most powerful army on the continent—began filling its dwindling ranks with over- and underage conscripts in a last-ditch stand against inevitable defeat.

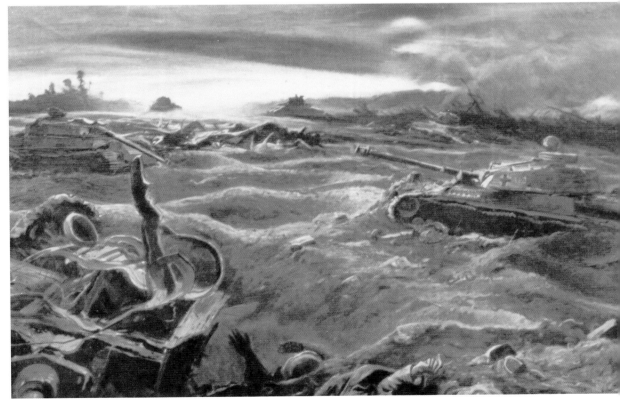

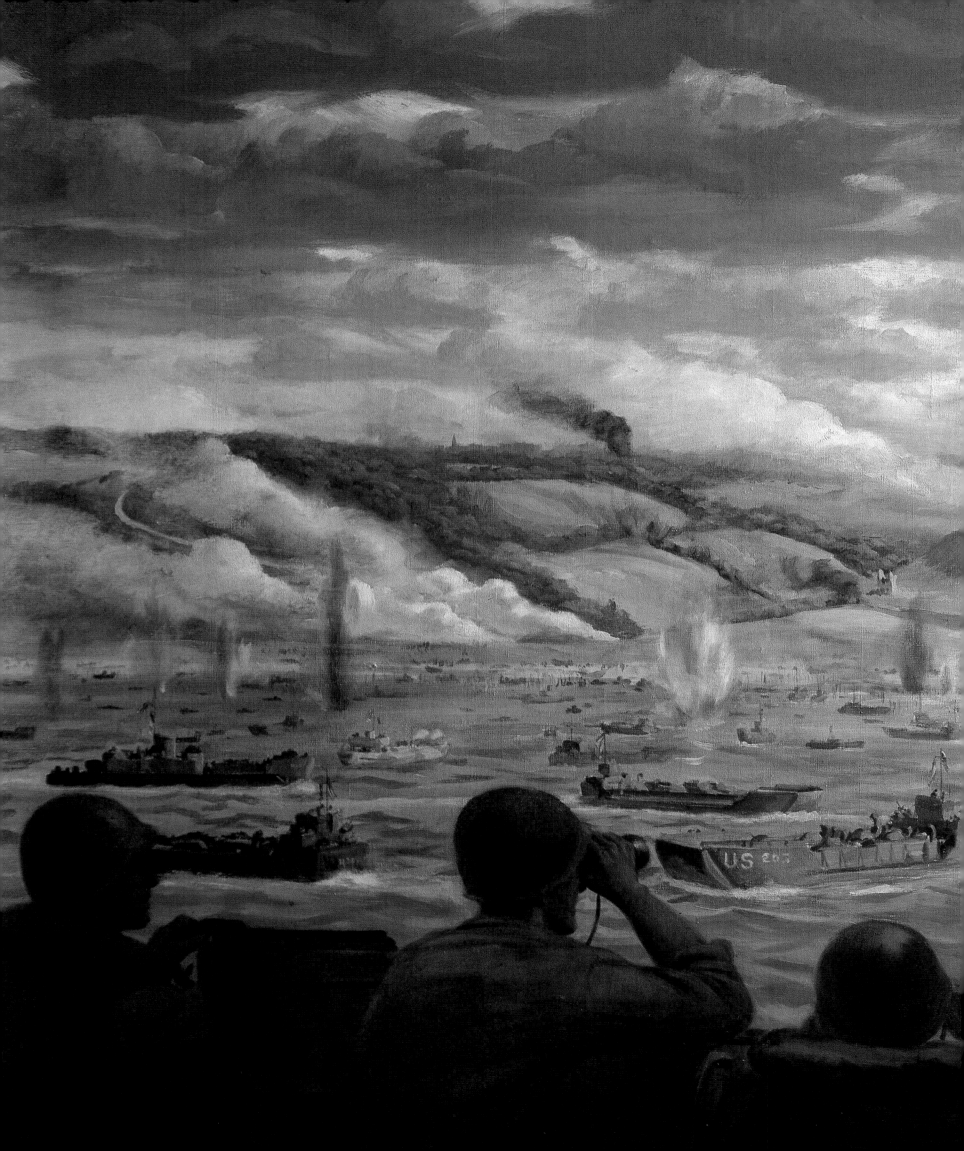

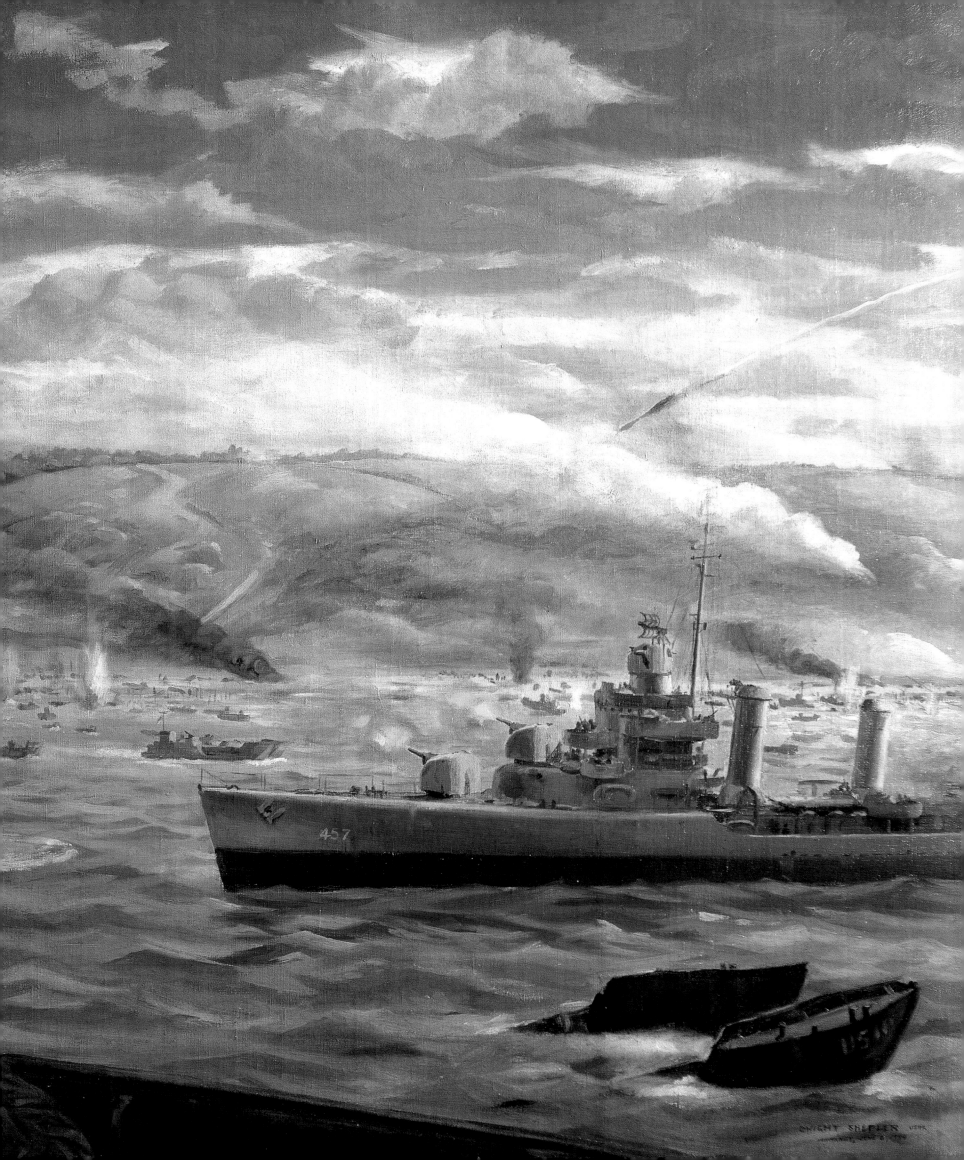

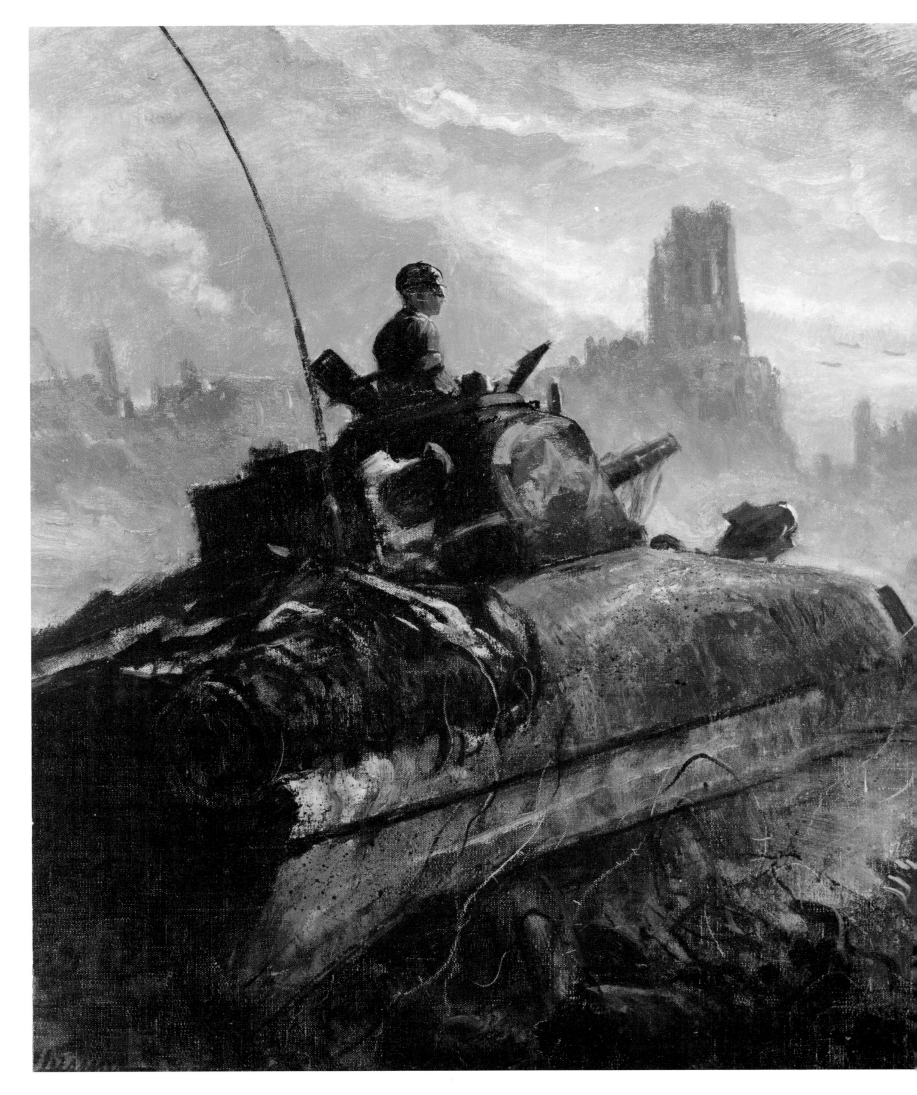

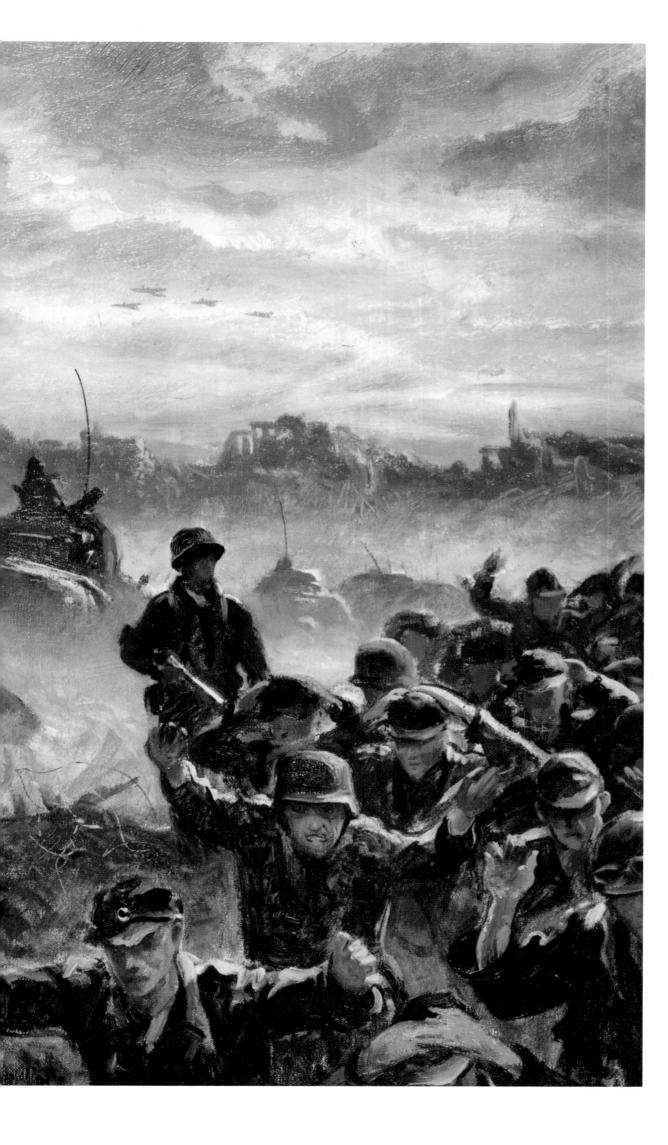

Left: Life artist Ogden Pleissner depicts American tanks slogging their way through the destroyed French town of St. Lô, while German prisoners march under guard in the foreground. The painting captures the universal destruction that occurred in the wake of a war that traversed Europe, moving from the Normandy beaches through France and into Germany, where the Western Allies finally joined the Russian armies converging from the east. As an artistic composition, this painting is extraordinary. The elliptical framing of the scene by foreground and border elements sets off the curving valley-of-death roadway. The indistinct figures and vehicles are silhouetted by the dust they churn up, while the ruins thrust up like jagged mountain peaks, evoking an eerie feeling of the sheer desolation of war.

U.S. Army Art Collection

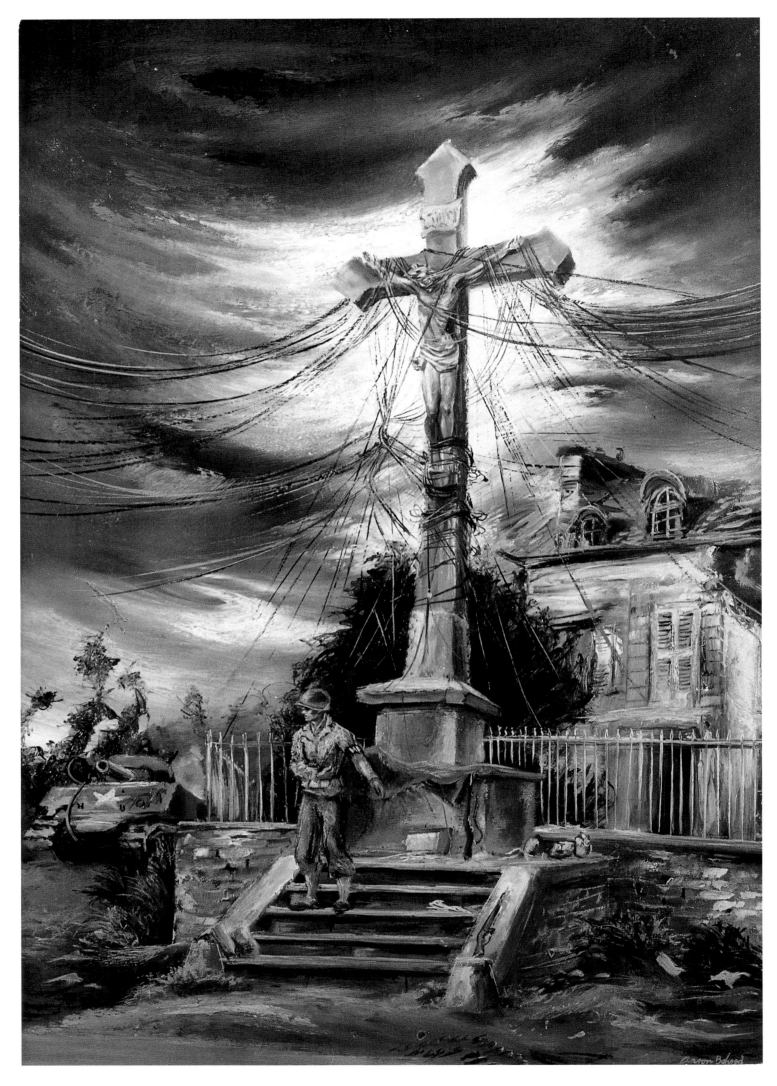

Against sound military advice, Hitler ordered his army to counterattack at the height of winter in the Belgian Ardennes sector. Marshalling almost all of their remaining strength, troops, and equipment, twenty-five German divisions penetrated deep into Belgium. They attacked six green U.S. divisions and created a gigantic "bulge" in the Allied lines, inflicting some 81,000 American casualties and very nearly capturing an entire American division in the process. It was a momentary disaster, yet the completely surrounded 101st Airborne Division in the little Belgian town of Bastogne refused to give up. When the German commander offered surrender terms, American Brig. Gen. Anthony McAuliffe famously replied, "Nuts!" and continued fighting until the Allies broke the German onslaught. McAuliffe's spirit epitomized the now-hardened American soldier.

Lashing out in desperation (and in defiance of the Geneva convention), the Germans massacred 150 U.S. prisoners. On the Allied side of the lines, Germans caught in American uniforms were summarily executed.

Life *Artist-Correspondent Tom Lea*

One of a long line of great combat artists to come out of World War II, Tom Lea was also one of the earliest to undertake such an assignment, starting before the United States entered the war.

Born in 1907 in El Paso, Texas, young Lea was a precocious draftsman, and after high school he was encouraged by his father to study art at the Art Institute

Opposite: Life artist Aaron Bohrod painted this incongruous scene in Normandy. With clear signs of the ravages of war around it, and backlit with a heavenly glow, the crucifix was drafted into service as a mooring tower for communications cables. ***U.S. Army Art Collection***

Above Left: Yank artist Sgt. Howard Brodie's deft hand and graphite pencil captured the terrific struggle the GIs went through in the final stages of the war. As Brodie later noted, "War, for all its negation, there is a beauty there when we're facing life and death that I've seen and experienced and am thankful for." ***U.S. Army Art Collection***

Above Right: Brodie was awarded the bronze star for heroism in combat and went on to cover the Korean and Vietnam Wars as a civilian. His bold, realistic style is easily recognizable. Here, three dog-tired GIs during the winter of 1944–45 try to warm some rations, and themselves, during a brief break in the fighting. ***U.S. Army Art Collection***

Left: Brodie shows the swift U.S. military justice for Germans caught in American uniforms: immediate death by firing squad. While tough by today's standards, it was deemed necessary to deal with such infiltrators quickly and with finality. ***U.S. Army Art Collection***

Above: Tom Lea on Peleliu in 1944. On assignment both before and during the war for *Life* magazine, the El Paso-born artist covered the conflict aboard ship with the Navy and on amphibious operations with the Marines in the Pacific. He also saw action in the China-Burma-India theater and the Mediterranean.
U.S. Marine Corps Art Collection

Below: Lea witnessed many scenes like this one depicting the casualties aboard ship following a Japanese air raid. Although a civilian, Lea did not shrink from placing himself in harm's way to personally witness the battles he would portray. *Life* turned over its collection of his paintings to the U.S. Army Historical Collection after the war.
U.S. Army Art Collection

of Chicago. He apparently studied far more than his required creative art courses, exploring a wide range of academic interests. Shunning modernism, he developed more along the lines of what are now referred to as the regionalists: artists like John Steuart Curry, Reginald Marsh, and Thomas Hart Benton, who depicted in stylized but realistic terms rural, city, and everyday life during the Depression. Lea's talents caught the attention of muralist John Warner Norton, and Lea became his student and later his assistant. Soon, Lea was winning his own mural commissions, mostly through the Treasury Department's fine arts program, and painting murals for post offices and federal buildings in Washington, Missouri, and his hometown of El Paso. He settled for a time in Santa Fe, then moved back to Texas, where he gained further fame.

In early 1941, as the United States began to mobilize for war by reinstituting the draft and revving up military production, Lea was hired as a full-time artist-correspondent by *Life* magazine to depict the nation's first steps toward preparedness. In so doing, he visited military installations around the country and went on a naval convoy patrol in the North Atlantic.

Lea, who had been reared in arid and landlocked El Paso, soon earned his sea legs. In mid 1942, *Life* sent him to the Pacific, where he was stationed aboard one of the few remaining U.S. aircraft carriers, the USS *Hornet*.

Arriving five months after Lt. Col. Jimmy Doolittle's electrifying Tokyo raid, which had taken off from the *Hornet* the previous April, Lea spent sixty-six days absorbing life aboard the formidable vessel and sketching and painting its activities and personnel. (The United States' four aircraft carriers had survived the attack on Pearl Harbor while away at sea, leaving the Japanese to concentrate on eliminating the numerous battleships.)

As it turned out, Lea's depictions of that autumn's sea battles in the Solomon Islands are the only visual record of some of those engagements, since the USS *Wasp* and the USS *Hornet* were both sunk and all photographic records aboard lost. While the *Wasp* was going down during a battle in September 1942, Lea watched through a telescope from the sister carrier *Hornet* and later painted the scene. A month later, when Lea left the *Hornet* to deliver his artwork to Navy headquarters at Pearl Harbor, the *Hornet*, too, was sunk—only four days after he left.

In a 1991 letter to the author, Tom Lea described his departure:

> I was not an eyewitness at the Battle of Santa Cruz. About 0100 on 22 Sept. 42, I rode a boatswain's chair down from the *Hornet* to the deck of the oiler USS *Guadalupe*. She debarked me at Espíritu Santo, code 'Button,' New Hebrides, and from there I made my way by various aircraft back to Pearl with all my sketches under seal, to C-in-C, Pearl. Admiral Nimitz, himself, in his office, told me of *Hornet*'s loss the night before.

In his letter, Lea also indicated that his depictions of the *Hornet*'s sinking were, indeed, reconstructions from survivors' vivid descriptions. Having lived aboard the *Hornet* for more than two months, he knew its every

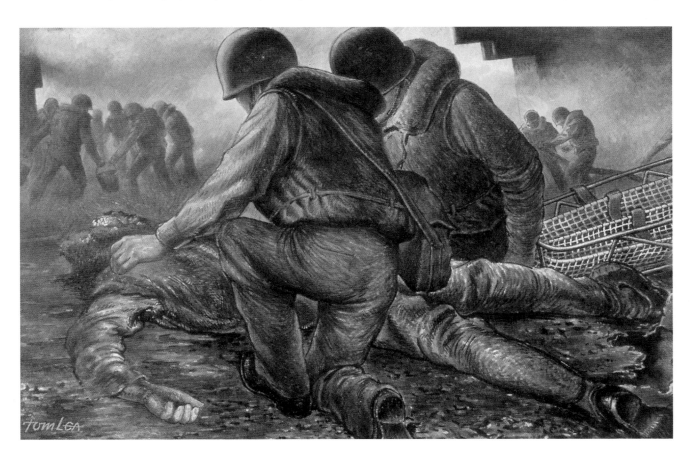

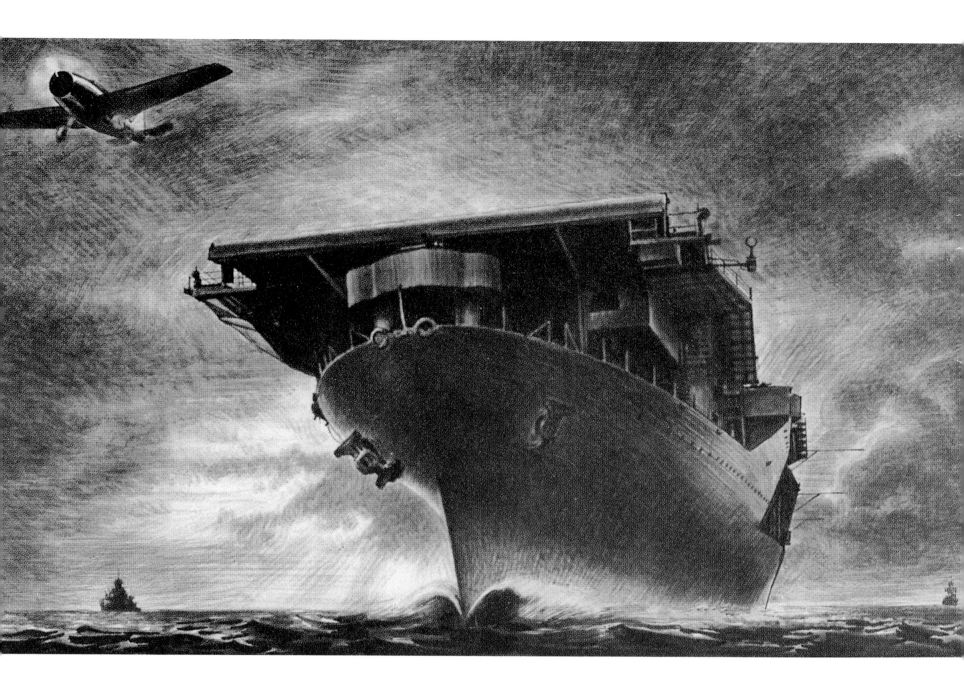

nook and cranny, as well as its heart and soul, and was thereby able to capture the momentous events and details of the Battle of Santa Cruz for all posterity.

Tom Lea went on to a variety of *Life* war assignments in other theaters of war: England, Italy, North Africa, Egypt, the Middle East, India, and over the "hump" into China, where he did portrait sketches of Brig. Gen. Claire Chennault, founder of the American volunteer "Flying Tiger" squadron, and Chiang Kai-Shek, leader of the Chinese Nationalist force. In Italy, he also had the opportunity to sketch (then) Maj. Gen. Jimmy Doolittle and his 12th Air Force in battle.

Back in the Pacific in 1944, Lea accompanied the first assault wave of the 1st Marine Regiment in the amphibious landing on 15 September on the island of Peleliu. The twenty-six-day battle was one of the bloodiest of the war, and Lea stayed with the Marines for thirty-two hours before returning aboard ship to render the sketches that he had drawn under fire.

In *Life*, Lea later described the equipment he carried into combat:

> …the belt with two filled canteens, first-aid kit and long black-bladed knife; and the pack with the poncho and shovel, the gloves, headnet and K-ration, the water-proofed cigarettes and matches and candy bar—and my sketch book and pencils and camera and films wrapped in the target balloon…my watch and identification wrapped in rubbers—and my grizzly coin for luck.

Just as the artist himself could not, it is difficult for the viewer to erase some of the visions Lea has portrayed. In *The Price*, a Marine just hit, with his left side, arm, and face a bloody mangle, is momentarily stunned in disbelief, before he falls, mortally wounded. And who could forget the wide-eyed zombielike stare of the Marine in *Down From Bloody Nose–Too Late*, who has endured God knows how many continuous hours or days of intense combat. These paintings from Lea's Pacific action are forever etched into the nation's memory.

Above: By circumstance, Tom Lea found himself aboard the U.S. aircraft carrier *Hornet* prior to the Battle of Santa Cruz in September of 1942. He was looking through a telescope at its sister carrier, USS *Wasp*, when the ship was hit by Japanese aircraft and the torpedoes that finally sank her. He recorded his vivid impression of that catastrophic event for posterity. Fortunately, he left the *Hornet*, depicted here, a few days before she, too, was sunk.
U.S. Army Art Collection

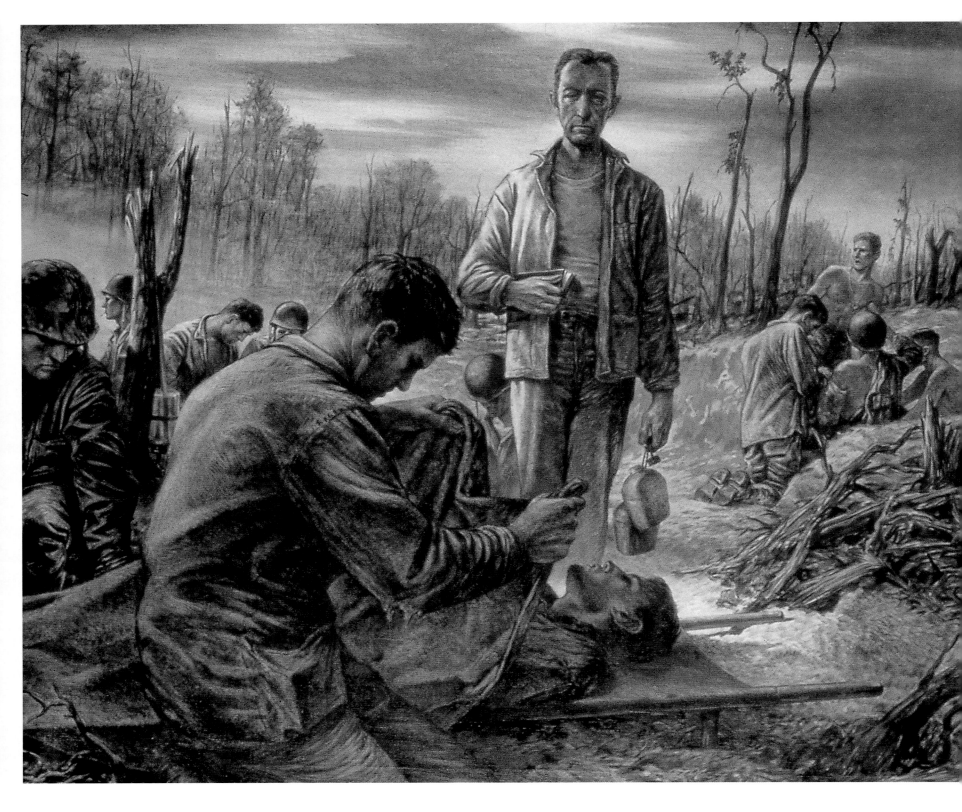

Above: "The padre stood by with two canteens and a Bible, helping. He was deeply and visibly moved by the patient suffering and death. He looked very lonely, very close to God, as he bent over the shattered men so far from home," Tom Lea wrote of a scene that he sketched and later painted.
U.S. Army Art Collection

VJ-Day found Lea preparing for the intended assault on the southern Japanese island of Kyushu. As he said later to writer, folklorist, and fellow Texan, J. Frank Dobie, whose books he had illustrated, "the war stirred me up…gave me confidence, showed me some hints of power and love and integrity in the human race." He also was very thankful that he got through unscathed. His work was included in the great *Life* collection that the magazine turned over to the Defense Department after the war, ending up later in the U.S. Army Historical Collection.

Following the war, Lea went on to other *Life* art assignments and to a dual career of art and writing. Among many of his writings, *The Brave Bulls* and *The Wonderful Country* were successful both as novels and as Hollywood motion pictures.

Lea was greatly influenced by his teacher, Chicago muralist John Norton, as well as by the landscape and inhabitants of his native Southwest. As he wrote in his sketchbook, "an artist grows from his land, taking nourishment from the soil under his feet and the sky over his

head. He is a microcosm holding within himself those forces that shaped him." Up through World War II, he worked mostly in oil, watercolor, pencil, charcoal, pastel crayon, and pen and ink stroked with a fine brush. In China, he acquired an ink stick with which he executed many works. Despite all of his other accomplishments, he always considered himself, by nature and training, a mural painter.

Lea at Peleliu: September 1944

Excerpts from Lea's account of the Peleliu landing, reproduced in *The United States Marine Corps in World War II*, not only capture the essence of deadly battle, but attest to Lea's eloquence as well:

> The iron bulkheads of the LVT [Landing Vehicle, Tracked] came above our heads; we could see only the sky.... Standing on a field radio case forward,

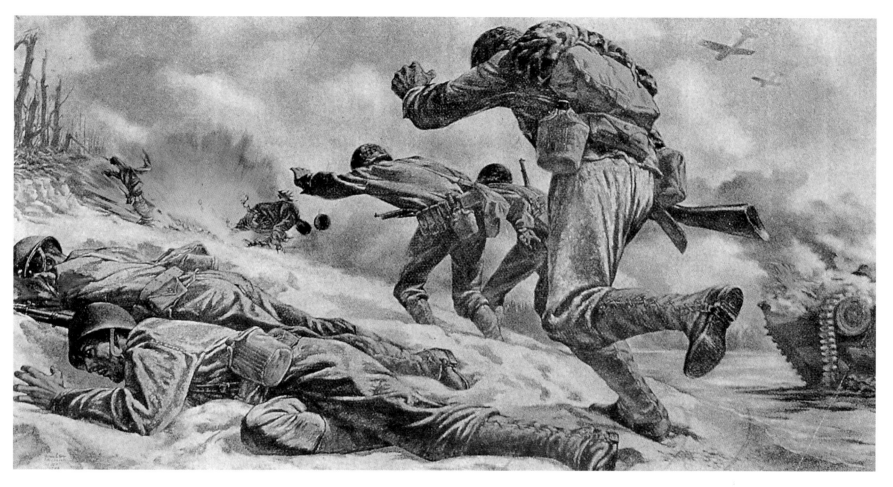

Above and Left: Like the attacking Marines, Lea had to overcome his fear as he went in with the assault waves in the Peleliu invasion. Located between the Philippines and Iwo Jima, Peleliu saw a brutal twenty-six-day fight between the Marines and Japanese defenders. Lea sketched through the first thirty-two hours, then returned later to cover further action.
U.S. Army Art Collection

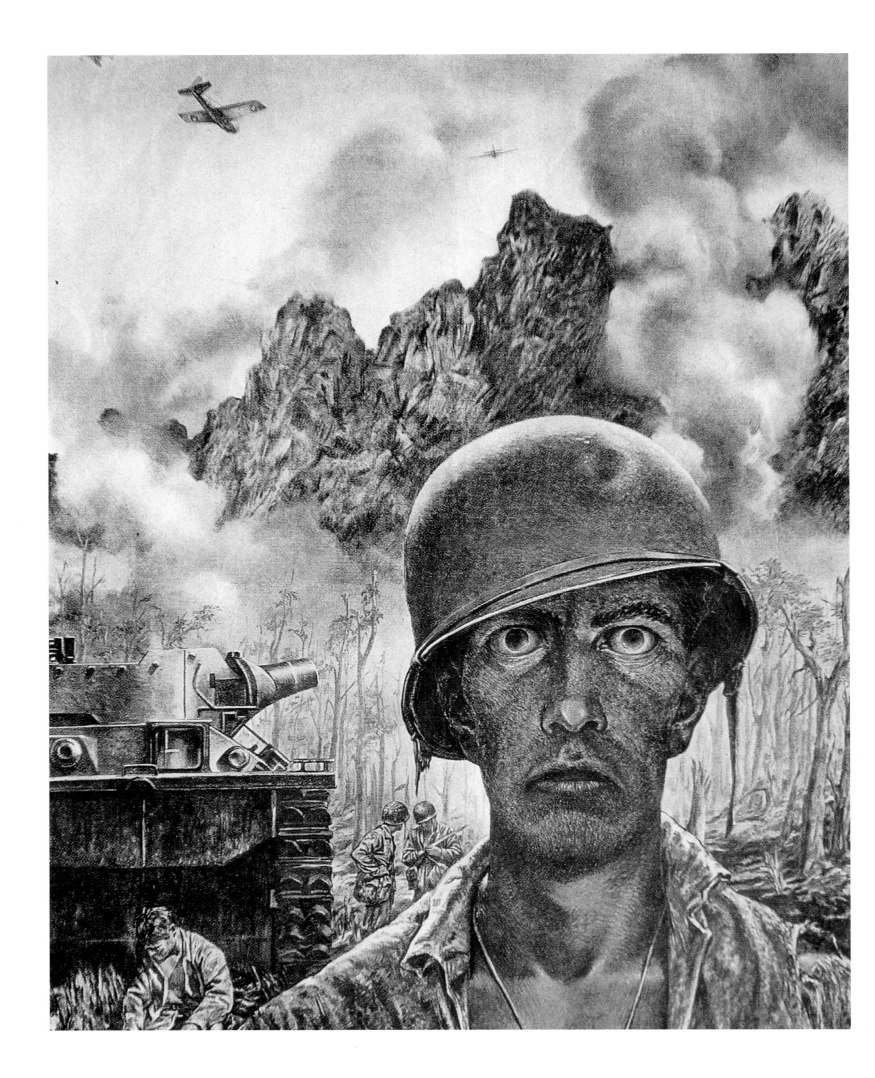

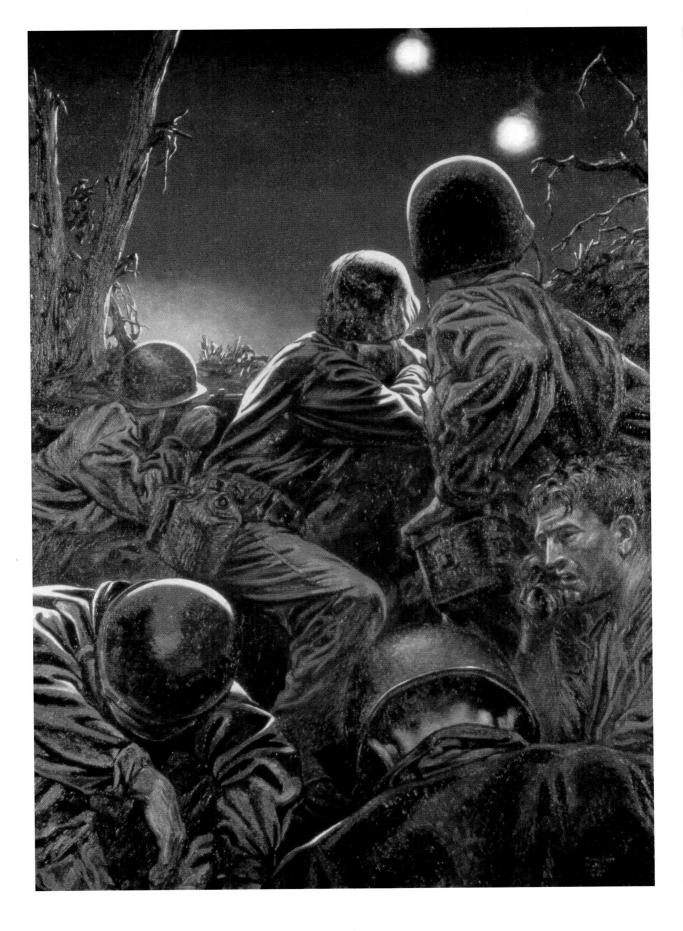

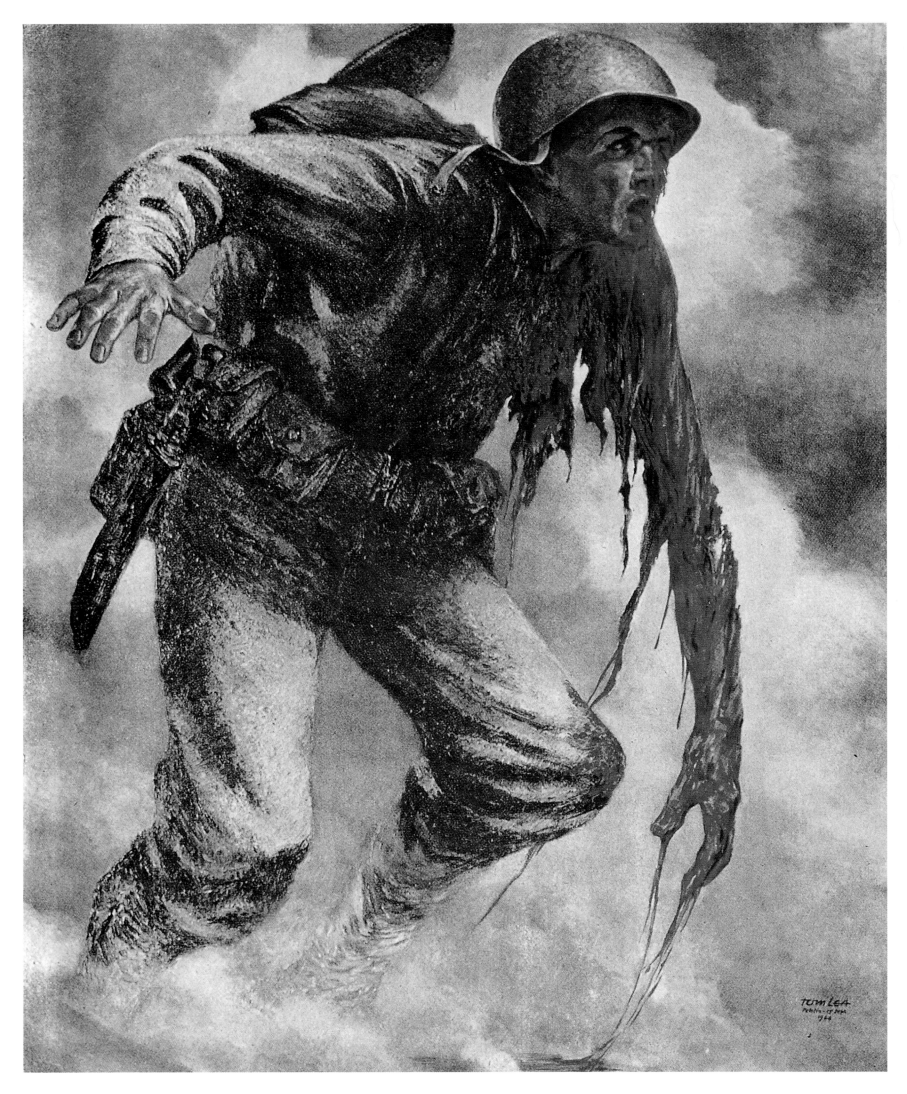

I managed to poke my head up so I could see the first wave of LVTs go in. As I watched, the silence came into my consciousness; our shelling had ceased. Only our tank treads churning the water marred the quietness….

Over the gunwale of a craft abreast of us I saw a Marine, his face painted for the jungle, his eyes set for the beach, his mouth set for murder, his big hands quiet now in the last moments before the tough tendons drew up to kill…. Then on the lip of the beach we saw many pink flashes—the Japs, coming out from under our shelling, were opening up with mortar and artillery fire on the first wave. Dead

ahead there was a brighter flash. Looking through his binoculars, [Capt.] Farrell told us, "They hit an LVT." The clatter of our treads rose to the pitch of a rock crusher and our hell ride began…. Suddenly there was a cracking rattle of shrapnel on the bulkhead and dousing water on our necks….

We ground to a stop, after a thousand years, on the coarse coral…. The air cracked and roared, filled our ears and guts with its sound…and we ran down the ramp and came around the end of the LVT, splashing ankle-deep up the surf to the white beach…. Suddenly I was completely alone. Each man drew into himself when he ran down that ramp, into that flame. Those marines flattened in the sand on that beach were dark and huddled like wet rats in death as I threw my body down among them…then I ran—to the right—slanting up the beach for cover, half bent over. Off balance, I fell flat on my face just as I heard the whishhh of a mortar I knew was too close. A red flash stabbed at my eyeballs. About fifteen yards away, on the upper edge of the beach, it smashed down four men from our boat. One figure seemed to fly to pieces. With terrible clarity I saw the head and one leg sail into the air….

I got up…ran a few steps, and fell into a small shell hole as another mortar burst threw dirt on me. Lying there in terror looking longingly up the slope for better cover, I saw a wounded man near me, staggering in the direction of the LVTs. His face was half bloody pulp and the mangled shreds of what was left of an arm hung down like a stick, as he bent over in his stumbling, shock-crazy walk. The half of his face that was still human had the most terrifying look of abject patience I have ever seen. He fell behind me, in a red puddle on the white sand.

Above: Tom Lea in 1995, after receiving the Marine Corps Historical Foundation's prestigious Col. John Thomason Art Award for his outstanding work portraying Marines in World War II. A display of his original paintings from the U.S. Army art collection was on view for the ceremonies at the Marine Corps University in Quantico, Virginia. As Lea later recalled, simply standing next to *The Price* brought back many vivid and painful memories from more than fifty years earlier.
Photo by H. Avery Chenoweth

Opposite: Under intense enemy fire on the beach at Peleliu, Lea witnessed the most unnerving experience in his combat art adventures—and turned it into a shocking portrayal of the horror, brutality, and pathos of war. A few yards from where Lea lay under a barrage of Japanese mortars, a charging Marine was ripped open on one side by an almost direct hit. Stunned, his eyes filled with terror and pain, he staggered and fell onto the hot sand, his blood making a crimson pool around him. He had not even seen his first Japanese soldier. Lea titled his painting *The Price*.
U.S. Army Art Collection

Top Left: Lea's eyewitness sketch of the gruesome scene depicted in *The Price*.
U.S. Army Art Collection

Bottom Left: Lea's sketch of Marines in action, on which he inscribed "War is Fighting and Fighting is Killing.
U.S. Army Art Collection

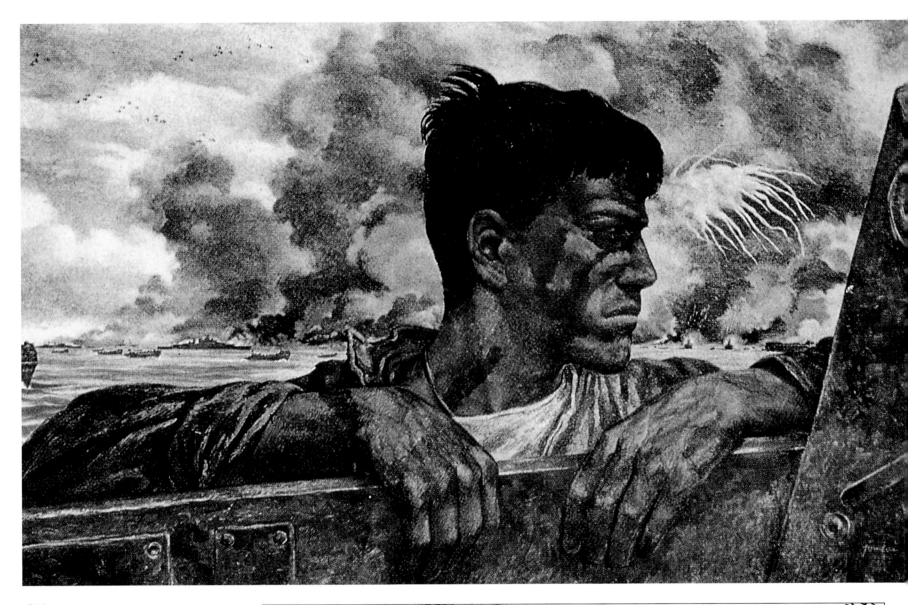

Above: As observed and painted by Tom Lea, a determined Marine is lost in thought as he approaches the island of Peleliu and possible death. Accompanying the Marines in this vicious assault in the Palau Islands was one of Lea's most harrowing assignments for *Life*. Lea went in with one of the first waves in an LCVP (Landing Craft, Vehicle, Personnel). Sketching the whole time, he experienced in two days some of the bloodiest fighting imaginable.
U.S. Army Art Collection

Right: When Lea executed the final painting, he departed from his original sketch, shown here, and changed the direction of the subject, possibly for artistic purposes.
U.S. Army Art Collection

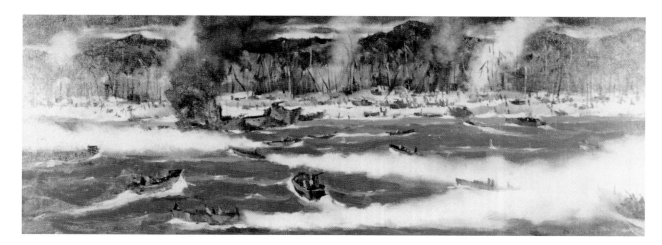

Left: Life artist Paul Sample was on hand for the 20 October 1944 invasion of Leyte, in the Philippines. He shows here a smoke screen being laid down by special landing craft to cover the reinforcements on D-Plus 1 (military shorthand for the day following the initial assault).
U.S. Army Art Collection

Below: Lt. Dwight Shepler observed the February 1945 Army paratrooper invasion of Corregidor island in Manila Harbor. In 1942, the island had been Gen. MacArthur's headquarters just before he escaped in a Navy PT boat.
U.S. Navy Art Collection

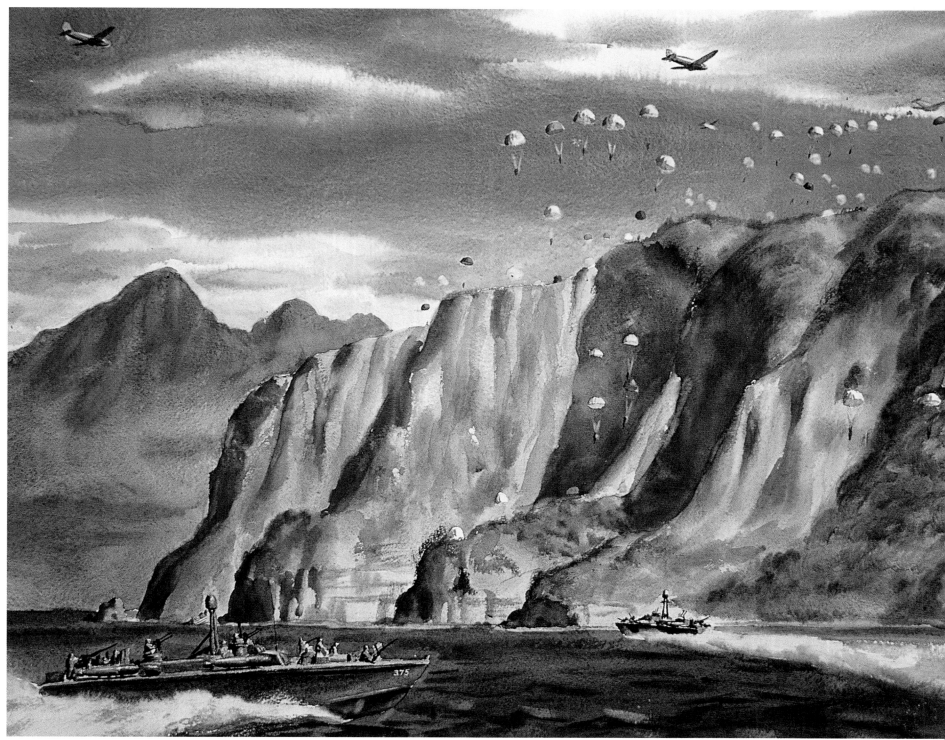

Above: Associated Press photographer Joe Rosenthal captured the moment when Marines raised the American flag over Mount Suribachi on Iwo Jima. The image would come to symbolize the struggles and sacrifices of the war.

The Defeat of Japan

In the fall of 1944, while Allied forces in Europe were charging toward the Rhine River and the heartland of Germany, the Pacific Allies—the United States, Great Britain, Australia, New Zealand—were converging on Axis enemy Japan as well.

Under Southwest Pacific commander Douglas MacArthur, one of five newly promoted five-star generals and admirals, the U.S. Navy put Army units ashore in the Philippines at Leyte. Later, U.S. forces would also subdue Mindanao to the south and Luzon and Manila to the north. MacArthur thus made good on his promise, "I shall return," made when he had been forced to leave Corregidor in 1942.

Fighting in the Philippines continued well into the following year, and in February of 1945 the V Amphibious Corps, made up of three U.S. Marine divisions, assaulted the tiny island of Iwo Jima, 665 miles (1070km) directly south of Japan. It was one of the most ferocious battles in history, lasting five weeks. AP photographer Joe Rosenthal's famous photograph of Marines raising the American flag atop Mount Suribachi on the third day of the battle became an icon of the war.

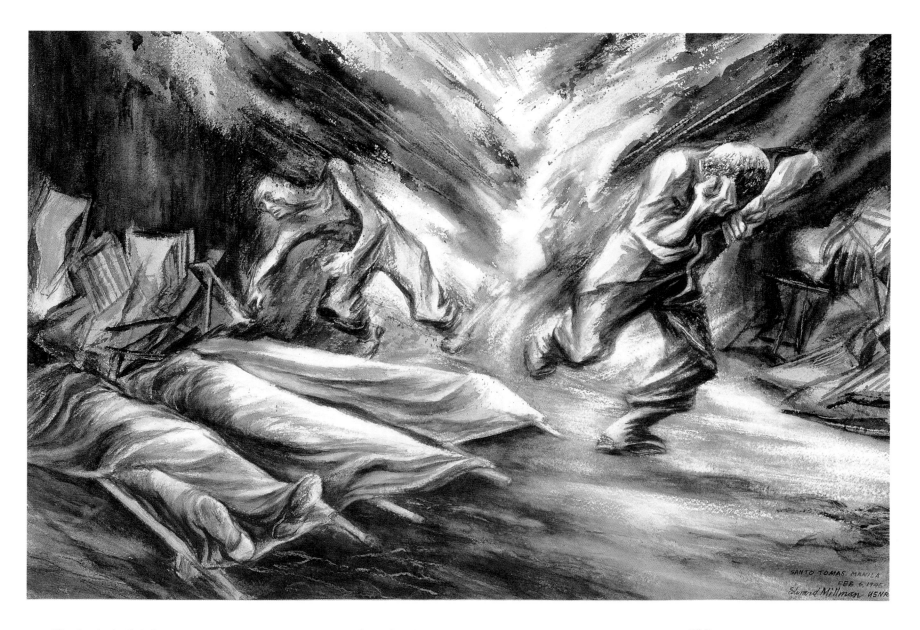

The battle for Peleliu cost the Marines more than 6000 casualties, 1121 killed in action. The Japanese lost all 10,000 of their defenders.

Covering Peleliu for *Life* magazine, Lea would write: "It was established later that the invasion of Peleliu as a stepping stone to the invasion of the Philippines had not been necessary—Gen. MacArthur had already bypassed the Palaus and landed at Leyte in the Philippines." Such are the ironies of war.

The Final Battles in the Pacific

Following the capture of Iwo Jima and, one thousand miles (1609km) to the west, the successful campaign in the Philippines, U.S. forces conquered Okinawa in a hard-fought, three-month battle. Initially seen as the staging ground for the anticipated bloody invasion of the Japan homeland, the battle of Okinawa was to close the final chapter in the Pacific war. Upwards of two million casualties were estimated by the Allies.

The Bloodiest Battle of the War: Iwo Jima

On 19 February 1945, a tiny eight-square-mile (21km²) volcanic island some 665 miles (1070km) south of Japan in the Pacific Ocean became one of the bloodiest battle-fields in history. After seventy-six days of American naval gunfire and aerial bombardment, 71,245 Marines in two and a half divisions stormed Iwo Jima's volcanic black sand beach under heavy fire from 23,000 deeply entrenched Japanese troops. It took five weeks of intense, bunker-to-bunker fighting to take the island. On the third day, however, Marines captured the dominant landmark, Mount Suribachi, and raised the Stars and Stripes for all on the island to see.

The casualty rate was high: 6821 Marines, 176 Navy doctors, and 542 medical corpsmen were killed; 19,217 were wounded; and 2548 other Navy, Marine, and Coast Guard personnel died in the surrounding areas. Some units suffered a staggering 100 percent casualties. Twenty-two Medals of Honor were awarded—eleven posthumously and five to Navy corpsmen. Only 216 Japanese survived.

Above: During the fighting in Manila, Japanese artillery pounded Army troops that had captured Santo Tomas University. Navy Lt. Edward Millman here interprets the hellish experience, with the Americans driven back into the entrance where their wounded had been collected.
U.S. Navy Art Collection

In describing the action, Pacific Commander-in-Chief Adm. Chester Nimitz gave the greatest tribute to those who had fought and died: "Uncommon valor was a common virtue."

Even before the battle ended, B-29 Superfortresses were using Iwo Jima as an emergency landing field for their bombing runs over Japan. The two atomic bombs that ended the war, however, were loaded and flown from the island of Guam, which was captured the previous year.

Cpl. Charles Waterhouse

Charles Waterhouse, in a beautifully designed book of his work published in 1994 entitled *Marines and Others*, wrote of being wounded at Iwo Jima:

> As the last member of my squad moves past, he pauses and squats, holding out his M1 rifle as a swap for my carbine, and disappears into the smoke. I am alone now, and still under occasional fire, which hits the rim of the hole just over my head to remind me I can still be a

Above: Col. Charles Waterhouse, USMC (Ret.)

Left: *Flotsam and Jetsam on Green Beach, Iwo* is the title of Waterhouse's final tribute to the battle on Iwo Jima.
USMC Art Collection

target. I still have a grenade in a pocket on the wrong side, wedged in by my carbine belt, and attempts are made to put a round in the chamber of the exchanged rifle. A paralyzed left arm and a twitching hand is not much help to hold the weapon and pull back the bolt, jammed by ashes. Futile attempts to kick it open are even more frustrating, accompanied by much profanity and effort.

During a quiet moment, I leave the hole at a crouch, dragging the rifle, moving away from Suribachi.

After several pauses on the deck, I reach the protective hummock of ash and straw bags around the remains of a small, knocked-out pill box. Alone and aware of possible or returning occupants, I brace myself against it to kick and swear at the useless rifle again, with still no luck. This is not a place to linger, so I make my way down the terrace to the beach, where intermittent mortars and artillery are falling. The machine guns seem to have problems of their own, further inland. There are no unoccupied holes near the water, so I select an open

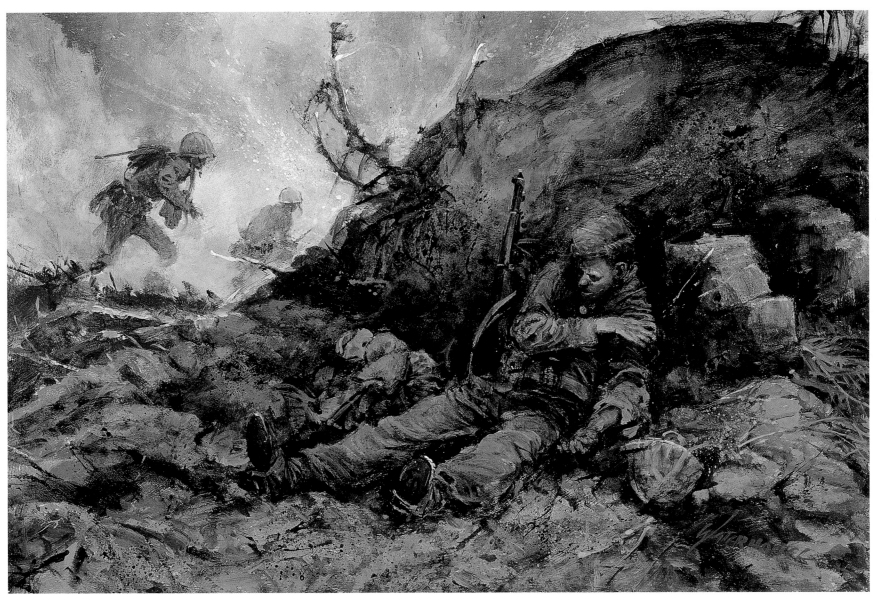

Above: In this self-portrait, Charles Waterhouse portrays himself as a wounded soldier. Waterhouse, as artist in residence at the Marine Corps historical division, painted this scene for the Marine Corps art collection twenty-five years after the event.
USMC Art Collection

Right: Lt. Mitchell Jamieson portrays a B-29 Superfortress coming in for an emergency landing on Iwo Jima after a bombing run on Japan. The island was needed for these contingencies, as well as to base escort fighters (with their shorter ranges) nearer to the bombers' targets.
U.S. Navy Art Collection

Opposite: In *Navajo Radio Code Talkers* Waterhouse portrays a very important—and little-known—aspect of the battles in the Pacific. Marines of Navajo Indian descent used their own language in radio communications, which the Japanese found impossible to interpret. Another Marine of American Indian descent was part of the group that raised the flag atop Mount Suribachi.
USMC Art Collection

Right: Coast Guard artist William G. Lawrence was a boatswain on one of the landing craft that brought wave after wave of Marines and supplies to Iwo Jima through the pounding surf and onto the black volcanic sand of the steep beach.
USCG Art Collection

Right: The Army-Marine invasion of Okinawa was the largest of the Pacific war. Fortunately, resistance was light initially. Lt. Mitchell Jamieson shows a steady stream of reinforcements marching inland to the fighting lines, while the vast armada of supply, troop, and combat ships remain anchored offshore.
U.S. Navy Art Collection

Below: As the end drew nearer, kamikaze suicide planes were Japan's last option to defend itself against the increasingly invincible American fleets. The enemy's loss of pilots had forced them to turn in desperation to meagerly trained "volunteers" who would fly their single missions to the death. Lt. Comdr. Dwight Shepler depicted a near miss he witnessed on the replacement *Hornet.*
U.S. Navy Art Collection

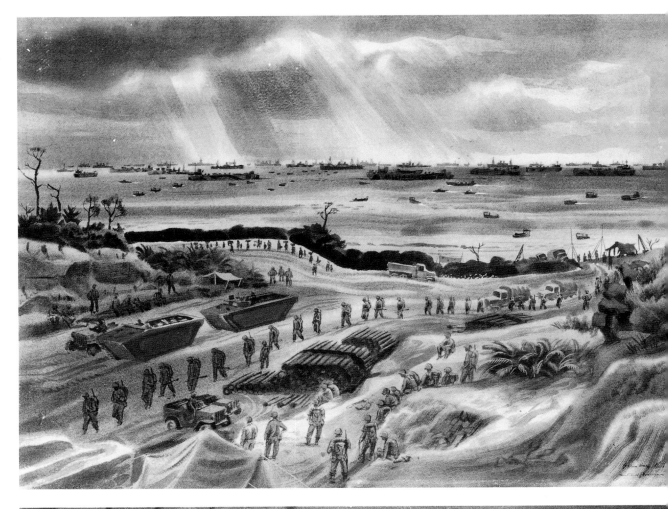

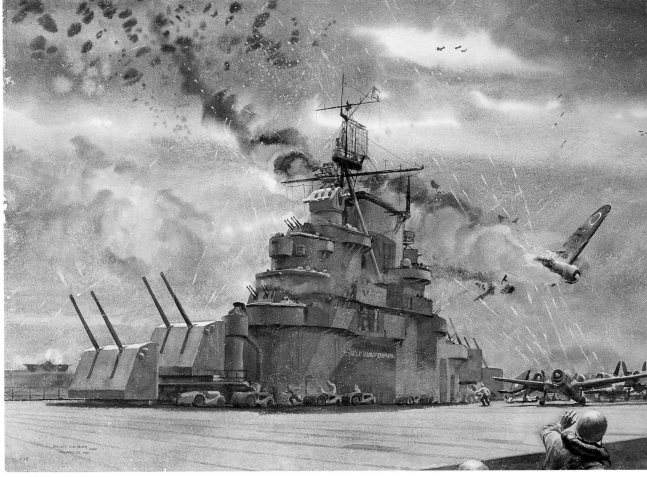

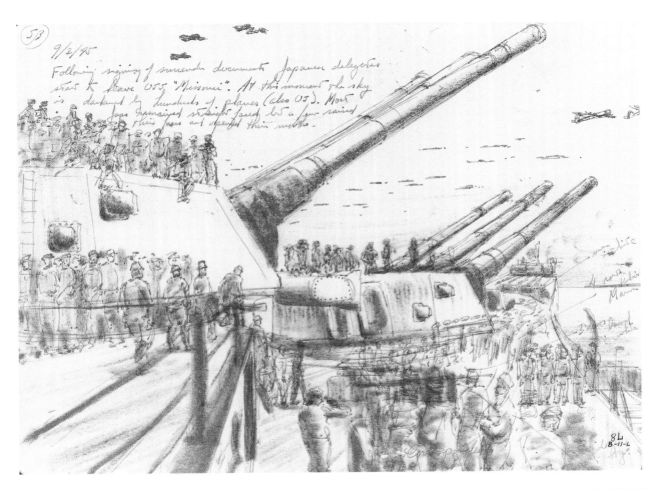

stretch of ashes, amid the debris on the beach. Using little crab-like wriggles to scoop out a very shallow depression in the ashes, I reflect on the chances of surviving a barrage. They are dim, and so is the weather—it's getting overcast, with a light, cold rain....

Flashes and sounds continue until a landing craft unloads in front of our holes. Then there is a yell for casualties, and several litter bearers appear with their burdens. Leaving the useless rifle, we shuffle through the ashes, step into the surf, and lurch over the ramp of the LCVP to sprawl on the deck next to the six or eight litter cases, braced against the bulkhead.

Fortunately, Cpl. Waterhouse's wound was not life threatening—and it was to his non-painting arm. He went on to become one of America's leading illustrators and a combat artist in Vietnam before rejoining the Marine Corps as an artist in residence. In 1990, he won the Col. John W. Thomason, Jr., Art Award.

Okinawa: Prelude to the Finale

The Allied sea, air, and land pincers progressed inexorably closer to the homeland of the Japanese Empire. Over the course of almost four years, island by island, the Pacific was reclaimed from its conquerors—at tremendous cost in lives and materiel.

With the fall of the Philippines and Iwo Jima, the obvious remaining strategic target was Okinawa, some

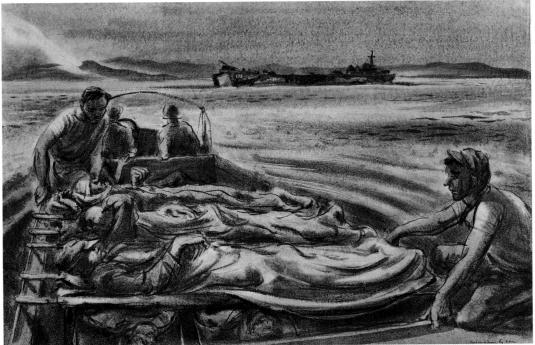

380 miles (612km) southwest of the three main Japanese islands. In April 1945, two Marine and two Army infantry divisions landed on the island. At first, resistance was relatively light, and the Marines secured the northern part of the island quickly. The bulk of three-month battle was ultimately fought over the southern countryside and cities. It was hard fighting, similar to the combat experienced in Europe in that there was a conventional main line

Above: Lt. Mitchell Jamieson portrays a grim task. The wounded went through long ordeals to receive proper treatment, from emergency aid on the battlefield and rough handling at sea, to the aid station for further lifesaving treatment and evacuation to a hospital ship. If the wound was serious enough, the journey ended with a trip home. Those were the fortunate ones. The dead were buried with honors near the battlefield.

U.S. Navy Art Collection

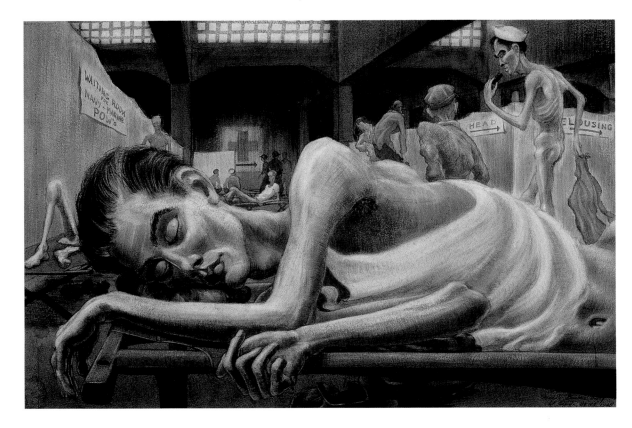

Right: Navy artist Standish Backus was one of the first to see liberated American prisoners of war in Japan. He documented the disturbing state of American POWs in *Recent Guests of Japan.* The United States was understandably shocked when it saw the conditions of the survivors.
U.S. Navy Art Collection

Below: Backus here portrays the *Aoba*, the last of the large battleships of the Imperial Japanese Navy, as she lay grounded, broken, and listing to starboard. Vegetation is beginning to grow over the rusting hulk—a jarring end for the navy that had started the war so aggressively at Pearl Harbor. American sailors, assisting in the Allied occupation of their former enemy's homeland, take a well-deserved break to celebrate with a few beers.
U.S. Navy Art Collection

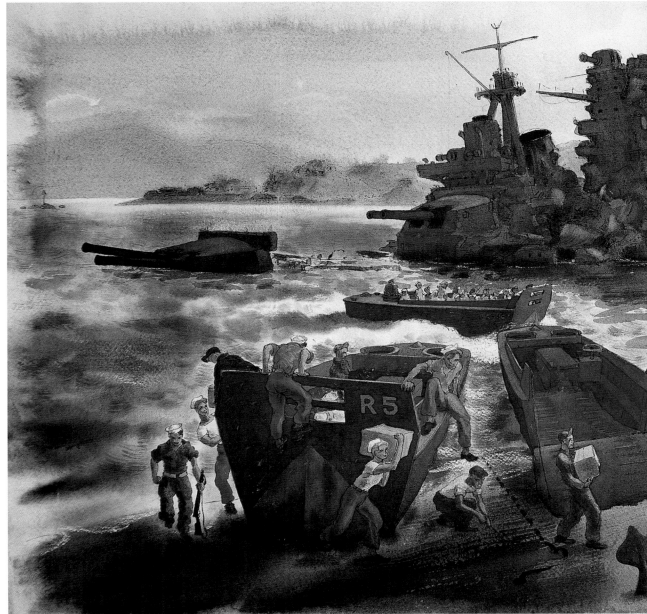

220 Art of War

of resistance (MLR) instead of the yard by yard jungle fighting experienced heretofore in the Pacific.

The Japanese unleashed most of their remaining naval and air forces on Okinawa. Ferocious sea battles put an end to the Japanese Imperial Navy, while its last-ditch kamikaze blitz inflicted thousands of Navy casualties on the high seas and near the landing beaches.

During the eighty-six-day battle, 148,000 civilians died, as did 75,000 of the 130,000 defending enemy troops. The Marines and Army soldiers suffered more than 14,000 casualties.

Fortunately, Japan surrendered unconditionally in August 1945, after the U.S. Army Air Corps dropped two atomic bombs from their B-29 Superfortresses, virtually wiping out the cities of Hiroshima and Nagasaki. Okinawa then became a staging area for the occupation of Japan.

V-J Day: 2 September 1945

The victorious Allies entered Tokyo Harbor in an impressive display of the naval might that had backed up the

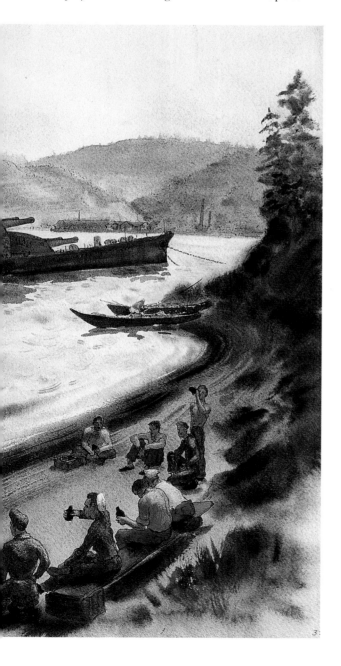

bombing raids they had rained on Japan for months. As the Japanese emissaries assembled aboard the "Mighty Mo," the U.S. battleship *Missouri*, to sign the unconditional surrender, a vast air armada of Navy, Marine, and Army Air Force aircraft filled the sky overhead in V formations signifying victory. It was a sight Commodore Perry could never have imagined ninety-two years earlier, when his small exploratory armada entered the same harbor.

Japanese Adm. Isoroku Yamamoto, the architect of the war, must have turned over in his grave to see his prediction after the attack on Pearl Harbor come true. As he had put it then, "I fear we have awakened a sleeping giant." (Yamamoto was killed by U.S. Army Air Corps P-38 Lightnings in the Solomons after a message describing his flight plan was decoded.)

Gen. Douglas MacArthur, a decorated veteran of World War I, became commander of the Allied powers in Japan and set up occupation headquarters in the Dai Ichi building in Tokyo. One of his first actions was to meet with the heretofore unapproachable Japanese Emperor Hirohito and order him to relinquish his assumed divinity and become known to the people. The general, however, did not depose him from the throne. MacArthur then assisted the Japanese in writing their first constitution, ushering in democracy.

Occupying American troops were on alert lest some Japanese refuse to surrender, but the operation progressed peacefully. In both Germany and Japan, the leaders of each aggressor nation were put on trial in world courts, with the worst transgressors found guilty of crimes against humanity and executed. The Holocaust slaughter of six million Jews and other captured nationals by Germany, as well as Japan's mistreatment of prisoners of war and entire populations, did not go unpunished.

Contrary to what had followed World War I, the victors this time created an organization to assure future world peace: the United Nations (U.N.). The United States unilaterally instituted the Marshall Plan to help Europe—including former enemy Germany—recover. Healing from the aftereffects of the war would take time, though Japan and the new Germany eventually became allies of the United States in the ensuing Cold War with the Soviet Union. The first test of this postwar solidarity would occur a mere five years later in Korea.

The Aftermath of the War

If one views it as a totally dedicated, cohesive national effort, the likes of which have never been seen before or since, World War II, the "Good War," is unarguably a watershed moment in U.S. history. Still, the times were tumultuous, and the eruption of world powers into a brutal, sustained conflict affected almost everyone,

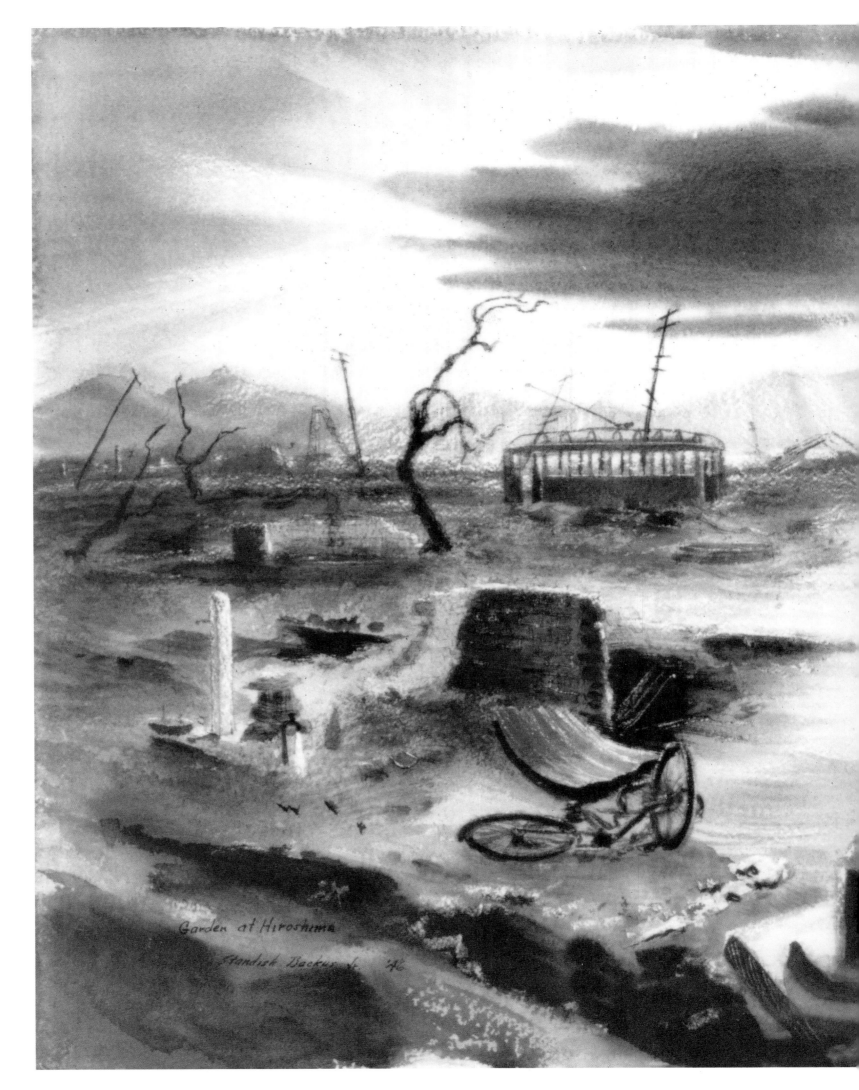

Garden at Hiroshima

Standish Backus '46

disrupting governments, national boundaries, and cultures. The conflict was even prolonged another forty-four years in a continuing Cold War, with occasional hot wars cropping up across a tense, polarized planet.

Even before the unleashing of the frightful power of the atom, the war had brought a degree of destruction unparalleled and previously unimaginable, Antietam and Verdun notwithstanding. It is hard to conceive on what a monumental scale the death occurred: for instance, 2500 killed at Pearl Harbor in a few hours; 250 lives snuffed out when a single naval shell burst aboard a ship; 1500 crew lost in minutes when a ship sank; 500 Marines mowed down in an hour coming ashore at Tarawa; fifty-three out of eighty B-17 bombers failing to return on a single raid over Germany; 370 Japanese planes shot out of the air in one engagement; 300,000 suffocated in each of two nights of aerial bombardment in Dresden and Cologne; 90,000 dead in Tokyo from one firebomb raid; and 80,000 killed in each of the two atomic bombs dropped on Hiroshima and Nagasaki—not to mention the 407,000 U.S. servicemen who died and the two million who were wounded; the ten million Russian soldiers and ten million Russian civilians who were killed; or the uncountable German casualties. All told, some sixty-four million souls perished around the globe as a direct result of the war.

Oddly, after World War II, combat artists (save for a very few) have chosen not to use war thematically, even as literature and motion pictures continue to explore it. Still, the work of American combat artists in World War II was commendable. So, too, was the combat art work of the British and other Allies. The enemy's combat artists were active as well, although much of their art captured by the victors smacked heavily of propaganda, the expected output of totalitarian regimes. Japanese combat art certainly leaned heavily in that direction.

Navy combat artist Standish Backus, USNR, who had gone into postwar Japan with the first occupation forces, perhaps best summarized the work of combat artists of all services:

> The Navy appreciates that the artist, in reporting his experiences, has the opportunity to convey to his audience a larger sense of realization of a subject, than has the photographer, with his instantaneous exposures, or the writer, who lacks the advantage of direct visual impact. The artist is limited only by degrees of his skill in portraying his sensitivities. Concurrently, it is to be understood that the artist is obliged to contemplate the subject reflectively, seeking to penetrate beyond the surface of factual representation, in order to present the true nature of the experience.

Arthur Beaumont and the H-Bomb

As the world's attention was focused on the United States after its total destruction of two Japanese cities, the emerging superpowers engaged in a race to stay ahead of each other militarily, with the United States maintaining a scant lead over the Soviet Union for almost a decade and a half. In order to do so, a series of atomic-hydrogen bomb tests were undertaken. The first were to test the effects of an atomic explosion at sea, then, in 1952, to test the theory of hydrogen fusion, far more powerful than the more primitive nuclear fission of the atomic bomb.

The tiny atoll of Bikini in the South Pacific was chosen for such a test in 1946, and its inhabitants were relocated. A number of obsolete ships and enemy hulks were then assembled as target zero. Attending these atomic tests, known as Joint Task Force One, was Navy artist Arthur Beaumont, who had been too old to serve as a combat artist earlier. (However, he did go on Navy expeditions to the Arctic and Antarctic in the late 1950s, and, late in the 1960s, accompanied and portrayed naval actions off the coast of Vietnam.) In 1946, Beaumont was one of the first to enter the drop zone following the largest man-made explosion ever, with its gigantic, corona-capped ball of radioactive water. At great risk of exposure to lingering radiation, the former Navy lieutenant captured in his watercolors the spectacle of that incredible moment and its aftermath.

In a letter to the author, the artist's son, Geoffrey C. Beaumont, shed light on his father's role as an artist and eyewitness to those atomic bomb tests. He wrote:

> In 1946, Admiral [William] Leahy arranged for my father to attend the highly secret Atomic Bomb tests at Bikini Atoll. His paintings at that time were classified, and there were major spatial distortions in the location of ships in the paintings as a result of that censorship. He also commented over the years that his paintings represented the most accurate portrayal of the colors of the plumes of smoke resulting from the A-bombs, as the extreme glare from the explosion was so intense that the light meters on the cameras inaccurately recorded the color. It was his accurate observation in one of his drawings that led to the Navy's discovery of the ice-cap which formed on top of the mushroom cloud in the Baker bomb test.

In the early 1950s, the U.S. atomic testing program was moved into the Nevada desert, some sixty miles (97km) northwest of Las Vegas, at Yucca Flat near Frenchman's Flat.

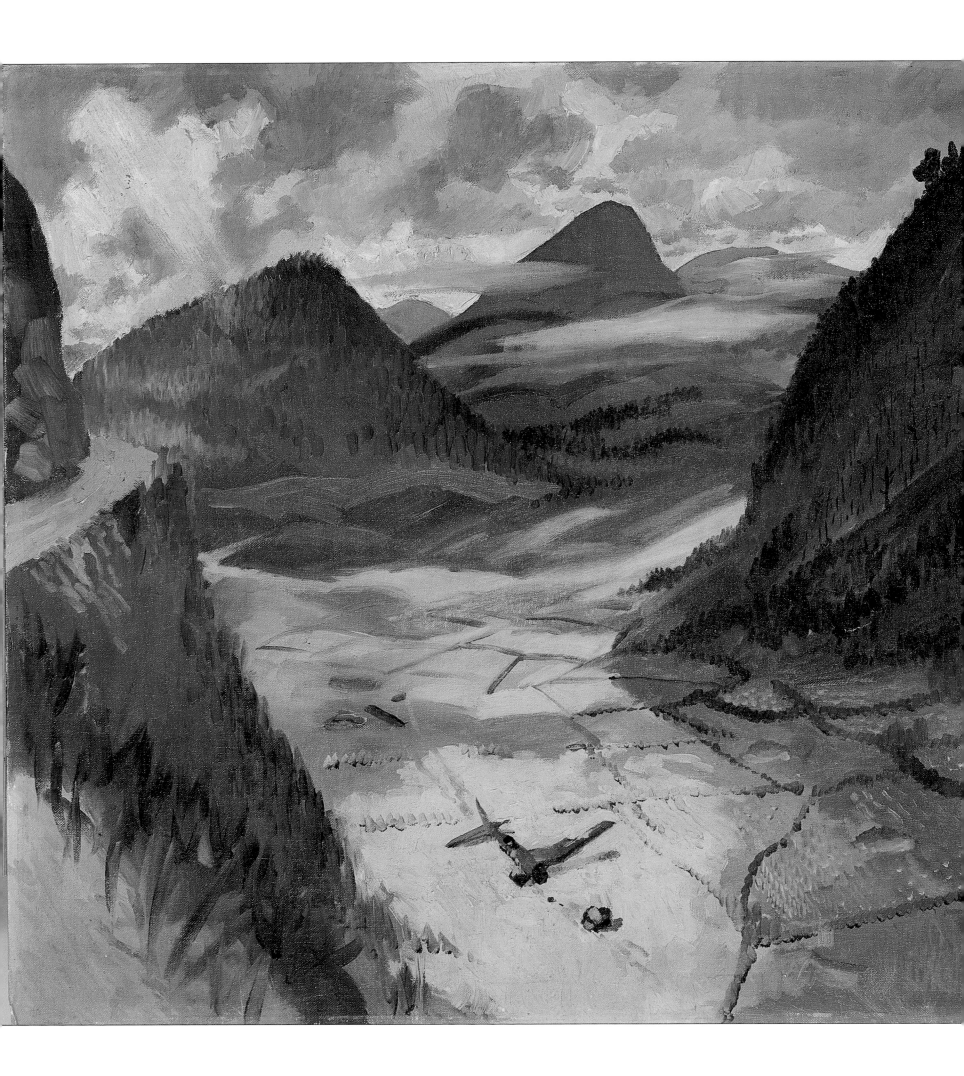

CHAPTER *Seven*

The Korean War: 1950–1953

The Korean War was a United Nations police action and an aftershock of World War II. The world had scarcely caught its breath when it found itself embroiled in a minor but important war on the Asian continent. The United Nations (consisting of the former Allies plus twenty other nations) was suddenly faced by the invasion of South Korea by communist North Korea, backed by China and the Soviet Union. (Itself a member of the United Nations, the U.S.S.R. had deliberately absented itself from the Security Council when a vote came to support South Korea; China did not become a member of the United Nations until years later.) Caught off guard, with its defenses down due to headlong demobilization at the end of World War II, it was all the United States could do to muster enough fighting units to put five infantry divisions into the field. The United States was also forced to mobilize most military reservists—many of whom had fought in World War II, had gone to college on the GI Bill, and were now on their way to starting families and careers. Eventually, nineteen nations would join the United Nations' side in the conflict.

In the summer of 1950, after losing two divisions trying to stop the invading North Koreans, the American troops were ignominiously forced, along with the ill-trained South Korean army, into a pell-mell retreat. They managed, however, to retain a toehold at the end of the Korean peninsula. In a brilliant stroke, Gen. Douglas MacArthur used the crack U.S. Marine 1st Division for an unexpected end run, landing amphibious units below the western end of the Demilitarized Zone (DMZ) at Inchon, near the capital of Seoul. Once on the offensive, the United Nations forces went deep into North Korea toward the Yalu River, which separated it from Chinese-controlled Manchuria. The inglorious history of that phase is too elaborate to cover here; suffice it to say, when China poured its million-man army into North Korea that December, the Marine division, fighting incredible odds (15,000 versus 150,000) against ten Chinese divisions, was the only U.N. unit that managed to fight its way back to the South intact—despite subzero temperatures, little air cover, exhaustion, and resupply problems. Incredibly, the Marines totally incapacitated eight Chinese divisions in the process.

Down in the Valley—also the name of a popular song at the time—is the title of this scene depicting a crashed Marine F4U Corsair.
M.Sgt. John C. DeGrasse, USMC, spotted it in Korea during his tour as a combat artist.
The lush valley stands in stark contrast to the wrecked airplane.
USMC Art Collection

After another year of seesaw fighting across the thirty-eighth parallel, which divided North and South Korea, the front lines were established in so-called peace talks. Trench warfare ensued for two more years until a cease fire was declared in 1953. As of the year 2001, there is still no peace treaty, and the United States still maintains a division on the DMZ that separates North and South Korea.

Combat Art Coverage in Korea

Their hands full with such dire matters as continuing defeats on the battlefield, the military understandably gave combat art coverage a low priority. The Navy had three artists on duty, Herbert C. Hahn, USNR, Hugh Cabot III, USN, and Russell Connor, and assigned them to cover Navy sea and air operations. Hahn flew on some combat patrols and produced some sketches. Neither the Army, the Coast Guard, nor the new U.S. Air Force assigned any artists. Only Howard Brodie, now a civilian, and John Groth, also a civilian, covered the war for *Collier's*. The other great publications did not assign artists as they had in World War II.

The First Marine Corps Combat Art Team

The Marine Corps, fresh from its experience with combat art in World War II, was quick to form a team this time, designating it The First Marine Corps Combat Art Team. Reserve officer and World War II veteran 1st Lt. Joseph A. Cain was put in charge. Quartered at Atsu, Japan, the team of artists consisted of Cain, M.Sgt. John C. DeGrasse, who had won scholarships to the Portland Institute of Fine Arts in Maine and the Pittsburgh Institute of Art, Sgt. Hubert A. Raczka, a veteran of Midway and Bougainville who was named one of *Life* magazine's nineteen most promising young artists in America, and photographer S.Sgt. Frank Few, a Guadalcanal and Peleliu veteran. The team made sporadic forays into battle areas to gather material, then worked it into finished paintings back in Japan. The results were marginal at best.

When the team returned to the States in late 1951, H. Avery Chenoweth was assigned as the new officer in charge of the Marine combat art team. A first lieutenant, he received art training at Yale, Princeton, and the Corcoran Gallery School of Art, and was a reserve officer who had served in Korea during all of 1951 as a rifle, machine gun, and recoilless rifle platoon commander in the 5th Marine Regiment of the 1st Division.

In 1952, located in a makeshift studio at a modified warehouse in Alexandria, Virginia, the Marine combat art team re-created scenes of the continuing war in Korea from memory, aided by photographic reference. Not

Above: M.Sgt. John C. DeGrasse's quick sketch of a Marine.
USMC Art Collection

Opposite: In his loose and easy style, DeGrasse captured this firefight in oil on canvas. Although the action was not identified by the artist, it appears to be a unit guarding a Marine M-26 tank unexpectedly hit by sniper fire. Despite the artist's rendering, bayonets were not usually attached in such situations and were used only in dug-in defensive situations or close-in attacks. Normally, too, a tank would not be caught so far forward in a hostile area, especially in such hilly terrain; the flanking hilltops would have been secured.
USMC Art Collection

Above: *Dusty March*, by 1st Lt. H. Avery Chenoweth, pictures a common, grueling ordeal during the hot, dry summer of 1951. Always short on equipment, the Marines often had to trudge along on long marches when truck transportation was not available. Were this an imminent combat situation, there would be flank patrols out on the ridgelines on each side for protection. This painting has been missing from the Marine Corps art collection since the Korean War.
USMC Art Collection

Right: While his rifle platoon was guarding a division command post, Chenoweth witnessed the first use of helicopters in combat. A quarter of a century later, he reconstructed the episode in a series of paintings depicting the entire operation.
USMC Art Collection

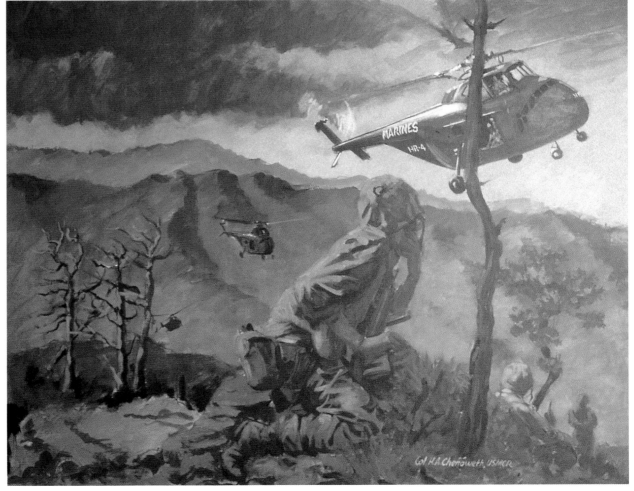

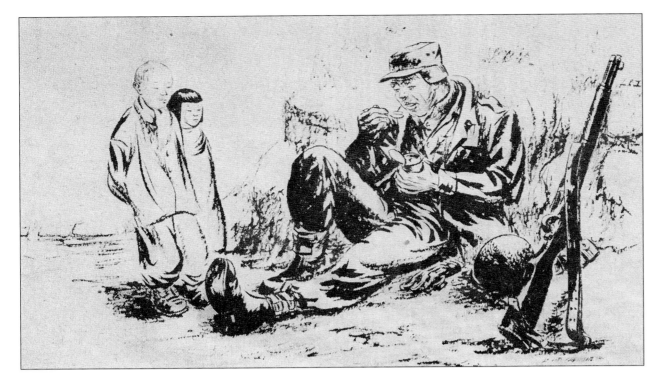

Left: A sketch by Chenoweth of a Marine taking a short break and devouring a can of beans and franks—no doubt stone cold. The polite Korean children probably received a cookie or bit of chocolate, as they often did from the Americans.
USMC Art Collection

Below: Chenoweth depicts the first helo-lift in warfare, in September 1951. Sikorsky HRS-1s of transport helicopter squadron HMR-161 delivered fresh troops to the line, lifted a rocket battery, and moved the division reconnaissance company to a mountain top, thus setting the stage for the rapid development of this new vertical dimension to warfare. The acrylic painting is a later reconstruction.
USMC Art Collection

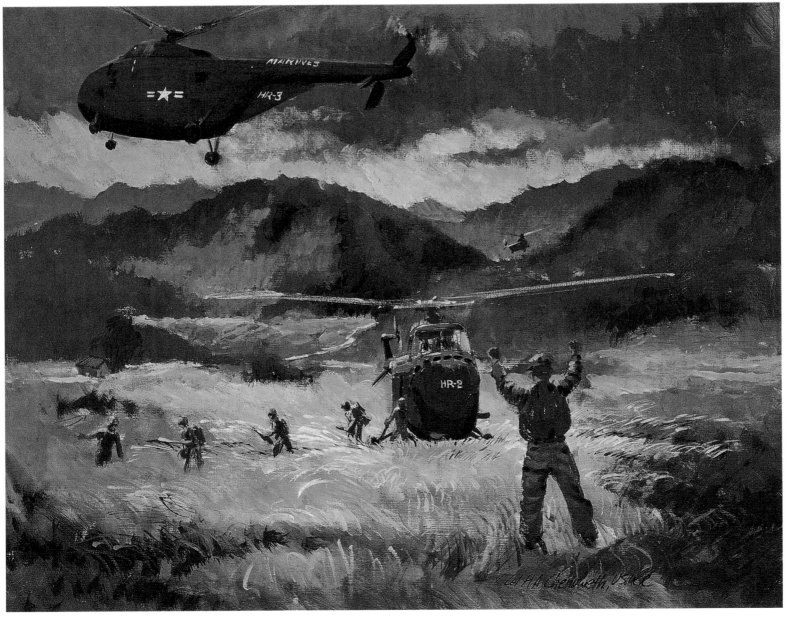

Right: Author H. Avery Chenoweth poses with his painting *The Road Back*. In 1952, Chenoweth, a first lieutenant in the Marine reserves, became officer in charge of the First Marine Corps Combat Art Team.

Below: Battle casualty handling by contracted South Korean laborers was sometimes unavoidably rough. Since the Koreans were familiar with the rugged terrain, they relieved combat troops from some of these types of chores. The time between being wounded and receiving the best surgical care decreased dramatically during the Korean War, due mainly to the use of the ubiquitous helicopter for evacuation. Helicopters could go places other vehicles could not, and could speed the casualties back to the proper aid station, M.A.S.H. unit, or even hospital ship in a matter of minutes instead of hours, subsequently saving many lives. The sketch is by Chenoweth.
USMC Art Collection

Opposite: A 1951 combat veteran with the 5th Marine Regiment, Chenoweth portrayed the heroic fighting withdrawal of the entire 1st Marine Division from the Chosin Reservoir in his reconstructed painting, *The Road Back*. When the Chinese entered the war in December of 1950 and struck the U.N. lines in full force, the Marine division had to fight its way back to the coast and evacuate in two grueling weeks of subzero temperatures, snow, and constant fire from ten Chinese divisions surrounding them. In the process, the Marines destroyed eight of the enemy divisions. Chenoweth had been a replacement at the tail end of the withdrawal, commanding a platoon of battle-hardened survivors under similar climatic conditions the rest of the winter of 1950–51.
USMC Art Collection

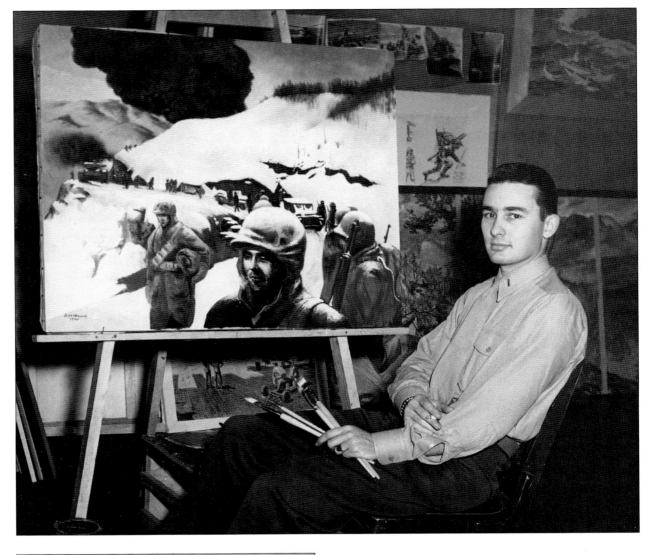

having been an assigned combat artist during the previous year's fighting, Chenoweth, like Capt. John Thomason in World War I, had been able only to sketch briefly, when the occasion presented itself, and in this way had unwittingly become a combatant-artist. His sketches, however, had been spotted by an alert officer, Capt. Sam Jaskilka, who directed him to the Division of Information for reassignment to the art team. One of the incidents that Chenoweth later re-created in a series of paintings depicted the first use of helicopters in the history of warfare. Observing from an outpost position, he had witnessed the copters landing directly behind the lines and disgorging troops, a sight he would never forget and one which his paintings capture.

Chenoweth was succeeded as officer in charge by 1st Lt. Russell J. Hendrickson, USMCR, an artist who had previously served as an infantry officer in Korea. By 1953, the team's efforts faded along with the war. The First Marine Corps Combat Art Team was not to be resurrected until 1990, when a team was formed to cover the Gulf War.

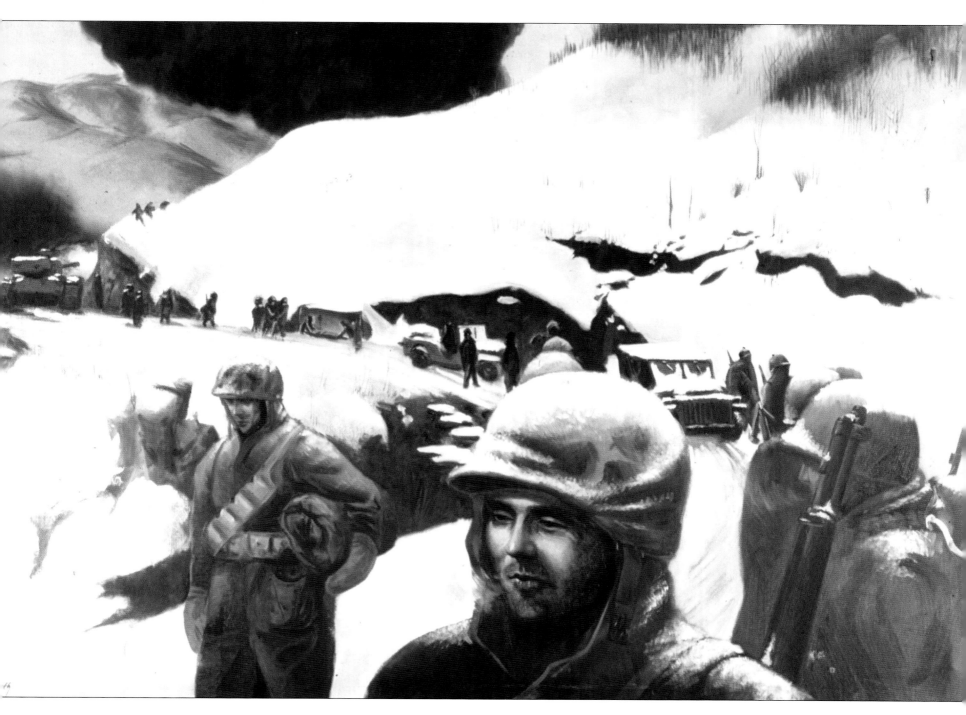

Several other Marine artists were mentioned in conjunction with the Second Annual Art Exhibit at the Navy Annex from 6–10 November 1954, sponsored by the BuSanda Recreation Association. They were S.Sgt. Charles W. Beveridge, Sgt. Robert C. Southee, and S.Sgt. Gordon Bess. Whether or not their art was derived from observed combat or contrived studio illustration is not clear; they were not, however, Marine Corps artists acting in any official capacity. Finally, 1st Lt. R.P. Davis turned in a sketch of the 1st Marine Regimental Command Post at Khe Johni, Korea, in September of 1951. John R. Chalk also turned in some work, and Reserve Col. John Rogers, who had been in an air group at Wonsan during the

Reservoir campaign, executed some sculptures based on his impressions of the war.

Other names that appear in the Marine Corps art archives are Sgt. Ralph Schofield, a veteran of the Chosin Reservoir, and M.Sgt. Donald E. Wilkerson, who served in Korea in 1952.

For several years following the Korean War, many of the works were exhibited nationally under both Marine Corps and Navy auspices. Unfortunately, due to changes in personnel and downsizing following the Korean War, many of the combat art paintings of the First Marine Corps Combat Art Team were lost or disappeared. (If the whereabouts of any are known, the

"HEY, SARGE! WHAT TIME IS LIBERTY CALL?"

Pages 234–235: In 1951, S.Sgt. Norval E. Packwood, Jr., USMCR, was sent to Korea to portray the human side of the war that so often escapes the lens of the camera. In his distinctive style, he did for the Marines of the Korean War what Bill Mauldin had done for the Army GIs of World War II. Marine Gen. Homer Litzenberg wrote of Packwood's humor: "As any military man will tell you, humor is a necessity on the battlefield. Man would be hard put at times to keep his sanity if it were not for his innate funnybone." Packwood's inimitable style is evident in these cartoons from his book *Leatherhead in Korea,* published by the Marine Corps *Gazette* in 1953. The legend for the top left cartoon on this page reads: "The bottom's burnt and the top is cold—try to get a couple bites out of the middle before it freezes."

Reproduction courtesy of the Marine Corps Gazette.

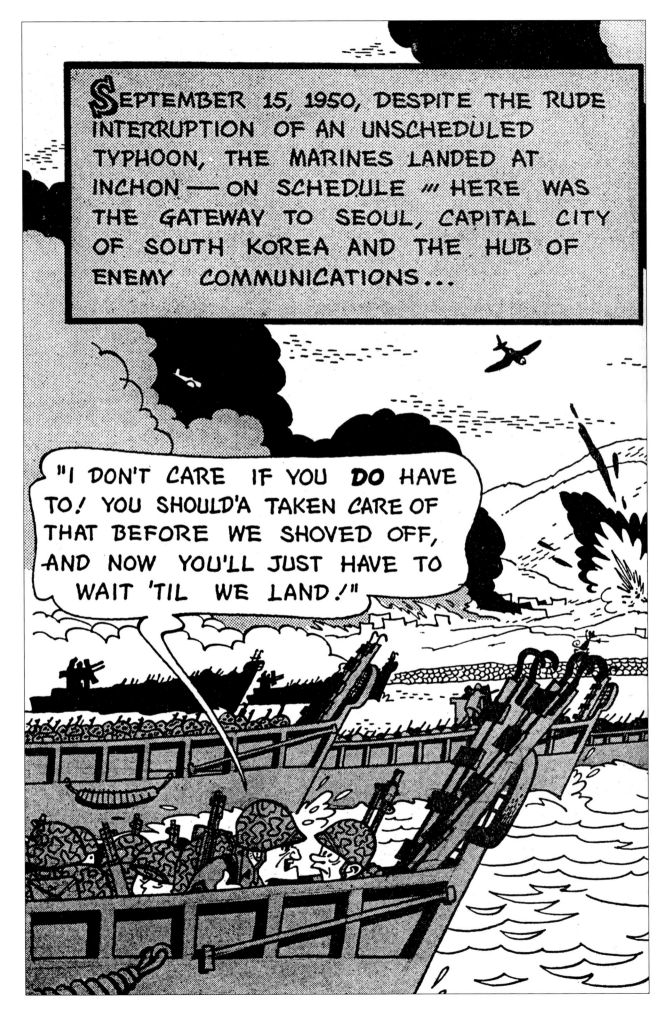

"RETREAT, HELL! WE MADE A 180 DEGREE TURN AND ATTACKED ON A NEW FRONT!"

"THE LOUSY ARTILLERY GETS ALL THE BREAKS ... A SWELL HOUSE TO LIVE IN!"

Marine Corps Historical Division at the Washington Navy Yard should be advised.) Years later, some were found in officers' clubs and other facilities and bases around the world and were properly cataloged. Possibly some ended up in private hands. Regardless, all of it remains government property.

Marine Humorist S.Sgt. Norval E. Packwood, USMCR

While the combat art team was painting in their studio, Marine Corps *Gazette* and *Leatherneck* magazines, located at Henderson Hall Marine facility across from the Navy Annex in Arlington, Virginia, had been under the direction of managing editor Col. Donald Dickson of World War II fame. Among its ongoing stable of artists, including George Booth, who would gain fame later as a *New Yorker* cartoonist, was S.Sgt. Norval E. Packwood. Packwood joined the Marines in 1948. He had attended the Chicago Art Institute, Abbott School of Art, and George Washington University. A top cartoonist, Sgt. Packwood was sent by the Marine Corps *Gazette* to cover the Korean war from his particular slant. The results were a steady stream of laughs for the magazine and, upon Packwood's return, a *Gazette* publication of his humorous insights entitled *Leatherhead in Korea*. Although he failed to gain the reputation he deserved, Packwood's humor did for the Marines of the Korean War what Bill Mauldin's and Fred Lasswell's had done for the GIs in World War II.

Humorous and satirical art seems to have been sporadic in all wars, published and forgotten; it was also for the most part amateurish. Post–Korean War conflicts failed to generate cartoonists who were of Mauldin and Packwood's caliber in the humor department. Certainly nothing of top quality came out of the Vietnam conflict, or later from *Desert Shield* and *Desert Storm*.

Civilian Combat Artists John Groth and Howard Brodie

Under the auspices of *Collier's* magazine, peripatetic civilian artist-illustrator John Groth went to Korea, the second of five wars he covered. Later referred to as the dean of combat artists, Groth also covered the Marines in Vietnam in the late 1960s.

After his release from the Army following World War II, where he had been a combat artist for *Yank*, Brodie returned to his job as sports artist for the *San Francisco Chronicle*. He covered other wars during his career, including Korea (for *Collier's*), French Indochina, and Vietnam. He wrote and illustrated a book of his experiences entitled *Drawing Fire: A Combat Artist at War*.

Above: Marine Reserve Sgt. Ralph Schofield sketched his experiences with the 1st Marine Regiment at Koto-ri, on the southern tip of the Chosin Reservoir. Here, he depicts Marines checking a Chinese prisoner.
USMC Art Collection

Right: In describing *Rifleman Morgan Weeps*, artist Howard Brodie commented, "Watching a wounded buddy, Morgan turns his head away. He is crying. I may have been the only one who noticed Morgan wipe tears from his eyes."
Courtesy of the artist

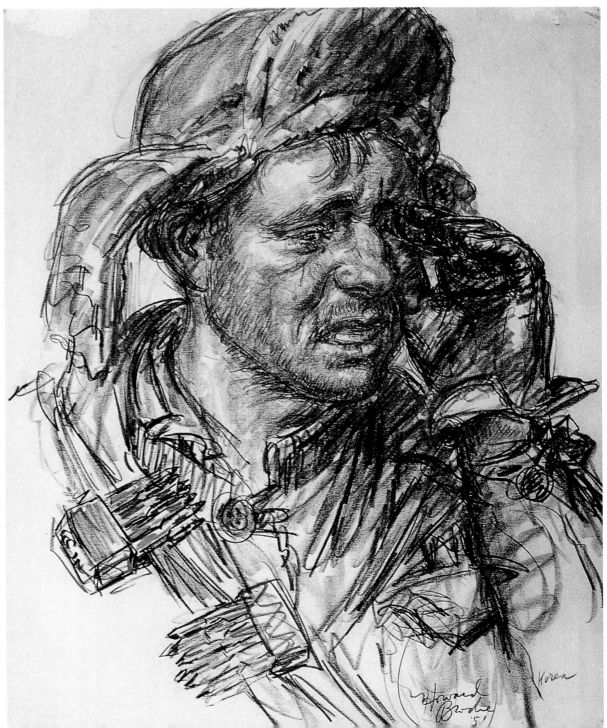

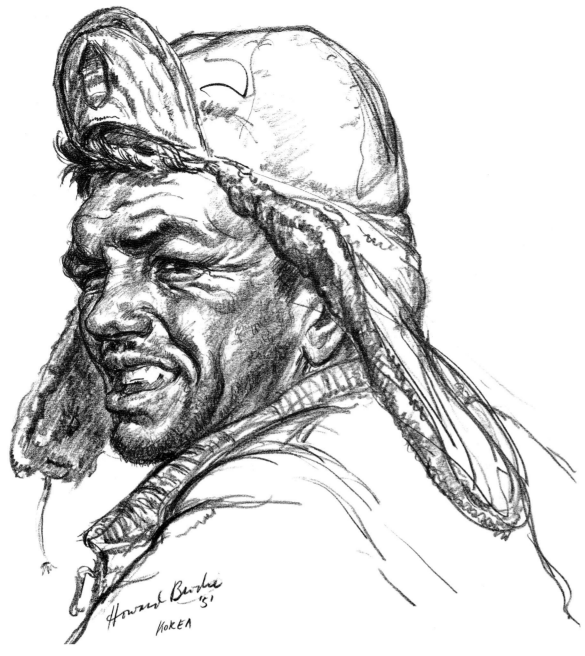

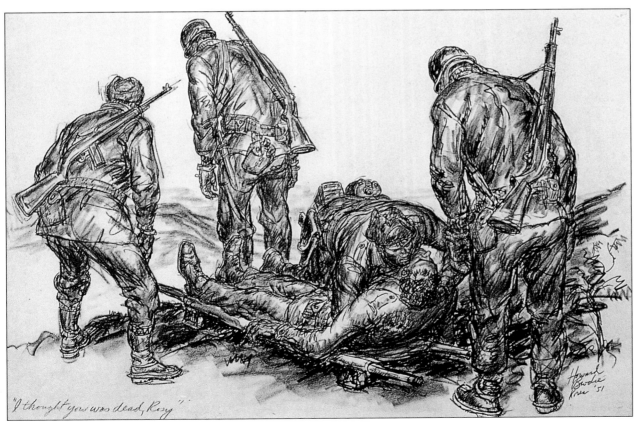

"I thought you was dead, Rosy"

America's First Stalemated War

After Gen. Douglas MacArthur was relieved of his command in 1951 for misjudging the Chinese threat, the Korean War wound down in its last two and a half years, with opposing forces remaining in static positions along the DMZ, facing each other in trenches as the belligerents had in World War I. The stalemate would last for more than fifty years, with ongoing peace talks at a spot in the middle of the neutral DMZ. The toll had been heavy. More than 33,686 Americans died in battle in three years, 2830 of other causes; 8168 are still listed as missing.

When the U.N. forces arrived in 1950, Korea was an undeveloped country of thatched roofs, ancient walled cities, few paved roads, no buildings over three stories, ox-drawn carts, and primitive farming methods. Along with the fighting, the combat artists in Korea sought to capture the rugged beauty of the country in their paintings.

Now, a half century later, Korea is a modern, bustling nation, and a leader in world technology—although still reinforced by the presence of U.N. troops. The Korean War has been virtually forgotten in the minds of the public—eclipsed by Vietnam and the more recent Persian Gulf War. While most wars were given national memorials in Washington, DC, the Korean War did not receive one until 1995, when Korean automobile manufacturer Hyundai sponsored it with a generous donation. In the public's mind, especially younger generations, Korea is a dim, confused memory kept alive in progressively shorter and shorter paragraphs in history books.

Atomic Tests in the New Atomic Age

In the spring of 1952, H. Avery Chenoweth, then a first lieutenant, and M.Sgt. DeGrasse were ordered to cover the atomic bomb tests in Nevada. The observers at "News Nob," watched through darkened glasses as the atom bomb exploded on a tower ten miles (16km) away, across the sandy floor of Yucca Flat. The Army exercise was designated *Desert Rock III*.

The following week, Chenoweth and DeGrasse, with hundreds of other Marines, were in shallow trenches 4000 yards (4km) from ground zero for the Marine test, *Desert Rock IV*, for which a Hiroshima-sized twenty-kiloton bomb was exploded 3000 feet (914m) above the target site. After the initial blast and radiation (from which their only protection was the trench), the Marines stood up and experienced the violent shock wave that raced toward them across the desert. Chenoweth and DeGrasse sketched the activities surrounding this early test of this awesome new destructive force. Chenoweth's watercolor sketches of the progression of the explosion from fireball to sky-obliterating cloud were published by the national wire services.

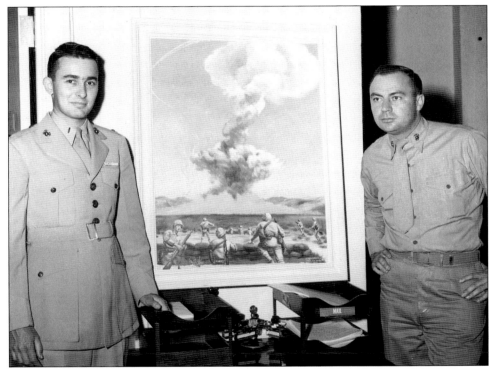

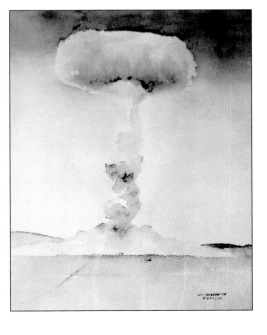

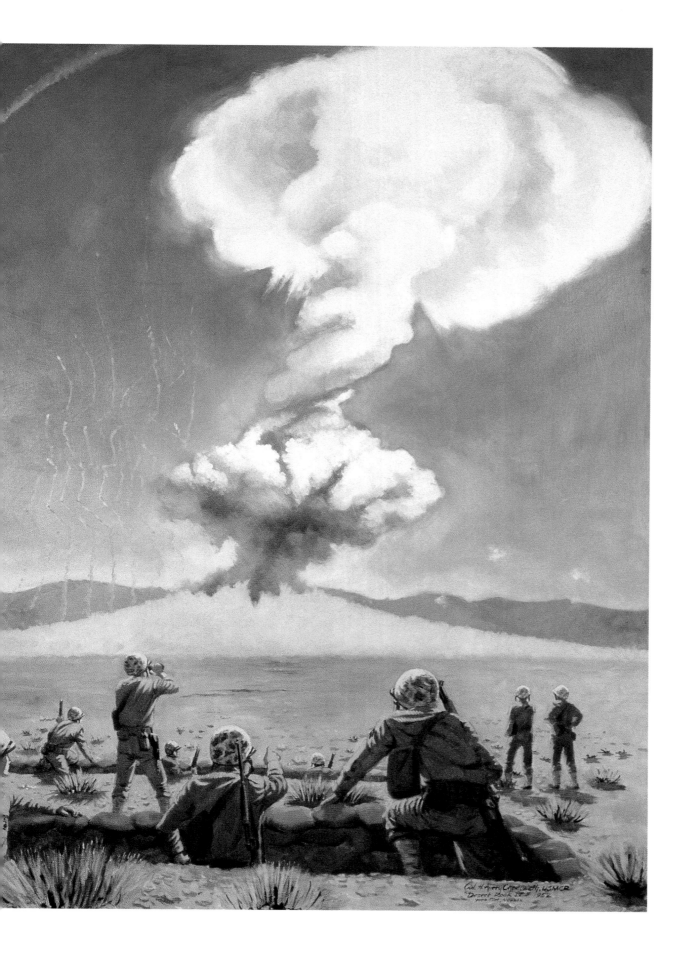

Opposite Top: Observers watch an atomic bomb test through darkened glasses.

Opposite Center: 1st Lt. H. Avery Chenoweth (left) and M.Sgt. John DeGrasse, both Marine combat artists, stand beside Chenoweth's original painting of *Desert Rock IV* at Yucca Flat, Nevada. This painting and a larger one by DeGrasse were displayed in the U.S. Capitol. On the way back to Marine Headquarters, Chenoweth's painting was swept out of the truck by a gust of wind and lost. Twenty-five years later, Chenoweth painted a duplicate of the missing painting from this photograph.

Opposite, Bottom Row: Chenoweth's on-the-spot watercolor sketches of the fireball at the *Desert Rock IV* atomic bomb tests. The thunderous, churning fireball, measuring 1500 feet (457m) in diameter, slowly sucked up sand and debris from the desert (left). As it cooled (center) it began to resemble the classic mushroom shape of an atomic cloud (right).

Left: As a participant–combat artist, Chenoweth made a painting of the Marine Corps atomic exercise *Desert Rock IV* in April 1952, shortly after he experienced it. The painting, however, was subsequently lost. More than two decades later, he repainted this version.
USMC Art Collection

CHAPTER Eight

Vietnam: The "Anti-War"

Almost a dozen years after the cessation of fighting in Korea, another limited war occurred in Asia that had reverberating side effects for the United States. The land was lush and tropical, with jungle, savanna, piedmont, and mountain terrain. In this setting, the technology of war underwent remarkable changes that spawned air mobile operations, river patrols, tactical and strategic air operations, short, intense small-unit engagements, no main line of resistance (MLR) but a tactical area of responsibility (TAOR) of 360 degrees at strong points, search-and-destroy missions, firebases and forts, landing zones (LZs) for helicopters, and defoliation chemicals. The enemy was different, too, with no large land armies, no air or naval resistance, only phantom-like guerrillas, the Vietcong (VC), and the small units of the North Vietnamese Army. With television and photo crews everywhere, Vietnam turned out to be the first fully photographed war, and the American public watched televised rebroadcasts of it in their homes every morning and evening.

Lacking clear national objectives—and with constant media scrutiny—the entire effort soon soured, and the undeclared war became very unpopular with the American public. Antiwar demonstrators rose up, orchestrating sit-ins, teach-ins, campus demonstrations, and draft card burnings. U.S. society was undergoing terrible upheavals. Drug, morale, and discipline problems, as well as racial tensions, were rampant, and the military was not exempt. After ten years of desultory effort, the United States extricated its fighting forces in the middle of the war, ultimately causing the collapse of American-supported South Vietnam.

In the war's ten years, the human tally was some 47,000 U.S. battle deaths (out of eight million in service), casualties that came in a conflict in which the enemy had been able to mount only comparatively small brush skirmishes. The United States tactics were to move speedily, drop from the skies and engage, then count the bodies and move on to another site. In a country confined to a small strip of coastal land, the retention of real estate was not always essential.

Eventually, however, the attrition of the war demoralized the American troops. It was a war that, ultimately, the public and many of those fighting it failed to support. Eventually unseating President Lyndon Johnson, the conflict in Vietnam became a bottomless pit into which the United States kept throwing men, arms, and money. The initial motive of saving a small Southeast Asian country from hostile communist takeover soon backfired, leaving its bitter aftertaste for a generation. Presidents Kennedy, Johnson, and Nixon all failed to convince the American public that the fall of South Vietnam would start a domino effect resulting in further communist conquests—or that it was preventing World War III.

In the final analysis, Vietnam was not a major war involving a wide range of confrontations on land, at sea, or in the air, nor one that mobilized a national effort behind it. Sadly, instead of returning heroes, our armed forces slunk home virtually in disgrace—many to fathers who had been hailed with ticker-tape parades following World War II.

Typical of the extraordinary beauty of his settings, William S. Phillips' 1987 painting, *Those Last Critical Moments*, depicts the twilight landing of an F-14 Tomcat on the *Kitty Hawk*, which served off Vietnam.

Courtesy of the artist

The Vietnam War Years

The exact dates of the Vietnam War are unclear. Most accounts synopsize the conflict as consuming a ten-year period from 1965–75.

In 1961, President Kennedy ordered U.S. military advisors to South Vietnam to assist the fledgling South Vietnamese army. The advisors were U.S. Army Rangers and CIA members, both of whom engaged in covert operations. In 1963, there were 16,000 American military advisors in the country; in 1964, 146 were killed in combat. In August of 1965, the Tonkin Gulf incident, in which a U.S. naval ship was attacked on the high seas, triggered U.S. retaliatory attacks on North Vietnam. Congress' subsequent Tonkin Gulf Resolution authorized President Johnson to "repel any armed attack against the forces of the United States and to prevent further aggression."

In 1965, two brigades of U.S. Marines landed at Da Nang, ostensibly to protect the airfield there. Eventually, thirty countries sent some form of military aid, including South Korea, which sent a combat infantry division, the Tiger division, perhaps in appreciation of those Americans who had given their lives defending South Korea a decade and a half earlier.

By 1968, the United States had sent 550,000 troops to Vietnam. Contrary to the public's conception, those half a million troops were not in constant combat; of that number, only 100,000—or roughly ninety maneuver infantry battalions—were combat forces. And of those battalions, fewer than 10 percent were ever engaged with the enemy at any given time. Nevertheless, the weekly casualty rate of 250 killed in action was too much for the American public—and the military, for that matter.

True to his election promise, in 1969 President Nixon ordered the first U.S. troop withdrawals from Vietnam, which were completed in 1972, leaving the South Vietnamese to fend for themselves. The Paris Peace Accords that the United States signed with the North Vietnam communist regime in 1973 concluded U.S. involvement in Vietnam, and a thousand or so American prisoners of war were released.

Two years later, the North Vietnamese, in violation of the Peace Accords, invaded South Vietnam in force and virtually unopposed. The South Vietnamese forces collapsed, mostly because their leaders had fled. In a frantic attempt to evacuate the remaining U.S. embassy personnel and straggling advisors in 1975, six soldiers and Marines were killed. The deaths of these American military personnel were the last casualties suffered by the United States in the undeclared war.

Right: As painted in oil by Lt. John Charles Roach, *Coming into the Wind* depicts the aircraft carrier USS *Enterprise* escorted by destroyer DD *Waddell* in the Tonkin Gulf, in the spring of 1969.

U.S. Navy Art Collection

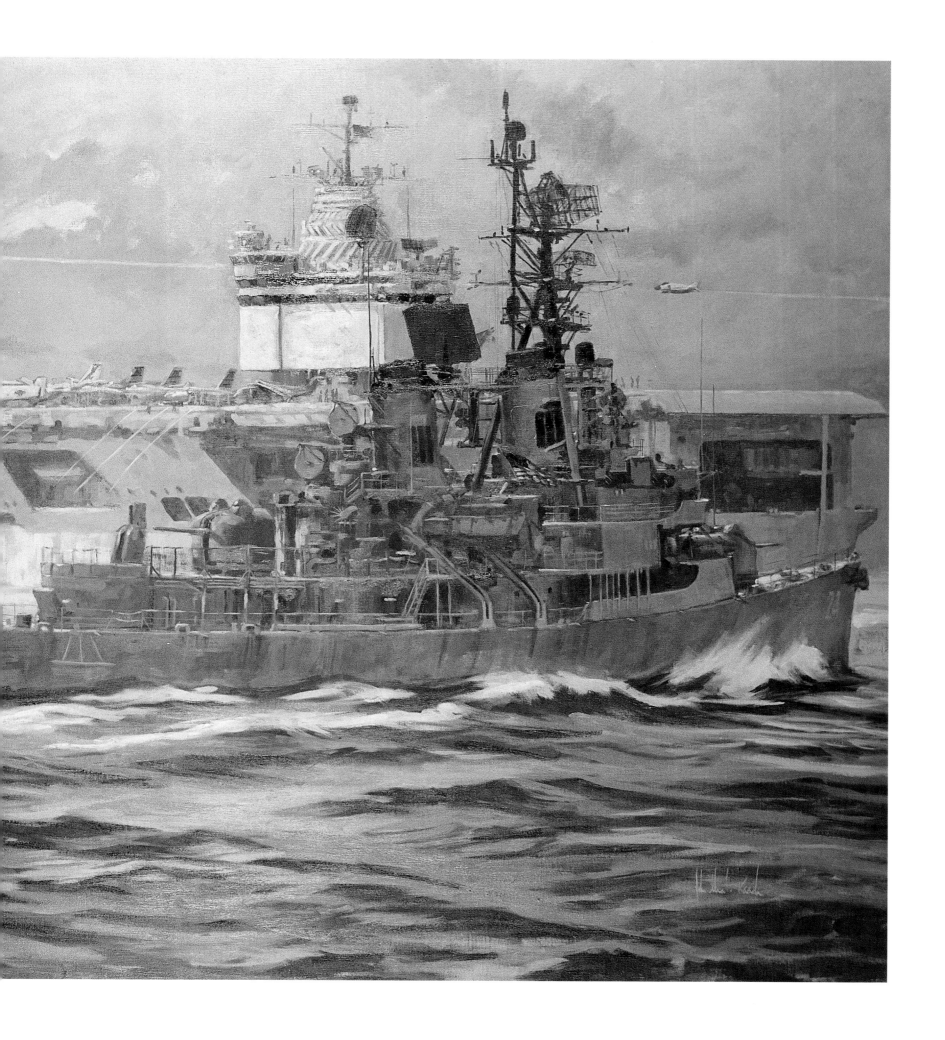

Above: *Sandbag Detail*, by Lt. John Roach.
U.S. Navy Art Collection

Right: NACAL artist Gerald L. Merfield depicts a Navy river patrol showing the flag at Cau Mau. The Navy referred to this duty as the "Brown Water" Navy, as opposed to the "Blue Water" Navy on the high seas.
U.S. Navy Art Collection

The Combat Art Programs of the Military Services

As early as 1965, the Navy, Marine Corps, and Army all began to plan for artistic coverage of the mounting war. The Marine Corps' Division of Information rose to the occasion quickly and recalled Col. Ray Henri to active duty to head the combat art program, which he had done so outstandingly in World War II. Henri organized the program, appointed Maj. Mike Leahy as assistant, and drew upon the talents of Marines already on active duty, reservists for whom he arranged short volunteer assignments in Vietnam, and civilian illustrators through the Navy Art Cooperation and Liaison Committee (NACAL) program. Col. Henri inherited Capt. John T. Dyer, USMCR, who was already in the I Corps sector of operations in northern South Vietnam. Dyer would serve two six-month active duty combat art tours in Vietnam, later becoming the civilian curator of art at the Marine Corps Museum at the Washington Navy Yard. Ultimately, the Marine art program consisted of three dozen uniformed artists and a dozen NACAL artists, all of whom created more than 3000 combat art works.

The Navy sent a number of its own personnel, including Lt. John Charles Roach, who was to cover the Persian Gulf War almost fifteen years later as well, and Comdr. Edmond Fitzgerald and Lt. Comdr. Salvatore Indiviglia, both reservists who volunteered to be recalled to active duty.

As it had in World War II, though failed to in Korea, the Department of the Army established the Army Combat Art Program in 1966 to "enlist the talents of qualified artists for recording military operations in Vietnam." It also invited civilian artists to observe and sketch military activities in Vietnam for 120-day periods, then to execute their works as they could after returning home. On duty, the program had two officers and eleven enlisted specialists who, as artists, were given free rein to produce artworks. They went out in teams of three. All told, fifty uniformed artists and twenty civilians produced more than 2000 artworks on the war for the Army.

Before the United States became involved in the war, the Navy's art program had been augmented, beginning in 1960, through the generous auspices of the Salmagundi Club of New York (a group of professional artists and patrons), which formed NACAL East, and members of the Municipal Art Department of Los Angeles, who formed NACAL West. The U.S. Air Force, meanwhile, utilized the Society of Illustrators for artist resources. Artists from all these groups were given thirty-day assignments, with transportation and lodging provided by the military services, to visit combat areas. In the case of the NACAL artists, their work became the property of the services that hosted them. The artists of the Society of Illustrators retained their own copyrights and allowed the services to use the works.

Despite a growing public disenchantment with the lengthening war in Vietnam, many institutions saw it as history in the making and sought to display visual interpretations of it. Military organizations mounted combat art exhibits, as did the New York Overseas Press Club. Most prestigious was the Smithsonian Institution's 1968 exhibition entitled "The Armed Forces of the United States as Seen by the Contemporary Artist." Under the auspices of the National Armed Forces Museum Advisory Board, the exhibit included an overview of combat art beginning in the colonial period. All the services were

Above: NACAL artist John Steel's acrylic *Seal Team Drop Off* shows a unit disembarking along a remote, swamp-tangled shore somewhere in Vietnam.
U.S. Navy Art Collection

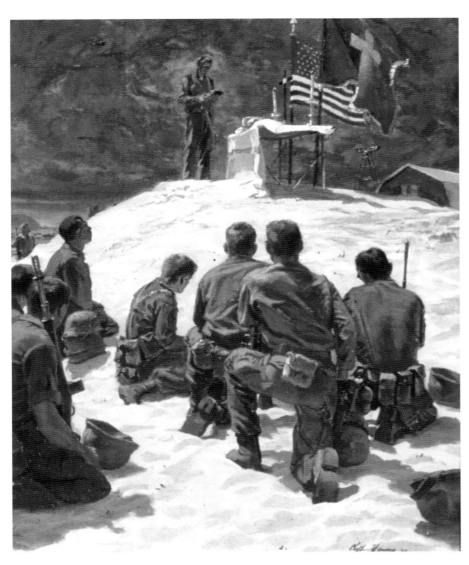

Above: NACAL artist Cliff Young caught a sensitive scene on the beach of the South China Sea near Da Nang. A Navy chaplain is conducting a memorial service for fallen Marines. Although it is a solemn moment, those participating are ever mindful of the danger everywhere; their weapons and gear are ready. On the horizon is Marble Mountain, the site of much fighting.
USMC Art Collection

Above Right: John Groth's color sketch depicts a Marine patrol checking civilian farmers near Marble Mountain outside Da Nang. The Vietcong would often disguise themselves as farmers.
USMC Art Collection

Opposite Top: Mass for the Fallen is John Steel's interpretation of a regular occurrence.
U.S. Navy Art Collection

represented except the Coast Guard, which, after the exhibit sent two artists to cover the Vietnam War. The Air Force was represented by a dozen contracted Society of Illustrators artists covering its operations in Southeast Asia, but two of its own, unfortunately, were not represented in the exhibits: Amn. William S. Phillips and Maj. Wilson Hurley.

Combat Art of the U.S. Navy

In addition to Lt. Roach, Comdr. Fitzgerald, who as a line officer had commanded an LST during World War II, covered Navy and Marine fighting in Vietnam as a civilian, while Lt. Comdr. Indiviglia was on active duty in Vietnam and did some fine work as well. Fitzgerald was a graduate of the California School of Fine Arts and a member of the National Academy of Design, the National Society of Mural Painters, the American Watercolor Society, and Allied Artists of America. Indiviglia was a graduate of the Leonardo da Vinci Art School, the School of Industrial Arts, and the Pratt Institute, as well as a member of the American Watercolor Society, the Artists' Fellowship, the American Veterans Society of Artists, and the Salmagundi Club of New York. Additionally, NACAL illustrator John Steel did some outstanding work for the Navy, as did Charles Waterhouse.

NACAL and the Salmagundi Club of New York City

Publications did not substantially underwrite combat art, as they had in World War II and Korea. Instead, the major effort of civilian artists this time centered around independent commercial illustrators in New York and Los Angeles. George Gray, a Coast Guard artist of World War II and successful illustrator, was appointed head of NACAL, operated by New York's famous Salmagundi Club of top illustrators, from which the artists to cover the war were selected.

While noted illustrators John Groth, Austin Briggs, Isa Barnett, Doug Rosa, Tom O'Hara, Charles Waterhouse, and portraitist John Daly Hart went to Vietnam as USMC-sponsored civilian artists, John Steel and Tom Van Sant were among those who undertook NACAL thirty-day tours as combat artists for the Navy. They all turned out first-rate work. A female artist, Christine "Trella" Koczwara, also went to the war zone, though she was probably not allowed to accompany combat patrols. (In 1965, female correspondent Dicky Chapelle, accompanying a Marine patrol, stepped on a land mine and was killed, no doubt precluding women from later going into combat under official auspices.) Instead, Koczwara concentrated on depicting civilians, orphanages, and rear echelon activities.

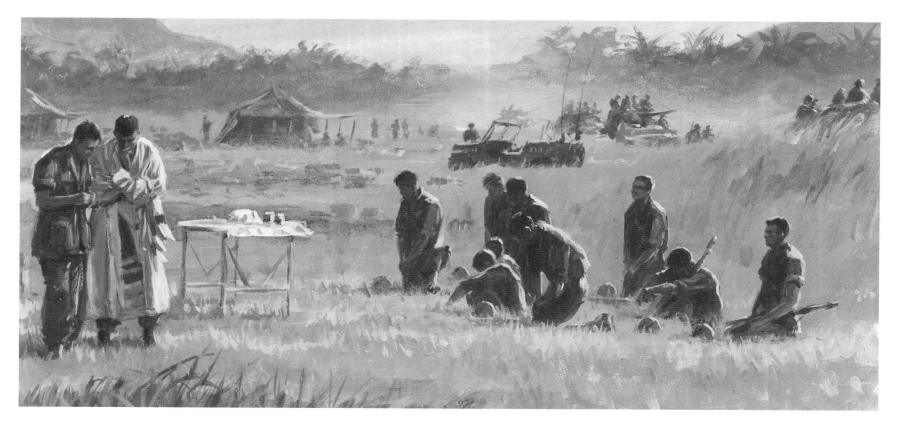

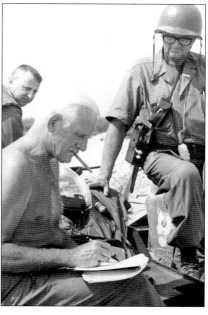

Above: Artist John Groth sketches while fellow combat artist Sherman Loudermilk looks on. Loudermilk had been a Marine combat artist in World War II. Formerly the art director of *Esquire* magazine, Groth, a combat art veteran of seven wars, observed, "In every war you see the same guys fighting—the eighteen- and nineteen-year-olds—all with the same look." The artist's works are in the permanent collections of the Museum of Modern Art, the Metropolitan Museum of New York, the Chicago Art Institute, the Library of Congress, the Smithsonian Institution, and the armed forces collections.

Left: Loudermilk captures Vietnam's tropical war in his strong, fluid watercolor style. He covered the war as a civilian artist.
USMC Art Collection

Right: Civilian artist-engineer R.G. Smith's sketch shows an F-4B Phantom II on a steam catapult about to be launched off the front of the flight deck of the nuclear-powered *Enterprise.* As an aeronautical engineer for Douglas Aircraft, Smith helped design the aircraft he depicts here.
Courtesy of the Artist

Below: Launch, Smith's finished painting of the sketch to the right, shows the F-4B Phantom II as well as a group of A-4 Skyhawks flying in formation overhead.
Courtesy of the Artist

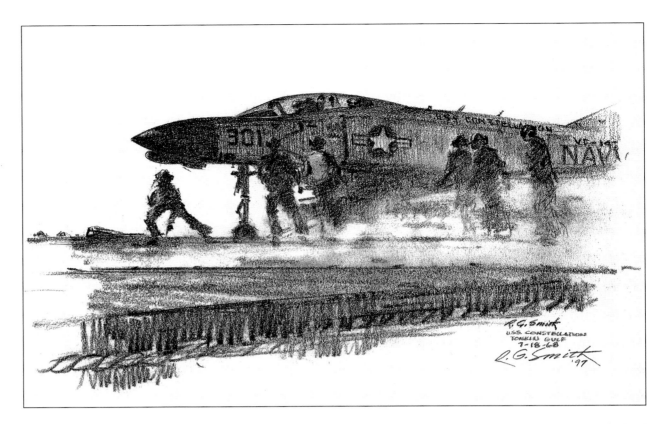

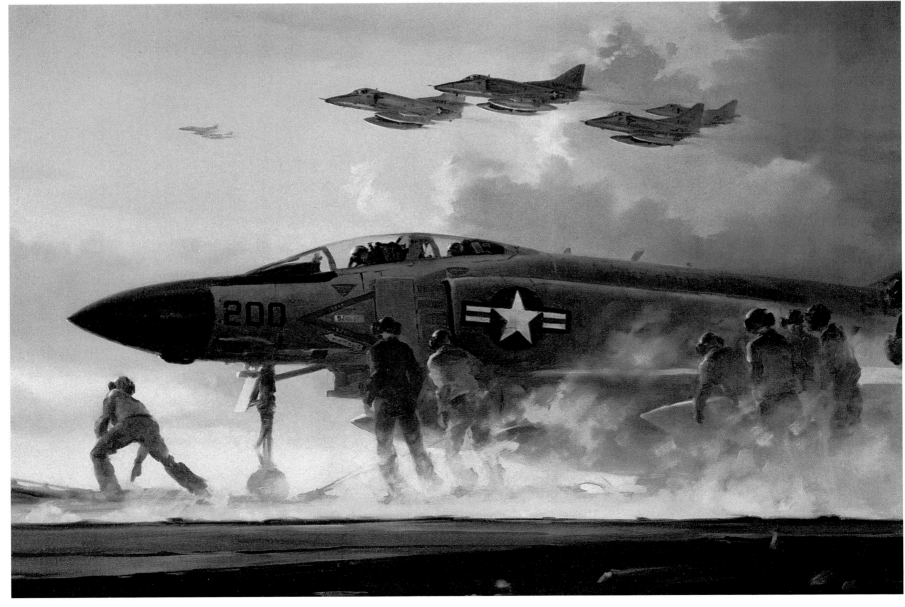

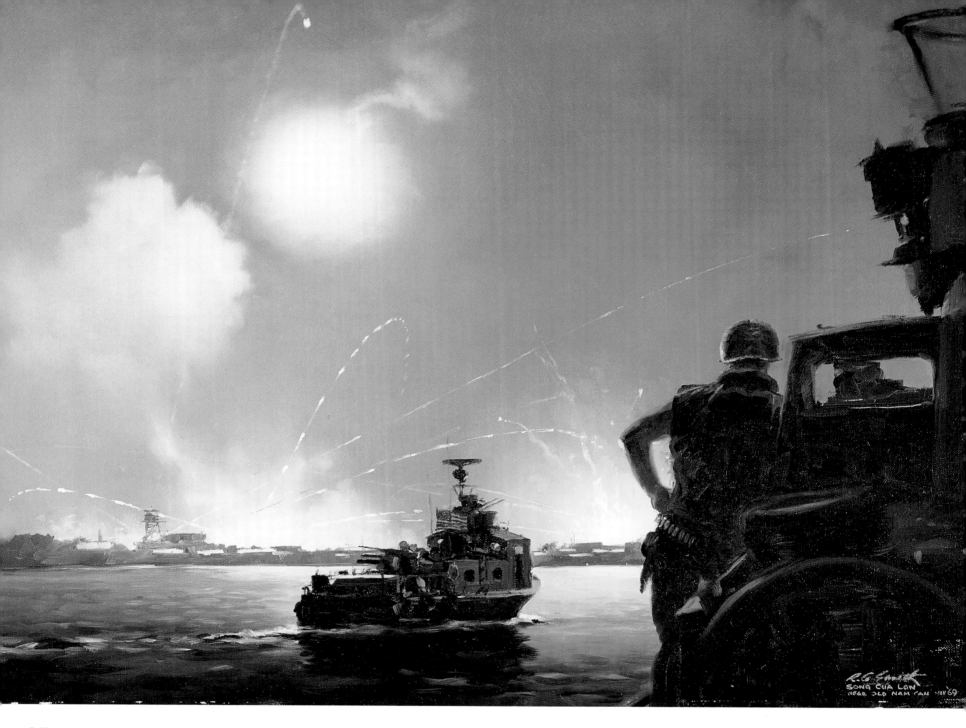

Above: R.G. Smith's *Night Firefight*.
Smith observed the confrontation from a
river patrol boat.
Courtesy of the Artist

Still, some civilian female correspondents and photographers did see combat, including Margaret Higgins and French photographer Cathy LeRoy, who was severely wounded. Two female artists from the Society of Illustrators went on combat missions with the Air Force.

Thus, the Navy, Marine Corps, and Coast Guard, which had not been represented in a 1968 Smithsonian Institution exhibition of combat art, benefited greatly from the efforts of civilian artists, and gave them all the assistance they required, short of stipends. Many, like illustrator Charles Waterhouse, covered both the Navy and the Marines. As a result of his work, and the publication of two of his sketchbooks, Waterhouse was invited to become artist in residence for the Marine Corps in 1973. Commissioned a limited-duty major in the Marine Corps Reserve, he came on active duty and specialized in historic reconstructions of highlights in Marine Corps history, a project that took him twenty years. During his tenure,

Waterhouse, who eventually retired with the rank of colonel, also depicted his being wounded on Iwo Jima.

R.G. Smith

Of the hundred or so artists that NACAL East and West provided, one name stands out among those who covered Navy-Marine-Coast Guard operations: Robert Grant Smith, better known by his initials "R.G."

Smith was, without challenge, at the very top of contemporary aviation artist–illustrators. His works appeared regularly in leading magazines, military publications, and corporate advertisements and prints, the latter available through the U.S. Naval Institute. His career as an artist was initially a sideline to his primary work as a draftsman, designer, and engineer for Douglas Aircraft.

As a child, his interest in aviation was kindled by the Lindbergh solo flight to Paris in 1927. As most youngsters did in the thirties, he built model airplanes. Later he

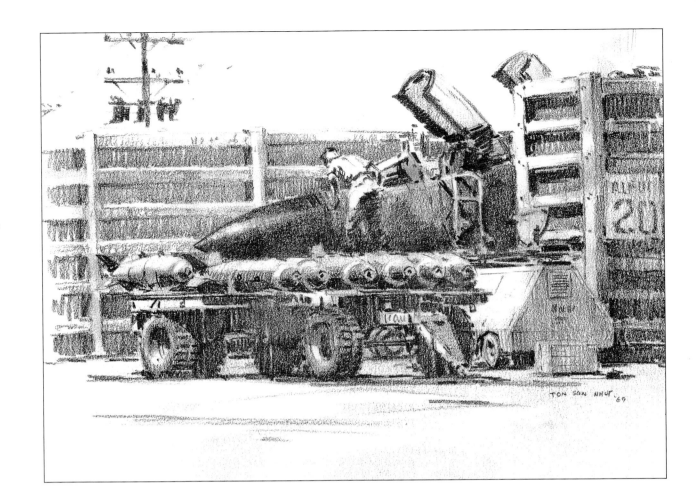

Right: R.G. Smith sketched this Air Force F-4 Phantom II being serviced and loaded with bombs for its next mission. It is berthed in a massive steel and earth protective revetment at Tan Son Nut airfield at Saigon in 1969. Smith often used such sketches as references to create larger paintings.
Courtesy of the Artist

Below: Smith's sketch of a Marine M-48 tank knocked off a road by a land mine in 1965 near Da Nang, the major seaport in the northern I Corps sector, where the 1st and 3rd Marine divisions operated. Mines, booby traps, and surprise guerrilla attacks by the Vietcong were a constant menace on patrol, although no U.S. forces encountered enemy mechanized armor. The device on the barrel of the 90mm gun is a muzzle brake.
Courtesy of the Artist

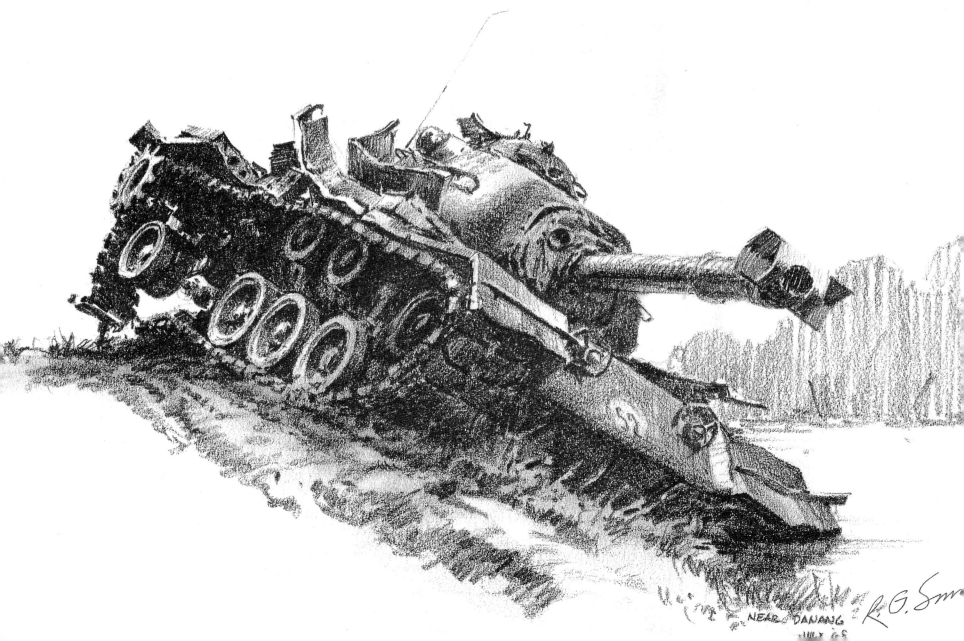

attended Polytechnic College in Oakland, California, and began the engineering and drafting work that attracted the attention of Douglas Aircraft. At Douglas, he developed as a skilled and talented engineer and draftsman, and his defense work designing combat aircraft was deemed important enough to keep him out of combat in World War II. His burgeoning artistic talent took a back seat to his helping design the famous SBD Dauntless dive bomber and later the A-4 Skyhawk—until he met Navy artist Arthur Edwaine Beaumont in the 1950s.

With a particularly strong talent for painting seascapes and ships, Beaumont had long been a successful commercial illustrator–artist. Vice Adm. William Leahy convinced him to accept a commission as a lieutenant in the Naval Reserve in 1933. This afforded Beaumont the official opportunity to paint scenes of U.S. naval activities. Resigning his commission a year later, Beaumont continued to paint the Navy all his life. Although never an actual combat artist (except for a brief observation stint aboard a ship off the Vietnam coast in 1967), he did depict major naval events and engagements that were used by the Navy Publicity office. Perhaps his greatest moment and contribution was his coverage of the Bikini atomic bomb test in 1946.

R.G. Smith encountered Beaumont at an art symposium in the early 1950s. Beaumont unleashed Smith's latent talent, exposing him to the finer points of artistic composition, its elements, and principles. As a consequence, Smith's art made a major leap forward.

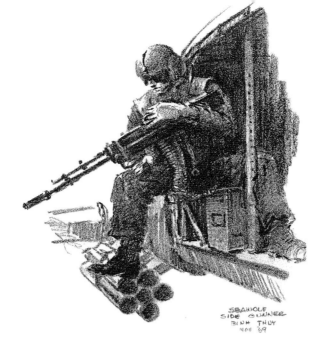

SEAWOLF
SIDE GUNNER
BINH THUY
NOV '69

Left: A side gunner in a helicopter about to take off from Bin Thoy in November 1969. R.G. Smith made this drawing on his second tour in Vietnam as a civilian combat artist. *Courtesy of the Artist*

Below: In Smith's *Vigil*, a gunner stands watch on a river patrol boat. *Courtesy of the Artist*

Smith's work can be viewed as a continuation of the military tradition of Thomas Birch, John Thomason (whose World War I sketches greatly influenced Smith as a young man), Dwight Shepler, and Tom Lea. Each of his paintings—imaginary, after-the-fact reconstruction, or an eyewitness portrayal—is undeniably a work of art. Whether he is depicting an aircraft returning to its ship in inclement weather, attacking through intense anti-aircraft fire, or simply escorting a battle squadron, Smith creates dramatic relationships of color and shape to transcend realism and reach a higher level of artistic quality. Smith contrasts lights and darks (chiaroscuro)—of clouds and water, ships and airplanes, or machines and people—in a way that reaches perfection in its spatial interplay.

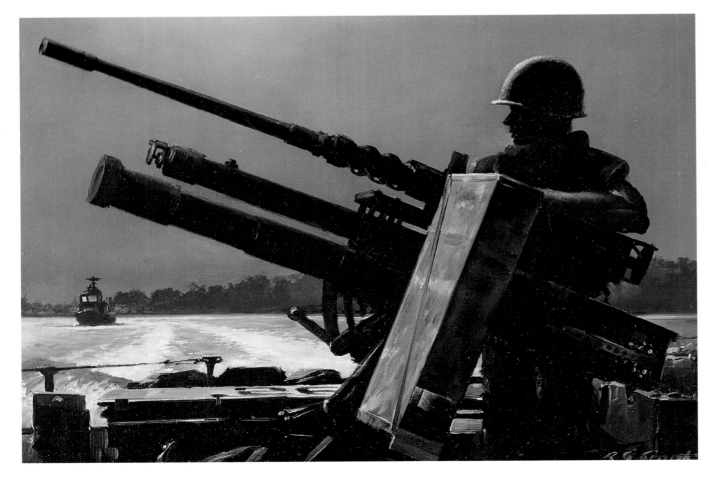

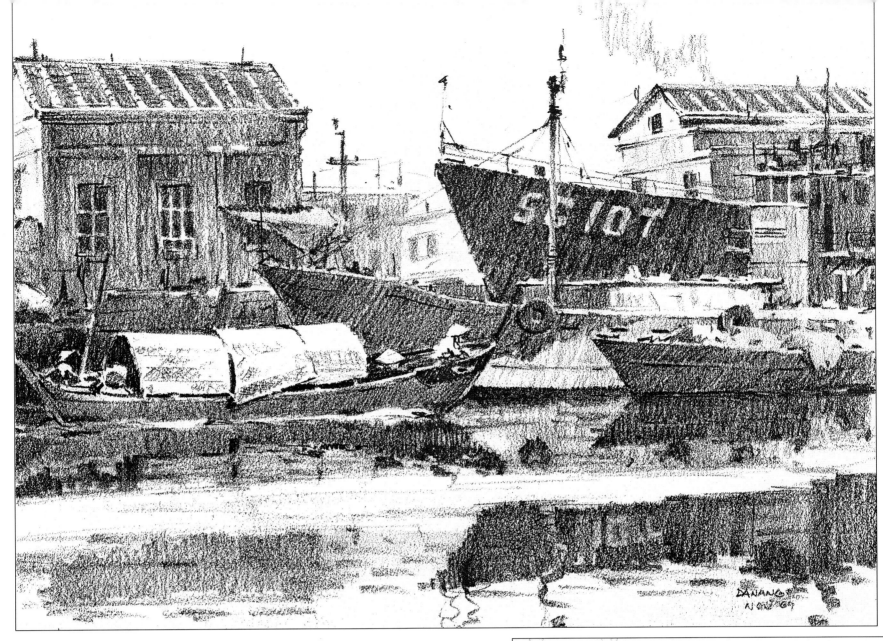

NIGHT PATROL
DIM RED-LITE ONLY
LIGHT SOURCE
7-10-68.
2:30 A.M.
SONG EE CHIEN

Pages 252—253: R.G. Smith made these sketches of soldiers and Vietnamese civilians and city life while covering Marine and Navy activities at Da Nang, Navy riverine patrols, and naval aviation offshore in the China Sea.
Courtesy of the Artist

Neither his ships nor his aircraft crowd the frame. There is always space designed in to carry their motion; giving inanimate ships and aircraft life is a mark of his genius. Smith was also one of those rare individuals able to simultaneously use both hemispheres of the brain to their fullest: the left, the logical, engineering side; the right, the creative, artistic side. He was an artist first, and an illustrator second.

Perhaps the quality that, above all, makes Smith's art so satisfying is the point of view as observer he creates for each work. There are no heroics, no melodrama, no exaggerated perspectives or action—and none of the impossible points of view of which illustrators are so fond. The angle he establishes for the viewer is always plausible. When looking at Smith's paintings, one instinctively feels like an eyewitness, relishing the overall scene, its details, and its stirring ambience.

Under the auspices of NACAL, Smith was able to put his artistic talents to the test twice, in two thirty-day tours of the Vietnam War in 1968 and 1969. At age fifty-four, he covered naval riverine operations along the coast and the Mekong Delta, going on fast power boat patrols and coming under fire sporadically. He executed some fine works depicting this phase of the war, particularly his painting of a nighttime firefight showing tracers and flares lighting up the sky, silhouetting a combat patrol. He also covered SEAL (sea/air/land) operations.

Among many accolades, R.G. Smith received the Public Service Citation from the Chief of Naval Operations. In 1973, he became the tenth person to be designated an honorary naval aviator, as well as an honorary Blue Angel. He was also one of the founding members of the American Society of Aviation Artists (ASAA). Having illustrated many types of aircraft, including the SBD Dauntless, A-4 Skyhawk, F-4 Phantom, and F/A-18 Hornet, he made this distinction: "The difference between an aviation artist and an aviation illustrator involves more than just the airplane, you must consider the whole environment—the earth and sky, sun and clouds."

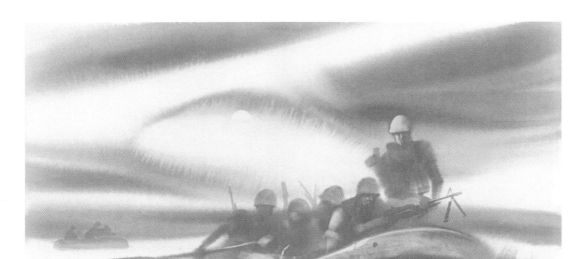

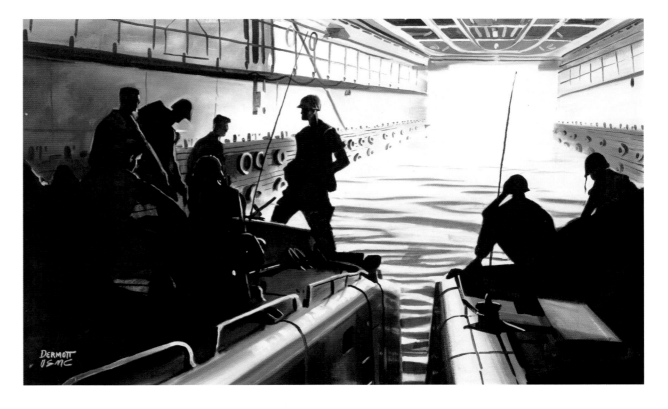

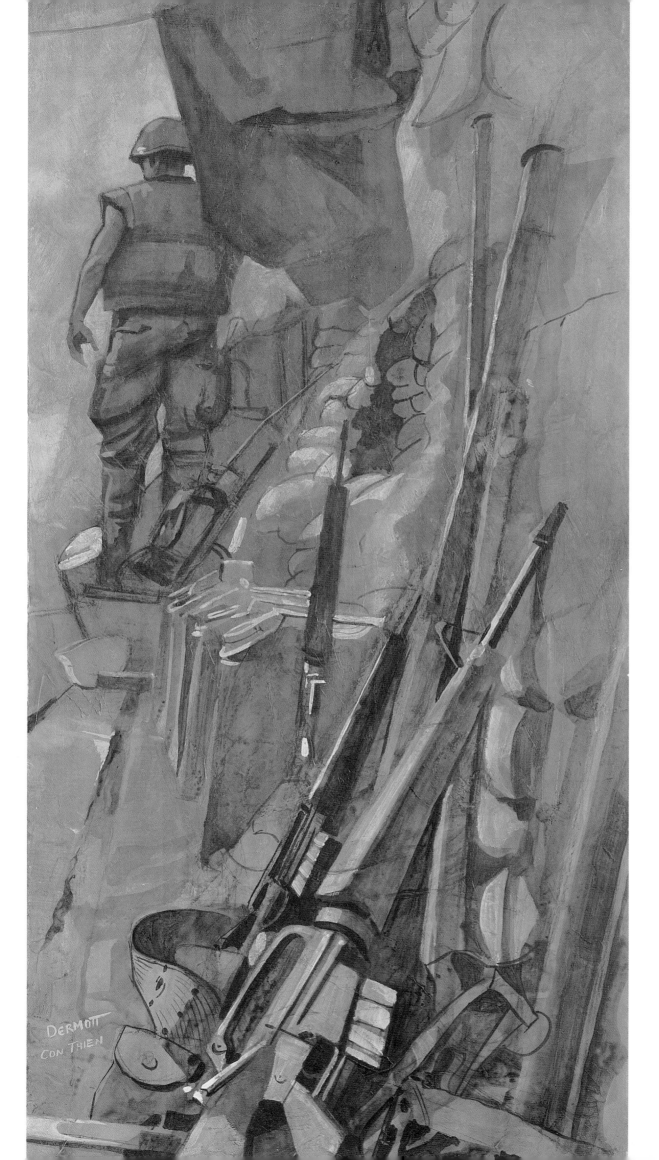

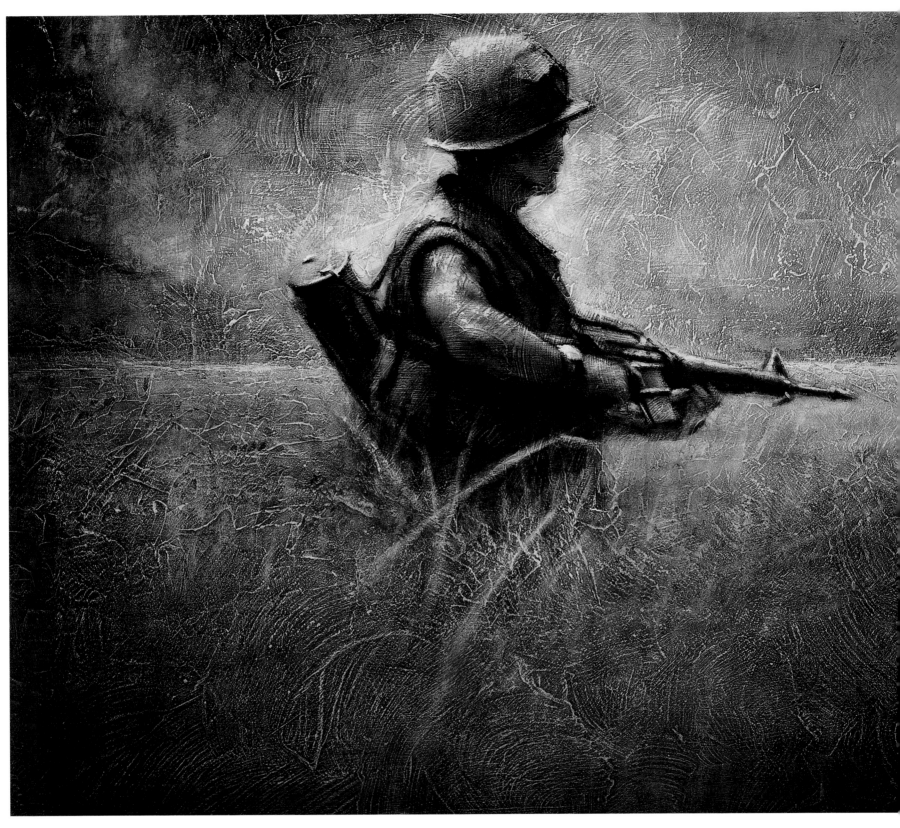

Above: Sgt. James A. Fairfax's *Point Man* portrays the unfortunate Marine who has the unenviable duty of leading a patrol toward an unseen enemy. He is usually the first one shot. **USMC Art Collection**

Smith thought of himself more as an engineer than an artist. As he expresses it, "To depict any surface with character, one has to understand exactly what is beneath it and what its function is." With no formal art training beyond his encounter with Beaumont, R.G. Smith instinctively realized that as the relationship between knowledge of human anatomy is essential to figure painters, so aircraft "anatomy" is necessary knowledge for the aviation artist.

The Marine Corps Combat Art Program

The Marine Corps Combat Art Program was again headed by Raymond Henri, called out of retirement as a colonel, and fell under the Division of Information at Headquarters, Marine Corps. Having done such a splendid job with the World War II efforts, Col. Henri dived into this new venture with enthusiasm. Ultimately, he secured for the Marine Corps Combat Art collection the works of more than three dozen Marine artists, including those in the NACAL program.

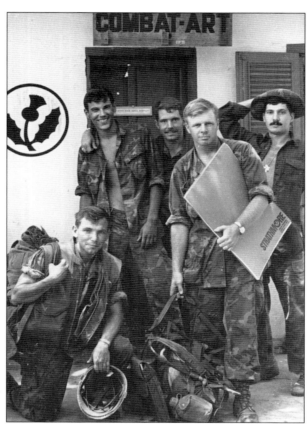

A number of Reserve Marine artists volunteered their services, including Capt. John T. Dyer, Maj. A. Michael Leahy, Lt. Cols. Peter "Mike" Gish and H. Avery Chenoweth, and, called out of retirement, Col. Houston Stiff, USMC, who had been awarded two Silver Stars in combat and received two Purple Hearts for wounds in World War II and Korea, and who was a former editor of the Marine Corps *Gazette*. All went back on full active duty and to the war zone.

Sherman Loudermilk, a Marine veteran and combat artist in World War II, volunteered as a civilian to cover

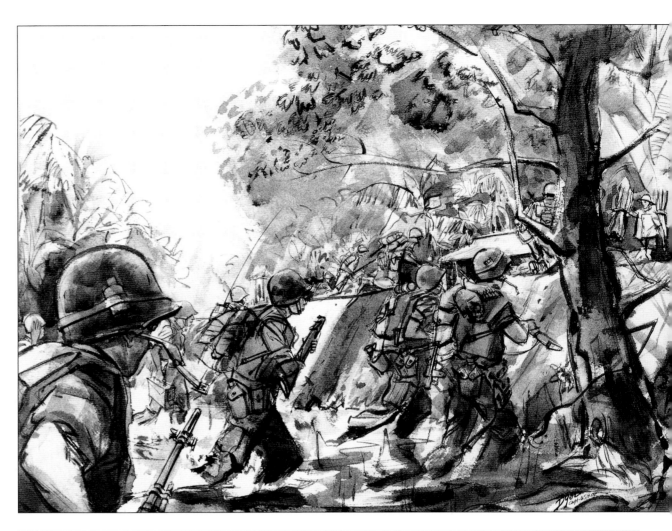

Above: Capt. John T. Dyer, USMCR, was the first combat artist under the Marine art program in Vietnam. A graduate of the Massachusetts College of Art and a cartoonist for the *Boston Globe*, he became the civilian curator of art at the Marine Corps Museum in 1971.

Above Right: *Pursuit*, a Dyer watercolor, captures Marines sloshing through a stream in pursuit of the evasive Vietcong in the jungles of South Vietnam.
USMC Art Collection

Right: Dyer did this quick sketch of three Marines carrying a wounded buddy to safety using a poncho as an improvised stretcher. Dyer was on duty in Da Nang when Col. Raymond Henri discovered that he was an artist and assigned him to the program as its first combat artist.
USMC Art Collection

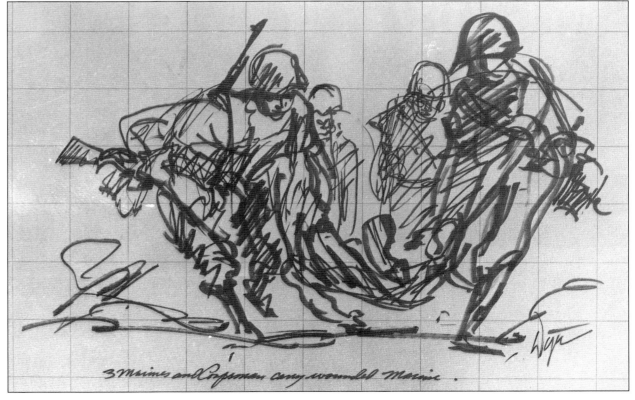

the Marines again, as did John Fabion, who had also done fine work during World War II. Already in uniform and reassigned to combat art or collateral art duties were Sgt. Robert M. Bossarte, Cpl. James R. Butcher, 1st Lt. Dan M. Camp, Cpl. Henry C. Casselli, Jr., Capt. Edward M. Condra III, Capt. Leonard H. Dermott, USMCR, Sgt. James A. Fairfax, 1st Lt. Ben F. Long IV, USMCR, Cpl. Gary Moss, CWO Wendell A. Parks, Col. John H. Rogers, USMCR (Ret.), Cpl. Robert L. Williams, and L. Cpl. Richard L. Yaco. Their works now reside in the Marine Corps combat art collection at the Marine Corps Historical Center at the Washington Navy Yard.

Capt. John T. Dyer

John "Jack" Dyer joined the Marine Reserve Platoon Leaders Class (PLC) program while at the Massachusetts College of Art. After graduation in 1960, he was commissioned a second lieutenant and went on active duty for three years. When released, he worked at the *Boston Globe* as an illustrator.

Upon learning of the Marine corps combat art program under the Division of Information, he volunteered, was accepted, and went back on active duty in August of 1966.

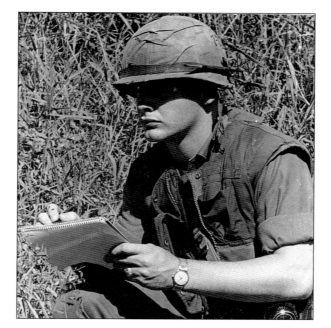

Left: Cpl. Henry Casselli.

Below: Casselli's fine draftsmanship shows in the touching sketch *Corpsman*. Casselli had witnessed the Navy medical corpsman trying to comfort a seriously wounded Marine, who awaits the arrival of further aid and evacuation back to medical facilities. Navy corpsmen were the unsung heroes of battle; they were not armed, and they risked their lives under fire rescuing the casualties of combat.
USMC Art Collection

He was sent to Vietnam in September of that year. Joining III MAF headquarters at Da Nang, he billeted at the Combat Information Bureau (CIB) with the civilian press.

From then until February 1967, Dyer went on field operations with both Marine divisions and a heliborne assault unit into the DMZ. He sketched and later produced watercolors of the events he witnessed back at the CIB. After completing that six-month tour, Dyer returned to duty in Washington, DC, before again heading for Vietnam in February 1968 following the Tet Offensive. For another six months, he sketched in Hue, Khe Sanh, and throughout the Marine northern I Corps sector.

Dyer was released from active duty in 1970 and returned to the *Boston Globe*. He was soon given the opportunity to become curator of the Marine Corps Combat Art collection.

Cpl. Henry Casselli

Cpl. Henry Casselli spent fourteen months in Vietnam as a combat artist and turned out some of the best work of the war. Afterward, he gained a degree of national recognition as his style matured and his work became more focused. Recalling his Vietnam experiences in an art magazine in the late 1980s, he said, "I had no idea of the horror that existed there. In a span of two days, it became very, very real. I sketched everything but the 'Gung Ho' mens' magazine stuff. I showed the emotion that existed between guys. I learned how to cry out there, how to hurt. I learned how to express my feelings. I was fortunate—I had a piece of paper on which to put it down. Lots of those guys couldn't do that. I knew what it was like to shoot at people, to get shot at. I knew what it was like to look at grenades coming at your feet and not going off. You think you're dead, but you're not."

Years later, in turning down a Marine Corps combat art request for him to cover operations in Beirut, Casselli vehemently stated, "Under no circumstances. The one thing I possess now that I didn't then is knowledge of the unknown."

Pfc. Austin Deuel

Of particular interest is an artist whose work went somewhat unappreciated by the Marine Corps combat art program: Marine Reserve Pfc. Austin Deuel. At first, he had tried to

offer his services to the NACAL West program. After receiving no assurance that he would get near the action, he opted instead to try the Marines, with whom he had served a tour five years previously. The timing proved right when he brazenly marched into the public information office at Camp Pendleton and found they were, indeed, seeking combat artists. Rejoining the Marine Corps Reserve as a private first class at age twenty-seven, Deuel was soon off to Headquarters, Marine Corps, and to the fledgling combat art program under Reserve Col. Raymond Henri and his assistant, Reserve Maj. Mike Leahy, who had left his teaching post at Famous Artists School to return to active duty.

Retired Col. Houston Stiff, USMC, also came aboard, and the two departed for the war zone at the same time, arriving just several weeks ahead of author (and, at the time, Lt. Col.) H. Avery Chenoweth.

Pfc. Deuel was not long getting into the thick of it. He soon learned how, at his lowly rank, to be taken seriously and how to get around—his robust six-foot three-inch (2m) frame was probably a contributing factor. Operating out of the Combat Information Bureau (CIB)

Left: Col. Houston Stiff was called out of retirement for a three-month tour in Vietnam as a combat artist. A former combat commander and veteran of World War II and Korea, Stiff knew exactly what to portray in order to convey what combat was like.

Below: Stiff's oil painting of two wounded Marines, temporarily patched up but waiting for further transfer to more advanced medical facilities, speaks for itself. Their wounds do not appear life threatening, and one might wonder whether they were contemplating a return to combat after recuperating—or hoping the wounds were serious enough to send them back to the States. No matter, they did their jobs and paid for it with a wound from either enemy shrapnel or a bullet, escaping death for the moment.
USMC Art Collection

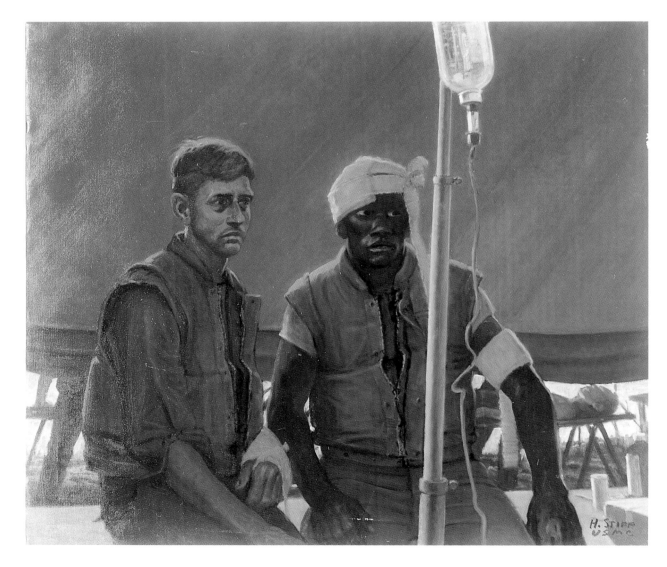

Above Left: Lt. Col. H. Avery Chenoweth, USMCR, an advertising executive on Madison Avenue in New York, volunteered for active duty as a combat artist in 1967 and 1969.
USMC Art Collection

Above Right: Giant cactuses were unexpected in the DMZ near the coast, inspiring Chenoweth's acrylic depiction of them.
USMC Art Collection

Right: Chenoweth's portrait sketch of Marine battalion commander Lt. Col. Pete Wickwire.
USMC Art Collection

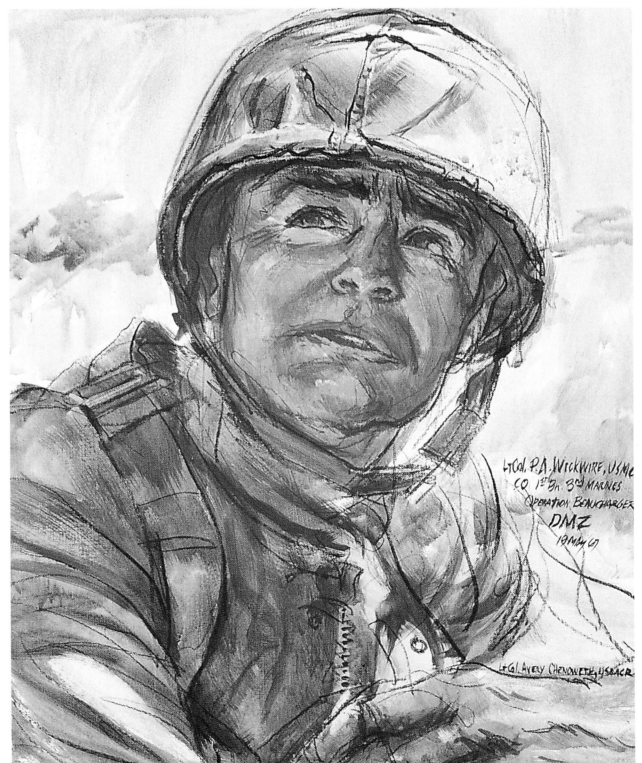

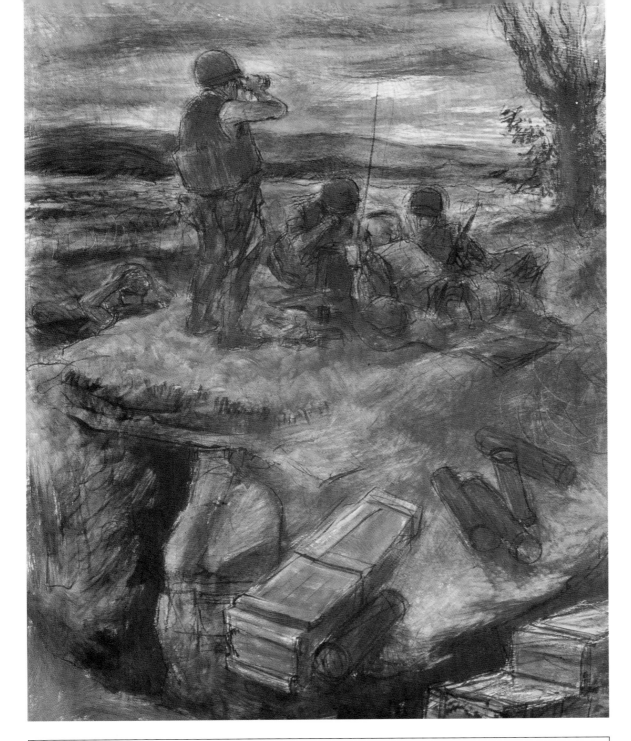

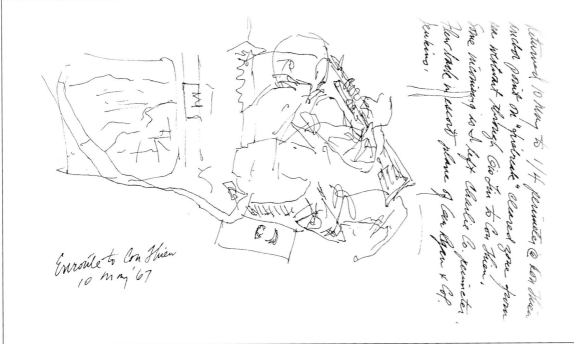

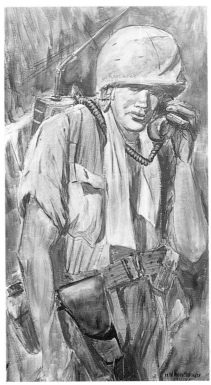

Top Left: Con Thien, by Chenoweth, depicts Marine positions on the DMZ. Con Thien was a DMZ outpost under continual artillery and mortar bombardment from the North Vietnamese. The Marines lived virtually underground with protective barbed wire encircling them.
USMC Art Collection

Bottom Left: Chenoweth made this sketch while en route to Con Thien in May 1967. He later used the sketch as a reference for his painting *In Hoc Signo....*
USMC Art Collection

Top Right: An oil portrait of Col. Raymond Henri, USMCR, by Chenoweth. Henri was responsible for the Marine Corps' combat art collection in World War II.
USMC Art Collection

Above: Radioman, a sketch by Chenoweth.
USMC Art Collection

O Club Bar
MAG 12
CHU LAI

Opposite Top: War was a part of everyday life for Vietnamese civilians. Here, Chenoweth sketched a typical street scene.
USMC Art Collection

Opposite, Bottom Left: A sketch by Chenoweth captures a support technician enjoying a moment of leisure.
USMC Art Collection

Opposite, Bottom Right: Chenoweth's sketch of Marines was displayed at the Smithsonian Institution and reproduced in *U.S. News and World Report* in 1965.
USMC Art Collection

Left: Chenoweth's drawings of the Officers Club Bar at Chu Lai.
USMC Art Collection

Below: A moonlit patrol is captured by Chenoweth.
USMC Art Collection

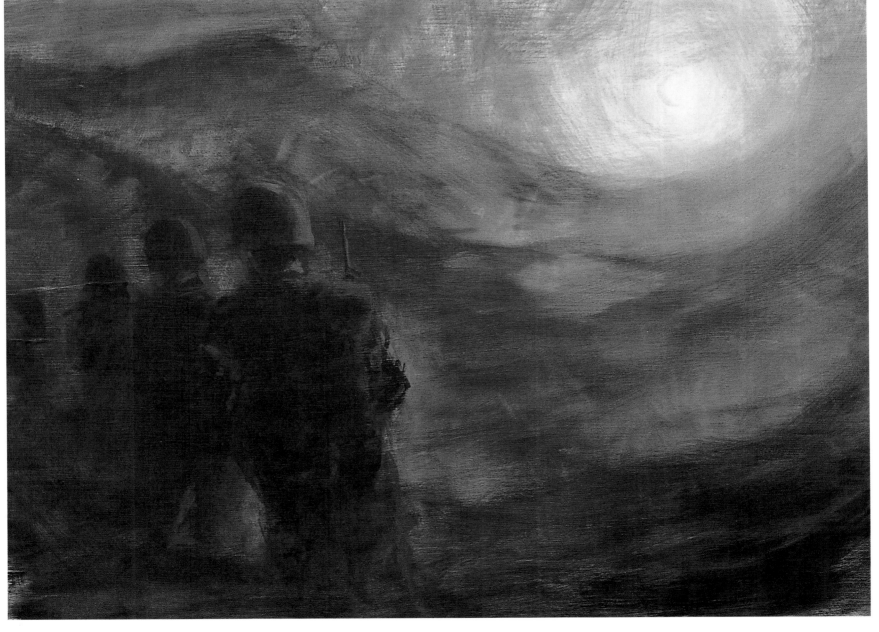

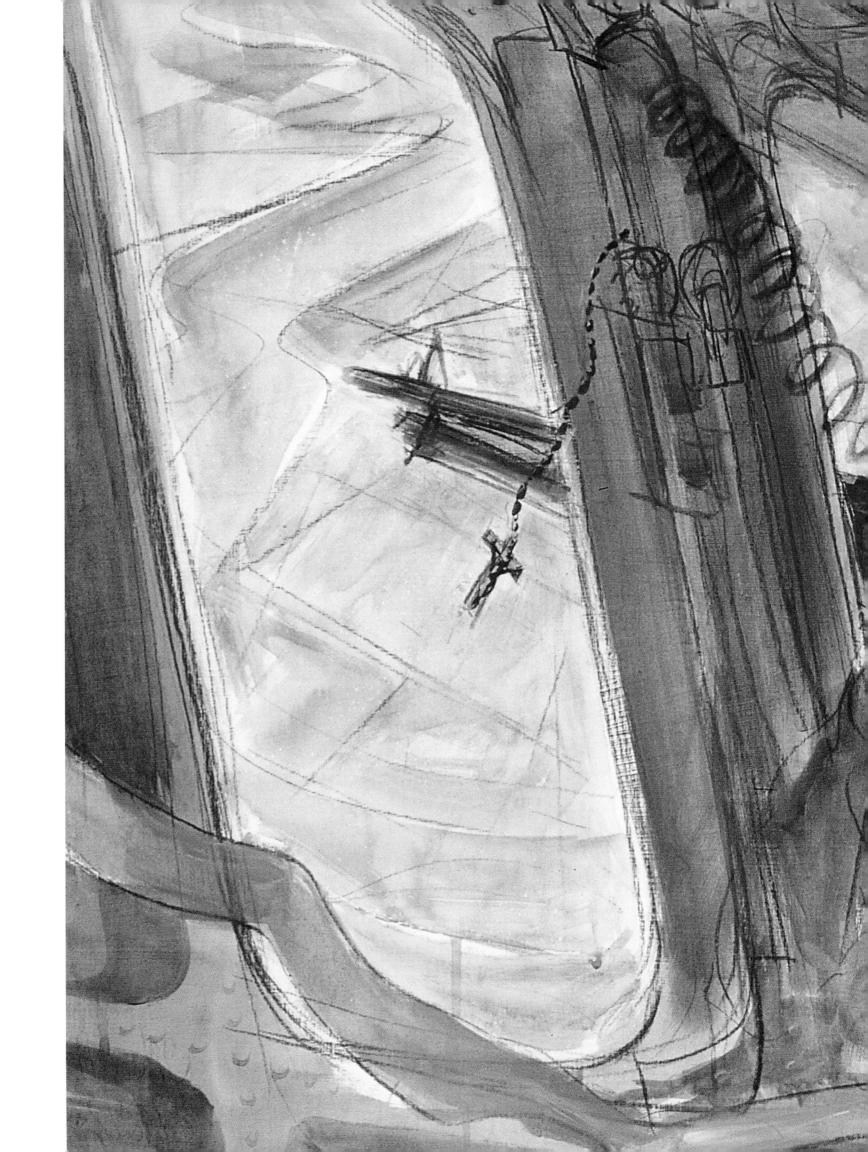

Left: In Hoc Signo..., by Chenoweth. The painting's title refers to a mystical sign in the sky observed by the Emperor Constantine: a golden cross, inscribed with the words "In hoc signo vinces" (With this sign you will conquer). The painting was inspired by the accidental and momentary crossing of a crucifix and an M-60 machine gun.
USMC Art Collection

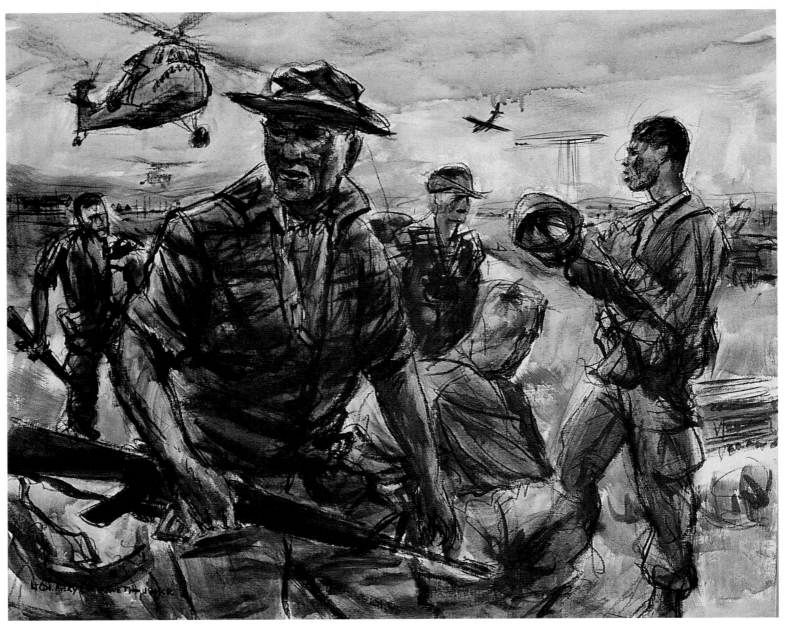

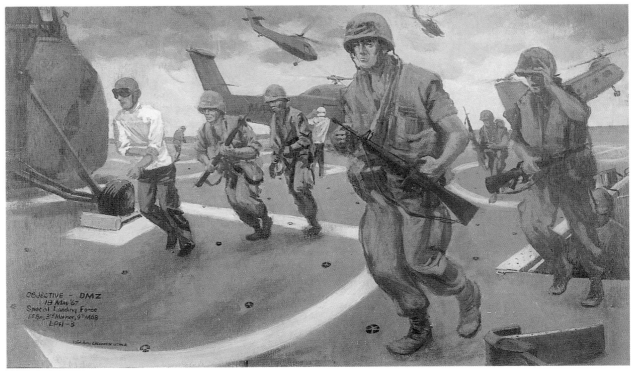

Above: As portrayed by Lt. Col. H. Avery Chenoweth, an insert team returns after a mission deep behind enemy lines. They were dropped in by chopper and picked up again days later. Their mission was covert reconnaissance.
USMC Art Collection

Right: Objective: DMZ, an acrylic painting by Chenoweth, shows a Special Landing Force of 2nd Battalion, 2nd Marines racing across the flight deck of the LPH (Landing Platform, Helicopter) *Okinawa* to board UH-34 Sea Horse choppers in 1967. Their mission, part of operation *Beaucharger*, was to sweep the demilitarized zone separating South from North Vietnam for Vietcong. Unfortunately, the squadron commander's helicopter was hit and everyone aboard was either killed or wounded. Chenoweth flew in with the second wave.
USMC Art Collection

Above: Maj. Edward M. Condra III, USMC was not technically in the combat art program, though he did produce some fine work. He served as an engineering officer supervising the short takeoff and landing strip construction at Chu Lai. **USMC Art Collection**

Top Left: A UH-34 chopper touches down on an air strip in a watercolor by Condra. **USMC Art Collection**

Bottom Left: Condra's sketch of Marine support personnel doing repair work. **USMC Art Collection**

Above: Marine CWO Wendell Parks specialized in sketching with wood burning tools on wooden ammo box lids, as well as pen and ink washes.

Right: The sure hand of Parks is evident in this sketch he did after participating in the 1968 street fighting in the ancient capital city of Hue. Here he shows Marines using an M-48 tank as protection from sniper fire. The fighting in Hue was particularly vicious, lasting two weeks and resulting in many casualties.
USMC Art Collection

at the Da Nang headquarters of the Third Marine Amphibious Force, he was able to cover a combined action platoon (CAP) protecting a local village, the horrific offensive (known as Union I) for Hills 881 South and North in April of 1967, and Operation *Hickory*, which later helped clear the DMZ.

At Hills 881 South and North (in northwestern South Vietnam, above Khe Sanh, in the Marine I Corps sector), the bloody battles that left 350 Marines killed and 1000 wounded had subsided by the time Deuel reached the area. However, he accompanied a group sent up the South hill to mop up and gather the Marine dead. Following an exhausting climb in the intense heat, a shocking sight of incredible carnage confronted him. Blood, body parts, and mutilated corpses littered the shell-scarred slope.

Within a few weeks of finishing his three-month tour, Deuel saw his last combat on Operation *Hickory*, in which Marine battalions swept the DMZ west of the fire base at Con Thien.

The paintings that Deuel completed, both at the CIB and later at his studio in California, were received with mixed reaction by Col. Henri at the Division of Information. One in particular, *Even God Is Against Us*,

Left: Pfc. Austin Deuel at work in his studio.

Below: Even God Is Against Us captures the horrifying scene of Marines bringing the wounded and dead off Hill 881 South, located near the DMZ in the northwest—where even the elements seemed to conspire against the troops. The week-long battles on 881 South and North had been ferocious. Marines complained of their new M-16 rifles jamming, and casualties were high. Deuel arrived at the tail end of the fighting to witness the battleground. Deuel later used the title of the painting for a book he published of the work he did in Vietnam.
USMC Art Collection

was rejected as too brutally graphic (one might ask if it were more so than Lea's *The Price* of World War II) to expose to the American public, a response Deuel describes in his book with the same title that he published twenty years later. While Henri's reaction was certainly valid in a climate of emerging negative public opinion of the war, Henri also judged Deuel's work to be somewhat amateurish when compared to other work coming from Marine and NACAL combat artists.

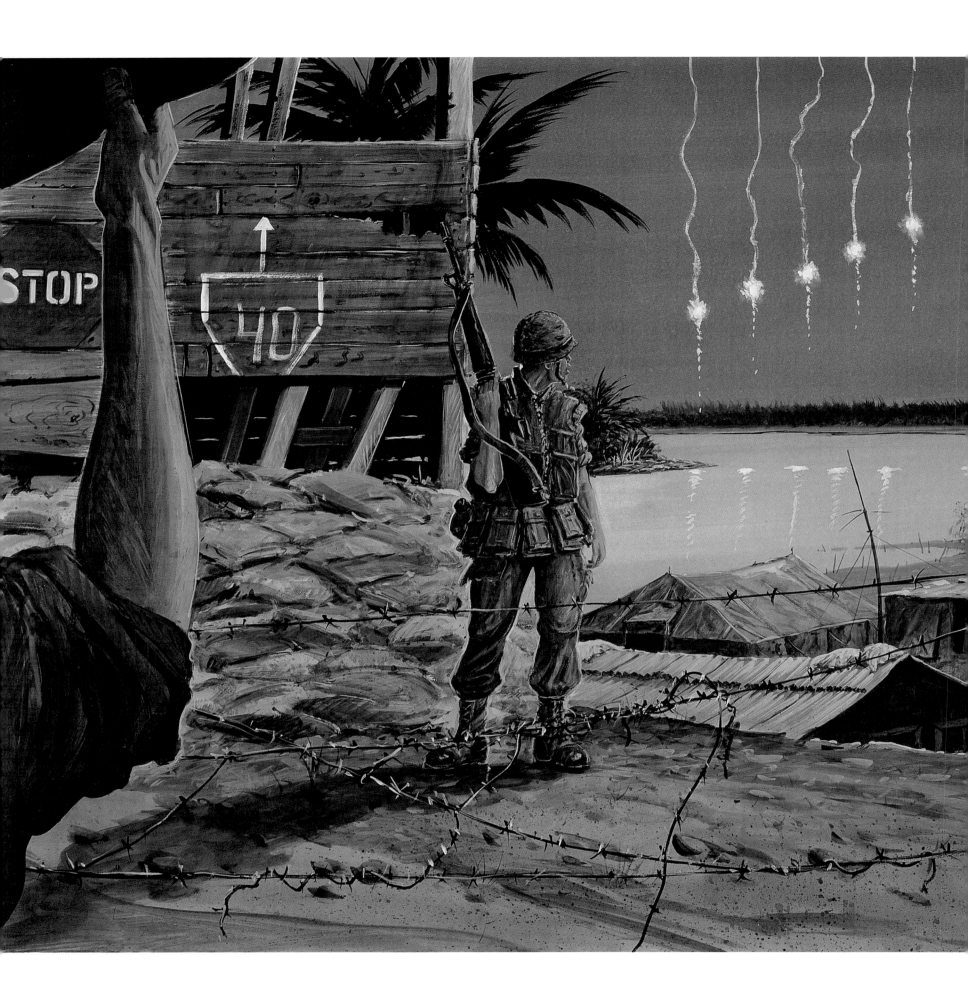

Looking back at Deuel's work thirty-five years later, it does display a naive quality, with an untutored, unsophisticated look. Objects are defined by sharp edges; everything is in focus; and there is no sense of atmosphere and little interplay of design elements and principles. Deuel himself admits he never studied art; he is self-taught. Nevertheless, his work does possess a directness, honesty, and sincerity that is compelling and valid. And he painted, in most cases, what he actually saw and experienced, either from memory or photographs he took himself. As all combatants are, he was profoundly affected by those brief battle experiences.

Austin Deuel went on to become a recognized regional artist of the Southwest, writing, illustrating, and publishing two books: one on the Southwest and one entitled *Vietnam: Even God Is Against Us*, which portrays Deuel's Vietnam experiences. Deuel is also a talented sculptor. Experienced with nothing more than very small clay studies, he was nevertheless commissioned to do a large, commemorative Vietnam memorial for the city of San Antonio, Texas. Artistically equal to Felix de Weldon's Iwo Jima statue in Arlington, Virginia, Deuel's is true combat art, depicting a moment he actually saw and experienced. Aside from Frederic Remington's sculptures based on the Plains War, Deuel's Vietnam Veterans' Memorial is the only public monument of note that depicts a specific event witnessed by the artist.

Left: Deuel did this watercolor, *Night Flares Across From Da Nang*, while on a 1967 combat art assignment with the Marine Corps. The port city of Da Nang was the headquarters location of the Marine I Corps Sector of operations, the northernmost sector terminating at the DMZ. Flares were popped sporadically to catch infiltrators that often floated down the Da Nang river.
Courtesy of the artist

Below: Marines dedicate a statue that Deuel sculpted for the Vietnam War Memorial in San Antonio, Texas. This is one of the very few combat sculptures of a specific witnessed encounter involving U.S. forces in existence. Deuel saw the event and re-created it in cast bronze. Many artists interpret themes, but Deuel's highly professional sculpting technique enhances a true, eyewitness account. The piece has moved many to tears.
Photo by John D. Baines

Left: Cpl. James Butcher's *Resupply at the Strip.* At Con Thien, the resupply of ammunition, rations, water, and replacements had to come in by helicopter, in this case a UH-53 heavy type. The dug-in tank is an M-60. Duty at Con Thien was some of the toughest of the war. Cpl. Butcher's style is very sophisticated for his age and training and exemplifies the best of the merging of abstraction and realism in combat art. **USMC Art Collection**

Vietnam: The "Anti-War" 275

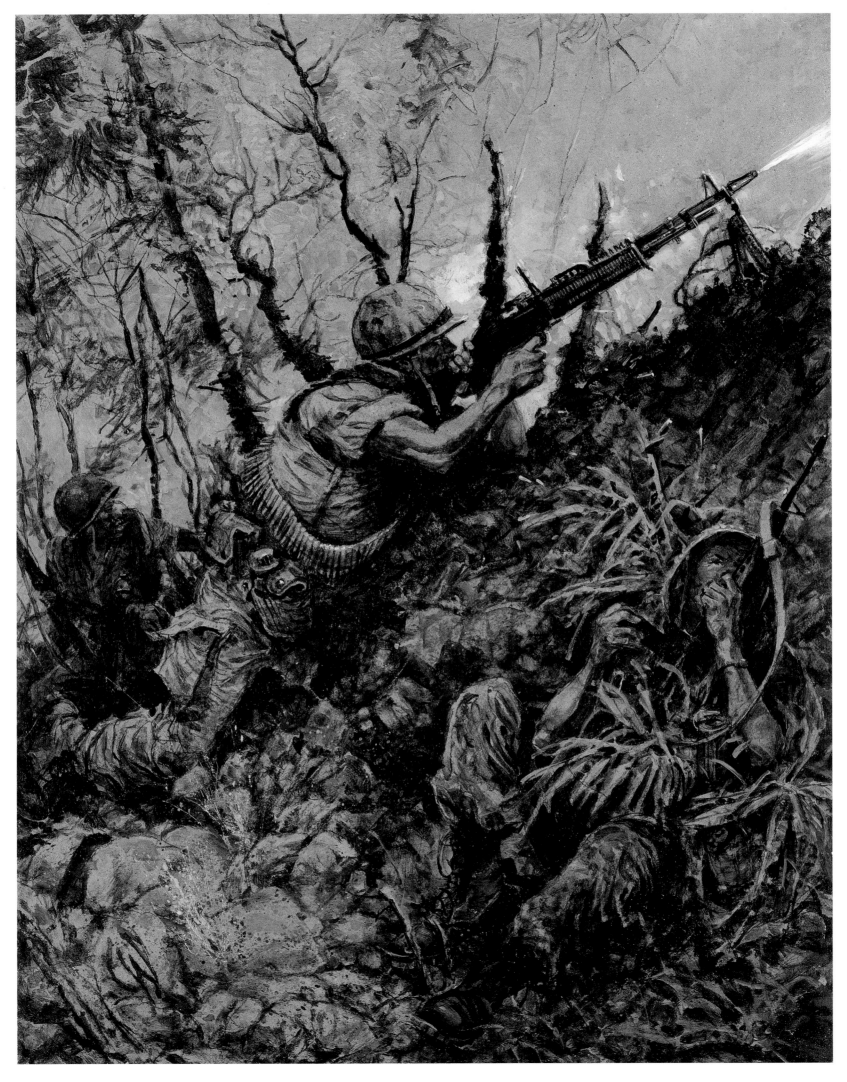

Above: Cpl. James Butcher in 1969. Butcher did some excellent semi-abstract renditions of the war.

Opposite: NACAL artist Charles Waterhouse sketched an M-60 machine gun in action.

Top Left: Butcher's felt-tip pen sketch depicts RF-4B gunless photoreconnaissance aircraft being refueled at Da Nang.
USMC Art Collection

Center: Waterhouse, a former Marine and veteran of Iwo Jima, sketched a line of wounded soldiers going to an aid station in Vietnam. Waterhouse was later commissioned a limited-duty officer and became artist in residence at HQMC.
Courtesy of the artist

Bottom Left: Marine combat artists gather for an exhibition of their work at the Overseas Press Club in New York City in 1968. (Left to right) Col. Raymond Henri, USMCR, director of the Marine Corps combat art program; Lt. Col. Peter Gish, USMCR; Brig. Gen. Frank Garretson, USMC director of information, HQMC; Lt. Col. H. Avery Chenoweth, USMCR; Lt. Col. Richard Stark, USMCR public information officer, New York; and Maj. Jack Dyer, USMCR.
USMC Art Collection

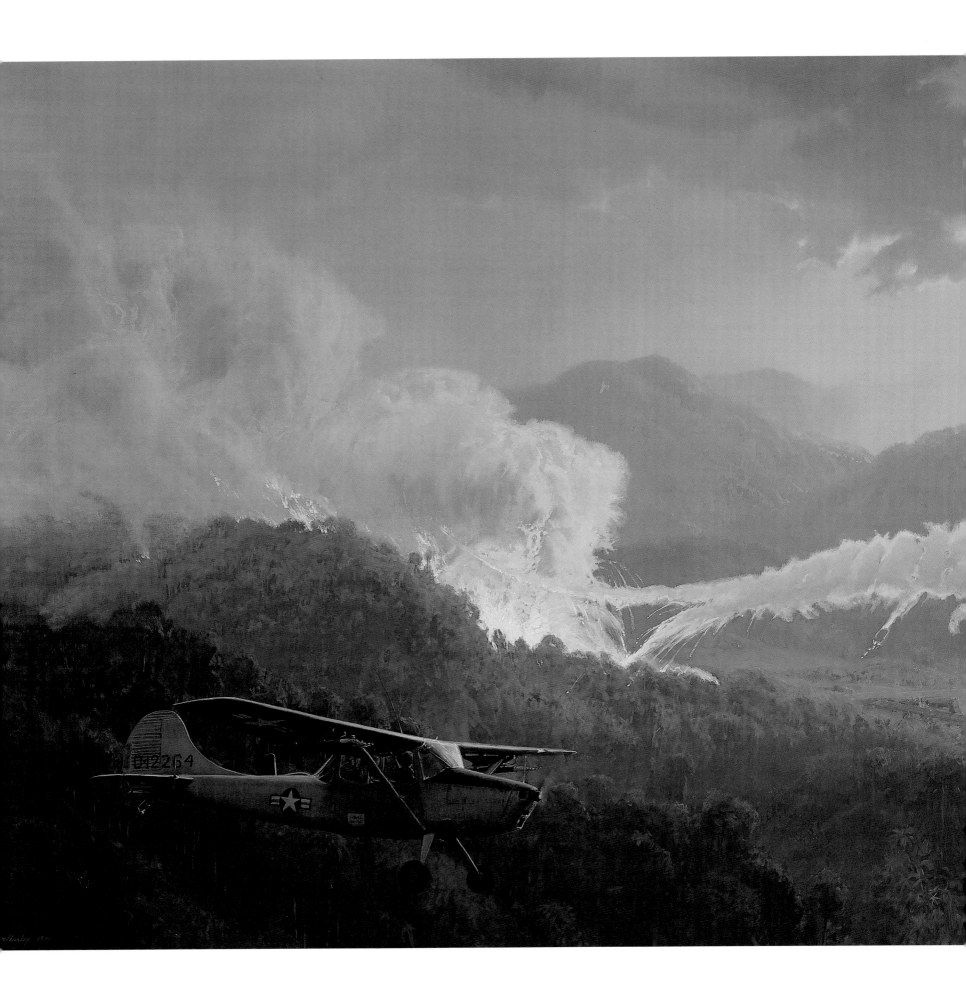

The U.S. Air Force Combat Art Program

The combat art program of the U.S. Air Force began after World War II, when the service was separated from the U.S. Army and became independent. The program inherited 800 paintings from the Army collection pertaining to aviation.

Korea had been its first war as an independent branch, and consequently, it hadn't provided for any art coverage. In 1951, the Air Force started to solicit civilian artists to cover Stateside operations before allying itself in 1954 with New York's Society of Illustrators, which would ultimately have artists covering Air Force activities all over the world. Noted aviation artist and officer of the society, Keith Ferris was instrumental in getting artists assigned to various projects.

When the Vietnam War began, the Society of Illustrators sent more than thirty leading illustrators on thirty-day tours to the battle areas, including USAF bases in Thailand. Many, like Wally Richards and Harvey Kidder, were able to fly combat missions, and Fred Mason got to fly with ace Col. Robin Olds. Bob McCall, who later painted the entrance murals for the National Air and Space Museum in Washington, DC, went, as did Al Pimsler, who also covered part of the ground phase. Miriam Schottland flew missions in Republic 105 Thunderchiefs and B-52 strikes over North Vietnam, as well as the first bombing strikes into Cambodia. Another woman artist of note, Maxine McCaffrey, covered the 1973 return of prisoners of war in the Philippines. Keith Ferris, who later painted the gigantic mural of World War II B-17s in the National Air and Space Museum, also did a 1968 tour at the Korat Air Force base in Thailand. Air Force policy was very strict about allowing civilian artists on combat missions; they wanted no possibility of civilians going down in Thailand—much less North Vietnam.

It should be readily apparent that, unlike Army, Navy, and Marine combat artists who are often right where the action is, only the pilots of the aircraft engage with the enemy, either in air-to-air combat or by sustaining anti-aircraft and missile fire from the ground. Therefore, artists who covered the Air Force—if they could not get rides in B-52 or C130 gunships—were compelled to portray base operations, training, maintenance, and support activities.

Two artists who were active duty members of the Air Force in Vietnam, however, did see combat: Amn. William S. Phillips and Maj. Wilson Hurley.

In a 1960 *National Geographic* article on twenty-four Society of Illustrators paintings of Air Force subjects, Gen. Curtis LeMay, chief of staff of the Air Force, stated, "To posterity, these paintings will furnish a priceless pictorial history of our Air Force in a brilliant era."

Above: Lt. Col. Wilson Hurley, USANG (Ret.).

Left: A forward air controller pilot and artist, Hurley portrayed himself flying a Cessna O-1 Bird Dog spotter plane. He has just marked a former French fort as a target for a low-level bombing run by F-100 Super Sabres. Spotters were used to mark military targets in order to avoid "friendly" or civilian casualties.
Wright-Patterson AFB Museum

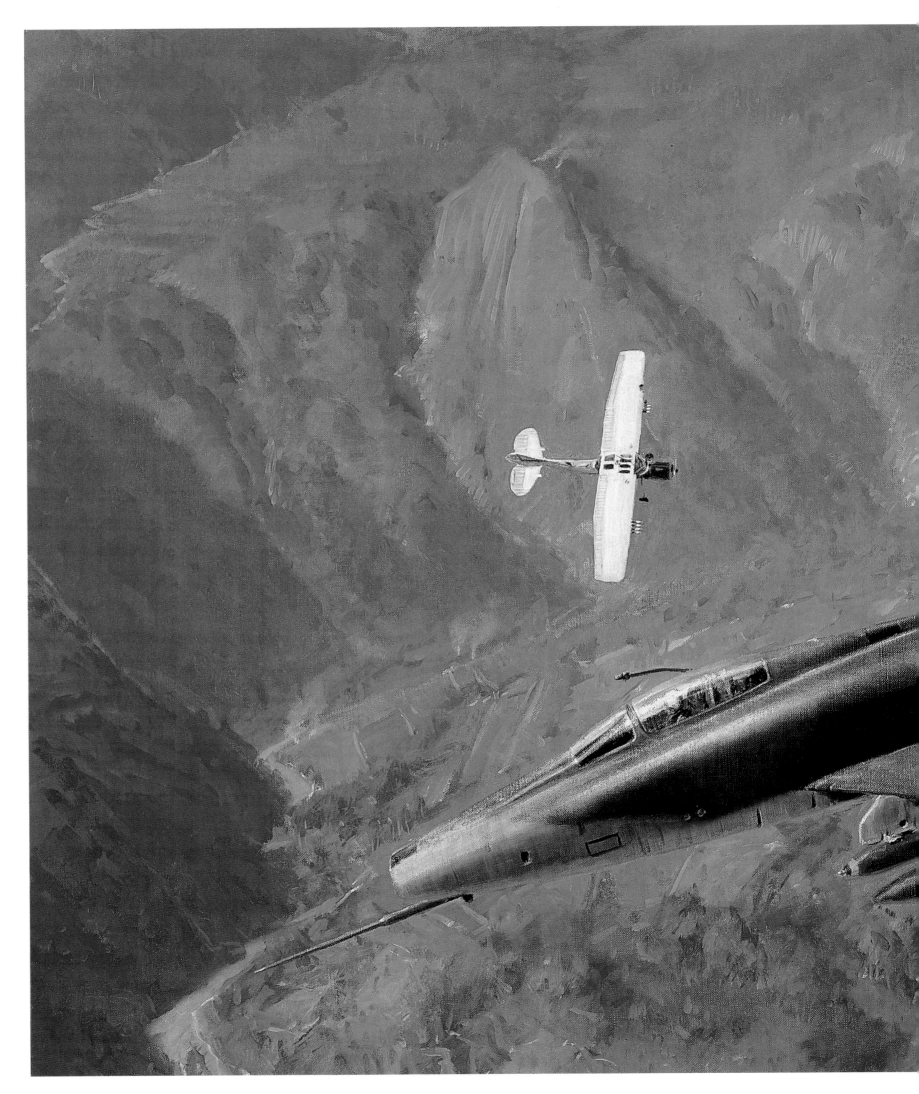

Left: In 1968, Keith Ferris flew backseat in a cell of eight F-4E Phantoms headed for the U.S. Korat airbase in Thailand. The long flight over the Pacific required two seven-hour legs and frequent refueling from aerial tankers. "I wanted to capture the feeling of hanging out there in the sun, hour after hour, over the vast Pacific and the relentless march into the unknown as these men faced their first combat tour," Ferris explains. Ferris titled the painting *Bad News for Uncle Ho,* which is what the Air Force thought these newer, internally armed aircraft meant for North Vietnam. ***Courtesy of the Artist***

Lt. Col. Wilson Hurley, USANG (Ret)

Wilson Hurley is a remarkable individual: a West Point graduate, lawyer, jet pilot—and an artist. He donated the paintings he did after returning from Vietnam combat duty to the Air Force museum at Wright-Patterson Air Force Base, Ohio. After the Vietnam War, Hurley, who lives in New Mexico, became one of the leading artists of the American Southwest.

Son of the famous Gen. Patrick Jay Hurley, secretary of war in the Hoover Administration, Hurley graduated from West Point in 1945, took flight training, and served as an aviator in World War II. He resigned his regular commission in 1949 and became a reservist. He was in law school when he was recalled for the Korean War, although he did not see combat duty. When released from active duty again, he completed law school and joined the Air National Guard in 1953. After practicing law in Albuquerque, New Mexico, for twelve years, he decided to close his practice and paint full time. Although he had painted and studied art all his life, this was a risky step—but one that met with great success.

During the Vietnam War in 1968, Hurley was recalled with the 120th Fighter Wing to extended active duty and served for eighteen months in combat as a forward air control pilot, flying 150 missions over seven months in small Cessna planes that served as target spotters for fighter-bomber strikes. His job was to make sure that only military targets, not civilians or friendlies, were hit. To do so, he had to fly low and slow—at great personal danger. For his courageous service, he was awarded the Distinguished Flying Cross.

While flying over the jungles, piedmont, and mountains of lush Vietnam, the artist in him was struck by the unique landscape and its vibrant colors. Hurley's artistic talent had been honed at West Point in his mechanical drawing classes and engineering courses. He said, "I realized that to become a good artist, I had to become a superior draftsman." In his youth, he had befriended noted artists John Young Hunter, Theodore Van Soelen, and Joseph G. Bakos, each of whom took him under his wing to instill an appreciation of art and beauty of the country, as well as to pass on the rudiments of art. Later, he studied with noted Western artists Joel Reid and Robert E. Lougheed.

Before his recall to Vietnam, Hurley had been a full-time artist for five years. In combat, however, he did no sketching, nor did he take a camera. Quite sensibly, he did not want anything to interfere with his combat duty. He said that he was there to do his job, and the price of a moment's inattention could be the death of a noncombatant, a friendly, or worse yet, himself.

Following the termination of his tour of duty, he did a number of paintings from memory that he donated to the Air Force. Hurley says of his combat art, "Painting as one who has participated in a historical event should give these works of art considerable value. Perhaps fifty years from now, if somebody wants to know what procedures were used on an air strike—the ground smoke markings

Above: Maj. Wilson Hurley's talent for painting landscapes is evident in this rendition of a regimental command post near his airfield. *Wright-Patterson AFB Museum*

Opposite: Hurley's *Sentry* depicts a lonely duty somewhat compensated for by the small gazebo's shelter from the monsoon rain (though it also perfectly silhouettes the airman for any intruder). To avoid any distraction during his combat duties, Hurley created his series of paintings of the war after his return. *Wright-Patterson AFB Museum*

and things like that—these paintings will be a valuable source of information." He admits that the Vietnam experience helped put his life into perspective: "I noticed when I came home, instead of starting where I left off, I started far beyond that point. I think it was because I had time to resolve a lot of my problems."

Although it took him a few years to gain recognition, he rose ultimately to the top of the ranks, alongside all-time great American landscape painters like Albert

Bierstadt and Thomas Moran, as well as contemporary—and former Marine—artists Howard Terpning, Harry Jackson, and Tom Dunn. In 1977, he won the prestigious National Cowboy Hall of Fame gold medal for a painting entitled *Winter Sunset, De Chelly*. And, in 1994, he was commissioned for a multimillion-dollar mural in the Cowboy Hall of Fame in Oklahoma City, Oklahoma; the mural consisted of five triptychs, each sixteen feet (5m) high by forty-eight feet (15m) wide, framed and installed.

for landscape painting, Hurley explains that he does not paint precisely what he sees: "…my landscapes [are] from my imagination. In my imagination I create not only what is before me and hence in the picture, but also what is behind me and around me."

The Society of Illustrators

Since 1961, artists from the hundred-year-old Society of Illustrators (SOI) of New York, and those from the SOIs of Los Angeles and San Francisco, as well as the newer Air Force Artists of Chicago, have covered U.S. Air Force activities all over the world. Similar to artists of the NACAL program, SOI artists are not paid, but are given transportation, meals, and billeting. Most donate their work to the military service, but retain the copyrights themselves.

Keith Ferris

As the son of a former Army Air Corps pilot growing up on military air bases, Keith Ferris developed a love of aviation that shaped his career. Unable to join the service due to an allergy, he opted instead to study aeronautical engineering at Texas A & M University. He also spent eighteen months in Randolph Air Field's Training Publications Unit, where he learned the basics of painting, before studying for a year at George Washington University and then at the Corcoran School of Art in Washington, DC. Following his training, rather than take a full-time salaried job, he steadfastly pursued his art as a freelancer. Soon, he began to pick up giant corporate clients like Sperry Rand and Pratt & Whitney and his career and reputation took off.

A thirty-nine-year member of the Society of Illustrators in New York, he was able to virtually form the Air Force art program. In his role as chairman of the Air Force Art Committee, Ferris continues at this writing to be instrumental in assigning artist-members to the Air Force art program. Thoroughly knowledgeable about all types of aircraft, Ferris flew on training missions in B-52s and KC-135s in order to get the right feel for his paintings; all told, he has flown in every nonsingle-seater aircraft in the USAF inventory. His fifty-three paintings in the Air Force collection reflect a unique lifetime career as the only freelance artist making his living solely from the creation, sale, and licensing of aviation art.

In 1966, he was able to go to Vietnam on a combat art mission, flying GIB ("guy in back seat") in the first squadron of Phantom F-4Es (the later model, with guns mounted internally) as they flew across the Pacific. They refueled in midair a number of times, until they reached their destination at the American base at Korbat, Thailand,

Above: Keith Ferris, in flight gear, stands next to one of his aircraft paintings.

Left: Rolling Thunder is artist Keith Ferris's portrait of an F-105D Thunderchief fully loaded and taxiing out for takeoff at Korat Air Force Base in Thailand. The sand-filled metal structures behind the aircraft are the "spots" where the aircraft are parked for protection from enemy air strafing and bombing attacks, as well as local ground mortar attacks. "Rolling Thunder" was the code name for the first air offensive against North Vietnam and involved almost every combat aircraft type flown by the Navy and Air Force. Three-quarters of USAF missions over North Vietnam in 1968 were undertaken by Thunderchiefs.
Courtesy of the Artist

Hurley had grown up in the shadow of his famous father while living in Virginia horse country. Enjoying the outdoors and developing an appreciation of the beauty of nature, he moved to New Mexico in the 1930s. His Vietnam paintings are a marvelous blend of the natural and the mechanical. His combat art from Vietnam is truly remarkable because of his unique mix of the surely drafted aircraft and the realistic yet imaginative landscapes and skyscapes into which they are set. Of his predilection

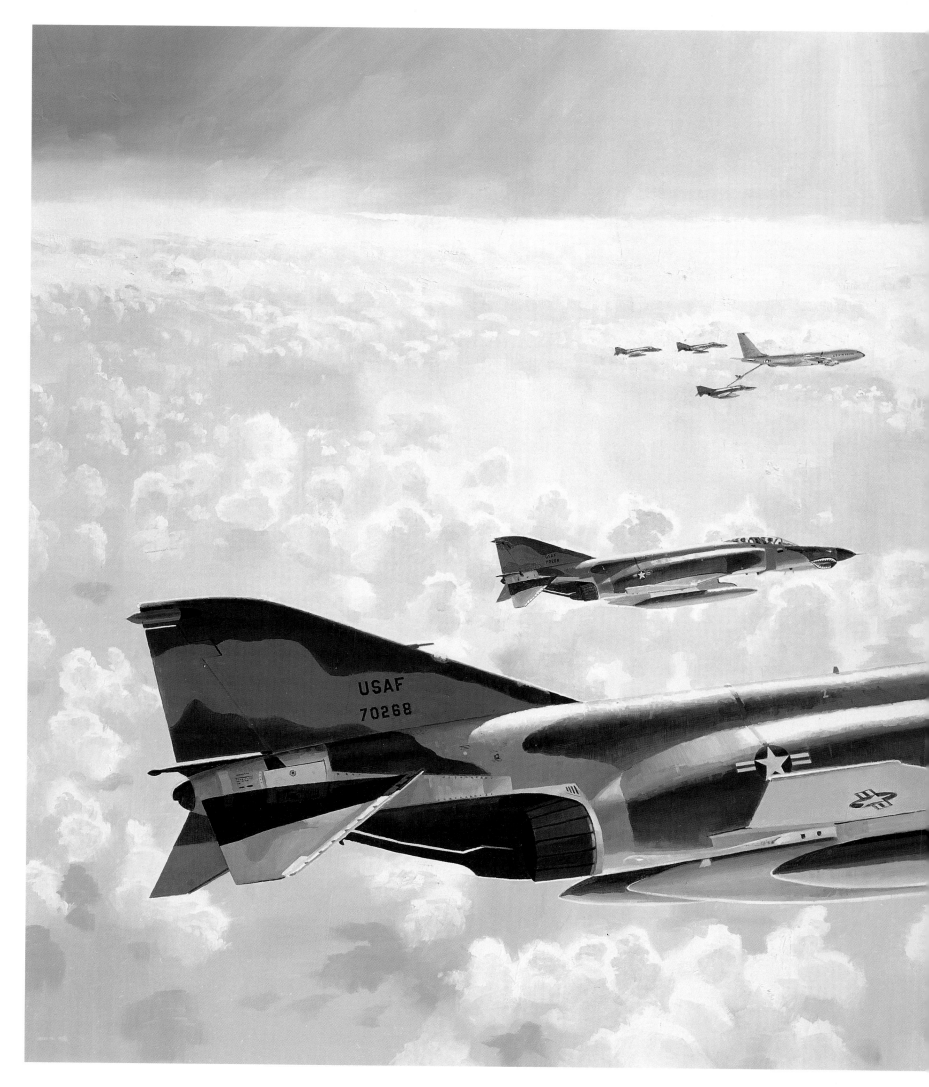

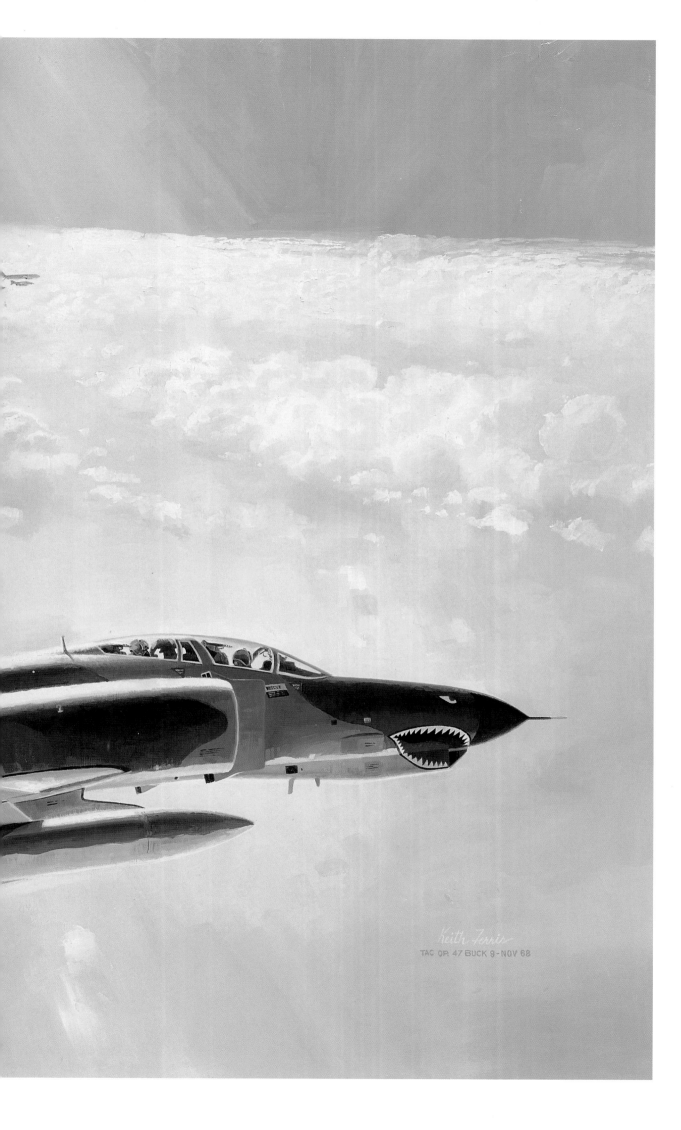

Left: In 1968, Keith Ferris flew backseat in a cell of eight F-4E Phantoms headed for the U.S. Korat airbase in Thailand. The long flight over the Pacific required two seven-hour legs and frequent refueling from aerial tankers. "I wanted to capture the feeling of hanging out there in the sun, hour after hour, over the vast Pacific and the relentless march into the unknown as these men faced their first combat tour," Ferris explains. Ferris titled the painting *Bad News for Uncle Ho,* which is what the Air Force thought these newer, internally armed aircraft meant for North Vietnam. ***Courtesy of the Artist***

where the group attached itself to the 469th Tactical Fighter Squadron.

Ferris flew many escort missions and a B-52 combat mission to the Mu Gia Pass over North Vietnam. In 1996, he flew on seventeen C-17 combat missions into Tuzla and Sarajevo, Bosnia. He also flew into Mogadishu, Somalia, on Air Force support missions. The rare honorary membership in the National Fraternity of Military Pilots of the Order of Daedalians was bestowed upon him in 1984.

Amn. William S. Phillips

When the Vietnam War started, the Air Force had a resident talent in young enlisted airman William S. Phillips, though he was assigned to perimeter guard duty at Tan Son Nhut airfield in 1965. Phillips, who had only studied art in high school, had wanted to pursue a career in art. After his father died, however, the only way he could get to college was through the military. So he joined the Air Force. Most of his guard duty was at night, leaving him time to sketch during daylight hours. All his sketches, unfortunately, were lost in transit, so his Vietnam work is reconstructed from memory. In a 1987 catalog of his art exhibit at the National Air and Space Museum, he recalled, "Vietnam is a beautiful place, especially down on the delta during the rainy season—everything is green and towering cumulus buildups reach 65,000 feet (19,812m) near the equator."

Phillips has since joined R.G. Smith and Keith Ferris as a dean of aviation art in the United States. Phillips has portrayed all types of aviation and is one of the most sought-after contemporary artists.

Above: Amn. William S. Phillips.

Far Left: In *Heading for Trouble*, Phillips painted two AH-1G helicopters of F Troop, 4th Cavalry, beginning a search-and-destroy sweep led by an OH-6A Loach chopper. Phillips later described the scene: "Though heavily armed, both the scouts and the gunships were in constant danger from hostile ground fire. These conditions and the proximity to the ground required the utmost skill and courage from each crew." Phillips makes the most of the dramatic natural background, either a dawn or sunset. **The Greenwich Workshop, Inc.**

Below: Phillips reconstructed these sketches from his duty at Tan Son Nhut airport in Saigon between 1965 and 1967. Though he was only able to sketch in his off hours and all of his work was later lost in transit back to the States, his wartime memories were so vivid that re-creating the work was not difficult for him. **Courtesy of the Artist**

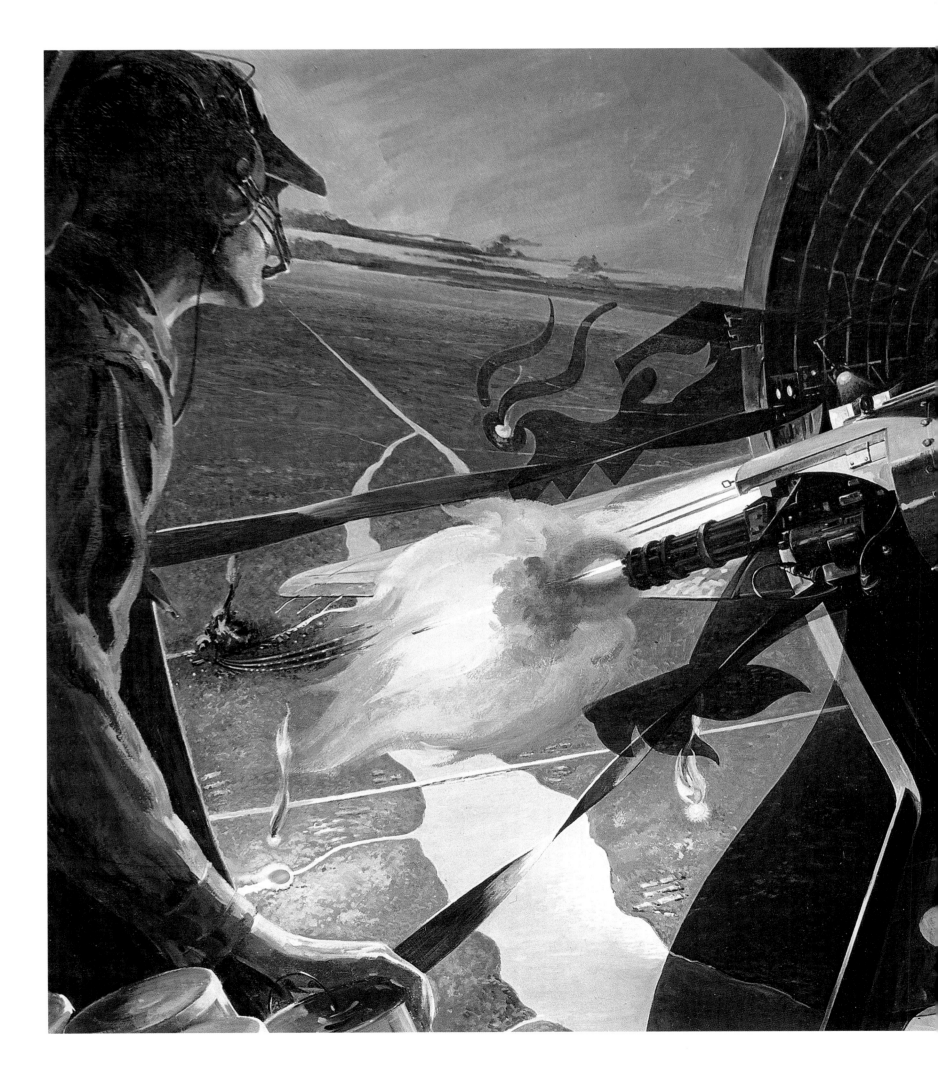

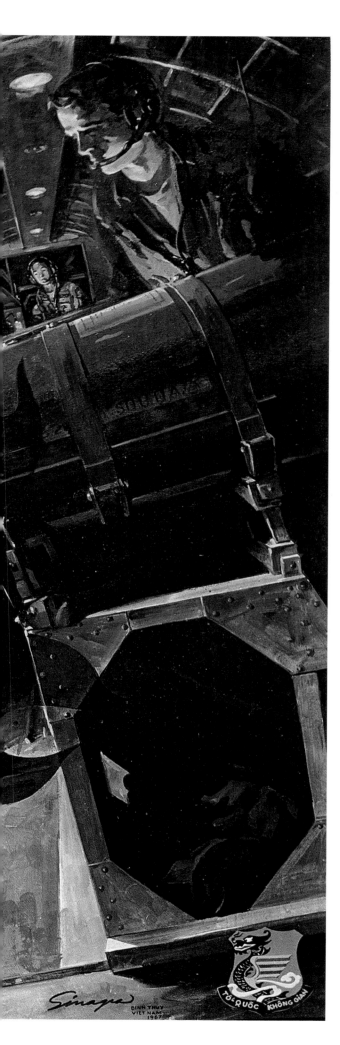

Attilio Sinagra

Society of Illustrators artist Attilio Sinagra wrote a detailed description of how he came to do the painting *Puff the Magic Dragon*:

> Puff [nicknamed "Spooky" by the men in Vietnam] carries three Gatling guns, each of which fires 6000 rounds per minute—totaling 18,000 rpm. On these AC-47 missions of seek and destroy, the ground contact is the Vietnamese airman who goes on every mission in order to verify the target and also to receive the final permission to fire. This is the required procedure, as against returning fire if fired upon.
>
> Upon verification of the target, the pilot is in complete command, ordering the Loadmaster, who is stationed by the open door, to jettison flares to light up the target. The pilot also fires the guns, using the sight by his left shoulder and pressing the fire button on the wheel beneath his left thumb.
>
> This painting is a composite of three missions on which I went also in two areas of Vietnam. The first two missions were in the Mekong Delta at Binh Thuy. On the first mission, we found a target. But the radio conked out, and we had to go back to the Base to get another plane. (Though we had a target, as evidenced by the ground fire at us, we did not return fire because we could not verify the target.)
>
> On a second mission, from midnight to 6 am, the moon was full and "Charlie" wasn't moving down below.
>
> The third mission was from Bien Hoa, north of Saigon. After firing on a target we pulled out of the area with the approach of the B-52s on their bombing run.

Many generous, humanitarian acts were undertaken by American forces in Vietnam on their own, such as one illustrated by Sinagra in *Off-Duty Medic Mission*. Many GIs shared their rations and even asked relatives at home to mail them things they could share with the Vietnamese they had come to know. In the I Corps sector, the Marines—using unsolicited, private donations—constructed a concrete block hospital specifically for children at Hoa Khanh, north of Da Nang. It was staffed by Vietnamese doctors and nurses and visited routinely by Navy doctors (even pediatricians) and corpsmen who contributed what they could to alleviate pain and suffering.

Miriam Schottland

Society of Illustrators artist Miriam Schottland was one of two women artists to go into combat with the Air Force in Vietnam. Discussing her painting *Missing Man*, she wrote, "The viewer is buried in the ground, looking up through the grass at the missing man formation. The painting uses exaggerated perspective—everything in it—the grass, insects and birds are all pointing to the vanishing point—which is the missing man—a vanishing point that isn't

Left: Attilio Sinagra portrays the nighttime gunship missions he accompanied in this composite, titled *AC-47, Puff the Magic Dragon*. Sinagra studied under Harvey Dunn at New York's Pratt Institute, where he later taught.
U.S. Air Force Art Collection

Right: Attilio Sinagra depicted a lesser known aspect of the war in his painting *Off-Duty Medic Mission*. As he later described it: "Perhaps not well remembered about the Vietnam experience were the many works of human kindness for the Vietnamese people by medical personnel," who treated civilians whenever they could.
U.S. Air Force Art Collection

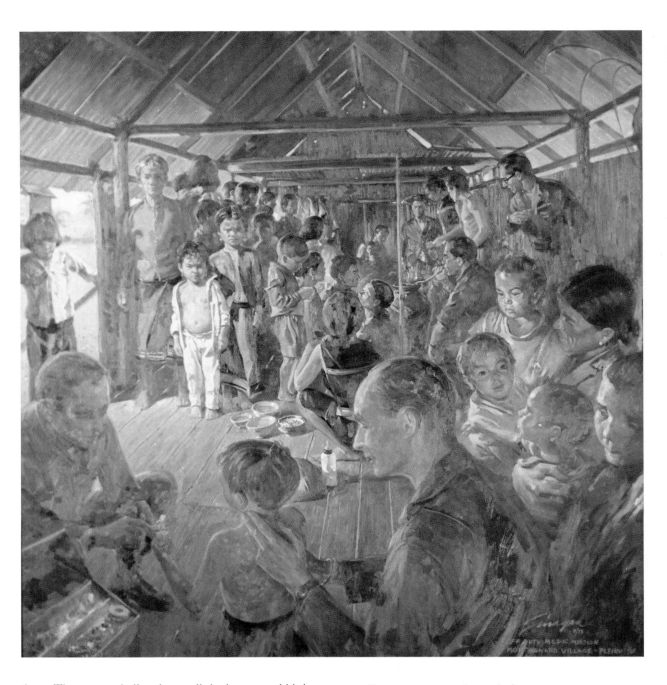

there. The sun symbolizes hope; all the insects and birds symbolize life. The poem was written by Debi Wood, age seventeen, whose father is a POW." The poem on the painting reads:

> I don't know what he suffers there
> I cannot feel his grief, despair,
> His agony is only known
> To men who have been caged alone.
> I only feel a selfish pain.
> A fear that I might pray in vain
> And never see again his face
> Or feel again his strong embrace.
> I need his love while I am young.
> With many fears to walk among,
> I need his help to guide me through.
> To him the dangers are not new.
> For how long must I wonder when
> My father will be mine again?

> How many years can he survive?
> Is he even now alive?
> Before it is too late to try,
> Before my life must pass him by,
> Please bring him home and I'll be then
> My father's little girl again.
> —Debi Wood

Robert T. McCall

McCall was a well-known American illustrator when he volunteered, through the Society of Illustrators, to cover the Air Force in Vietnam. He had studied at the Columbus Fine Arts School in Ohio and had done advertisements for major corporations, as well as specializing in jet aircraft illustrations for such companies as United Aircraft, Douglas, Goodyear, and Sperry Instrument Company. His works appeared in *Time*, *Life*, *Collier's*, *Newsweek*, and most major national publications.

Left: Miriam Schottland, on assignment in Vietnam for the Air Force, produced this sensitive antiwar painting she titled *War and Peace*. The stacked rows of lethal bombs for the aircraft are portrayed stored in a field of flowers. Schottland sought this type of subject matter, which suited her unique personal style, rather than the obvious combat aspects of the war.

U.S. Air Force Art Collection

Below: Although not combat art per se, Schottland's *Missing Man* is an eye-teaser with subtle implications. Upon close inspection, one sees that the point of view is from someone (presumably the missing pilot) on the ground, looking up through lush foliage as a squadron— with one aircraft missing in the formation— flies low overhead. The missing pilot is left, perhaps, to wonder about his fate—rescue, death, or imprisonment.

U.S. Air Force Art Collection

Right: Robert T. McCall sketched this view of the defense perimeter surrounding the air and naval base at Cam Ranh Bay, on the east coast of Vietnam. The Americans developed the port facilities, and the base later became a major supply and transit site for the entire country. When the United States pulled out in 1973 and North Vietnam won the country, Cam Ranh Bay became a Russian naval facility.
U.S. Air Force Art Collection

Below: Neil Boyle's *Spoils of War* depicts the unwanted legacy American soldiers left behind in Vietnam—orphaned children they had fathered. As mixed race children, they were mostly shunned by the South Vietnamese and ended up in orphanages that were valiantly maintained by religious orders with little or no help from either the Vietnamese or United States governments. Eventually, some were fortunate enough to be claimed by their natural fathers and were able to emigrate to the United States to live with them. Others were simply abandoned to grow up as outcasts—the real "spoils of war."
U.S. Air Force Art Collection

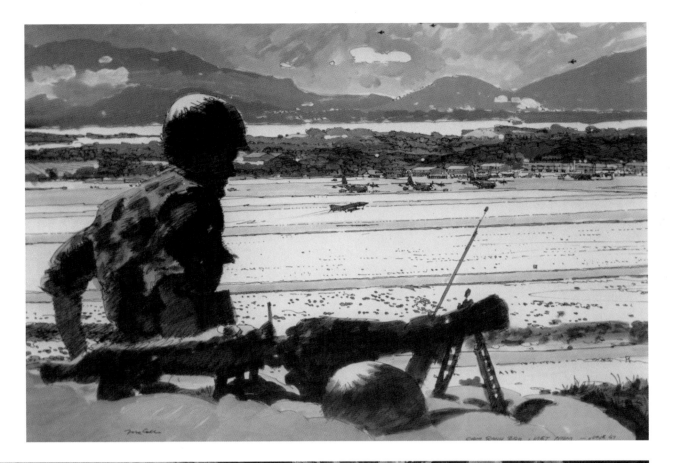

AMERICAN FLAG RETURNS FROM HANOI
By Maxine McCaffrey
USAF Art Collection

Over time, McCall has donated more than fifty-eight artworks to the Air Force art program. His most memorable artworks are the gigantic murals that grace the entrance to the Air and Space Museum in Washington, DC. They depict the space flight program with breathtaking imagination.

Neil Boyle

In describing his painting *Spoils of War*, Society of Illustrators artist Neil Boyle said, "This orphanage was just a twenty-minute ride by truck out of Saigon—probably controlled by the VC (Vietcong) after dark. Too bad you can't show how a place smells in a painting."

These orphanages, for the most part, were pitiful, heartbreaking sights that one never forgets. Despite their obvious signs of ill health—many had untreated sores, lesions, and limps—the children always put on a happy face, a trait that often came, under the circumstances, from their innate desire to be adopted by anyone who visited them. They would try to ingratiate themselves with their friendliness, and the bolder ones would openly ask visitors to take them with them. Their desire for mothers and fathers was so compelling that only the most insensitive visitor could resist tears. Many worthy charitable and church groups helped the children, but, unfortunately, could not take care of them all.

Maxine McCaffrey

Calling herself an artist-patriot, illustrator Maxine McCaffrey covered Air Force activities in Vietnam and Thailand in 1967 and the 1973 return of the POWs in the Philippines. She donated more than sixty paintings to the Air Force art collection. In 1975, the Air Force presented

Top Left: Because she knew some of the pilots imprisoned by the North Vietnamese, Maxine McCaffrey took special interest in her assignment to record visually their return from captivity, which she did in her unique, loose drawing and wash style evident here in *Bringing the American Flag Home.* Of her work for the Air Force, she said, "Those people among us who had the ability to put concern for them into dramatic pictures which could move others of our citizens to action in their behalf and who did not, missed a great opportunity of really using their ability to great purpose. I thank God I followed my intuition and did the little I did, counter to the popular attitude."
U.S. Air Force Art Collection

Bottom Left: McCaffrey's *Operation Homecoming: Return of POWs* depicts the March 1973 scene at Clark Air Force Base, Manila.
U.S. Air Force Art Collection

Bottom Right: Maxine McCaffrey, in a portrait by Nathalee Mode.

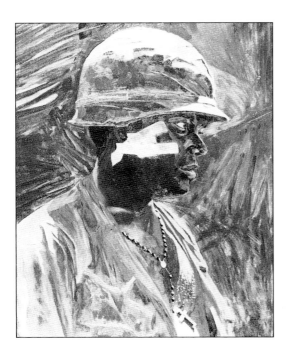

Above: Using a sure, fluid technique, Army Sp4c. Stephen H. Sheldon executed this watercolor in 1967. The wounded soldier, probably awaiting his return to combat, is from the 1st Cavalry Division.
U.S. Army Art Collection

Right: Here, Army 2ndLt. Augustine Acuña portrays troops interrogating South Vietnamese villagers. As the soldiers inquire about the whereabouts of Vietcong guerrillas, they struggle with both the language barrier and a degree of mistrust from villagers, who quite often had no idea what the fighting was about.
U.S. Army Art Collection

Bottom Left: Acuña's *Scout Dog* depicts one of the highly trained guard and attack dogs used on combat patrols. These dogs often saved entire patrols by detecting the enemy before an ambush could occur. In appreciation for their service, many canines were cited for bravery and even awarded medals. When the U.S. forces abandoned South Vietnam, though, the Pentagon ordered the attack dogs left behind. Because they were difficult to domesticate, the Vietnamese would often butcher and eat them instead.
U.S. Army Art Collection

Bottom Right: Patrolling South Vietnamese villages was always an arduous and thankless task. There was always a danger that some villagers were Vietcong, or at least sympathetic to their cause. In Acuña's *Checking Long Binh*, a wary GI keeps his guard up.
U.S. Army Art Collection

Opposite: Artist Peter Copeland, a civilian who covered the Army, sketched this soldier for a painting titled *Vietnam Ambush Patrol*.
U.S. Army Art Collection

her with its highest honor in the field of arts and letters, the Gill Robb Wilson Award.

McCaffrey specialized in POW paintings, discovering from released POWs that they knew of her work even in the prisons and credited it with helping them endure the emotional devastation of extreme torture and abuse. Sadly, McCaffrey died at the height of her career following the war.

Combat Artists of the U.S. Army

The Army organized nine teams of artists to cover the war in Vietnam from 15 August 1966 through 15 June 1969, when the art program ended. Artists from the ranks, as well as civilian artists (both independents and those affiliated with the Salmagundi Club of New York), undertook 120-day assignments to cover the war. The military provided transportation, food, and lodging, and retained

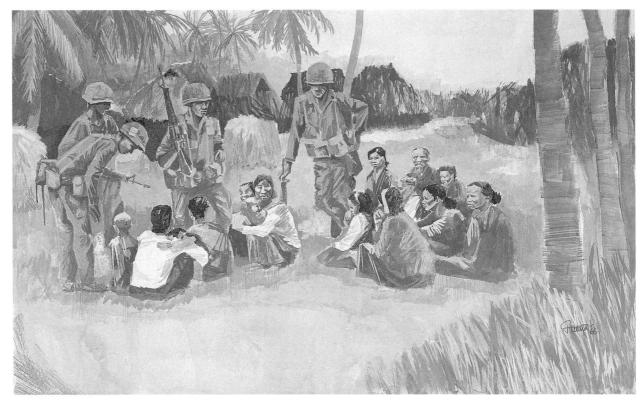

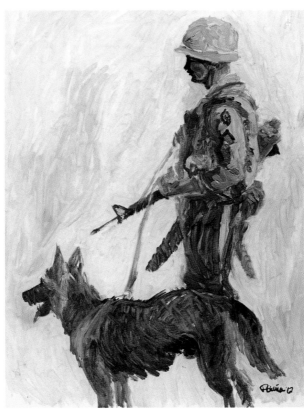

Viet Nam
Search Ambush Patrol.
4th DIV.
Dak To area
Dec. 1967

PC

Right: A combat weary GI pauses after a particularly hard operation in *Soldier in Vietnam* by Sp4c. Victory von Reynolds. Expressing either exhaustion or grief, von Reynolds's soldier is experiencing the postcombat emotional letdown commonly known as battle fatigue.
U.S. Army Art Collection

Below: Ever Present, an engraving by Donald Sexauer, portrays the ubiquitous chopper that could always be heard off in the distance. It was both the supply source and lifeline for the troops, and the civilian population became resigned to its reverberating *flop-flop* sound. Although not depicted here, villages such as these often had TV antennas dotting the roofs.
U.S. Army Art Collection

the rights to the works; the civilians received no compensation. Evidently, some NACAL artists covered the Army as well, perhaps through unintentional overlapping or serendipitous encounters.

The uniformed, active duty artists were released from regular duties and reassigned to the combat art program. They were sent in teams of five, each team under the supervision of a civil employee at Army headquarters. After their allotted time "in country," the military artists went to Hawaii where a studio was provided for them to finish their paintings. The civilians returned home to finish their works in their own studios, delivering them within a year, as stipulated by their contracts.

In all, thirty-six soldiers participated, as did twenty civilian artists. Their work is in the permanent art collection at the Army's Center for Military History in Washington, DC, and is displayed from time to time. As public domain property, it is available for use in publications and other publicity endeavors.

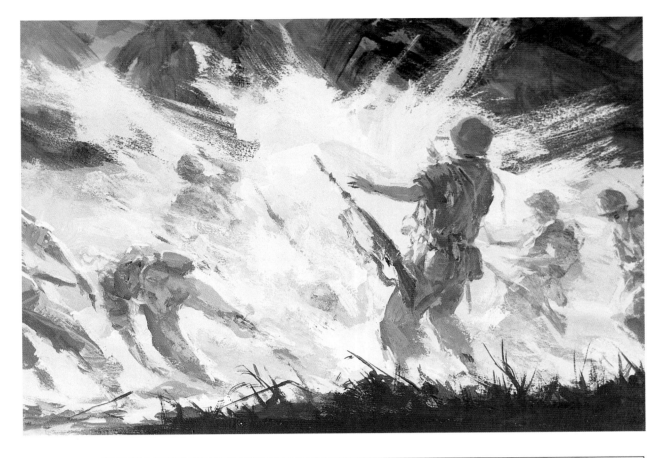

Left: Observed or imagined, *Mine on Patrol* by NACAL artist John Steel dramatically captures the terrifying split second following the explosion of an antipersonnel mine.

Below: Relatively fast and small, the Huey helicopter could perform as a gun/command ship, supply chopper, or rescue vehicle. If there was a mission, the Huey could do it. It is depicted here in Sp4c. Paul Rickert's *Helicopter Pickup.*

Page 300, Left: In Vietnam, a few artists experimented with styles other than traditional realism. Army artist Pvt. Stephen Sheldon here turns a very common situation into one of artistic interest by abstracting the forms and colors.
U.S. Army Art Collection

Pages 300—301: With this semiabstract treatment, Army artist Horatio A. Hawks has accomplished an exciting interpretation of jungle warfare in Vietnam. In the tangle of arbitrary foliage shapes, Hawks has captured the madness and struggle of combat within a natural camouflage that is both friend and foe. He has created a sense of motion with the blurring of some of the background foliage.
U.S. Army Art Collection

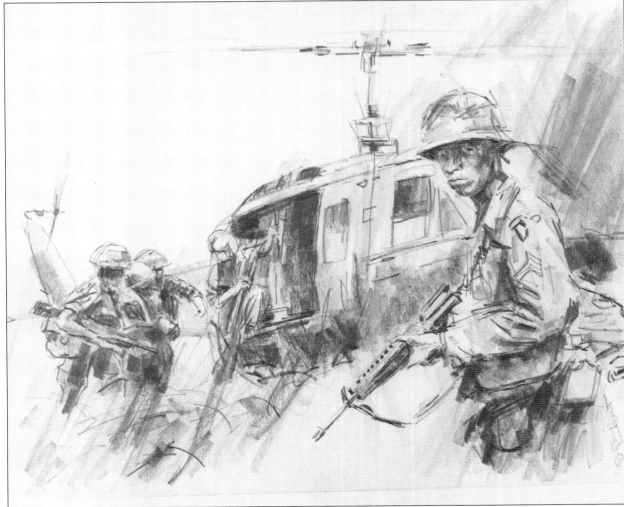

Most of the Army's active duty artists were specialists 4th and 5th Class; however, two were lieutenants, John O. Wehrle and Augustine Acuña. Their work exists mostly in watercolors and ink sketches rather than finished paintings.

George Dergalis

In *Combat Art in the Vietnam War*, Joseph Anzenberger relates an extraordinary episode that attests to art's ability to transcend war.

George Dergalis, a NACAL artist working with the Army near Saigon, went on a mission to deliver reparation payments to a small village. Warned that the Vietcong controlled a site across the river, Dergalis nevertheless spotted a cleared area on the river banks where he wanted to sketch.

Armed only with a .45-caliber pistol (unusual for a civilian), he brazenly seated himself in the open, within view of both friend and foe, and proceeded to sketch. Shortly, he felt the presence of someone looking over his shoulder. Stealing a sideward glance, he detected a black-clad figure, Vietnamese features, sandals, and a pistol and two grenades in a belt. A hand jarred his shoulder; when Dergalis looked up at the guerrilla, he motioned for him to continue.

Thoroughly mesmerized, the enemy watched the artist work for some time, then, in gestures and Vietnamese, conveyed the idea that he wanted the artist to draw a picture of him. Dergalis motioned for his guest to sit in front of him. He sketched for some time, then held up his sketch pad and showed it to his sitter. A grin spread across the face of the adversary, who unceremoniously ripped it out of the sketchbook and melted back into the bamboo foliage with it. After allowing his adrenaline to subside, Dergalis casually gathered up his art materials, stood up, and strolled back to his party and their vehicles behind the village.

All the while—unbeknownst to him—Dergalis' group had been watching the whole episode and had had him covered by their guns. No doubt the enemy across the narrow waterway had done so as well.

Combat Art of the U.S. Coast Guard

The Coast Guard eventually utilized the NACAL program to cover Vietnam. Apollo Dorian and Noel Daggett, in particular, depicted Coast Guard activities controlling shipping along the Vietnamese coast and along its many rivers. Both did outstanding work in what was an especially hazardous undertaking. Coastal and riverine patrols involved checking civilian boat traffic. Compounded by the difficult language barrier, differentiating between friendly South Vietnamese and infiltrating Vietcong—or Charlies—was an almost impossible task.

This Page: These sketches by Lt. Comdr. John McGrath depict the brutal conditions endured by POWs in Vietnam. They appeared in his book *Prisoner of War: Six Years in Hanoi,* published by the Naval Institute Press. Offering the enemy only their name, rank, and serial number, the imprisoned officers set up a chain of command and a crude system of communications. Despite complete isolation from each other and the concerted efforts of their captors to prevent it, the prisoners communicated through hand signals and surreptitious notes hidden around the compound, giving the men goals and a morale boost. Those who resisted were beaten and often endured days upon days of barbaric torture. Toilet facilities were less than primitive. McGrath had to make a commode out of a rusted, jagged bucket. With no strength to squat and get himself up again, he put his filthy sandals on the rim in order to sit. McGrath described the constant stench as unbearable.

Reprinted by permission from John M. McGrath, **Prisoner of War: Six Years in Hanoi** *(Annapolis, MD: Naval Institute Press, ©1975)*

POW Art
Lt. Comdr. John M. McGrath, USN

Unique in the annals of warfare and combat art are the visual records of prisoners of war. From prison, Smn. Charles DeNoon was able to depict the burning of the *Philadelphia* in Tripoli harbor, while Pvt. Robert Knox Sneden's and Lt. Robert L. Meade's work offers visual insights into the plight of Union prisoners during the Civil War. In World War II, after his capture on Wake Island, (later) Brig. Gen. Woodrow M. Kessler recorded his experiences in a brutal Japanese prison camp, as did another U.S. Marine Corps survivor, James R. Brown. Still later, USAF intelligence officer Theodore Gostas, captured near Hue in 1968, was treated as a spy and spent his entire internment in solitary confinement; he painted his tortured experiences years afterward.

Perhaps the most remarkable visual account of the agony and torture that Vietnam-era prisoners of war suffered comes from drawings by Navy Lt. Comdr. John "Mike" McGrath, a flyer shot down over enemy territory. After release from his bitter ordeal at the "Hanoi Hilton" prison camp, he re-created his experiences in a book he wrote and illustrated entitled *Prisoner of War: Six Years in Hanoi.*

McGrath's account and other written tales of North Vietnamese prison camp atrocities, including Arizona Senator John McCain's, portray the miserable conditions with which American POWs in Vietnam were forced to contend. Many endured years of harsh captivity, lack of medical care, severe malnutrition, inhumane treatment—yet most survived against incredible odds. Captivity was thus a special form of combat, often worse—and far more prolonged—than the stress and pain of conventional battle.

Right: I'm Hit is a disturbing pastel painting by former Army demolition specialist Richard Russell Yohnka that speaks eloquently of the personal agony and pain of warfare. The red is not blood red, but pure cadmium, perhaps even more arresting in its choice. As a protest of war, *I'm Hit* is as shocking as Tom Lea's *The Price* is. **National Vietnam Veterans Art Museum**

Opposite: We Regret to Inform You..., a poignant oil painting by former Air Force Sgt. Cleveland Wright, depicts the devastating moment that came to mothers, fathers, and loved ones all too often during the Vietnam War. In its naive, untutored style, somewhat reminiscent of that of World War I artist Horace Pippin, it delivers a grave and powerful statement. **National Vietnam Veterans Art Museum**

For some veterans, expressing their deep-seated scars from the war in visual terms became a form of therapy. McGrath purged the hideous memory of the barbarism to which he had been subjected for six years, exposing in the process an ugly aspect of warfare. As he later wrote:

> My drawings are too soft; I was unable to portray the actual hardness of the conditions we lived under—the dimly lit rooms and claustrophobia-inducing cells; the lack of adequate food, which, combined with filth, caused disease and indescribable discomfort. It is difficult to sketch a vitamin and protein deficiency that results in beriberi; and no picture can convey the impact of constant plagues of lice, heat rash, biting bed bugs, mosquitoes, cockroaches, and rats. Add to this the hostility and brutality of the guards, who had been taught from childhood to hate Americans, and the sum total is an unbelievable existence for hundreds of American fighting men who somehow survived the ordeal.

Aftereffects of the War: War Art as Therapy

A few combat artists (Cpl. Charles Waterhouse, Pfc. Austin Deuel, Howard Brodie) and combatant–artists (Lt. Comdr. John McGrath) published their sketches, finished art, and verbal recollections of the Vietnam War. Deuel did so in his excellent book *Vietnam: Even God Is Against Us*. He also expressed the tragedy of war in a monumental sculpture for the Vietnam War Memorial in San Antonio, Texas.

While literature always seems to produce antiwar reactions, there do not seem to be any other important protestations of the war in the realm of combat art—though a great deal of war art was produced as a therapeutic tool. For some disturbed war veterans, personal visual expression presented a means of coming to grips with the irrepressible nightmares that forever seared their memories—nightmares that, to this day, many have not been able to shake off. In the 1970s, an organization called Washington Project for the Arts in Washington, DC, and the Vietnam Veterans Art Group in Chicago were independently formed to collect and exhibit some of the work of these troubled artists, amateur and professional alike.

Although personally interpretive art falls outside the purview of this book, the art of the Vietnam Veterans Art Group and the National Vietnam Veterans Art Museum in Chicago deserves special mention. The two groups' initial intention was to collect the visual output of Vietnam veterans still troubled by their experiences long after the war had ended; 131 of these artists are still painting in the year 2001.

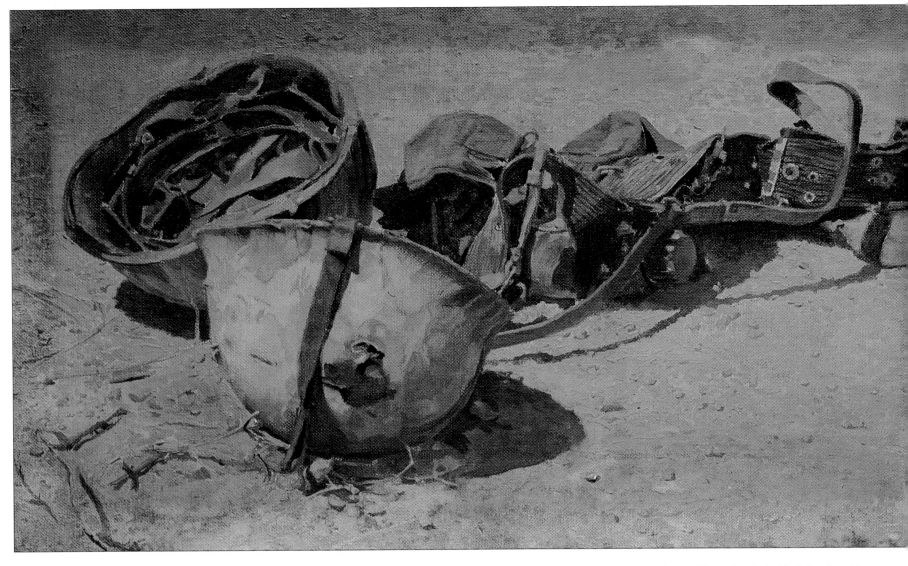

Above: *Helmets at Que Sanh*, a well-known painting by Lt. Col. Peter Gish, USMCR, sums up the aftermath of battle—and war itself. **USMC Art Collection.**

As president of the National Vietnam Veterans Art Museum, Ned Broderick, a Marine combat veteran and a graduate of the American Academy of Art in Chicago himself, states:

> Creativity comes from two basic sources: pain and isolation. The Vietnam War gave us that without end. The war was fought by a small percentage of our generation, who after serving in this brutal, divisive and often bizarre crusade, returned to an America which at best wished to ignore their sacrifice.
>
> This greatly increased their bitterness and isolation. I personally felt that the basic concept of home no longer existed; the word "home" was meaningless. This emotional pressure cooker created an artistic subculture of artists who found it necessary—absolutely necessary—to paint the truth about that war—their truth, as they saw it and felt—and feel it still!

Most of these Vietnam veteran artists had previously studied art or demonstrated artistic abilities. Some had tried to paint while in Vietnam, and others pursued art seriously after the war, realizing that they could satisfactorily express their pent-up memories of battle experiences artistically. America had been firmly behind the doughboy of World War I, and the GI of World War II, and a little less so, the soldiers in Korea. Perhaps the absence of support by the general public during the Vietnam War took its toll on some combatants, spurring them to express their pain through art.

Summary

Throughout the Vietnam War, both military and civilian artists plunged into war art coverage wholeheartedly. Except for some of the highlights shown here, though, NACAL and the Society of Illustrators, for the most part, failed to produce art comparable to Lt. Comdr. Dwight Shepler's, Tom Lea's, and Sgt. Kerr Eby's of World War II. Much of their art looks as if it is meant for story illustration, with blank areas left for copy overlay. Some illustrators kept their slick, magazine styles, and as a result, rarely conveyed a sense of combat; their pieces look more like studio exercises or advertisements for defense contractors.

Interestingly, the decade of the war saw a flurry of activity in the art world that brought forth pop art, op art,

FIGHTING THIRD

minimalism, conceptualism, photo-realism, and the likes of Andy Warhol, Robert Rauschenberg, Richard Estes, Christo, and other innovative creators. The combat artists in uniform, however, were generally not influenced by these tumultuous trends that coincided with contemporary social upheavals. Only one or two seemed to have ventured successfully past absolute realism into semiabstraction. For the most part, only a few of the combat artists of the Navy, Marine Corps, and Air Force attained the maturity of the greats of World War II. But some did go on to make similar reputations for themselves in the fine art world after the war, most notably William S. Phillips, R.G. Smith, and Wilson Hurley, who was named by the Franklin Mint as one of America's eight best landscape artists.

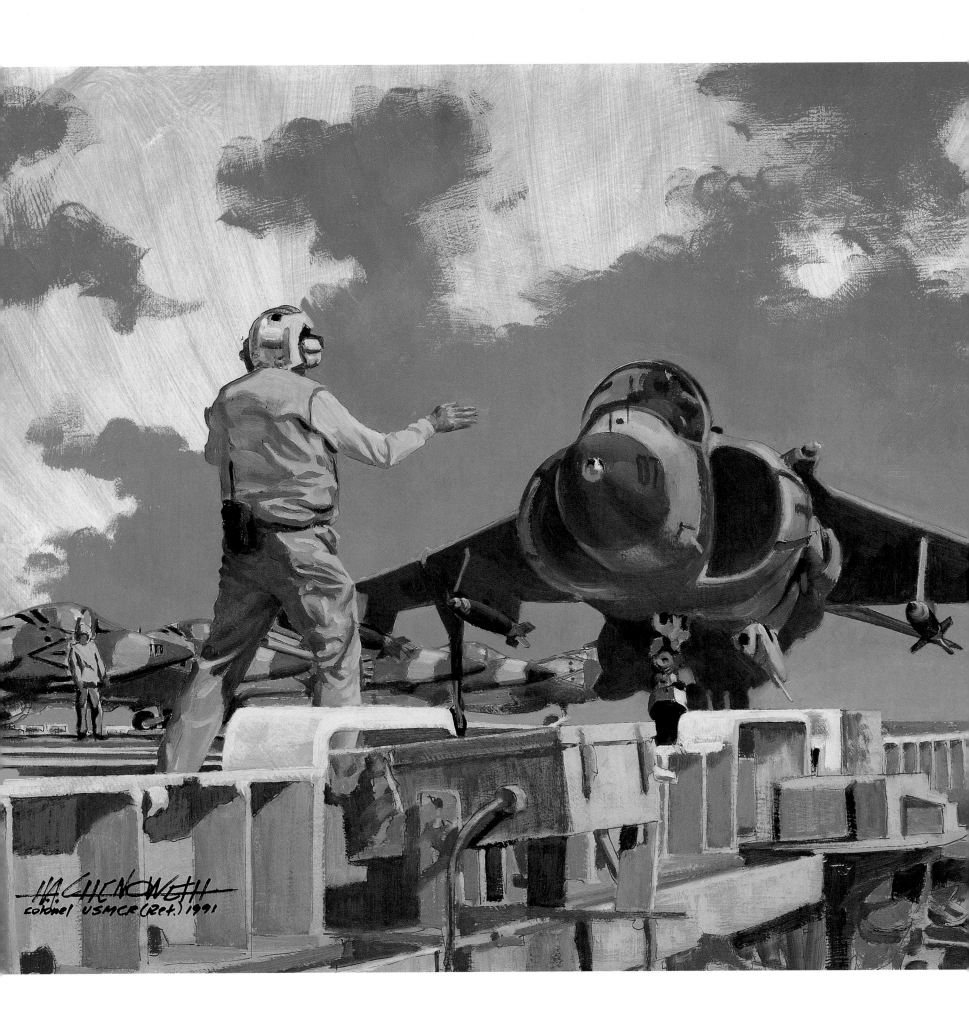

HA CHENOWETH
colonel USMCR (Ret.) 1991

Late Twentieth Century Engagements

The Cold War was, in many ways, a deadly chess game with apocalyptic consequences. The two super powers, the American-led North Atlantic Treaty Organization (NATO) and the Soviet Union–led Communist bloc countries, continually tested each other's strength and will, with varying degrees of military friction, espionage, and open confrontation seen in countries across the globe. Every Western-backed government seemed to have a counterpart backed by the Communist bloc. Consequently, the United States, in addition to large and serious commitments in Europe, Korea, and Vietnam, spent a great deal of time focusing on small flare-ups on the borders of the Iron Curtain and elsewhere. Marines were sent into Lebanon in the 1950s by President Eisenhower to project a stabilizing presence; into the Dominican Republic in 1965 to prevent a rebel communist takeover; into Lebanon again in 1983 to protect American nationals during a civil war and Syrian and Israeli invasion (with the tragic loss of 241 Marines in the terrorist bombing of their barracks); and into Grenada shortly afterward to oust Cuban militants. Finally, just prior to the Persian Gulf War, the U.S. forces stationed in Panama, augmented by assault units flown in, swept dictator Manuel Noriega out of power, putting him in jail in the United States to await trial on drug charges.

These sometimes hastily initiated operations left U.S. military services unprepared to cover the events with combat artists, who for the most part were inactive reservists. Press photography was usually pooled, and official military photography often failed to capture an adequate historical record, even for artists to work from later. Consequently, artistic depictions have been limited to after-the-fact reconstructions, in many cases, unfortunately, not by eyewitnesses.

Yet, in the tradition of the mid-nineteenth century artists' coverage of scientific expeditions and explorations, the various military services had been assigning artists with the title "combat artist" to joint military exercises throughout the world. While not actual combat missions, these activities have presented valid training opportunities for artists.

It is difficult to retain continuity in the military, and succeeding commanders fluctuate in their desire for an artistic record (and even in their assessment of its importance), so momentum is often lost. Fortunately, during the Lebanon crisis of the 1980s, top combat artist Marine Reserve Maj. John T. "Jack" Dyer, curator of art at the Marine Corps Historical Center at the Washington Navy Yard, was recalled to active duty and sent to Beirut. His watercolors and quick sketches of that operation are superb. Unfortunately, during the Grenada operation in 1983, some extraordinary feats had to be reconstructed after the fact. The choice to assign Marine Reserve Lt. Col. Mike Leahy, former aviator and Vietnam combat artist, was a good one. By questioning participants and eyewitnesses and visiting the battle sites on the island, Leahy was able to illustrate what happened with a high degree of accuracy, if not a bit of melodrama.

Author H. Avery Chenoweth's acrylic painting of a Harrier from the 4th Marine Expeditionary Brigade (MEB) in the Persian Gulf. Hard-hitting Marine air units were stationed aboard amphibious assault ships in the Persian Gulf and operated in conjunction with units from the 3rd Marine Aircraft Wing based at Bahrain and in Saudi Arabia. At the last moment during the ground war, it was decided that the landing of Marine amphibious forces ashore at Kuwait City was not necessary.

USMC Art Collection

Right: Maj. John T. Dyer, USMCR, curator of art at the Marine Corps museum, volunteered for active duty as a combat artist to cover the Lebanon operation in 1983. Here, his watercolor depicts Marine snipers of GOLF Company, 2nd Battalion, 8th Marines, in sandbagged positions around the Beirut International Airport.
USMC Art Collection

Bottom Left: Lt. Col. Donna Neary, USMCR, the only uniformed woman combat artist of any of the services, covered many combined multinational combat exercises in Europe, including Norway, where she sketched this Marine in snow gear.
USMC Art Collection

Bottom Right: In *Beirut Noel*, Dyer captures an unusual Christmas moment.
USMC Art Collection

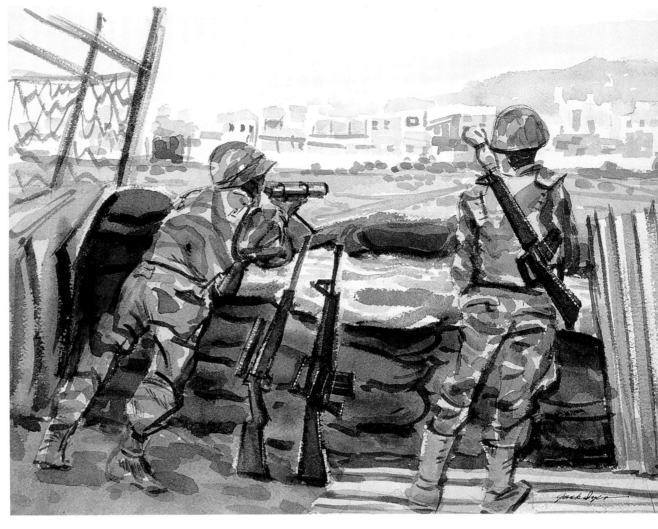

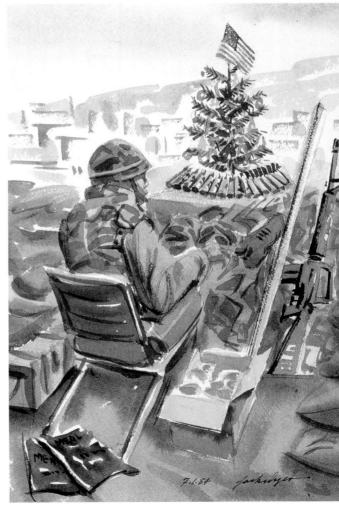

Operation *Just Cause* in Panama was also covered after the fact by civilian and former Marine Anthony Stadler, who visited that country. He did not attempt, however, "to re-create the battles in an illustrator's fashion. Instead, he chose to portray the garrison and the tropical ambience of the scene in his distinctive subdued, almost sketchy style, using Cézanne-like brush strokes.

Joint and coordinated exercises of NATO forces involving the Navy and Marines in Norway were covered by Lt. Col. Donna J. Neary, USMCR. Though she would not experience actual combat until the Somalia operation, Neary covered these important training exercises artistically, much as Navy artist Arthur Beaumont and author H.A. Chenoweth had the atomic bomb tests. She is perhaps best known for her "Uniform Series," which includes, besides the standard work and dress uniforms, those of the Marine Band, as well as a special print portraying the uniforms and personal equipment used for Operation *Desert Shield* and *Desert Storm*.

In 1981, the Coast Guard, ever limited in budget but cognizant of the importance of artistic historical records, inaugurated the Coast Guard's art program (COGAP), under the administration of the Salmagundi Club of New York. This has afforded artists and illustrators the opportunity to cover all aspects of Coast Guard activities on a volunteer basis. Artists are issued special identity cards and are at liberty to visit nearby Coast Guard activities or to be assigned to a thirty-day tour, which includes transportation and lodging. All other costs are borne by the artists, and they relinquish all rights to the art, including reproduction. When artwork is finished, it is submitted to Salmagundi for committee evaluation and acquisition. Former Coast Guard combat artist George Gray is the Salmagundi chairman of the COGAP program, serving in much the same role he did for the NACAL program in Vietnam.

The Persian Gulf War
The Navy's Combat Art Program

When Iraq invaded Kuwait, the Director of the Naval Historical Center, Dr. Dean C. Allard, was quick to recall to active duty Naval Reserve Comdr. John Charles Roach,

Below: Former Marine Anthony Stadler undertook an after-the-fact art assignment to cover the U.S. military operation that ousted dictator Manuel Noriega in Panama. Combat artists could not be activated in time to cover the actual operation, so Stadler did a series of watercolors of the sites where the action had taken place. Pictured here is the Rodman Naval Air Station. **USMC Art Collection**

A New Style of Warfare

With the Iraqi invasion of Kuwait on 2 August 1990, a crisis in the Middle East erupted. The United States responded immediately by forging a coalition of U.N. military forces to free the unfortunate country. The U.S. Navy and the U.S. Marine Corps were quick to react, both from the military and combat art standpoint. During Vietnam, the public could choose from three networks broadcasting previously recorded material. Now there was instant, global, satellite television broadcast live from everywhere in the war zone—including the enemy's side. Twenty-four hours a day, the entire world was able to monitor every detail of the Operation Desert Shield buildup. When the shooting war started, viewers could actually watch in their living rooms as the U.S. air bombardment erupted over the Baghdad skyline. Privates to generals were able to telephone their families at almost any time and from anywhere to inform them of their status. With global satellite communications and portable positioning devices, "smart" bombs guided by TV, accurate long-range cruise missiles, and robotic aerial surveillance craft, warfare had evolved considerably.

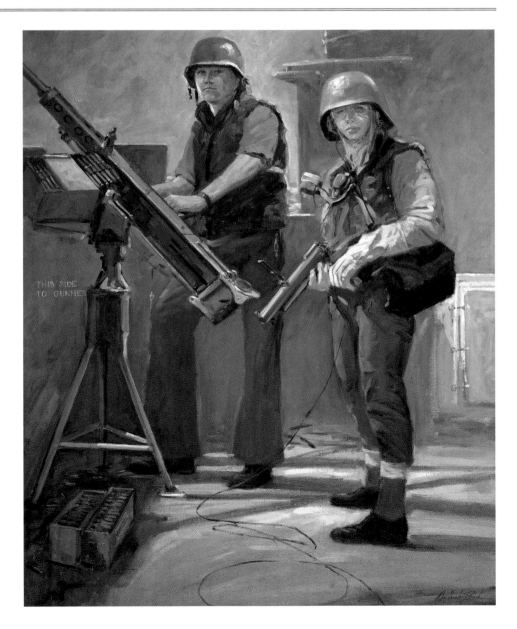

who had produced excellent art from the Vietnam conflict. Roach was sent to the Persian Gulf along with the first American units, arriving there in early August. For forty-one days, he covered sea and land activities of both the Navy and Marines in the buildup phase. Upon returning to his studio in Washington, DC, he completed a number of paintings for the Navy collection before being ordered back overseas to cover *Desert Storm,* the actual combat phase of the operation. Later, the Navy also dispatched Reserve Comdr. William G. Beck to cover Operation *Desert Storm.* Beck was aboard ship during the last part of the air campaign of *Desert Storm,* arriving at Kuwait International Airport early on the morning of 28 February 1991, just after the cease-fire was going into effect.

As Allard observed, "The accomplishments of naval reservists—both historians and combat artists—were outstanding. They mobilized quickly, skillfully documenting the Navy's important role in the Middle East crisis. We simply could not have covered such a wide scope of key events without their support."

Comdr. John Charles Roach, USNR

John Roach has the distinction of having been the first combat artist to have reached the Persian Gulf. A week after Iraq invaded Kuwait, he was on his way, arriving in Saudi Arabia before any other artists from any other services. Roach was thus able to provide a valuable record of the first months of *Desert Shield,* when the efforts of all services mingled in mutual support. Consequently, he was able to capture a compelling visual record of Navy and Marine, as well as some Army and Air Force activities. In brutal heat and otherwise exhausting conditions, he was often on the go day and night, sketching and taking pictures constantly.

When not on active duty, Roach is a professional artist and muralist, concentrating largely on naval subjects. His murals adorn the Pentagon, the U.S. Capitol, and Navy facilities at Pearl Harbor. He also was the concept designer for the Navy Memorial in Washington, DC. Periodically, Roach's prints of naval scenes and battles are published by the U.S. Naval Institute in Annapolis, Maryland. Born in 1943 in Ft. Lauderdale, Florida, he studied at L'École des Beaux-Arts in Paris and earned his Master of Fine Arts degree at American University in Washington, DC.

On the subject of his combat art, Capt. Roach said, "There is value in having an artist-participant with military men and women deployed in the field. It is the artist's responsibility to speak for the soldier or sailor, to show the things which must be painted, to serve as the spokesman for those who endure the trial of war."

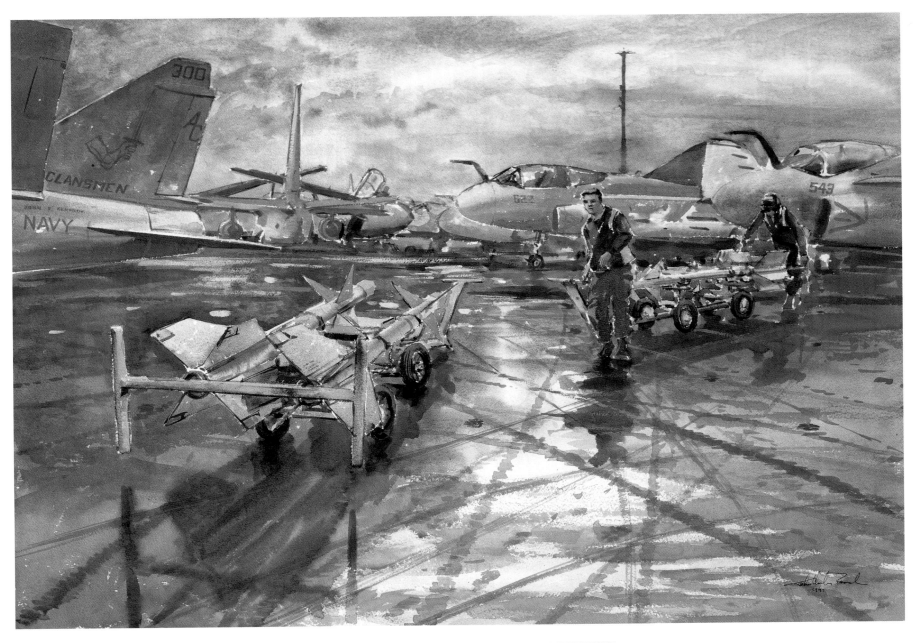

The Marine Corps Combat Art Program

The reaction of retired Marine Brig. Gen. Edwin H. Simmons, director of the Marine's Division of History and Museums, to the impending war in the Persian Gulf was similar to Allard's. Still, the administrative wheels ground slower for the Marines. Author H.A. Chenoweth, at the time a retired reserve colonel, was approached by Simmons for voluntary recall to head the combat art program, an assignment he had held forty years previously. Marine Sgt. Charles G. Grow, the graphics chief at South Carolina's Parris Island Recruit Depot, was reassigned as a combat artist, while former Marine and civilian artists who had been assigned to the Marines and Navy in Vietnam also expressed interest in covering the conflict. It took until late November 1990, however, for Chenoweth and Grow to receive their orders, and they arrived at First Marine Expeditionary Force Headquarters in Al Jubail, Saudi Arabia, in mid-December.

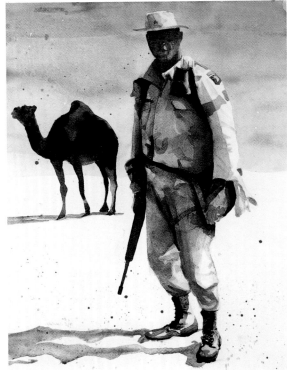

Above: In *First Round Live Loads*, Navy combat artist Comdr. John Charles Roach sketched in watercolor the deck crews loading live ordnance on A-6E Intruders. They are preparing for attacks on Iraqi targets during the combat phase of the Gulf war, *Desert Storm*. **U.S. Navy Art Collection**

Left: Army combat artist Sp4c. Peter G. Varisano portrays the new American desert soldier. **U.S. Army Art Collection**

Opposite: In *.50-Calibre Watch*, Roach paints two gun crewmen on an unidentified ship in the Persian Gulf. The Navy played a critical role in controlling sea traffic in the Gulf, and when the shooting war started, ship-launched, long-range Tomahawk cruise missiles were some of the first weapons fired against Iraqi military targets. **U.S. Navy Art Collection**

Above: Retired Marine Brig. Gen. Edwin H. Simmons, the director of the Marine Corps historical division and a decorated three-war veteran, was prepared to immediately cover the pending war. He sent historians to augment division and force units, directed photographers to capture the scene, and mobilized specialists to collect artifacts from the battlefields. To supplement the visual aspect of history, he alerted combat artists to potential assignments.

Right: The inside cover of Col. H. Avery Chenoweth's personal sketchbook records his itinerary and a map for orientation in case he got lost or captured.

Below: Dockside, Al Jubail by Chenoweth depicts the large Persian Gulf port that served as the major supply point for the *Desert Shield* and *Desert Storm* operations. The Marine Corps already had fully stocked transport ships harbored at Diego Garcia in the Indian Ocean, so when President George Bush ordered U.S. troops to Saudi Arabia, the ships were able to unload at Al Jubail within days.

USMC Art Collection

Almost immediately, Grow was attached to a reconnaissance unit patrolling the Saudi-Kuwaiti border and was one of the first Marines to see action after January 16, when *Desert Shield* changed to *Desert Storm*. He was called upon to sketch accurately an enemy emplacement just over the border for a possible artillery mission. Viewing the site with binoculars, he made a sketch, complete with compass azimuth and other specifics, which was used to destroy the target. Grow was recommended for the Navy Commendation Medal.

Col. H. Avery Chenoweth, USMCR (Ret.)

Chenoweth's mission was to lay the groundwork for artists yet to arrive, as well as to create his own art of the military activities. When the air phase of *Desert Storm* began on 16 January 1991, he covered the 3rd Marine Air Wing stationed at the Sheik Isa facility on Bahrain, from which the F/A-18 Hornet and A-6E Intruder squadrons operated, and the AV-8B Harrier squadrons based both in Saudi Arabia and on the 4th Marine Expeditionary Force Flagship, the USS *Nassau* (LHA-4). Soon, another Marine

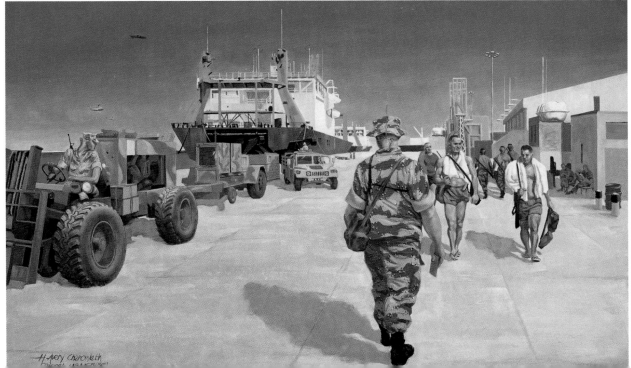

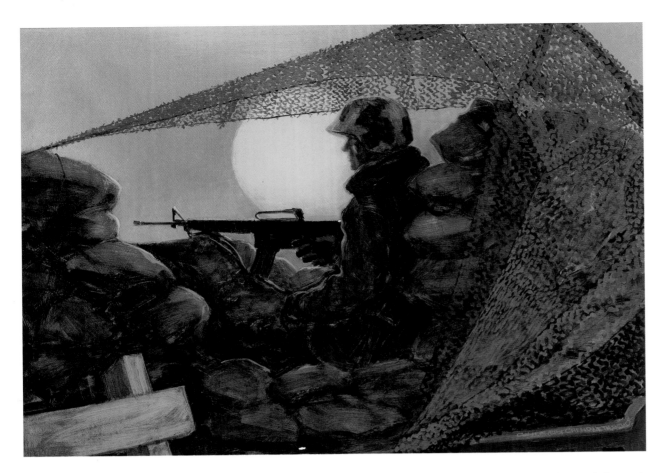

Left: H.A. Chenoweth's *Sentry Post at Marine Expeditionary Force 1* details a common scene at headquarters in Al Jubail, Saudi Arabia, during operations *Desert Shield* and *Desert Storm*. A steel storage bin has been used to give the sentry an elevated position on the perimeter, and it was sandbagged for protection against shrapnel and small arms fire. Sentry work was lonely duty. A mesh camouflage net was strung up to partially block the hot desert sun. The threat of Iraqi infiltrators or guerrillas was a real and present danger. **USMC Art Collection**

Bottom: Most troops from all services were quartered in worker camps near larger cities. Security was tight, and before entering any compound, all weapons had to be cleared. As shown here in an acrylic by Chenoweth, at the checkpoint a barrel filled with sand was tilted, and each entrant aimed his weapon into it and pulled the trigger. If the weapon fired, the owner faced a stiff reprimand all the way up the chain of command. Although all military personnel carried a weapon, ammunition was only issued to those on police and guard duty. Units going in on the ground war phase were issued limited rounds. **USMC Art Collection**

Reserve artist was joined to the unit: G.Sgt. Gerald E. Sabatino, a member of the Nassau County, New York, police department who had been recalled with the 6th Communications Battalion.

When the ground war began on 24 February 1991, the three members of the Marine Corps combat art team were attached to the 1st Marine Division. Grow accompanied Grizzly, one of the four assault task forces, while Chenoweth and Sabatino went with the command post group. Although the actual fighting turned out to be relatively light, all three came under hostile fire and witnessed the blitzing Marine attack, the incredible numbers of prisoners taken, and the astounding burning of all of the Kuwaiti oil fields by the retreating Iraqis. While Grizzly was held up in mid Kuwait on the last day, the division command post group, with Chenoweth and Sabatino, followed on the heels of the point assault Task Force Ripper and arrived at Kuwait International Airport shortly after the last great tank battle of the war, in which Ripper destroyed a hundred enemy vehicles, including sixty tanks, without sustaining a single casualty. That evening, 27 February 1991, sitting in the glow of some seventy-five oil well fires rimming the debris-strewn airfield, Chenoweth executed his last combat sketch of the war.

Early the next morning, the thirty-four day air and one hundred-hour ground war was declared over by President George Bush, and Chenoweth and Sabatino detached and drove into Kuwait City on their way back to Marine Expeditionary Force headquarters in Saudi Arabia. En route, they became the second American military unit to enter the destroyed and deserted city, and the second to arrive at the abandoned American Embassy.

Unbeknownst to the world, a sixteen-man Marine group of 2nd Force Recon, code named Piglet 2-1, had secured the embassy two days previously. Earlier that same morning, just as the cease-fire had taken effect, another Marine Reserve combat artist, Lt. Col. Keith McConnell, arrived. Locating Task Force Ripper in bivouac, he sketched their activities in the flush of victory.

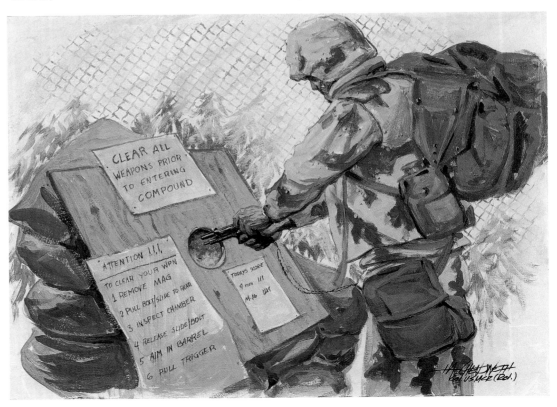

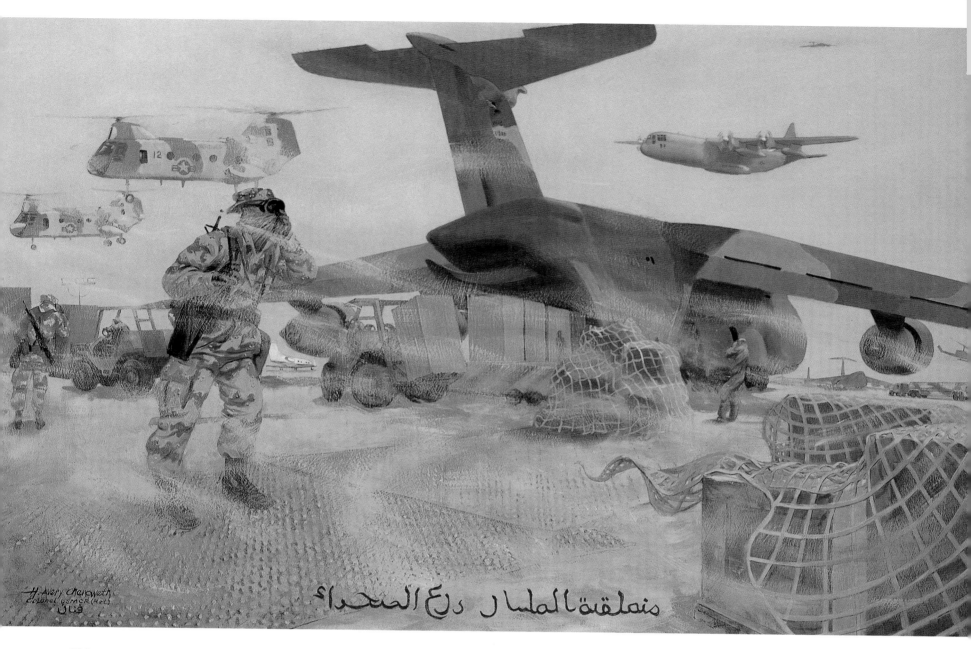

منطقة النقل السلاح دن ع الصحراء

Above: Col. H.A. Chenoweth's painting of a typical day's air traffic at Al Jubail airport. As a sentry stands guard with his cotton scarf wrapped around his mouth and nose against the gale-force wind whipping the sand everywhere, two Sea Knight choppers pass low overhead, and a C-130 Hercules cargo plane takes off. Meanwhile, crewmen unload an Air Force C-5 Galaxy super cargo transport. The Arabic inscription at the bottom translates as, "sands of time...at Mantekat Al-Matar [airport]." **USMC Art Collection**

Right: *Chow Line,* a colored pencil sketch by Chenoweth, depicts troops from many coalition nations billeted in Camp 5. The chow hall was open almost twenty-four hours a day. Military personnel carried their weapons with them at all times—everywhere they went. To misplace or lose a weapon in a combat zone was a court martial offense. **USMC Art Collection**

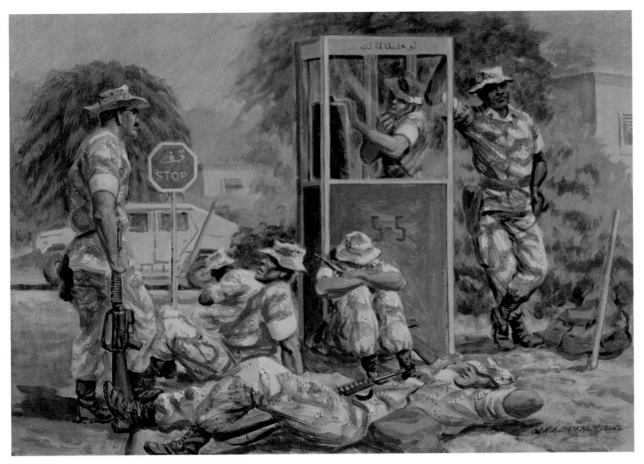

Left: Calls Waiting, by Col. Chenoweth. Public phone booths, oddly enough, were plentiful in the camps, and with telephone credit cards, it was easy to call home often. The problem was that homesick servicemen and women often did not realize how much the calls cost and were shocked to get monthly bills, sometimes approaching a thousand dollars, that almost equaled the lower ranks' take-home pay.
USMC Art Collection

Bottom Left: Chenoweth depicts troops sandbagging shelters for protection from Iraqi SCUD missile attacks. Giant concrete drainage pipes reinforced with sandbags were used as ready-made shelters.
USMC Art Collection

Below: Training and maintenance of weapons and equipment consumed all working hours during the war. What little time there was for leisure mattered not, for there was nowhere to go and nothing to do. Saudi towns were off limits, and pickup sports were the main recreation. As seen in this sketch by Chenoweth, the training was conducted in the open desert, under sprawling camouflage netting to cut the fierce rays of the sun.
USMC Art Collection

Late Twentieth Century Engagements

"AIR BOSS" CDR D. STEWART, USN
DESERT STORM, VMA-331
LHA-4 USS NASSAU, 4th MEB

Above: Col. H. Avery Chenoweth, USMCR (Ret.).

Top: The Air Boss by Chenoweth shows Comdr. Dave Stewart, responsible for the launching and landing of the forty Harrier jets aboard LHA-4 *Nassau*, at work. The artist spent time with the 4th Marine Brigade and 3rd Marine Aircraft Wing in the Persian Gulf. **USMC Art Collection**

Right: Chenoweth's notebook sketch shows the basis for *The Air Boss*. **USMC Art Collection**

The Author's Gulf War Experience

Shortly after the Iraqi invasion of Kuwait, the author, sixty-two-year old Marine Reserve retiree Col. H. Avery Chenoweth, then of Beaufort, South Carolina, was asked to head the Marine Corps combat art program for Operation *Desert Shield*. Below, the author offers his personal reminiscences of his time spent in the Persian Gulf.

With special permission for recall to active duty granted from the Secretary of the Navy, I reported to the Marine Corps Historical Center at the Washington Navy Yard. Dispatched forthwith to the Middle East as a field representative to set up and coordinate the combat art program, I arrived in December. It was my third war, and my second as a bona fide combat artist.

Mindful that I had never been given any directives or guidance when I headed the First Marine Corps Combat Art Team during the Korean War, nor anything on the two similar assignments in Vietnam, I drafted a memorandum of standard operating procedures for all Marine combat artists to follow [see page 334].

Since arid desert conditions precluded reliance on such aqueous art media as watercolor and acrylics, my team and I concentrated on pen and ink and pencil drawings, backed up with color photography. Based on my previous combat experience in Vietnam, I took into the field a fixed-focus, two-step, focal length amateur

35mm camera and a single-lens reflex professional 35mm Nikon with a zoom lens, which I carried in a special belt holster. I shot ASA 200 Ektachrome transparencies exclusively. (The film turned out to be a good choice. It could be stopped down enough for bright daylight on the desert and was fast enough in overcast, sand-swept conditions, as well as at twilight. Ektachrome could also, upon occasion, be processed by the Marine field photo unit at I MEF headquarters.)

Far different from Vietnam, *Desert Storm* required an individual equipment load approaching eighty pounds (36kg). The load included a full gas suit and overboots with mask, gloves, and atropine injections, as well as a

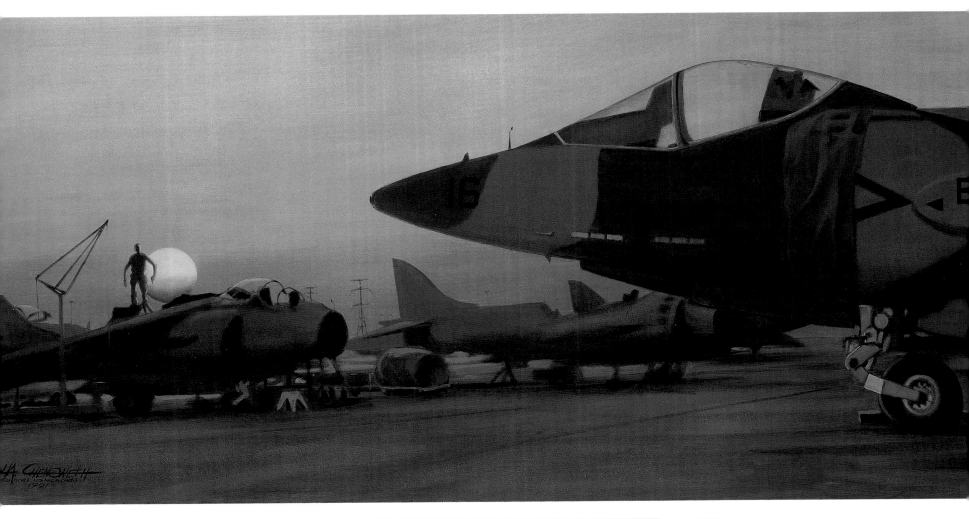

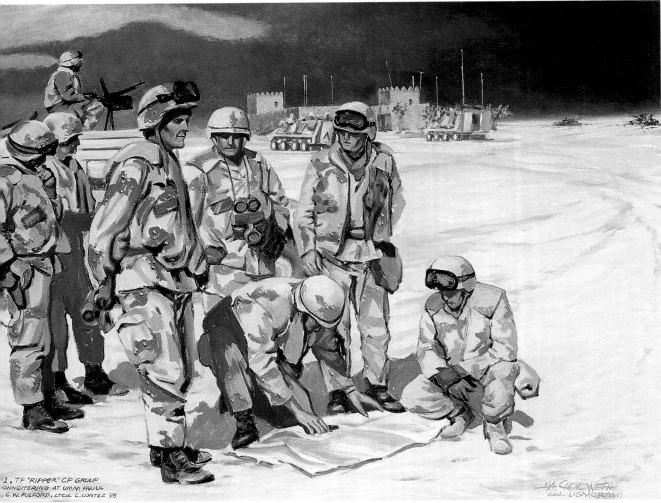

Above: An acrylic by Chenoweth depicts routine maintenance on AV-8B Harriers of Marine Air Group MAG-13, based at King Abdul Aziz airfield south of Al Jubail, Saudi Arabia. **USMC Art Collection**

Left: Chenoweth portrays staff members from Task Force Ripper, the lead mechanized assault element of the 1st Marine Division, conferring the day before the ground attack. They are at Observation Post 4, the As-Zabr Saudi police border post where Marines had first defeated an Iraqi mechanized force a month earlier. Marine Col. Carlton W. Fulford and key leaders study the terrain over their target area and the dreaded mine field barrier some 6.25 miles (10km) inside Kuwait. **USMC Art Collection**

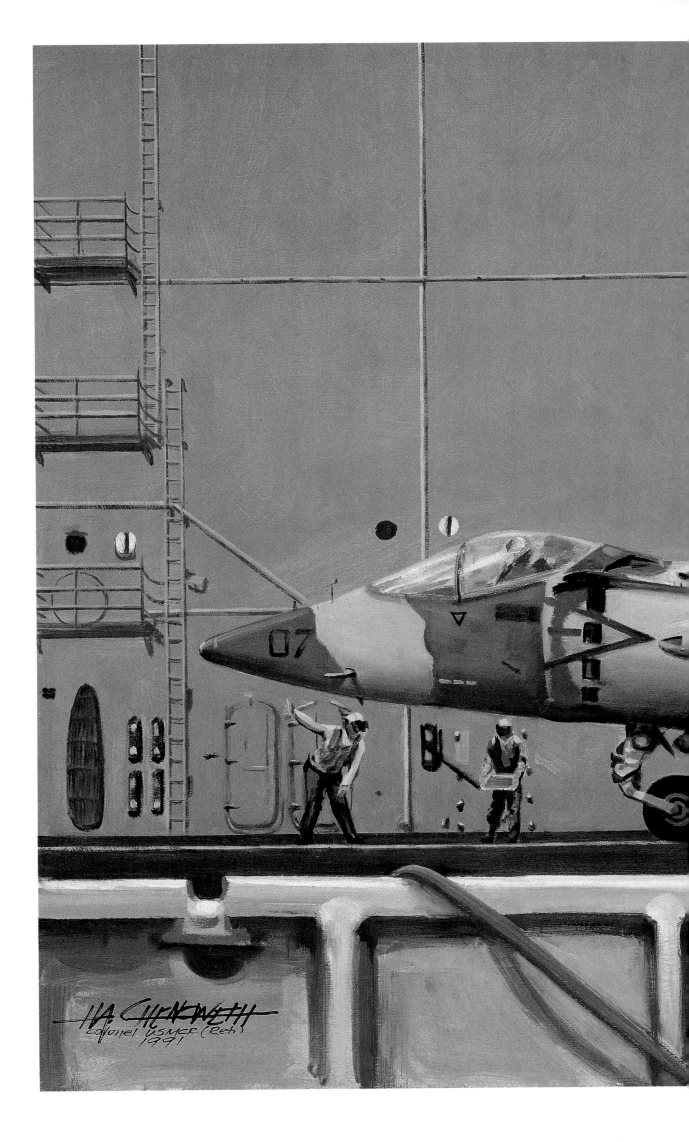

Right: In this painting by Chenoweth of a Harrier, the angle of the numeral "4" and the cables slung over the deck—even the figure leaning toward the left—are all deliberate design devices that augment the feeling of the aircraft about to take off to the left.
USMC Art Collection

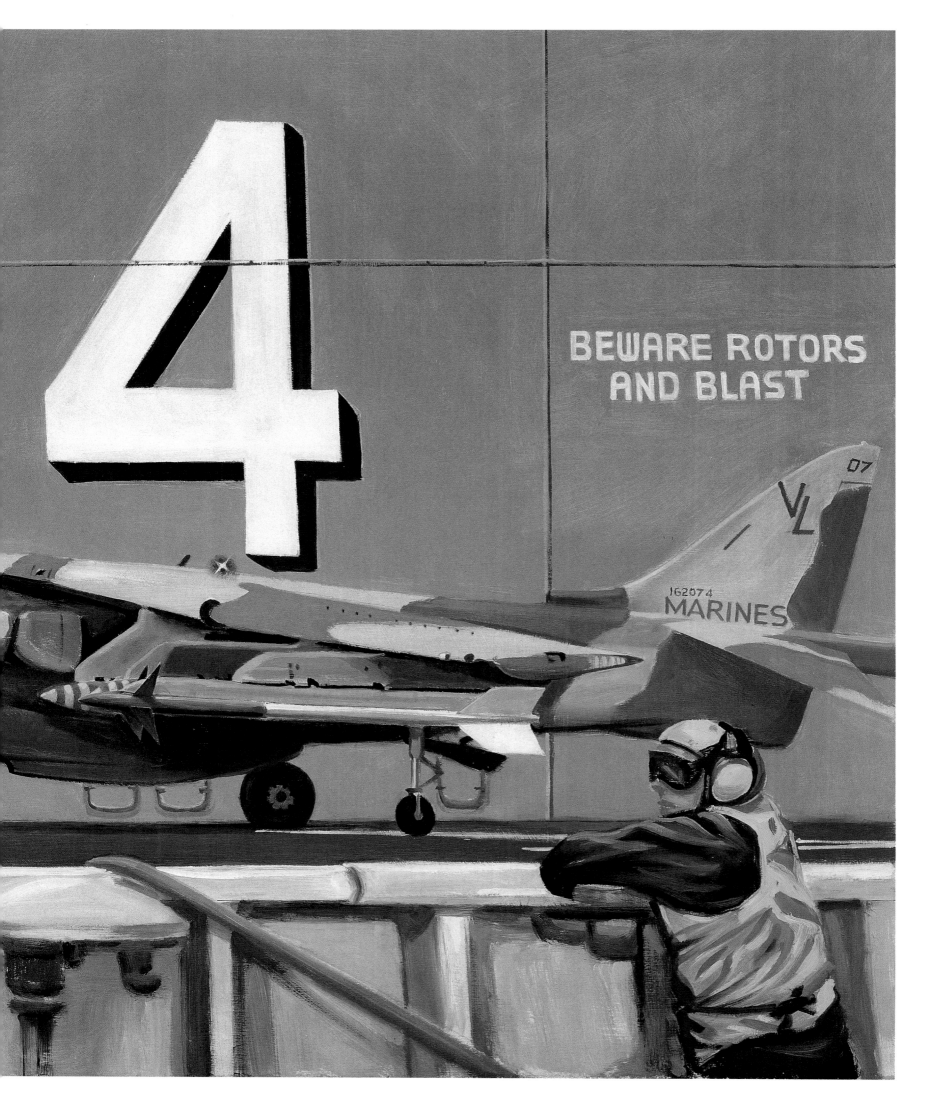

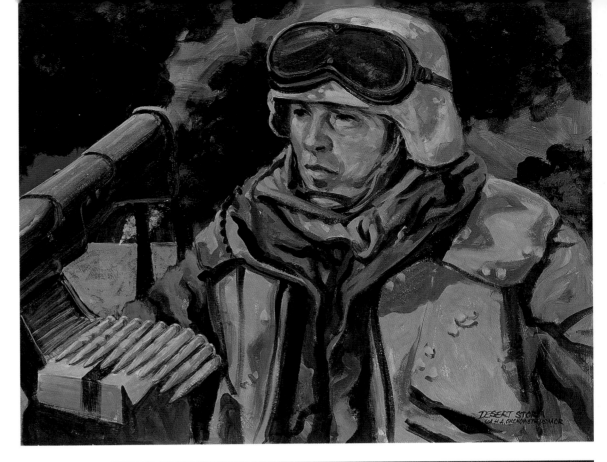

Right: Chenoweth portrays the new Marine, wearing a "Fritz" helmet with goggles, "chocolate chip" desert cammies, a gas protective suit, and a flak vest. New equipment included improved weaponry, global position finders, night-vision devices, computers, and many other things undreamed of in earlier wars.
USMC Art Collection

Below: A Marine Humvee from Task Force Ripper, with its TOW anti-tank missile, blasts its way into Kuwait City in this work by Chenoweth.
USMC Art Collection

Opposite: MOPP-4, by Chenoweth shows Marines in their full poison gas protection gear.
USMC Art Collection

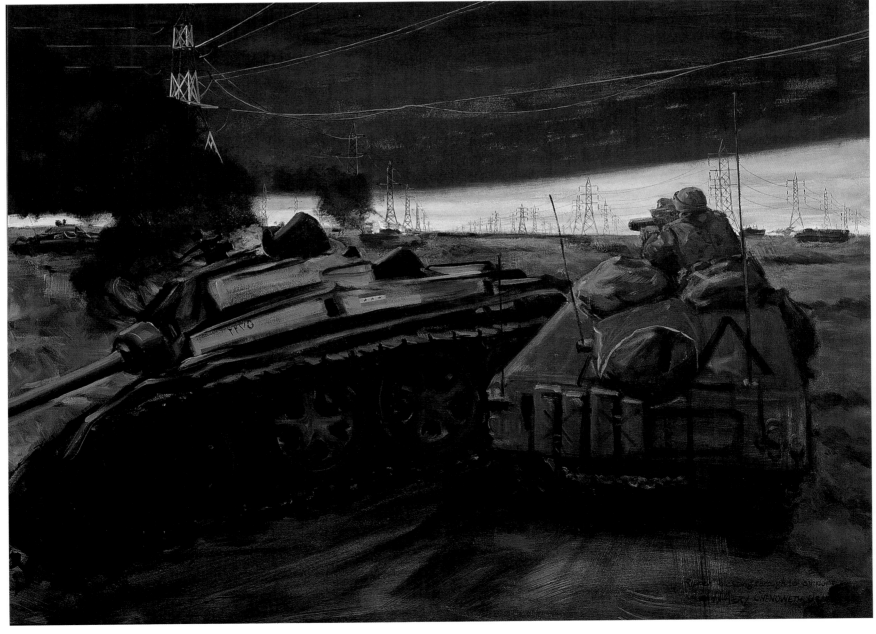

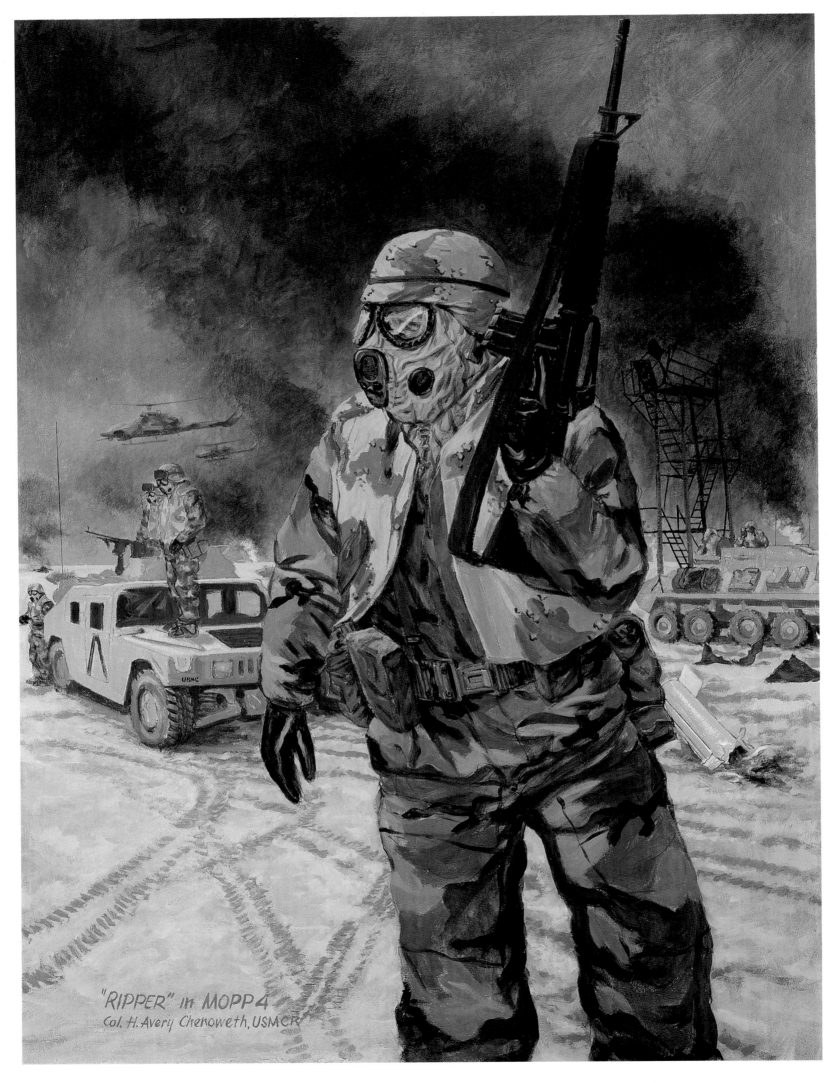

"RIPPER" in MOPP 4
Col. H. Avery Chenoweth, USMCR

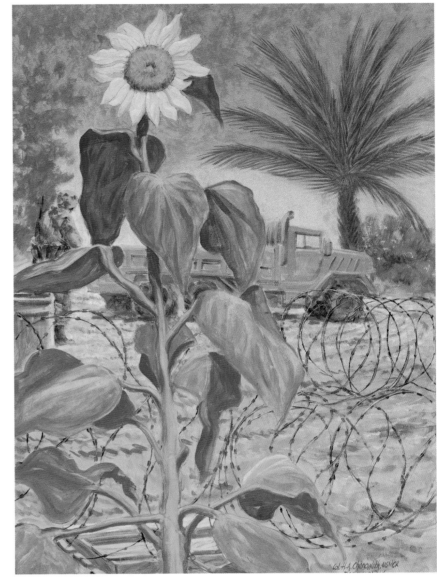

Above Left: Survivor is Chenoweth's rendering of a lone sunflower he observed growing out of the sterile sand next to a road with heavy military traffic in Camp 5. Each day on the way to the chow hall, he would speak to it, encouraging it to "hang in there." Passing Marines could hardly conceal their amusement at the sight of a senior officer talking to a flower. Weeks later, he passed by to discover some insensitive soul had whacked off the beautiful flower. It lay forlorn and decaying in the sand at the base of its stalk—a sad casualty of war. **USMC Art Collection**

Above Right: Chenoweth's finished painting based on his earlier sketch. **USMC Art Collection**

Right: Makeshift guardposts at I MEF were manned by Marine Reservists from Weapons Company, 3rd Battalion, 24th Marines out of Springfield, Missouri. **USMC Art Collection**

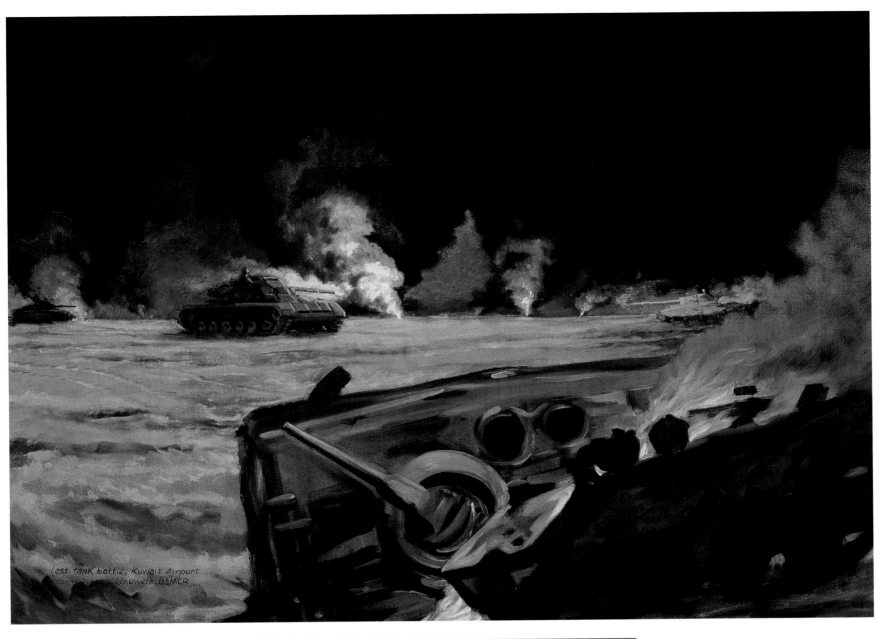

Last tank battle, Kuwait Airport
Col. H. Avery Chenoweth, USMCR

"SODAMN INSANE"
LCU 1656, LHA-4
DUBAI HARBOR
3 JAN 91

SODAMN INSANE

Above: Task Force Ripper's tanks slug it out with the Iraqi armor guarding the Kuwait International Airport in this work by Chenoweth. The Marines destroyed one hundred enemy vehicles without a single casualty of their own. The artist passed the scene about a half hour afterward, with the tanks still in place, their guns smoking. He reconstructed this painting as he imagined it must have looked a short time earlier. *USMC Art Collection*

Left: Chenoweth sketched this tank waiting for deployment aboard an LCU (Landing Craft, Utility) in Dubai Harbor. On the tank's barrel is inscribed a not-so-affectionate moniker for Saddam Hussein. *USMC Art Collection*

Right: The 1st Marine Division slogs through the mud in this painting by Chenoweth. Smaller vehicles and motor bikes had a rough time as the large trucks and other heavy equipment churned up the wide ruts into deep muddy sloughs. An oil cloud also descended, plunging the whole area into pitch darkness at midday. The "Λ" symbol is the Arabic number "7," which was easy to recognize.

USMC Art Collection

G+3, 1st MAR DIV CP DISPLACING FORWARD
PAST BURQAN OIL FIELD FIRES

Below: In *Armageddon*, Chenoweth captures the scene as, on Wednesday morning, 27 February 1991, the Iraqis torched the remaining oil heads in every oil field in Kuwait. The sky lit up like red moonlight, and daybreak passed unrecognized, obscured by the heavy black cloud hovering over the battlefield. It turned cold and rainy as well. A 155mm heavy artillery "time-on-target" barrage occurred simultaneously, with all guns in the entire Marine division firing on the same target at the same time.
USMC Art Collection

second hermetically sealed gas suit, plus an armored vest, helmet, goggles, ALICE (all-purpose lightweight individual carrying equipment) pack with essentials, an individual weapon, plus two cameras and a satchel for art equipment. With the meals-ready-to-eat (MREs)— vast improvements over the "bully beef" of the Spanish-American War, the hardtack of World War I, the C and K rations of World War II, Korea, and Vietnam—it added up to a 100-pound (45kg) load. Fortunately, the ground war phase of *Desert Storm* took place in late February, when the desert weather was cool and rainy. Fortunately, too, it was a hi-tech, mechanized war—not a foot-slogging affair—and the art team was issued a commercial Jeep Cherokee (I had it painted sand color at the motor pool) to drive with the armored columns in the attack. Recalling my Korean War experience, I put sandbags on the floorboards of the jeep to afford some meager protection against the anticipated land mines.

The matter of side arms was moot with Marine combat artists; we were issued the standard 9mm Beretta service semiautomatic pistol. We also went through what is termed "fam-firing" in order to familiarize ourselves with our weapon. (In 1967, I had simply been issued a weapon upon arrival and was given no opportunity to fam-fire it. Caught during an ambush in the jungle of Vietnam, I drew my Colt .45-caliber pistol, whereupon the round jammed going into the chamber as I drew the slide back to cock it.) When in bivouac at a facility where water was plentiful, we were able to paint with watercolors. Oils and acrylics, however, were largely left until we returned to our own studios. I returned home to complete the more than sixty finished Persian Gulf War oils, acrylics, and drawings that I added to the Marine Corps Historical Center's combat art collection. I remained on active duty for another year in order to finish the paintings.

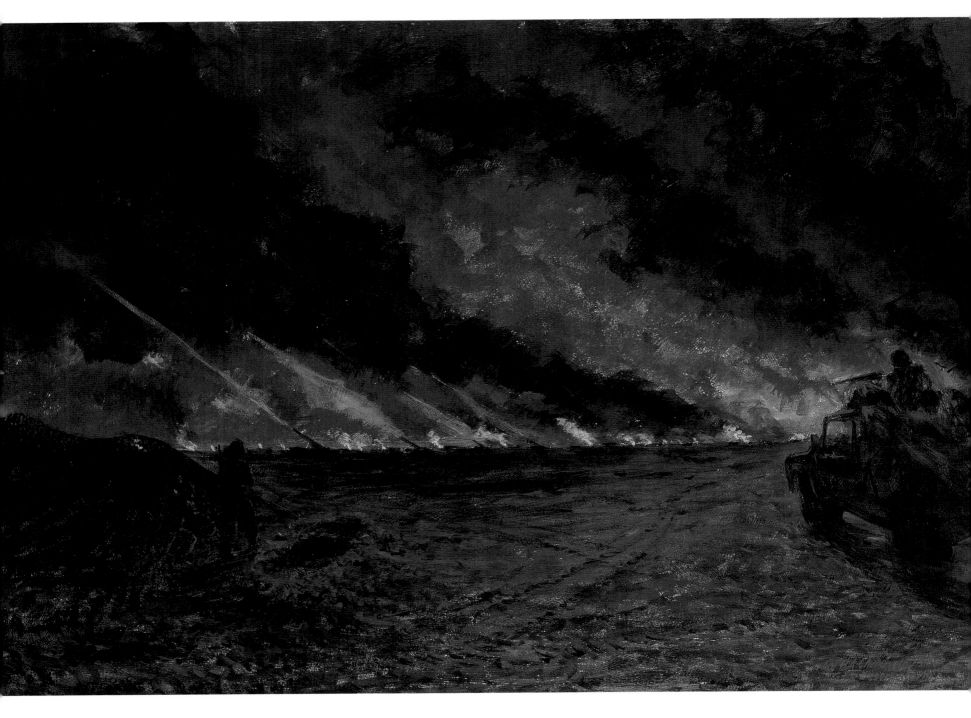

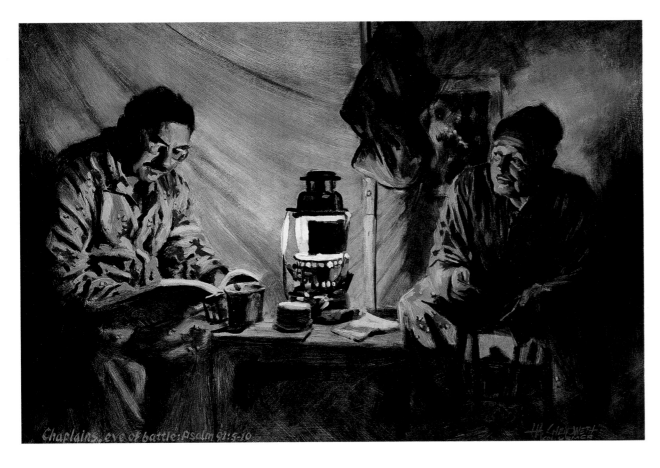

Chaplains, eve of battle: Psalm 91:5-10.

CDR STAN SCOTT, USN
DIV CHAPLAIN
DESERT STORM
21 FEB 91

LT / REV. FATHER THEOFANIS DEGAITAS.
GREEK ORTHODOX CHAPLAIN

1 MARDIV MAIN
21 FEB 91

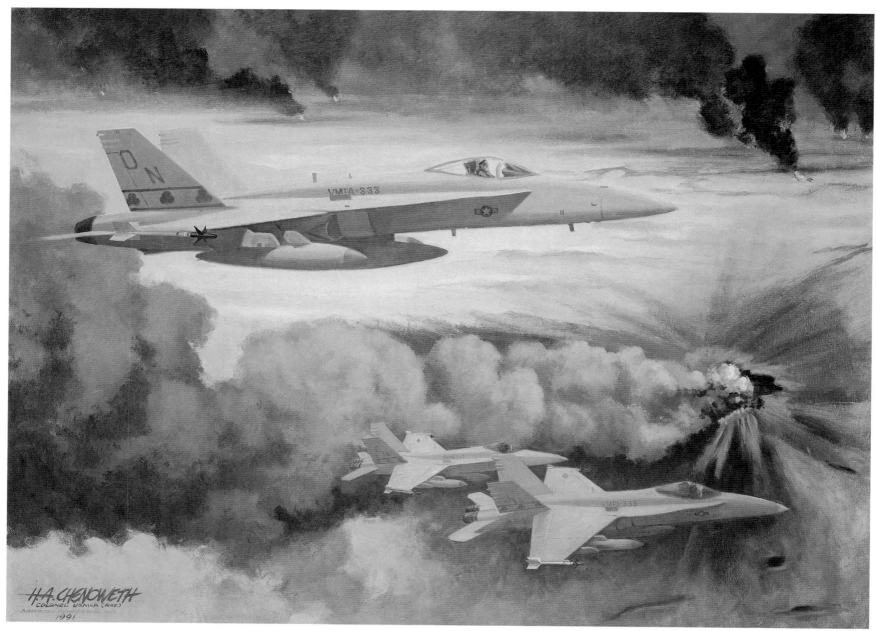

Above: Chenoweth took some liberties in this acrylic painting of Marine F-18 Hornets from Trip Tray squadron, Marine Corps Air Station, Beaufort, South Carolina, passing over the burning oil fields of Kuwait. The artist flew in a helicopter and took photos; a pilot took a similar photo from his jet. Chenoweth combined his view and the pilot's. Only after the cease-fire were Hornets able to fly this low. During the war, they had to pull out of their dive bombing runs at 12,000 feet (3658m) to avoid ground antiaircraft and missile fire. *USMC Art Collection*

Right: Kuwait International Airport on the last night of the war. Chenoweth made this color pencil sketch by the glow of the oil fires. The occupation of the airport by the 1st Marine Division came on the heels of the last tank battle of the war. *USMC Art Collection*

Opposite Bottom: The finished painting of the occupation of Kuwait International Airport. *USMC Art Collection*

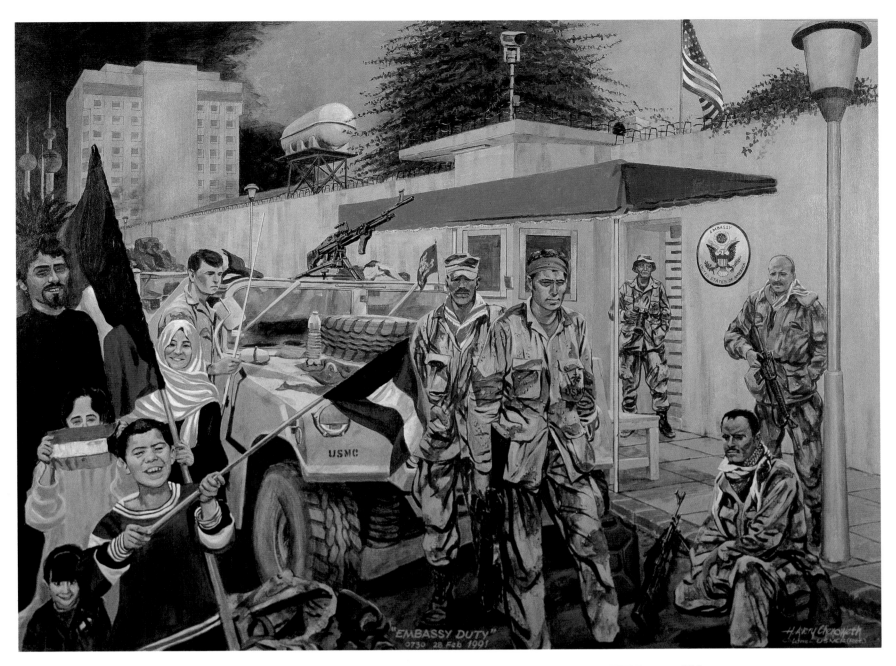

"EMBASSY DUTY"
0730 28 Feb 1991

Above: The newly liberated American Embassy in Kuwait City in a painting by Chenoweth, who portrayed himself standing in the doorway. The embassy was recaptured by a sixteen-man Marine unit of Force Recon. Designated Piglet 2-1, the unit barreled its way without opposition into the middle of the city midway during the ground war. Securing the embassy, it checked for mines and booby traps and raised the American flag. On Thursday, 28 February 1991, when Chenoweth and G.Sgt. Gerald E. Sabatino arrived in their jeep just before the cease-fire, they found the embassy in good hands. An Army unit rappelled from a helicopter hours later and made the claim official for Army Gen. Norman Schwartzkopf's press and TV photo-op. Pictured from left to right are: Cpl. Kenneth Meadows, S.Sgt. Edmund Maziarski, Sgt. Terry Wyrick, Chenoweth, Sgt. Kenneth Christo, and Cpl. Matthew Robbins.
USMC Art Collection

Marine Combat Artists' Standard Operating Procedures Memorandum, December 1990

MISSION

Your assignment as combat artist is to cover in art form and in various media the operations and activities of the First Marine Expeditionary Force in Operation Desert Shield and to do so in a professional manner that will accurately record, interpret, capture, and otherwise give vent to personal impressions that will serve to portray for all time the visual impact of this historical event.

Each artist is uniquely and professionally qualified and is expected to be original in approach and work, affording the viewer, ultimately, visual insights and capturing the "essence" of action from details to panoramas, be they transportation, bivouac or battle. Collectively the work of each artist will add importantly to the whole.

BACKGROUND

As a combat artist, you are continuing a long and valuable tradition in the military and in the U.S. Marine Corps in particular. Beginning with the inimitable examples of combat sketches under fire of (then) Capt. John W. Thomason in World War I, the Marine Corps has amassed a considerable and important collection of combat art covering World War II, Korea, Vietnam, and the intervening engagements and exercises throughout the world. Combat art is not merely an adjunct to written and photographic history—although it does compliment and complement both—it exists as a separate, valid form of recording with its own integrity and form of human expression, which affords another dimension in the interpretation and commemoration of Marine Corps activities....

If, however, you find yourself in a critical combat situation, you will revert to the command in which you find yourself and carry out orders appropriate to your rank—still retaining your art mission as well, if that is at all possible. Remember, "Every Marine is a rifleman."

... Your work on this assignment, too, is considered to be Government property and should be properly identified and shipped back to the historical center on a regular basis. Repros will be afforded you so that you will have a record and resources for future work. No work will be copyrightable.... You and your work in the field are unique; you will attract attention and, possibly, criticism stemming from envy. Keep in mind: (1) you are on a serious military assignment, (2) you are exercising a high degree of professionalism, and (3) the work you are producing is important, is valuable AND it is government property once you execute it (sketches included). Consider well this last point because often an artist might be persuaded or tempted to part with a sketch or piece out of friendship or pressure from higher ranks....

ARTISTIC GUIDELINES

It is imperative that your work be firsthand and original. The distinctive way that you as an artist see the activity and record it is what makes combat art valid.... If you should witness or participate in combat, depict truthfully what you saw. Do not create heroic imaginary or corny hand-to-hand stuff that would not be believable. Temper the "blood and guts" with a balance.

Also, Marines will look good and Marines will look bad, depending on the circumstances. You depict what you see and don't pull any punches. However, if you have the choice of picturing a Marine on duty, say, out of uniform with a cutoff skivvy shirt and no head gear, look for an alternate who projects the proper image of a Marine. Your artwork can be a valuable, positive reinforcement to Marine Corps efforts in this crisis on which the eyes of the world are focused—as well as to posterity.

No rules or limiting criteria are being set. You create your own artistic expressions as you see them....

MODUS OPERANDI

You set your own work methods. You may want to spend a week in the field with a unit followed by a finishing period to complete your works under more favorable conditions. Work out a plan and keep to it. Should you want to cover air or sea operations, the logistics will have to be carefully worked out with Public Affairs and Operations.

CONCLUSION

Use your time and this opportunity wisely. It could turn out to be the one outstanding opportunity in your career both in art and in the Marine Corps.

Sgt. Charles G. Grow

Born on 30 March 1964 in Jefferson City, Tennessee, Charles Grow showed early artistic promise and started entering art contests in the fourth grade. He subsequently won many state contests, including California, Tennessee, and Southeast regional art competitions, as well as Hallmark and Scholastic competitions on both the regional and national levels. He enlisted in the U.S. Marine Corps on 4 March 1982 and won the "Best Art in the Marine Corps" awards in 1984 and 1986, as well as "Best Illustration in the Marine Corps" citations in 1985 and 1987. While acting as chief of the graphics shop at the Marine Corps Depot on Parris Island, South Carolina, he also studied art part time at the Savannah College of Art and Design, winning an editorial illustration contest there, as well as the Presidential Scholarship in 1988, 1989, and 1990. His artwork has been published in *Artifacts*, *The Los Angeles Times*, *Flight*, *Rogersville Review*, and *Kingsport Times*, and he has illustrated two books. Following the Persian Gulf War, Grow was commissioned a warrant officer; in 1992, he won the Col. John W. Thomason, Jr., Art Award.

Coast Guard and Air Force Combat Art

Unfortunately, the Coast Guard, under the Department of Transportation, did not send artists to the Persian Gulf; consequently there was no coverage of the Coast Guard activities along the Saudi coast or in the Gulf intercepting embargo-breaking shipping and patrolling for mines. The Air Force director of art declined the services of the Society of Illustrators, citing the potential danger involved.

Army Combat Art

The Army assigned two graphics specialists, Sfc. Sieger Hartgers and Sfc. Peter G. Varisano, to cover the war. They spent forty days in the desert of Saudi Arabia at Army Central Headquarters in November and December 1990, taking photographs and doing watercolor paintings of the *Desert Shield* activities. Capt. Mario H. Acevedo also turned in some art work of his experiences. Their work is now in the collection of the Army Center for Military History in Washington, DC.

Below: In *Preparing for Battle*, Sgt. Charles G. Grow sketched a Marine in a British model MOPP gas protective suit. Formerly the training aids chief at Parris Island, Grow was ordered to special duty as a combat artist. After the war, he was promoted to commissioned warrant officer.
USMC Art Collection

Right: In Sgt. Charles Grow's watercolor, titled *Enemy Tank Wreckage*, Iraqi tanks and other military vehicles litter the desert as far as the eye can see; they have been destroyed by the advancing mechanized forces of the 1st and 2nd Marine Divisions and accompanying helicopter gunships. There were no Marine casualties. Thousands upon thousands of surrendering Iraqi soldiers were left in their wake. The 2nd was led by the Army Tiger tank brigade in the new Abrams M1-A1 tanks to augment the Marines' own Abrams and older M-60s.
USMC Art Collection

Above: *Night Firefight*, a colored pencil drawing by Sgt. Charles Grow, depicts close incoming tracers during a late January firefight against more than fifty probing Iraqi tanks. The Iraqis took heavy losses and withdrew to attack Khafji on the coast instead, again losing. Prior to the ground war, Grow was on constant patrol along the Kuwaiti border and engaged in numerous exchanges with enemy forces.
USMC Art Collection

Right: Army Sfc. Sieger Hartgers' color sketch captures a nurse at the 18th Airborne's 5th M.A.S.H. unit. Very few soldiers were wounded or killed in the four-day ground war, so these medics had little to do other than oversee routine sick calls.
U.S. Army Art Collection

Far Right: *Soldiers at Camp Dragon*, a watercolor and colored pencil sketch by Hartgers, portrays a sergeant of the 18th Airborne Corps. He is depicted at Ad Damman, Saudi Arabia, on 26 November 1990, during the buildup of coalition forces in Operation *Desert Shield*.
U.S. Army Art Collection

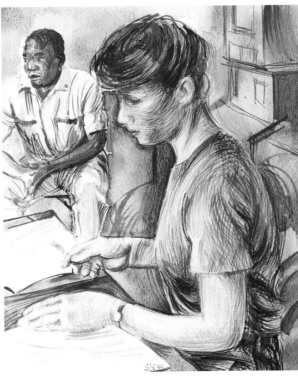

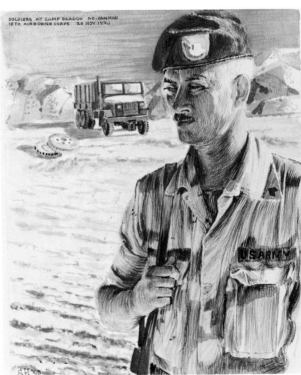

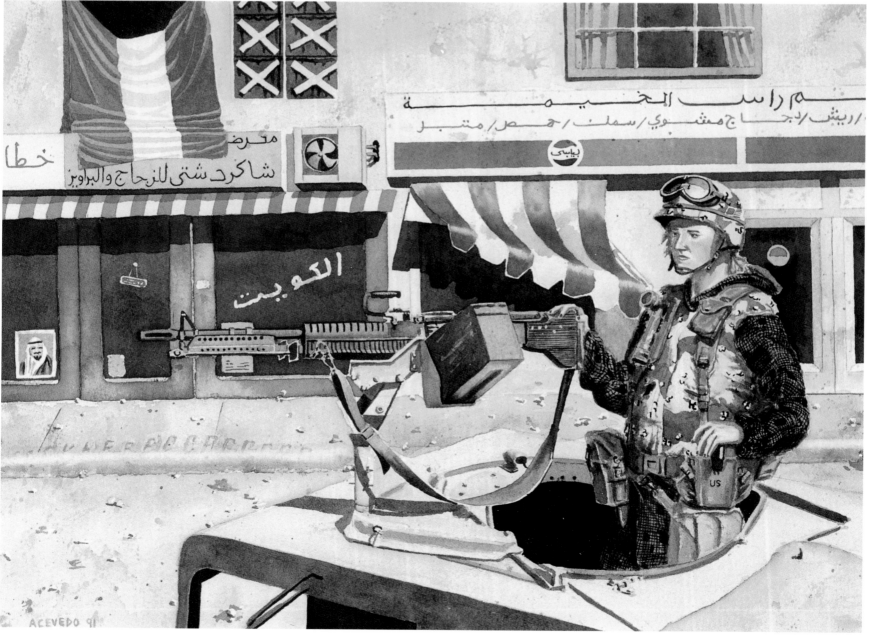

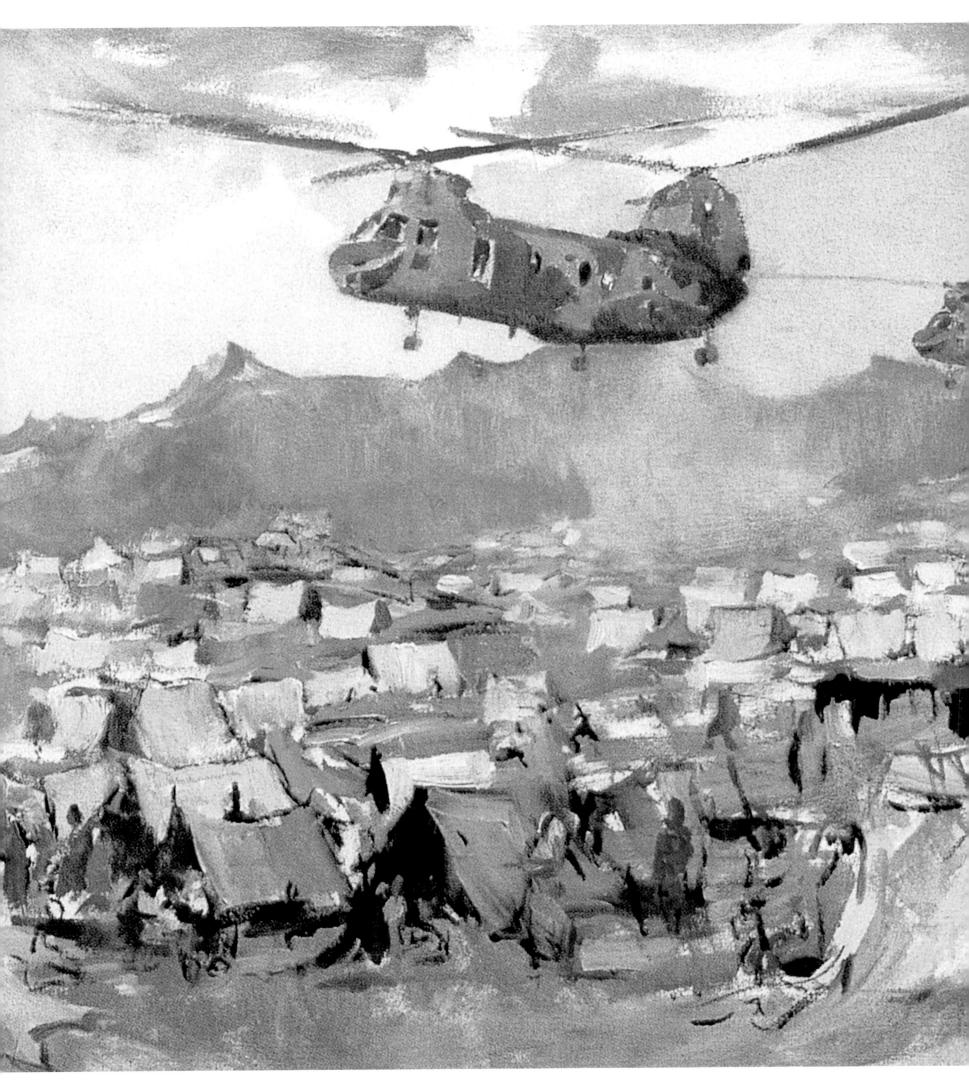

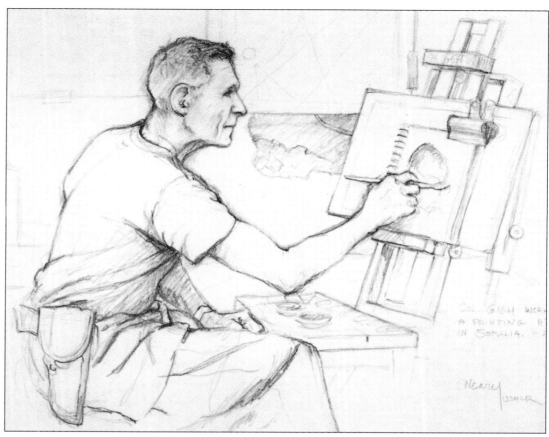

Operation **Provide Comfort:** *Assisting the Kurds of Northern Iraq*
Col. Peter "Mike" Gish, USMCR (Ret.)

Recalled to active duty after *Desert Storm*, Col. Peter Gish left his teaching position at Fairfield University in Connecticut for a sixty-day assignment to cover Operation *Provide Comfort*. A former Marine helicopter pilot and a combat artist in Vietnam, Gish depicted Marine Corps efforts in northern Iraq, where the indigenous Kurds were being persecuted by the remnants of dictator Saddam Hussein's Iraqi army. Both Marine and Army contingents were involved in the humanitarian rescue operation under the auspices of the United Nations. Food, clothing, shelter, and medical supplies were provided to the helpless refugees, who were forced to flee their homes in the towns and villages and encamp as best they could in the rugged, barren mountains. Gish sympathetically portrayed this noncombat, humanitarian operation, the kind of mission the Marine Corps is frequently called upon to perform.

Operation **Restore Hope:** *Marine Corps Combat Artists in Somalia*

The success of Marine Corps combat art coverage in the Persian Gulf War set the stage for the assignment in 1993 of artists to Operation *Restore Hope*, the international relief effort of the United Nations in Somalia, below the Horn of Africa on the Indian Ocean. The Navy, the Coast

Left: Painted in oil by sixty-seven-year-old Col. Peter Gish, *U.S. Marine CH-46s Arrive With Relief Supplies* depicts helicopters assigned to the 24th Marine Expeditionary Unit. The choppers ferried much-needed supplies to the Kurdish refugees encamped along the Turkish-Iraqi border immediately following the Gulf War. It was Gish's third combat assignment, his second as an artist. He had previously served in World War II and covered Vietnam as a combat artist. He would later cover Somalia as well. **USMC Art Collection**

Above: Lt. Col. Donna Neary sketched Gish at work painting a watercolor. **USMC Art Collection**

Guard, and even the Army were caught off guard and unable to mount artists to cover the mission—only the Marine Corps did so.

The U.S. Marine Corps historical division assigned Col. Peter Gish and Lt. Col. Donna Neary for thirty-day tours. Capt. Burton E. Moore, USMCR, a Vietnam veteran and combat artist sent the previous year to Cuba's Guantanamo Bay Naval Base to cover the Haitian boat refugees being collected there, was also assigned for a sixty-day period when Neary left.

Gish was active in covering a full scope of Marine activities that included mostly the safeguarding of relief supplies through lawless areas for delivery to outlying distribution points. He executed many excellent on-the-spot watercolor paintings, much as he had done previously in the Kurdish operation in Northern Iraq.

CWO Charles Grow, USMC, was the photo officer for the 2d Marine Division. While not able to be assigned specifically as a combat artist by the U.S. Marine Corps historical division, he nevertheless made some operational sketches, as he had previously done in the Gulf War.

The Marine Corps combat artists of the Somalia operation spent only a few weeks onsite, then worked their sketches into finished paintings in their own studios following their release from active duty.

Lt. Col. Donna J. Neary, USMCR

Lt. Col. Donna Neary (later promoted to colonel) became the first female, active duty, uniformed combat artist in history to cover a combat operation. Although Somalia was not a bona fide combat zone, the U.S.-U.N. Operation *Restore Hope* did occur in a hostile military environment. All forces were armed for combat, and they were subjected to sporadic sniper fire, with firefights breaking out often.

A well-known illustrator and military historical print maker, Neary had, ten years previously, received a direct commission as a limited duty officer/combat artist and was active in the Marine Reserve historical unit at the Marine Corps Historical Center in Washington, DC. Thus, she was quickly mobilized for active duty to cover the Somalia operation and was attached to the Deputy Joint Task Force Headquarters at Mogadishu.

During her thirty days "in country," Neary did sketches and took photographs in order to execute highly realistic paintings when she returned to her studio in Virginia. Accompanying Marine combat patrols and food convoys, she was laden down with the almost hundred-pound (45kg) normal load of combat Marines.

Prior to her assignment, she took the familiarization course at the Quantico pistol range. As the first female Marine in a combat situation, she also found no separate accommodations or special treatment; she was confronted with minor inconveniences with hygiene facilities and often had to sleep in tents with male officers. (As she recalls it, she became very adept at changing clothes inside her sleeping bag.) In the broiling African sun, she also shed twelve pounds (5kg) of body weight and suffered several bouts of dehydration, a common malady.

Neary also accompanied Belgian and Australian army patrols to such interior and distant sites as Bardera, Kismayu, and Baidoa, as well as to the seaport, airport, and town of Mogadishu. She reported hearing incessant gunfire, nearby firefights with Marines, and generally the sounds of a highly tense situation. Often, she and Gish would go on the same patrol, but the two combat artists worked alone.

Capt. Burton E. Moore, USMCR

Capt. Burton E. Moore—or Burton E, as he is known in the civilian art world and his hometown of Charleston, South Carolina—is a well-known wildlife artist who won the Federal Duck Stamp competition in 1986. Since his boyhood and graduation from the Citadel, Moore had developed a keen interest in military history and combat art, growing up studying the works of many of the combat artists previously mentioned. A combat veteran of Vietnam, Moore was quick to accompany recon teams, patrols, and sniper teams. He even made a practice parachute jump with an Italian army unit.

Moore was the only combat artist in Somalia to be directly subjected to hostile fire. He happened to be at the American Embassy compound in Mogadishu when it was attacked. With camera and sketchpad in hand, he dashed to the roof of the embassy with a quick response team, including a sniper. As a firefight ensued, Moore crouched behind a small parapet with the Marine team and photographed and sketched their counter fire. Moore wrote of his experiences in Somalia:

> Mogadishu is like Vietnam on a nice day. The city is the most troublesome place, with its labyrinth of rocky, back streets, war debris, and buildings for hiding weapons. Every day, some way, some where, some how, there is shooting. During the two months I was there, I accompanied various Marine units on foot and motorized patrols, sweeps of known trouble spots, night and day raids into weapons compounds. We draw occasional fire. Some Marines are wounded, two are killed. As are the "bad guys" with their Russian-made AK's. Young Somalis have no adult supervision and throw rocks at us. Some use "David slings," and they're good at it! I have seen Marines whose faces were brutalized by these missiles, a lethal weapon. Young Somalis chew

Below: Although Somalia was not a war, the hostile environment was certainly a combat zone, and there were frequent firefights. In *Marine Sniper*, an oil painting by Col. Peter Gish, the sniper is using a long-barrel, .30-caliber precision piece, with which he could hit a target at 2000 yards (1829m).
USMC Art Collection

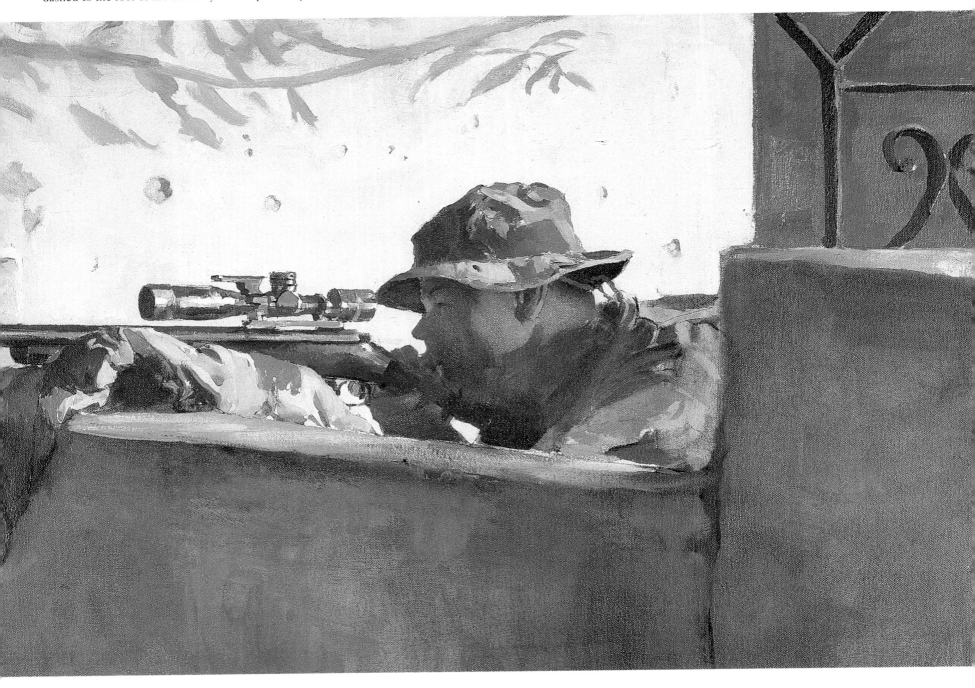

Above: Lt. Col. Donna Neary was the first uniformed female combat artist in history. The 1989 recipient of the Col. John W. Thomason, Jr., Art Award, she specialized in depicting military uniforms and battle scenes. Recalled to active duty, she was sent to cover the humanitarian operation in Somalia. Several years later, she was promoted to colonel.

Right: Carrying all the combat equipment required, including a pistol, as well as her sketchbook and camera, Neary accompanied U.S. Marine, Belgian, and Australian combat patrols and food distribution convoys in the U.N. relief operation. In *Unloading, Mogadishu,* villagers distribute relief supplies under the watch of an armed guard. Following the 1993 Somalia mission, she reported, "No matter what village we were in, the villagers unloading the trucks would chant and sing while the work progressed."
USMC Art Collection

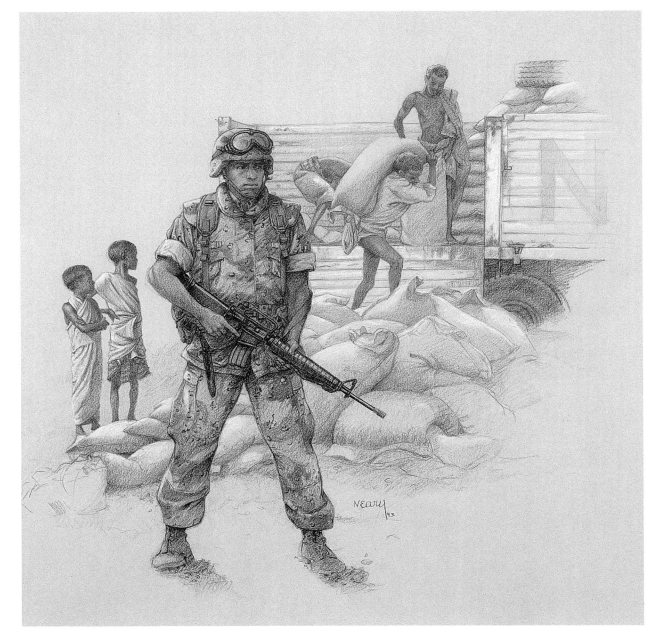

Khat, use drugs when available, issue forth foul epithets which they claim to have heard on rare American television, and brutalize their own people. Most Somalis, though, seem pleased that Marines are here to restore order and demonstrate their pleasure when being fed by the U.N.

As an occasional hunter, I naturally relate to combat art, because a combat artist is a hunter. It is a search for the opportune moment to record a rare instant of action that offers a canvas of composition and perspective. In a low-intensity conflict like Somalia, this can be difficult. Unlike Iwo Jima, which offered an all-encompassing panorama of Marines under fire and returning fire, these types of interventions can be frustrating to an artist. Remember, it's the artist's job to find it. He has to be in the right place, at the right time, and accept the accompanying stress when the metallic density of the air gets high. But, as in hunting, you have to have that ten percent skill to make that ninety percent luck work for you.

U.S. Forces in Bosnia

Even before the 1989 demise of the Soviet Union, Eastern European countries had been asserting their desire for freedom, spurred, in great measure, by the ten-year Soviet struggle to subdue Afghanistan. The Afghan conflict would have even sharper repercussions for the Soviet Union than Vietnam had had for the United States, hastening, as it did, the collapse of the Soviet empire.

As the Eastern bloc splintered, Poland and Czechoslovakia formed their own democratic governments, with the latter breaking into the Czech Republic and Slovakia. Ever a hotbed of ethnic unrest, however, the Balkans disintegrated into civil war, ethnic cleansing, and religious persecution. The Yugoslavia that dictator Marshal Tito had forged after World War II as an independent communist state segmented into breakaway provinces Croatia, Slovenia, Bosnia-Herzegovina, Kosovo, and Serbia. Smoldering, centuries-old ethnic and religious

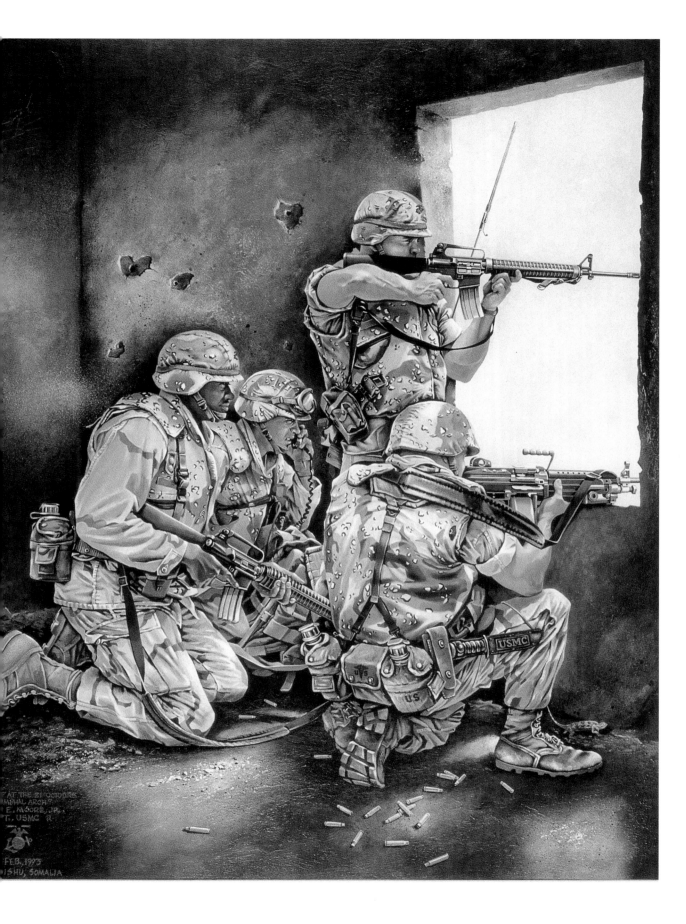

Above: Capt. Burton E. Moore, USMCR

Left: Moore painted Marines in action in Somalia. Moore described his experience on patrol with Marines of the 3rd Battalion, 11th Marines: "A fifty-yard dash to the guts of a bombed-out hotel, rounds impacting all about, dust, slicing chips of concrete...diesel smoke...inside, hunkered down...two simultaneous explosions, one an outgoing Nigerian recoilless rifle round, the other, a Chi-Com RPG [rocket propelled grenade] slams into the outside wall. It partially collapses, more daylight, rounds impacting on walls inside. Some bullets spent, spinning around on the floor. Surprisingly, very few casualties. One Marine has kneecap shot off. He's mad as hell. 'I'll never run again!' 'Sure you will. Look at it this way—a plastic unit with rubber bands and no arthritis when you're fifty!' Laughter...he tries, too. Another Marine gets slight head wound. Marines return concentrated fire. Then it's over. Just like that.
USMC Art Collection

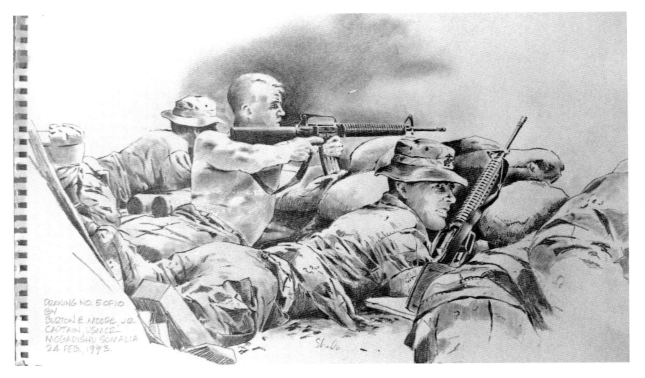

DRAWING NO. 5 OF 10
BY
BURTON E. MOORE, JR.
CAPTAIN, USMCR
MOGADISHU SOMALIA
24 FEB., 1993.

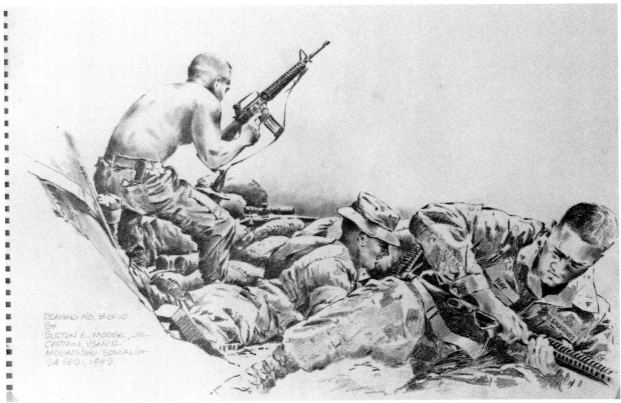

DRAWING NO. 8 OF 10
BY
BURTON E. MOORE, JR.
CAPTAIN, USMCR
MOGADISHU SOMALIA
24 FEB., 1993.

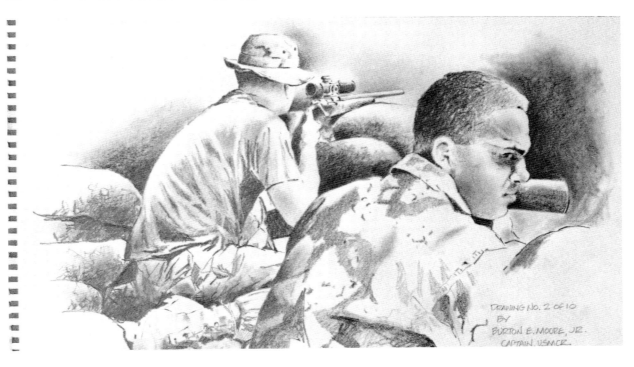

DRAWING NO. 2 OF 10
BY
BURTON E. MOORE, JR.
CAPTAIN, USMCR

intolerance exploded unchecked. Bosnia's fight for independence from Serbia eventually prompted the 1991 intervention of the United Nations, supported by U.S. air power and peacekeeping ground troops.

Haiti—Operation Uphold Democracy

Following decades of military rule, in 1991 Haitians elected Jean-Bertrand Aristide president in the country's first-ever free and democratic election. Aristide was ousted and forced into hiding soon after, however, and Haiti was once again under the rule of a de facto military regime that enforced its control with the use of terror. Seeking to escape the brutal conditions under the dictatorship, thousands of Haitian refugees fled the country; many attempted to enter the United States.

In the face of widespread reports detailing human rights abuses in Haiti, the United Nations Security Council enacted a resolution authorizing the use of force to restore the democratically elected government. The United States responded with Operation *Uphold Democracy*, forming a multinational force to respond to the U.N. mandate. In mid-September 1994, as U.S. forces were poised to invade Haiti, an eleventh-hour diplomatic effort succeeded and the de facto regime agreed to step down peacefully. The United States sent troops to oversee the transition. Aristide returned to office and, in 1995, the U.S. peacekeeping forces were replaced with U.N. troops.

The Future of Combat Art

In 1989, the Berlin Wall was dismantled, thus concluding, block by vanishing block, a strange era in the annals of war. As the Soviet Union's remaining military was dispersed among the confederated Russian states, the Cold War's battles of subterfuge quickly gave way to the emergence of the United States as the lone remaining superpower. After a tense, four-decade standoff that was more about military buildup than armed engagement, it is not unfounded to question whether, given the apocalyptic possibilities, there will be any future wars on the scale of those of the twentieth century.

At the opening of the last decade of the twentieth century, the nature of war changed dramatically. The Gulf War, a four-day blitz of highly mobile tank and infantry divisions preceded by thirty days of computer-guided aerial bombing, was a carefully managed affair, both in terms of the military and the media. Responsible for shaping the public view, public affairs officers were charged with keeping world opinion firmly on the side of the multinational coalition formed to liberate Kuwait and eliminate the Iraqi threat to Middle East oil.

As the century came to a close, military strategy shifted subtly from combat preparation to social and political engineering. Whatever their successes or failures, the missions in Somalia, Haiti, Bosnia, and Kosovo carved out new roles for U.S. forces. The twenty-first century

Opposite and Below: The Fight at the 21 October arch, known to U.S. Marines as "K-4," in Mogadishu on 25 February 1993, was captured in these sketches by Capt. Burton Moore. He wrote about his experience: "The U.S. Embassy compound. Marines prepared to defend against attackers. Rifle fire is exchanged. I get quick sketches and photography of this. From there, I hustle over to the roof of the old embassy building, where I know there are snipers of Jump Team No. 1, 1st Force Recon, 5th Marines. I have a special and vested interest in these people; I was one a quarter of a century ago…Automatic rifle rounds are now impacting and 'cracking' around us, slamming into sandbags and concrete; the 'crack, crack, crack' followed by the 'pop, pop, pop' from the distant muzzle report of an AK Soviet bloc weapon, familiar to Vietnam veterans with its rather slow, cyclic rate of fire, somewhat like the old U.S. BAR. From this episode, I get ten large graphite, sequence drawings."
USMC Art Collection

began cataclysmically with the events of 11 September 2001, the most devastating attacks on the United States since Pearl Harbor. Almost the entire sequence of attacks—as well as the continuing coverage of its aftermath—was seen in real-time detail all over the world via satellite television. Combat art will have to struggle to compete with the vivid and instantaneous video images that are now so readily available. But it should be kept in mind that the personal interpretation of events by creative individuals who have witnessed them is essential to a civilized society, despite its momentary impracticability.

The number of surviving combat veterans is dwindling fast. World War II veterans are in their seventies and eighties and Vietnam veterans are now in their fifties or beyond, while, due to the Persian Gulf War's accelerated pace and low casualty rate, its veterans have little tangible experience of extended combat. Few in the United States under the age of forty have been in the military; in contrast, during the Vietnam era, a majority of the male population had served in the military or in one war or another. As the nation's collective memory of war is replaced by the necessarily distorted depictions to come out of Hollywood, personal interpretations of combat by eyewitnesses might begin to lose their resonance with the public

The combat art in this volume, as the interpretation and portrayal of great events by the gifted artists among us, should be valued and preserved. It should be treasured in the national historical archives and exhibited from time to time, not only to remind us of the sacrifices of the past, but to serve as a visual admonition that we must try to avoid them wherever possible in the future.

Above: Army artist Carl "Gene" Snyder made this pen-and-ink sketch, titled *On Watch in Bosnia,* in 1997.
U.S. Army Art Collection

Left: This checkpoint portrayed by Col. Peter Gish is indicative of the routine military operations, other than food distribution, that were undertaken by Marines in Somalia.
USMC Art Collection

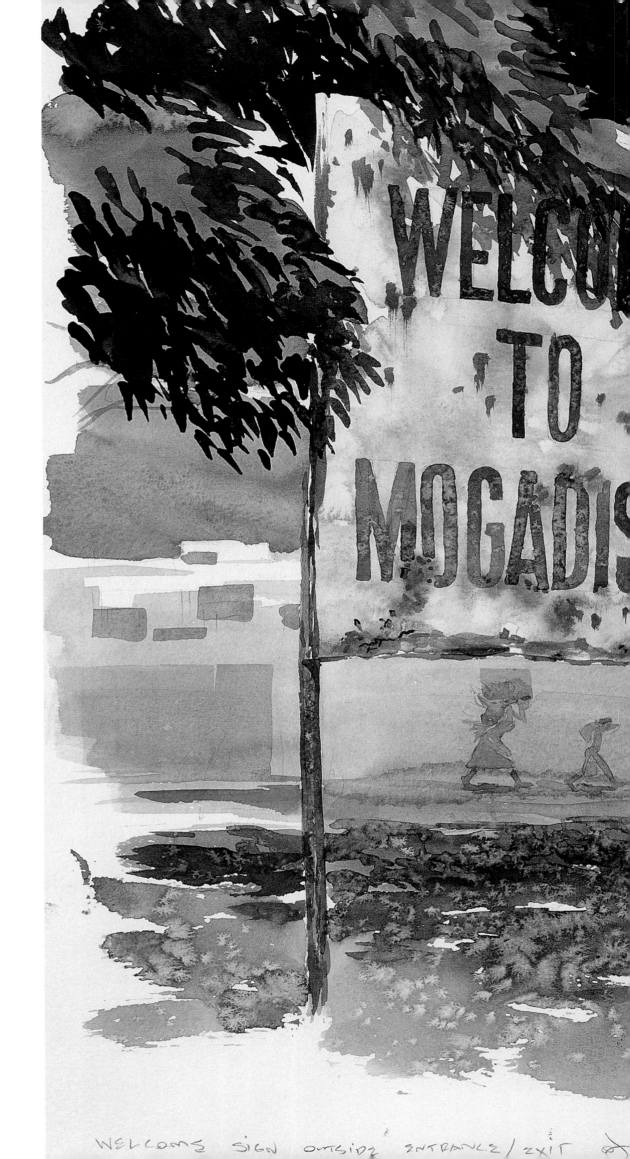

Right: In CWO Charles Grow's watercolor *Welcome to Mogadishu*, a simple billboard tells a larger story. The worn and faded sign was just outside the airport and greeted everyone arriving in Somalia.
USMC Art Collection

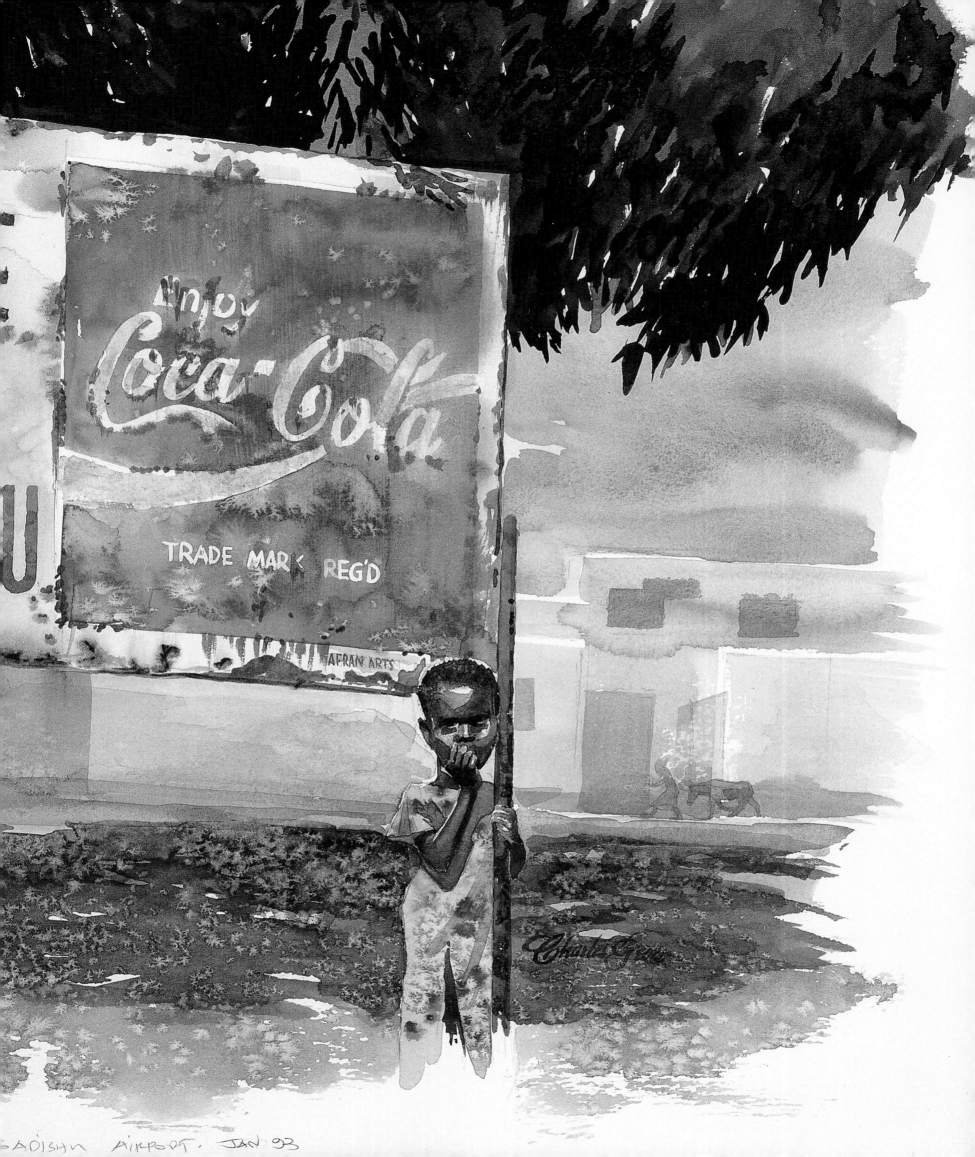

Enjoy
Coca-Cola
TRADE MARK REG'D

AFRAN ARTS

Charles Reid

BADISHA AIRPORT. JAN. 93

Right: Another scene by CWO Charles Grow captures the contrast of modern machines and military armament with a totally impoverished country. Though humanitarian aid was given and hundreds of lives were saved in Somalia, starvation continues, factions continue to fight, and after the Marines left, later U.S. forces trying to oust the powerful and corrupt local war lords were ultimately forced to pull out, badly bruised. **USMC Art Collection**

Below: Sfc. Peter Varisano, who had also covered the Gulf War, painted Army GIs patrolling the streets of Mogadishu in 1994. **U.S. Army Art Collection**

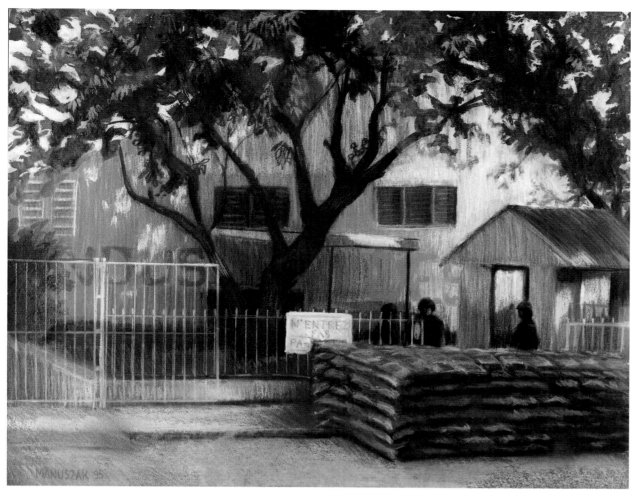

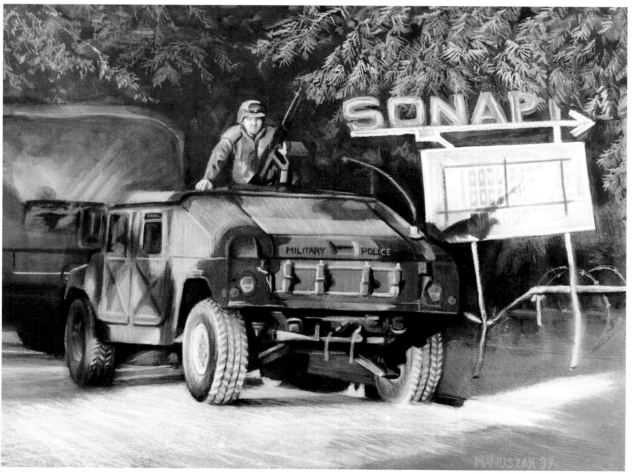

Left: *N'entrez Pas*, by Army combat artist
Jeffrey Manuszak, depicts peacekeepers in
Haiti in 1995.
U.S. Army Art Collection

Below: U.S. troops joined the U.N.
peacekeeping SFOR units in enforcing a
truce between Serbs and Bosnians. Manuszak
here portrays military traffic at a crossing
somewhere in Bosnia in 1997.
U.S. Army Art Collection

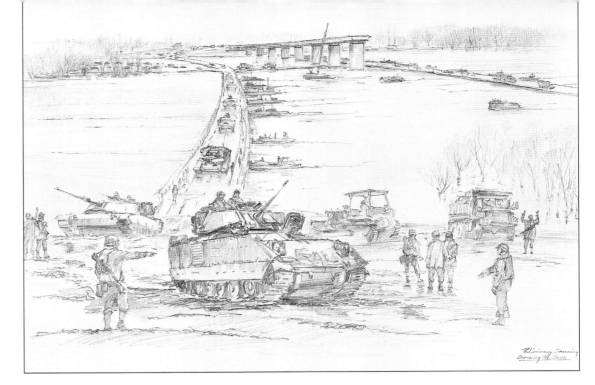

Right: Capt. John C. Roach, USNR, covered the Bosnia operation for the Navy. In these three preliminary, on-the-spot sketches for later paintings, Roach captures a modern mechanized force sweeping into a rural Bosnian landscape in 1997. **U.S. Navy Art Collection**

Above: An artist with the Army in Bosnia in 1997, Sgt. Carl E. Snyder used bold shapes and colors to portray an all-too-common (and altogether nerve-wracking) scene in *Probing for Land Mines*.
U.S. Army Art Collection

Left: 536 Engineers is Snyder's colored pencil sketch of soldiers taking a break during a work project in Bosnia.
U.S. Army Art Collection

Afterword

Below: Col. H. Avery Chenoweth made this sketch while en route to Al Jubail from Masirah during the Persian Gulf War. Weekly courier flights in twin-engine, commercial-type aircraft between I MEF headquarters and the units afloat in the Persian Gulf and on Bahrain afforded air taxi service for visiting officials.
USMC Art Collection

Opposite: Marine S.Sgt. Michael D. Fay was the first combat artist to be sent to the war in Afghanistan. In January and February of 2002, he accompanied members of the combat assessment team platoon of weapons company BLT (Battalion Landing Team) 3, of the 26th Marine Expeditionary Unit. A reservist with more than ten years' service, Fay studied at the Philadelphia College of Art and the Pennsylvania Academy of Fine Arts. In *Khandahar: Setting Trip Flares*, Fay depicts a team setting flares on the perimeter of a rudimentary airfield captured by the Marines. Any intruder would trip the flares, thus alerting the base. He used both a 35mm camera and a digital camera to take reference photographs for his on-site sketches and later oil paintings.
USMC Art Collection

Art is a human activity having for its purpose the transmission to others of the highest and best feelings to which men have risen.

LEO TOLSTOY
What Is Art?, 1898

War kills and destroys. It is an ugly, brutal endeavor all in the name of national interest, or, worse, supposed honor or acquisition. Even if an artist subscribes to the aphorism that "beauty is truth," why would he elect to record, by his artistry, the horrors of war?

To those who have not "seen the elephant," war may be imagined as exciting, glorious—even glamorous. Exciting it is, in a terrifying way; glorious seldom, and then only in retrospect to the survivors; and glamorous only in dress parades. Mostly, war is a banal, boring, bloody, wasteful business. Nevertheless, it becomes the defining event in the lives of many of its participants.

The question for combat artists then remains: why? Some were participants, soldiers with often hidden talents who emerged as artists. Others, their talents already fully developed, were dispatched either in uniform, under orders, or as civilians under contract to an armed service or the news media.

To render their vivid observations of the order and chaos, the bravery and terror of war into enduring art was a challenge to the artist just as doing one's duty under fire was to the combatant. Combat art, in contrast to the reconstruction of historical military scenes by artists removed from the event, was executed by artists on the spot. As young Ewing Allison put it in *My Old Kentucky Home*, "The very texture of every enduring work of art must imbed the glowing life of its own times and the embers of the past. If it does not cover space as history, it must plumb the depths of emotion in an individual to reach the universal perception."

Col. H. Avery Chenoweth's selection of American combat art covers two and a quarter centuries. More than half this period was also covered by photographers. The camera, however, catches only one moment of a moving scene. A few photographers possessing coup d'oeil—true artists of the lens—capture well-composed dramatic views of combat with lasting impact, like Joe Rosenthal's shot of the flag-raising on Iwo Jima. Most, however, merely record a one-dimensional scene. Artists, in contrast, are able to combine several discrete impressions into an overall composition that tells a story in a more complete manner,

and as the statement of an individual. This personalization becomes even more important in today's mechanistic, impersonal, technological age. Combat art can be viewed as the faint cry of the individual "visual historian" from the wilderness of the battlefield.

Chenoweth, himself a combat Marine in the Korean War and a combat artist in both the Vietnam and Persian Gulf wars, has resurrected in this book many forgotten and unsung artists in order to recognize their significant achievements and save their names and works from oblivion and the oversight of modern art critics.

Now that Chenoweth has so thoroughly defined the field, *Art of War* should provide a starting point for further research. Moreover, it should lead the way for the armed services of all nations to recognize the continuing value of combat art as a historical record and tool for building esprit de corps. In fact, the military services over the past sixty years have developed differing but effective combat art programs that have deployed artists to every war and excursion America has ventured into. Chenoweth's spotlighting of these programs will go far in ensuring their continuation.

—Brooke Nihart
Colonel, U.S. Marine Corps, Retired
Former Deputy Director for Museums

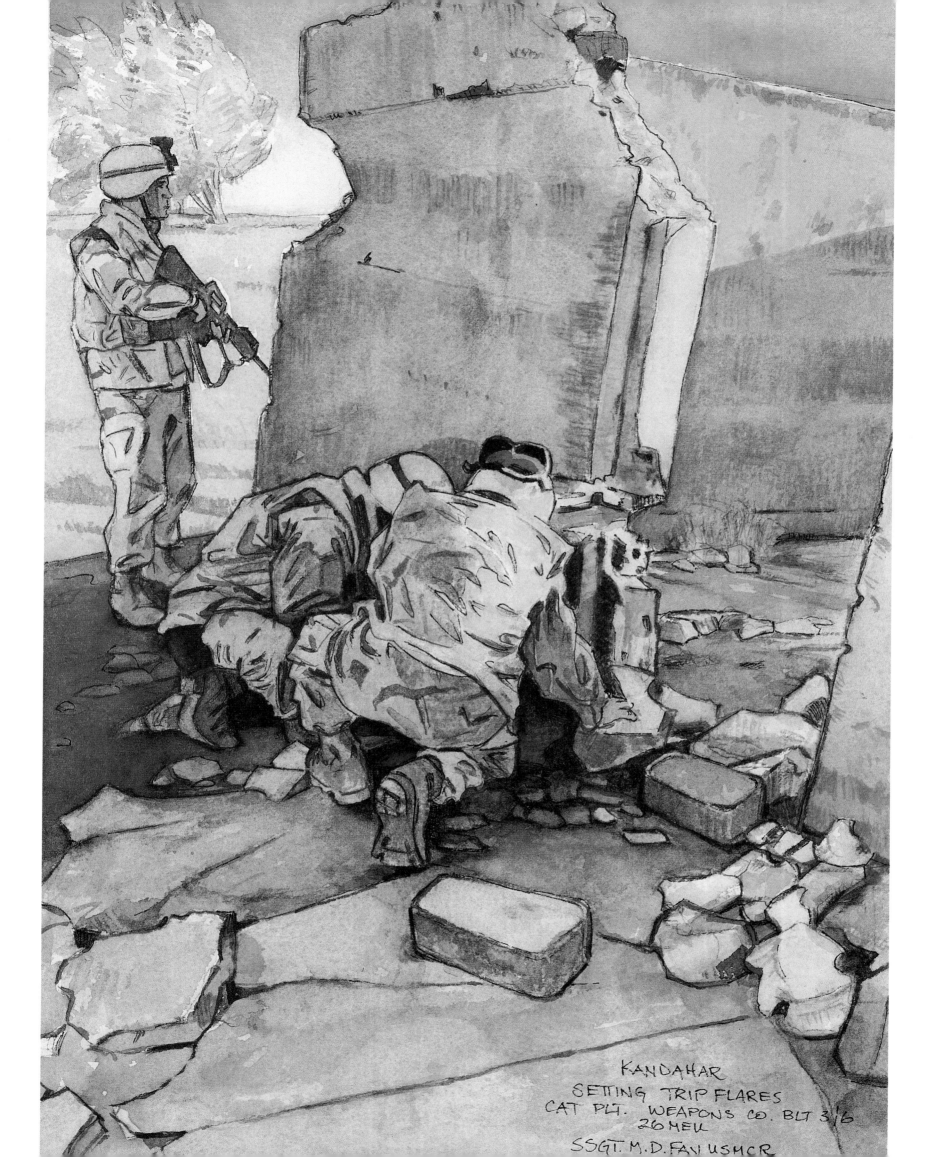

KANDAHAR
SETTING TRIP FLARES
CAT PLT. WEAPONS CO. BLT 3/6
26 MEU
SSGT. M.D. FAY USMCR

Appendix

Combat Artists by War and Branch

Precolonial to Revolutionary American

PRECOLONIAL
Mackellar, Patrick, Maj. HMA
Smith, Thomas, Capt.

CONTINENTAL NAVAL SERVICES
Parke, Matthew, Capt., Continental Marines

CONTINENTAL ARMY
Gray, Henry, Lieutenant
Peale, Charles Willson, Col.
Trumbull, John, Colonel

CIVILIAN
Blodget, Samuel
Davies, Thomas
Doolittle, Amos
Earl, Ralph
Remick, Christian
Revere, Paul
Robelle, L.
Ropes, George
Smith, Thomas
West, Benjamin
Willobank, John Benson

FOREIGN
Crépin, Louis
Dodd, Robert
Elliott, William, Lt.
Guérin, M.
Jocelin
Mitchell, Thomas
Monamy, Peter
Notté, C.J.
Ozanne, Pierre
Paton, Richard, Sir
Pocock, Nicholas
Pyle
Serres, Dominique, the Elder
Toulénard

The United States from 1789 to 1860

Agate, Alfred T. (civilian)
Barralet, John James
Barton, Charles C., Lt., USN
Birch, Thomas
Bowers, John
Buchanan, Franklin, Lt.–Capt., USN;
 Adm., CSN
Buttersworth, James C.
Buttersworth, Thomas
Butterworth, James E., Jr.
Chamberlain, Samuel
Chapman, Carlton T.
Cornè, Michele Felice
Dodd, Robert
Hamilton, James (civilian)
Heine, Wilhelm (William) (civilian)

Hoogland, William
Hornbrook, T.L.
Ladd, J.M. USN
Meyers, William H. WO, USN
Nebel, Carl
Newell, J.P.
Porter, David, Capt., USN
Powell, William
Roux, Antoine
Salmon, Robert A.
Savage, Edward
Schelky, J. C.
Smith, J.R.
Southerland, T.
Strickland, William
Tanner, Benjamin
Thomas, E.B., USN
Tiebout, Cornelius
Walke, Henry N. Lt.–Rear Adm., USN
Walker, James
Whiting, D.P., Capt. USA
Wilkes, Charles, Lt., USN

The Civil War

ARTIST-JOURNALISTS
Alden, J.M.
Bierstadt, Albert
Blythe, David
Chapin, John R.
Crane, W.T.
Darley, F.O.C.
Davis, Theodore R.
Forbes, Edwin
Gifford, Sandford
Homer, Winslow
Hope, James
Jewett, J.S.
Johnson, Eastman
Lovie, Henri
Lumley, Arthur
Mason, F.H.
Matthews, A.F.
Mead, Larkin G.
Mosler, Henry
Nast, Thomas
O'Neal, James
Schell, Frank H.
Scott, Julian
Simplot, Alexander
Steadman
Strother, David H.
Taylor, J.E.
Vizzitelly, Frank
Volck, Adalbert Johann
Waud, Alfred R.
Waud, William
Weir, Robert

CIVILIAN
Alden, James Madison
Alexander, P.W.
Chappel, Alonzo
Cohen, Lawrence B.

Combe, Voltaire
DeFontaine, F.G.
DeHaas, Mauritz H.
Dunmore, Earl of
DuPonte, Durant
Elder, John A.
Enderton, Sherman
Giroux, C.
Grinevald, A.
Hamilton, James
Henderson, D.E.
Henry, Edward Lamson
James, D.
Jenkins, D.C.
Joffrey, J.
Johnson, Eastman
Joinville, Prince de
Kennedy, D.J.
Key, John Ross
Leutze, Emanuel
Lowrie, Alexander
McFarlane, D.
McLeod, William
Olney, George W.
Perry, George
Ponticelli, Giovanni
Porter, John C.
Sener, Jas. B.
Shepardson, W.
Sommer, Otto
Stuart, Alexander Charles
Torgeson, William
Walker, James
Walker, William Aiken
Watterson, Henry
Webb, Nathan
Wood, Thomas Waterman

CONFEDERATE STATES ARMY
Bingham, George Caleb
Chapman, Conrad Wise
Redwood, Allen Carter
Sheppard, William Ludwell
Wilson, Hunt P.

CONFEDERATE STATES NAVY
Blackford, B.L., Smn.

UNION ARMY
Beard, F.
Becker, J.M.
Berckhoff, Henry
Berghaus, A.
Bersanski, H.
Bonwill, S.E.H.
Brown, H.E.
Blythe, David Gilmore
Dielman, F.
Ellsbury, G.
Fox, S.
Gifford, Sanford Robinson
Hillen, C.E.
Hope, James
Hough, E.B.

McCallum, A.
Mullen, E.F.
Reader, Samuel J.
Reed, Charles W.
Scott, Julian
Sheldon, William H. Knox
Schell, Fred
Taylor, James E.
Trexler, J.S.
Williams, G.F.

UNION NAVY
Barton, Charles C., Capt.
Garland, Francis, Smn.
Grattan, John W., Lt.
Laycock, Thomas F., Acting Master
Porter, David Dixon, Rear Adm.
Smith, Xanthus, Smn.
Walke, Henry N., Rear Adm.

U.S. MARINE CORPS (UNION)
Meade, Robert L., Lt.

FOREIGN
Manet, Édouard

Spanish-American War

CIVILIAN
Christy, Howard Chandler
Glackens, William
Luks, George Benjamin
Remington, Frederic Sackrider
Reuterdahl, Henry
Schreyvogel, Charles M.
Sheldon, Charles M.
Thulstrup, Thure de
Wilson, W.O.
Zogbaum, Rufus Fairchild

ARMY
Post, Charles Johnson, Pvt.

World War I

CIVILIAN
Fischer, Anton Otto
Foster, Will
Gribble, Bernard Finegan (English)
Hornby, Lester G.
Orr, Louis
Pointer, K.K.
Poole, Burnell
Sargent, John Singer
Schoonover, Frank E.
Schreyvogel, Charles M.
Schmidt, Harold von
Woolf, Samuel Johnson
Yohn, Frederic C.
Zogbaum, Rufus Fairchild

ARMY
Aylward, William James, Capt.
Duncan, Walter Jack, Capt.
Dunn, Harvey Thomas, Capt.
Eby, Kerr, Sgt.
Harding, George Matthews, Capt.
Morgan, Wallace, Capt.
Peixotto, Ernest Clifford, Capt.
Schnakenberg, Henry, Medical Corps
Smith, J. André, Capt.
Townsend, Harry Everett, Capt.

MARINE CORPS
Thomason, John W., Jr., Capt.

NAVY
Benton, Thomas Hart, USN
 (enlisted, noncombat)
Bouché, Louis, USN (enlisted, noncombat)
Reuterdahl, Henry, Lt. Comdr., USN
Rockwell, Norman, USN
 (enlisted, noncombat)
Ruttan, C.E.

CIVILIAN (STATESIDE)
Bellows, George
Brown, Arthur
Christy, Howard Chandler
Coughland, John A.
Cox, Kenyon
Daugherty, James
Falls, Charles B.
Feininger, Lyonel
Flagg, James Montgomery
Gaul, Gilbert
Georgi, Edwin
Gibson, Charles Dana
Giles, Howard
Held, John, Jr.
Leyendeker, Frank Xavier
Leyendeker, Joseph Christian
May, Ole
Meyers, Henry Morse
Pennell, Joseph
Riesenberg, Sidney H.
Rogers, W.A.
Schmidt, Harold von
Shafer, L.A.
Underwood, Clarence F.
Woyshner, Paul
Wyeth, N.C.

World War II

U.S. WAR DEPARTMENT
Arms, John Taylor
Biddle, George
Baily, Vernon Howe
Beall, Cecil Calvert
Benton, Thomas Hart
Cook, Howard
Cornwell, Dean
Crockwell, Douglass
Fredenthal, David
Jansen, Richard
Jones, Joe
Knight, Clayton
Laning, Edward
Lopez, Carlos
Marsh, Reginald
Martin, Fletcher
Pleissner, Ogden
Poor, Henry Varnum
Rockwell, Norman (noncombat)
Schlaikjer, Jes

ARMY
Anthony, Ed
Brodie, Howard, Sgt.
Bromberg, Emmanuel
Cuming, Willard, Lt.
Davis, Harry, T.Sgt.
Dows, Olin
Duncan, Frank D., T.Sgt.
Fisher, Loren Russell

Gold, Albert, Sgt.
Greenhalgh, Robert Sgt.
Lane, Leslie
Mactarian, Ludwig, T.Sgt.
Mauldin, William, Sgt.
Miller, Barse
Radulovic, Savo, T.Sgt.
Raible, Karl
Reep, Edward, Capt.
Ruge, John, Sgt.
Scott, John
Shannon, Charles, Sgt.
Simon, Sidney
Siporin, Mitchell, T.Sgt.
Standley, Harrison
Stefanelli, Joseph
Vebell, Ed
Von Riper, Rudolph C., Lt.
Weithas, Arthur

NAVY
Backus, Standish, Jr., Lt. Comdr., USNR
Barclay, McClelland, Lt. Comdr., USNR
Beaumont, Arthur, Lt., USNR (noncombat)
Coale, Griffith Baily, Lt. Comdr., USNR
Cummings, William, Comdr.
Draper, William F., Lt., USNR
Eisenberg, George S., PO
Falter, John, Chief Specialist–Lt., USNR
Freeman, Frederich William, Lt. Comdr., USNR
Grigware, Edward, Lt., USNR
Jamieson, Mitchell, Lt.–Lt. Comdr., USNR
Millman, Edward, Comdr.
Murray, Albert K., Lt.–Lt. Comdr., USNR
Russo, Alexander, PO
Scott, Howard
Shepler, Dwight Clark, Lt. (jg)–Lt. Comdr., USNR
Sugarman, Tracy, Lt. (jg), USNR
Urbscheit, Lawrence, CPO
Whitcomb, Jon, Lt. (jg), USNR

MARINE CORPS
Allen, Marion A., Cpl., USMCWR
 (noncombat)
Arlt, Paul, T.Sgt.
Bald, Kenneth, Lt.
Bernard, Chuck A., M.Sgt.
Boulier, Francis Loren, S.Sgt.
Brinkman, Lawrence, S.Sgt.
Brown, James R., Capt.
Clymer, John Ford, S.Sgt. (noncombat)
Cochran, J.D., Pfc.
Content, Dan (noncombat)
Corriero, Guy
DeGrasse, John C., Sgt.
Denman, James Patrick, Sgt.
Dickson, Donald Lester, Capt.–Col., USMCR
Donahue, Victor P., T.Sgt.
Donovan, James A., Col.
Drout, William J., Sgt.
Dugmore, Edward Francis, Pfc.
Dunn, Tom, Sgt. (noncombat)
Ellsworth, Paul R., Pvt.
Eno, Malcolm L., Lt.
Fabion, John, Sgt., USMCR
Gemeinhardt, Walter Fritz, M.Sgt.
Gibney, Richard, Cpl.
Gunnis, William H.V., Capt.
Harding, George Matthews, Maj., USMCR
Hart, Robert N., Sgt.
Hios, Theodore, Pvt.
Iglesburger, M.L., Cpl.

Jackson, Harry Andrew, Pfc.
Jaeger, Henry, Cpl.
James, Roland P., Sgt.
Jones, Walter Anthony, Cpl.
Kessler, Woodrow, Brig. Gen.
Lacy, Stan, Pfc.
Laidman, Herbert Hugh, 1st Lt.
Lasswell, Fred (cartoonist, noncombat)
Loudermilk, Sherman, T.Sgt.
Lovell, Tom, S.Sgt. (noncombat)
McCann, Arthur T., Cpl.
McDermott, John R., Sgt.
McNerney, E.A., Lt.
Moss, Donald, Cpl.
Noir, Robert
Parmelee, Jim
Pate, Norman, Pfc.
Perin, B., Capt.
Raymond, Alexander "Alex" Gillespie, Maj., (cartoonist, noncombat), USMCR
Rhoads, Fred, Cpl.
Roman, D.N., Sgt.
Seese, Wayne, Pfc.
Shreve, Carl J., 1st Lt.
Smith, Elmer, Pfc.
Stiff, Houston, Lt.
Tepker, Harry F., Pfc.
Terpning, Howard A.
Tyree, Ralph B., Pfc.
Valerio, Gerard A., Cpl.
Waterhouse, Charles H. Cpl.
Wexler, Elmer, M.Sgt.
Wolfe, Cynthia, Cpl., USMCR (noncombat)
Wolff, Richard T., Pfc.
Wronski, Edward A., Sgt.
Young, Joe, Pfc.

COAST GUARD
Antreasian, Gary Z.
Asplund, Torre, CBM, USCGR
Daley, Robert
DeBurgos, Ralph
Dickerson, R.
Fischer, Anton Otto, Lt. Comdr., USCGR
Fisher, James
Floherty, John J., Chief Specialist, USCGR
Gildersleeve, Jack B.
Gray, George
Gretzer
Groehnke, Sherman
Jensen, Smn.
Keeler, Jack
Lawrence, William Goadby
Livingston, Robert
Payne, George
Riley, Ken
Senich, Michael
Thomas, Norman Millet
Vestal, Herman B.
Wisinski, John, CWO
Wood, Hunter, CBM

ABBOTT LABORATORIES CIVILIAN ARTISTS
Anderson, Carlos
Baer, Howard
Benney, Robert
Benton, Thomas Hart (noncombat)
Blume, Peter
Boggs, Franklin
Bonestell, Chesley
Brodie, Howard
Criss, Francis
Curry, John Steuart (noncombat)

Dehn, Adolph
Eby, Kerr
Fiene, Ernest
Freeman, Don
Greenwood, Marion
Hirsch, Joseph
Hoffman, Irwin
Levi, Julian
Lopez, Carlos
Marsh, Reginald
Martin, David Stone
McCrady, John
Porter, George Edward
Schreiber, Georges
Shane, Fred
Smith, Lawrence Beal
Tolegian, Manuel
Turnbull, James

LIFE MAGAZINE CIVILIAN ARTISTS
Baskerville, Charles
Billings, Henry
Bohrod, Aaron
Craig, Tom
Davis, Floyd
Fredenthal, David
Hurd, Peter
Kadish, R.
Labaudt, Lucien
Lea, Tom
Marsh, Reginald
Martin, Fletcher
Mitchell, Bruce
Perlin, Bernard
Pleissner, Ogden
Reindel, Edna
Sample, Paul
Sheets, Millard
Turnbull, James
Vidar, Frede

Korean War

CIVILIAN PUBLICATIONS
Brodie, Howard
Groth, John

ARMY
Pike, John

AIR FORCE
No official artists, no coverage

COAST GUARD
No official artists, no coverage

MARINE CORPS
Bess, Gordon, S.Sgt.
Beveridge, Charles W., S.Sgt.
Cain, Joseph A., Capt., USMCR
Chalk, John R.
Chenoweth, Horace Avery, 1st Lt., USMCR
Davis, R.P., 1st Lt.
DeGrasse, John C., M.Sgt.
Few, Frank, Sgt., USMC (combat photographer)
Hendrickson, Russell J., 1st Lt., USMCR
Morris, Gary, Lt. Col.
Packwood, Norvall E., Jr., T.Sgt., USMCR
Raczka, Hubert A., Sgt.
Rogers, John H., Col., USMCR
Schofield, Ralph, Sgt.
Southee, Robert C., Sgt.
Wilkerson, Donald E., M.Sgt.

NAVY
Cabot, Hugh III
Connor, Russell
Hahn, Herbert C., USNR

Vietnam War

NAVY ART COOPERATIVE LIAISON (NACAL)
Abril, Ben
Anderson, Dave
Andrews, Marion
Apollo, Dorian
Arnold, Robert Waite
Barbour, Arthur J.
Barnett, Isa
Baumgartner, Warren
Bender, Bill
Benney, Robert
Benson, Robert J.
Bollendonk, Walter
Brightwell, Walter
Brigs, Austin
Brodie, Howard
Brown, Marbury H.
Bye, Randolph
Carr, Gordon
Clive, Richard
Coombs, William
Cotter, Michael
Daggett, Noel
Darrow, Paul
Demetropoulos, Charles
Dergolis, George
DeThomas, Joe
Fabion, John
Fieux, Robert E.
Finch, Keith
Garrett, Stuart
Gray, George
Groth, John
Halladay, Robert
Hart, John Daly
Haun, Robert Charles
Hayward, George Peter
Ject-Key, David Wu
Johnson, Cecile
Kaep, Louis J.
Kingham, Charles R.
Klebe, Gene
Koczwara, Christine ("Trella")
Lacy, Ernest
Liorente, Luis
Loudermilk, Sherman
McCaffrey, Maxine
Menkel, George
Merfield, Gerald L.
Michini, Tom
Miret, Gil
Molina, Charles
O'Hara, Tom
Ortlip, Paul
Redknapp, Teri
Rosa, Douglas
Schlem, Betty Lou
Scott, James L.
Scott, Jonathan
Shall, George
Smith, Robert Grant ("R.G.")
Smith, R. Harmer
Soldwedel, Kipp
Solovioff, Nick
Soltez, Frank
Steel, John

Terpning, Howard
Thompson, Richard
Van Sant, Thomas R.
Waterhouse, Charles H.
Wilbur, Ted
Williams, Robert L.
Winslow, Marsella

SOCIETY OF ILLUSTRATORS OF NEW YORK, CHICAGO, AND LOS ANGELES (Providing artists for the Air Force combat art program)

Akimoto, George
Boyle, James Neil
Bradbury, Jack Harley
Campbell, Collin Bruce
Ellis, Dean
Ferris, Keith
Gramatky, Hardy
Green, Richard
Geissmann, Robert
Groth, John
Ishmael, Woodie
Kidder, Harvey
Mason, Fred
Magougian, Charles
McCaffrey, Maxine
McCall, Robert
Muenchen, Alfred
McKeown, Wesley
Pimsler, Al
Richards, Walter
Schaare, Harry
Schottland, Miriam
Sinagra, Attilio
Stoessel, Kurt
Swanson, Robert C.
Waterhouse, Charles

OTHER CIVILIAN ARTISTS

Abraham, Theodore
Alexander, Samuel B.
Bowen, Edward J.
Buchanan, Warren W.
Clark, Brian
Coleman, Robert T.
Cook, H. Lester
Copeland, Peter
Drake, James R.
Farrington, David N.
Flaherty, William E., Jr.
Garner, Philip V.
Graves, David E.
Hardy, James S.
Harrington, William C.
Hoettels, William R.
Johnston, Barry W.
Jones, Phillip W.
Knight, Robert C.
Kurtz, John D.
Lopez, Daniel T.
Matthais, Stephen
McDaniel, Kenneth T.
Moody, Burdell
Myers, Robert T.
Nelson, Jim
Pala, Ronald E.
Pollock, James R.
Prescott, William L.
Rakowsky, Roman
Randall, Stephen H.
Rigby, Bruce N.
Schol, Don R.
Schubert, Thomas B.

Shannon, Charles
Stewart, Craig L.
Strong, John R.
Thomas, Frank M.
Von Reynolds, Victor
Williams, E.C.
Wilson, Ronald A.

AIR FORCE

Gostas, Theodore, Lt.
Hurley, Wilson, Lt. Col., USAFR
Phillips, William S., Amn.

ARMY

Acuña, Augustine, 2nd Lt.
Blum, Roger A., Sp.4
Bogdanovich, Alexander A., Sp.4
Crook, Michael R., Sp.4
Drendel, Theodore E., Sp.5
Lavender, Davis, Sp.5
McGee, Dennis O., Sp.4
Nelson, Jim
Porter, William G., Sp.4
Rickert, Paul, Sp.4
Sanchez, Felix R.
Scowcroft, Kenneth J., Sp.6
Sexauer, Donald
Sheldon, Stephen H., Sp.4
Wehrle, John O., 1st. Lt.

MARINE CORPS

Anderson, David, Pfc
Bossarte, Robert M., Sgt.
Butcher, James R., Cpl.
Camp, Dan M., Capt.
Casselli, Henry Calvin, Jr., Sgt.
Chenoweth, Horace Avery, Lt. Col., USMCR
Condra, Edward M., III, Capt.
Crossley, Keith, Sgt., USMCR
Dermott, Leonard H., Capt.
Deuel, Austin, Pfc., USMCR
Dyer, John T., Capt., USMCR
Fairfax, James Addison, Sgt.
Gish, Peter M. ("Mike"), Lt. Col., USMCR
Henri, Raymond, Col., USMCR (Ret.) (nonartist; Director, Combat Art Program)
Jackson, Harry Andrew (former Marine)
Laidman, Hugh (former Marine)
Leahy, Albert M. ("Mike"), Major, USMCR
Long, Ben F., IV, 1st Lt., USMCR
Loudermilk, Sherman (former Marine)
McConnell, Keith A., Lt., USMCR
Moss, Gary M., Cpl.
Parks, Wendell A. ("Tex"), WO
Rogers, John H., Col., USMCR (Ret.)
Stiff, Houston ("Tex"), Col., USMC (Ret.)
Williams, Robert L., Cpl.
Witt, John Joseph (civilian)
Yaco, Richard L., Lance Cpl.
Young, Alex, CWO-3, USMCR

NAVY

Fitzgerald, Edmond J., Comdr.
Indiviglia, Salvatore, Lt. Comdr.
McGrath, John M., Lt. Comdr.
Roach, John Charles, Ens., USNR
Scott, James, Lt. Comdr., USNR

VIETNAM VETERANS

Michel, Karl
Olsen, Richard J.
Wright, Cleveland
Yohnka, Richard Russell

Persian Gulf War

ARMY

Acevedo, Mario H., Capt.
Hartfers, Sieger, Sp.1
Varisano, Peter G., Sp.1

COAST GUARD

Orwig, Daniell, Lt. (jg), USCGR

NAVY

Beck, William G. ("Chip"), Comdr., USNR
Roach, John Charles, Comdr., USNR

MARINE CORPS

Chenoweth, Horace Avery, Col., USMCR (Ret.)
Fitzpatrick, Richard M., Cpl.
Gish, Peter M. ("Mike"), Col., USMCR (Ret.)
Grow, Charles G., Sgt.
McConnell, Keith A., Lt. Col., USMCR
Sabatino, Gerald E., Gunnery Sgt., USMCR

Somalia, Panama, Haiti, Bosnia, and Kosovo

ARMY

Cassidy, Gary N. ("Butch"), Col. USA (Ret.)
Hawks, Horatio
Manuszak, Jeffrey, Sgt.
Snowden, Henrietta, E-8
Snyder, Karl ("Gene"), Sgt.

MARINE CORPS

Alejandre, Arturo, Sgt., USMC
Condra, Edward M. III, Col., USMC
Dyer, John T., Major, USMCR (Ret.)
Gish, Peter Michael, Col. USMCR (Ret.)
Grow, Charles G., CWO
Leahy, Albert M. ("Mike"), Lt. Col., USMCR
Moore, Burton E., Capt. USMCR
Neary, Donna J., Lt. Col., USMCR

NAVY

Roach, John Charles, Capt. USNR

CIVILIAN

Crossley, Keith
Stadler, Anthony F. (former Marine)
Witt, John Joseph
Young, Cliff

Bibliography

Preface

Fleming, William. *Arts & Ideas*, 6th ed. New York: Holt, Rinehart & Winston, 1980.

Keegan, John and Joseph Darracott. *The Nature of War*. New York: Holt, Rinehart & Winston, 1981.

Osborne, Harold, ed., *The Oxford Companion to Art*. Oxford: Clarendon Press; New York: Oxford University Press, 1970–1987.

Smith, Bradley. *The USA: A History in Art*. Garden City, N.Y.: Doubleday & Co., 1975.

Smith, S.E., ed. and comp., *The United States Marine Corps in World War II*. With an introduction by Lt. Gen. Julian C. Smith, USMC. New York: Random House, 1969.

Introduction

Chastel, Andre. *Art of the Italian Renaissance*. Translated by Linda Murray and Peter Murray. New York: Arch Cape Press, 1983.

Chenoweth, H. Avery. "A Study of American Combat Art." Master's thesis, University of Florida, 1956.

Eby, Kerr. *War*. New Haven: Yale University Press, 1936. With an introduction by Charles Chatfield. New York: Garland Publishers, 1971.

Runes, Dagobert D., and Harry G. Schrickel, eds. *Encyclopedia of the Arts*. New York: Philosphical Society, 1946.

Gardner, Helen. *Art Through the Ages*. New York: Harcourt, Brace & Company, 1948.

Kirstein, Lincoln. *American Battle Painting: 1776–1918*. (Catalogue for a 4 July–4 September 1944 exhibition.) Washington, D.C.: National Gallery of Art and Smithsonian Institution, 1944.

Library of Congress. *An Album of American Battle Art: 1775–1918*. (Based on a 4 July 1944 exhibition at the Library of Congress.) Washington, D.C.: U.S. Government Printing Office, 1947.

Natkiel, Richard. *Atlas of American Wars*. Greenwich, Conn.: Bison Books, 1986.

Heller, Jonathan, ed. *War and Conflict*. (Selected images from the National Archives, 1765–1970.) Washington, D.C.: National Archives and Records Administration, 1990.

Yadin, Yigael. *The Art of Warfare in Biblical Lands: In the Light of Archaeological Study*. Vol. 2. Jerusalem: International Publishing Co. Ltd., 1963.

Chapter 1: Auspicious Beginnings

American Naval Battles: being a complete history of the battles fought by the Navy of the United States from its establishment in 1794 to the present time…with twenty-one elegant engravings. Boston: J. J. Smith, Jr., 1831. Registered proprietor, Horace Kimball.

Stein, Roger B., ed. *American Naval Prints From the Beverly R. Robinson Collection*. Annapolis, Md.: U.S. Naval Academy Museum, 1976.

Cresswell, Donald H., comp. *The American Revolution in Drawings and Prints: A Checklist of 1765–1790 Graphics in the Library of Congress*. With a foreword by Sinclair H. Hitchings. Washington, D.C.: Library of Congress, 1975.

Flexner, James Thomas. *America's Old Masters: First Artists of the New World*. New York: Viking Press, 1939.

Jensen, Oliver. "The Peales." *American Heritage: The Magazine of History* 6 (April 1955): 40–51.

McSpadden, J. Walker. *Famous Painters of America*. New York: Dodd, Mead and Co., 1916.

Morgan, John Hill. *Paintings by John Trumbull at Yale University*. New Haven: Yale University Press, 1926.

Olds, Irving S. "Early American Naval Prints." *Art in America* 23 (December 1955): 22.

"Patriot Painter." *Time* (4 July 1955): 40–41.

Sellers, Charles Coleman. *Charles Willson Peale*. New York: Charles Scribner's Sons, 1969.

Smith, Charles R. *Marines in the Revolution: A History of the Continental Marines in the American Revolution, 1775–1783*. Illustrated by Maj. Charles H. Waterhouse, USMCR. Washington, D.C.: History and Museums Division, Headquarters, U.S. Marine Corps, 1975.

Chapter 2: First Half of the Nineteenth Century

"The First Academic Staff, U.S. Naval Academy." *U.S. Naval Institute Proceedings* 61 (October 1935): 1389.

Herring, James, and James B. Longacre. *The National Portrait Gallery of Distinguished Americans*. Vol. 1. New York, 1835.

Lundeberg, Phillip. "Legacy of an Artist-Explorer." *Pull Together* (Newsletter of the Naval Historical Foundation and the Naval Historical Center), (Spring/Summer 1989).

Mahan, Alfred Thayer. *The Influence of Sea Power upon History, 1660–1805*. Novato, Calif.: Presidio Press; Greenwich, Conn.: Bison Books, 1980. Includes excerpts from *The Influence of Sea Power upon the French Revolution, 1793–1812*.

Knox, Capt. Dudley W, USN. *Naval Sketches of the War in California: Reproducing Twenty-eight Drawings Made in 1846–47 by William H. Meyers, Gunner on the U.S. Sloop-of-War Dale*. With an introduction by Franklin D. Roosevelt. New York: Random House, 1939. One thousand copies printed at Grabhorn Press, San Francisco, 1939.

Peabody Museum of Salem. "Michele Felice Cornè 1752–1845. Versatile Neapolitan Painter of Salem, Boston & Newport." (Catalogue for a 1972 summer exhibition at the Peabody Museum of Salem.) With a foreword and notes by Philip Chadwick Foster Smith, Curator, Maritime History, and an introduction by Nina Fletcher Little.

Peters, Harry T. *Currier and Ives: Printmakers to the American People*. Garden City, N.Y.: Doubleday, Doran and Co., 1942.

Roscoe, Theodore, and Fred Freeman. *From Old Navy to New, 1776 to 1897: Picture History of the U.S. Navy*. New York: Crown Publishers & Charles Scribner's Sons, 1956.

Stein, Roger B. *Seascape and the American Imagination*. New York: Clarkson N. Potter in association with the Whitney Museum of American Art, 1975.

Chapter 3: A Nation Divided: 1861–1864

An Album of Civil War Battle Art. Applewood Books: Bedford, Mass., 1988.

Bassham, Ben L. *Conrad Wise Chapman. Artist & Soldier of the Confederacy*. Kent, Ohio: Kent State University Press, 1998.

Buchanan, Lamont. *A Pictorial History of the Confederacy*. New York: Crown Publishers, 1951.

Curry, Andrew. "A Yankee's Doodle Diary. He Wrote and Painted in North and South." *U.S. News & World Report*. (Nov. 27, 2000).

Forbes, Edwin. *Thirty Years After: An Artist's Story of the Great War*. 4 vols. New York, 1890.

Guernsey, Alfred H., et al., eds. *Harper's Pictorial History of the Great Rebellion*. New York: Harper's Weekly, 1866.

Hodson, Pat. *The War Illustrators*. New York: Macmillan Publishing Co., 1977.

Lewis, Charles Lee. "Alonzo Chappel and His Naval Paintings." *U.S. Naval Institute Proceedings* 60 (March, 1932).

Meredith, Roy. *Mr. Lincoln's Camera Man: Mathew B. Brady*. New York: Charles Scribner's Sons, 1946.

"Mr. Davis and Mr. Russell." *Harper's Weekly* 450 (July 20, 1861).

Naval History Division. *Civil War Naval Chronology, 1861–1865*. Parts I, IV, and V. Washington, D.C.: Naval History Division, Office of the Chief of Naval Operations, U.S. Navy Department, 1961.

"Our Artists During the War." *Harper's Weekly* 339 (June 3, 1865).

"Our Artist Overhauled at Memphis." *Harper's Weekly* 397 (June 22,1861).

Pierce, Greg. "Soldier's Paintings Capture the Drama of Conflict." *The Washington Times*. (Aug. 28, 1999).

Poesch, Jessie. *The Art of the Old South: Painting, Sculpture, Architecture & the Products of Craftsmen, 1560–1860*. New York: Harrison House, 1983.

Rawls, Walton. *The Great Book of Currier & Ives' America*. From the Harry T. Peters Collection. New York: Cross River Press; Harrison House, 1979.

Sears, Stephen W., ed. *The American Heritage Century Collection of Civil War Art*. With a foreword by Bruce Catton. New York: American Heritage Publishing Company, 1974, 1984.

Sears, Stephen W., ed. *The Civil War: A Treasury of Art and Literature*. New York: Hugh Lauter Levin Associates, Inc., 1992.

Sneden, Robert Knox, Pvt. *Eye of the Storm. A Civil War Odyssey*. Edited by Charles F. Bryan, Jr., and Nelson D. Lankford. New York: The Free Press, 2000.

Howorth, Lisa, ed. *The South: A Treasury of Art and Literature*. Center for Study of Southern Culture at the University of Mississippi, Beaux Arts Edition. New York: Hugh Lauter Levin Associates, Inc., 1993.

Chaitin, Peter M. *The Coastal War: Chesapeake Bay to Rio Grande. The Civil War Series*. Alexandria, Va.: Time-Life Books, 1984.

Walke, Henry N. *Naval Scenes and Reminiscences of the Civil War…*. New York: F.R. Reed & Co., 1877.

Wilmerding, John, et al., eds. *American Light: The Luminist Movement, 1850–1875*. Washington, D.C.: Princeton University Press

———. *American Marine Painting*. 2nd ed. New York: Harry N. Abrams, 1987.

———. *Robert Salmon: Painter of Ships & Shore*. With an introduction by Charles D. Childs. Boston: Boston Public Library, 1971.

Chapter 4:
The Spanish-American War

Craze, Sophia. *Frederic Remington*. New York: Crescent Books, Crown Publishers, 1989.

Davis, Richard Harding. *Cuba in War Time*. Illustrated by Frederic Remington. New York: R.H. Russell, 1900.

Davis, Richard Harding. *The Notes of a War Correspondent*. New York: Charles Scribner's Sons, 1911.

Jackson, Martha. *Illustrations of Frederic Remington*. With a commentary by Owen Wister. New York: Bounty Books, Crown Publishers, 1970.

Chapter 5:
The Dawn of the Twentieth Century

"Art and the War." *North American* 208 (September 1918): 423.

"Art and the War." *The Outlook* (November 6, 1918): 329.

"Art as the Chronicler of War." *The Nation* (July 6, 1916): 20–21.

"Artistic Inspiration of the War." *International Studio* 57 (November 1915): 76.

"Artists in War-Time." *Literary Digest* (January 12, 1918): 26.

"Battle Front: Pictures by F.C. Yohn." *Scribner's Magazine* 44 (October 1918): 392.

"Battle-torn Second Division Cheered by Thousands Along Parade Lane in Fifth Avenue." *New York Herald*, (August 9, 1919): 3.

Calvert, Egeria. "Painting War." *The Craftsman* 29 (March 1916): 632.

Reynolds, Francis J., and C.W. Taylor, eds. *Collier's Photographic History of the European War: Including Sketches and Drawings Made on the Battle Fields*. New York: P.F. Collier and Son, 1919.

Cornebise, Alfred Emile. *Art from the Trenches: America's Uniformed Artists in World War I*. College Station, Tex.: Texas A&M University Press, 1991.

Eby, Kerr. *War*. New Haven, Conn.: Yale University Press, 1936. With an introduction by Charles Chatfield. New York: Garland Publishers, 1971.

Fairman, Charles E. *Art and Artists of the Capitol of the United States of America*. Washington, D.C.: U.S. Government Printing Office, 1927.

"Fighting Artists." *Literary Digest* (December 9, 1916): 1539.

"Future of the War Artist." *Literary Digest* (October 20, 1917): 27.

Galsworthy, John. "Art and the War." *The Atlantic Monthly* 116 (November 1915): 624–28.

Holliday, Robert Cortes. "Posing the War for the Painter." *The Bookman* 47 (July 1918): 512.

"How American Artists Help the Navy." *Scientific American* (June 2, 1917): 552.

"Kennington's Art." *The Studio* 126: 17.

Marshall, S.L.A., Brig. Gen. USA, Ret. *The American Heritage History of World War I*. New York: Crown Publishers, 1982.

"A New Form of High Art: Painting the Air Battles." *Literary Digest* (March 30, 1918): 32–34.

Norwood, W.D., Jr. *John W. Thomason, Jr*. Southwest Writers Series 25. Austin, Tex.: Stock-Vaughn Company, 1969.

"On Pictures Suggested by the War." *International Studio* 62 (July 1917): 40.

"Orpen's Official War Pictures." Literary Digest (June 29, 1918): 29.

Ratcliff, Carter. *John Singer Sargent*. New York: Abbeville Press, 1982.

Stars and Stripes. A complete file of the official newspaper of the American Expeditionary Forces, February 8, 1918–June 13, 1919. Printed in France.

Rosenfeld, Arnold. *A Thomason Sketchbook: Drawings by John W. Thomason, Jr*. With an introduction by John Graves. Austin, Tex.: University of Texas Press, 1969.

Thomason, John W., Jr. *Fix Bayonets! and Other Stories*. New York: Charles Scribner's Sons, 1925.

Tucker, Allen. "Art and the War." *North American Review* 208 (September 1918): 423–426.

"War in Art." *The Nation* (July 15, 1915): 102.

"War's Failure to Inspire the Modern Artist." *Current Opinion* (November 6, 1918): 123.

Willock, Roger. *Lone Star Marine: A Biography of the Late Colonel John W. Thomason, Jr., U.S.M.C.* Princeton, N.J.: Privately published, 1960.

Zogbaum, Rufus Fairchild. "War and the Artist." *Scribner's Magazine* 62 (January 1915): 16.

Chapter 6:
World War II: 1941–1945

Abbott, Jere. "Fine Arts and the War." *The American Scholar* 12 (Summer 1943): 374.

"Aftermath of War: Paintings of Ben Shahn." *Fortune* 32 (December 1945): 169–71.

"Airmen in the Aleutians." *Life* 22 (May 1944): 56.

"American Artists Report the War." *Connoisseur* 114 (December 1944).

"American Battle Painting." *The Studio* 130 (November 1945): 152–53.

"Americans in Britain before D-Day." *Life* 29 (October 1951): 77.

"American Naval Paintings." *The Studio* 130 (September 1945): 90.

"Arnold Hoffman Paints a New Dark Age." *Design* 53 (April 1952).

"Art and the Navy." *The Art Digest* (October 15, 1942): 15.

"Art in the White House." *Art News* 45 (February 1947): 37.

"Art Talk: Cartoons." *The Commonweal* 31 (July 1942): 341.

"The Artist and the War." *The New Yorker* (May 3, 1943): 47.

"Artist Bernard Perlin Makes Mission to Greek Mainland." *Life* (February 26, 1945): 47.

"The Artist Reporter: 1855–1945." *Art News* 44 (September 1945): 12.

"Artists and Battles." *Newsweek* (July 24, 1944): 90.

"Artists' Battalion." *Art News* 42 (May 1–14, 1943): 6.

"Artists for Victory." *Art News* 42 (April 15–31, 1943): 26; (May 1–14, 1943): 27; (October 1–14, 1943): 28; (October 15–30, 1944): 33.

"Artists Portray the Role of Soldiers of Mercy." *The Art Digest* (May 15, 1945): 12.

"Authentic War Art." *The Art Digest* (December 1, 1944): 11.

Baldwin, Hanson W. *The Navy at War: Paintings and Drawings by Combat Artists.* New York: William Morrow and Co., 1943.

Barker, Virgil. *American Painting: History and Interpretation.* New York: Macmillan Co., 1950.

"Battle for the Philippines." *Fortune* 31 (June 1945): 156–64.

Bell, Andrew. "War Art." *The Studio* 129 (April 1945): 116–117.

Biddle, George. *Artist at War.* New York: Viking Press, 1944.

"Binford Paints New York Harbor at War." *The Art Digest* (January 1, 1945): 8.

Blaikley, Ernest. "Orpen as War Artist." *The Studio* 128 (December 1944): 176.

Boswell, Peyton. "Review of the Year." *The Art Digest* (January 1, 1945): 3.

"Call to Action." *Magazine of Art* 35 (March 1942): 96–101.

Chrysler Corporation. *Significant War Scenes by Battlefront Artists, 1941–1945.* Chrysler Corporation, 1951.

Coale, Griffith Baily. *Victory at Midway.* New York: Farrar & Rinehart, 1944.

Coates, Robert H. "The Art Galleries: Reports from the Front." *The New Yorker* 28 (August 1943): 43.

———. "The Art Galleries: 1776–1918." *The New Yorker* (October 7, 1944): 52.

"Coming Home to the Carnegie." *Art News* 44 (October 15–31, 1945): 11–13.

"Congress Fumbles the Ball." *The Art Digest* (August 1, 1943): 3.

"Convertible Bandwagon." *Harper's Magazine* 194 (June 1947): 574.

Crane, Aimée. *Marines at War.* New York: Charles Scribner's Sons, 1943.

Crane, Aimée, ed. *G.I. Sketchbook.* New York: Penguin Books, 1944.

"The Cruise of the Campbell." *Life* (July 5, 1943): 53–77.

DeBrossard, Charles. "Art as Propaganda." *Art and Industry* 39 (November 1945): 144.

Draper, William F. "Jungle War: Bougainville and New Caledonia." *The National Geographic Magazine* 85 (April 1944): 417–432.

———. "Painting History in the Pacific." *The National Geographic Magazine* 86 (October 1944): 408–424.

———. "Victory's Portrait in the Marianas." *The National Geographic* Magazine 88 (November 1945): 599–616.

Dunlap, William. *History of the Rise and Progress of the Arts of Design in the United States.* With an introduction by William P. Campbell. 3 vols. Edited by Alexander Wyckoff. New York: Benjamin Blom, 1965. (First published 1834.)

"Ensign Mitchell Jamieson Paints Embarkation." *Life* (May 3, 1943): 70.

"Faces of U.S. Fighting Men." *Art News* 44 (December 1–14, 1945): 10.

Farber, Manny. "Artists for Victory." *Magazine of Art* 35 (December 1942): 275.

Fischer, Katrina Sigsbee. *Anton Otto Fischer—Marine Artist: His Life and Work.* Brighton, Sussex: Teredo Books, Ltd., 1977.

Frank, Benis M. *Denig's Demons and How They Grew: The Story of Marine Corps Combat Correspondents, Photographers and Artists.* Marine Corps Combat Correspondents and Photographers Association, Inc. Washington, D.C.: More & More, 1967.

"From the Solomons." *The Art Digest* (February 15, 1945): 13.

"G.I. Realists." *The New Yorker* (August 28, 1944): 57.

Greeley, Brendan, Lt. Col. USMC (Ret.). "Paso por Aquí: An afternoon with Tom Lea." *Naval History.* Annapolis, Md.: United States Naval Institute, April 1995.

"Greenland at War." *Life* (September 6, 1943): 76.

"Guns and Brushes." *Magazine of Art* 35 (October 1942): 214.

Guptill, Arthur L. *Norman Rockwell Illustrator.* With a preface by Dorothy Canfield Fisher and an introduction by Jack Alexander. New York: Watson-Guptill Publications, 1946.

Hammel, Eric. "Threat Proven Deadly." *World War II* (July 1991): 50–57.

Harries, Meirion, and Susie Harries. *The War Artists: British Official War Art of the Twentieth Century.* London: Michael Joseph in association with the Imperial War Museum and the Tate Gallery, 1983.

Hersey, John. "Experience by Battle." *Life* (December 27, 1943): 48–84.

Hersey, John. *Into the Valley: A Skirmish of the Marines.* Illustrated by Maj. Donald L. Dickson, USMC. New York: Pocket Books, 1943.

"Historical Naval Paintings in Thrilling Show." *The Art Digest* (September 15, 1945): 12.

Hjerter, Kathleen G., comp. *The Art of Tom Lea.* With an introduction by William Weber Johnson. College Station, Tex.: Texas A&M University Press, 1989.

Holme, Bryan. "U.S. Naval Paintings." *The Studio* 130 (September 1945): 90–91.

Horwarth, David. *The Seafarers: The Dreadnoughts.* Alexandria, Va.: Time-Life Books, 1979.

"How British Artists Paint Victory at Sea." *The Art Digest* (December 1, 1944): 14.

"Japanese Memory." *Time* (September 16, 1946): 56.

"Joe Jones Gains in Creative Power." *The Art Digest* (February 1, 1945): 17.

Jones, James. *WW II.* New York: Grosset & Dunlap, 1975.

"Kerr Eby Depicts Truth and Terror of Battle." *The Art Digest* (May 1, 1945): 12.

King, Cecil R.I. "Marine Painting and the National Tempo." *The Studio* 22 (October 1941): 89–100.

Kirstein, Lincoln. "American Battle Art: 1588-1944." *Magazine of Art* 37 (March 1944): 104; (April 1944): 146; (May 1944): 184.

Klinkenborg, Verlyn. "Thomas Hart Benton Came from Missouri—and He Showed 'Em" *Smithsonian* (April 1989): 82–101.

Lawker, Brian, and Nicole Newnham. *They Drew Fire: Combat Artists of World War II.* New York: TV Books, 2000.

Lea, Tom. Battle Stations: *A Grizzly from the Coral Sea, Peleliu Landing.* Illustrations by the author. With an introduction by Al Lowman. Dallas: Still Point Press, 1988.

"Life War Art Competition." *The Studio* 125: 52.

"Life War Paintings at National Gallery." *The Art Digest* (July 1, 1943): 5.

"Life's Artists Record a World at War." Life (April 30, 1945): 42.

Life's Picture History of World War II. New York: Time, Inc., 1950.

MacLennan, Nancy. "Our Naval Exploits: A Pictorial Record." *The New York Times Magazine* (August 15, 1943): 249.

Mangravite, Peppino. "Congress Vetoes Culture." *Magazine of Art* 36 (November 1943): 264–65.

Mauldin, Bill. "War Humor in Three Wars." *The New York Times Magazine* (March 22, 1953): 24–25.

Mackenzie, DeWitt. *Men Without Guns*. Catalogue of the Abbott Laboratories Collection of Paintings of Army Medicine. Philadelphia: The Blakiston Co., 1945.

Meyer, Susan E. *America's Great Illustrators*. New York: Harry N. Abrams, 1978.

McCausland, Elizabeth. "Art in Wartime." *The New Republic* 110 (May 15, 1944): 676.

McCormick, Ken, and Hamilton Darby Perry. "Britain's Finest Hour: Artists as Witnesses." *The Quarterly Journal of Military History* (Autumn 1988).

McCormick, Ken, and Hamilton Darby Perry eds. *Images of War: The Artist's Vision of World War II*. With a foreword by John Hersey. New York: Orion Books, 1990.

Montross, Lynn. *The United States Marines: A Pictorial History*. New York: Holt, Rinehart & Winston, 1959.

"Night Landing on New Britain." *Life* (August 21, 1944): 48–56.

"On an Aircraft Carrier." *Collier's* (January 8, 1944): 16.

"On Leave with Australia's Art." *Art News* 43 (October 1–14, 1944): 11–12.

Our Flying Navy. Text prepared with assistance of the office of Deputy Chief of Naval Operations (Air). With an introduction by James Forrestal, Secretary of the Navy; a preface by Arthur W. Radford, Rear Adm., USN; and a foreword about the pictures by Thomas Craven. New York: The Macmillan Co., 1944.

"The Pacific War." *Life* (October 8, 1945): 45.

Pagano, Grace. "The War—As Seven Artists in the Britannica Collection See It." *The Art Digest* (April 1, 1945): 36.

"Paul Sample's Naval Aviation." *Life* (January 4, 1943): 36.

Paulding, C.G. "Art Talk." *The Commonweal* (July 31, 1942): 341.

"Peleliu, Tom Lea Paints Island Invasion." *Life* (June 11, 1945).

"Pep in War Pictures." *Art and Industry* 33 (October 1942): 90.

"Pictures from New York from *Life*'s Exhibition of War Pictures. *The Studio*, 126, (pp.) 165.

Phillips, Christopher. *Steichen at War*. New York: Portland House & Harry N. Abrams, 1987.

Pointer, Larry, and Donald Goddard. *Harry Jackson*. With a foreword by Peter H. Hassrick; introduction by John Walker. New York: Harry N. Abrams, 1981.

"Portrait of Battle." *The Art Digest* (October 1, 1944): 1.

Read, Herbert. *A Concise History of Modern Painting*. With a preface by Benedict Read. New York: Oxford University Press, 1974.

Reed, Judith Kaye. "He Saw the War Coming." *The Art Digest* 1 (August 1945): 7.

Reep, Edward. *A Combat Artist in World War II*. Lexington, Ky.: University Press of Kentucky, 1987.

Reynolds, Clark G. *War in the Pacific*. New York: Military Press, Random House, 1990.

Ringle, Ken. "The Artist's Brush With War." *The Washington Post* (January 25, 1991): Section D1.

"Seamen's Art Annual Tours the Nation." *The Art Digest* (February 15, 1945): 15.

Seddon, Richard. "War Art of the Past." *The Studio* 125 (June 1943): 161.

"Service Memorial." *The Art Digest* (December 1, 1945): 26.

Shepler, Dwight. *An Artist's Horizons*. Barre, Mass.: Fairfield House Publishing, 1973.

Slavin, Peter. "The Art of War." *Navy Times* (February 11, 1991): 39.

"Soldiers at Work: Tom Lea." *Life* (April 27 ,1942): 44.

"Spare Time Art Is Fun, and G.I.'s Prove It at the National Gallery." *Art News* 44 (July 1–31, 1945): 14–15.

"Spearhead: Sketches by John Groth." *Collier's* (January 6, 1945): 16–17.

Stars and Stripes. April 13, 1945–August 16, 1945.

Stechow, Wolfgang. "Art Studies during the War." *College Art Journal* 6 (Summer 1947): 291.

"Studio War Art." *Life* (June 12, 1944): 76.

Sugarman, Tracy. *My War: A Love Story in Letters and Drawings*. New York: Random House, 2000.

Sutherland, Mason. "Navy Artist Paints the Aleutians." Paintings by Lt. William F. Draper, USNR. *The National Geographic Magazine* 84 (August 1943): 157–176.

Taylor, Francis Henry. "Beauty for Ashes." *The Atlantic Monthly* 173 (March 1944): 88.

"Three Victory Exhibitions: (1) The War at Sea, (2) American Artists Report the War, and (3) Pictures of D-Day and After." *The Connoisseur* 113, 114 (December 1944): 122–127.

"Tom Lea Aboard the U.S.S. Hornet." *Life*, (22 March 1943): 48.

"Tom Lea Paints the Invasion of Peleliu." *Life*, (11 June, 1945): 61–67.

"Tom Lea Paints the Last Day of the Hornet. " *Life*, (2 August 1943): 42–49.

"Tom Lea Paints North Atlantic Patrol." *Life* (May 25, 1942): 53–61.

"Under Fire with a Sketch Book: Drawings by Sgt. Howard Brodie." *Travel* 81 (August 1943): 14.

"United States Sends Artists to War Front." *The Art Digest* (May 1, 1943): 13.

"Unlimited Emergency." *Magazine of Art* 34 (June 1941): 289.

"U.S. Government War Art." *Life* (April 6, 1942): 58–60.

"Visual History—1942." *Magazine of Art* 35 (April 1942): 140–143.

"War and the Artist Once More." *Magazine of Art* 35 (February 1942): 80.

"War and Museums." *Magazine of Art* 35 (April 1942): 146–147.

"War and People: Paintings by David Fredenthal." *Life* (January 28, 1946): 50.

"War Art Commissioned by Life." *Life* (June 28, 1943): 6–8.

"War Art of the Past." *The Studio* 125: 161.

"War Artists of the Last World War: Letter of Andre Smith to the Editor." *The Art Digest* (October 1, 1943): 4.

"War in the Pacific: Drama at the Met." *The Art Digest* (August 1, 1945): 1.

Wellquist, Jerome. "Feeble War Art." *The Nation* (October 2, 1943): 88–89.

"With Aaron Bohrod on Three Fronts." *The Art Digest* (August 1, 1945): 1.

Chapter 7:
The Korean War: 1950–1953

Harrison, C.W. Col., USMC. Letter to the author. September 14, 1955.

"Korea Five Years Ago." *Life* (October 9, 1950): 70–72.

Chapter 8:
Vietnam: The "Anti-War": 1965–1975

Ferrier, Jean-Louis, ed. *Art of Our Century. The Chronicle of Western Art. 1900 to the Present*. New York: Prentice Hall Press, 1988.

Nallantine, Ian, ed. *The Aviation Art of Keith Ferris*. New York: Peacock Press, Bantam Books. 1978

Blake, John. *Aviation Art*. New York: Exeter Books, 1987.

Brodie, Howard. *Drawing Fire: A Combat Artist at War. Pacific, Europe, Korea, Indochina, Vietnam*. With a foreword by Walter Cronkite. Los Altos, Calif.: Portolá Press, 1996.

Brown, Milton W., Sam Hunter, John Jacobus, Naomi
 Rosenblum, and David M. Sokol. *American Art:
 Painting, Sculpture, Architecture, Decorative Arts,
 Photography.* New York: Harry N. Abrams,
 1979.
Deuel, Austin. *Vietnam: Even God Is Against Us.*
 Escondido, Calif.: Impressions West, 1988.
Dyer, John T. "Colonel Charles Waterhouse, Artist-
 in-Residence, Retires." *Fortitudine* (Winter
 1990–91): 17–18.
Franklin Mint Gallery of American Art. *Wilson Hurley.
 A Biographical Sketch.* Vol. 1. Franklin Center,
 Penn.: Franklin Mint Gallery of American Art,
 1974.
History of the United States Navy. Italy: Chevprime
 Ltd., 1988.
Kemp, John R. "Henry Casselli." *American Artist*
 (August 1987): 53.
Krakel, Dean. "Wilson Hurley…With the Wind in
 His Face." *Persimmon Hill*

 (Publication of the National Cowboy Hall of
 Fame and Western Heritage).
Lkinka, Karen, "Wilson Hurley. Windows of the
 West." *Southwest Art* (November 1994).
McCain, John, and Mark Slater. *Faith of My Fathers: A
 Family Memoir.* New York: Random House,
 1999.
McGrath, John M. *Prisoner of War, Six Years in Hanoi.*
 Annapolis, Md.: Naval Institute Press, 1975,
 1988.
Reed, Walt, and Roger Reed. *The Illustrator in
 America, 1880–1980:
 A Century of Illustration.* The Society of
 Illustrators. New York: Madison Square Press,
 1984.
Sinaiko, Eve, ed. *Vietnam: Reflexes and Reflections.* New
 York: Abrams, 1998.
Tillman, Barrett. "In Profile: R.G. Smith." *Naval
 History* (Spring 1988): 64–67.
Waterhouse, Charles. *Marines and Others.* Edison, N.J.:
 Sea Bag Productions, 1994.
———. *Vietnam War Sketches from the Air, Land, and
 Sea.* Rutland, Vt.: Charles E. Tuttle Co., 1970.

Chapter 9:
Late Twentieth Century
Engagements
Larsen, Tricia. "Massive Build-up in Persian Gulf
 Matter of Record." *The Officer* (November
 1991): 12–13.
Lucie-Smith, Edward. *Lives of the Great Twentieth
 Century Artists.* New York: Rizzoli International
 Publications, 1986.

Public Documents
Congressional Record. Vol. 8, (June 19, 1943): 7, 164.

Other Sources
The Confederate Memorial Museum, Richmond, Va.
Corcoran Gallery of Art, Washington, D.C.
Department of Naval History, Washington, D.C.
The Frick Art Reference Library, New York, N.Y.
The Historical Society of Pennsylvania, Philadelphia,
 Pa.
Leatherneck Magazine, Quantico, Va.
Library of Congress, Washington, D.C.
The Marine Corps *Gazette,* Quantico, Va.
The Marine Corps Historical Center, U.S. Navy Yard,
 Washington, D.C.
Marine Corps Historical Foundation, Quantico, Va.
The Mariner's Museum, Hampton Roads, Va.
Maryland Historical Society, Baltimore, Md.
Metropolitan Museum of Art, New York, N.Y.
The Museum of American Art, Washington, D.C.
Museum of Fine Arts, Boston, Mass.
National Archives and Records Administration,
 Washington, D.C.
National Gallery of Art, Washington, D.C.
Navy Historical Foundation, Navy Yard, Washington,
 D.C.
The Navy Museum, Navy Yard, Washington, D.C.
New Britain Museum of American Art, New Britain,
 Conn.
New York Public Library, New York, N.Y.
The Peabody Museum of Archaeology, Harvard
 University, Cambridge, Mass.
Public Library of Boston, Boston, Mass.
Smithsonian Institution, Washington, D.C.
U.S. Air Force, Art Section, Pentagon, Washington,
 D.C.
U.S. Air Force Museum, Wright-Patterson AFB, Ohio
U.S. Army Center for Military History, Washington,
 D.C.
United States Coast Guard Academy Museum, New
 London, Conn.
United Stated Marine Corps, History and Museum
 Division, Navy Yard, Washington, D.C.
United States Naval Academy Museum, Annapolis,
 Md.
United States Naval Institute, Annapolis, Md.
United States Naval Institute Proceedings, Annapolis,
 Md.
The Walker Art Gallery, Baltimore, Md.
Yale University Art Gallery, New Haven, Conn.

Exhibition Catalogues
Henderson, Mary S. *Into the Sunlit Splendor: The
 Aviation Art of William S. Phillips.* Smithsonian
 Institution, Washington, D.C., 1987.
National Armed Forces Museum Advisory Board. *The
 Armed Forces of
 the United States as Seen by the Contemporary
 Artist.* Smithsonian Institution, Washington,
 D.C., 1968.
Naval Historical Center. *Your Navy: From the Viewpoint
 of the Nation's Finest Artists.* Naval Historical
 Center, Washington Navy Yard, Washington,
 D.C., 1976.
Simmons, E.H. Brig. Gen., USMC (Ret.). *Every Clime
 and Place…Marines at Home and Abroad: 1974-
 1984.* Marine Corps Museum, Building 58,
 U.S. Navy Yard, Washington, D.C.
World War II Through the Eyes of Thomas Hart Benton.
 Marion Koogler McNay Art Museum, San
 Antonio, Tex., December 7, 1991–
 April 5, 1992.

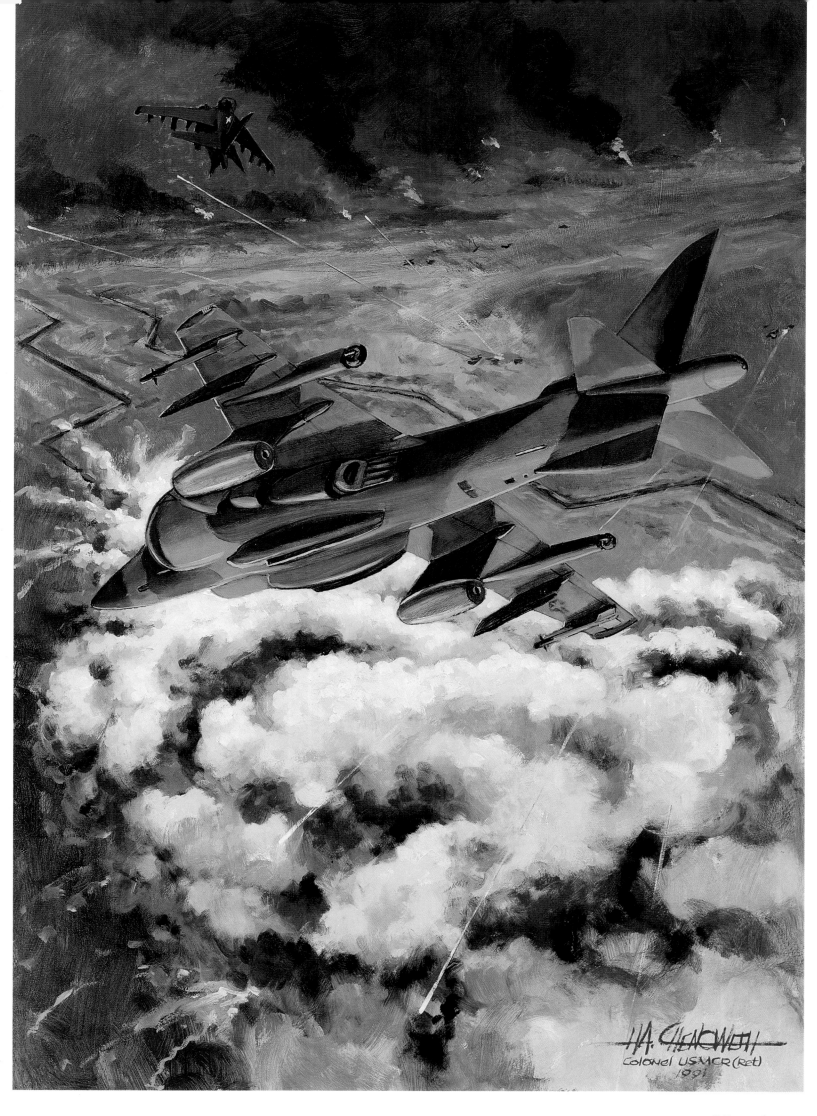

Page 367: With no way to photograph or accompany these AV-8B Harriers in low-level air strikes against Iraqi targets in the burning Kuwaiti oil fields, Chenoweth reconstructed the scene in *Fiery Air Strike* from his own observations.

The versatile Harrier is a British-designed VSTOL ("vertical short takeoff/landing") jet aircraft used only by the U.S. Marine Corps. The relatively small, sub- to transonic fighter is capable of hovering in mid-air, vertical lift-off and descent, has a range of 454 nautical miles, and can carry an assortment of armament, including AIM-9 Sidewinder and AGM-65 Maverick missiles, a 25mm six-barrel gun pod, and external fuel tanks. The Marine Harriers were the most forward-deployed fixed-wing aircraft in the war, operating off LHAs 35 miles (56km) off the Kuwaiti coast.
U.S. Marine Corps Art Collection

Pages 368–369: Author Avery Chenoweth here depicts two Marine pilots, Lt. Col. Tom A. Benes (squadron commander, left) and Capt. Mark Wise, of VMFA-333 ("Trip Tray"), home-based at MCAS Beaufort, South Carolina. They are walking across the Sheik Isa airfield, Bahrain, following a successful bombing run over enemy-held positions in Kuwait during the thirty-two-day air war phase of operation *Desert Storm*.

In the background are an Air Force C-10 cargo plane and F/A-18 Hornets of Beaufort squadrons 333 and 451. Overhead, a flight of two Hornets "breaks" to come into the landing pattern while two A-6E Intruders from VMAQ-2 take off in the distance. Security around the air facility was tight in anticipation of terrorist attacks and sabotage. The holes in the camouflage netting were caused by "friendly fire" (in this case, an accidental discharge from an aircraft's wing missile as it was taxiing). The message painted in red on the two 2000-pound (909kg) MK-84 bombs reads, "To Saddam from 333 wives!" It was one of many such messages that were "mailed" daily to the Iraqi dictator by Marine pilots.
U.S. Marine Corps Art Collection

Page 370: Navy artist Albert K. Murray's forte was portraiture, as *A U.S. Cox'n—Riviera Invasion*, this informal yet poignant study of a sailor in the invasion of southern France, attests. During the war, Murray painted portraits of many leading naval officers and after the war became a leading American portraitist. Of this painting, the artist noted: "Typical of much American youth in the U.S. Navy is Boatswain's Mate First Class C.J. Nelson from Oklahoma, a cox'n on the beachhead of southern France. He is one of three brothers in the Navy. Resourceful, dependable, and possessing a high degree of courage, he is a vital part of the fleet."
U.S. Navy Art Collection

Pages 372–373: Murray's *Loading, Salerno Beach* depicts an Army half-track and crew waiting to be loaded onto an LST at Salerno, Italy, prior to the invasion of southern France. Of the painting, Murray said, "This half-track crew had expected to load their outfit at 0900, but as midday rolled around with still no word, they fixed some chow. It was the old story of waiting and standing in line. The dry and wet runs on the Salerno beach were refreshers for the anticipated French invasion."
U.S. Navy Art Collection

Page 374: In *The Mechs Take Over*, Murray painted a dramatic nighttime scene using all the tricks of lighting at his disposal. Of the image, the artist wrote: "Riding easily from her mast, this 'Z ship' awaits the scaffold being brought over by the mechanics, who will insert it below her engines. Then ordnance men will check her bombs and armament, and gasoline will be taken aboard. In the background another ship glides down to the lighted strip, her own landing light reaching earthward like a finger as she eases into the landing. A truck brings in some gear. In the Navy, hardly any organization is without a mascot, dogs being the great favorite."
U.S. Navy Art Collection

Page 377: Murray portrays an American sentry at a converted Spanish fortress, most likely El Morro, in Puerto Rico, in early 1943. Calling the image *Behind These Walls*, Murray said of the painting: "Behind these walls the German U-boat menace in the Caribbean was brought to a standstill. Built by the Conquistadors to form the heaviest defenses in the New World, these massive fortifications now house the modern efficient joint (Army and Navy) operations control activities that have spelled disaster to the U-boats venturing into Caribbean waters. Air-conditioned, bomb-proofed, and modernized in every way, the fortress carries only a memory of the clank of old Spanish armor in its long underground passages. The station wagon has just brought in the mid-watch. The alert, efficient-looking sentry typifies the activity within."
U.S. Navy Art Collection

Page 379: Murray noted of his *Navy Cooks—In Brazilian Jungle*, painted in mid-1944, "If it is true that an army marches on its stomach, then it may well be said the Navy's lighter-than-air crews fly on theirs. Deep in the Brazilian jungle, just over the equator, lies a strategic operating base. Few USO shows reach into its remoteness, but morale is high and so is this unit's operational record. One of the main factors stems directly from the galley, the fame of which has spread several thousand miles up and down the coast. There is real pride in this shared by all hands. Unglamorous, but capable and efficient, these ship's cooks beside their jungle clearing prepare new evidence of their far-flung reputation."
U.S. Navy Art Collection

Page 381: Stationed briefly in British Guiana in the spring of 1944, Murray participated in a multipurpose exercise along the Essequibo River. Of his *Junglewise—Training and Recreation*, Murray wrote, "Training for survival in the jungle has in this case been nicely joined with needed recreation. With packs of equipment, medical personnel, and emergency field rations, this group is spending many days deep in the jungle. They will visit famed Kaiteur Falls after a long and arduous journey, returning with experience that will enable them to carry on with increased understanding and enthusiasm at their remote base. Much of the journey is made by boat over the numerous jungle streams. Just after dawn, they are here about to push off to a new portage around rapids."
U.S. Navy Art Collection

Pages 382–383: In Murray's *First Flour to Reach Southern France*, a U.S. Liberty Ship unloads supplies onto the decks of the smaller boats in St. Tropez harbor, protected from low-flying enemy aircraft by tethered barrage balloons. "Tremendous was the ovation received by our troops in southern France. Equally tremendous was the reception accorded each truckload of flour arriving in various cities from the Liberty Ship, the SS William D. Pender. Great cheers would rise as these vehicles appeared. They were old French charcoal-burning wrecks with such mountainous loads of flour that they seemed about ready to cave in. Many ships did get stalled in fords bypassing blown-out bridges, but were hauled out by GI trucks. LCTs worked around the clock getting the flour ashore at St. Tropez."
U.S. Navy Art Collection

Page 384: Murray was able to observe directly the preparations for the invasion of southern France mounted from Salerno, part of which he portrayed in *Loading Engineers—Salerno*. "These were veteran troops whose mission in the amphibious team was a vital one," Murray wrote. "They would clean off the mines from the beach, peg down wire-burlap road beds for vehicles, run bulldozers, blow out antitank walls and other barricades, salvage stalled vehicles and ships, assist in unloading, tape off mine fields, and generally help keep things rolling on and off the beachhead."
U.S. Navy Art Collection

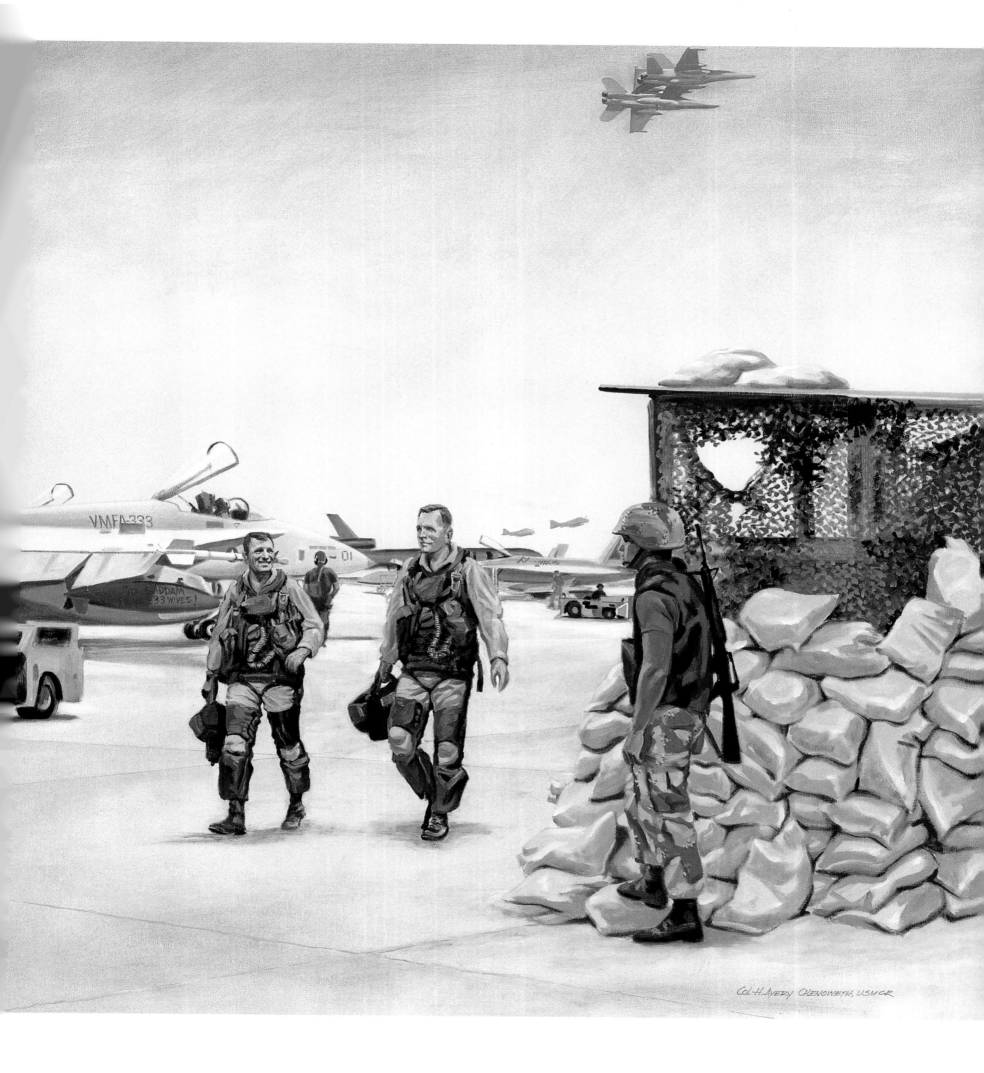

Col H. Avery Chenoweth, USMCR

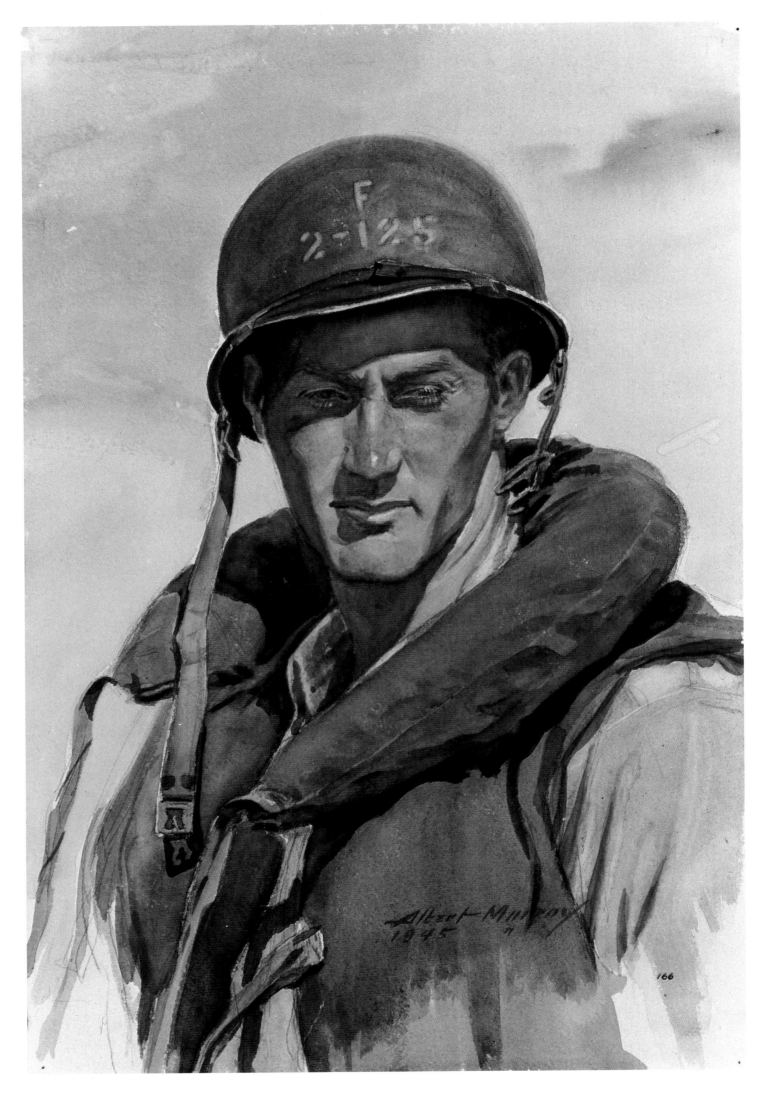

Index

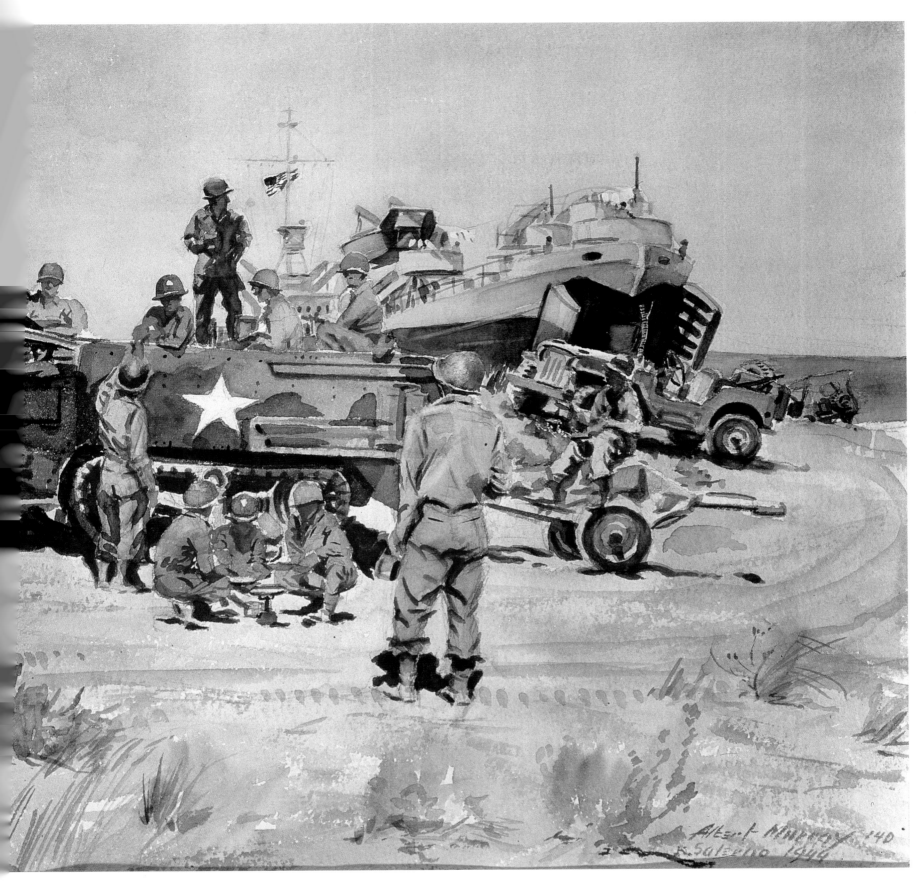

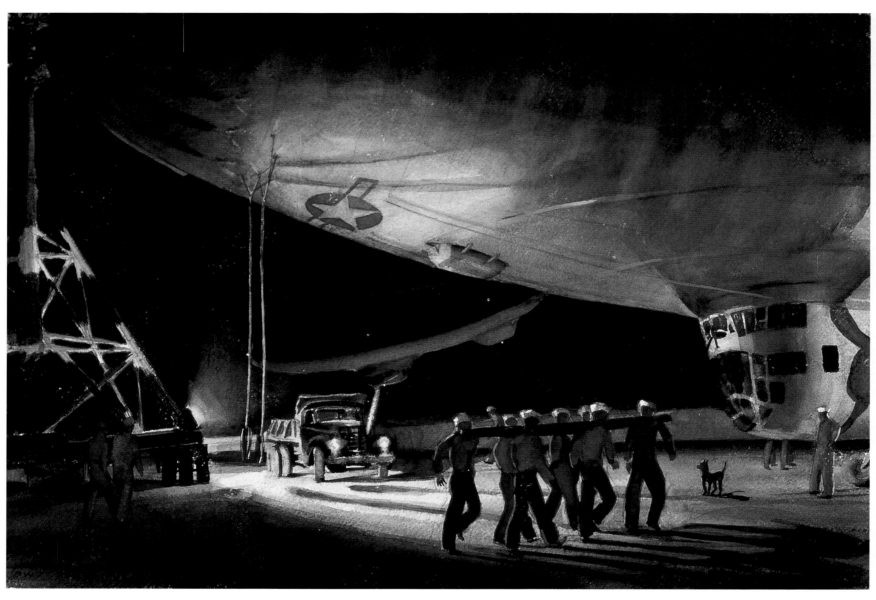

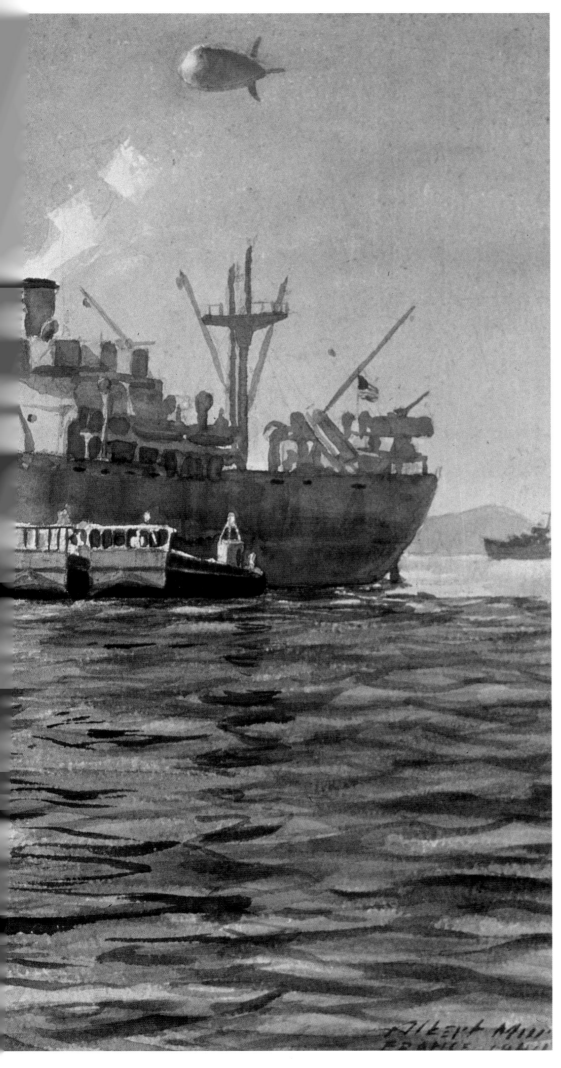